THE AGES OF MAN

THE AGES OF MAN

MEDIEVAL INTERPRETATIONS

OF THE LIFE CYCLE ❧ *Elizabeth Sears*

PRINCETON UNIVERSITY PRESS

157297

Copyright © 1986 by Princeton University Press

Published by Princeton University Press, 41 William
Street, Princeton, New Jersey 08540

In the United Kingdom: Princeton University Press,
Guildford, Surrey

All Rights Reserved

Library of Congress Cataloging in Publication Data will
be found on the last printed page of this book

ISBN 0-691-04037-0

This book has been composed in Linotron Bembo type

Clothbound editions of Princeton University Press books
are printed on acid-free paper, and binding materials
are chosen for strength and durability

Printed in the United States of America by Princeton
University Press, Princeton, New Jersey

To William S. Heckscher

CONTENTS

List of Illustrations, ix List of Abbreviations, xv Preface, xvii

INTRODUCTION 3

PART ONE

I. THE SEASONS OF LIFE 9
Pythagorean Roots, 10 The Cosmological System in Greek
Antiquity, 12 The Tetradic Diagram, 16 Quaternaries in Medieval
Arithmology, 20 Humoral Theory, 25 The Computistical Context, 31

II. SEVENS IN THE LIFE CYCLE 38
Antique Septenary Speculation, 39 Septenary Cycles in Medieval
Thought, 44 The Seven Ages and the Seven Planets, 47

III. THE AGES OF MAN AND THE AGES OF WORLD HISTORY 54
Augustine's Exegesis of the Days of Creation, 55 The Diffusion of the
Six-Age Scheme, 58 Interpretations of the Six Vessels at Cana, 69
The Ages of Man in the Bible Moralisée, 74

IV. TIMES OF CONVERSION IN THE HUMAN LIFE 80
Interpretations of the Parable of the Workers in the Vineyard, 80
Variations on the Theme, 88 The Three Magi as the Ages of Man, 90

PART TWO

V. POPULAR COSMOLOGY 97
A Doctor and a Moralist on the Four Ages of Man, 99 Trecento
Poets Describe the Course of Life, 103 The Rule of the Planetary
Gods, 107 Cycles of the Twelve Ages and Twelve Months, 113

VI. THE AGES OF MAN IN THE PREACHER'S REPERTORY 121
Exegetical Thought Popularized, 122 Entries on the Ages of Man in
Preachers' Compendia, 124

VII. THE MORALIZED LIFE IN IMAGES 134
Series of the Seven Ages, 134 Some English Accounts of Life's
Passage, 137 The Tree of Wisdom, 140 Wheels of Life, 144 Trees
of Life, 151 Steps of Life, 153

Notes, 157 Bibliography, 207 Index of Manuscripts, 221
Index, 225 Plates, 237

157297

ILLUSTRATIONS

1. Paris, Bibliothèque Nationale, ms. lat. 6400 G (Isidore, *Liber de natura rerum*), fol. 122v, tetradic diagram. Photo: Bibliothèque Nationale.
2. Biblioteca Apostolica Vaticana, cod. Pal. lat. 1581 (Remigius [?], Commentary on Boethius, *Consolatio philosophiae*), fol. 35r, tetradic diagram. Photo: Foto Biblioteca Vaticana.
3. Paris, Bibliothèque Nationale, ms. lat. 12999, fol. 7r, tetradic diagram. Photo: Bibliothèque Nationale.
4. Ghent, Universiteitsbibliotheek, ms. 92 (Lambert of St. Omer, *Liber floridus*), fol. 228v, tetradic diagram. Photo: Universiteitsbibliotheek, Ghent.
5. Anagni, Cathedral, vault of bay in crypt, tetradic diagram with busts of the four ages of man. Photo: Conway Library, Courtauld Institute of Art.
6. Cambridge, Gonville and Caius College, ms. 428 (*Tractatus de quaternario*), fol. 28v, tetradic diagram with figures of the four ages of life. Photo: Gonville and Caius College, by permission of the Masters and Fellows.
7. Paris, Bibliothèque Nationale, ms. lat. 11130 (William of Conches, *Philosophia mundi*), fol. 48r, tetradic diagram. Photo: Bibliothèque Nationale.
8. Oxford, Bodleian Library, ms. lat. Misc. e. 2 (Johannicius, *Isagoge ad Tegni Galieni*), fol. 3r, tetradic diagram. Photo: Bodleian Library.
9. Oxford, Bodleian Library, ms. Ashmole 328 ("Byrhtferth's Manual"), p. 85, tetradic diagram. Photo: Bodleian Library.
10. Oxford, St. John's College, ms. 17 ("Ramsey Computus"), fol. 7v, "Byrhtferth's Diagram." Photo: St. John's College.
11. London, British Library, ms. Harley 3667 ("Peterborough Computus"), fol. 8r, "Byrhtferth's Diagram." Photo: British Library.
12. Dijon, Bibliothèque Publique, ms. 448, fol. 8or, tetradic diagram. Photo: Bibliothèque Publique de Dijon.
13. New York Public Library, ms. 69 (John of Sacrobosco, *Computus ecclesiasticus*), fol. 38v, tetradic diagram. Photo: New York Public Library, Rare Books and Manuscripts Division, Astor, Lenox and Tilden Foundations.
14. Montecassino, Monastery Library, ms. 132 (Hrabanus Maurus, *De naturis rerum*), p. 150, the six ages of man. Photo: Monastery Library, Montecassino.
15. Biblioteca Apostolica Vaticana, cod. Pal. lat. 291 (Hrabanus Maurus, *De naturis rerum*), fol. 68r, the six ages of man. Photo: Foto Biblioteca Vaticana.
16. Ghent, Universiteitsbibliotheek, ms. 92 (Lambert of St. Omer, *Liber floridus*), fol. 20v, diagram of the six ages of the world. Photo: Universiteitsbibliotheek, Ghent.
17. Wolfenbüttel, Herzog August Bibliothek, cod. Guelf. 1 Gud. lat. (Lambert of St. Omer, *Liber floridus*), fol. 31r, hexadic diagrams. Photo: Herzog August Bibliothek.
18. Canterbury, Cathedral, north choir aisle, the Miracle at Cana, the six ages of the world, and the six ages of man. Photo: National Monuments Record, London.
19. Canterbury, Cathedral, north choir aisle, detail: the six ages of man. Photo: author.

20. Toledo Cathedral (*Bible moralisée*), vol. III, fol. 21r, upper right, the six hydriae and the six ages. Photo: Foto Mas, Barcelona.

21. London, British Library, ms. Harley 1527 (*Bible moralisée*), fol. 23r, lower right, the six hydriae and the six ages. Photo: British Library.

22. Paris, Bibliothèque Nationale, ms. fr. 167 (*Bible moralisée*), fol. 251r, lower left, the six hydriae and the six ages. Photo: Bibliothèque Nationale.

23. London, British Library, ms. Harley 1527 (*Bible moralisée*), fol. 5r, upper right, Zacharias and Elizabeth and the five ages with Moses. Photo: British Library.

24. Paris, Notre-Dame, Portal of the Virgin, the six ages of man. Photo: author.

25. London, British Library, ms. Add. 28106 ("Stavelot Bible"), fol. 6r, Genesis initial. Photo: British Library.

26. Vienna, Österreichische Nationalbibliothek, cod. 2739★, fol. 4v, Noah, the third hour, and *adolescentia*. Photo: Österreichische Nationalbibliothek.

27. Vienna, Österreichische Nationalbibliothek, cod. 2739★, fol. 10v, Abraham, the sixth hour, and *iuventus*. Photo: Österreichische Nationalbibliothek.

28. Vienna, Österreichische Nationalbibliothek, cod. 2739★, fol. 11v, Moses, the ninth hour, and *senectus*. Photo: Österreichische Nationalbibliothek.

29. Vienna, Österreichische Nationalbibliothek, cod. 2739★, fol. 12v, Christ, the eleventh hour, and *etas decrepita*. Photo: Österreichische Nationalbibliothek.

30. Parma, Baptistery, right jamb of west portal, Parable of the Workers in the Vineyard. By Benedetto Antelami. Photo: Conway Library, Courtauld Institute of Art.

31. Stuttgart, Württembergische Landesbibliothek, Bibl. fol. 23 ("Stuttgart Psalter"), fol. 84r, the three Magi. Photo: Bildarchiv Foto Marburg.

32. Klosterneuburg Altar, the three Magi. By Nicholas of Verdun. Photo: Chorherrenstift Klosterneuburg.

33. Paris, Bibliothèque Nationale, ms. fr. 12323 (Aldobrandinus of Siena, *Le régime du corps*), fol. 99r, the four ages of man. Photo: Bibliothèque Nationale.

34. Biblioteca Apostolica Vaticana, cod. Reg. lat. 1256 (Aldobrandinus of Siena, *Le régime du corps*), fol. 42v, the four ages of man. Photo: Foto Biblioteca Vaticana.

35. Paris, Bibliothèque Nationale, ms. fr. 12581 (Philippe de Novarre, *Des IV tenz d'aage d'ome*), fol. 387r, first of the four ages of man. Photo: Bibliothèque Nationale.

36. Paris, Bibliothèque Nationale, ms. fr. 12581 (Philippe de Novarre, *Des IV tenz d'aage d'ome*), fol. 390r, second of the four ages of man. Photo: Bibliothèque Nationale.

37. Paris, Bibliothèque Nationale, ms. fr. 12581 (Philippe de Novarre, *Des IV tenz d'aage d'ome*), fol. 395r, third of the four ages of man. Photo: Bibliothèque Nationale.

38. Paris, Bibliothèque Nationale, ms. fr. 12581 (Philippe de Novarre, *Des IV tenz d'aage d'ome*), fol. 401v, fourth of the four ages of man. Photo: Bibliothèque Nationale.

39. Biblioteca Apostolica Vaticana, cod. Barb. lat. 4076 (Francesco da Barberino, *I documenti d'amore*), fol. 79v, tetradic diagram. Photo: Foto Biblioteca Vaticana.

40. Biblioteca Apostolica Vaticana, cod. Barb. lat. 4076 (Francesco da Barberino, *I documenti d'amore*), fol. 76v, the hours of the day and the ages of life. Photo: Foto Biblioteca Vaticana.

41. Biblioteca Apostolica Vaticana, cod. Barb. lat. 4076 (Francesco da Barberino, *I documenti d'amore*), fol. 77r, the hours of the day and the ages of life. Photo: Foto Biblioteca Vaticana.

42. Foligno, Palazzo Trinci, the Moon, an hour of the day, and the seventh age of life. Photo: author.

43. Venice, Palazzo Ducale, exterior arcade, capital, the first and second of the seven ages of man under planetary influence. Photo: author.

44. Venice, Palazzo Ducale, exterior arcade, capital, the seventh of the seven ages of man and death. Photo: author.

45. Padua, Church of the Eremitani, choir, the Moon and the first age of life. By Guariento. Photo: Museo Civico di Padova.

46. Padua, Church of the Eremitani, choir, Venus and the third age of life. By Guariento. Photo: Museo Civico di Padova.

47. Padua, Church of the Eremitani, choir, Mars and the fifth age of life. By Guariento. Photo: Museo Civico di Padova.

48. Padua, Church of the Eremitani, choir, Saturn and the seventh age of life. By Guariento. Photo: Museo Civico di Padova.

49. Oxford, Bodleian Library, ms. Can. Misc. 554, fol. 171r, the Moon and the first age of life. Photo: Bodleian Library.

50. Modena, Biblioteca Estense, ms. lat. 697 (α. W. 8. 20) (*Liber physionomie*), fol. 4v, the Moon and the first age of life. Photo: Biblioteca Estense.

51. Modena, Biblioteca Estense, ms. lat. 697 (α. W. 8. 20), (*Liber physionomie*), fol. 7v, Saturn and the final age of life. Photo: Biblioteca Estense.

52. London, British Library, ms. Add. 16578, fol. 52r, the Moon. Photo: British Library.

53. Vienna, Österreichische Nationalbibliothek, cod. 2642 (Boethius, *Consolatio philosophiae* in French translation with gloss), fol. 33r, schema of the elements and tetradic diagram. Photo: Österreichische Nationalbibliothek.

54. Paris, Bibliothèque de l'Arsenal, ms. 3516 (Gossuin of Metz, *Image du monde*), fol. 179r, tetradic diagram. Photo: Bibliothèque Nationale.

55. Paris, Bibliothèque de l'Arsenal, ms. 1234 (roll), tetradic diagram. Photo: Bibliothèque Nationale.

56. New York, Pierpont Morgan Library, ms. M. 813 (Book of Hours), fol. 2v, the first age of man (January). Photo: Pierpont Morgan Library.

57. New York, Pierpont Morgan Library, ms. M. 813 (Book of Hours), fol. 19r, the twelfth age of man (December). Photo: Pierpont Morgan Library.

58. Madrid, Biblioteca Nacional, cod. Vit. 24-3 (Book of Hours), p. 7, a bad and a good man at the fifth of twelve ages (May). Photo: Biblioteca Nacional.

59. Madrid, Biblioteca Nacional, cod. Vit. 24-3 (Book of Hours), p. 14, a bad and a good man at the last of twelve ages (December). Photo: Biblioteca Nacional.

60. Dublin, Chester Beatty Library, ms. 80 (Jean Raynaud, "Viridarium"), fol. 6v, first of the six ages of man. Photo: Chester Beatty Library.

61. Dublin, Chester Beatty Library, ms. 80 (Jean Raynaud, "Viridarium"), fol. 7r, five of the six ages of man. Photo: Chester Beatty Library.

62. London, British Library, ms. Add. 11390 (Jacob van Maerlant, *Der naturen bloeme*), fols. 1v-2r, six ages of man and death. Photo: British Library.

63. Baltimore, Walters Art Gallery, ms. 171 (Dirc van Delf, *Tafel van den Kersten Ghelove*), fol. 30r, the seven ages of man. Photo: Walters Art Gallery.

64. Baltimore, Walters Art Gallery, ms. 171 (Dirc van Delf, *Tafel van den Kersten Ghelove*), fol. 32v, the seven ages of the world. Photo: Walters Art Gallery.

65. Munich, Bayerische Staatsbibliothek, clm. 19414, fol. 180r, five ages of man. Photo: Bayerische Staatsbibliothek.

66. London, British Library, ms. Royal 6 E. VII (Jacobus, "Omne bonum"), fol. 67v, children at play. Photo: British Library.

67. Paris, Bibliothèque Nationale, ms. fr. 22531 (Bartholomaeus Anglicus, *De proprie-*

tatibus rerum in French translation), fol. 99v, four ages of man. Photo: Bibliothèque Nationale.

68. Paris, Bibliothèque Nationale, ms. fr. 9141 (Bartholomaeus Anglicus, *De proprietatibus rerum* in French translation), fol. 98r, six ages of man. Photo: Bibliothèque Nationale.

69. Minneapolis, University of Minnesota, James Ford Bell Library, 1400/f Ba (Bartholomaeus Anglicus, *De proprietatibus rerum* in French translation) [not foliated], seven ages of man and death. Photo: James Ford Bell Library.

70. Paris, Bibliothèque Nationale, ms. lat. 8846, fol. 161r, the seven ages of man illustrating Psalm 89 (90). Photo: Bibliothèque Nationale.

71. Foligno, Palazzo Trinci, corridor, first of the seven ages of man. Photo: Warburg Institute.

72. Foligno, Palazzo Trinci, corridor, fourth of the seven ages of man. Photo: Warburg Institute.

73. Foligno, Palazzo Trinci, corridor, sixth of the seven ages of man. Photo: Warburg Institute.

74. Foligno, Palazzo Trinci, corridor, seventh of the seven ages of man. Photo: Warburg Institute.

75. Siena, Cathedral, pavement, the seven ages of man [reconstruction]. By Antonio Federighi. Photo: author.

76. Siena, Cathedral, pavement (transferred to the Museo dell'Opera del Duomo), second of the seven ages of man. By Antonio Federighi. Photo: author.

77. Siena, Cathedral, pavement (transferred to the Museo dell'Opera del Duomo), third of the seven ages of man. By Antonio Federighi. Photo: author.

78. Longthorpe Tower (Northants.), north wall, the seven ages of man. Photo: Department of the Environment, London (British Crown Copyright).

79. New York, Pierpont Morgan Library, ms. G. 50 (Book of Hours), fol. 29r, lauds and the second age of life. Photo: Pierpont Morgan Library.

80. New York, Pierpont Morgan Library, ms. G. 50 (Book of Hours), fol. 68r, none and the sixth age of life. Photo: Pierpont Morgan Library.

81. London, British Library, ms. Add. 37049, fols. 28v–29r, "Of the Seuen Ages." Photo: British Library.

82. Paris, Bibliothèque de l'Arsenal, ms. 1037, fol. 5v, Tree of Wisdom. Photo: Bibliothèque Nationale.

83. New Haven, Yale University, Beinecke Rare Book and Manuscript Library, ms. 416, fol 6r, Tree of Wisdom. Photo: Beinecke Rare Book and Manuscript Library.

84. Paris, Bibliothèque Nationale, ms. fr. 9220 ("Vrigiet de solas"), fol. 16r. Tree of Wisdom. Photo: Bibliothèque Nationale.

85. London, Wellcome Institute for the History of Medicine, ms. 49, fol. 69v, Tree of Wisdom. Photo: Wellcome Institute Library.

86. Cambridge, Fitzwilliam Museum, ms. 330, no. 4, Wheel of Fortune. By William de Brailes. Photo: Fitzwilliam Museum.

87. London, British Library, ms. Arundel 83 ("Psalter of Robert De Lisle"), fol. 126v, Wheel of Life. Photo: British Library.

88. Dublin, Trinity College Library, cod. 347, fol. 1r, Wheel of Life. Photo: Trinity College.

89. Kempley (Glos.), Church of St. Mary, north wall of nave, Wheel of Life. Photo: National Monuments Record, London.

90. London, British Library, ms. Arundel 83 ("Psalter of Robert De Lisle"), fol. 126r, *Duodecim proprietates condicionis humane*. Photo: British Library.

91. London, Wellcome Institute for the History of Medicine, ms. 49, fol. 30v, Wheel of Life. Photo: Wellcome Institute Library.
92. Munich, Bayerische Staatsbibliothek, cgm. 312, fol. 98r, Wheel of Life. Photo: Bayerische Staatsbibliothek.
93. Lilienfeld, Stiftsbibliothek, cod. 151 (Ulrich of Lilienfeld, *Concordantia caritatis*), fol. 257v, tree of the twelve ages of life. Photo: Stiftsbibliothek, Lilienfeld.
94. Lilienfeld, Stiftsbibliothek, cod. 151 (Ulrich of Lilienfeld, *Concordantia caritatis*), fol. 258r, tree of the twelve ages of life. Photo: Stiftsbibliothek, Lilienfeld.
95. New York, Pierpont Morgan Library, ms. M. 1045 (Ulrich of Lilienfeld, *Concordantia caritatis*), fol. 258v, tree of the twelve ages of life. Photo: Pierpont Morgan Library.
96. New York, Pierpont Morgan Library, ms. M. 1045 (Ulrich of Lilienfeld, *Concordantia caritatis*), fol. 259r, tree of the twelve ages of life. Photo: Pierpont Morgan Library.
97. Florence, Biblioteca Medicea Laurenziana, ms. Plut. 42-19 (Brunetto Latini, *Tesoro*), fol. 96r, tree of the ages of life. Photo: Biblioteca Medicea Laurenziana.
98. British Museum, Steps of Life. By Jörg Breu the Younger. Photo: Warburg Institute.

ABBREVIATIONS

ACW	Ancient Christian Writers.
AHDLMA	*Archives d'histoire doctrinale et littéraire du Moyen Âge.* Paris, 1926ff.
BT	Bibliotheca scriptorum graecorum et romanorum Teubneriana.
CCAG	Catalogus codicum astrologorum graecorum. Brussels, 1898-1953.
CCL	Corpus christianorum, Series latina. Turnhout, 1953ff.
CMG	Corpus medicorum graecorum. Leipzig and Berlin, 1908ff.; Berlin, 1947ff.
CSEL	Corpus scriptorum ecclesiasticorum latinorum. Vienna, 1866ff.
Dekkers, *Clavis*	Eligius Dekkers. *Clavis Patrum latinorum.* 2nd. ed. Steenbrugge, 1961.
Diels, *Fragmente*	Hermann Diels. *Die Fragmente der Vorsokratiker.* 11th ed. Zurich and Berlin, 1964.
EETS, o.s.	Early English Text Society, original series. London, 1864ff.
EETS, e.s.	Early English Text Society, extra series.
FC	Fathers of the Church.
GCS	Die griechischen christlichen Schriftsteller der ersten drei Jahrhunderte. Leipzig, 1897ff.
GRLMA	Grundriss der romanischen Literaturen des Mittelalters.
LCL	Loeb Classical Library.
MGH	Monumenta Germaniae historica.
PG	J.-P. Migne. Patrologiae cursus completus, Series graeca. Paris, 1857-1866.
PL	J.-P. Migne. Patrologiae cursus completus, Series latina. Paris, 1844-1864.
SC	Sources chrétiennes. Paris, 1941ff.
Schaller-Könsgen, *Initia*	Dieter Schaller and Ewald Könsgen. *Initia carminum latinorum saeculo undecimo antiquiorum.* Göttingen, 1977.
Thorndike-Kibre, *Incipits*	Lynn Thorndike and Pearl Kibre. *A Catalogue of Incipits of Mediaeval Scientific Writings in Latin.* Rev. ed. Cambridge, Mass., 1963.
Walther, *Initia*	Hans Walther. *Initia carminum ac versuum medii aevi posterioris latinorum.* Göttingen, 1959.
Walther, *Proverbia*	Hans Walther. *Proverbia sententiaeque latinitatis medii aevi.* Göttingen, 1963-1969.

PREFACE

THE SUBJECT of this study is the human life cycle as it was described and interpreted by artists and writers of the Middle Ages. Its focus is narrow, if its range is broad, for the theme of the ages of man, *aetates hominum*, was well and precisely defined. Medieval thinkers, like their antique forebears, understood the periodization of life to be an issue. They defended several different systems of age division, but in all their descriptions followed a set formula. Proceeding from birth and infancy to decline and death, they duly considered each phase in turn. Medieval artists similarly portrayed the stages of life in the most systematic manner conceivable. By the early Middle Ages the convention had been established that each age in sequence should be represented by the figure of a man (or, very rarely, a woman) who revealed his age through physical appearance and attributes or action. The subject was a popular one. Evidence for interest is wonderfully forthcoming. The authoritative systems were studied in the medieval schools. And when school learning was made available to a wider audience in the later Middle Ages, the theme came to have an important place in popular art and literature.

Recent decades have seen renewed interest in the life cycle. Not only have historians of childhood and the family turned their attention to the theme, but biologists, anthropologists, sociologists, and psychologists have charted the progress of human development according to criteria proper to their disciplines. Their work, perhaps, makes us more sensitive to medieval efforts to interpret the same complicated phenomenon. Erik Erikson, to name an influential commentator on life's course, has defined eight ages of man. The number eight is one no medieval scholar would have chosen; "psychosocial" growth is an alien concept. But when Professor Erikson aligns the ages with certain strengths or "virtues," the last being wisdom, one feels on familiar ground. As the present study seeks to operate within medieval structures of knowledge, explicit comparisons between past and present views will not be drawn. Yet it is rather to be hoped that a reader might seek to discover whether the Middle Ages had an equivalent concept of "middle age," or "second childhood," or even "childhood" itself (as some have denied), whether youth held the same preeminent place it has today, whether old age was so little favored. The answer to these questions, one may suggest, will not be straightforward.

As I have devoted at least an age of my own life to this project, I have had time to amass a great many debts of kindness. The book began as a doctoral

dissertation, submitted to the Department of the History of Art at Yale University in 1982. I would like to thank the institutions which supported my research at that time. The Samuel H. Kress Foundation awarded me a fellowship of two years' duration to the Warburg Institute, University of London. It was a great privilege to have daily access to that unique scholars' library with its suggestive ordering of books and its ceaselessly changing group of international visitors. A grant from the Wellcome Trust enabled me to remain in London as a fellow of the Wellcome Institute for the History of Medicine, to work in another intriguing library, rich in resources. Generous funding from these foundations, and more recently from Princeton University, has allowed me to examine monuments and manuscripts in France, Spain, Germany, Austria, and Italy, as well as England and America. I would like to thank the staffs of the institutions whose works appear in this study for allowing me access to their holdings and, in many cases, for arranging that photographs be made. Finally I must thank the Department of Art and Archaeology at Princeton for having subsidized the expense of preparing the manuscript for publication, through the Ione May Spears Fund and the Publications Fund, and for having granted me a leave so that I might revise the text.

Many individuals have offered valuable counsel and advice in the course of my research and writing. I am grateful to my principal dissertation advisor, Professor Walter Cahn, who first suggested the topic, to Dr. Michael Evans at the Warburg Institute, and to Dr. Vivian Nutton at the Wellcome Institute for their conscientious critical readings of the initial version of the text. Professor Alan Nelson at Berkeley and Professor John Burrow at Bristol, both engaged in the study of the ages of man from the standpoint of medieval English literature, very kindly shared their ideas with me. Professor Friedrich Ohly, Dr. Heinz Meyer, and Dr. Christel Meier gave generously of their time during a productive visit I made to Münster. Professor Karl-August Wirth in Munich has supplied a fund of information and advice over the years, for which I am particularly grateful. Nor can I fail to thank my friend and mentor, Professor William S. Heckscher, who led me into iconographical study even as an undergraduate and who has, since then, been a constant source of inspiration and support and, more tangibly, of bibliographical references. There are many others whose help I am happy to acknowledge. I can but name David d'Avray, Christopher Baswell, Adelaide Bennett, J. Bruce Breckenridge, Peter Brown, Charles Burnett, Almuth Seebohm Désautels, Ana Domínguez Rodríguez, Gunar Freibergs, Peter Godman, Anthony Grafton, Monica Green, Jill Kraye, Kristen Lippincott, Charles McClendon, James Marrow, Walter Melion, Nigel Morgan, Lowry Nelson, Barbara Newman, Per Gunau Ottosson, Alison Peden, Robert J. van Pelt, John Plummer, J. J. Pollitt, Lucy Sandler, Shari Taylor, Frances Terpak, Joseph Trapp, and Roger Ward.

THE AGES OF MAN

INTRODUCTION

HE EARLY Middle Ages had a list of seven things not to be found in this world, only to be found in the heavenly kingdom. Never could there be "life without death, youth without age, light without darkness, joy without sorrow, peace without discord, will without wrong, a kingdom without change."[1] Desirable conditions are deemed evanescent; time brings change. Notably youth, like life itself, is aligned with the good, age with the bad. A mysterious process, if a fundamental feature of human existence after the Fall, aging seemed to demand definition and explication. God had made man the focal point of an ordered world. The structure of human life, the number and duration of its phases, this implied, could not be arbitrary. To discover the harmonious pattern of human development was to learn something vital about man and, by extension, about the universe. It was also to gain insight into the purpose of life and, thus, into kinds of conduct which might ensure the well-being of body and soul.

Many different systems of age division were formulated over time, the roots of some to be sought in remote antiquity, the origins of others to be located in the medieval centuries. Once codified, the schemes tended to endure, the ordered vision of life they presented proving powerfully attractive. Writers and artists passed on the received wisdom, transmission following definable, if complicated, routes. Given schemes were associated with particular spheres of thought: natural philosophical works described different systems than did, say, exegetical tracts. Even if the number of ages happened to coincide, the cast of observations differed markedly. All this has a bearing upon the way one approaches the material.

Scholarly practice in the past, by and large, has been to impose a numerical ordering on collected material. Life itself, youth and age, and the three-, four-, five-, six-, seven-, ten-, and twelve-part schemes have been treated in succession. German scholars of the nineteenth century first used the scheme, finding in it a means of organizing the references which they had culled from Greek, Latin, and German texts.[2] Franz Boll, whose lengthy article "Die Lebensalter" appeared in 1913, employed the structure to advantage.[3] As the author of classic studies on astrology and contributor of the entry on the hebdomad to Pauly-Wissowa's *Real-Encyclopädie*, he placed particular emphasis on the role of cosmological speculation and number symbolism in the genesis of the systems. The range of primarily antique references to the theme which he assembled

remains impressive, unsurpassed in fact. No writer after him has undertaken anything so comprehensive, if more specialized studies of value have been produced. Art historians, too, have adopted the numerical organizational form, and not only in iconographical reference works. When, for example, Samuel C. Chew turned his attention to Renaissance works, he discussed the bridge, stairway, and circle of life and then proceeded from the three to the twelve ages of man.[4] Suse Barth, in a doctoral thesis concerning representations of the ages of life in nineteenth- and twentieth-century art, briefly surveyed the principal age divisions by number.[5] The form seems harmless enough, but it has affected interpretation. E. Eyben, in an important article on the divisions of life in Roman antiquity, gathered lists of terms employed by Roman writers to describe the three, four, five, six, and seven ages of man.[6] No longer a convenient armature for organizing information, numerical progression has become a key to historical development: the three-part division of life is said to have evolved from the polarity between youth and age, as Boll had suggested, and the four-, five-, and six-age systems to have been produced, in time, by a further division of each of the three primary ages.

Another kind of ordering is adopted in the present study. The effort has been to draw connections and make alignments suggested by the primary material itself, the criteria being such factors as the context in which a given age scheme was described, its sources, the motivations for its use, the function which it served. In sharpening the structure, it proved useful to consider the evidence in relation to medieval schemes of the divisions of knowledge and the medieval school curriculum. Certain lines of thought seemed to emerge, traditions, one may call them, so long as one avoids the model of an underground stream which surfaces periodically. Surviving manuscripts make plain that inherited ideas about the ages of man were revived repeatedly, that respected texts were copied and quoted often, that well-established schemes of age division were illustrated many times.

In settling upon an organizing armature, the aim was to balance thematic, chronological, and regional factors. Themes govern the chapters; chronology helps to determine the order of treatment within each; regional groupings are made when material permits. Broadly speaking, one progresses from schemes born in natural philosophy to those nurtured in scriptural exegesis and in moralizing art and literature. The sequence, which might be said to imitate the medieval progression from literal to figurative, is followed twice. For the study is divided into two parts on chronological grounds. In the first, which extends through the twelfth century, the monastic and cathedral schools provide the setting, and the chief issue is the redefinition of the classical and patristic heritage. Each chapter begins later in time than the one before, the advantage being that the influence of one system or one kind of thinking on the genesis

of another can be closely followed. In the second part the primary sources date from the thirteenth to the fifteenth century. This is, of course, the time which saw a great dissemination of knowledge with the foundation of the universities, the establishment of the mendicant orders, and the increased use of the vernacular tongues; it is bracketed by the rise of printing. The principal issue in this section is the manner in which inherited school learning on the ages of man was adapted to new purposes in a changing intellectual climate.

Conclusions are based on the evidence of both texts and images, though particular weight is placed on pictorial documents. The study, in fact, began as an attempt to provide an apparatus for looking at the corpus of imagery. Comparisons between the two modes of description are revealing. Given texts and images can be shown to correspond in structure, that is, in the numbering and naming of the ages and in the correlations drawn between the ages and other sets of ideas. There is sometimes, too, an interesting give and take in characterizations of the individual phases of life. Yet writers and artists worked within conventions proper to their own disciplines. One will discover that artists made use of a relatively small repertory of forms, independently conceived. They drew distinctions between the different ages of man through physical characteristics—size, posture, the length and color of hair, the presence or absence of beard—and through costume and attribute: whip tops and other toys, bows and arrows, writing tablets, mirrors, falcons, flowering branches, scepters, swords and shields, axes, money bags, spindles and distaffs, rosaries, books, crutches, and other items were given to appropriate figures. Certain stock characters were created—the swaddled baby, the frolicsome child, the youthful falconer, the military man in his prime, the prosperous older man, and the very elderly man bent over a stick among them—and these were used time and time again, painters and sculptors combining them to form shorter and longer cycles as context demanded.

The amassing of primary documents, textual and pictorial, represented a critical first stage in the proceedings. In undertaking the project one had in addition to the comprehensive studies already mentioned—works which more or less bypass the Middle Ages—a number of useful motif studies. Those devoted to the correlation between the ages of man and the ages of the world were, perhaps, the most important of these.[7] Monographic treatments of individual literary works and pictorial programs supplied often valuable commentary and suggestions for further research. Reference works of various types provided lists of texts and images under the headings, the "Ages of Man," "Les âges de l'homme," "Die Lebensalter." Manuscript catalogues suggested leads for research while traveling. Public indexes and photographic collections—the Institut de Recherche et d'Histoire des Textes in Paris, the Index of Christian Art in Princeton, the Warburg Institute's Photographic Collection,

and that at the Conway Library in the Courtauld Institute—made available otherwise untraceable material. One can only hope that the sampling of documents which resulted, a large one, is indeed a representative one.

It should be frankly stated at the outset that the theme of the ages of man was a bookish one. The divisional systems, articles of knowledge, were passed on in the schools. Each scheme described an ideal life. No one ever died before seventy, no matter what life expectancy might have been in the society at large. Historical circumstances changed, but the schemes lived on, slowly adapting as new functions were imposed upon them. Their study is a problem in the history of ideas. For the life cycle, like other natural phenomena, was given learned interpretation in the Middle Ages. It was found to contain salutary lessons. The descriptions of the ages of man introduced in the following pages do not mirror medieval life so much as they reflect medieval meditations, conscious and deliberate, on the nature and meaning of human existence.

PART ONE

I. THE SEASONS OF LIFE

THE PROCESS of aging reveals itself most unequivocally, perhaps, in physical change. External appearances and bodily capacities alter dramatically in time. The medieval natural philosopher recognized this, observing that man, like the plants and animals, passes through a predictable sequence of phases in his life: born small, he grows to reach physical perfection before commencing his decline. Yet the Christian philosopher knew, too, that man was made in the image of God (Gen. 1:27), that he alone was endowed with a rational soul. At once sensate and intelligent, composed of corruptible flesh yet bearer of an immortal spirit, man was believed to be pivotal in the hierarchy of creation. The progress of human life could accordingly be defined on many different grounds—bodily, mental, moral, spiritual. But the definition of physical development was prior to the other kinds of description; it provided an armature around which other sorts of observations could be ranged. Thus we begin here, with the reflections of natural philosophers on the course of life and the schemes of age division which they favored, the first of these being the four ages of man.

The quadripartite life was defined within a cosmological system developed in antiquity and subsequently transmitted to the Middle Ages. A system for understanding the natural order, it found the roots of nature to lie in the tetrad. Through number, microcosm and macrocosm were bound together. The life of man was seen to correspond to a temporal cycle in the greater world: just as the year was divided by the solstices and equinoxes into four parts, so the human life, another finite stretch of time, had its four seasons. This did not imply that human development was governed by seasonal changes. Aristotle drew the distinction between man and the animals and plants in this regard:

> The seasons of the year are the turning-points of their lives, rather than their age, so that when these seasons change they change with them by growing and losing feathers, hairs, or leaves respectively. But the winter and summer, spring and autumn of man are defined by his age.[1]

Man's childhood was likened to spring, his youth to summer, his maturity to autumn, and his old age to winter. The metaphor was a powerful and enduring one, as evocative to poets as it was convincing to cosmologists.

Medieval thinkers, inheriting the scheme of the four ages of man, made their contributions in its application. By integrating antique tetradic thought into

Christian cosmology, they found the four ages a place in medieval learning
and in the medieval school curriculum. The study of tetradic texts and images
takes one to the mathematical end of the seven liberal arts, that is, to the
disciplines of the quadrivium (arithmetic, geometry, music, and astronomy)
rather than the subjects of the trivium (grammar, dialectic, rhetoric). It leads
one to physics, as opposed to ethics or logic, according to another scheme of
the divisions of knowledge, Stoic in origin.[2] Hrabanus Maurus, ninth-century
schoolman, supplies a definition of physics, embracing both schemes, which
conveniently sets the limits of our sphere of operations in the first two chapters.
By his reckoning, *physica* is divided into seven parts: arithmetic ("the science
of numbers"), astronomy ("the law by which the stars rise and set"), astrology
("the order and nature and power of the stars and the revolution of the heav-
ens"), mechanics, medicine ("the science of healing, devised to maintain the
body in balance and health"), geometry, and music.[3] These, then, were the
disciplines a Christian might study to better appreciate the wonder of the created
world, including God's masterpiece, man.

Pythagorean Roots

THE CORRELATION between the progress of life and the course of the year was
associated in ancient Greek thought with the name of Pythagoras, by tradition
the first man to call himself a philosopher. Diodorus Siculus, compiler of a
universal history in the mid-first century B.C., is a witness:

> The Pythagoreans divided the life of mankind into four ages, that of a
> child (παῖς), a lad (νέος), a young man (νεανίσκος), and an old man
> (γέρων); and they said that each one of these had its parallel in the changes
> which take place in the seasons in the year's course, assigning the spring
> to the child, the autumn to the man, the winter to the old man, and the
> summer to the lad.[4]

Diogenes Laertius, writing some 250 years later, recorded the same informa-
tion, adding that each of the four ages of man lasted twenty years and attributing
the analogy to the sixth-century sage himself.[5] Ovid made the point more
dramatically. In the final book of the *Metamorphoses* he portrayed Pythagoras
in the act of delivering a public address which summarized his view of the
cosmos. Speaking of the impermanence of things in the world, Ovid's phi-
losopher drew an extended comparison between the changing year—tender
spring, robust summer, mellow autumn, tremulous winter—and the unfolding
life of man.[6]

Whether the correlation is in fact early Pythagorean cannot easily be deter-
mined. The original teachings of Pythagoras and his school are notoriously
difficult to pin down, tenets of the thought having been reworked by later

Platonic, Neopythagorean, and Neoplatonic philosophers even as they were transmitted.[7] Pythagoras himself, a figure held to be a god while he lived—a man who believed in the transmigration of souls, discovered the musical intervals, and founded a brotherhood—left no literary remains. Still it may be said that the idea to divide the human life into four parts on the model of the quadripartite year is consistent with what can be reconstructed of early Pythagorean thought.

A distinguishing aspect of Pythagorean speculation involved the place of number in the natural order. Numbers were considered to be first principles, causes, the essence and substance of sensible things.[8] They received worshipful reverence. Mathematical properties were invested with extramathematical meaning: the number three, a triad possessing a beginning, a middle, and an end, came to signify a totality; four, divisible into equal parts $(2 + 2)$ and the product of equals (2×2) stood for the abstract concept, justice. Attention centered almost exclusively on the numbers of the decad, one through ten. Ten, pivotal in the sequence of numbers, comprising all the rest, was much revered, not least for being the sum of the first four integers $(1 + 2 + 3 + 4)$. These four numbers, collectively called the "tetractys," held a prominent place in Pythagorean thought. Envisioned as a triangular figuration of ten points in four rows, the tetractys was a mystical symbol held to epitomize Pythagorean wisdom. It served the Pythagoreans as an oath: "No, by him who transmitted to our soul the tetractys, containing the source and root of everlasting nature."[9]

Surviving tracts on number, if late in date, confirm the importance of the tetrad in Pythagorean thinking. These works, written in a distinctive literary form, are products of the theology of number, called "arithmology" in modern scholarship to distinguish it from arithmetic proper. Based on the decad, the texts characteristically review the powers, properties, and associations of a single number, or several, or all ten numbers in sequence.[10] The entries on the number four tend to be lengthy. And in them one regularly finds listed the tetrad of the ages of man, often in conjunction with the four seasons.

When Theon of Smyrna compiled his *Exposition of Mathematical Knowledge Useful to the Study of Plato* in the first half of the second century A.D., he prefaced a survey of the numbers of the decad with a treatment of the tetractys.[11] Using the term to denote any group of four things, Theon named eleven instances of its appearance in the natural order. The set of the first four numbers, understood to be a generative sequence, appears at the head of the list and the remaining ten tetrads are correlated with it either explicitly or implicitly. The tenth tetractys is the series of the four seasons, and the eleventh, that of the four ages of man: παιδίον, μειράκιον, ἀνήρ, γέρων. The four ages appear again among the tetrads listed in an anonymous *Theologumena arithmeticae* of the fourth century A.D., a work structured on the decad which draws heavily upon earlier writings.[12] Just as there are four seasons of the year, its author

states, there are four seasons of man: παῖς, νεανίας, ἀνήρ, γέρων. The Neoplatonist Hierocles recorded the information in his fifth-century *Commentary on the Golden Verses of Pythagoras*.[13]

Some evidence exists that theories of age division had practical consequences for the Pythagorean brotherhood. Before the dissolution of the original school in the latter half of the fourth century B.C. and after its revival in the first century B.C., members of the Pythagorean sect, living communally, followed a set way of life which encouraged moderate and regular habits, obedience to authority, and concern for mental and bodily health. Descriptions of this life indicate that educators paid heed to the ages of man, believing that the successive phases would remain unconnected unless continuity were achieved through education. Four ages were named, and these provided a structure around which to organize human activity: children were to be trained in literary and other disciplines, adolescents in the customs and laws of the state, mature men were to give themselves to business and public service, old men to reflection, judgment, and counsel.[14]

The Cosmological System in Greek Antiquity

THE ROLE of the tetrad as an ordering principle extended beyond the Pythagorean sphere. A comprehensive cosmological program based upon it emerged in antiquity as various thinkers recognized tetrads in the macrocosm and microcosm and set up correspondences, initially unsystematic, between their component parts.[15] The lines were laid by the Presocratic philosophers. Empedocles, indebted to Pythagorean teaching on many counts, believed the whole world to be composed of a tetrad of distinct substances which mixed and separated. While others had sought the source of things in one, two, or three primary elements, Empedocles numbered the elements at four, naming them in his fifth-century poem *On Nature*: "fire and water and earth and the limitless height of air."[16] The four primary qualities—hot, cold, wet, and dry—were being defined concurrently, finding a place in the cosmological systems of Anaximander and others as pairs of contraries. Sometimes considered to be primary substances themselves, they were also identified with the elements, singly and in pairs. In time it was resolved that fire was hot and dry, air was hot and wet, water was cold and wet, and earth was cold and dry. As a corollary, fire and water, partaking of opposite qualities, were opposites, and so too were air and earth.[17]

If the elements of the world were four, it was inevitable that the elements of the human body should prove to be four. By the late fifth century B.C. a tetrad of humors had been identified comprising blood, phlegm, and two types of gall, one lighter, one darker.[18] The humoral system is first set out in works

of the so-called Hippocratic Corpus, a heterogeneous group of medical writings now believed to have been collected under the name of Hippocrates in the early Hellenistic period. The tract *On the Nature of Man*, generally dated to c. 400 B.C., contains the most systematic account of the theory in the Corpus. Its author begins by criticizing those philosophers and doctors who suggest that the human body is composed of a single element or a single humor. By his reckoning the body of man is composed of four distinct substances—blood, phlegm, yellow gall, and black gall—which together are responsible for health and pain. Health results from a perfect admixture of all the humors, pain from the excess or deficiency or isolation of one of them. Through the four qualities, regarded as primary elements, the humors acquire affinities with the seasons. Phlegm, the coldest humor, increases in winter; blood begins to grow in spring with the advent of the warm and rainy season; yellow gall dominates in dry, hot summer; black gall comes to the fore in dry, cooling autumn.[19]

Its parts so well integrated, the tetradic system formed a self-buttressing whole. Additional tetrads readily accrued. By the Greco-Roman period grandiose schemes had been developed which included among their members the temperaments, the principal fevers, the cardinal organs, and, on a macrocosmic level, the directions, the winds, the heavenly points, and the zodiacal signs in four groups of three. The four ages of man were imbedded in this system, and it is in this light that they must be studied. A comparison between descriptions of the quadripartite life in two classes of texts, medical and astronomical, proves instructive.

Certain texts in the Hippocratic Corpus show the ages being bound to other tetrads. In the *Aphorisms*, an enduringly popular collection of medical precepts, individuals of each phase of life are observed to fare well in corresponding times of the year: "As for the seasons, in spring and early summer children and young people enjoy the greatest well-being and good health; in summer and part of autumn, the aged; for the remainder of autumn and in winter, the middle-aged."[20] In *Regimen*, a tract based upon the theory that the body of man is a mixture of two elements, fire and water, the ages are defined by the four qualities. The child ($\pi\alpha\hat{\iota}\varsigma$) is composed of moist and warm elements and thus grows quickly; the adolescent ($\nu\varepsilon\eta\nu\acute{\iota}\sigma\kappa\varsigma$), as a result of an increase in fire and the drying effect of growth and exercise, is characteristically warm and dry; the mature man ($\dot{\alpha}\nu\acute{\eta}\rho$), his growth complete, is cold and dry; the old man ($\pi\rho\varepsilon\sigma\beta\acute{\upsilon}\tau\eta\varsigma$), since he experiences an increase in water, is cold and moist.[21] Medical theory had its effect on medical practice. As early as the fifth century B.C. doctors began to concern themselves with regulating the living habits of their patients as a means of ensuring their physical well-being. Various therapeutic practices were recommended to compensate for dangerous excesses and deficiencies; imbalances were to be corrected through the studied appli-

cation of contraries. Thus in *Regimen* the young, since they are prone to be moist and hot, are advised to follow a dry and cool regime in food, drink, and exercise.[22]

Tetradic theory never satisfied empiricists. It tended to find favor with physicians belonging to the rational or "dogmatic" school of medicine, adherents of which sought the hidden causes of disease and believed that the art of healing must rest on an understanding of nature as a whole. The pneumatic school, a medical sect which stood in this tradition, founded probably in the first century B.C., seems to have adopted the system wholeheartedly. In an eclectic textbook associated with the school, the pseudo-Galenic *Definitiones medicae*, recently dated to the end of the first century A.D., one finds the ages of man correlated not only with the seasons and qualities but also with the humors. The formula set out, in which the individual is hottest at birth and driest at prime, was to become classic. Children (νέοι), it is said, are hot and moist like spring, and in this age blood abounds. Those in their prime (ἀκμάζοντες) are hot and dry like summer, and yellow gall dominates. Men of middle age (μέσοι) are cold and dry like autumn, and black gall is strong. Finally old men (γέροντες) are cold and moist like winter, and phlegm is abundant.[23]

With Galen, physician and philosopher of the second century A.D., tetradic theory found its most valuable advocate. An avowed follower of Hippocrates and a prolific writer, Galen took it upon himself to explicate, defend, and promulgate what he took to be the teachings of the master. Starting from the succinct system outlined in the Hippocratic *On the Nature of Man* and drawing on the work of his immediate predecessors, especially the pneumatic physicians, he developed and extended humoral theory in the light of his own beliefs.[24] In his *On the Elements According to Hippocrates*, an early work, he credited Hippocrates with having discovered the relation between the qualities and elements. Enlarging upon this, he forged a link between the elements and humors by suggesting that the four elements enter the body in the form of food and drink, where they are transformed by the heat of digestion into the four humors.[25] Galen brought together many sets of four in addition to the elements, the humors, and the qualities.[26] Citing Hippocrates, he drew the familiar correlation between the seasons of the year and the ages of man in *On the Doctrines of Hippocrates and Plato*.[27]

One of Galen's concerns was the way in which the qualities could be blended in the human body. He concluded that there were nine possible mixtures or "temperaments," namely, the perfect balance of all four, the predominance of a pair of humors, or the rule of a single humor.[28] In supporting the idea that each individual had his own special mixture of qualities and that this mixture affected his mental and moral as well as his physical characteristics, he contributed to the developing theory of the four constitutions or temperaments. In later antiquity and the Middle Ages it was popularly believed that the

predominance of a particular humor determined an individual's character and appearance. A colorful descriptive lore developed around the figures of the sanguine, the choleric, the melancholic, and the phlegmatic man. Related to this tradition is a passage in a short anonymous text probably produced in the second or third century A.D. entitled *On the Constitution of the Universe and of Man*. Here the four ages are characterized in the light of the humors which have dominion in each period of life, and unusual descriptions are the result. Children, one reads, because of their sanguine constitution, are playful and full of mirth and when they are tearful quickly recover. But youths, owing to a predominance of yellow gall, are spiteful and inclined to anger and when angered only slowly relax. Adults, full of black gall, are idle and timid, and when they go mad it is very difficult to bring them round. Old men, dominated by phlegm, are gloomy and forgetful and when they go mad persist in this state without change.[29]

Such medical descriptions of the ages are grounded in the material world. The human body is understood to be an ever-changing mixture of elements. As time passes, the balance of qualities alters and an individual's physical and even psychological make-up responds. The physician, of necessity, concerned himself with the motion and flux of the sublunary world; astronomers and astrologers looked to the heavens. Their interest lay in the effect of the perpetual revolutions of the heavenly bodies on the life of man. When they adopted tetradic theory, they added extramundane sets of four to the system.

Ptolemy, greatest of the Greek astronomers, active in the second century A.D., introduced the analogy between the ages of man and the seasons in his astrological *Tetrabiblos* to explain why Aries, the zodiacal sign which coincides with the vernal equinox, is taken to be the first of the twelve signs. Introducing the four qualities, he says that spring is believed to inaugurate the yearly cycle since it is moist like any young creature is moist, and it is succeeded by hot summer, dry autumn, and cold winter just as childhood is followed by the similarly tempered second, third, and fourth ages of life. Other tetrads enter the picture. The four regions and angles of the horizon and the winds which blow from the cardinal points are described: the dry eastern winds are called *Apeliotes*, the hot south winds *Notus*, the moist west winds *Zephyrus*, and the cold north winds *Boreas*. As in medical writings, so in astrological texts, practical considerations are introduced. Ptolemy indicates that all of these factors are of importance in calculating the strength of the stars. He cautions the astrologer to bear in mind the qualities of the seasons, ages, and angles, for stars are more potent in sympathetic circumstances.[30] In the scale of his tetradic program Ptolemy was outdone by his successor, Galen's contemporary, the astrologer Antiochus of Athens. Also concerned to explain why the zodiacal signs begin with Aries, Antiochus drew the correlation between the seasons and ages of man. But he proceeded to define a system containing not only the

twelve signs and the seasons and the ages, but also the cardinal winds, qualities, conditions, humors, temperaments, and their colors.[31]

This then is the fully developed tetradic system, admired as much for its formal beauties as for its practical efficacy. Greek in origin, it was incorporated into Latin learning at an early date. With it came the quadripartite life. A number of Roman men of letters would treat this theme. In the medical sphere there is Celsus, a polymath of the early first century A.D., who introduced the ages of man at several points in his text on medicine, within discussions of regimen. Drawing upon the Hippocratic *Aphorisms*, he noted that individuals at different stages of life prosper at different seasons of the year.[32] Latin astrology is represented by Manilius's poem the *Astronomica*, also composed in the early first century A.D. In this work the author described the manner in which the four heavenly quadrants, defined by the four heavenly points, control the four parts of the human life: the interval extending from the point at which the sun rises to the summit of the sky governs the early years; from the summit to the point of sunset, childhood and youth; from the western horizon to the lowest point of the heavenly circle, the adult life; and from this point back to the eastern horizon, the last years.[33]

Yet more distinguished writers than these drew upon the motif of the four ages of man. Cicero, in his essay *De senectute*, had his spokesman Cato describe the one-way course of life. The aging moralist observes that each age has its proper character, to be garnered in its time, naming the weakness of children, the spirit of youths, the sobriety of the established age, and the fullness of old age.[34] Horace, in the *Ars poetica*, urged dramatists to present the ages in a fitting manner. For the child (*puer*), the beardless youth (*imberbis iuvenis*), the figure of manly age (*aetas virilis*), and the old man (*senex*) have their distinctive character traits, which he vividly describes.[35] Ovid, we have seen, characterized the four ages in relation to the seasons in his *Metamorphoses*.[36] These works were available for study in the Middle Ages. But more critical in the transmission of tetradic cosmological thought, and with it the division of life into four phases, were the textbooks, the summary works produced by compilers in late antiquity which drew upon ancient natural philosophy.

The Tetradic Diagram

As EARLY Christians sifted through the antique heritage, sorting out useful from harmful lines of thought, they seem to have viewed tetradic cosmology with equanimity. The Bible, in affirming that God had ordered all things "in measure, and number, and weight" (Wisd. 11:21), offered tacit support. The pagan system, based on number, provided a key for describing the rational design by which the created universe was bound together. Furthermore, and

not insignificant in the early Middle Ages, it was blessedly simple, fully comprehensible to the philosophically naive. Subtle intellects might explore its precepts, but students of even average ability could memorize them.

It was, in fact, by means of school texts that the principles of the tetradic system were passed on. The information was preserved in tracts transcribed in medieval scriptoria. And a manuscript, one should recall at the outset, is a different kind of commodity than a printed book. Handwritten texts, each unique, could be easily modified to serve particular educational requirements. A scribe might transcribe all or part of a work; he might juxtapose it with other texts; he might provide marginal or interlinear glosses. He also had the option to embellish his copy with didactic illustrations. These often took the form of diagrams, graphic devices introduced to aid in reading a text. Tetradic thought was regularly explicated by means of such "schemata"; they played a critical role in transmitting the principles of the system. While technical diagrams had been used in antiquity,[37] it was in the Middle Ages that the unpromising pictorial form blossomed to become a field for artistic invention.[38]

Several different diagrams were created to illustrate the tenets of tetradic cosmology.[39] The most popular of these, of particular interest to us since it so often incorporated the ages of man, appears first and in its simplest form in copies of Isidore of Seville's *Liber de natura rerum* (fig. 1). The many surviving manuscripts of the work, a handbook of natural history with Christian allegorical elements which Isidore compiled in 613, contain no fewer than seven cosmological diagrams. All but one are circular; all are announced in the text. So distinguishing a feature were the schemata that the tract gained for itself the popular title "Book of Wheels," *Liber rotarum*.[40] The diagram under discussion was devised to demonstrate the relationships between the elements of the world, the seasons of the year, and the humors in man through their shared qualities. It was accordingly labeled *mundus, annus, homo*. The Merovingian scribe who drew the *rota* reproduced as figure 1 whimsically inserted the bust of a man under the word *homo*, thereby doubling the rubric with a pictorial device.[41]

Isidore used the schema to illustrate a particular concept, that of the "syzygy," or interconnection of the elements. His source was a Christian work, an exposition of the six days of creation, Ambrose's *Hexaemeron*. The Church Father, drawing on antique natural philosophy, had held forth on the elements in his exposition of God's work on the third day. Observing that each element is characterized by a mixing of qualities, he suggested that the four are linked in a circuit of alliances, each stretching out two arms, that is, each sharing qualities with its neighbors: water, cold and wet, is joined to earth by the shared quality of cold and to air by the quality of wetness; air mediates between the contrary elements, water and fire; fire stands midway between air and

earth. The figure of a circle, Isidore says, demonstrates the interlocking of the separate elements ("Quorum distinctam communionem subiecti circuli figura declarat").[42]

Yet the schema, incorporating the seasons and the humors as well, does more than this. Through arcs, lines, variations in script and color, the several sets of concepts are at once isolated and integrated. Each quaternary inhabits its own ring, and each of its members is flanked by the pair of qualities which characterizes it. Related members of the different sets, those which share two qualities, fall into alignment. Thus air, spring, and blood at the left of the diagram are shown to be characteristically hot and wet; fire, summer, and gall at the top are hot and dry; and so through the list. Opposite entities lie opposite to one another, and intermediate entities, joined to their neighbors by a single quality, lie between. In short, the place of any member within the system can be ascertained visually.[43] Though there is no reason to assume that Isidore himself invented the schema, its popularity in the western manuscript tradition certainly begins with his tract and is in part dependent upon its continuing influence.

As the diagram migrated to other contexts, it picked up additional tetrads and came to serve different purposes. The ages of man quite understandably found a place early on. Not even a change of rubric was required since the theme was readily subsumed under the heading *homo*. With the addition of the phases of life, the diagram became more balanced: both of the macrocosmic quaternaries—the elements and the seasons—were then supplied with micro-cosmic counterparts, the humors and the ages. In fact, one of the chief functions of the schema would be to illustrate the antique concept, pervasive in the Middle Ages, that man was a small world and the world, a great man.[44] Plato was the authority behind the idea, and platonizing Christians could turn to his cos-mological dialogue, the *Timaeus*, available in part in the translation of Calcidius, for information. But they could also approach the theory in its Neoplatonic reworkings by such writers as Macrobius and Boethius. Certain glossed man-uscripts of these late antique works contain tetradic diagrams which incorporate the ages of man.

Many medieval schoolmen would comment on the famous hymn to the "father of all things," sung by the personified Philosophy in Boethius's *Con-solation of Philosophy* (*circa* 525). The hymn, which begins "O you who govern the world with eternal reason" ("O qui perpetua mundum ratione gubernas"), was valued throughout the Middle Ages as a summary of the view of the cosmos revealed in the *Timaeus*.[45] It contained many passages in need of elu-cidation. When one commentator, often identified as Remigius of Auxerre (d. 908), read the enigmatic statement that the soul is "middle" of a threefold nature (vv. 13-14), he suggested that man's rational soul was meant, midway between the soul of the beasts and the spirit of the angels, in harmony with

the world. Man is thus called *microcosmos* in Greek, or *minor mundus* in Latin. But for Remigius this analogy had a specific meaning: "For just as the world is composed of four elements and four seasons, so man is composed of four humors and four seasons."[46]

The gloss continues, "Let us then see the concord between the world and man," and a systematic review of all members of all the tetrads and their interrelations is supplied. Nested in this gloss, in a tenth/eleventh-century manuscript in the Vatican (fig. 2), there appears a copy of Isidore's *mundus-annus-homo* diagram. Earlier in the commentary, when glossing the passage "You bind the elements according to number" (v. 10), Remigius had enlarged upon the concept of the "synzygiae" of the elements. But the *rota* was used rather to illustrate the relation of macrocosm to microcosm. The ages of man were now incorporated, the words *aetates hominum* even inscribed on the rim.[47] The lengthy text was thus summarized, reduced to a single figure. When an anonymous compiler made a pastiche of the commentary, transcribed in a twelfth-century miscellany in Paris, he chose to retain the diagram (fig. 3).[48]

As a symbol of the relation of macrocosm and microcosm, the figure might itself serve to gloss a text. A small square diagram appears alone in the margin of an early twelfth-century Welsh copy of Macrobius's commentary on Cicero's *Dream of Scipio*.[49] Each of four quadrants contains an element, a season, an age—*pueritia, adolescentia, iuventus, senectus*—and a humor. A passage in Macrobius's fifth-century text, "Therefore natural philosophers call the world a great man and man a little world,"[50] was sufficient to call it forth. An inscription in the center confirms its meaning: "microcosmos [glossed *homo*], id est minor mundus."

The diagram might stand on its own, making its point visually without aid of a text. Lambert of St. Omer included an idiosyncratic *rota* within a series of astronomical schemata in his *Liber floridus*, the great cosmological compendium he compiled around the year 1120 (fig. 4).[51] The schema departs from the Isidoran model in its internal patterning. *Homo* now takes pride of place in a central roundel, *annus* above it and *mundus* below. Bars inscribed with the four humors extend out toward roundels ringed with the names of the macrocosmic seasons and elements. Within these roundels the microcosmic ages and humors appear, together with an unusual tetrad, one which Lambert may have introduced as a display of his erudition. Martianus Capella's fifth-century allegory *On the Marriage of Philology and Mercury* was his source. There one reads that Apollo possessed four urns, of iron, silver, lead, and glass, each containing one of the seeds and elements of the world and each bearing a divine epithet.[52] Lambert inserted this tetrad into his diagram. He thus correlated spring, air, *adolescentia*, and blood with the smile of Jove (*risus Iovis*); summer, fire, *iuventus*, and red gall with the flame of Vulcan (*vertex Vulcani*); autumn, earth, *senectus*, and black gall with the breasts of Juno (*ubera Iunonis*); and winter,

water, *etas decrepita*, and phlegm with the ruin caused by Saturn (*exitium Saturni*). His diagram was a self-sufficient entity, drawing on texts but attached to none.

A diagram might also appear outside of a manuscript.[53] On the ceiling of a bay in the crypt of the Cathedral of Anagni, painted c. 1250, a *rota* sets out the relations between macrocosm and microcosm with clarity (fig. 5).[54] The letters H O M O once again occupy the center of the composition, circumscribed by that oft-repeated phrase, "mikrocosmos, id est minor mundus." The names of the humors and the ages are inscribed close by; those of the elements and the seasons of the greater world are positioned toward the periphery. An intrusion of pictorial forms distinguishes the diagram. The artist, and it is thought that he was working from a manuscript model, illustrated the concept of man the microcosm in its twin aspects, elemental and temporal. In the very center of the composition, at the point where the four quadrants converge, there appears a specimen of "man," nude, stiffly frontal, surely representing the human who contains all the elements of the world within himself. Around him the phases of life unfold. Busts of men of different ages occupy the midpoints of the quadrants. A round-faced boy (*pueritia*) represents the first age, and a smooth-cheeked youth (*adolescentia*), the second. A middle-aged man with a short dark beard stands for prime (*iuventus*), and a hoary-headed gentleman with long hair and beard represents old age (*senectus*). This is microcosmic man whose life follows the pattern of the course of the year.

On the walls of the same bay there appears a linear diagram of the elements together with the figures of Galen and Hippocrates, major proponents of the tetradic system represented above. In the preceding bay, badly damaged, a zodiacal schema adorns the vault and a group of ancient sages appears on the wall. It has been asked what role these cosmological images played in the overall program, a grand cycle which combines biblical, apocalyptic, and hagiographical subjects. Most have rightly stressed Christian receptivity to natural philosophy insofar as it accorded with the creation story in Genesis. At Anagni the nature of man and the created world is set out as a preliminary to a recounting of events in the history of salvation.[55] The tetradic diagram was adopted for use, the device by this time having become almost a hieroglyph for the antique cosmological system.

Quaternaries in Medieval Arithmology

CHRISTIANS contemplating the universe which God had created in six days discovered numerical beauties in the world order a pagan would never have suspected. Standing at the very head of the Latin exegetical tradition, Victorinus of Pettau (d. 304?), in his *De fabrica mundi*, used numerological methods to interpret the days of creation. The seventh day receives his best efforts, but

the fourth, which he calls the *tetras*, is also singled out for attention. It was on this day that the sun and moon were created in heaven to mark the times (Gen. 1:14-19). By their movements the seasons are determined, four in number, just as the elements of the world are four. Ancient cosmology knew these tetrads, but not the others that he names: the four living creatures before the throne of God (Apoc. 4:6), the four gospels, the four rivers flowing in paradise, and the four generations of peoples—Adam to Noah, Noah to Abraham, Abraham to Moses, and Moses to Christ.[56]

Ambrose, explicating another passage in Genesis, "But in the fourth generation they shall return hither" (Gen. 15:16), was led to expound the powers of the number four along Neopythagorean lines. The tetrad, he says, is the root of the decad $(1 + 2 + 3 + 4)$ and the midpoint of the hebdomad in that three numbers precede it and three succeed it. Further, there are four books in which the Gospel was brought to completion, four mystical animals, and four parts of the world from which the assembled sons of the church extend the kingdom of Christ, coming from the East and the West, the North and the South. But for Ambrose, four is also the number of the ages of man—*pueritia, adolescentia, iuventus, maturitas.*[57]

Medieval arithmological speculation, fostered because of its great usefulness in biblical exegesis, developed on lines laid in antiquity. Latin versions of Neopythagorean and Neoplatonic tracts supplied models. Particularly influential were the early fifth-century works of the North Africans, Macrobius and Martianus Capella. Martianus's *On the Marriage of Philology and Mercury*, a textbook of the Liberal Arts in allegorical form, contains a classic survey of the numbers of the decad within a description of the art of arithmetic.

The setting is a wedding feast. The pagan gods have assembled to celebrate the marriage of the personified Philology, who represents learning, to Mercury, the god of eloquence. Each of the seven Liberal Arts, handmaidens to Philology, is asked to deliver a discourse on her discipline, and the personification of Arithmetic, one member of the quadrivium, steps up in turn. She is presented as a very imposing figure, most admirably adept at finger counting. From her forehead emanate one, two, and finally ten rays in pairs and triplets which multiply and then resolve into a unity, a graphic demonstration of the powers of the number ten. Pythagoras, bearing a torch, stands by her side as she delivers her exposition on mathematics. Before discoursing on arithmetical theory proper, she reviews the properties and attributes of the first ten numbers. Arriving at the number four she ponders:

> What shall I say about the tetrad? In it is found the sure perfection of a solid body; for it comprises length, [breadth,] and depth. The full decad is the sum of four numbers, arranged in order: namely, one, two, three, and four. Likewise, the hecatontad is the sum of four decads: namely, ten,

twenty, thirty, and forty—which make a hundred. Also four centenary numbers produce a thousand: namely, one hundred, two hundred, three hundred, and four hundred. Ten thousand and other multiples are completed in a similar manner. Moreover, it is plain to see that there are four seasons of the year, four principal regions of the sky, and four primary elements. Then, too, are there not four ages of man (*hominum etiam quattuor aetates*), four vices, and four virtues? The number four is assigned to the Cyllenian [Mercury] himself, for he alone is regarded as the fourfold god.[58]

The tract had a wide influence. Much studied in the medieval schools during the high Middle Ages, it was frequently copied whole or in part.[59] Glosses began to be prepared for the text in the Carolingian period. Remigius of Auxerre (d. 908), in the course of what would become a standard commentary, turned his attention to the statement that there are four ages of man. These he identified as *infantia, pueritia, adolescentia*, and *iuventus*, an incomplete sequence which represents "the condition of growth beyond which man increases neither in cleverness nor in bodily stature."[60] Remigius was very possibly trying to harmonize the fourfold with the sixfold system of age division, the latter also circulating in his time. Yet he was familiar with the tetradic scheme: some, he acknowledges, call the fourth age *senectus*.[61]

A Christian arithmological text published with the works of Isidore of Seville, the *Liber numerorum*, can be considered a revision and expansion of Martianus Capella's survey of the decad.[62] A comparison of the two texts is instructive, for it shows the Christian numerologist at work. Not only are all references to the pagan deities eliminated, there are significant structural differences as well. Since numerical references in the Bible are not confined to the decad, the author felt called upon to treat numbers 11 through 16, then 18, 19, 20, 24, 30, 40, 46, 50, and 60. Within each entry, too, he departed from his model. The section on the tetrad opens with a question borrowed from Martianus: "What shall I say about four?" The personified arithmetic is then quoted on the composition of ten, one hundred, and one thousand. But where *Arithmetica* had listed tetrads which appear in the natural world, the early medieval author turned to scripture. Four is the number of the evangelists spread over the four parts or angles of the world and the number of the rivers of paradise. Further, Noah's ark was constructed of "quadrated" wood (Gen. 6:15), and the arc of the covenant was carried with four gold rings (Exod. 25:12-14). At length he picks up the thread and observes that there are four elements, seasons, ages, virtues, and vices, like a glossator listing each tetrad in full. Arriving at Martianus's statement on the ages of man he says: "Of mortal things as well, four are the periods of life: beginning, growth, stability, and decline," borrowing his terms from medical writings.[63]

Christian arithmologists clearly felt no compunction about introducing the

theme of the ages of man into their discussions. Byrhtferth, a monk of Ramsey in East Anglia, did so in a short tract on sacred numbers which he appended to his computus manual, written in the year 1011.[64] Adopting a grand manner, he guided his readers through the mysteries of the first twenty numbers, digressing to comment on a host of higher numbers in the course of his survey. The *quaternarius* receives quite detailed treatment. Byrhtferth observes that there are four virtues, four seasons, and four evangelists identified as the four animals in the book of Ezekiel, four letters in Christ's name (D E U S) and four in Adam's, two equinoxes and two solstices, four principal winds, four elements, and four parts of the world. The number is also "encircled with fourfold honor" in the human life, there being four ages of man—*pueritia, adholescentia, iuventus,* and *senectus.* "With sincerity of mind and with no haughtiness of heart," he proceeds to treat the concord which exists between the seasons, the elements, and the ages, listing the members of the sets with their distinguishing qualities.[65] Small marginal figures inscribed with the initial letters of the evangelists (M M L I) and the letters D E U S and A D A M are introduced to elucidate the text. But a more precise illustration is provided by a *rota* found earlier in the same manuscript, in the computistic section, a diagram which incorporates no fewer than six of the tetrads named, including the ages of man (fig. 9).[66]

Byrhtferth's treatment of the quaternion, more than his discourses on the other numbers, was grounded in the natural world. So, too, when an anonymous Anglo-Saxon wrote an entire treatise on the "force and power of the number four," a *Tractatus de quaternario,* he in fact produced a handbook of tetradic cosmology. The text, which exists in a single manuscript dated to the early twelfth century, has yet to be edited or properly studied.[67] A decided curiosity, enthusiastically illustrated with inhabited initials and a quantity of fairly crude diagrams, it contains a wide range of esoteric information. Divided by no accident into four books, the tract surveys a number of tetrads in the natural world. It is punctuated with eighteen *rotae* of different sizes, as well as other varieties of schema. The circular figures are characteristically divided into quadrants by means of a large "X," and many of these are peopled with personifications. Groups of four figures, both male and female, gesturing or holding attributes, represent the elements, the directions, the humors, the seasons, the winds, the points in the course of the sun, and the phases of the moon, as well as the ages of man. Few of these themes are commonly depicted by means of human figures, and the results are eccentric: the humors appear in the guise of river deities pouring fluids from urns (fol. 23v).[68]

It is in this exceptional context that the unique diagram of the stages of life must be viewed (fol. 28v, fig. 6). A verse inscription circumscribing the *rota* identifies its subject matter: "The four ages, as is shown here and as they are seen, are ordered to complete the span of the human life" ("Quatuor etates, velut hic patet atque videntur, humane vite spatium conplere iubentur"). Fig-

ures in feminine costume occupy the four sections. *Pueritia* (cold and wet), sitting cross-legged and raising her left hand, begins the sequence at the top of the diagram. She is followed by *iuventus* (hot and wet), a figure holding a branch. If one continued to read in a clockwise direction, *decrepitas* would come next, but name and qualities argue against this. *Senectus* (hot and dry), at the left, sits winding thread onto a spool. *Decrepitas* (cold and dry), below, wearing a long headcloth, sits on a stool and spins with a distaff and spindle. Additional inscriptions at their feet identify the concordant humor—phlegm, blood, red gall, and black gall.

The text which follows the diagrammatic image, though of little help in identifying the figures, establishes the author's opinions on the ages of life. He devotes seven sections of his third book to the subject of the ages of man (fols. 29r-32v), presenting therein two divisional schemas, the four ages preferred by physicians and the seven ages favored by philosophers. He treats both, acknowledging that his consideration of the heptadic plan has little place in a treatise concerning the number four. Two different sequences of the four ages of man are offered, both of which find parallels in surviving medical tracts. According to some, it is said, a hot and wet *adolescentia* to age 25 or 30 is followed by a hot and dry *iuventus* to 45 or 50, a cold and dry *senectus* to 55 or 60, and finally, a cold and wet *senium*.[69] The author himself favors, and defends at length, a different system, one which relates closely, if not precisely, to the preceding diagram. In this scheme the first age, called *adolescentia* or *pueritia*, is cold and wet, similar to phlegm, and extends to age 14; *iuventus*, hot and wet, similar to blood, lasts until 45 or 50; *senectus*, hot and dry, similar to red gall, ends at 60 or 65; *senium* (*decrepitas* in the schema), cold and dry, comparable to black gall, extends to the limit of life. But he suggests the names be changed to *pueritia*, *adolescentia*, *iuventus*, and *senectus*, the same set which Byrhtferth, among others, had adopted.[70]

The pictorial cycle, unparalleled and early in date, raises interesting questions. Even the identity of the figures is uncertain. They are possibly to be viewed as personifications. Certainly there was ample antique precedent for giving female form to abstract concepts of feminine gender. *Aetas*, "age," is a feminine noun, as are the names of the individual ages. Following this line of interpretation, the figures' attributes and actions would be signs of their time of life: *pueritia* makes a playful gesture, *iuventus* holds a branch in reference to youth's vigor and generating powers, later a fairly common attribute, while *senectus* and *decrepitas* engage in sedentary activities appropriate to the enfeebling years of decline.[71] Possibly, however, the motif in question is the thread of life.[72] The figures would not be the Fates themselves, as these were three in number and all equally engaged in fashioning and cutting the thread. But because the Fates were women and because it is women who spin, the artist would have put the thread in the hands of female figures. As he had personified others of

the tetrads in the book, context helps to account for the appearance of female representatives of the phases of life. Later artists would not follow suit, but would virtually always illustrate the ages of man with men. Only in the fourteenth century and after, in special circumstances, were the parallel lives of women depicted.

The four ages thus continued to find a place in the "literature of the decad," even in the Christian reworkings of the Neopythagorean form. A book-length discussion of the powers of four called forth a detailed discussion, but even short entries in arithmological works demanded a mention. When additional information on the ages was needed, it was often to medical works that the writers seem to have looked, to accounts of man's physical development based on the changing composition of his body.

Humoral Theory

THE ART of medicine, itself divided into two parts, theoretical and practical, had a somewhat floating status in medieval thought. Since medical practice demanded a working knowledge of pharmacology, surgery, and dietetics, it could be ranked with the mechanical arts, judged to be a manual skill rather than an intellectual discipline. But it could also be elevated and defined as the art which embraced the seven liberal arts in itself and required mastery of them all.[73] Certainly a knowledge of medical theory was recognized to contribute to an understanding of the world order. Natural philosophers were well acquainted with the doctrine of the humors and, in this connection, with the four ages of man.

Relatively few of the classics of ancient Greek medicine were available to the Latin West in the early Middle Ages. Certain works had been translated in late antiquity, before language difference was so much a barrier. For the most part, however, physicians had to make do with a fairly impoverished body of summary material. Surviving medical manuscripts contain a sprinkling of genuine works of the ancients, but they abound in short summary tracts and medical epistles, often anonymous or pseudepigraphic.[74] An early medieval scholar might read about the ages of man in the ever popular Hippocratic *Aphorisms*, translated in the sixth century, probably in Ravenna. The text was frequently copied, often with commentary, and much used in teaching.[75] *Regimen*, too, was available, if harder to come by. This work would have supplied some classic correlations: the child (*puer*) is hot and moist, the youth (*iuvenis*) stays hot but grows drier, the man (*vir*) becomes dry and cold, and the old man (*senex*) is cold and moist.[76] A few Galenic works had been passed on,[77] and Oribasios's two compendia of ancient medicine, the *Synopsis* and *Euporista*, compiled at the end of the fourth century, were translated into Latin in the fifth or sixth century.[78] However, equally respected sources of information on

humoral theory in general and the ages of man in particular would have been such derivative works as Vindicianus's *Epistula ad Pentadium* and the *Sapientia artis medicinae*.

Written in the late fourth century A.D., Vindicianus's letter contains a body of tetradic material presented in a matter-of-fact manner, as a rehearsal of accepted learning. The author, prominent in North Africa, wrote to his nephew with the intention of passing on "Hippocratic" learning, in Latin. The human body, he observes, is composed of four humors which possess certain qualities (hot, wet, cold, dry, sweet, bitter, sour, salty), reside in certain parts of the body, and dominate in different seasons of the year, parts of the day, and ages of life. They are responsible for features of personality and varieties of pulse, and their superabundance causes illness. Of the ages he says that phlegm with blood has dominion in boys to age 14 (*pueri*), then red gall, again with some blood, in youths to age 25 (*iuvenes*). In the period lasting to the forty-second year the greatest portion of blood dominates, together with black gall, and, finally, phlegm rules until extreme old age, as it did in boys.[79]

The same sequence of humoral dominance was adopted in the *Sapientia artis medicinae*, a brief tract, probably dating to the sixth century A.D., comprising in its first part a similar range of medical material revolving around the number four. The periods of life, which again terminate at ages 14, 25, 42, and death, are said to be ruled by phlegm, then red gall (together with blood from the fifteenth year), then black gall, and finally phlegm once more (after the fifty-sixth year). The anonymous author adds therapeutic advice:

> From the day on which the child is born up to age 14 he is phlegmatic and rheumatic. Once this age is reached, the blood becomes hotter and red gall increases; now phlebotomy is appropriate. Red gall dominates to age 25 and black gall increases and dominates to age 42. Up to age 30, purging is proper; should the necessity arise, however, do not inquire about age but use common sense, as is written. After age 56, the fluids and heat of the body diminish, and rheum and phlegm dominate. At this time suspend phlebotomy in favor of purging and heat therapy. And if the head was purged in childhood, let it be purged again, both on account of its heaviness and the dullness of the eyes. Sex should be avoided concurrently.[80]

The outstanding and unusual feature of the system adopted in both these works is the appearance of both a phlegm-dominated childhood and a phlegmatic old age. This was the result, perhaps, of an effort to reconcile the indispensable presence of blood in the body at all stages of life with the theory of the successive rule of the various humors. Yet the system never really took hold, possibly owing to its asymmetry, possibly because it contradicts the theory, to which many subscribed, that natural heat is greatest as the child

leaves its mother's womb. More widely known was the program commencing with sanguine childhood. This was the system followed, for example, in a tetradic diagram copied into a tenth-century medical miscellany in Chartres. The manuscript contains works of Galen, pseudo-Galen, and pseudo-Soranus; the schema, a *rota* on the Isidoran model, was inscribed on a leaf inserted rather arbitrarily into the text of Galen's *De medendi methodo ad Glauconem*. Labeled *mundus-homo-tempus* in this case, it incorporates the elements, seasons, humors, and ages, and also the four directions and the twelve winds. *Pueritia* and blood appear together in the same arc, as do *adolescentia* and red gall, *iuventus* and melancholy or black gall, and *senectus* and phlegm.[81] This formula circulated even outside the medical sphere. It was the scheme favored by twelfth-century cosmographers when they described man in their tracts on the nature of the world.

A cosmological work originally published with the works of Bede, sometimes placed in the ninth century but now coming to be accepted as a twelfth-century product, gives an outline of the tetradic system with a pronounced medical slant. The subject of *De mundi celestis terrestrisque constitutione*, as its title suggests, is the nature of the heavens and the earth, the world soul and the human soul. In the opening section the relation between the world and man is set out. Four elements, it is stated, constitute the sensible world, to which nothing is added and from which nothing departs. The human body, in contrast, is in a constant state of flux and maintains itself only if materials enter and leave in due proportion. "For there are four humors in man which resemble the different elements, increase in different seasons, and dominate in different ages. Blood resembles air, increases in spring, and dominates in childhood (*pueritia*). Red gall resembles fire, increases in summer, and dominates in adolescence (*adolescentia*). Black gall resembles earth, increases in autumn, dominates in maturity (*maturitas*). Phlegm resembles water, increases in winter, dominates in old age (*senectus*). When these abound neither more nor less than is right, man thrives."[82] A more schematic rendition of the material cannot be imagined.

Some of the implications of the theory were explored by the distinguished twelfth-century scholar and teacher, William of Conches, a man associated with the platonizing school of Chartres. The provocative account of human development he included in several of his works reflects his interest in discovering the principles by which the physical universe operated. The scheme is set out first in his *Philosophia mundi*, a cosmological tract probably written in the 1120s, and then again in the revised and expanded version of the work in dialogue form, the *Dragmaticon*, produced between 1144 and 1149. It receives mention in a gloss on Plato's *Timaeus*, at the point where the perturbation of immortal souls as they enter the human body is discussed.[83] William's purpose was to correlate the relative heat and moisture of the body at each stage of life

157297

with developing intellectual capacity. The first age, he says, inexperienced and ill suited to learning, is characteristically hot and wet. Food is digested at once and desired again. A dense vapor is generated by this frequent influx and efflux, which ascending to the brain, the seat of understanding, disorders it. But *iuventus*, though still hot, is drier, and the disturbing vapor is not so much produced. The age is very well adapted to discernment and understanding, especially if the light of diligent learning is kindled. In the succeeding age, *senectus*, dry but cold, the memory is strong but the strength of the body weakens, and in the final age, *senium*, which is cold and wet and characterized by an increase in phlegm, memory too loses force and men become puerile. With the complete extinction of natural heat comes the dissolution of soul and body.[84] William adds, further along, that instruction is best begun in adolescence since, as Plato says, this age of man is similar to wax which is neither too soft nor too hard to take and retain an impression. However, and this is comforting, learning ends only with death.[85]

William set out the tetradic system in a more straightforward manner in the sections devoted to the seasons in his two cosmographical tracts. Winter, first, is correlated with water, phlegm, and *aetas decrepita* since these are cold and wet. Cholerics and youths (*iuvenes*) are said to fare well in this season, while phlegmatics and the aged (*decrepiti*) do badly. The worst illnesses arise from phlegm, like quotidian fever, the less grave from gall, like tertian fever. And it is beneficial to increase the intake of food at this time of year. The same formula is applied to each of the seasons, and the ages, in turn—*pueritia, iuventus,* and *senectus.*[86] Schemata ornament and explicate the texts of both the *Philosophia mundi* and the *Dragmaticon*, copied in great number.[87] In the *Dragmaticon*, a tetradic *rota* was regularly used to illustrate the section on the seasons, William having made reference in the text to a "visible figure."[88] The schema was not heralded in the corresponding section of the *Philosophia mundi*, hence it is not so standard a feature in this work and appears in various forms and sizes. A particularly fine example, executed in firm red line, is to be found in a small volume of the mid-twelfth century in Paris (fig. 7).[89] Each tetrad occupies a separate ring, and the interconnections between its members through shared qualities are set out with lucidity. Compatible members of the different tetrads are united by means of pairs of vertical and horizontal lines, *puericia, iuventus, senectus,* and *senium* finding their place. As an added feature, the four qualities are inscribed in the center of the *rota* in such a way that the single quality particularly characteristic of each entity is aligned with it. The diagram is as learned as its form would allow.

William of Conches was a scholar steeped in the Latin school tradition. He prepared commentaries on some of the most distinguished and difficult works in the medieval curriculum. In addition to Plato's *Timaeus*, he glossed Boethius's *Consolation of Philosophy*, Macrobius's *Commentary on the Dream of Scipio*,

and Martianus Capella's *On the Marriage of Mercury and Philology*, among others. During his lifetime, however, the intellectual world was rocked by an influx of new texts, Chartres receiving them early on. William refers a number of times to medical texts of Arabic origin, only recently available, the *Pantegni* of Constantinus Africanus and the *Isagoge* of Johannicius.[90] The effects of the sustained translating activity in Italy and Spain which had begun in the late eleventh century were beginning to be felt.

Ancient Greek texts as well as Byzantine and Arabic reworkings of ancient material were now made available to western scholars.[91] Humoral theory gained authority with the translation or retranslation of such works as the Hippocratic *Aphorisms* with its Galenic commentary and Galen's *On the Elements According to Hippocrates* and *On the Temperaments*. It was also to be approached through Haly Abbas's *Royal Book* and Avicenna's *Canon*, Arabic compendia dating to the later tenth and early eleventh centuries respectively, which aimed to present the whole of the medical discipline in systematic fashion. Each of these works included, within a treatment of theoretical medicine, a discourse on the humors which incorporated a description of the ages of man.

It was Constantinus Africanus, a monk of Montecassino and the earliest of the important translators, who first made available much of the content of the *Royal Book* of ʿAlī ibn al-ʿAbbās, known to the West as Haly Abbas. His translation, produced in the late eleventh century, circulated as the *Pantegni*. Here, in the first book of the section devoted to theoretical medicine, in the chapter concerning the mutation of the complexions according to the ages, it is stated that life is divided by doctors into four parts—*pueritia, iuventus, senectus,* and *senium*. The pivotal ages are 30, 40, and 60, but *pueritia* is subdivided into *infantia* and *pueritia*, each lasting fifteen years.[92] A treatment of the relative heat and moisture of each period follows immediately. Further on, in the section of the encyclopedia which concerns practical medicine, the consequences of the mutations of the complexions are treated and regimens are supplied for *infantes, pueri, iuvenes,* and *senes* (*in senectute et senio*).[93]

Avicenna (Ibn Sīnā) set out a similar schema of the ages in his *Canon*, the great survey of the medical art which would so influence scholastic medicine. It was translated by Gerard of Cremona, working in Spain, in the last quarter of the twelfth century. Again there are four ages of life: the period of growth to age 30 (*etas adolescentie*); that of stability, to 35 or 40, which is called the age of beauty (*etas pulchritudinis*); that of initial decline before strength is lost, to 60 (*etas senectutis*); and then that of manifest weakness, to the end of life (*etas senium*). The first age, however, is further divided into five parts rather than two. A period in which the legs are not yet fit for walking is followed by the age of dentition when the limbs are still weak and the gums are not filled with teeth. Next comes the phase in which strength has been achieved and dentition is complete. This is succeeded by the period when sperm is produced, which

lasts until the appearance of facial hair. Finally, there is an age of bodily strength which ends with the cessation of growth.[94] Avicenna elsewhere in the work described the pulses and urine types characteristic of each stage of life and offered advice on suitable regimen.

Working out of the Greek tradition, the Arabic theorists gave support to the humoral system which the West had long known. They named four ages of man, as tetradic thought demanded, making finer distinctions in the earlier years of life. Their efforts ensured the ages of man a place in the discussion of theoretical medicine. Another Arabic medical synthesis, far shorter, enabled one to get to the information on the ages of man more easily.

The *Isagoge ad Tegni Galieni* of Johannicius (Hunain ibn Ishāq), an extremely schematic introduction to humoral medicine, was translated into Latin in the late eleventh century, with the first wave of texts, perhaps by Constantinus Africanus himself.[95] It was one of a series of brief medical writings collected together in the twelfth century to form a handbook of ancient medicine, given the name *Articella* when published in the fifteenth century. The anthology, which normally included Hippocrates' *Aphorisms* and *Prognostics*, Theophilus on urines, Philaretus on pulse, and Galen's *Tegni*, would come into its own in the thirteenth century and later, when it would be prescribed reading at the new universities.[96] The *Isagoge*, heading the group, supplied an outline of the medical discipline. Theoretical medicine was first distinguished from practical medicine then subdivided into the naturals, the non-naturals, and the contra-naturals, a system also followed in the *Pantegni*. The naturals were in turn divided into eleven parts, and the ages of man fell into this category:

> There are four ages, namely, *adolescentia*, *iuventus*, *senectus*, and *senium*. The period of adolescence is hot and moist, and in this time the body increases and grows up to the twenty-fifth or thirtieth year. Prime follows, which is hot and dry, a time in which the body remains in perfection without any diminution of strength, and it ends in the thirty-fifth or fortieth year. Next comes old age, cold and dry, the period in which the body begins to lessen and decrease, although strength does not fail, and it lasts to the fifty-fifth or sixtieth year. Extreme old age follows, which is cold and moist with the gathering of the phlegmatic humor, and during this period there is a decline in strength, and the period ends with the end of life.[97]

As in the systems in the *Pantegni* and the *Canon*, the ages total four and they terminate by age 30, 40, 60, and death.

Despite certain differences, the learning would not have struck a western reader as unfamiliar. It is not surprising that an owner of one manuscript containing the *Articella* should have adorned his text with a tetradic diagram (fig. 8). The manuscript in question, now in Oxford, was copied c. 1200 and

received its schema about a century later.[98] The figure incorporates a standard selection of tetrads, not necessarily those listed in the text. The humors, qualities, ages, elements, and directions are ranged around a central medallion, inscribed *mycrocosmus*, following long precedent. The age designations, however, are those of Johannicius, a set which departs from the early medieval *pueritia-adolescentia-iuventus-senectus*. Two phases of old age, *senectus* and *senium*, are now distinguished, as they were in Constantine's *Pantegni*. The system would circulate. William of Conches, we have seen, adopted it in his account of human development, and it is followed in many of the diagrams which illustrated his work (fig. 7).

Medical theory, then, an important component of medieval natural philosophy, supplied classic definitions of the ages of man based on the changing composition of the human body. Yet there was another way the theme of the quadripartite life might be approached, namely, through the study of time. Temporal cycles, including the seasons and the ages of man, were of interest to the medieval scholar for very particular reasons.

The Computistical Context

A PROPER medieval education included, within its program of quadrivial studies, instruction in the art of reckoning time. This branch of learning, the *computus* as it was called, served a practical end. A churchman was expected to know how to determine the date of Easter and the other moveable feasts of the ecclesiastical year. The calculation demanded a certain skill, it having been established that Easter must fall on the Sunday after the first full moon following the spring equinox. To provide the necessary instruction a particular kind of schoolbook, the computus manual, came into being in the early Middle Ages. Normally a composite work, as the many surviving manuscripts attest, a computistic volume contained not only tracts written by identified authors but also short anonymous texts, collections of extracts, dialogues, epistles, mnemonic verses, and various kinds of tables and diagrams.[99] The computist was no purist. He would often include information only loosely related to his main theme, particularly if it could be considered in some way relevant to an understanding of the nature of time and its measurement and meaning.

The theme of the ages of man had its place in computistic works. Nor is the reasoning behind this difficult to discover. An age of life is a division of time, part of a microcosmic cycle believed to correspond to cycles in the macrocosm. Computistic tracts, those which aimed at a well-rounded treatment of their subject, regularly offered definitions of the divisions of time, ranging from the very smallest to the largest conceivable interval. It was into these discussions that descriptions of the ages of man were introduced, microcosm being correlated with macrocosm. The medieval divisions of time do

not correspond, in every case, to our own. A schoolboy in eighth-century
Britain might have memorized the following set, standard for centuries with
slight variations. In a dialogue preserved in a number of manuscripts a pupil
asks his master "How many divisions of time are there?" and receives the reply
"Fourteen." "What are they?" "Atom, moment, minute, point, hour, quad-
rant, day, week, the three-month season, year, cycle, age, seculum, and uni-
verse. And these fourteen divisions of time are found in the rising and setting
of the sun and in the waxing and waning moon."[100]

Two of the divisions, "season" (*vicissitudo*) and "age" (*aetas*), encouraged
digressions on the ages of man. Bede, the great master of the computistic
genre, took both opportunities when composing his *De temporum ratione* (A.D.
725). Since this was his chief computistic work, a tract much copied and widely
read in the high Middle Ages, the inclusion of material on the life cycle takes
on significance. "Age" gave rise to a chapter on the ages of the world (ch. 66)
in which the historical epochs were counted at six and aligned with six ages
of man, following a line of thought established in biblical exegesis.[101] "Season"
was represented by a section entitled "On the Four Seasons, Elements, and
Humors" (ch. 35). As the rubric suggests, this chapter had to do with tetradic
cosmology. The excursus included, as a matter of course, an account of the
four ages of man.

Bede's exposition of tetradic material is orthodox. Treating first macro-
cosmic matters, he defines the seasons on the basis of the four qualities—hot,
wet, cold, and dry—revealing how the position of the sun determines the
relative heat and moisture in each. Having compared the seasons to the elements
of the world which share the same qualities, he turns to man, "called by the
sages *microcosmus*, that is, *minor mundus*." The four humors in the human body
are shown to be responsive to temporal rhythms. As the seasons progress,
Bede indicates, the humors increase in order, hot and moist blood growing in
hot and moist spring, and so through the list. The same pattern of increase
can be observed in the periods of man's life: "And in children (*infantes*) blood
is very strong, in adolescents (*adolescentes*) red gall, in the aging (*transgressores*)
black gall, that is bile mixed with the sediment of dark blood, and phlegms
dominate in old men (*senes*)."[102]

The prominence given to the humors suggests that Bede's source for this
section was a medical text.[103] He in fact concluded his tetradic excursus with
a description of the four temperaments. A constitutional dominance of blood,
by his account, produces cheerful, compassionate, loquacious people; red gall,
lean, fleet, bold types; black gall, steadfast, heavy, cunning men; and phlegms,
slow, sleepy, forgetful people. The chain of association—from the seasons, to
the humors and the seasons, to the humors and the ages, to the humors alone—
reveals something of the process by which information accrued to a computistic
text.

Bede's tracts on time, having largely replaced earlier efforts in the field, laid the ground for further developments. Used as textbooks in the Carolingian schools,[104] they provided inspiration for later writers of computus manuals, among them Helperic of Auxerre and Hrabanus Maurus in the ninth century and Abbo of Fleury in the tenth. Abbo, a teacher respected for his broad knowledge of the liberal arts, did much to further computistic study.[105] Invited to England during a period of monastic reform, he spent two years (986-988) in the newly founded abbey at Ramsey in East Anglia. There he tutored the monk Byrhtferth, who went on to produce his own manual in the year 1011. While Abbo's writings, like Bede's, enjoyed a wide influence, the texts being standard items in computistic compendia, Byrhtferth's *Enchiridion* exists in a single copy.[106] Yet this work more nearly succeeds in taking one into the medieval schoolroom. Byrhtferth, teaching both novices and ill-trained local clerics, coaxed them to learn. He wrote in both Latin and native Anglo-Saxon, and filled his book with visual aids.

Byrhtferth clearly admired tetradic thinking. He rehearsed its principles at several places in his works, not only in his arithmological tract.[107] So convinced was he by the fourfold division of man's life that he divided the text of his *Vita S. Ecgwini* into four parts so as to show what the saint did in boyhood, adolescence, manhood, and old age.[108] The tetradic material presented in the manual is highly schematic. Very near the beginning of his work Byrhtferth summarizes some standard information, in Latin, then in Old English. First observing that there are significations and qualities and names of the twelve winds and four seasons and four ages of man (*pueritia, adolescentia, iuventus, senectus*), he then proceeds to link the seasons, the ages, the elements, and the humors on the basis of their qualities. Bede was his guiding light. Again blood is said to be strong in children, red gall in adolescents, phlegms in old men, and black gall, melancholy, *in transgressoribus*, so unusual an age designation that Byrhtferth felt compelled to explain it, "that is, those in their prime (*iuventute*)."[109] Further on, at the point where he treats the summer equinox, it occurred to him to supply, in Old English, another list of tetrads: he notes that there are two solstices and two equinoxes in the twelve months, the twelve signs, four seasons, four ages of man, four letters in Adam's name, and four elements, and the letters D E U S in God's name.[110] At another place he makes the pronouncement, in Old English, that "priests must know this with complete accuracy, that there are four Ember Fasts in the year, just as there are four seasons and four ages, and two solstices and two equinoxes."[111] Elsewhere, having described the seasons, he informs the reader that there are also four elements and four cardinal virtues.[112]

Byrhtferth in each case furnished a diagram to clarify the text. That which once accompanied the first passage is all but torn away; the others survive intact. But only in the schema which illustrates the second text, that triggered

by the mention of the equinox, were the ages of man incorporated into a comprehensive system. The diagram, which includes all the enumerated tetrads, takes the form of a *rota*, skillfully executed in orange, red-orange, dark green, and brown (fig. 9). Its appearance had been announced, its didactic function established: "We will draw a diagram of all these things here in order that the young priest who beholds these may be the more learned." Emphasis, following the text, was placed on the equinoxes and solstices. Inscribed in green bars, they mark the cardinal points and divide the figure into quadrants. The letters DEUS, making a cross, are placed in the very center of the composition. Adam's name is inscribed in an encircling ring along with the names of the four directions in Greek. East (*Anathole*) takes the position of honor at the top of the diagram, but it is not correlated with spring. The temporal cycles—the months together with the signs of the zodiac in Latin and Old English, the seasons, and the ages of man—all begin at the solstice inscribed at the base of the figure. *Pueritia* thus appears in the bottom left quadrant, along with January, Capricorn, and spring; *adolescentia*, *iuventus*, and *senectus* follow in a clockwise direction.

This diagram, and the others in the manual, pale before Byrhtferth's schematic summa, the brightly colored display diagram which must represent his final statement on tetradic cosmology. Two copies survive. One is to be found in the "Ramsey Computus," a miscellany transcribed at Ramsey c. 1090 (fig. 10).[113] The other, less distinguished artistically, was once part of the "Peterborough Computus," a manuscript dated c. 1122 (fig. 11).[114] It is the earlier copy which carries the attribution to Byrhtferth, monk of Ramsey, along with the identification of the composition as a harmony of the months and seasons: "hanc figuram edidit bryhtferð monachus ramesiensis cenobii de concordia mensium atque elementorum."[115] A marginal notation spells out its contents in familiar list form: "This figure contains the twelve signs, and two solstices, and the two equinoxes, and the four seasons of the year. In it are written the four names of the elements and the names of the twelve winds, as well as the four ages of man. The four letters of the name of the protoplast Adam are simultaneously conjoined."[116]

The months and elements, given prominence in the entitling rubric, are distributed along the perimeter of the composition and determine its shape. At the cardinal points, the four elements, fundamental components of the world, are inscribed in roundels, their respective qualities being supplied on connecting bars. The twelve winds, four primary and eight secondary, which originate in different directions on the medieval wind rose, are inscribed in the same roundels. Toward the center there appear the four directions or parts of the world, both in Latin and transliterated Greek, along with the large letters ADAM. Adam's name, taking center stage as it did in the closely related *rota* in the manual (fig. 9), binds the sets together. Byrhtferth, in his arithmological

work, quoting "the Fathers," had explained that the initial letters of the parts of the world in Greek—*Anathole, Disis, Arcton,* and *Misymbrios*—form the name of the first man.[117] This was part of a well-developed lore recorded in many Anglo-Saxon texts. Not only had God sent four archangels to the four corners of the world to discover the letters of Adam's name, but he had created him from all the elements of the creation: the earth, the sea, the sun, the clouds, the wind, the stones, the holy spirit, and the light of the world.[118] "Protoplast Adam," containing in himself all the parts of the world and all its elements, is thus a meaningful centerpiece for the diagrammatic composition.

Temporal tetrads, the months taking prominence, are aligned at the diagonals. The solstices and equinoxes are inscribed at the horizontals and verticals (cf. fig. 9). The months along with the zodiacal signs sweep around the periphery of the figure in arcs, each set of three being juxtaposed with a roundel containing the corresponding season. In these roundels the ages of life are correlated with the seasons, microcosm aligned with macrocosm. The durations of the four ages are supplied, Byrhtferth taking advantage of the space afforded to include the starting points and periods of the various units of time. *Pueritia,* he believes, lasts to age 14, *adolescentia* to 28, *iuventus* to 48, and *senectus* to 70 or 80. His system is based on progressions in sevens, a line of thought to be defined in the next chapter.

Recent study of the "Ramsey Computus" has established that Byrhtferth himself probably assembled the texts contained within the manuscript and that he composed his manual as a guide to their use.[119] The original diagram, then, would have been copied into the original miscellany, possibly prepared for it as a kind of frontispiece.[120] Nor was this intrusion of a self-sufficient tetradic schema into a computistic handbook an isolated occurrence. Another example is provided by an early eleventh-century miscellany copied in France, possibly in an abbey with Fleury connections (fig. 12).[121] The manuscript contains the works of Bede and Helperic as well as a poem on the Easter cycle written by Agius of Corvey in the year 863. A tetradic schema appears at the head of the poem, although unrelated to it in content. Remarkable for the wild, trumpeting figures of the four winds perched at its cardinal points, the *rota* is otherwise straightforward. The elements, seasons, and humors are inscribed with their qualities. The four ages of man—*infantia, adolescentia, iuventus, senectus*—are written in roundels which, significantly, interlock with a central circle inscribed *microcosmus.* A tetradic diagram was a versatile commodity.

The study of the computus, if practical in orientation, had broader consequences. A knowledge of time cycles gave insight into the operations of the physical universe. Honorius Augustodunensis, when he compiled his single-volume exposition of the world, the *Imago mundi,* in about 1110, devoted the second book to time and adopted the form of a computistic tract.[122] Following precedent, he proceeded through the divisions of time. Reaching the seasons,

he paused at man, the microcosm: "The human body is tempered by the same qualities, whence it is called *microcosmos*, that is, *minor mundus*. For blood, which grows in spring, is wet and hot. And it is strong in small children (*infantes*). Red gall, increasing in summer, is hot and dry. And this abounds in youths (*iuvenes*). Melancholy, that is, black gall, increasing in autumn, abounds in those of more advanced age (*provectiores*). Phlegms, which dominate in winter, abound in old men (*senes*)."[123] The passage closely parallels Bede's treatment of the humors in the *De temporum ratione*, the probable source.[124] Honorius was a synthesizer whose contribution lay in making accessible inherited information. For computistic material, an important component of the sum of early medieval learning, he turned to his most illustrious predecessors.

The continuities in this sphere of learning are striking. And even with the appearance of scientific texts newly translated from the Greek and Arabic, the computistic genre retained its long-established form; the thirteenth-century computist merely had a greater range of sources with which to work. When John of Sacrobosco, an Englishman connected with the new University of Paris, prepared a computus manual, he included among his topics certain of the divisions of time. In his treatment of the seasons he observed that the four parts of the year are joined, through the qualities, to the four regions of the world, the four cardinal winds, the four elements, the four humors, and the four ages of man.[125] He promised that the interrelations of the tetrads would be set out in a figure and, in fact, used an elaborate tetradic diagram to do his work for him. In a French manuscript of the thirteenth century there is a particularly artful rendition of the customary type, embellished with Gothic drolleries (fig. 13).[126] The eight overlapping arcs of Isidore's *rota* have become four great semicircles, intersecting to create large spaces capable of holding all the information which the author wished to include. In each sector, in conformity with the text, a part of the world, a wind, an element, a season, a humor, and an age of man are listed. But the sequence of age designations departs from the early medieval norm. Now one finds the set popularized in Arabic medical works, in particular, the *Isagoge* of Johannicius—*adolescentia, iuventus, senectus, senium*.

Where lay the enduring appeal of the tetradic system? Something of its intellectual attraction can be gleaned from the words of a poet. Alan of Lille, in fashioning his learned allegory, the *Plaint of Nature*, possibly in the 1160s, drew on currents in twelfth-century natural philosophy. Nature, personified, describes her role in forming man on the model of the harmoniously ordered universe, as God's deputy. Speaking of the correspondences to be discovered between the world and man, she likens the seasons to the ages and the ages to the seasons:

See how the universe, with Proteus-like succession of changing seasons,

now plays in the childhood of Spring, now grows up in the youth of Summer, now ripens in the manhood of Autumn, now grows hoary in the old age of Winter. Comparable changes of season and the same variations alter man's life. When the dawn of man's life comes up, man's early Spring morning is beginning. As he completes longer laps in the course of his life, man reaches the Summer-noon of his youth; when with longer life he had completed what may be called the ninth hour of his time, man passes into the manhood of Autumn. And when his day sinks to the West and old age gives notice of life's evening, the Winter's cold forces man's head to turn white with the hoar frost of old age. In all these things the effects of my power shine forth to an extent greater than words can express.[127]

II. SEVENS IN THE LIFE CYCLE

EVEN, ever revered as an especially potent number, the number of perfection, was understood to inform the progress of the human life in two ways. According to one line of thought, the older of the two, critical points in the life cycle occurred at intervals of seven years. When the idea is first documented, in an elegy attributed to Solon, the ages total ten and the span of life is divided into equal phases terminating at years 7, 14, 21, 28, 35, 42, 49, 56, 63, and 70. Following the other line of thinking, the human life in its entirety was divisible into seven distinct periods. Sometimes these seven ages were tabulated in hebdomads of years, single and multiple (7, 14, 21, 35, 49, 63, 98, for example), but the durations of the ages in other cases deviated widely from the hebdomadic sequence or received no mention at all. In an astrological context the correlation between the ages and the seven planets was the determining factor, and the lengths of the phases of life were computed according to the "period" of each planet.

While the seven-age system was one of the most important and long-lived of the divisional schemes, familiarity with Jaques's speech in Shakespeare's *As You Like It* (II, vii) leads, perhaps, to an overestimation of its role. If an early medieval scholar had been asked to name the number of ages, he might just as well have answered four, five, or six, as seven. Even in the later medieval period, when the fortunes of the sevenfold system steadily improved, it continued to receive competition from these and other divisional schemas. The notion that the phases of life succeeded one another on seventh years, on the other hand, was remarkably pervasive and exerted an influence on most of the systems of age division at some point. Even in instances when the pattern broke down in later life, the limits of the early stages of growth tended to be fixed at 7, 14, and 21 or 28. Until very recent times, of course, the legal boundary between youth and adulthood was placed at the twenty-first year.

The present chapter runs parallel to the previous one in many respects and, in a sense, completes it. Again the subject is a system of age division which found its origins and justification in number speculation and which was incorporated into comprehensive descriptions of the natural order. Arithmological, medical, and astrological sources once more come into play. Nonetheless, there are telling differences. Hebdomadic thought did not have so defined a place in the edifice of medieval learning as did tetradic thinking. The idea that life progressed in seven-year stages was so well established it hardly required

comment. The seven-age system itself was, perhaps, slightly suspect on account of its astrological associations; the correlation with the planets, if known in the early Middle Ages, was effectively suppressed. Yet both lines of thought were to prove extremely tenacious. They will run as leitmotifs through this study.

Antique Septenary Speculation

THE NUMBER seven seems always to have had a peculiar hold on the popular imagination. Sevenfold groups of people, objects, and actions turn up with remarkable frequency in folklore, myth, and ritual, the world over.[1] The roots of the veneration of the number are ancient, preliterate. Its powers were celebrated in the ancient Near East long before Pythagorean and Neopythagorean arithmologists treated it in their surveys of the decad. The Old and New Testaments, Near Eastern in origin, abound in hebdomadic references, a phenomenon which inspired Jewish and Christian exegetes to write in praise of the number.

The early Pythagoreans gave due consideration to the hebdomad, if the tetrad and the decad seem to have played a greater role in their descriptions of the natural order. Philolaus, traditionally the first of Pythagoras's followers to have committed the sect's beliefs to writing (c. 400 B.C.), is reported to have likened the hebdomad, unbegotten and unbegetting, to Athena, the motherless, virgin goddess.[2] Proros of Cyrene, a Pythagorean active, perhaps, toward the end of the fourth century B.C., seems to have written a treatise devoted entirely to the number seven.[3] Neopythagoreans carried the thinking further. In the many arithmological works surveying the numbers of the decad which survive from the Greco-Roman period, the powers of seven are minutely described. Varro in the first century B.C. and Hermippus of Berytus in the early second century A.D. produced texts, now lost, devoted exclusively to the hebdomad.[4]

Authors treating the number tended to rehearse a relatively fixed body of lore.[5] Seven was venerated first for its mathematical properties. Since, as a prime number, it had no factors in the decad apart from one and because, unlike its fellow prime numbers three and five, it was not a factor of another number within the decad, it was described as ungenerated and ungenerating; these were the grounds for its association with the motherless, virgin Athena. It was observed, too, that the first seven numbers added together totaled the perfect number twenty-eight, a perfect number being defined as one equal to the sum of its factors ($1 + 2 + 3 + 4 + 5 + 6 + 7 = 1 + 2 + 4 + 7 + 14$). Seven was also said to represent the organic body as this is composed of three dimensions (length, breadth, height) and four limits (point, line, surface, solid).

Copious lists of appearances of the number in the natural world were drawn up, many members of which seem curious to the modern eye. There were said to be seven planets, seven stars in the Pleiades and the Great Bear, as well

as seven vowels in Greek, seven strings on the lyre, and seven movements (up, down, forward, back, right, left, in a circle), well demonstrated in dancing. The human body was believed to be composed of seven parts (the head with seven openings, the neck, torso, two legs, and two arms) and endowed with seven visceral organs (the stomach, heart, lungs, liver, spleen, and two kidneys). Herophilus, the great Alexandrian anatomist, found the human intestine to measure twenty-one (3×7) cubits in length, according to one arithmologist, twenty-eight (4×7) cubits, by the report of another.[6]

The number was especially bound up with the periodization of time.[7] One of its common epithets was "critical moment" ($\kappa\alpha\iota\rho\acute{o}s$). The lunar month of twenty-eight days was divided into four periods of seven days, and the moon was observed to pass through seven phases in its monthly cycle. Each equinox, and similarly each solstice, was seen to begin in the seventh month, or seventh sign, after the previous one. More relevant to our theme was the conviction that seven controlled rhythms of natural growth and decay. The entire human life from conception through ultimate decline was described in terms of phases lasting seven hours, seven days, seven months, and seven years. This was true in sickness as in health. The progress of disease could be charted on the basis of symptoms manifest on seventh days. Arithmological and medical thought were intimately connected.

Two ancient Greek authorities, Solon and Hippocrates, are frequently cited in Neopythagorean discussions of the number seven in the life cycle. Solon, one of the seven Greek sages, active in the early sixth century B.C., wrote a poem outlining ten ages of man, each lasting seven years.[8] The earliest ages he defined on the basis of physiological change, the later phases according to psychological development. In the first hebdomad of years the boy grows and loses his first set of teeth, in the second he shows signs of approaching puberty, in the third he begins to grow a beard. The fourth age is the period of greatest strength, the fifth is appropriate for marriage and childbearing, the sixth is characterized by a well-trained understanding. In the seventh and eighth periods mental and verbal facility are strongest, but these powers begin to weaken in the ninth. With the completion of the tenth hebdomad of years, death can no longer be considered untimely. Seventy, here made the terminus for the human life, was a cipher for the life span in antiquity.[9] A Hebrew hymnist, lamenting the transience of things, expressed much the same idea in Psalm 89 (90), verse 10: "The days of our years . . . are threescore and ten years. But if in the strong they be fourscore years: and what is more of them is labor and sorrow."[10]

Hippocrates' opinions on the ages of man, as quoted by the later arithmologists, derived ultimately from a section of a text entitled *On Sevens* included in the Hippocratic Corpus. The treatise, preserved in its entirety only in two copies of a corrupt Latin translation, falls into unequal parts. The first eleven of fifty-three chapters concern the place of seven in the universal order; the

remainder are given over to a discussion of fevers. Like the rest of the tracts attributed in antiquity to the fifth-century physician, this one is now considered to be pseudepigraphical. The nature of its sources and its date of composition, however, remain disputed. Some earlier scholars considered the numerological section to be a direct copy of a Presocratic original. Others, more convincingly, see it as a compilation drawn from a variety of sources; it has been dated as late as the first century B.C.[11]

The pseudo-Hippocratic tract is infused with a Pythagorean faith in the power of number and its role in shaping the cosmos. Seven is held to order the world and its parts. The universe has seven spheres, and seven heavenly stars control the cycle of the seasons. There are seven winds, seven seasons, seven ages of man, seven parts of the human body, seven functions of the head, seven vowels, seven parts of the soul, and seven parts of earth. The chapters are characteristically short and schematic. Having treated the seven seasons (*seminatio, hiems, plantatio, ver, aestus, autumnus, postautumnus*), the author briefly surveys the ages of man. The Latin text is translated here.

> In like manner there are seven seasons in the nature of man, called ages: *puerulus, puer, adolescens, iuvenis, vir, senior, senex*. They are as follows: *puerulus* up to seven years, until the exchange of teeth; and *puer* up to the emission of seed, fourteen years, to twice seven; and *adolescens* to the appearance of the beard, twenty-one years, to three times seven, to the completion of the body's growth; *iuvenis* is perfected at 35 years, at five times seven; and *vir* up to 49 years, to seven times seven; and *senior*, 63, to 9 hebdomads; then *senex* to fourteen hebdomads.[12]

The striking resemblance to Solon's scheme suggests that the elegy was one of pseudo-Hippocrates' sources.[13] The characteristics of the first four ages accord generally, and the progress of life in sevens of years is carried as far as it will go within the rigorously hebdomadic program of the tract. Structure did much to determine content. One wind was subtracted from a standard octave. Three seasons were added to the tetrad. Ten ages became seven. This last was accomplished by parceling out the three extra hebdomads to the fourth, fifth, and six ages. Pseudo-Hippocrates' text, even if dated as late as the first century B.C., remains the earliest surviving witness to the seven-age scheme.

Solon's elegy and the extract from *On Sevens* were incorporated into many later arithmological texts. When they fail to make an appearance, a dissertation on the role of seven in embryology and aging is normally to be found in their place. The passage on the ages of man has thus been regarded as a key text by scholars seeking to separate the extant arithmological works into families and to sort out their interrelations.[14] That line of arithmologists related through citation of Solon and Hippocrates includes an odd mix of writers, Jewish, Christian, and pagan, who used the same material to different purpose. Among

Greek speakers, Philo Judaeus, working in Alexandria in the early first century
A.D., extolled the merits of seven in an exegetical treatment of the seventh day
of creation;[15] Clement of Alexandria, writing c. 200, introduced hebdomadic
matter into a consideration of the sabbath rest within an exposition of the
Decalogue;[16] Anatolius, in the third century A.D., presented information on
seven as part of a survey of numbers of the decad.[17]

Latin writers were also acquainted with the material. The third-century
grammarian Censorinus, possibly drawing upon Varro, paraphrased Hippo-
crates and Solon in a discussion of systems for numbering the ages of man.
Hippocrates, by his account, divided the ages into seven steps ending respec-
tively at 7, 14, 28, 35, 42, 56, and the last year of life; the sequence does not
precisely match that in the medieval translation of *On Sevens*. In an inversion
of the probable historical process, Solon is reported to have subdivided Hip-
pocrates' third, sixth, and seventh ages so that each of the ten would comprise
seven years. Censorinus was himself wholly convinced by the system: "Among
those cited, they seem to have approached most closely to nature who have
measured the human life by hebdomads. For after each seventh year or so,
nature reveals certain nodes and displays something new in them."[18]

Ambrose praised the number seven in an epistle to Horontianus (A.D. 387)
in connection with the seventh day of creation. He claimed to treat the number
not in the way of the Pythagoreans and other philosophers, but rather according
to the form and divisions of spiritual grace (Isa. 11:2-3). Nonetheless, he in-
troduced a number of septenaries pagan in origin, including the views of the
two ancient Greeks on the ages of man. He summarized their opinions, dis-
tinguishing Hippocrates who named seven ages from Solon who described
seven-year periods. The text is rich in age terms, for Ambrose, in his citation
of Hippocrates' text, supplied not only abstract designations for the ages but
also gave their equivalents for individuals of each phase. Thus *infantia, pueritia,
adolescentia, iuventus, virilis aetas, aevi maturitas*, and *senectus* are said to corre-
spond to *infans, puer, adolescens, iuvenis, vir, veteranus*, and *senex*.[19]

Arithmologists standing in the other line of textual transmission, that marked
by the absence of reference to Solon and Hippocrates, characteristically included
a summary of medical ideas on human development in their discourses on
seven. The summary is sometimes attributed in part to the Peripatetic philos-
opher Strato (third century B.C.) and the physician Diocles of Carystus (fourth
century B.C.). A full account in Greek may be found in the *Theologumena
arithmetica*, an anonymous survey of the decad compiled in the fourth century
A.D.[20] Macrobius incorporated a closely related version in his commentary on
Cicero's *Dream of Scipio*, where the prophecy of Scipio's death at fifty-six (7×8)
served as a starting point for a numerological digression.[21] Other Latin writers
had given abbreviated accounts of the same material in their numerological
surveys, namely, Varro in his *Hebdomades*, according to the second-century

polymath Aulus Gellius,[22] Calcidius in his fourth-century commentary on the *Timaeus*,[23] Favonius Eulogius in yet another gloss on the *Dream of Scipio*, dating to the late fourth century,[24] and Martianus Capella in his *On the Marriage of Philology and Mercury*.[25] Since Macrobius's text, a mainstay of medieval literary culture, contains a particularly full rendering, it is appropriate to consider it in some detail.

The relevant section begins, "Seven is the number by which man is conceived, developed in the womb, is born, lives and is sustained, and passing through all the stages of life attains old age; his whole life is regulated by it."[26] A string of examples follows, demonstrating the assertion. Seed planted in the womb, viable if it does not escape by the seventh hour, is enclosed in a sack on the seventh day. Growth then proceeds in seven-day phases: "On the second hebdomad drops of blood appear on the surface of the aforementioned sack; on the third hebdomad they work their way into the humor within; on the fourth hebdomad this humor coagulates so that there is a curdling intermediate between flesh and blood, as it were, both liquid and solid; and occasionally, indeed, on the fifth hebdomad a human shape is being molded in the substance of the humor, no larger than a bee in fact, but in such a manner that on that small scale all the limbs and the distinct contour of the whole body stand out."[27]

The growth of the embryo having been charted, a consideration of postnatal development commences. In the seventh hour after birth it is determined whether an infant has been fated to live or to cease breathing. The remains of the umbilical cord are shed after one seven-day period, the eyes begin to turn toward light after two, the whole face turns toward moving things after seven. Teeth emerge after one seven-month period, the child sits after two, begins to form words after three, stands firmly and walks after four, gives up suckling after five. The characteristics of the ages, next enumerated, show similarities to those outlined in Solon's elegy. A second set of teeth appears and the child can speak clearly after the seventh year, puberty is attained after two hebdomads of years, a beard covers the cheek and growth in height stops after three, growth in breadth terminates after four. Full strength is achieved with the fifth hebdomad: a boxer's career has been made or lost by this point. Vigor is retained to the sixth seven-year period and beyond. Forty-nine, seven multiplied by itself, is the perfect age. Seventy, produced by joining seven with the perfect decad, represents the complete life span; at this time a man retires from service to engage in the exercise of wisdom.

Macrobius, following his source, never stopped to add up the total number of ages. His concern was to observe hebdomadic rhythms in the life cycle, first in units of hours, then days, months, and years. This vagueness is characteristic of properly medical literature as well. When writers on regimen took it upon themselves to survey the entire life cycle, supplying hygienic advice for each age, they would only rarely establish the sum total of phases. Aging was

understood to be a fluid process. Yet the idea of progress in seven-year leaps made itself felt.

Galen, to name one case, carried the theme of the ages of man through the first five books of his tract *On Maintaining Health*, a text which would be translated into Latin in the twelfth century. His advice, geared to the man in perfect health with leisure to look after himself, extends through the phases of life from birth to death. Numerical ages are supplied only occasionally. Galen begins by describing the care of the infant to the third year (I, 7-9), noting that a three- or four-year-old can safely be taken in a chariot or a boat and that a seven-year old can ride a horse. He continues with suitable regimens for the period from the first to the second seven years and from the second to the third (I, 12). In Book II, which extends to manhood, he covers the third hebdomad (II, 1ff.). When discussing bathing, Galen mentions the fourth period of seven years (III, 4), and later reveals that he himself began to follow a course of regimen in his twenty-eighth year (V, 1). Old age, which he divides into three periods (V, 12), is treated in some detail, but since time affects individuals differently—one octogenarian may be stronger than another seventy-year-old (V, 3)—he does not specify the durations of the phases.[28]

In sum, the seven ages of man, when described in antique arithmological or numerologically cast medical literature, appear largely as a result of the conscientious passing on of Hippocratic learning. It is in astrological thought that the seven-age system would really come into its own, Ptolemy's influential text of the second century A.D., the *Tetrabiblos*, providing the earliest surviving account of planetary influence on the ages of life. Since the ancient and medieval astrological writings form a class apart, however, it is appropriate first to examine hebdomadic motifs as they appear in medieval arithmological and medical texts.

Septenary Cycles in Medieval Thought

FOR ITS KNOWLEDGE of sevens in the life cycle, the Middle Ages was indebted to antiquity. Medieval writers introduced variations into the tradition, but ancient arithmology provided the starting point. The Hippocratic tract *On Sevens* was itself translated into Latin, probably in the sixth century, and was subsequently available in the West, if not widely so: the text is preserved in two manuscripts dated to the late ninth and mid-tenth century respectively.[29] More important sources of hebdomadic lore were the summaries preserved in the writings of staple authors. Both branches of the ancient tradition were represented. Ambrose's epistle to Horontianus provided an account of both Hippocrates' and Solon's views. In the works of Macrobius, Martianus Capella, and Calcidius, the medieval scholar could have learned about hebdomads in human development.

One can, in fact, follow the circulation of the material. Commentators as well as copyists played their part. A gloss on Macrobius's *Commentary on the Dream of Scipio*, one found in several German and Italian manuscripts of the eleventh and twelfth centuries, demonstrates the process. Toward the end of his discourse on the phases of life, Macrobius had observed that the seventieth year marks the perfect span of the human life, seventy being formed from the union of the decad and the hebdomad. The anonymous commentator, in order to throw light on the passage, introduced related material. Turning to Ambrose's letter, he took from it the Church Father's rendition of Solon's program of growth in hebdomads in which ten periods of seven years mark the full life.[30] So it is that a scholar of the Middle Ages wove together the two branches of the ancient arithmological tradition.

Martianus Capella's consideration of hebdomadic progressions, if far briefer than that of Macrobius, was as widely known. The text appears in the numerological section of his *On the Marriage of Philology and Mercury*. Arithmetic, personified, as she discourses on the number seven, confines her remarks to the following:

> The teeth appear in infants in the seventh month, and the second teeth come in the seventh year. The second hebdomad of years brings puberty and the faculty of producing offspring; the third brings a beard to the cheeks; the fourth hebdomad marks the end of the increase in stature; the fifth marks the full flowering of the young manhood.[31]

The text received different kinds of attention. An anonymous Carolingian poet reworked the entire survey of the decad, adding certain Christian elements. Following his source closely, he cast the section on aging in hebdomads thus:

> Sic parvulis in mense dentes septimo
> Surgunt, et hi mutantur orbe septimo;
> Secunda septimana tum pubem movet;
> Florem genarum prestat inde tertia;
> Augmenta statureque quarta terminat;
> Quinta iuventutis micat perfectio.[32]

Commentators sought to explicate the passage. Remigius of Auxerre (d. 908) glossed certain words and supplied numerical equivalents for the ages: the second hebdomad represents the year 14 or 15; the third, 21; the fourth, 28; the fifth, 35. In describing the fifth hebdomad (*iuvenalis aetas*), he reintroduced an idea he had used earlier in describing the first four ages of man: "This is the state of growth beyond which man increases neither in cleverness nor in bodily stature."[33]

The text also made its way into the *Liber numerorum*, that early medieval arithmological pastiche included with reservation in Isidore's canon.[34] The

author again manipulated his source, deleting obviously pagan elements and
adding Christian material. His section on seven begins with a description of
the properties of the number. Though he forbears drawing a connection with
the pagan deity Minerva, he follows Martianus in explaining that the *septenarius*
is born from nothing, neither generates nor is generated. Quickly shifting to
a Christian idiom, he paraphrases a passage from Gregory the Great's *Moralia
in Iob* to the effect that seven is composed of three, the first odd number, and
four, the first even number, which multiplied together give twelve. Three, it
is said, illustrates the mystery of the Trinity, four, the performance of the
cardinal virtues; twelve is the number of the apostles made perfect in the spirit
of a sevenfold grace.[35] He continues by listing sevens found in scripture, among
them the seven gifts of the Holy Spirit (Isa. 11:2-3), the seven eyes on the
stone laid before Jesus in the vision of Zacharias (Zach. 3:9), the seven loaves
which were divided among the people (Matt. 15:34), and the seven candlesticks
representing the seven churches which John saw grouped around Christ (Apoc.
1:12-20). Then, having named seven classes of philosophy (*arithmetica, geo-
metria, musica, astronomica, astrologia, mechanica, medicina*), he returns to Marti-
anus Capella and says that there are seven phases of the moon, seven circles,
seven days, and seven transformations of the elements and observes that seven-
month parturitions first bring forth the fully formed human. Coming finally
to the passage on aging, he follows Martianus closely as far as the fifth heb-
domad but extends the survey to age forty-nine by covering an additional two
seven-year periods: the sixth hebdomad represents a weakening; the seventh
is the beginning of old age.[36] The author does not explicitly state that there
are seven ages. In earlier sections he had named four periods of life and six
ages of man. Nonetheless, obeying an arithmological instinct, he rounds out
the number of hebdomads to seven.[37]

Byrhtferth of Ramsey offers no help on this occasion: his examples of the
septenarius, "which is so adorned with golden wreaths as to reach the very
throne of highest God," are largely scriptural.[38] But a twelfth-century Austrian
poet, Priester Arnold, did include the seven ages of man among a collection
of septenaries in a vernacular poem he wrote praising the number seven, "Lob-
lied auf den heiligen Geist."[39] The seven gifts of the Holy Spirit form the core
of the work, and other religious hebdomads are described at its beginning and
ending. In one section, however, sevens in the natural order are listed, namely,
the seven heavens, seven stars, seven suns, seven phases of the moon, and
seven days of the week (stanza 21). The phases of the moon, described in five
stanzas, are compared to the life of man (22-26), and the fact that John con-
secrated seven churches in Asia is said to indicate allegorically that every man
is created by seven (31). At this point the author, following precedent, treats
both the pre- and postnatal life, beginning with the first six weeks in the growth
of the embryo (32) and proceeding to the seven ages of man (*siben alter der*

liute). He counts off the ages, giving their names in Latin: *infancia, puericia, adolescencia, iuventus, etas, senectus*, and *decrepita etas*, the last of which brings our life to an end (33).[40] Priest Arnold's work, if viewed as a synthesis of Christian hebdomadic thinking, has its idiosyncrasies. Yet its roots are clear. Of the Latin age terms used, only *etas* is unusual. But then the poet needed a word which would rhyme with *daz*.[41]

The seven-age system circulated in the high Middle Ages; Priest Arnold knew about it, if he had terms for only six of the ages. But other schemes existed alongside, giving it competition. When it came to calculating the durations of the ages, however, there were few alternatives to the hebdomadic system. A sampling of brief texts on the ages drawn from early medieval medical miscellanies brings home the point. These indicate that a hebdomadic sequence might be followed, with more or less rigor, in descriptions of four, five, six, or seven ages of man.

In Vindicianus's epistle to Pentadius, discussed in the last chapter, the first three of four ages terminate at 14, 25 (rather than 28), and 42 years respectively. The same sequence was adopted in the *Sapientia artis medicinae*, although the fifty-sixth year was also singled out for attention.[42] In a one-line note inscribed in a tenth-century manuscript in Chartres, five ages are enumerated in multiple hebdomads, totaling ten altogether: "*Infantia* has 7 years; *puericia*, 7; *adolescentia*, 7; *iuventus*, three times 7; *senectus*, four times 7."[43] In a contemporary miscellany in Paris six ages are listed, their durations being given first—to 7, 14, 27 (*sic*), 48 or 49, 70 or 80, and beyond—and their equivalents in hebdomads then supplied: "*Infantia* has one hebdomad of years, that is, 7 years; *pueritia* another 7; *adulescentia* two hebdomads, that is, 28 years; *iuventus* three hebdomads, that is, 49 years; *senectus* four hebdomads, that is, 77 years, 11 hebdomads; *senium* [also called *decrepitus* and *nimium senex*] has no fixed number of years."[44] Finally, a ninth-century medical manuscript in Paris contains a text describing the ills to which each of seven ages is particularly susceptible. Again the ages accumulate in hebdomads, their limits being set at 7, 14, 28, 48, 56, 70, and 74 years.[45] The progressions in each case are measured, age following age at rhythmic intervals. The life cycle thus takes its place in an ordered universe where harmony and due proportion reign.

The Seven Ages and the Seven Planets

UNDERLYING the correspondence drawn between the ages of man and the planets was the conviction that the heavenly bodies exert a controlling influence on the life of man and that the character and complexion of the individual and of whole societies were determined by celestial forces. The immortal soul caged in its corporeal prison was understood to be of the same essence as the spirit diffused throughout the universe. Man, the microcosm, was believed to have

a sympathy with the planets, to be daily affected by their movements. At some time after Hellenistic astronomers and astrologers had established that a total of seven planets (the five wandering stars and two luminaries) occupied seven spheres and were presided over by seven planetary deities, the idea emerged that each planet had dominion over a single phase of life. The Moon, the heavenly body closest to earth, controlled infancy. Mercury, Venus, the Sun, Mars, Jupiter, and distant Saturn, working outward through the spheres, governed the succeeding ages.

The concept, although it would become common knowledge after its canonization by Ptolemy in the first half of the second century A.D., played but little role in the technical business of casting horoscopes. Astrologers engaged in forecasting individual destinies on the basis of the configuration of the heavens at birth were led to consider the archetypal pattern of the human life only insofar as it affected their predictions. Just as the doctor was advised to take the age of his patient into account when prescribing regimen, so the astrologer was cautioned to pay heed to age in his prognostications. Ptolemy, as a preface to his treatment of the seven ages and the seven planets, wrote:

> In the same fashion, dealing with the division of time, one must take as a basis in each single prediction the differences and special proprieties of the temporal ages, and see to it that we do not, in the ordinary, simple treatment of matters incident to the inquiry, carelessly assign to a babe action or marriage, or anything that belongs to adults, or to an extremely old man the begetting of children or anything else that fits younger men.[46]

The kinship between medical and astrological thought with regard to the ages of man extends further. Medical theory suggested that a man, though fundamentally sanguine, choleric, melancholic, or phlegmatic, passed through four distinct phases in his life characterized by the dominance of one particular humor. In the same way, while each individual remained throughout his years a "child" of the planetary deity who presided over his horoscope, he yet came under the temporary control of each of the seven planets in turn.

Tetradic elements were integrated into the celestial system. The planets, if not subject to the constant change characteristic of the sublunary world of the elements, were equally to be defined through the four primary qualities: they were assigned heating, moistening, cooling, and drying powers, the first two generative, especially in combination, the last two destructive. In Ptolemy's view, the Sun was heat itself; the Moon, whose movements clearly affected the oceans and rivers, was associated with wetness. Positioned between them, Mercury oscillated, now dry, now wet, while Venus, hot from the Sun, was predominantly moist. Red Mars was hot and dry; well-tempered Jupiter, hot and wet; far-off Saturn, removed from the earth and sun, cold and dry.[47] It was an easy step to distribute the humors among the planets: phlegm was put

into correspondence with the Moon, red gall with Mars, blood with Jupiter, and melancholy with Saturn.[48] Still, astrologers favored not the four- but the seven-age scheme of life.

Ptolemy supplies the earliest surviving account of planetary influence on the ages of man in his astrological work, the *Tetrabiblos*. He is not believed to have invented the correlation, which is put forward in a chapter on the division of times tacked onto the end of the text.[49] Nonetheless, the implied structure of the universe and the personalities of the deities who lend each age its character are thought to suggest that a Greek rather than an oriental astrologer shaped the program. Ptolemy's detailed descriptions of the phases of life develop on the assumption that the attributes of each age accord with the nature of its ruling planet. The Moon is responsible for the moist and unstable bodily state, the rapid growth, and the unperfected soul characteristic of infancy. Mercury, taking over childhood, works upon the rational soul, implanting the seeds of learning and making manifest individual peculiarities. Venus incites in youths sexual desire, incontinence, passion. The Sun, Lord of the middle sphere, brings to the fourth age control over the actions of the soul, a desire for social prominence, a new sobriety. Mars offers, with a sense of passing prime, misery and anxiety and an urge to noteworthy achievement. Jupiter grants to the elderly a release from toil and brings with it dignity and prudence and a desire for honor and acclaim. Finally Saturn introduces in the final phase of life, along with a general cooling and slowing, a lack of spirit, a feebleness, and a dissatisfaction.

It is a satisfying system, convincing, even compelling, if the underlying assumptions are accepted. The progress outward through the spheres and the passage through life, both unalterable sequences, match up without great distortion of either. Only the unpleasant Martian interlude, isolated between two well-favored periods, stands apart from the usual characterization of the years of maturity. Who is to say if it is not borne out by experience? Both the physical properties associated with the planets—the Moon's ever changing appearance, Saturn's feeble light and dilatory movement—and the traits assigned to their deities in mythology—Mercury's quick intelligence, Venus's amorous nature—find ready metaphoric parallels in the ages to which they are related.

As an added dimension, the durations of the ages are astronomically determined. Each planet had been assigned a "period" based, so far as can now be determined, on the apparent length of its cyclic movement from a posited stationary earth. Only a small amount of illicit juggling was required to fashion a credible sequence. The Moon rules for four years, a figure possibly drawn from the number of its quarters. Mercury has dominion for ten years, half its assigned twenty years. Then Venus exerts an influence for her eight years, the Sun for nineteen years, its so-called Meton cycle, Mars for fifteen years, Jupiter

for twelve, and Saturn, its period lasting thirty years, to the end of life.[50] The terminal points of the ages are thus fixed at 4, 14, 22, 41, 56, 68, and death. Only two—14 and 56—fall on the hebdomad, the former no doubt as a result of conscious manoeuvre, fourteen being the accepted age of puberty.

The governing impulse, clearly, was to impose a sevenfold structure on the whole of human life. The rhythms of man's existence, it was assumed, must be affected by the motions in the upper world. Earthly cycles must mirror the celestial order. Thus the planetary gods, in sequence, took control of phases of life. In the same way, they dominated other blocks of time. Each claimed, and in fact continues to claim, rule over one of the seven days in the recurring week.[51] Each was given charge of a period of world history. Schemes exist in which all seven planets had their turn. Firmicus Maternus, in his *Mathesis* (A.D. 334-337), described a system according to which the Moon ceded control of time to Saturn, Jupiter, Mars, Venus, and Mercury in succession, that is, to each of the wandering stars working inward through the spheres; under the tutelage of these planets the world progressed from barbarity to civilization.[52]

Ptolemy's *Tetrabiblos*, an acknowledged classic, was copied by the Byzantines, translated by the Arabs, and commented on by writers in both Greek and Arabic.[53] The correlation between the ages and the planets was taken up by such influential astrologers as Abu Ma'shar (mid-ninth century A.D.), whose *De revolutionibus nativitatum* was translated into Greek in the century after it was written.[54] Miscellaneous fragments in Greek manuscripts show that the astrological system of age duration was followed even when the connection with the planets was not drawn explicitly.[55]

But before the complex of ideas was transmitted to the West, another component was introduced, namely, the role of the planets in prenatal development. Astrology offered one means of explaining the fact, accepted without reservation in antiquity and the Middle Ages on the authority of Hippocrates, that a child born in the seventh or ninth month might live, while one born in the eighth would not.[56] Since each of the seven planets in order from Saturn to the Moon had control over a month-long phase of the embryo's development, it was fully formed, hence viable, in the seventh month. Indeed, if born under the Moon, its hopes for survival were good. But then the planetary cycle began to repeat itself. Cold, dark Saturn taking over the eighth month produced sickly offspring. Only with the passing of the rule to beneficent Jupiter in the ninth month did chances improve for the newborn infant. A number of Arabic writers recorded this bit of embryological theory, sometimes with a complementary description of planetary influence on the ages of man.

The Cordovan historian 'Arib ibn Sa'id (tenth century A.D.) incorporated a particularly detailed account of the astrological learning in his *Book on the Generation of the Fetus and the Treatment of Pregnant Women and the Newborn*, along with a collection of ancient views on the subject of the ages of man.[57]

Within a discourse on eighth-month parturitions, the author advanced the opinion of those who believe in the power and influence of the stars. The planets, each characterized by one or more of the four primary qualities, are said to govern the developing embryo (ch. VI). Under cold and dry Saturn the unformed fetus remains insensible and incapable of movement. Under hot and wet Jupiter it becomes flesh, white and rounded if male, red and banana-shaped if female. Nerves and blood appear when control passes to hot and dry Mars. The fetus begins to move and its sex becomes plain under the influence of the hot and dry Sun. The brain, bones, and skin appear under cold Venus, and the tongue and hearing under hot and dry Mercury. Finally the fetus, fully developed, begins to push outwards under the control of the swiftly moving Moon. If it does not emerge from the womb at this time, it again falls to the rule of Saturn and Jupiter.

Having reported that every individual is believed to undergo change every seven years, the author proceeded to summarize the Hippocratic division of life into seven parts—to 7, 14, 21, 35 (the end of growth), 49, 63 to the end—derived from *On Sevens*. But life can also be divided into four periods, he says; this was the opinion of the ancients, and, God willing, he will discuss it at a later point. The tract does indeed conclude with a treatment of the ages of man. The doctor's scheme of four is given, a system in which the ages, characterized by the dominance of humors and paired qualities, terminate at 18, 35, 60, and—the last possible year of life—120 years. Representing the astrologers' opinion, the Ptolemaic system is put forward with small variations and additions. Beginning with the cold and wet Moon, ʿArib charts the influence of each planet through to Saturn, whose period of thirty years brings the seventh age to a close at ninety-eight. After this point, he says, the planetary cycle begins again and, with the renewed influence of the Moon, the individual weakens and his faculties fail.

The West long knew virtually nothing of this particular strain of astrological theory. Neoplatonic writings, most notably Macrobius's *Commentary on the Dream of Scipio*, kept current a notion of celestial influence on the formation of man. The immortal soul, originating in the realm of the fixed stars, was imagined to descend through the seven spheres on its way to inhabit the mortal body. As it did so, taking on intoxicating matter, it received qualities from each of the planets in succession, Saturn through the Moon.[58] Isidore of Seville (d. 636) knew something of the theory, but he recorded it with self-protective disdain. While he could describe the planets, their positions, their paths, and their periods with a good conscience, he was less easy when the subject of the lunar week led him to comment on the planetary gods:

The pagans even took the names of the days from these seven stars, because they believed themselves to be in a certain respect formed through them;

they say they have fire from the lower atmosphere, spirit from the Sun, the body from the Moon, speech and wisdom from Mercury, pleasure from Venus, ardor from Mars, moderation from Jupiter, and slowness from Saturn. Such indeed was the folly of the pagans who fabricated such absurd fictions.[59]

A knowledge of the correlation between the ages and the planets seems to have reached the West only later. The writer of the *Tractatus de quaternario* (early twelfth century?), it may be recalled, departed at one point from his theme of four to describe a sevenfold scheme of age division, that preferred by philosophers. After naming seven ages—*infantia, pueritia, adolescentia, iuventus, senectus, senium, decrepitas*—and characterizing them with terms borrowed from Macrobius, he went on to state, "And the philosophers describe the seven ages according to the seven planets and according to the natures of the seven planets." The schematic review of the heavenly bodies and their qualities which follows, running from the cold and wet Moon to cold and dry Saturn, is carefully stripped of all extrascientific information.[60] While the author did not have access to Ptolemy, one wonders where he would have come by the ideas if not through the translation centers in Italy and Spain.

The twelfth and thirteenth centuries saw the appearance in the West of many classic texts of Greek and Arabic astrology and astronomy.[61] Ptolemy's *Tetrabiblos* was translated from the Arabic by Plato of Tivoli in 1138, then again by Egidius de Tebaldis in the mid-thirteenth century, and by others as well. Abu Maʿshar's *De revolutionibus nativitatum* had appeared in a translation from the Greek by the thirteenth century. Latin writers rapidly assimilated the information contained in the various texts. Hermann of Carinthia, one of the earliest of the translators active in Spain, responsible for Latin editions of works by Ptolemy and Abu Maʿshar among others, wrote a philosophical tract of his own, completed in 1143. Drawing on both Latin and Arabic learning, he presented, in his *De essentiis*, a vision of the universe as a harmonious whole.[62] The sublunary world, comprising the four elements, responds to the musical movements of the heavenly bodies. The planets, in their role as mediators, stimulate generation below. When man mates, as the child is conceived, they begin to exert their influence.

When the seed has been received, the Saturnian virtue immediately comes forward to keep it in position; with a healthy digestion Jupiter nourishes the seed kept in position; then Mars consolidates it; after this the Sun brings form to it; Venus temperately expels from the formed embryo the left-overs; Mercury, moderately checking the process of expulsion, retains what is necessary; finally Lucina comes forward and completes the ripe birth with her two powers. She herself, forthwith, takes up the tender new-born babe, and protects it until, when the influx of lunar matter and

nourishment ceases—in that it has been poured through and distributed to make the body grow—and when the sensations have gradually been excited, and the paths of the soul have been opened up, Mercury comes next to give instruction for the reason until he brings the child forward into Venus' adolescence; after this, when light-hearted voluptuousness has now been tamed, he rises into the youthful fullness of Apollo, who carries him forward as far as the status of Mars' virtue. At this point, when the manly mind has been strengthened, the authority of Jupiter follows on. The last age is that of Saturn, who makes the end continuous with the beginning by completing the circle of nature.[63]

Hermann's description is self-consciously symmetrical. Influence passes from Saturn through to the Moon and, after birth, from the Moon back to Saturn. Each planet in turn governs a phase of life, its duration unstipulated. Each takes charge of an individual's physical and mental development until it is time to pass control along.

Once the astrological source material was available, the notion of planetary control of the ages began to circulate. Alfred of Sareshel, an Englishman well acquainted with the newly translated works, known to have traveled to Spain, incorporated a related account of the effect of the planets on embryonic growth in his *De motu cordis* (early thirteenth century).[64] Vincent of Beauvais included a chapter, "On the Operation of the Planets in the Formation of the Embryo," in his *Speculum naturale*, one part of the vast encyclopedia he composed in Paris in the mid-thirteenth century.[65] As astrological thought gained ground in the later Middle Ages, the theory of planetary influence on the seven ages of man became a commonplace. In the fourteenth and fifteenth centuries it would inspire important pictorial cycles, to be considered in the second half of this study. Artists, most notably Guariento, responding to the astrologers' finely drawn characterizations of the ages, would use their newly developed skills to create subtle portraits of changing dispositions.

III. THE AGES OF MAN AND THE AGES OF WORLD HISTORY

ECULAR learning was approved by the Christian scholar, so long as its value was not judged too high. The liberal arts, theoretically at least, were to be studied in preparation for the important work of the theologian, the correct interpretation of scripture. Augustine, in his influential handbook on exegesis begun c. 396, *On Christian Doctrine*, argued for the relevance of a knowledge of languages, of natural history, of numbers and music, of history, and of disputation to unlocking the meaning of biblical enigmas.[1] In many places, of course, the Bible spoke openly and plainly and proclaimed the faith directly. But in others the truths were obscured, conveyed in similitudes which required clarification by the man of faith. Following established procedures, working from the more clear to the less clear, from the literal to the figurative, the exegete was to reveal the hidden sense of these difficult texts. A given passage might yield many meanings, in all or one of four senses—literal, allegorical, tropological, or anagogical; each interpretation was to be tested against established truth.

Nowhere in the Bible were the ages of man set out schematically. Yet the theme played a significant role in scriptural exegesis, commentators applying their knowledge of the life cycle to the elucidation of numerous obscure biblical passages. The commentaries in question characteristically explicate sequences of events or groups of things: the seven days of creation, the six vessels at the Marriage of Cana, the five hours of the Parable of the Workers at the Vineyard, the four directions of the plan of the Heavenly Jerusalem, and the three vigils in the Parable of the Three Vigils are among the numbered sets which were put into correspondence with the ages of man. Function influenced form: variant schemes and new characterizations of the ages emerged as exegetes defined the course of life in relation to these biblical sets and sequences and drew from the pattern of human existence an edifying message.

Most important of the systems born in exegesis, judged by its impact, was that developed by Augustine as he contemplated the meaning of God's work at the beginning of the world. The Church Father, in comparing the human life to the linear course of the history of salvation, microcosm to macrocosm, named and described six ages of toil before death. Taken out of its original context, the six-age system circulated widely, both alone and paired with six

ages of world history. Medieval natural philosophers of the high Middle Ages were as inclined to adopt this scheme of age division as the four- or seven-age systems, despite the flawless antique credentials these last could boast. And it was in order to represent six ages of man that medieval artists first developed an iconography for rendering the course of life.

Augustine's Exegesis of the Days of Creation

AUGUSTINE established his critical correlation between the six ages of the world and the six ages of man in an interpretation of the creation story in Genesis (1:1-2:3). A one-time member of the Manichaean sect, he took as his point of departure the Manichees' criticism of the biblical narrative. God's nature, they had argued, was demeaned by the suggestion that he should have worked for six days and then required rest on the seventh like a man fatigued after strenuous effort. Augustine countered this "childishly" literal reading by taking away the veil to reveal the spiritual sense of the story. God's word was not audible, time-bound.[2] The events described did not occur in a temporal sequence at all. God created the world, from nothing, not in time but *with* time, all things together: "Qui manet in aeternum creavit omnia simul" (Ecclus. 18:1).[3] The biblical account of a sevenfold program of creation informs the sensitive interpreter that the history of the world, as set out in scripture, is unfolding in seven phases. It reveals that man must toil for six epochs but that in the seventh he will enjoy eternal repose in God.

Augustine developed the idea in detail, fixing the endpoints of the biblical epochs, drawing metaphoric parallels to the days of creation, and also elaborating an analogy to the course of human life. Many of the elements of his program were not original to him. Recent studies have established his debt to Roman historiography and to Christian millennial speculation: the course of history had previously been compared to the life of a single man; the creation week had earlier provided a model for determining the shape of the history of salvation. Nonetheless, scholarly inquiry has upheld the novelty of his synthesis and confirmed its impact.[4]

Augustine gave the concept its fullest exposition in his *On Genesis against the Manichees*, an early work (A.D. 388-390), though he referred to the linked themes of the days of creation, the ages of the world, and the ages of man, especially the last two, repeatedly in his writings.[5] The first age in the history of salvation, he held, extended from Adam to Noah in ten generations. It was the infancy of the world considered as a single man (*infantia*), the period when mankind began to enjoy the light, well compared to the first day when God created light. There was a deluge at the close of this period, at the "evening of this day," which corresponds to the deluge of forgetfulness (*diluvium oblivionis*) by which our infancy is effaced. The second age, from Noah to Abraham in ten

generations, is comparable to childhood (*pueritia*). On the second day God made a firmament and divided the waters below and the waters above. This epoch was not destroyed by a deluge, in the same way that childhood is never erased from memory, yet a people of God was not engendered, for this age is not suited to procreation. In his *City of God* (A.D. 413-426) Augustine added that a language, Hebrew, was then acquired, for in childhood man learns to talk: *infantia* is named for its inability to speak (*quod fari non potest*). The third age, from Abraham to David in fourteen generations, is the adolescence of the world (*adolescentia*). Just as on the third day God separated the dry land from the waters, so in the third age the people of God, thirsting for a rain of divine commandments, were separated by Abraham from the Gentiles living in unstable error. This age was able to generate a people of God as the adolescent has the capacity to bear children.

The fourth age in turn extended from the reign of David to the Babylonian captivity. It corresponds to the period of prime (*iuventus*), which rules among the ages, and is comparable to the fourth day, when the stars were made in the firmament. The Sun, the heavenly body linked to the fourth age of life in astrological thought,[6] signifies the splendor of the reign. The fifth age, from the Babylonian exile to the coming of Jesus Christ, was likened to the period of decline from prime to old age (*iuventus* to *senectus*), when the individual is no longer in the former and not yet in the latter. This *senioris aetas* is termed πρεσβύτης by the Greeks, among whom *senex* is called γέρων. In the fifth age the strength of the kingdom was broken as when a man grows old. It is well compared to the fifth day, on which fishes and fowls were created, for then the Jewish people began to live among nations as in the sea and to have no fixed abode like the birds which fly. Finally the sixth age, not yet finished, began with the preaching of Jesus Christ. In this period, as in old age (*senectus veteris hominis*), the carnal kingdom was greatly weakened, the temple destroyed. Yet on the sixth day the earth produced a living spirit (*anima vivens*) as in senectitude a new man (*novus homo*) is born to a spiritual life, and on this day man was created in the image of God as in the sixth epoch our Lord was born in the flesh. An evening will close this era. But in the morning of the seventh age, an age which shall have no evening, the Lord will come in splendor and men of good works shall find their rest in him.

Augustine's is a tightly meshed system, one as well integrated as the Ptolemaic scheme of the seven ages and the seven planets. All three temporal cycles—the biblical week, the history of the world, and the life of man—are shown to share a pattern, six plus one: six periods of labor find consummation in one of rest, the last infinite, scarcely fathomable. Augustine followed long precedent in drawing the connection between microcosm and macrocosm. But where in pagan writings could one find an analogy so ingenious as that he

made between the biblical deluge and the deluge of forgetfulness which erases man's early memories? Or that forged between the prepubescent youth and the human race yet unable to engender a people of God?

Number as well as analogy bound the hexads together. Augustine was a staunch defender of the value of arithmology in scriptural exegesis, and few used it so effectively as he. In others of his works he praised the powers of the number six, a number never especially prominent in Neopythagorean thought. Ancient mathematicians and arithmologists had described it as a "perfect" number, owing to its property of being equal to the sum of its factors $(1 + 2 + 3)$. Christian exegetes applied the knowledge to an understanding of creation.[7] Augustine, marveling at the timeless, necessary relation between six and its aliquot parts, maintained that six in the biblical narrative expressed the perfection of God's works. In a late commentary, the *Literal Meaning of Genesis* (A.D. 401-415), he went so far as to say that God had created the world in six days for the reason that six is a perfect number.[8] Seven, the number of the Holy Spirit, was perfect in another way. As the sum of three and four, defined in ancient mathematics as the first odd and the first even number, it was taken to express an unlimited quantity. The sabbath rest, for Augustine, signified complete perfection.[9] Beyond seven, there was eight, considered the number of resurrection since Christ had risen on the day after the sabbath, the eighth day. Augustine envisioned an eighth day, an eighth age, outside of time, in which a final and perfect beatitude would be achieved.[10]

The human life, then, in Augustine's view, was divided into six ages and a seventh after death. He did not explicitly describe the seventh age in his *On Genesis against the Manichees*, but he implied the existence of an individual as well as a communal sabbath rest after the second coming. And when in a nearly contemporary work, his *Of True Religion* (A.D. 390), he drew a contrast between the earthly, external man and the *novus homo*, reborn within, he described a sequence of seven *spiritales aetates*. The seventh of the stages of spiritual growth—ages which cannot be defined in terms of years—was identified as eternal rest and perpetual beatitude.[11]

Augustine would surely have been acquainted with the pagan seven-age system. Hippocrates' description of the seven ages of man, as put forward in the pseudepigraphical *On Sevens*, was quoted widely in arithmological works. Ambrose, under whose influence Augustine had fallen in Milan, even cited the passage in connection with the days of creation.[12] The Ptolemaic correlation between the seven ages and the seven planets would have been known in North African circles. It may be that Augustine took the existing hebdomadic scheme as a challenge, that he developed a Christian version of the sevenfold course of life as a reply to pagan thinking. Nonetheless, it is the sixfold division of the period of man's toil on earth, both in the macrocosm and microcosm, that

may be called the hallmark of Augustine's thought in this area. He himself went the first step toward codifying the scheme in the fifty-eighth of his *Eighty-three Different Questions* (A.D. 388-396):

> Now the end of the present world, being, as it were, the old age of an old man (if you should treat the entire human race as an individual), is designated as the sixth age, in which the Lord has come. For there are also six ages or periods in the life of the individual man: *infantia, pueritia, adolescentia, iuventus, gravitas*, and *senectus*. Accordingly the first age of mankind is from Adam until Noah, the second, from Noah until Abraham. These are completely obvious and well-known divisions of time. The third is from Abraham until David, for this is the way in which Matthew the evangelist divides it. The fourth is from David until the Babylonian exile. The fifth is from the Babylonian exile until the Lord's coming. As for the sixth, one should anticipate its lasting from the Lord's advent until the end of the present world. In this sixth age, the outer man (who is called the "old man") is corrupted by old age, as it were, and the inner man is renewed from day to day. Then comes the eternal rest which is signified by the Sabbath.[13]

This is the formula the Middle Ages would know.

The Diffusion of the Six-Age Scheme

AUGUSTINE'S system of age division enjoyed a remarkable success. Quite predictably, later commentators on Genesis adopted his exegetical stance and rehearsed the correlations he drew. But the sexpartite schemes of the historical and human ages also circulated independently. Within a few generations of the Church Father's death, the North African poet Dracontius could name the six ages of man in a poem as casually as he referred to the four seasons of the year.

The work in question, the *Satisfactio*, was written in prison, Dracontius addressing it to his jailor, the Vandal King Gunthamund (A.D. 484-496). Having put exempla of royal mercy before the king in elegiac distichs, he observed that peoples change, times pass. Nature has its cycles; only man's life does not return. "There are six ages of man from the very beginning to old age," says the poet, "and each season has its proper character." He then defines the phases of life through contrast. "Does ingenuous childhood ever naturally assume the bustling activity of grown-ups, or is listless old age possessed of lusty voice? The stripling does not act childishly; the young boy ventures not to handle the soldier's weapons; he knows not love's passion before his years have matured; nor is the lad withered when down is on his cheek. Man in his prime is in the thick of action, and trembling old age lacking keenness and destitute of nim-

bleness deplores its lot."[14] Dracontius attempts to do with six ages what Cicero and Horace had done with four.

In a second prison poem, the *De laudibus Dei*, in hexameters, Dracontius turned his attention to another hexad, the six days of creation. A seventh-century reworking of this section, called the "Hexaemeron" when separated, demonstrates further the influence of Augustine's thought. Eugenius, Archbishop of Toledo (d. 657), undertook the redaction at the request of the Visigothic King Chindaswinth.[15] The poem's most serious flaw, in Eugenius's estimation, was the omission of an account of the seventh day. He remedied the deficiency in his *Monosticha*, placed at the end of the work. Why is the seventh day called a day of rest? Because rest will be granted to man after six epochs and after six ages. Thus, for Eugenius, as for Augustine, the phases of life were six, plus one:

> Sex sunt aetates hominis et septima mors est.
> Prima tenet ortum generis infantia simplex,
> altera deinde pueritia mollis habetur,
> tertia, quae sequitur, ipsa vocitatur adulta,
> quarta gerit virtutis opem speciosa iuventa,
> quinta senecta gravis et in ultima tempora vergens,
> sexta venit senium, quae vitae terminat aevum.

> There are six ages of man and the seventh is death.
> The first, simple infancy, comprises the birth of the race,
> The second, then, is considered to be tender boyhood,
> The third, the age which follows, is called adult,
> The fourth, handsome youth, carries on manly work,
> The fifth, old age, is burdensome as it draws toward the end,
> The sixth, senectitude, comes and terminates the life span.[16]

Poets, however, did not turn the six-part division of life into a scholarly commonplace. Writers of school texts, Isidore, Bede, Hrabanus Maurus, and others, accomplished this feat. Their works, modestly intended to be useful, to supply information, were staple items in the proper ecclesiastical library. Isidore (d. 636), Bishop of Seville in Visigothic Spain, played a key role. In his great compendium, the *Etymologiae* or *Origines*, produced over a number of years, he supplied classic definitions of the ages of man, simple, straightforward, and quotable. Isidore's ambition in the work was to cover the widest possible range of topics: the liberal arts were treated, as were medicine, law, time, books, the ecclesiastical grades, the heavenly hierarchy and the orders of the faithful, the church and various sects, man, the animals, the universe and its parts, the earth and its parts, cities, architecture, stones, agriculture, war, games, ships, clothing, food, tools, and furniture.[17]

How might a Christian justify forays into such areas of knowledge? Augustine gave theoretical support. In his *On Christian Doctrine* he suggested that someone collect and explain the references to geographical places, or animals, or herbs and trees, or stones and metals in scripture, as certain scholars had done for foreign names and Eusebius had done for history.[18] From such a stance, compilations like Isidore's came into being. Called "encyclopedias" in modern scholarship, the works might be described as books on the nature and properties of things. Intended as tools for the study of scripture, they were not reference works in the modern sense. There were tables of contents, but such artificial ordering devices as alphabetization were used sparingly. The very organization of material conveyed information. In the structure was to be found an interpretation of the divisions of knowledge and the order of the world.[19]

Isidore's text is distinguished by the consistent use of etymologies to define concepts. The method, a grammarian's technique, reflects the ancient belief that the meaning of an idea is to be discovered in the roots of its name. Isidore himself defined etymology as "the source of appellations" (*origo vocabulorum*), and claimed: "A knowledge of etymology is often necessary in interpretation, for, when you see whence a name has come, you grasp its force more quickly. For every consideration of a thing is clearer when its etymology is known."[20]

In Book V of the *Etymologies* Isidore turned his attention to words associated with time and time divisions, there proceeding from the smallest to the largest temporal unit, from "moment" to "age." *Aetas*, it is claimed, has several applications: "The word 'age' is used variously, both for one year, as in annals, and for seven, as of a man, and for one hundred, and for an indeterminate stretch of time." Seven years is thus made the measure of an age of man; Isidore would adopt the hebdomadic formula in practice. This microcosmic age has a macrocosmic parallel:

> "Age" is properly employed in two ways, either of a man—as in *infantia, iuventus, senectus*—or of the world; the first age of the world extends from Adam to Noah, the second from Noah to Abraham, the third from Abraham to David, the fourth from David to the Babylonian exile, the fifth, then, to the coming of the Saviour in the flesh, the sixth, now ongoing, to the end of the world.[21]

The list of the ages of man, here, is incomplete since Isidore's primary interest lay in the ages of the world: he used the definition to introduce a universal chronicle running from creation to the reigns of the Visigothic kings, in six Augustinian ages. The six-age scheme would be that preferred above all others by medieval chroniclers.[22]

The principal definitions of the ages of man appeared in another book of the *Etymologies*, Book XI, "On Man and Monsters." After a description of the parts of the body and before a consideration of marvelous creatures and races,

Isidore defined a plethora of terms related to age and aging. The account begins unhesitatingly: "The stages of life are six: *infantia, pueritia, adolescentia, iuventus, gravitas,* and *senectus.*" Augustine had given just this list in his *Eighty-three Different Questions.* Isidore's debt to the Church Father becomes even more apparent in the etymologies; many ideas and phrases are drawn directly from *On Genesis against the Manichees.*[23] Augustine, however, did not set the limits of the ages, which Isidore supplies: to 7, to 14, to 28, to 50, to 70, to death.

> The first age is *infantia,* extending from the child's birth into the light of day until the age of seven years. The second age is *pueritia,* that is, pure and not yet old enough to reproduce, and lasts until the fourteenth year. The third is *adolescentia,* an age mature enough for reproduction, lasting until the twenty-eighth year. The fourth, *iuventus,* is the strongest of all the ages, and ends with the fiftieth year. The fifth age is that of riper years, that is to say, of mature judgment, *gravitas,* and is the gradual decline from youth into old age: the individual is no longer young, but he is not yet an old man. It is that period of life's maturity which the Greeks call πρεσβύτης, for an old man among the Greeks is not called a *presbyter* but γέρων. This age commences with the fiftieth year and ends with the seventieth. *Senectus* is the sixth stage and is bounded by no definite span of years, but whatever of life remains after those earlier five stages is marked up to old age. *Senium* is the final part of old age, so named because it is the terminus of the sixth age. The philosophers have distributed human life among these six periods, within which limits it is changed and goes on and finally comes to its end, which is death.[24]

Further etymologies for age terms are supplied: from the definitions of *infans, puer, puella, puberes, puerperae, adolescens, iuvenis, vir, mulier, virgo, virago, femina, senior, senes, senex, anus, vetula,* and *canities,* certain additional information about the ages can be gained.[25] *Infans,* one learns, receives its name from young child's inability to speak (*fari nescit*), a state resulting from the imperfect ordering of its teeth. *Iuvenis* is so called because the individual begins to be able to give help (*iuvare*). Just as the thirtieth year is the perfect age in men, so the third is the strongest in beasts. A man is called *vir* because his strength (*vis*) is greater than that in a woman. *Senes,* some believe, are named from a diminution of perception (*sensus*), since, on account of old age, men behave in a foolish manner. Doctors say that foolish men have colder blood, intelligent men, hot; thus *senes,* in whom the blood becomes cold, and *pueri,* in whom it has not yet become warm, are alike in having less sense. One has here a scientific rationale for the phenomenon of second childhood. On the subject of old age, Isidore shows the ambivalence which many later writers would express. *Senectus,* he says, brings with it many things, both good and bad. It frees us from very violent masters, imposes measure on enjoyment, breaks the force of desire,

strengthens wisdom, and confers more mature understanding. But at the same time old age is very miserable with infirmity and bitterness. Isidore fittingly brings the sequence to a close with definitions of *mors* and death-related terms, among them *funus, cadaver, defunctus,* and *sepultus.*

A closely similar account of the ages of man is to be found in another of Isidore's works, a very early one, the *Differentiae.* Here his purpose was to draw distinctions between similar terms and between related ideas, and in this way to arrive at the essence of concepts. In the course of the first book, dedicated to "differences between words," he compared several age designations—*iuventa* and *iuventus, puerpera* and *puella, pueritia* and *pubertas, senium* and *senectus, vir* and *homo,* and *vir* and *virus.*[26] In the second book, the more philosophically ambitious of the two, he considered "differences between things." Wide-ranging in subject matter, arranged systematically rather than alphabetically, this book anticipated the *Etymologies.* Six ages were similarly listed; further age terms were defined. The influence of Augustine's *On Genesis against the Manichees* is not, however, apparent in the characterizations of the stages of life, and their sequence varies slightly. Durations are counted in strict hebdomads: to 7, to 14, 28, 49 (when women can no longer give birth), 77, and death. Isidore wishes to indicate that his system is not an arbitrary one. *Infantia* and *pueritia* are assigned one hebdomad each because of their simplicity; *adolescentia,* characterized by both intellect and activity, is given two; *iuventus,* with intellect, activity, and bodily strength, has three; *senectus,* having these three and also the trait of gravity, receives four; *senium* is said to have no fixed term of years.[27]

Manuscript evidence establishes the wide distribution of Isidore's works. Popular in Spain, they seem to have made their way north even in the seventh century, to circulate in Italy and France, England and Ireland in pre-Carolingian times; the diffusion of the writings was only fostered by the Spanish emigrations resulting from the Arab conquest in 711. Literally hundreds of copies of the texts were made in the following centuries.[28] Later writers mined the works, especially the *Etymologies.* The definitions of the ages of man were quoted widely. When one discovers an isolated passage on the ages of man in an early medieval manuscript, it usually proves to be derived ultimately from Isidore.

Canonized as a hexad, the ages of man could find a place in arithmological literature under the number six. So they appear in the *Liber numerorum,* to introduce the Isidoran work just one more time. The entry on the *senarius* begins with an account of its numerical properties: six is a perfect number, the sum of its parts. In this number of days God completed the world, and in this number of ages world history runs its course. Other significant appearances are gathered from nature and the Bible, from both the Old and New Testaments: Ezechiel saw a man carrying a measuring reed six cubits in length (Ezek. 40:5); Christ transformed six vessels of water into wine (John 2:1-11). The number is to be discovered in the hierarchy of things. There are nonliving

objects, like stones; living things, like trees; sensible beings, like animals; rational creatures, like man; immortal creatures, like angels; and highest of all, God himself. The perfection of six is also to be found in the human life. There are six ages of man—*infantia, pueritia, adolescentia, iuventus, senectus, senium.*[29]

Computistic tracts and chronicles also incorporated descriptions of the six ages. Isidore's definitions of temporal terms, as contained in the *Etymologies*, Book V, were consulted, but in this sphere the Iberian had a rival in Bede, master computist. In the *De temporum ratione*, it may be remembered, Bede twice spoke of the ages of man; in the section on the seasons he named four ages of man,[30] but under the heading "Age" he defined six. Augustine, again, was a source. Bede's correlation between the world epochs and the ages of life shows the specific influence of the *City of God*. In a passage in this work Augustine had worked backward from the reign of David through the first three ages of the world, comparing each in turn to an age of man. Bede reversed the sequence and supplied analogies where they were lacking, the ages he described being *infantia, pueritia, adolescentia, iuventus, gravis senectus*, and *decrepita etas*. His theoretical account of "age" again prefaces a universal chronicle, extending this time from the beginning of the world to the future coming of the Antichrist, the Day of Judgment, and the seventh and eighth ages.[31]

Later computists and chroniclers would freely borrow from Isidore and Bede. When Pacificus of Verona (d. 844) wrote a computus manual, he drew most of his material from Bede's *De temporum ratione* but incorporated in it Isidore's definition of "age" from the *Etymologies*, Book V.[32] His contemporary Hrabanus Maurus hedged his bets and quoted both authorities in his own *De computo*, using Isidore's definition to introduce Bede's concise survey of the ages of the world.[33] Byrhtferth of Ramsey reproduced Bede's account and translated it into Old English, suppressing, however, references to the ages of man.[34] Honorius Augustodunensis, writing in the early twelfth century, quoted neither author verbatim, but systematically listed six ages of man and six ages of the world in the computistic section of his *Imago mundi*, a work which also contained a chronicle of the six ages.[35] Romualdo, Archbishop of Salerno, to indicate just how far the information spread, introduced his own universal chronicle, running from creation to the year 1178, with a treatment of the ages again traceable to Bede's *De temporum ratione* and Isidore's *Etymologies*, V. Yet Isidore had here named only three ages of man. Romualdo's list, symmetrically, includes six: *infantia* to age 7, *pueritia* to age 14, *adolescentia* from 15 to 28, *iuventus* to 49, *senectus* from 50 to 79, and *decrepita* from 80 to the end.[36]

The full-fledged definition of the six ages of man contained in the *Etymologies*, Book XI, circulated widely in the medieval schools. Students might memorize the information, or so the text of pseudo-Alcuin's *Disputatio puerorum* would suggest. In this dialogue the interlocuter, having received a satisfactory account of the six ages of the world, asks the number of the ages of man, the *minor*

mundus. Just as many, he learns, as in the *maior mundus*. Pursuing the point, he asks for their names, their order, and their durations. His respondent replies by reciting Isidore's list, etymologies and all.[37] The chapter from the *Etymologies* was quoted, whole or in part, alone or with the preceding account of the parts of the body, in all manner of didactic miscellanies. The opening six definitions were transcribed in a ninth-century medical codex in Paris.[38] The entire chapter was copied in a contemporary manuscript, now in Rouen, which includes computistic material.[39] It was summarized in another ninth-century miscellany in Paris.[40] Many of the etymologies were cited in a school compendium with German glosses written c. 1020, the *Summarium* of Heinrich.[41] The section on the ages was appended, regularly, to bestiaries of the "second family" of texts, among whose members may be cited a well-known twelfth-century codex in Cambridge.[42]

The passage from Isidore's *Differentiae* had its own influence. It would seem to be the source behind a text on the ages of man copied, with variations, in many early manuscripts; names and durations of the ages correspond precisely. Here the medieval predilection for lists comes noticeably to the fore. The tabulation of the six ages of life was often introduced along with other recherché information: the number of bones, veins, and teeth in the human body might be given, or the names of the ecclesiastical grades, or varieties of herbs useful in healing. Such lists of the six ages are to be found in two ninth-century manuscripts in Cambridge and one in London, in tenth-century manuscripts in Chartres and Munich, and in eleventh-century manuscripts in Bonn and in the Vatican.[43] A related text appears in a twelfth-century miscellany in Oxford which has been associated with the school of Anselm of Laon. In this case the physical changes which mark the progress of the human life are set out within a hebdomadic structure. *Infantia* lasts for seven years, *pueritia* for another seven; *adolescentia* doubles this period and ends at 28; *iuventus* doubles the whole previous period and ends at 56; the rest of life is allotted to *senectus*. Though only five ages are named within this programmatic system, the author knew six. He ends: "*virilis aetas* is similar to *iuventus*."[44]

The six ages of man had become an article of school learning. It is not remarkable that a twelfth-century commentator, thought by some to be Bernardus Silvestris, should have applied the knowledge to the interpretation of a Latin classic, pagan but almost divine, Virgil's *Aeneid*. Following precedent, he discovered in the first six books of the epic an allegory of the human soul in its journey through life. The first book treats the nature of birth and the first age of man, *infantia*: Aeneas was tossed in the sea by the winds of Aeolus just as the spirit is perturbed when it takes on flesh. Similarly the second book concerns the second age, *pueritia*, so named because "pure," as Isidore said, when the individual has the capacity to talk; the third book is about *adholecentia*, the fourth about *iuventus*, and the fifth about *virilis etas*. The analogy is not

explicitly carried through to the sixth book, but then, this appropriately is the book in which the hero descends to the underworld, there to acquire wisdom.[45]

Isidore's influence extended in other directions. The definitions of the six ages in the *Etymologies*, Book XI, were versified. In a poem transcribed at Fulda in the ninth century which is preserved in a manuscript now in Munich and survives in at least two later codexes, six ages unfold: *infantia, pueritia, adulescentia, iuventus, aetas senioris*, and *senectus*. In the Munich manuscript their durations, Isidore's precisely, are written in the margins: 8 (though the poem speaks of seven years), 14, 28, 50, 70.

> Sex gradibus hominum tota distinguitur aetas
> Mores atque actus habitus vultusque notando.
> Primus namque gradus ille est quem infantia claudit,
> Septenis annis de parvo famine dicta.
> Dehinc alius constat, pueritia quem tenet annis.
> Similiter septem de puris vultibus acta.
> Tertius ergo gradus bis septem continet annos,
> Gignere quem posse iam adulescens indicat aetas.
> Ordine post sequitur aetas et quarta iuventus,
> Quodque iuvare satis possit hoc nomine signat.
> Quinquies haec denos ab origine terminat annos.
> Quinta aetas senioris erit quae vergit ad ima,
> Quod minus atque sciat hoc nomine personat ipso.
> Ultima nam restat, quae finit cuncta senectus.
> Haec et decrepita resolutis viribus exstat.
> En tibi bis octo descripsi versibus ista,
> Aetatisque gradus grammate vix tetigi.[46]

Isidore's thoughts on the ages of man were also transmitted within the so-called encyclopedic tradition. That is to say, when later writers compiled large-scale compendia, they regularly used his work as a source. Hrabanus Maurus, true, went further than this. His own encyclopedia, completed in the 840s, called *De naturis rerum* or *De universo*, is but a revised, more emphatically Christian version of the *Etymologies*. Abbot of Fulda and Archbishop of Mainz in turn, Hrabanus was a teacher whose task was to make useful knowledge available to his monastic colleagues. Originality is not to be expected, nor is it found. Quotations selected from Isidore's work form the heart of the Carolingian compendium, which now opens not with the liberal arts, but with God and the angels. Hrabanus conscientiously amplified his borrowings with scriptural citations and moralizing commentary. He regularly supplied the spiritual sense of things in order to create a tool more effective for biblical exegesis.[47]

The chapter on the ages of man, again preceded by an account of the parts

of the body but now followed by genealogical material, begins as a word for word transcription of the first section of Isidore's text. Hrabanus makes his additions in the further definitions of age terms. Having defined *iuvenes*, for example, he goes on to say, "*Infantes*, and *adolescentes*, and *iuvenes* signify mystically those who grow in the grace of God, and vigorously oppose the devil. Whence the apostle John says in his Epistle: 'I am writing to you, young men (*adolescentes*), because you have conquered the evil one. I am writing to you, little ones (*infantes*), because you know the Father. I am writing to you, young men (*iuvenes*), because you are strong and the word of God abides in you' [I John 2:13-14]. But *puer*, *adolescens*, and *iuvenis* are also to be found aligned with wickedness when they signify foolishness or impudence. Whence it is written: 'Folly is bound up in the heart of a child (*puer*), and the rod of correction shall drive it away' [Prov. 22:15]."[48]

Much scholarly attention has focused on a single copy of Hrabanus's *De naturis rerum*, one produced in the monastery of Montecassino in 1022-1023, because it received a full set of illustrations. Unusual subjects treated in Isidore's work are given pictorial form, if crudely. Many, among them animal sacrifice, amphitheaters, baths, the Curia, marble-cutting, and the pagan deities, recall the world of late antiquity. A representation of the ages of man, the earliest surviving rendering of the theme, heads the chapter "De aetatibus hominum" (fig. 14).[49] In it six figures appear lined up in a row, placed against a neutral ground. An infant bound in swaddling bands starts the sequence at the left. A boy, nude, covering his genitals with his hand, hovers above him. Three figures in tunics of different lengths, peach, green, and lilac in color, are grouped in the center: the middle figure holds a stick; the man on his right is bearded. The line ends with the curiously out-sized figure of an old man—his beard bright blue, his head-cloth white, and his tunic orange and yellow—who holds one hand at his chin and carries a stick in the other.

The collection of attributes and gestures, relatively scant, bears a certain relation to the accompanying text. The nudity and modest gesture of the child may refer to the fact that *puer* derives from *purus*, because the boy is not yet able to reproduce. The costume of the old man is similar to that worn by a magus in the illustration to the chapter "De magis" (XV, 4).[50] This, his gesture of contemplation, and his commanding stature, contribute to express the wisdom of his years. In terms of composition, the image is oddly disjointed, suggesting that it is but an abbreviated copy of an earlier illustration. The position of the feet of the child might indicate that he once stood upon a hillock. The height of the old man suggests that he was positioned further forward than the others. The vestigial interaction between the figures leads one to believe that they were not intended to be quite so schematically presented. Arguments, both historical and stylistic, have been put forward to support the idea that a Carolingian prototype stands behind the pictorial cycle.[51] Other witnesses to

the existence of early medieval copies have been introduced. A fully illustrated German manuscript, dated 1425, contains a cycle closely related to the Montecassino version, but not a copy of it. The structurally similar illustration of the ages of man (fig. 15) might aid in reconstructing the earliest representations. The composition has been rationalized and the costumes updated; the figure of manly age now wears plate armor. Still, landscape elements and more probable relations between figures might not be merely fifteenth-century contributions.[52]

Fritz Saxl took the argument for an earlier prototype a step further. He suggested that a Carolingian artist had available a lavishly illustrated copy of Isidore's *Etymologies*, produced in Visigothic Spain, and that Hrabanus borrowed both texts and images from his seventh-century model.[53] Manuscript evidence does not support Saxl's unverifiable claim; the hundreds of surviving Isidore manuscripts contain no such pictorial cycle. It can be granted, however, that the representation of the ages of man preserved in the Montecassino copy of Hrabanus's work looks back to an earlier era; it stands quite apart from the medieval images which begin to proliferate in the later twelfth century. The late antique tunics, the priestly head-cloth on the oldest figure, and the suggestion of pictorial space point to a model produced in a classicizing milieu.

Another encyclopedic work, very different in kind, offers an intriguing synthesis of early medieval views on the ages of man from the point of view of a twelfth-century ecclesiastic. The *Liber floridus*, an idiosyncratic mélange of useful and interesting information, survives in the autograph manuscript, now in Ghent, as well as nine later copies.[54] Compiled by Lambert, canon at St. Omer, over a period of years (1112-1121)—possibly illustrated by him too[55]—it contains a varied assortment of texts and images, the "flowers of diverse authors," arranged in often baffling fashion. Some scholars have regarded the book as an unsystematic jumble of randomly selected texts; others have been determined to discover a consistent message and method uniting the whole.[56] It seems indisputable that the recurrent themes which weave in and out of the work reveal general directions in Lambert's thought: not every juxtaposition may be considered significant, but meaning may be discovered in the entire fabric. An emphasis on the purpose of human history gives the book its special character. The historical texts which Lambert collected and the corresponding images together make up a kind of universal chronicle running from the creation of the world to the end of the sixth age, and then to the coming of the Antichrist and the Last Judgment. Lambert's bias is that of a man living in northern France. He devotes special attention to local events and to the role of his countrymen in that historical event which he believed to be pivotal in the scheme of salvation, the first Crusade. Around this core he gathered a wealth of information concerning the created world, introducing religious texts to give the whole a specifically Christian cast.

The theme of the ages of man appears as a recurrent motif: four, six, and seven ages are named. Four ages—*adolescentia, iuventus, senectus*, and *etas decre-pita*—are aligned with the seasons, humors, and elements in a tetradic diagram (fol. 228v, fig. 4).[57] Six and seven ages are listed in connection with the ages of the world, the six world ages holding a prominent place in his work. Lambert often used a sixfold structure to order historical data (fols. 23v, 32v, 33v-46r, 46v-47r, 232v), and he devised circular diagrams to set out the events of each age. In a *rota* divided into six sectors, labeled *Mundi etates usque ad Godefridem regem* and inscribed *Mundus*, he listed the principal personages in each of the six ages beginning with Adam, Noah, Abraham, David, Heber, and Octavi-anus respectively (fol. 20v, fig. 16). The sequence of notable persons ends with Godfrey of Bouillon, a knight of Flanders and the first ruler of the Latin kingdom of Jerusalem. Godfrey's taking of the Holy City in 1099 is recorded; the semicircle delimiting the roster of men of the last age bears the remarkable rubric, "The sixth age to the capture of Jerusalem." Is Lambert making the suggestion that history is approaching its resolution, that with the recovery of Jerusalem, the sixth age is passing away and the seventh is nigh? Would this help to explain why he listed seven ages of man rather than six in the text below, labeled *microcosmos*? As history was entering a final old age beyond the sixth age, so the human life acquired a seventh mortal phase. Lambert's list of the ages of man corresponds precisely to that in the *Etymologies*, Book XI, as far as *senectus*. But this age receives a terminus of eighty years, and an *etas decrepita* extending to the end of life is added.[58]

The various threads of Lambert's historical and cosmological beliefs come together in an image no longer present in the autograph manuscript but pre-served in the late twelfth-century copy of the book now in Wolfenbüttel (fig. 17) and in other codexes of the "W" group.[59] Two *rotae* appear stacked one above the other, each divided by overlapping arcs into six segments. The top schema represents the macrocosm. An inscription encircling the figure of an old man, nude, reads, "The greater world and the ages of the *saecula; mundus* is so called from motion (*motu*), and *saecula* from sixfold cultivation (*seno cultu*), for the human life passes through six ages." The lower *rota* is given over to the microcosm. Its inscription, encircling the figure of a child, again nude, reads, "The lesser world, that is, man and his ages with the elements of the world to which no rest is granted."[60]

The elderly figure representing the macrocosm juggles roundels inscribed "day" and "night" and "year" and "month"—time cycles arising from the "motion" of the upper world. Around him, six semicircles mark the divisions of the *saecula*. Each sector contains a day of creation and the work of that day, an age of the world, a part of the body and a metal, an hour of the day (first, third, sixth, ninth, tenth, and eleventh), an age of man, and the termination of the age of the world and its duration. The constellation of themes thus

includes the hexads aligned by Augustine in his exegesis of the creation story in Genesis, elements of the Babylonian king Nabuchodonosor's first dream (Dan. 2:29-45),[61] and the hours of the day named in the Parable of the Workers in the Vineyard (Matt. 20:1-16), made six by the addition of a tenth hour.[62] Quotations from Augustine on creation and the power of the number six appear in the background.

In the lower *rota* the child holds roundels inscribed with the four elements "to which no rest is granted" and two of the four seasons, winter and summer. Each of the six sectors contains an age of life and its duration, together with a season and/or element and their respective qualities. Lambert's six-age scheme is a contraction of the sevenfold plan he used before (fig. 16); he chose to discard *gravitas* extending to seventy years rather than relinquish *etas decrepita*. *Infancia* lasting to age 7 is likened to spring, a flourishing first age; *puericia* to age 14 is juxtaposed with swift air and unstable wind; *adolescentia* to 28 parallels burning fire and hot summer; *iuventus* to 50, like dry autumn verging on winter, is warm; *senectus* to 80, like cold winter verging on the last setting, is oppressive; finally, *decrepita etas* to the end of life compares to the earth.[63] Around the outside of the circle there are quotations, again drawn from Augustine, concerning man and the elements and the uncorruptible nature of the eternal life.

The image is a concise visual statement of the Augustinian view of man and history deriving ultimately from the Church Father's anti-Manichaean exegesis of Genesis. The source of the diagrams' structure is not difficult to determine: Lambert has converted the tetradic *mundus-annus-homo* schema, designed to demonstrate the relation between macrocosm and microcosm, into a hexadic device. The elements and the seasons, unevenly distributed among the six sectors, clearly attended the diagram as it was adapted to a new function. Here the *rota* was used to compare the progress of the human life not to an annually recurring time cycle, the four seasons, but rather to the unique, linear pattern of human history. The two diagrams, identically structured on a hexadic plan, demonstrate the numerical harmonies existing between the individual man and the cosmos.

Interpretations of the Six Vessels at Cana

IF COMPUTISTS and chroniclers, encyclopedists and natural historians appropriated the sexpartite divisions of life and history, still scriptural exegesis remained the proper sphere of the six ages of man and the six ages of the world. The hexads, having been defined in relation to the creation story, became part of the exegete's repertoire, potentially useful in the elucidation of other biblical enigmas. The gospel account of Christ's first public miracle, the changing of water into wine at the marriage in Cana (John 2:1-11), was particularly ripe for allegorical interpretation. Incidental details reported by the evangelist, seem-

ingly pointless in a literal sense, were discovered to hold edifying significance
when read spiritually.

The mother of Jesus, it was narrated, learning there was no more wine,
informed her son and instructed the attendants to do as he told them. "Now
six stone water-jars were placed there, after the Jewish manner of purification,
each holding two or three measures. Jesus said to them, 'Fill the jars with
water.' And they filled them to the brim. And Jesus said to them, 'Draw out
now, and take to the chief steward.' And they took it to him.'" The steward
then, tasting the water which had become wine, observed that the bridegroom,
contrary to custom, had reserved the good wine until the poorer had been
drunk.

The story was one of miraculous transformation. Literally, water had become
wine: something base had been transformed into something richer, more per-
fect. Exegetes contemplating the metamorphosis found in it a metaphor of
fulfillment. In the change was contained the contrast between a shadow and
the light, the flesh and the spirit, the old order and the new, the letter of the
Bible and its spiritual sense.[64] Other aspects of the story tantalized, and their
interpretation had to harmonize with the understanding of the mystic trans-
formation. Why were there two or three measures? And why did John record
that there were six water-jars, no more, no less? Answers were supplied from
an early date. Origen, the great third-century Alexandrian, found in the two
or three measures support for his theory of biblical interpretation. The measures
signify that some passages in scripture have only two senses while others have
three; that is, some have only a spiritual and a moral meaning, while others
have a historical meaning as well. The six vessels apply to those who are purified
in this world, for the world and everything in it was brought to completion
in six days, six being a perfect number.[65]

Augustine's spiritual reading, also arithmologically based, would establish
the major lines of interpretation for the medieval West. The miraculous trans-
formation, he held, contained a message about the fulfillment of Old Testament
history. The prophecy of times past, when Christ was not perceived in it, was
water, and the wine lay hidden within. For if one reads the prophetic books
without the knowledge of Christ, they are insipid; but if he is understood in
them, they not only taste but inebriate. The vessels were six because there
were six ages of prophecy, six distinct ages which would be like empty vessels
if not filled by Christ.[66] The ages are those defined on the model of the creation
week with one exception: they run from Adam to Noah, Noah to Abraham,
Abraham to David, David to the Babylonian exile, but now from the exile to
the appearance of Christ's precursor, the prophet John the Baptist, and from
John the Baptist to the end of the world. Christ came in the sixth age, and the
old order was fulfilled.

Augustine did not correlate the ages of man with the ages of the world in

this context. But it was an inevitable step. In the sixth century Caesarius of Arles (d. 542), a man who as bishop adapted many of Augustine's sermons to his pastoral needs, introduced the six ages into a sermon on the Lord's changing water into wine. The six vessels remain figures of the six ages of the world, their contents transformed when Christ is understood in Old Testament prophecy. But Caesarius observes, too, that six ages are recognized in the life of man—*infantia, pueritia, adulescentia, iuventus, senectus*, and an advanced age (*permatura*), also called *decrepita*.[67] He draws in the theme by a process of association; the ages are not integrated into the interpretation.

Augustine's approach was favored in the many medieval homilies prepared to explicate the text, produced in great number since the gospel account of the miracle was one of the mass readings for the second Sunday after Epiphany. Bede compared the vessels to the ages of the world in an influential homily; this was the text selected to represent the feast in the Carolingian homiliary often attributed to Paul the Deacon.[68] Smaragdus of St. Mihiel and Haimo of Auxerre in the ninth century adopted the Augustinian interpretation in their own homilies, also contained in collections organized to follow the liturgical year.[69] Irish writers knew the argument,[70] as did Anglo-Saxon: Aelfric prepared a sermon using the correlation between the vessels and the ages of the world, while Byrhtferth of Ramsey included the information in his arithmological text.[71] Bruno of Segni and Rupert of Deutz are among the twelfth-century followers.[72]

The ages of man were not introduced in these texts. The option was taken, however, by Hugh of St. Victor (d. 1141), the "second Augustine." By his reckoning, the six vessels signified both six ages of the world and six ages in the human life—*infantia, pueritia, adolescentia, iuventus, virilis aetas, senectus*. Developing the sorts of analogies Augustine had drawn in his commentary on Genesis, Hugh bound the hexads together. Infancy, again, is said to be erased by a flood of forgetfulness just as humankind was first destroyed by the deluge. But now the passage of life becomes a process of coming to know God. The individual man, like the whole human race, submits to progressive restraints: the discipline and rules and counsel to which the adolescent is first subject find parallels in the circumcision and the commandments and the government by the Judges in the third age. Man is led to the divine: in old age, the period which corresponds to the sixth age under grace, he longs for things to come. God is ever present in the world. When the individual finds delight in his judgments, when in the mind of man God's work becomes sweet through spiritual understanding, then water is turned to wine.[73]

An important component of the understanding of the vessels as current in the twelfth century had found expression in the work of Gregory the Great (d. 604). The miracle in Gregory's view contained a lesson in the levels of spiritual interpretation. The vessels filled with water represent our hearts filled

initially with the narrative of sacred scripture. The water is changed to wine when, through the mystery of allegory, this *historia* is converted into spiritual understanding.[74] According to this line of interpretation, one which could be extended to include all four senses of scripture, significance lay in the nature of the transformation, not in the number of vessels submitted to the change. The approaches were compatible. Both lines of thought surface in a short poem attributed to Hildebert of Le Mans (d. 1133), a poet well acquainted with the works of Gregory:

> Sunt hydriae mentes doctrinae fonte repletae.
> Historicus sensus, aqua; vinum, spiritualis.
> Cum nos historiam revocamus ad allegoriam,
> Tunc aqua fit vinum. Quia sex aetatibus orbis
> Volvitur, has hydrias scribit sex esse Ioannes.

> The vessels are our minds filled with the wellspring of doctrine.
> Water is the historical sense, wine, its spiritual meaning.
> When we tie history to allegory, the water becomes wine.
> Since the world revolves in six ages,
> John writes that the vessels are six in number.[75]

The exegesis of the miracle at Cana inspired the earliest extant pictorial cycle incorporating the ages of man. Three panels surviving from one of the twelve "typological windows" in Christ Church Cathedral, Canterbury, recently dated c. 1180, illustrate the biblical event and its spiritual significance (figs. 18, 19).[76] Records of the inscriptions on all the windows were made in the Middle Ages; thus, despite extensive loss and damage, the range of subjects can be reconstructed in full.[77] The program originally comprised a life of Christ extending from the Annunciation to the Resurrection; each New Testament antitype was flanked by types drawn from the Old Testament and extrabiblical sources. The Marriage at Cana and its types—the ages of the world and the ages of man—survive in their original relationship, though not in their original position. No longer in "Fenestra quarta" of the northeast transept, the window devoted to the public ministry of Christ, the panels are now to be found in the north aisle of the cathedral.[78]

The miracle itself is represented in a large circular medallion. Six figures sit behind a feast table laden with food. Reading from left to right they may be identified as the chief steward, the wedding couple, Joseph (?), the "mother of Jesus," and finally Christ, who gestures to an attendant to fill the hydriae with water. Before the table the first attendant pours water into an urn while a second presents a bowl of wine to the steward for tasting. In the foreground six vessels—yellow, green, and white—stand in a row.

On the left, in a semicircular panel, six robed and bearded men are shown seated in a hemicycle, as antique sages were regularly portrayed. An inscription

in the field above identifies them as representatives of the six ages of the world: "sex etates sunt mundi." The first figure, labeled Adam, holds a hoe "to till the earth from which he was taken" (Gen. 3:23), a symbol of his fall. Next comes Noah bearing a two-storied ark, then Abraham with a flame and a knife in reference to the sacrifice of Isaac. David, king and psalmist, follows, crowned and holding a harp. *Iechonias* sits beside him with crown and scepter; the selection of this figure to represent the juncture between the fourth and fifth ages—the Babylonian exile—was probably based on Matthew's genealogy of the ancestors of Christ: "And Josias begot Jechonias and his brethren at the time of the carrying away to Babylon. And after the carrying away to Babylon Jechonias begat Salathiel . . ." (Matt. 1:11-12).[79] Christ, cross-nimbed, holding an open book, completes the series. Circumscribing the scene there is a distich which originally read: "The hydria holding measures represents any one age; the water gives the historical sense, the wine signifies the allegory" ("Ydria metretas capiens est quelibet etas; limpha dat historiam, vinum notat allegoriam").

A line of male figures of increasing age, labeled *sex etates hominis*, occupies the panel to the right of the scene of marriage (fig. 19). The artist used the awkward shape of the armature to advantage, fitting the smaller figures into its upward curve so that the six would form an isocephalic group. The members of the series are again identified through inscriptions and attributes: *infantia* is represented as a seated child; *pueritia* as a boy in short tunic holding a playing stick and ball; *adolescentia* as a scepter-bearing figure; *iuventus* as a bearded, sword-bearing man; *virilitas* as a bearded man holding a money pouch and loaf; and finally *senectus* as a bearded, balding figure with a T-shaped crutch. The inscription circumscribing them, restored from the manuscripts, reads: "By performing the first of his miracles God here transforms the water of vices into the wine of good ways" ("Primum signorum Deus hic prodendo suorum in vinum morum convertit aquam vitiorum").

The designer of the program, drawing on well-established lines of biblical exegesis, correlated the six vessels with both the macrocosmic and microcosmic ages and distinguished between them according to the levels of scriptural interpretation. The literary source most closely related to the Canterbury program is the *Pictor in carmine*, a late twelfth-century guide for painters, English in origin. The work, still unedited, comprises a series of distichs which pair New Testament events, running from the Annunciation to the end of the world, with their types, drawn largely from the Old Testament. It was the author's wish that they be inscribed and illustrated in churches.[80] He supplied several alternatives for the subject "Christ changes water into wine." Five couplets appear under the heading "Allegorical Understanding of the Six Hydriae through the Six Ages of the World"; four were listed under "Tropological Understanding of the Six Hydriae through the Six Stages of the Human Life."[81]

Both in this text and in the window at Canterbury, the ages of man, placed within a system of levels of interpretation, were assigned to the moral sphere. The transformation of base water into rich wine was taken to signify the passage from vice to virtue, made possible through God. Each age, this seems to suggest, has the potential for good. Character traits can be well or badly applied. The artist's task was to define the nature of each stage of life through suggestive symbols. The simplicity of childhood and the carefree nature of playful boyhood were easily rendered. "Adolescence," the age postpuberty, extending in Isidore's system to age twenty-eight, is given a scepter, a symbol of strength and preeminence. Madeline Caviness finds in the attribute a reference to the contemporary English practice, inaugurated by Henry II, of crowning the heir to the throne even in childhood.[82] While one might expect *iuventus*, prime, to be honored with a kingly token, it is worth noting that in an English wheel of life dated c. 1240, two ascending figures stationed between the child and the adult, as well as the man on top, carry scepters (fig. 86).[83] *Iuventus*, the period when man is able to "help" (*iuvare*), carries a sign of military prowess, a sword. He is followed by a man bearing tokens of accepted responsibility. Venerable old age, last, is shown suffering from physical debility.

Through the attributes the artist affirms the proper course of human life. Underlying his selection there is, perhaps, a proper suggestion of moral ambivalence. Each has the potential for misuse: the money bag and bread can signify avarice and miserliness as well as provision. Exegesis supplied only the armature: the ages of man had to be six in number, like the vessels, like the ages of the world. Within this structure the artist was free to develop an interpretation of the human life through visual signs.

The Ages of Man in the Bible Moralisée

IN PARIS, in the early thirteenth century, one of the greatest of manuscript illuminating projects was undertaken under royal patronage. The *Bible moralisée*, a fully illustrated Bible commentary containing in the most complete of the surviving copies nearly 5500 images, came into being.[84] Passages were selected from every book of the Bible, Genesis through the Apocalypse, to provide the historical narrative. Verse by verse commentary was prepared to reveal the spiritual sense of the divine word. Biblical extracts and exegetical comments, set out alternately in vertical columns, both received illustration. The images, contained in medallions which flank the texts, were lined up, one above the other, four to a column. Learned images, they interpret the texts. Representations of the ages of man were introduced to illustrate the spiritual sense of two biblical passages, despite the fact that the texts in question did not specifically call for them (figs. 20-23).

The interpretation of the six vessels at Cana provided one opportunity to

represent the life cycle. In four of the fourteen extant manuscripts of the *Bible moralisée*, the miracle and its type are represented.[85] The earliest surviving copies, two manuscripts presently in Vienna which were painted in the 1220s, lack a Gospels.[86] The miracle was illustrated, however, in the third volume of a copy in Toledo Cathedral which only slightly postdates these two; much of the Gospels section of the manuscript is thought to have been produced by artists of the same workshop (fig. 20).[87] The biblical event is represented again in a codex now divided among Oxford, Paris, and London, produced in Paris c. 1235-1245 (fig. 21),[88] and in two manuscripts of the same family, namely a line-and-wash copy dating c. 1300 now in London and a mid-fourteenth-century copy in delicate grisaille now in Paris (fig. 22).[89]

The events at Cana are presented in three pairs of images. The second of the three concerns the meaning of the six vessels. A narrative scene illustrates the biblical extract: "Six stone water-jars were there, and Jesus said to his ministers, 'Fill the jars with water.' And they filled them to the brim." In the Toledo manuscript Christ gestures to two attendants who empty buckets of water into urns, arranged in two rows of three. In the Oxford-Paris-London codex and the two related copies, a single attendant, under Christ's direction, pours water from a jar to fill the six hydriae while the feast proceeds to the right. The spiritual sense is supplied below: "This signifies that the scripture of the Law was given to men of six ages, but at that time Christ lay hidden in it, just as the water was insipid."[90]

The passage clearly refers to the ages of the world; it expresses the idea, ultimately derived from Augustine, that when Christ was not understood in Old Testament prophecy, transmitted to men in six epochs, it remained tasteless and insipid.[91] Yet the adjacent image in each case shows the ages of man. Artists depicted rows of six figures of increasing stature joined together by a long scroll, the "scripture of the Law," held by Christ. In the Oxford-Paris-London family of manuscripts the figures are endowed with no attributes but for caps and, in the hand of the most elderly, a knobbed stick. The iconography of the image in the Toledo manuscript is rich and eccentric. The cycle begins with youths who carry the implements of activities in which they might engage: a seated child holds a ball, a boy carries a bow and arrow, and an adolescent supports a falcon on his wrist. Aristocratic leisure at an end, a bearded man, mature and faced with new responsibilities, splits a log with an axe, a unique motif. The man of later years rests his head on his hand in a languid manner. Finally, remarkably, an old man with a curly white beard and a T-form crutch sucks the breast of a young woman standing at his side. The motif seems to express rejuvenation. Does the woman have a particular identity? Is she Wisdom, nurturing man in the sober age of life? Or, better, is she the Church and this an inventive application of the motif of *Ecclesia lactans*? The individual man, Augustine had claimed, is reborn to a spiritual life in his senectitude. Is he then

nourished by the Church, established with the coming of Christ in the sixth age, the old age, of the world? A verse from the Song of Songs (4:10), one addressed to the *sponsa* who was allegorically interpreted as the Church, reads: "How beautiful are thy breasts, my sister, my spouse! thy breasts are more beautiful than wine."[92]

In another instance artists of the moralized Bibles took the occasion to represent the ages of man (fig. 23). The narrative this time was supplied by Luke (1:5-45). An angel had revealed to Zacharias in the temple that his wife, though advanced in years, would bear a child, John. He did not believe and, in punishment, was deprived of speech. But after his return, Elizabeth did conceive and she hid herself for five months. In the sixth month she was visited by Mary, her kinswoman, and as she was greeted the babe in her womb "leapt for joy."

The brief text in the *Bible moralisée* reads: "Elizabeth conceived and secluded herself for five months." In the Oxford-Paris-London copy and other manuscripts of the family, artists illustrated the passage with an image of Elizabeth holding a spindle, and Zacharias, head on hand, bearing an open book inscribed with pseudo-Hebraic characters. This book would be the tablet on which he wrote, "John is his name," while still unable to speak (Luke 1:63). The spiritual sense of the event is given below: "This signifies that the spiritual teaching of the Law pregnant in promises lay hidden in five ages of the saeculum and in the five books of Moses."[93]

The interpretation had venerable roots. Augustine had seized upon the number six and brought the story into line with his understanding of the sexpartite history of salvation. Just as the prophecy which had lain hidden for five ages began to be manifested in the sixth age, so Elizabeth concealed herself for five months, but in the sixth month, at the Visitation, John in her womb rejoiced.[94] In a commentary on the Gospels now dated to the seventh or eighth century, the five months were understood to represent the five thousand years of the seculum or the five books of Moses.[95] Hrabanus Maurus identified Elizabeth as the antitype of the Old Law or prophecy. When the infant in her womb leapt for joy, the spirit in the letter of scripture rejoiced at the coming of Christ; the whole Old Testament, pregnant with the Holy Spirit, proclaimed the incarnation of the Saviour to the world.[96]

This line of interpretation includes no reference to the ages of man. The text in the *Bible moralisée* speaks of the five ages of the world. Nonetheless, the artists of the Oxford-Paris-London manuscript, and other copies in this line, portrayed the phases of life. In the medallion adjacent to the commentary, a horned Moses sits with the volumes of the Pentateuch on his lap while, to his left, five male figures of increasing size are aligned in a row. The selection of attributes is more varied than in the companion image to the Miracle of Cana in the same family of manuscripts. An infant stretches his right arm forward.

A child training for chivalrous pursuits holds a sword and carries a falcon on his wrist. The falcon, awkwardly supported, may have been intended for the adolescent, next in line, who holds nothing. The last two figures bear tokens of their strength: a man with a cap holds a sword, and a bearded man with a cap holds a paddle-like stick.[97]

So closely bound were the themes of the ages of the world and the ages of man that, once again, macrocosm could be substituted for microcosm without explanation. Who was responsible for this erudite manipulation of imagery? Robert Branner envisioned "iconographers," one or more, in each atelier that produced a *Bible moralisée*. The individuals selected the biblical passages to be transcribed, added the moralizations, and instructed the team of artists how best to illustrate the texts.[98] By dispensing with the idea of a prepared model book and emphasizing the role of memory and common artistic training in the illustration of the Bibles, Branner aimed to account for both similarities and differences in the nearly contemporary manuscripts. Reiner Haussherr similarly explained textual variations by suggesting that different compilers were responsible for separate redactions of the *Bible moralisée*. He accordingly rejected Laborde's identification of the author as the Dominican Hugh of St. Cher—author of a related *Postilla in universam Bibliam* dated c. 1230-1235—and argued that Hugh and the compilers of the *Bible moralisée* alike had access to standard works of twelfth-century school exegesis.[99]

The advisor who conceived the idea of representing the world epochs by means of the ages of man was based in Paris. Surviving documents, both literary and artistic, establish the wide diffusion of the sixfold theme in this particular milieu. Royal city, university city, cosmopolitan Paris had been a meeting place for scholars and students for over a century. The study of the sacred page had been carried on with vigor. Authorities had been sifted and new theological syntheses produced.[100] A number of prominent figures who spent all or part of their teaching careers in Paris, influenced by Augustine's thought, adopted his analogy between the six ages of man and the six ages of the world. That controversial thinker and powerful teacher Peter Abelard (d. 1142) made use of Augustinian ideas in his *Expositio in Hexaemeron*, a commentary on the first two books of Genesis prepared for Heloise. In the literal account of creation he found moral and allegorical truths: the six days in which God brought the world to completion signify the six ages in which salvation will be achieved, ages which pass like the life of a single man.[101] Robert of Melun (d. 1167), Abelard's successor on the Mont Ste.-Geneviève, employed the Augustinian metaphor in his theological summa, the *Sententie*, written between 1152 and 1160. Before turning to the problem of creation, Robert classified the various divisions of history and in this context correlated the six ages of the world with the six ages of man, drawing extended analogies between them.[102]

The Canons Regular of the Abbey of St. Victor in Paris, men living according to the Rule of St. Augustine, made use of the scheme in many of their writings. Influential teachers, they held by the conviction that human knowledge must serve the approach to divine wisdom, that the arts must serve scriptural study. Hugh of St. Victor (d. 1141), active in the 1120s and 1130s, set out this educational philosophy in his *Didascalicon*, a work in the genre of *On Christian Doctrine*. Sympathetic to Augustine's thought, he interpreted the six vessels of the miracle at Cana in terms of the six ages in the history of salvation and the six ages in the life of man, as we have seen.[103] Hugh's close follower, Richard of St. Victor (d. 1173), copied this interpretation of the miracle into his own handbook for the study of scripture, the *Liber exceptionum*.[104] Godfrey of St. Victor, a man who had studied the arts and theology in the schools of Paris before becoming a canon at the Abbey of St. Victor, introduced the Augustinian correlation in his *Microcosmus*, a work written late in life, c. 1185. The subject of his tract was man; Godfrey's concern was to establish the dignity of this creature called the "world" in Latin, *microcosmus* in Greek. Human history and man's life are shown to be equally in flux, running in parallel, through six ages.[105]

The scheme of the six ages of man circulated independently. In an anonymous twelfth-century tract on philosophy and its parts, believed by its recent editor to contain both Victorine and Chartrain elements, the hexad appears in a nest of tetrads. The writer proceeds through the four humors and the four qualities, the four elements and the four seasons, but coming to the ages of man he feels obliged to reconcile two systems. According to one scheme, he says, the ages are six in number. Supplying traditional etymologies, he names *infantea* (*sic*) to 7 years, *pueritia*, complete in the 15th year, *adolescentia* to 21, *iuventus*, oddly enduring to 32 or 33, *virilis etas* to 50, and *senectus* to 80. After 80, the time called *senium* or *etas decrepita*, he says, paraphrasing Psalm 89:10, nothing remains but labor and sorrow. According to the other scheme, there are four ages. But the subdivision of three of these ages produces the longer set, clearly preferred.[106]

So authoritative was the divisional scheme that the six ages of man were represented on the facade of Notre-Dame Cathedral itself, one of a series of panels devoted to cosmological themes. On the Portal of the Virgin, its sculpture produced c. 1210-1220, personifications of Earth and Sea, the twelve signs of the zodiac, and the twelve labors of the months are represented below the scenes of the Assumption and Coronation of the Virgin in the tympanum; the ages of man appear on the right face of the trumeau (fig. 24), balanced by what must be the four seasons, symmetrically extended to six, on the left face.[107] The sequence of the ages begins with a boy, simply clad in a belted robe. Above him a youth, holding a bow perhaps, stands between two trees as a bird flies off to his left. An adolescent bears a falcon on his left hand and leads

a dog with his right. More heavily garbed, the last three figures represent the sober chapters of life. Their movements become increasingly disjointed, their beards longer, and their faces more downcast as they age. The final figure, given a cap and heavy mantle, once leaned upon a stick. It is an understated cycle. Size, posture, and gesture do most of the work; attributes merely confirm that youth is a time of pleasure, old age one of physical discomfort.[108] The range in pictorial motifs is not so different from the cycles in the *Bible moralisée*. And in each case an article of school learning was communicated, namely, that the life of man unfolds in six phases. At Notre-Dame the progress of the human life was juxtaposed with other natural cycles in twelves and sixes; in the manuscripts a correlation with the linear sequence of the ages of the world was implied.

The designers of the moralized Bibles drew upon a well-established line of thought, firmly based in patristic exegesis, adopted by the most influential thinkers of their day. That the ages of man were six, natural historical as well as theological works would have confirmed. That the six ages of the world were bound to the six phases of life, Parisian masters proclaimed as an article of faith. Texts might have suggested to the learned "iconographer" that microcosmic be substituted for macrocosmic ages. Yet it is also possible that a pictorial cycle, like that which survives by sheer good fortune in the Canterbury window (figs. 18-19), provided the inspiration. Whatever the precise source, the images in the *Bible moralisée* demonstrate again the wide acceptance of the ultimately Augustinian scheme of the six ages of man in the medieval West.

IV. TIMES OF CONVERSION IN THE HUMAN LIFE

BIBLICAL exegesis, it might be argued, was the major source of creative thinking on the ages of man in late antiquity and the earlier Middle Ages. It gave birth to the widely followed sexpartite system of age division, a scheme in which an antique notion of harmony between microcosm and macrocosm was given a specifically Christian cast. It bred, too, other programs of age division, schemes less indebted to pagan philosophy, more emphatically oriented toward the business of being a Christian. In elaborating these schemes, to which we now turn, the exegete was concerned not so much with all mankind as with the individual man and woman. Personal salvation, the personal history of each Christian in relation to his faith, was the determining theme. The progress of life continued to be charted in relation to temporal cycles in the greater world, but the cycles in question were often drawn from the course of a single day, sometimes the day as given shape by liturgical practice. The different phases of life, no matter how many in number, were seen to be periods in which one could turn to God. Churchmen urged their listeners to respond to the call, to be assured that God would accept them at whatever age they came. At all ages of life, they said, it is right to praise God; at each age it is fitting to apply one's particular qualities and strengths to doing God's work.

Gregory, rather than Augustine, dominates this chapter. The sixth-century Church Father, Pope and pastor, living in a Europe beleaguered by barbarians, was much concerned to bring new converts into the fold. In his classic interpretation of the Parable of the Workers in the Vineyard, he exhorted Christians to come to God at any hour of the day, at any stage of life. Structures of thought he codified would have a wide influence, both on medieval exegetes and medieval artists.

Interpretations of the Parable of the Workers in the Vineyard

HAD AUGUSTINE not given his authority to a sixfold division of the human life, the system of the five ages of man might well have held pride of place among Christian writers. Before Augustine wrote, the practice of identifying the five hours named in the Parable of the Workers in the Vineyard with five

points in human history and five times of conversion in the human life had been inaugurated. A number of Early Christian authors independently subscribed to the five-age scheme. It was, in fact, introduced in the very earliest application of the ages of man theme to an exegetical problem, an interpretation of the life of Christ, albeit an unorthodox one, put forward by Irenaeus, Bishop of Lyons in the early second century A.D.

Irenaeus argued in his anti-Gnostic tract *Adversus haereses* that Christ did not die in his prime, but rather lived to pass through the full cycle of the ages of man. By this means, he who assumed the flesh for the sake of man's salvation avoided no human condition but justified and sanctified each stage of life in turn before submitting to death:

> For He came to save all through means of Himself—all, I say, who through Him are born again to God—*infantes, et parvuli, et pueri, et iuvenes, et seniores.* He therefore passed through every age, becoming an infant for infants, thus sanctifying infants; a child for children, thus sanctifying those who are of this age, being at the same time made to them an example of piety, righteousness, and submission; a youth for youths, becoming an example to youths, and thus sanctifying them for the Lord. So likewise he was an old man for old men, that he might be a perfect Master for all, not merely as respects the setting forth of the truth, but also as regards age, sanctifying at the same time the aged also, and becoming an example to them likewise.[1]

Irenaeus's reluctance to accept an early date for Christ's death was grounded in polemic. His purpose was to counter the Gnostic belief that Christ was baptized at age thirty—in witness to the thirty eons in the *pleroma*—and then preached for a single year before his death. Not content to demonstrate that he must have spent no fewer than three Passovers in Jerusalem by scriptural authority, Irenaeus sought to restore to him the venerable age of a Master denied him by Gnostic heretics. Living to experience all the ages of man, Christ fulfilled his role of being a perfect mediator between God and man.

That Irenaeus considered there to be five and only five ages of man is confirmed some chapters further on when he inveighs against Gnostic applications of number and letter symbolism to scripture and the natural order. His list of well-known pentads which the Gnostics ignored because five had no place in their world order includes not only the five loaves blessed by Christ (Matt. 14:19), the five wise and five foolish virgins (Matt. 25:2), the five fingers on the hand, and the five senses, but also man's five ages—*infans, parvulus, puer, iuvenis,* and *senior.*[2] Other writers favored the system. The Roman encyclopedist Varro was one, by the testimony of both Censorinus and Servius.[3] Among Christian authors, Tertullian, Irenaeus's later contemporary, acquainted by his own admission with the works of Varro and Irenaeus, named five ages through

which the body and soul together pass.[4] Clement of Alexandria, writing c. 200, exhorted those who lived without virtue as children, adolescents, youths, and men to know God at least in their old age.[5] Later, just after A.D. 400, Prudentius would characterize five ages thus:

> Sic aevi mortalis habet se mobilis ordo.
> Sic variat natura vices: infantia repit,
> infirmus titubat pueri gressusque animusque,
> sanguine praecalido fervet nervosa iuventa,
> mox stabilita venit maturi roboris aetas,
> ultima consiliis melior sed viribus aegra
> corpore subcumbit mentem purgata senectus.

> Such changes may be seen in human life,
> Which varies with each age: the infant crawls,
> The boy totters both in step and mind,
> The robust youth with fiery passion burns,
> Then comes the time of ripe maturity,
> And last old age, sagacious but infirm,
> In body falters, but is sound in mind.[6]

When Christian exegetes came to interpret the Parable of the Workers in the Vineyard (Matt. 20:1-16), they had ample support for recognizing in the five times of day five times in the human life.

In this parable Christ compared the Kingdom of Heaven to the *paterfamilias* who went out at five different hours to hire laborers for his vineyard. In the early morning (*primo mane*) he made an agreement to pay some men a *denarius* for a day's work. He went out again at the third hour, and at the sixth, and at the ninth, and at the eleventh, and each time hired another group of workers, promising to pay them a just amount. At the end of the day he instructed his steward to pay the workers, beginning with the last hired and proceeding to the first. All alike received a *denarius*. When the first men to have been called complained that they were given no more than those who had worked for a single hour, the householder responded that he did them no injustice; it was his right to be generous as he chose. The parable ends with a dark prophecy: "Even so the last shall be first, and the first last; for many are called, but few are chosen."

Various elements of this enigmatic tale received allegorical exposition. The *paterfamilias* was understood to signify Christ; the vineyard was his church; the *denarius* referred to eternal salvation. Interpreters turned their attention to the hours at a very early date. The Gnostics, according to Irenaeus, added the five figures together ($1 + 3 + 6 + 9 + 11$) and arrived at thirty, the number of eons in the *pleroma*.[7] Origen in the third century gave a more acceptable reading, one which would have a long life in the West. The day, he suggested, could

signify the course of history or the life of man. Five orders of workers were consigned to labor in the vineyard: these are Adam, Noah, Abraham, Moses, and the men of their times, the fifth order established by the coming of Christ. At five hours men were called: these hours are five times when people enter the kingdom of God, in childhood or adolescence, as adults or old men, or at the very end of life.[8]

Jerome, in a commentary which would circulate in the Middle Ages, took much the same line. He observed that connections had been drawn between the hours and biblical figures "sent into the vineyard," and he enumerated them. But it seemed to him that the workers called at the different times signify those who become Christian at different stages of life. The laborers of the first hour are Samuel, Jeremias, and John the Baptist, men who upon leaving their mothers' wombs were believers in God. Workers of the third hour are those who begin to serve God from puberty (*a pubertate*); those of the sixth hour have taken up the yoke of Christ as adults (*matura aetate*); those of the ninth, at an advanced age (*aetate declinante ad senium*); and those of the eleventh, in extreme old age (*ultima senectute*).[9]

Augustine, possibly because the parable afforded no opportunity for the elaboration of a sixfold symbolism, considered it only in two sermons, one undated, one late. The five hours, for him, represent Abel, Abraham, Moses and Aaron, and the prophets, together with the righteous men of their respective generations, and, finally, all Christians. Equally, they signify those who begin to be Christians as they leave their mother's wombs (*recentes ab utero matris*), those who convert as *pueri*, as *iuvenes*, as they approach old age (*vergentes in senium*), and when extremely aged (*omnino decrepiti*).[10] The age designations bear little relation to those used elsewhere in his writings: he describes individuals, not epochs or periods of life, avoiding the rubrics *aetates mundi* and *aetates hominis*.

Gregory the Great (d. 604), then, provided the definitive interpretation of the parable. In his much-quoted nineteenth homily he gave two interpretations of the hours, as his predecessors had done. The householder collected workers for the cultivation of his vineyard at five times because God has not ceased to gather *praedicatores* to instruct the faithful from the beginning of the world to the end. The hours signify the periods from Adam to Noah, Noah to Abraham, Abraham to Moses, Moses to the coming of the Lord, and the coming of the Lord to the end of the world. Moses, it should be noted, who did not have a prominent place in the Augustinian sexpartite scheme, is regularly an articulation point in the five-age system.

Gregory went on to interpret the hours as symbols of the ages of man and, as he did so, compared the progress of human life to the course of the natural day. *Mane* is *pueritia*; the third hour is *adolescentia*, for there is an increase in the heat of this age which corresponds to the sun advancing to its height; the

sixth hour is *iuventus*, the period in which full strength is achieved, as when the sun is fixed at the midpoint of its course; the ninth hour is *senectus*, when the heat of youth declines just as the sun descends from its height; the eleventh hour is the age called *decrepita* or *veterana*. Some men, Gregory says, are led to a good life at every one of these ages. He urges his listeners to reflect on what they do and to consider if they work in God's vineyard. He advises them to come late if not early, and thus uses the exegesis to make an edifying exhortation.[11]

Circumstances favored the wide diffusion of the text. The Parable of the Workers in the Vineyard was itself one of the readings for Septuagesima Sunday. Extracts from Gregory's homily served as lessons for that day, read at matins, from an early date.[12] The text was copied into an influential homiliary attributed to Paul the Deacon.[13] Medieval exegetes borrowed freely from it, incorporating Gregorian material into their commentaries on Matthew and into homilies for Septuagesima Sunday. Smaragdus and Hrabanus Maurus followed the text closely, while Haimo of Auxerre and Aelfric enlarged upon it.[14] Twelfth-century commentators were well acquainted with the interpretation.[15]

The homily, too, provided a program for artists. The Genesis initial in the Stavelot Bible, a miniature painted by Mosan illuminators in Stavelot between 1094 and 1097 (fig. 25), is a case in point. Its iconography has been shown to derive very specifically from the readings for Septuagesima Sunday, readings which included the first chapter of Genesis along with the parable and extracts from Gregory's homily.[16] The initial "I" of *In principio*, the opening words of Genesis, was normally embellished with representations of the days of creation. In the Stavelot Bible there were represented instead seven scenes from the life of Christ extending from the Annunciation to the Second Coming, flanked to the left and right by cycles of the ages of the world and the hours of the parable.

Events from biblical history are represented in the row of medallions to the left, each amplified by further vignettes depicted in the intervening spaces. The sequence of world ages, read from bottom to top, matches Gregory's precisely. The first age extends from Adam, shown toiling after the expulsion from Paradise, to Noah, who receives the command to build the ark and occupies it; the second age extends from Noah to Abraham, represented first in the act of sacrificing his son, then offering a ram; the third extends from Abraham to Moses, who responds to the Israelites' worship of the Golden Calf by breaking the received Tablets of the Law; the fourth extends from Moses to Christ, shown addressing the apostles, his work continued in their missionary efforts; the last extends from the Coming of the Lord to the end of the world, vividly illustrated by angels with trumpets calling the dead to rise. In the right-hand column the *paterfamilias* is represented five times in the act of hiring workers for his vineyard. The hours are inscribed in the right margin, reading again

from bottom to top, *primo mane, ad tertiam, ad sextam, ad nonam*, and *ad unde-cimam*. Between the roundels the workers are represented cultivating the vines—digging, planting, pruning, and harvesting—and, the work complete, demanding their pay. In the uppermost roundel, labeled *voca operarios*, the steward distributes the wages.[17] The three temporal cycles culminate at the top of the composition in the Last Judgment. The workers of the eleventh hour and the sixth age of the world appear closest to the figure of the Lord and thus fulfill the prophecy, "Even so the last shall be first, and the first last." In a calculated move the workers receive their pay, the *denarius* of "eternal salvation," directly across from the scene of the resurrection at the end of time. Standing at the head of the Creation story, the initial is an eloquent expression of the scheme of Christian salvation which began to unfold at the beginning of the world.

There was no place in this program for the microcosmic component of the Gregorian interpretation, that is, the times of conversion in the life of man. But all three cycles were explicitly correlated in a sequence of miniatures in an Austrian prayerbook, dating c. 1200, now in Vienna (figs. 26-29).[18] The manuscript, a small devotional book prepared for a woman (*peccatrix*), follows a regular plan. Line and wash illustrations of Old and New Testament events appear on verso folios; related prayers are transcribed in single columns on facing recto pages. Four of the miniatures form a subset within the whole. The focus of this small series is the ages of the world. Full-page representations of Noah, Abraham, Moses, and Christ lie adjacent to prayers which refer to each "servant of God" and his history.[19] The hours of the day and the ages of man, not mentioned in the facing texts, are depicted in medallions fixed onto the frame of each illustration.

While there is every likelihood that Adam originally inaugurated the cycle, Noah, together with the third hour and *adolescentia*, heads the sequence at present.[20] He appears with three figures, probably his three sons; the ark in which he himself and a few others were saved, according to the prayer, appears in the background. Noah stands before the Lord, possibly receiving the covenant from him (Gen. 9:8-10). On the frame above there is a rosette inscribed in red, *hora tertia*. On the lower bar of the frame there appears a roundel enclosing the half-length figure of a youth, labeled *adolescentia*, holding a bow and arrow. In the succeeding image the Lord establishes his covenant with Abraham through the sign of the circumcision (Gen. 17), an event referred to in the accompanying prayer. Sarah and Hagar, the women who gave sons to the "father of a multitude of nations," stand to either side. *Hora sexta* is fixed to the frame above. *Iuventus*, a military figure with a moustache and a slight beard carrying a grey and red sword and a shield with a strap, appears beneath the feet of Abraham.

Moses, in the following scene, speaks to the people of Israel, identifiable as Jews by their pointed hats, and God appears in the clouds above. This may be

a representation of God's meeting with Moses and the consecrated people at
Mount Sinai before the establishment of a covenant through the Ten Com-
mandments (Exod. 19:9ff.). The accompanying prayer makes general reference
to the flight from Egypt and the attainment of the promised land. The rosette
above is labeled *hora nona*. The rectangular medallion below contains a bearded
figure, *senectus*, holding a scroll inscribed "this is old age" ("*Daz ist daz alter*").
In the final miniature, Christ, with a gold cruciform halo, holding a book in
his left hand and making a gesture of blessing with his right, stands with the
apostles about him. Above his head a rosette is inscribed *hora undecima*. Below
his feet an old man clutching his long beard and resting his right hand on a
T-form crutch represents *etas decrepitas* (*sic*), the last age of man.

Parable exegesis clearly stands behind the cycle: the members of the three
correlated sets are precisely those named by Gregory in his homily. But the
emphasis has shifted to the ages of the world or, more accurately, to the various
times in history when God made binding promises to man. The hours of the
day are relegated to a subsidiary role, and the ages of man are compared not
only to the hours, as they are in parable commentaries, but also, through
physical juxtaposition, to the ages of the world. Thus the coming of Christ
represents both the final hour and the old age of the world considered as a
single man. The attributes for the ages of man—bow and arrow, sword and
shield, stick—serve to amplify and reinforce the written labels. Fairly aggressive
symbols, reflections of manly, secular pursuits, it might seem odd that they
should adorn a woman's prayerbook. But the repertory of attributes, limited
and quite stable from earliest appearances, varied little according to context.

A particularly sensitive rendering of the parable and its exegesis appears on
the right jamb of the west portal, the Last Judgment portal, of the Baptistery
in Parma, a structure begun in 1196 (fig. 30).[21] The sculptor, Benedetto An-
telami, succeeded in narrating and explicating the story simultaneously, with
a striking economy of means. The themes drawn together correspond to those
in the Vienna prayerbook, but their integration is far more subtle. The tall and
narrow panel is divided into seven spaces by a rhythmically undulating vine
branch. In the lowest space the householder, without halo but clothed in the
robes of a religious figure, calls the first laborer to work in his vineyard (*vineam
domini sabaoht*). The worker, remarkably, is a young child, clad, as all the
workers are clad, in a short tunic and three-strap sandals. The householder
rests a hand on his head. Inscriptions correlate the hiring at the first hour
(*primam mane*) with the first age of man (*infancia*) and the first age of the world
(*prima etas seculi*).

In the next scene the householder hires two youthful workers, one holding
a spade and a pruning knife, the other, seated, holding a knife. The inscriptions
read *hora tercia*, *puericia*, and *secunda etas*. Above this scene a pair of adolescents
bearing knives are hired; *sexta*, *adulescencia*, and *tercia etas* are inscribed beside

them. Next the *paterfamilias* speaks to a bearded young man holding a knife and a mattock; the inscriptions are *nona*, *iuventus*, and *quarta etas*. An identical figure is hired in the following scene; beside him are inscribed *unde*, *gravitas*, and *quinta etas*. To complete the sequence, a bearded worker resting his weight on his mattock, as if on a crutch, is called to work in the vineyard; the inscriptions read *cima*, *senectus*, and *sexta etas*. At the very top the six workers (*operarii*) are aligned in two rows: the younger three, of increasing size, stand in front of the older three, all bearded. The householder, who carries a money bag, hands a *denarius* to the oldest of the workers, thereby paying the last of the men first.

Compositional subtleties are many. The winding vine branch at once suggests a vineyard setting and separates the successive episodes in the parable story. As the vine moves up the panel it creates semicircular spaces wider at the outside edges. The *paterfamilias*, who is represented six times in the act of hiring workers and once paying them, stands at the widest point in each case: visual monotony is minimized as the figure moves from side to side up the panel. Exegetical interpretation is introduced in an understated manner. The workers, bearing agricultural implements, maintain their identity as laborers throughout. Size differentiation alone establishes that each, too, represents a particular phase of life. Inscriptions serve to confirm the point made visually. Working within the confines of parable illustration, Benedetto Antelami thus gave the cycle an added resonance, the solution ingenious and unique.[22] As the story unfolds, its significance is conveyed.

Augustinian ideas clearly influenced the designer of the program. Beginning with the correspondences drawn between the five hours, the five ages of the world, and the five ages of man, he extended the cycles to a more familiar six. Since the ages of the world were designated by number, he did not have to choose between Moses and David as the inaugurator of the fourth epoch. Designations for six ages of man were widely available: the set is that found in Augustine's *Eighty-three Different Questions*, Isidore's *Etymologies*, and elsewhere.[23] The five hours of the day were made six by more dubious means: the eleventh hour was split into two parts, *unde* and *cima*. Yet even for this manoeuvre the designer might have found textual support. In the *Historia scholastica*, written c. 1170, Peter Comestor had suggested that the eleventh hour stood for both the fifth and the sixth ages, eleven being the sum of five and six.[24]

On the opposite jamb Antelami represented another sixfold theme, the Works of Mercy: to feed the hungry, to give drink to the thirsty, to welcome the stranger, to clothe the naked, to visit the sick, and to go to those in prison (Matt. 25:34-36). The hexadic cycles balance one another as they progress upwards, by conscious design. Both find fulfillment in the scenes of the Last Judgment and the resurrection of the dead which appear in the tympanum

above; in this, as others have observed, the program is reminiscent of that in the Genesis initial of the Stavelot Bible (fig. 25). The Works of Mercy are named in the Gospel within a description of the Last Judgment: men will be consigned to eternal punishment or admitted to eternal life on the basis of their acts. Equally, the Parable of the Workers in the Vineyard is eschatological in tone. It hints darkly at the mystery of attaining everlasting life. The exegesis of the parable, which Antelami so lucidly portrayed, makes its message explicit.

Variations on the Theme

AT EVERY age of life, Gregory had said, God calls workers into his vineyard. In another parable, the Parable of the Three Vigils, he discovered a related message. Christ here had urged vigilance on the part of the servants of God (Luke 12:35-38):

> Let your loins be girt about and your lamps burning, and you yourselves like men waiting for their master's return from the wedding; so that when he comes and knocks they may straightway open to him. Blessed are those servants whom the master, on his return, shall find watching. Amen I say to you, he will gird himself, and will make them recline at table, and will come and serve them. And if he comes in the second watch, and if in the third, and finds them so, blessed are those servants!

Gregory read the parable as a lesson in God's enduring patience. The three vigils are the ages at which one may turn to the "ways of life." If one is negligent in the first watch, that is to say, in the first age, *pueritia*, one should not lose hope or cease from good work, for God blessed those servants watching at the second and third vigils. This second vigil is *adolescentia* or *iuventus*, ages which Gregory equates on the authority of Ecclesiastes 11:9, "Rejoice young man in thy youth" ("Laetare iuvenis in adolescentia tua"). The third vigil is *senectus*. The man who is not vigilant in the first watch, who does not turn from perverseness to the ways of life in childhood, may yet awaken in his youth; the negligent youth may come to his senses in old age. God, in his great compassion, awaits our return. Despised, he calls us back.[25]

The three vigils thus signify three times of life, though Gregory named four ages in the course of his commentary. The interpretation would be followed by a number of later writers, Bede, Smaragdus of Saint-Mihiel, and Haimo of Auxerre among them.[26] It was paraphrased in the *Glossa ordinaria*, that comprehensive Bible commentary compiled in the early twelfth century by Anselm of Laon and his assistants.[27] It seems also to have influenced writers on liturgy. As commentators sought to explicate the shape of the existing liturgy, to discover a spiritual justification for the content and order and times of public prayer, they adopted patterns of thinking from biblical exegesis.

Honorius Augustodunensis, to meet the twelfth-century writer of the *Imago mundi* in another capacity, suggested that three lessons were read in the night office because the Lord in the parable imposed three vigils, vigils which signify three ages, *pueritia, iuventus,* and *senectus.*[28] John Beleth, writing in the mid-twelfth century, interpreted the three lections in much the same way: they signify three ages—*puericia, iuventus, senectus*—times in which, lest we be seduced by the devil, we must persevere, by proper vigil, in praising God.[29]

The canonical hours gave structure to the liturgical day. "Seven times a day I have given praise to thee," reads Psalm 118:164. In the sequence of hours of the divine office, the whole life of man was seen to be summarized. Honorius Augustodunensis wove the exegesis of the Parable of the Workers in the Vineyard into his account. The hours signify not only the seven ages of the world but also seven times in the life of the individual, for "the law of the Lord teaches him in diverse ages, as if in diverse hours, as it were, to work in the vineyard." Honorius explains that as we reflect upon the stages of life at each hour we find cause to praise God. This begins in *matutina* when we remember *infantia,* the age in which we are born into the world and are brought from the night of error into the light of truth in baptism. Similarly we glorify God in all the succeeding hours, in *prima,* recalling *pueritia* when we begin to become acquainted with books, in *tertia,* recalling *adolescentia* when we take orders, in *sexta,* signifying *iuventus* when we advance to the grades of deacon or presbyter, in *nona,* indicating *senectus* when many receive high ecclesiastical offices, and in *vespera,* bringing *decrepitas* to mind when many among us who have lived vain lives, as if standing idle in the forum of the parable, turn to a better life. In *completorium* we reflect upon our end and hope to be saved through confession and penitence.[30]

This is a very particular view of the human life, a view from inside a religious community. Other writers spoke more generally. For John Beleth, the hours—matins-lauds, prime, terce, sext, none, vespers, and compline—were simply to be correlated with seven ages, *infantia, pueritia, adolescentia, iuventus, senectus, senium,* and *decrepita etas.*[31] Sicardus of Cremona (d. 1215) concurred and added that by praising God seven times a day we indicate symbolically that he is to be praised at all times, throughout the course of history, throughout the life of man.[32]

Temporal progressions triggered these interpretations. Spatial coordinates provided the inspiration in another case. Certain exegetes introduced the ages of man into their discussions of the plan of the heavenly Jerusalem as revealed to John in the Apocalypse (21:13): "On the east are three gates, and on the north three gates, and on the south three gates, and on the west three gates." There were twelve portals but four approaches, and these approaches were understood to signify four times of conversion in the human life.[33] For Bruno of Segni (d. 1123) those coming from the east convert to the faith in the first

age of life (*primaeva aetas*), those entering through the northern gates convert in adolescence (*adolescentia*), a difficult age when the devil is particularly active in deceiving man, those going in through the southern gates convert in the prime of life (*iuventus*), and those for whom the western portals lie open begin to repent and serve God in old age (*senectus*). Almost inevitably the gates signify, too, the epochs of history in which men enter into the faith, here four in number: the period from the beginning of the world to the time of the Babylonians, from Nabuchodonosor to Christ, from Christ to the Antichrist, and from the Antichrist to the end.[34] Bruno did not fail to observe a similarity to the exegesis of the Parable of the Workers in the Vineyard. In a homily for Septuagesima Sunday he drew explicit parallels between the five hours in the parable and the four directions of access to the temple of the heavenly Jerusalem, harmonizing the two by having *iuvenes* and *senes*, individuals coming in at the sixth and ninth hour, enter through the southern gate. "The temple and the vineyard have the same significance: for the holy Church is the vineyard in which we work and the temple in which we pray."[35]

Any age, all these texts agree, is the right age for coming to know God. The interpretation of biblical motifs and liturgical practice provided an excuse for making this salutary point. Context determined the number of ages; there might be three or four, five or seven. All the schemes were known elsewhere. But these writers were not concerned to justify a particular system or to establish man's place in the cosmic order on the basis of analogies to the greater world. Their aim was to convey an edifying message, beneficial to their listeners. In the structure of life they found an armature for their teaching.

The Three Magi as the Ages of Man

THE THREE-AGE system had a different kind of history than did the four, five, six, or seven. It was not so bookish a divisional scheme as the others. Arithmologists might point out that the number three signified a totality. The Pythagoreans, Aristotle records, seeing that the triad (1, 2, 3) had a beginning, a middle, and an end, believed it to represent a whole.[36] Working on the same assumption, Aristotle himself described the whole of life in three ages, phases in which adulthood was understood to be a mean between the extremes of high-spirited youth and subdued old age.[37] But no one needed a philosopher to tell him that things come in threes. Even as scholars spun their learned schemes, the three-part division of life held its own in myth and folklore. One is, perhaps, justified in introducing the riddle of the Sphinx at this point: "What is that which has one voice and yet becomes four-footed and two-footed and three-footed?" Oedipus saved Thebes by supplying the answer: a man at three times of life, who first crawls, then walks, then supports himself on a stick.[38]

Closer to home, a description of the sun god contained in Martianus Capella's

fifth-century allegory *On the Marriage of Philology and Mercury* suggests a three-age system based on the sun's cyclic movement. Sol is reported to have joined the assembly of the gods, and "as he entered, his face shone like a boy's, in mid-course he looked like a young man out of breath, while at the end of his course he seemed like a declining old man."[39] Martianus observed elsewhere in the tract that the ages of man were four in number and that growth proceeded in hebdomads, but here, using the language of myth, he implied that three ages encompass the whole of life.

The Magi who came to adore the Christ child, named in the Bible as bearers of three gifts and consequently themselves numbered at three, were identified in medieval opinion with the three ages of man. Yet the motif was not rooted in scripture or scriptural commentary. Its origin is to be sought in folklore, its diffusion to be followed in apocryphal texts, popular literature, and works of art. The biblical account of the Adoration was itself far too brief to satisfy (Matt. 2:1-12). From an early date, elements of the scriptural narrative received colorful amplifications and additions.[40] Reported only to have traveled "from the East," the Magi's lands of origin and racial types were specified and their royal pedigrees established. Details of their journey were supplied, and their previous and subsequent adventures were narrated. Full descriptions of their persons, both appearance and apparel, were made. Certain texts and a significant number of medieval images indicate that the gold-bearing magus was an elderly man, one of his companions a man of middle age, and the other a beardless youth.

Irish writers of the early Middle Ages, with their well-attested taste for extrabiblical lore, supply the earliest of the extended descriptions of the Magi in the West.[41] A passage in the so-called *Collectanea* or *Excerptiones patrum*, a compendium of esoteric information once attributed to Bede, more recently to an eighth-century Irishman, conjures up a vivid image of the oriental kings. Melchior, the bearer of gold, is said to be an old man, hoary with long beard and hair, luxuriantly garbed in a purple tunic, a short green mantle, shoes worked in purple and white, and a mithraic cap. Caspar, next, the bearer of frankincense, is described as an unbearded youth with red hair; his tunic is green, his short mantle red, and his shoes purple. Finally Balthasar, who offered myrrh, is called dark and fully bearded; he is outfitted in a red tunic, a short white mantle, and green shoes.[42] Curious lore, it would be recorded in a number of medieval texts, many of them Irish.[43] The passage offers a graphic description of the mysterious kings, so graphic that a visual model seems to be implied.

Art, in fact, provides the surest index for the development of the motif, the number of surviving representations being so large. Very early renderings of the Adoration show the Magi as a row of beardless youths, two, three, four, or even six in number. During the fourth century their number was fixed at three. At about the same time they came to be loosely differentiated according

to age. There are several contenders for first systematic representation of three-aged Magi. The ivory cover of the Etchmiadzin Gospels (mid-sixth century) has received much attention in this regard, and one of the Monza ampullae (late sixth century) is often cited as its follower.[44] Without color, of course, dark and white beards cannot be distinguished and differentiation according to age cannot be confirmed. A mosaic at S. Apollinare Nuovo in Ravenna, which can be dated 561, would fulfill the requirements but for the fact that the relevant panel was heavily restored in modern times and its original appearance is uncertain.[45]

Manuscript evidence confirms that Magi of three ages were being represented in the West by the Carolingian epoch. In an image in the early ninth-century Stuttgart Psalter, the kings are of three distinct ages (fig. 31).[46] The figures, it is worth noting, conform quite precisely to the description in the eighth-century *Collectanea* of pseudo-Bede: one magus has a white beard, one has a dark beard, and the third appears beardless. The colors of their engulfing mantles correspond to those designated for the Magi's *tunicae*, purple for the elderly, red for the middle-aged, green for the youthful magus. Young Caspar even has red hair, as the text stipulates.[47]

Artists did not consistently adopt the motif in the early Middle Ages. Through the eleventh century, as the increasingly abundant corpus of images reveals, three-age representations appear along with virtually every other possible combination of white- and dark-bearded and beardless figures in seemingly random fashion. Only later would the form stabilize. From the end of the twelfth century the most common iconographic type would consist of an elderly man with a curly white beard, his crown often respectfully removed, genuflecting before the Christ child and offering him a gift of gold, as his dark-bearded and beardless companions look on. This was the compositional formula adopted by Nicholas of Verdun, master goldsmith, when he represented the scene on his forward-looking Klosterneuburg Altar of 1181 (fig. 32).[48] The artistic convention was as widely followed in Byzantium as in the West. In the Byzantine "Painter's Manual," a guide to painting written by Dionysius of Fourna in the early eighteenth century, but the fruit of centuries of tradition, the Adoration of the Magi is described as follows: "A house, and the Virgin sitting on a stool, holding the infant Christ, who makes the act of blessing. The three Magi are before her holding their gifts in golden caskets; one of them is an old man with a long beard, and kneeling bare-headed he looks at Christ and holds his gift in one hand and his crown in the other. Another has an incipient beard and the other is beardless, and they look at each other, pointing out Christ."[49]

What was the rationale behind the motif, so widespread, so tenacious? Expositions of the idea are few: exegetes, having no authoritative text, had no reason to consider it. Yet at one point the description of the Magi contained

in *Collectanea* did inspire an interpretive comment. Copied into the ninth- or tenth-century "Catechesis celtica," the passage was given a moral reading. Understood in a spiritual sense, its author observes, the ages and apparel of the Magi give us instruction in seeking and finding God. For the old age of the first teaches us to maintain a sober character; the youth of the second urges us toward activity and a lively mind in God's commandments; the perfect age of the third admonishes us to lead a perfect life in all things.[50] There are thus three ages, middle age understood to be the mean between extremes. But now the Christian is urged to use his particular talents in carrying out God's works.

Exegetical treatments of the Adoration, although they do not mention the ages of the Magi, contribute to an understanding of the motif. Augustine recognized the Magi to be the first of the Gentiles to honor Christ.[51] Leo the Great (d. 461) understood them to be representatives of all people, all nations.[52] By the Carolingian period, as a pseudo-Bedan commentary on Matthew indicates, the allegorical interpretation destined to hold sway through the Middle Ages had been fixed: "Mystically the three Magi signify the three parts of the world, Asia, Africa, and Europe, or the human race which received its seed from the three sons of Noah."[53] In the Stuttgart Psalter the representation of the Magi (fig. 31) served as a gloss to Psalm 71, 10-11: "The kings of Tharsis and the islands shall offer presents: the kings of the Arabians and of Saba shall bring gifts: and all kings of the earth shall adore him: all nations shall serve him." It was not a great step to extend this notion of universality from a spatial to a temporal sphere. Three signifies a totality. In the Magi all men at every stage of life pay homage to Christ.

Popular belief found curious confirmation in the corporal remains of the Magi. Marco Polo, visiting the Persian city of Saba in the mid-thirteenth century, was shown three tombs containing the bodies of *Baltasar*, *Gaspar*, and *Melchior* and told that "the said three bodies are still all whole and have hair and beards as when they were alive."[54] Similarly, the more famous remains discovered at the Church of S. Eustorgius in Milan in 1158 and transferred to Cologne under Archbishop Rainald of Dassel in 1164, were said to have been preserved uncorrupted, with skin and hair intact. Robert of Torigni, Abbot of Mont-Saint-Michel, in a chronicle written before 1182, added that according to eyewitness report the Magi in Cologne, as far as could be determined from the face and hair, seemed to be 15, 30, and 60 years of age respectively.[55]

The miraculous discovery of the Magi's relics helps to explain the increasing attention paid to the three kings in the later Middle Ages, a popularity observed in the mutually influential spheres of literature, drama, and art. The most widely circulated account of all, John of Hildesheim's *Historia trium regum*, written on or near the bicentenary of the translation of the relics, was a synthesis of all available lore, eastern and western in origin. It includes no specific mention of the ages of the Magi, but it does give their respective heights: *Melchiar* was

small, *Balthazar* medium-sized, and *Jaspar* large.[56] Petrus de Natalibus, Bishop of Equilio, in his *Catalogus sanctorum* of the end of the fifteenth century gave the Magi's ages as 60, 40, and 20, making the comment "so they are regularly painted."[57] The motif, nurtured not in scholarly but in popular spheres, thus maintained its force into the late Middle Ages. Nonacademic evocations of the theme of the ages of man would, in fact, multiply in the thirteenth to fifteenth century, as the second half of this study will reveal.

PART TWO

PART TWO

V. POPULAR COSMOLOGY

SCHOOLMEN of the high Middle Ages had subscribed to several different systems of age division, each having weighty authority behind it. The Church Fathers and later exegetes, pagan philosophers and doctors, even Arabic thinkers, could be summoned in support of one or other of the schemes. Roger Bacon is a witness to the state of opinion in the thirteenth century. In the computus manual he wrote between 1263 and 1265, the learned Franciscan offered a considered definition of the ages of man under the heading *etas*, the clarity of which reveals his scholastic training.[1] The term "age," he says, is used properly in three ways, "transumptively" in one. Properly it can refer to the span of life of any man, commonly held to be one hundred years, as it is said in Ecclesiasticus (18:8): "The number of the days of men at the most are a hundred years." It can also signify the point after which a man can be accepted for legal business, as it is taken in John (9:21): "Ask him; he is of age." It is used in a third way for a fixed portion of the whole human life. Subdivisions are necessary in this category, for some, Roger explains, say there are four ages, others say seven, others six. Johannicius is his source for the four-age scheme; he takes his description of hot and wet *adholocencia*, hot and dry *iuventus*, cold and dry *senectus*, and cold and wet *senium* straight from the *Isagoge*, that much-read introduction to Galenic medicine, translated from the Arabic in the late eleventh century.[2] In speaking of the seven ages he refers to "certain doctors," again Arabic, who divide *adholocencia* into *noviter genita*, *dencium plantativa*, and *puericia*, after which they place *iuventus*, *virilitas*, *senium*, and *decrepita etas*.[3] The six-age system receives especially extended treatment. Following precedent, Roger employs etymologies to define the various age designations. But from the meaning of the terms, his particular aim is to demonstrate that each phase is distinguished according to powers natural only to man. The human, for example, has the capacity to speak; thus in the first age, which lasts to the third year, he is called *infans* because of an inability to perform this act (*non fans*). Roger provides a summary by quoting a popular mnemonic distich which names the six ages in sequence:

> Infans inde puer, adoloscens, inde iuventus,
> Inde vir, inde senex, etates signo tibi sex.

In its "transferred" sense, *etas* is applied to the ages of the world. In good Augustinian fashion, Roger correlates each of six epochs with a phase of human

life, beginning with the first age, to seven years, erased from memory just as the first era was destroyed by the deluge.[4]

Virtually all the schemes of age division nurtured in the medieval schools were perpetuated in the later Middle Ages. Philosophers continued to describe the place of man in the natural order; theologians rehearsed established lines of patristic exegesis. But laymen, too, now came by the traditional learning. Through popularizing tracts on the nature of the world, as well as vernacular translations of school texts and their increasingly accessible Latin counterparts, cosmological thought became part of the public domain. Preaching contributed to the diffusion of scriptural exegesis and the schemes of age division proper to it. The old systems held their own.

These very real continuities, however, underscore significant changes in attitude, well documented in the abundant texts and images on the theme of the ages of man which survive from the thirteenth, fourteenth, and fifteenth centuries. Popular moralists now appropriated the theme for use in their edifying discourses: their tendency was to emphasize the brevity and wretchedness of this life and the possibilities for wickedness proper to each age. Innocent III gave classic expression to the point of view in his influential tract *On the Misery of the Human Condition*, written in 1195. Life is presented as a vile and miserable experience: everything is labor and sorrow from the moment man is conceived in sin, formed from filthy sperm and fed on unclean menstrual blood, until the time he dies and his body becomes the food of worms.[5] Moral instruction meted out to the lay public, whether by preachers, poets, essayists, dramatists, or artists, proclaimed life to be a vanity. Pleas and warnings were addressed to members of specific age groups, and the entire pattern of human life was used to impart an edifying message. The inherited schemes of age division were recast, and a few new schemes were created in this worthy cause.

A passage from a "Regimen of Health for Spiritual and Devout Men," composed by a Carthusian of Erfurt in the first half of the fifteenth century, serves to set the tone. The tract, standing in a long line of guides for maintaining health, opens with an account of the painful consequences of the fall of man. Our sufferings are great, it is said, though God in his mercy has granted us the medical art as a solace. Miseries and woes plague us in every one of six stages of life—*infantia, puericia, adulescencia, iuventus, senectus,* and *decrepita etas.* The catalogue is thorough.

> First we are exposed to danger in the mother's womb, we then issue forth with great pains and peril for our mothers. Then, in infancy, we suffer many infirmities, troubles, and anxieties: for at that time, with much labor and sorrow, we learn to walk, to speak, and to perform the functions of human life. In childhood we are beaten into learning the various arts and are in great misery and labor and sorrow. In adolescence we contemplate

marriage, and there, too, anguish and dangers threaten. For accursed is the man who is allotted a bad wife. Similarly accursed is the woman who acquires a man of wickedness with whom she is bound to remain all the days of her life and to keep silent, nay, rather to be disturbed. And conversely the man with the woman. Moreover in prime, when the man must support his wife and children, various labors and hindrances present themselves: he meets with opposition in his various dealings in the family, among the maids, among the servants, among the neighbors, among friends and strangers, and can scarcely find genuine faith in anyone. In old age, there being more concerns and anxieties than in the previous ages, man becomes tiresome to himself and is filled with misery in soul and body. For various bad passions disturb his spirit without ceasing: now immoderate anger, now vain delight, now hope of worldly honor and dignity, now sorrow which often brings about the death of the spirit.[6]

A Doctor and a Moralist on the Four Ages of Man

IN THE YEAR 1256 Aldobrandinus of Siena, a Tuscan physician, dedicated a tract on regimen, in French, to a noble patron, Beatrice of Savoy, Countess of Provence. Included in it, among all manner of therapeutic prescriptions, were suggestions for right living in each of the ages of life, types of behavior calculated to maintain the body in health. About the year 1260 Philippe de Novarre, a jurist, soldier, and diplomat of Lombard origin who had long served the Cypriot nobility, prepared a moral tract, in French, organized around the ages of man. In it advice was offered to individuals of each age, moral counsel designed to ensure the well-being of the soul. Both writers, laymen, adopted the time-honored tetradic scheme of age division, but they applied the knowledge to different ends.

Tracts on regimen, like that by Aldobrandinus, long had little currency in the West. The translating activities of the twelfth and thirteenth centuries made certain works in the genre available, Greek and Arabic both. The pseudo-Aristotelian *Secretum secretorum* was one which reached a wide audience. Probably composed in an Islamic milieu, the work takes the form of a letter of advice on rulership and regimen written from Aristotle to his pupil Alexander the Great. A section was translated into Latin by John of Seville in the mid-twelfth century, a full translation was made by Philip of Tripoli in the first half of the thirteenth century. Vernacular versions, French, English, German, Icelandic, Italian, Catalan, and Portuguese among them, followed after.[7] The tract, in addition to moral counsel, provided advice on maintaining health, some of it directed toward times of year, some to times of life. At one point the seasons were compared to the ages, and the changing aspect of the earth was described on analogy to the life of a woman. Spring was likened to a most

beautiful bride, adorned with many colors, summer to a spouse of perfect age, autumn to a woman of full age, indigent in attire, and winter to an old woman stripped of clothing, close to death.[8]

The *Secretum* would help to foster the production of works on hygiene. Roger Bacon, who prepared a glossed version of the tract, enjoying all its curious lore, also wrote works on regimen, most of them directed toward preserving youth and retarding the accidents of old age.[9] Other natural philosophers concerned themselves with the issue of aging. Aristotle had considered youth and age in a tract included in the *Parva naturalia*, there defining old age and death as the exhaustion of natural heat. Albertus Magnus (d. 1280), German Dominican, prepared a work to elucidate Aristotle's views, *De iuventute et senectute*, as part of his great commentary on the philosopher's corpus. In the course of this tract he defined four ages of man according to their changing qualities, first comparing the flux to alterations in the relative heat and moisture in the lunar cycle. The first age, *puerilis*, he divided into five parts, as Avicenna had done. The second he called *iuventus* or *virilis*, preferring the latter term since *iuventus* seemed to pertain to *pueritia*. The third, then, he named *senectus* and the fourth, *senium* or *aetas decrepita*. He proceeded to establish the reasons why a body formed from contrary qualities must necessarily age.[10] Later Arnald of Villanova (d. 1311), mystic theologian, physician to members of the Aragonese court, prepared a tract called *De conservanda iuventute et retardanda senectute*, borrowing heavily from Roger Bacon's work.[11] Some of this scientific learning would be popularized by vernacular writers for the use of an elite clientele. It is here that Aldobrandinus of Siena comes in.

The thirteenth-century physician adapted his tract *Le régime du corps* to the requirements of his noble patron. He wrote it in French and divided it into four parts, discussing first regimen in general, then the parts of the body, foods, and physiognomy.[12] It is in a chapter at the end of the first book, following upon a consideration of the care of the infant when he is born, that the topic "How one should care for the body in each age and retard old age and keep oneself young" is broached. Aldobrandinus begins by quoting "the physicians" (*li phisitiien*) who say that there are four ages, which he names in Latin—*adolescentia, iuventus, senectus, senium*. His sources are largely Arabic: at this point his debt to Johannicius is clear. The succeeding paragraph is, in fact, a fair translation of the relevant passage in the *Isagoge*, condensed somewhat and departing from it with regard to the duration of *iuventus* (to 40 or 45 rather than to 35 or 40). Aldobrandinus adds, following Avicenna in part, that if we wish to speak more "subtly" we can say that there are seven ages and find in the first age three phases: *infantia*, from birth until the appearance of teeth, *dentium plantatura*, from the appearance of teeth until the seventh year, and *pueritia*, until the fourteenth year.[13] He sets out his hygienic advice according to this program, giving counsel on diet, bathing, medication, purging, and

bleeding for the different times of life. After the thirty-fifth year, for example, in order to retard old age he suggests that one should avoid overwork, anger, and too many thoughts, live in joy and comfort, make use of nourishing things that render the blood clear, drink wine, and bathe once or twice a month to purge and cleanse the superfluities of the body.[14]

Philippe de Novarre, at the end of a distinguished career, set himself the task of writing an edifying tract patterned on the ages of man, *Des IV tenz d'aage d'ome*.[15] He was seventy years old—an age traditionally taken to mark the full span of the human life—and felt that his wide experience gave him the authority to offer counsel to others. His adoption of the fourfold scheme of age division was a calculated one; the tetrad runs through the work as a leit-motif. Philippe drew the parallel between the course of life and the passage of the year explicitly: "Li printemps de Pascour seursenble a enfance, et estez a jouvent, et rewains au moyen aage, et yvers a viellesce" (II, 73). He assigned twenty years to each phase, a neat system of age duration which, one might recall, had been attributed to Pythagoras himself. To each of the ages he devoted one of four principal books.

Stern and rather uncompromising in tone, the work is filled with advice on how each age of life should best be lived. Its oppressiveness is tempered, however, by piquant observations drawn from the author's personal experience and engaging information taken from his reading, including, it is thought, the *Secretum secretorum*. Contemporary with Aldobrandinus of Siena's *Régime du corps*, it has a distinctly different tone. The doctor, concerned with the main-tenance of bodily health, prescribes gently moderate habits for every stage of life. The moralist, seeking to improve character, urges rigorous self-denial and the subordination of wicked impulses. Aldobrandinus advises that children should be entrusted to the care of masters who encourage them to learn without blows. Philippe is of the spare-the-rod-spoil-the-child school. Do not display too much affection toward children, he says. Few perish from punishment, but many from indulgence. It is better that a child cries for his own good than that a father weeps for his wickedness ("car mialz vaut qu'il plort por son bien, que ne feroit se li peres plorast por son mal") (I, 7). Teach a boy belief in God, a trade, and the ways of courtesy. Teach a girl obedience, spinning and sewing rather than reading and writing, and modest manners.

On the subject of youth the aging moralist grows passionate. He finds it a perilous age, a period of overweening pride, contempt, quarrelsomeness, am-orousness. It is well named *jovanz*, etymologically speaking: there is too much joy (*joie*) and too much windy pretension (*vent/vant*) (II, 56). In this, the summer of life, a man should behave honorably and valiantly and work to store up goods for the rest of his days. A woman, in greater danger, should be given no opportunity to go wrong. The next age, *moien aage*, is the time to administer one's gains effectively and to be an example to others in wisdom, goodness,

and strength of character. One might note the unusual use of the now standard
designation "middle age" to describe these years. Finally, in old age, it is seemly
to wrap up one's affairs, to do good works, to repent and give thanks to God,
and to act one's age: it is pitiful to behave as if still young. Following these
edifying words, organized in a fourfold structure, the author extends the te-
tradic motif in concluding *sommes* and describes a set of four good and profitable
things—*souffrance, servise, valor,* and *honor.* Each of these virtues is deemed
especially applicable to one of the four ages.

Neither the medical nor the moral tract demanded illustration. Certain sur-
viving copies of the texts contain miniatures; others do not. When images were
introduced, they served to mark the headings of chapters and summarily iden-
tify the content within. In the earliest of the extant illuminated manuscripts of
the *Régime du corps,* a handsome copy of the late thirteenth century in Paris,
the "E" which opens the section on the ages of man frames a cluster of four
figures.[16] A small child with a ball, a youth provocatively turning his back, a
robed man, and an older man with curly hair and a beard, seated, together
represent the life cycle. A copy dated c. 1300, now in London, contains a more
schematic representation.[17] The crossbar of the "E" and a vertical line form
quadrants which loosely confine the four figures; they stand upon the structural
members of the initial against a gold ground. Aging is indicated by the presence
of a beard, increasingly full, on the last three figures, by a greater sobriety of
dress, and by an increasing constraint in movement; the last figure, enfolded
in a mantle, leans upon a stick. In a related manuscript in Paris four men, little
distinguished from one another, only two of whom are bearded, stand in pairs
on a gold ground above and below a crossbar (fig. 33).[18] Another format was
adopted in a fifteenth-century manuscript in the Vatican (fig. 34).[19] The four
figures, in line and wash, occupy a rectangular field preceding the text. Paired
again, all garbed in grey robes, the men stand in a row. The adolescent now
holds a bow, the two men of middle years, one bearded, hold gloves, and the
elderly man, balding, with long beard, supports himself on two sticks.

Ornamentation of this kind, of course, increased the value of the manuscript
for the lay collector. None of the images might be said to convey information
useful to a health-conscious reader. At best they confirm obvious truths: chil-
dren are small and wont to play, old men are feeble and infirm. The figures
might as readily have illustrated the moral treatise. A related cast of characters
is represented, in fact, in one of the best and most complete of the surviving
texts of *Des IV tenz d'aage d'ome,* a copy included in a vernacular miscellany
of the thirteenth century in Paris (figs. 35-38).[20] The miniatures mark the major
divisions of the tract. The first phase of life, *anfance,* is represented in this case
by means of a child with blond hair in a pink tunic, his hand held by a woman.
Jovens is a blond youth with both hands raised. A figure with a T-shaped crutch
stands for *moien aage,* and an old man with a fringe of a beard, dressed in a
blue robe and a pink mantle, supporting himself on two crutches, represents

the fourth age, *viellesce*. Illuminators in both cases were satisfied to adopt an understated iconography, one sufficient to make the point that the ages of man were four in number: in the Paris copy of the *Régime* the artist was scarcely concerned to indicate age differentiation at all (fig. 33).

Trecento Poets Describe the Course of Life

DANTE knew there to be four ages of man. He presented the scheme in the *Convivio*, examining it at length in this erudite commentary he wrote between 1304 and 1307 to explicate certain of his poems. His original plan had been to prepare a series of fifteen tracts on themes of love and virtue, prose and verse alike written in the vernacular, for carefully defended reasons (I, 5-13). Only four were brought to completion. The fourth, the longest, concerns the virtue of nobility. In the seventh stanza of the *canzone* around which the commentary was written the quality of the noble soul in each of four times of life is described:

> Ubidente, soave e vergognosa
> è ne la prima etate,
> e sua persona adorna di bieltate
> con le sue parti accorte;
> in giovinezza, temperata e forte,
> piena d'amore e di cortese lode,
> e solo in lealtà far si diletta;
> è ne la sua senetta
> prudente e giusta, a larghezza se n'ode,
> e 'n se medesma gode
> d'udire e ragionar de l'altrui prode;
> poi ne la quarta parte de la vita
> a Dio si rimarita,
> contemplando la fine che l'aspetta,
> e benedice li tempi passati.
> Vedete omai quanti son l'ingannati!

In her first age she is obedient, sweet, and bashful, and she adorns her body with the beauty of well-matched parts. In the prime of life she is self-controlled and strong, full of love and wins great praise for courtesy, and she takes delight only in observing the law. In old age she is prudent and just, and has a reputation for generosity, and rejoices to hear and speak well of others. Finally, in the fourth phase of life she returns to God as a bride, contemplating the end that awaits her and blessing the stages through which she has passed. See then how many are the deceived![21]

In the commentary the stages of life are precisely defined, Dante having recourse in his explanations to the works of classical and contemporary writers

alike.[22] Imagining the course of life on a visual model, he compares it to the dome of the heavens, that arch on which the celestial bodies, causes of things below, rise and fall. The span of an individual's arch of life is determined by his particular complexion, the mixture of qualities which, too, varies according to age. The combinations are hot and wet, hot and dry, cold and dry, cold and wet respectively. For this traditional learning the poet acknowledges himself indebted to Albertus Magnus.[23] Dante compares the ages to other temporal cycles, to the seasons of the year, and also to the hours of the day. The stages of life are said to correspond not only to spring, summer, fall, and winter, but also to four intervals—to terce, to none, to vespers, and from vespers—while sext at midday marks the high point of life (IV, 23, 14). The ages are then distributed around the arch. *Adolescenza*, the period of increase, is said to continue until the twenty-fifth year. *Gioventute*, the perfect age, which finds its roots, as in Latin, in the verb *giovare*, to help, extends to age forty-five. Its total duration is twenty years, divided so as to fall symmetrically on either side of the peak of the arch, fixed at the thirty-fifth year. Old age, *senettute*, matches the first age in enduring twenty-five years, to finish at seventy. Ten years or so make up the period called *senio* (IV, 24, 1-5).

For the idea that certain kinds of behavior are particularly proper to each age, Dante evokes the authority of Cicero's *De senectute* (IV, 24, 8).[24] He explores a sequence of virtues, *obedienza* first, named in the poem as one of the qualities especially appropriate to a noble adolescence. He enlarges upon the notion, indicating that the adolescent needs to be obedient to the commands of those older than he: "The youth who enters into the bewildering forest of this life could not keep the right path unless it was pointed out to him by his elders."[25] Dante's moral instruction keeps pace with the poem, continuing until he has described the final age when the individual turns to God, longing for the end, and enters a quiet harbor at last.

Francesco da Barberino, Dante's precise contemporary, was a man trained and active in the legal profession, but poet and artist as well. Tuscan in origin, he studied in Florence, Bologna, and Padua, and resided for a time in Provence. While in France, between 1309 and 1313, he completed a work, *I documenti d'amore*, offering instruction in courtly love, in Italian verse.[26] Its twelve books concern twelve different virtues—Docility, Industry, Constancy, Discretion, Patience, Hope, Prudence, Glory, Justice, Innocence, Gratitude, and Eternity. Barberino, like Dante, glossed his poems, but he wrote the commentary in Latin rather than in the vernacular, first translating his verses into Latin prose to provide an intermediary text. This practice, more in keeping with school tradition, enabled him to quote Latin authorities directly, without assimilation.

Barberino was an artist in his own right, not a painter but a *designator*, as he claimed. There is every indication that he involved himself in the production of the two earliest manuscripts to survive, now in the Vatican. He is thought

to have partially transcribed and to have illustrated the incomplete first copy, and then, upon his return to Italy in 1313, to have written and supervised the illumination of the second, a fully complete display copy.[27] Through page layout, he kept the various grades of text distinct. Each folio contains two columns of verse, bracketing them, the Latin translation, and circumscribing both, the Latin gloss, written in a tiny hand with many abbreviations (cf. fig. 39). Barberino relied on illustrations to clarify didactic points. He devised his figures as he proceeded, making text and image interdependent. Portraits of personified virtues head each of the twelve books, their appearance receiving explication in the text. Didactic schemata are scattered throughout the gloss.

The elaborate commentary, representing sixteen years of labor and study, is wide-ranging in information, intimate in tone. Barberino keyed each of his learned digressions to passages in the Latin prose text. In Book VII, devoted to the virtue of Prudence, in the section dealing with the sea and sailing, two passages encouraged discussions which, in turn, seemed to call for diagrams incorporating the ages of man. The word "day" in the phrase *usque quo dies* gave the author an opportunity to comment on the course of the sun. This led to a description of the seasons, their qualities, and the temperaments and ages which fare best in each. Barberino's source for the lengthy discourse, one discovers, was a mid-twelfth-century cosmological tract, William of Conches' *Dragmaticon*. From this school text he no doubt extracted, too, the tetradic *rota* which accompanies the gloss (fig. 39).[28] In it the ages of man—*pueritia, iuventus, senectus, senium*—are aligned with the elements, seasons, humors, and complexions according to the classic formula.

Earlier in the section, the phrase "at dawn" (*in aurora*) had encouraged a digression on the day and its divisions, again derived from the *Dragmaticon*.[29] This led, in turn, to an enumeration of the seven liturgical hours. And these were illustrated by means of an intriguing set of images which Francesco claims were present in another of his works, an *officiolum* presumed lost. In the *figurae*, he boasts, the hours and the ages are represented together "so that in compline the blessed virgin has died, the ages are complete, and the day is finished" (figs. 40-41).[30] The cycle proceeds accordingly, from the first hour, that of the night office, to the last. A row of seven roundels, now in an extremely poor state of preservation and difficult to decipher, occupies the bas-de-page. In the center of each a woman inhabits a globe encircled by a river and adorned with flowers and a small pink house. The sun and a quarter moon, opposite one another, orbit around her, the position of the radiant sun in the sky marking a time of day and, metaphorically, a time of life.

Matutinus and *nox* are inscribed about the first disk; Barberino observes in the text, without explanation, that night is shown instead of an age. A female figure sits in the center, head in hand, garbed in grey-brown robes. The cycle continues in the second roundel with dawn, the keyword. *Aurora*, rather than

prime, and *infantia*, the first of six ages, are the inscriptions which circumscribe a female figure, half-turned, her hands raised to her long blond hair. *Tertia* and *pueritia* are written about a woman placing a leafy wreath on her head and looking at herself in a mirror. In the *sexta-adoloscentia* disk, when the sun is overhead, a figure with curly hair sits holding a garland, and in the *nona-iuventus* roundel a mother embraces a child. *Vespera-senectus* is represented by a figure in a high-waisted robe who walks with a stick, and finally, in *completorium-decrepita etas*, a woman with an apparently youthful face lies down as if asleep. Barberino suggests that the coordinated cycles are to be read as narratives, *ystorie*. The figures do not seem to be representatives of the six ages strictly speaking. The virgin, a maiden, not religious in appearance,[31] shows little sign of physical aging, but responds sympathetically to the passage of time. Her occupations and demeanor reflect the quality of different points in the daily recurring course of the sun and, figuratively, in the course of life. She revels in her beauty in the early phases, she cares for a child in prime, she moves stiffly as the day draws to a close, and she sleeps the last sleep in the final hour of night and the last age of life.

Barberino applied his talents in design to monumental painting as well as illumination. He reports having planned a program for the Episcopal Palace in Treviso which included the figures of Mercy, Justice, and Conscience. He indicates, too, that he had studied Giotto's recently completed frescoes in the Arena Chapel in Padua, commenting with favor on the personification of Envy.[32] Connections between miniature and monumental painting represent a promising field of study. It is interesting to discover that the cycle of the hours and the ages which ornamented Barberino's literary work should also be preserved in a monumental fresco cycle. In the early fifteenth century several rooms of the Palazzo Trinci in Foligno received decoration. Seven roundels were painted on the higher reaches of a lofty hall (fig. 42), a room called the "Camera delle stelle" in a fifteenth-century inventory, which was also decorated with figures of the seven planetary gods and enthroned personifications of the seven Liberal Arts.[33] Quatrains of Italian verse in the socle below, inscribed with the filigree initials proper to manuscripts, identify the ages of man. The first disk, *matutinus-nox* in Barberino's cycle, now becomes the last and represents a seventh age of life (fig. 42). *Infantia* in the second roundel, "similar to dawn," is represented this time by a boy first encountering the "misfortune and misery of our life."

> Simele all'aurora se dimostra
> Infantia sumpta per la prima etate
> Vagiendo per gran calamitate
> E per miseria dela uita nostra.[34]

The next inscription is lost, but the image of a fashionably dressed woman

gazing at herself in a mirror finds a parallel in the manuscript cycle. In the roundel given over to *sexta-adolescentia*, however, it is an elegant young man who holds a laurel wreath. *Nona-iuventus* is again represented by a mother and child. The image accompanying vespers is lost. At *completorium-senectus* a soberly clad woman sits head on hand. The identical figure occupies the roundel now given over to the seventh age, *decrepita etas*. This is the "harsh and heavy" age, the period in which strength diminishes until cruel death extinguishes it completely:

> Decrepita Etas assai aspera et forte
> Allora che noturna et mattutina
> Già tucta la potentia se declina
> fin chella extingua poi la crudel morte.

The program is essentially that of the codex. A manuscript source, perhaps one of Barberino's own works, no doubt stood behind it.[35] There has been a certain shift in orientation. The wall-painter was concerned throughout to distinguish the phases of life more clearly, even introducing male figures to bring the cycle more into line with standard iconography. The ages now number seven rather than six, and the theme is worked into a hebdomadic program.[36] The figures, too, are juxtaposed with the planetary gods, if not linked to them systematically according to the astrologer's scheme. The Moon and the Sun, dramatically presented as deities in chariots drawn by horses, the one all ghostly white, the other deep red, mark the beginning and end of the planetary cycle. Mercury and Venus appear between the two luminaries, imitating astronomical order, but the remaining three planets in succession—Mars, Jupiter, and Saturn—double back and fill the intervening spaces. A proper matching of the ages with their ruling planets was not possible. In other circumstances, however, Italian artists would take the astrological correlation as a point of departure and make it the focus of pictorial programs of some complexity.

The Rule of the Planetary Gods

THE TRANSLATING activities in Spain and Italy in the twelfth and thirteenth centuries had let loose a flood of accumulated lore on the all-pervasive influence of the planets. Not only were the seven celestial bodies held to govern the aptitudes, disposition, and appearance of individuals. To each were assigned certain professions, moral qualities, parts of the body, diseases, metals, trees, animals, even foods. Planetary rule was understood to extend to human development. With the translation of Ptolemy's *Tetrabiblos* and Arabic astrological works, the ancient scheme of correlating the planets with phases in embryonic growth and with the seven ages of man came to be known.[37] Western astrol-

ogers introduced the astrological system of age division into their own com-
pendia, and artists illustrated it. A noteworthy number of texts and images
dealing with the theme were produced in northern Italy, Padua in particular.

Guido Bonatti, whom Dante assigned to the eighth circle of Hell (*Inferno*
XX, 118), professional astrologer in the second half of the thirteenth century,
briefly court astrologer to the tyrant Ezzelino da Romano in Padua, was a
figure of enduring reputation. He received high praise in a late fifteenth-century
chronicle of famous astrologers, one organized, ironically perhaps, according
to the traditional six ages of Christian salvation. Simon de Phares, its author,
describes Guido as a great astrologer and philosopher, "le plus grant qui fust
en la terre de son temps," a man who wrote a summa of all the parts of
astrology considered excellent by all later astrologers even up to his own day.[38]
The work in question, the *Liber astronomicus*, was composed as a survey of the
astrological science, Guido drawing heavily on the newly translated material.
His descriptions of the natures of the planets and "what mark they make on
lower things according to the difference in the qualities of their movements"
owes much to Alcabitius (al-Qabīsī), whose *Isagoge* had been translated by John
of Seville in the previous century.[39] Like Alcabitius, Guido, in his descriptive
portraits of the seven planets, named the periods in human growth which fall
under their sway. The sequence begins with Saturn, masculine and diurnal,
his rule said to extend over such diverse phenomena as fathers, old and venerable
things, depth of knowledge and good counsel, water-related works like mills,
bridges, and ships, the cultivation of the land, epilepsy, leprosy, distant and
wearisome travels, mental affliction, and evil ideas. This planet also oversees
the first phase of growth after the seed is deposited in the womb, binding and
collecting the material from which the fetus is formed. Moreover, if Saturn is
rising an individual born during the daytime will not live out a full natural
life, reaching at the most the beginning of old age (*initium senectutis*), though
one born in the night, unless prevented by an unnatural event, will live to the
end (*finis senectutis*). Jupiter, along with his other duties, is said to impart spirit
and life to the fetus and to govern the period from youth to prime, called
iuventus, that is, from 14 or 21 to 40 or 45. Mars reddens the fetus by means
of blood and controls the years of prime (*iuventus*) from 22 to 45 inclusive. In
this manner Guido proceeded through all the planetary spheres to the Moon.[40]

If the information on the stages of life presented in these chapters was un-
systematic and sometimes contradictory, the author later made amends by
independently surveying planetary influence in the life cycle, first its place in
the conception of children and then, more briefly, in the whole of life. Here
the Ptolemaic system of age duration as determined by the periods of the planets
was summarized: the Moon rules for four years, Mercury for ten, Venus for
seven (rather than eight), the Sun for nineteen, Mars for fifteen, Jupiter for
twelve, and Saturn for thirty, when the cycle begins repeating itself.[41]

The astrological scheme would circulate. It was set out on one of the late fourteenth-century capitals on the exterior of the Palazzo Ducale in Venice, a series as beautifully carved as it is iconographically rich. The capital's eight faces are decorated with eight male figures set in leafy foliage who represent the seven ages of man and death (figs. 43-44).[42] Inscriptions on the abacus above each figure reveal which planet is in control of his period of life and for how long its influence extends. The Moon governs the first age, *infancia*, for four years; Mercury, *puericia*, for ten; Venus, *adolesencia*, for seven; the Sun, *iuventus*, for nineteen; Mars, *senectus*, for fifteen; Jupiter, *senicies*, for twelve; and Saturn, *decrepita*, to death. The very last phase is death itself, the penalty of sin ("Ultima est mors pena peccati"). Ptolemy, of course, is the father of the scheme, if it has not been recognized in the scholarly literature. As Guido Bonatti assigned seven years rather than Ptolemy's eight to Venus, his *Liber astronomicus* may be cited as a possible source.

Astrological thinking did not, however, determine the artistic program. The planetary deities themselves do not appear, if they are to be found on a capital four columns away. Life takes its course, the artist placing greater emphasis than usual on mental development as an index of growth. The sequence begins with an infant, partly nude, holding a cartouche now empty of inscription. A boy then learns to read: he holds a tablet inscribed with the first eleven letters of the alphabet (fig. 43). This seems appropriate to the time which falls to Mercury, the god whose role it is to impart the seeds of learning. But in the following scene, that which represents the age under Venus, a slightly older figure appears, now studying a tablet marked with numbers. The Sun-dominated period of prime is portrayed by an often-encountered character, the falconer. The age controlled by the war god Mars is quite fittingly represented by a soldier in armor with a sword. Jovian old age is an elderly man in scholar's dress serenely reading a book, and Saturnine decrepitude is represented by a yet older man leaning on a stick. At the end of the cycle a figure lies on his deathbed (fig. 44). The characters each find at least generic parallels in the large corpus of ages of man imagery, all but that of the adolescent student learning his numbers. Venus is not regularly believed to inspire a pubescent youth to the study of arithmetic. The art of calculation was clearly much prized in mercantile Venice.

Nearby Padua was a city notorious for its interest in astrology. Its famous school, founded in 1222, becoming prominent from the 1260s, excelled in the subjects of the quadrivium and particularly in astrology and medicine, disciplines closely entwined.[43] Noted astrologers made Padua their home. Peter of Abano, a zealous defender of astrological principles and their usefulness in medical practice, lectured at the school. In his *Conciliator*, a work he completed in 1303 while probably still at Paris, he supplied an account of the Ptolemaic system of the seven ages of man under planetary influence when debating a

medical issue, whether the child (*puer*) or the young adult (*iuvenis*) is more temperate.[44] Jacopo de' Dondi, designer of an astronomical clock installed in the Carrara Tower in 1344, seems to have lectured in astronomy, as did his son Giovanni, inventor of a planetarium set up in 1364 which showed the movements of the seven planets.[45] Civic monuments were decorated with astrological cycles. The walls of the great Salone in the Palazzo della Ragione provided a setting for a vast cosmological program incorporating the zodiacal signs, the planets in their houses, and the months, as well as religious motifs. The building was severely damaged by fire in 1420 and subsequently repainted by Nicolò Miretto and Stefano da Ferrara. But legend has it that Giotto was the original artist and Peter of Abano his iconographer.[46] And in the Church of the Eremitani, an Augustinian foundation, the planetary gods were represented ruling over the phases of human life in one of the most elegant and eloquent cycles of the ages of man to have come down to us, if in a sadly damaged state. Photographs alone document the part totally destroyed in World War II.

Guariento decorated the church's *capella maggiore*, it is thought, in the early 1360s. Giotto's masterly frescoes in the neighboring Arena Chapel clearly had influenced him. For below scenes from the lives of Saints Augustine, James, and Philip, Guariento painted a sequence of seven monochrome vignettes on red and green marbleized backgrounds, small in scale, which call to mind Giotto's seven virtues and vices, in grisaille, enclosed in marbleized frames. Guariento's figural groups inhabit trilobate spaces. In each case a planetary deity is flanked by a male and a female figure, the former to his favored right, the latter to his left, who together stand for one of the stages of life (figs. 45-48).[47] Only in Padua, perhaps, a city self-consciously committed to the study of astrology and the allied arts, could such a cycle have appeared on the walls of a church.

Guariento represented astrological ideas with subtlety. He demonstrated the qualities engendered by the controlling planets through nuances of gesture and expression as well as by attribute. The product, as informative as a literary description, makes a statement about the world of manners and appearances. In that a contrast is pointed between the lives of men and women, the frescoes merit some attention as a document of medieval mores. The cycle begins with the Moon. A boy and girl frolic to either side of the crowned deity, identified by the quarter moon she bears on her lap. They are as active as the swiftly moving planet which controls them: the boy, brandishing a whip, rides a stick horse; the girl, carrying a doll in the folds of her garment, pulls a wheeled toy. Beside Mercury, who appears in the guise of a scholar seated before a desk,[48] a boy with a scroll in one hand eagerly scrutinizes a book on a lectern and a girl sits holding a distaff at her waist. The god, supervising the instruction of his young charges, grasps the boy's wrist and directs his hand to a line of text;

he hands a spindle to the girl. Education was not egalitarian. An elegantly dressed couple stands by the dignified figure of Venus, tinted pink, who admires herself in a mirror. The two young people look across at each other, making eye contact for the first and only time in the cycle; the maid coyly raises the hem of her skirt.

In the succeeding image the majestic, yellow-hued solar deity, supplied with a tiara, an orb, and a scepter, seated on a lion throne, is flanked by a couple in the prime of life. A gentleman who has clearly renounced his youthful waywardness stands in a sedate posture, his arms crossed in the folds of a heavy mantle, and looks over at the seated figure of a woman. She is occupied in cutting bands of tape drawn from a plate on her lap. Next Mars, a dashing, armored deity astride a horse, appears between two figures of sober mien. A man, helmed and bearded, is literally encumbered by tokens of the prosperity for which he strives at this anxious age: he places one hand on the hilt of a sword and carries two sacks with the other. A woman, again involved in simple domestic chores, winds wool from a spindle. Beside regal Jupiter, robed, crowned, and carrying an orb, a couple sits quietly enjoying the tranquillity granted to the elderly. A man garbed in a robe with a fur shoulder-piece peruses a book on the desk before him. A woman holding in her hands a string of beads with a cross, an early form of rosary, devotes herself to prayer and meditation. Finally, a scantily clad Saturn resting his head on a mattock is flanked by the huddled figures of an old man and woman with lined faces, both trying to warm themselves over braziers. The man reclines; the woman, bent, head on hand, pokes at the fire. Thus they come to the same end, if their occupations differed markedly through the course of their lives.

A nearly identical series of images is to be found in a manuscript from Padua now in Oxford containing tracts by the distinguished Paduan mathematician Prosdocimus of Beldomandi. It is identified as having been written in 1435 by his nephew Candus (fig. 49).[49] Colored drawings of the planets and the ages appear without text on seven consecutive folios, following upon a series of pictures of the constellations. It is reasonable to suppose that the drawings are copies after Guariento's frescoes, much simplified; both could, of course, derive from a common manuscript source. The miniaturist has flattened the space, dispensing with the background patterning, the floorline, and much of the furniture, and has substituted for the broad trilobate frames quatrefoil shapes which crowd the figures uncomfortably. Small changes in iconography are evident. Mercury is shown giving the boy a book rather than directing his hand to a text. Venus, with unlaced bodice and raised skirt, becomes more the seductress, and Saturn now leans on a spade. Lacking the artistry of Guariento's frescoes, the images yet document a continuing interest in the pictorial cycle.

A variation of the program is to be encountered in the so-called *Liber physionomie*, a northern Italian codex in Modena roughly contemporary with the

Oxford manuscript (figs. 50-51).[50] Now there are more vignettes, twelve in all, since the signs of the zodiac, Aries through Pisces, determine the sequence. At the top of each of twelve folios a sign is named, its symbol is depicted, and the character of individuals born under it is described in a short text. Below, in the bas-de-page, a planetary deity is represented in the company of a man and a woman at one of the stages of life.

It was standard astrological knowledge that each of the zodiacal signs was associated with a particular planet. Cancer and Leo, the summer signs, were the "houses" of the two luminaries, the Moon and the Sun respectively; the other ten signs shared the remaining five planets between them.[51] In Guariento's program the appropriate signs had been represented to either side of the planetary deities. In the *Liber physionomie* the planets were physically placed in their zodiacal houses, the result being that the Moon and the Sun were represented once and the remaining five deities twice. The artist extended the cycle of the ages of man so that, when necessary, two pairs of figures, rather than one, were engaged in activities characteristic of a particular time of life. Since the zodiacal signs follow in the correct astrological sequence, the stages of life with their ruling deities do not. However, if one reorders the images so as to run through the planetary spheres from the Moon to Saturn, the human life from childhood to extreme old age passes before one's eyes.

The boy and girl under control of the Moon once again ride a stick horse and pull a wheeled cart in postures nearly identical to those in the Paduan frescoes (fig. 50). A scholarly Mercury, in the house of Virgo, again directs a boy's attention to a line of text, this time pointing to it himself, and hands the girl a spindle. But the second Mercury, in Gemini, a bearded man studying an armillary sphere, is flanked by a slightly older boy holding a book and by a seated girl with an unidentified object in her lap. Venus, in one case nude (*Libra*), in one case clothed (*Taurus*), in both studying her reflection in a mirror, is accompanied by aristocratically dressed young adults who look toward one another. The men now more visibly court the ladies: the first, strumming a mandolin, serenades a maiden who lifts her skirts, as in the fresco; the second holds a flower. The Sun takes charge over a man, this time less soberly dressed, who extends a hand toward a woman, engaged once more in cutting bands of cloth. An armored Mars on horseback is joined by a warrior, now without money bags, and by a woman again winding thread from a spindle (*Aries*). The second Mars, seated, holding the model of a walled city, is accompanied by a warrior and a woman winding thread off a stand (*Scorpius*). Under royal Jupiter the elderly again devote themselves to contemplative pursuits. In one image, as in the fresco, a man in a fur collar reads at a desk and a woman holds a rosary (*Sagittarius*); in the other he carries a book and she, kneeling, garbed in black, reads in a presumably devotional work (*Pisces*). Finally a robed and crowned Saturn bearing a vexillum is accompanied by a man leaning on a crutch and a woman with hands clasped (*Aquarius*). The Saturn of the type

painted by Guariento appears again flanked by old folk warming themselves over braziers (*Capricornius*) (fig. 51).

Seven of the images in the cycle bear a relatively close resemblance to the figural groups painted in the Church of the Eremitani in Padua. Five show no correspondence at all. In these five the planetary deities are distinctly different from their counterparts, seeming to come from another source, while the figures of the ages are represented with a similar range of attributes which merely reinforce the characterizations of the periods of life in question. Since the correspondence between the seven ages and the seven planets following in order through the spheres stands at the core of the program, and since the extra five images are in fact redundant, one must assume that the shorter cycle represents the original conception. Guariento himself would probably have had recourse to a manuscript model. It is difficult to imagine that the cycle should have been conceived for the church. Further, elements of the program circulated independently in manuscripts. Not only do the figures of the planets and the ages later turn up in the *Liber physionomie*, a codex with no clear connections to Padua, but precisely the same set of planetary deities is to be found in a Bavarian manuscript dated 1378, four of the seven figures surviving (fig. 52).[52]

Impetus for the development of the iconographic type, one in which the ages of woman are unusually represented along with the ages of man, might be sought in the emerging concept of "children of the planets." For there was created in time a visual equivalent to those lists found in astrological works describing the personalities and activities of individuals born under a given planet. By the early fifteenth century, images had been produced in which a ruling deity hovers above a landscape dotted with figures of both sexes, and of all ages, engaged in occupations which reveal their planet-inspired dispositions.[53] In Guariento's cycle the determining theme was not in fact the ages of man but planetary influence over human conduct at various periods of life. In the symmetrical composition both sexes were shown to fall under celestial domination.

Cycles of the Twelve Ages and Twelve Months

THE PRACTICE of drawing correspondences between macrocosm and microcosm and, more specifically, of aligning temporal cycles in the greater world with the life cycle had become second nature by the later Middle Ages. The analogy between the four seasons and the four ages of man, the weight of centuries behind it, had endured to become a commonplace. What antiquity and the high Middle Ages did not supply, however, was the more elaborate conceit, that of coordinating the twelve months of the year with a full sequence of twelve ages of man. This was a late medieval contribution, and from the start, evocations of the analogy took on a melancholy tone and a moralizing cast.

The tetradic cosmological system had itself become known to lay audiences along many channels. Classic school texts had been translated into the vernacular, and popular cosmological tracts had been composed. Boethius's *Consolation of Philosophy*, a work studied in the universities, was translated many times into several languages. French versions, produced from the thirteenth to the fifteenth century, were particularly numerous. Platonist concepts of the world order, especially as found in Philosophy's famous hymn (III, 9),[54] were thus made available to those who could not trust their Latin. A very early version, one prepared by an anonymous Burgundian, is preserved in a manuscript in Vienna dating to the mid-thirteenth century. Gloss material, dense around Philosophy's hymn, "O tu qui gouvernes le monde par pardurable raison," was translated along with the text. School diagrams were submitted to the same process (fig. 53).[55] In a decorated rendition of Isidore's *mundus-annus-homo* diagram, eight intersecting arcs contain the elements and the seasons of the macrocosm while an inner ring marks off the microcosm: "In this way the elements form the lesser world" ("issi forment li element le menor monde"). *Homo*, translated *home*, takes the central position. The names of the humors and the ages of man, now *enfance, cressance, iouent, veillere*, are inscribed around. With red and blue flowers adorning its rim, this is hardly the severely functional diagram which accompanied the earlier commentaries (figs. 2, 3). In the linear schema of the elements above, the spaces between the lines joining elements and qualities were colored in so as to form geometric patterns, rendering the whole eye-catching, if indecipherable.

Latin texts such as Honorius Augustodunensis's early twelfth-century *Imago mundi* found counterparts in works like Gossuin of Metz's popular didactic poem, the *Image du monde*. This tract, its first redaction completed in 1245, offered a comprehensive description of the world and its parts in three short books.[56] Gossuin, who may have studied at the University of Paris, wrote for laymen in a form no longer congenial to the serious scholar. Manuscripts of the work, extremely numerous, were often illustrated with colored, sometimes gilded, diagrams. A copy of the poem in a northern French vernacular miscellany dated c. 1268, ends with a decorative *rota* in red and black, joined on the same page by a plan of the heavenly spheres (fig. 54).[57] The diagram has as its chief theme the year and its parts. Small roundels on the diagonals give a count of the number of months, weeks, days, and hours in the year, while larger roundels at the principal points contain the major tetrads of the macrocosm and microcosm, including the seasons; a ring containing the months encircles the whole. The schema's various components are inscribed in a mix of Latin and French, precise vernacular equivalents of certain terms apparently not occurring to the translator. The ages, along with the zodiacal signs and the humors, are given in the older tongue according to the early medieval system—*puericia, adolescentia, iuventus, senectus*.

The tetradic diagram continued to be used as a teaching aid. A singularly ambitious version was copied, apart from any text, in a French roll manuscript of the mid-fourteenth century (fig. 55). It appears among a series of moralizing schemata which follow upon Peter of Poitiers' diagrammatic chronicle of world history in six ages, the *Compendium historiae in genealogia Christi*.[58] The format and content of the manuscript suggest that it was meant to be used for group instruction, a speaker's tool, rather than for private study. The great *rota*, most of its constituent members illustrated with pictures, seems to have been designed to make the principles of the cosmological system as palatable as possible. It provides a view of the Christian cosmos. God the Father is placed at the center of the whole, his hand raised in a sign of blessing: "I order, I create, I bestow all things" ("Omnia dispono, creo singula, cunctaque dono"). Around him, tetrads of the created world are arrayed in eight concentric circles. Large intersecting arcs isolate clusters of similar entities in a manner reminiscent of the tetradic *rota* in John of Sacrobosco's computistic tract (fig. 13). The four elements are represented in the innermost ring of the schema. Around them are arranged the seven planets with the corresponding days of the week, unevenly distributed. The ages of man appear next, succeeded immediately by the temperaments, the seasons, and the signs of the zodiac in large figured roundels, then the winds and the directions.

The illustrations are lively, if of dubious quality, and several are accompanied by verse inscriptions. Migratory, these verses appear in different contexts, both alone and within schemata. The lines inscribed with the temperaments were extracted from the *Regimen sanitatis Salernitanum*, a popular medical poem supposed to have been shaped by members of the school of Salerno in the twelfth or thirteenth century.[59] Those which accompany the ages of man normally appear as the third, second, seventh, and sixth members of a set of seven verses in diagrammatic "Trees of Wisdom," to be discussed at a later point (figs. 82-85). The artist represented the ages as half-length figures bearing attributes and, in creating them, was influenced to some degree by the juxtaposed inscriptions:

> Informans mores, in me flos promit odores.
> Est michi sors munda, nature purior unda.
> In dubio positus est homo decrepitus.
> Hoc reor esse senum, sensum discernere plenum.[60]

Adolescencia holds the flower which "gives forth its perfumes"; *iuventus*, inappropriately aligned with boyhood's verse, carries a ball; *senectus*, "cast into doubt," bends over a stick; and wise *senium* extends a hand outwards. The ages, once again, are those named by Johannicius in his *Isagoge*, but no longer interpreted in the light of their physical qualities.

The analogy between the seasons and the ages of man, basic to tetradic

cosmology, was adapted in various ways by writers and artists of the later Middle Ages. Liturgical symbolists had already established that the reason fasting is undertaken on the Ember Days, four times a year, is that there are four seasons which call us from the love of the Creator through their delights. Further, we abstain in three-day periods each time because three and four joined give twelve, the number of months.[61] William Durandus, in his thirteenth-century work on liturgy, the *Rationale divinorum officiorum*, added that since the seasons represent the ages, we fast in spring so that we may be *pueri* through innocence and in the following seasons so that we may be made *iuvenes* through steadfastness, *maturi* through sobriety, and *senes* through prudence and an honorable life.[62] Thus, by self-denial four times in the year we work to adopt virtues particularly associated with each of the four ages. The author of a versified "Life of Christ" written in Chester in the fourteenth century picked up the motif and enlarged upon it. Having compared the seasons and the ages in three stanzas, he proceeded to define the consequent reasons for fasting:[63]

> In Marche therfore fasten we ay
> that we moun verray childer be
> by innocentschip, as I say,
> and clannes of lyf, leue ȝe me.

> In somer faste we, in gode fay,
> that we moun ȝong be of pouste,
> alle vices to putte away
> thurgh studfastenesse in that degre.

> In heruest fast we witterly
> to be sober and meke also,
> as to mon falles couenable
> when ȝouth and wildschip is ago.

> In winter fasten we boute faynyng,
> to be old and wise i-wys
> by holy dedes and gode lyuyng,
> as that clerkes leues this,

> Or to amende by suche fastyng
> that we han done byfore amys,
> in tho eldees God despising
> so to amende vs gode hit is. (ll. 5085-5104)

A cosmological cycle thus becomes a model for right conduct.

Though it may have required but a small leap of the imagination to extend the comparison between the phases of life and the divisions of the year from four to twelve, the step does not seem to have been taken before the fourteenth century.[64] It is in manuscripts of this period that an anonymous poem on the

subject, "Les douze moys figurez," begins to appear.[65] The governing analogy is stated in the opening verses: like the twelve months which change 12 times in the year, man changes twelve times, every six years, to complete a life seventy-two years in duration:

> Il est vray qu'en toutes saisons
> Se change douze foiz li hons:
> Tout aussi que les douze moys
> Se changent en l'an .xij. foiz
> Selon leur droit cours de nature,
> Tout ensement la creature
> Change de .vj. ans en .vj. ans
> Par .xij. foiz; cilz .xij. temps
> Sont .lxxij. en nombre;
> Adonc s'en va gesir en l'ombre
> De viellesce ou il faut venir,
> Ou il convient jeunes mourir.[66]

The parallel is spelled out systematically in succeeding verses. For six years the infant, like January, has neither force nor strength. But then, like the year moving toward spring, at 12 and 18 he grows and increases in beauty and warmth, and at 24, the April of life, he is strong and gay, noble and amorous. As May reigns among the months, so, at 30, man is at the peak of his bodily development, capable with a sword. At 36 he is hot and passionate like the month of June. But at 42 he can no longer be called a youth (*varlet*) for he begins to decline. In the autumnal periods, 48 and 54, it is well for him to see to his harvesting in preparation for a quiet old age, since in the October of life, at 60 years, becoming old and hoary, he despairs if he is poor. At 66, as in November when the trees have lost leaf and flower, he sees he is passing and that, poor or rich, his heirs desire his death. At 72, as in stark December, no pleasure remains to him. From this gloomy thought the poet proceeds to another. Life in real terms is far shorter than seventy-two years, in that thirty-six years are lost in sleep, fifteen in youthful ignorance, and another five in sickness or in prison. A man thus has but sixteen years at his disposal, and if he marries unwisely he will never have any good in life.

With its wistful tone and homely observations, the poem is a product of its times. If the ingenious analogy between the ages and the months did not meet with favor earlier, perhaps it was because the human life, particularly in its later phases, does not readily bear so many subdivisions. The moralist, however, welcomed the opportunity to elaborate upon the woes and sorrows of old age. This is layman's cosmology, lying outside learned traditions. Numerical symmetries, in sixes and twelves, are enjoyed for their own sakes while time-honored hebdomadic progressions are abandoned.

The poem made its way into a popular handbook, *Le compost et kalendrier des bergiers*, printed in Paris in 1493 by Guy Marchant and reprinted frequently in the sixteenth century in French, English, and Germanic tongues. As the title of the work suggests, it was first and foremost a computus manual, a genre of text in which the theme of the ages of man had long found a place. Intended for laymen, it contained, in addition to information about time and celestial cycles, practical advice of moral, medical, and astrological import. The compiler was so enamored with the twelvefold system of age division that he not only copied the poem but also had his narrator, an unlettered shepherd, enlarge upon it in both of two prologues.[67] The *bergiers*, one reads, believe that man lives naturally to seventy-two years, increasing in beauty, strength, and vigor for the first thirty-six, declining for the rest. Further, the four parts of his life, each eighteen years in duration, can be compared to the four three-month seasons, while the twelve parts of his life can be seen to parallel the twelve parts of the year. The ages are named on the basis of their virtues—youth, strength, wisdom, and age (*jeunesse, force, saigesse, viellesse*).

Recast so as to comprise twelve quatrains, the poem was copied, not illogically, into the calendars of Book of Hours, one stanza per month. In a few late medieval manuscripts, and in some printed Books of Hours as well, the quatrains serve as captions for pictorial cycles. A tiny manuscript in the Morgan Library, a Book of Hours made just after 1500 for Philibert de Clermont, Seigneur de Montoison, contains a sequence of twelve full-page representations of the ages of man (figs. 56-57).[68] A scribe from Bourges, writing in a handsome humanist hand, transcribed the verses onto classicizing frames which surround the individual images. In each case a cast of characters acts out the occupations proper to a given stage of life. The growing tendency, observable in the fourteenth and fifteenth centuries, to include narrative elements in representations of the life cycle finds resolution here, each representation becoming a genre scene in its own right. The poem in its French version and later English translation begins:

> Les six premiers ans que vit l'homme au monde
> Nous comparons a Ianvier droictement,
> Car en ce moys vertu ne force habonde
> Non plus que quant six ans ha ung enfant.

> The fyrst .vj. yeres of mannes byrth and aege
> May well be compared to Janyuere.
> For in this monthe is no strength no courage
> More than in a chylde of the aege of .vj. yere.[69]

As this verse provided the artist with no visual clues, he went his own way, interpreting the first age to be a time of frolic. Four boys play stick ball in a courtyard under the sign of Aquarius (fig. 56). In the February of life the

children receive instruction from a venerable teacher, for in this age an indi-vidual is ready to learn: "l'esperit se ouvre, prest est a enseigner." March, producing verdure, corresponds to the next six years. Two boys demonstrate their freedom from responsibility by hunting with bows and arrows: they are "sans soucy and sans cure." Gracious April's man is courteous, amorous, pleasing to women. The artist represents a gentleman leading a lady in a long crimson dress, her female attendant behind her. Courtly activity continues in the month of May. The man in full flower rides a white plumed horse through a forest.

Having reached his peak at 36, the man, so the poet says, must seek a wife. The artist accordingly shows him taking the hand of a woman while others look on. At 42 years, as his beauty passes, like the July flowers, a man must be wise or he never will be. The miniaturist places him in his family circle, where he sits with his wife and two children. In August, as the fruits of the earth are gathered, so toward 48 one must acquire goods to support old age. The period is represented, not by means of an agricultural vignette, but through a scene of commerce. A man reaches into a money sack and purchases goods from figures bearing a bag and basket. A moral is pointed in the next image. If one has not amassed goods, if in September one has a "granche vuide," the poet says, it is now too late. The illuminator picked up the motif and painted an empty grange, barrels turned on their sides, and a despairing individual. But if a man is rich he can provide for his wife and children, no longer having to work in the October of life. A family scene is introduced to signify this happy state. November, 66 years, brings age and sickness. A doctor examines a urine glass in the classic formula of medical care. December brings the end of the year and, metaphorically, the end of life. A man lies in bed, his household about him and a priest by his side (fig. 57).

The cycle presents a striking contrast to those earlier images in which figures representative of the ages of man stand in a row. Now life unfolds in a social context. The artist, maintaining a dialogue with the poet, responds to his suggestions where applicable. But he succeeds in creating a coherent interpre-tation of the human life running parallel. Sensitive to the concerns of a secular patron, he places his man in society. Civic values are affirmed, the pious individual being shown the happy consequences of responsible behavior. If a man does his lessons at the proper time, if he marries after a respectable court-ship, if he supports his family through sound commercial ventures, he will come to a good end and die a Christian death. The success of the pictorial program may be gauged by the fact that it was reproduced, with small varia-tions, in printed Books of Hours, the first two editions having been produced in Paris in 1509.[70]

The religious element is more pronounced in a cycle decorating a French Hours now in Madrid, the "Book of Hours of Charles V," dated to the early

sixteenth century (figs. 58-59).[71] Twelve quatrains in French characterizing twelve ages of man are again accompanied by moralizing illustrations. But the specific purpose of the calendar, revealed in the prologue, was to indicate the form and manner of living in the world so as to ensure the salvation of the soul. In the verses a contrast is drawn between the life of the bad man and that of the good. The artist consequently represented a double cycle, the parallel lives of the vicious and the virtuous man from infancy to death. Two children are born in January, "cold, naked, weak, and miserable."

> Froit, nu, impotent, miserable:
> Cy est nostre commencement.
> Dieu veulle qui soit agreable
> A Dieu le pere omnipotent.

The wicked individual proceeds along the path to perdition, whoring, gaming, and fighting, while his noble opposite studies, gives alms, and prays. In the lusty month of May the contrast is particularly pronounced: the bad youth rides with a lady who clings to his arm; his virtuous counterpart flagellates himself to punish and control libidinous urges (fig. 58). The good man models his life on the example of Christ. In August he washes the feet of his brethren, while his opposite bathes in a tub with a naked woman. Only too late does the bad man regret his wasted life. He must ask for alms which the good man dispenses. Come December and their respective deaths, the devil claims the soul of his servant while angels bear the soul of the good man to heaven (fig. 59). Thus the human life, divided into phases on analogy to a temporal cycle of the greater world, becomes the armature for a moral tale.[72]

VI. THE AGES OF MAN IN THE PREACHER'S REPERTORY

THE TASK of instructing the layman in the Christian faith and in Christian morals had been undertaken by the higher clergy sporadically, with more or less commitment, throughout the earlier Middle Ages. By the thirteenth century, however, a more enthusiastic attitude toward popular edification prevailed. An army of preachers, friars as well as members of the clergy, became actively engaged in proclaiming the wisdom of the church and urging lax Christians to turn from their wickedness.[1] As sermon writing grew in sophistication, the loose structure of the scriptural homily gave way to a tighter, more schematic, organizational form, better suited to public teaching. Manuals for preaching were prepared. In an early work in the genre, Alan of Lille's late twelfth-century *Ars praedicandi*, the function of the public instruction is defined in this way:

> By means of what is called "preaching"—instruction in matters of faith and behavior—two aspects of theology may be introduced: that which appeals to the reason and deals with the knowledge of spiritual matters, and the ethical, which offers teaching on the living of a good life. For preaching sometimes teaches about holy things, sometimes about conduct.[2]

The preacher's first task was to expound the meaning of scripture according to authoritative opinion. A reading from the Bible normally provided him with a starting point. He would teach and he would give moral counsel. Wishing to attract large audiences and to hold their attention, he made his moralizing discourses sweeter by introducing into them interesting and engaging material: surviving sermons of the later Middle Ages are sprinkled with stories from classical history, mythology, saints' lives, and romance, with allegories, fables, history, proverbs, poems, and personal anecdotes, and with facts of natural history. To facilitate his endeavors, the preacher was newly provided with an array of reference tools. Biblical concordances were produced, as were subject indexes to theological and philosophical texts, model sermons, and lists of the figurative meanings of terms found in scripture (*distinctiones*).[3] Encyclopedic compendia supplied more general information; in these widely distributed works, often produced by and for preachers, the ages of man were many times described, and sometimes illustrated.

Exegetical Thought Popularized

BIBLICAL exegesis involving the ages of man circulated in the later Middle Ages to become material for vernacular writers. The sermon, spoken and written, was certainly one of the vehicles by which this inherited learning entered the public domain. In view of the state of scholarship, statements about the transmission of ideas remain tentative. Large numbers of unpublished homiletic texts, in Latin and the vernacular, must be studied before the diffusion of school exegesis can be traced.[4] For now a few case studies, drawn virtually at random, will have to suffice.

Since John 2:1-11 was the Gospel lesson for the Second Sunday after Epiphany and Matthew 20:1-16 that for Septuagesima Sunday, a preacher had an opportunity to comment on the Miracle at Cana and on the Parable of the Workers in the Vineyard once in every year. If familiar with earlier exegetical traditions, he might have interpreted the six vessels named in the former or the five hours described in the latter with reference to the ages of man.[5] Were he to seek aid in a collection of biblical *distinctiones*, he might have been led directly to these well-established lines of approach. This would have been the case had he turned to the distinctions assembled by Alan of Lille before 1195, one of the few such works available in print. Under the word *hydria* the sermon-writer would have read that this vessel signifies the heart, whence in the Gospel the six vessels signify the hearts of men of six ages which are filled with water, that is, with the historical sense of scripture. This is a Gregorian reading of the miracle.[6] Consulting the entry for *mane* he would have discovered that "morning," in one sense, means the beginning of time, as in the Gospel: "Simile est regnum caelorum." He would then have read extracts from Gregory's homily on the Parable of the Workers in the Vineyard and learned that the five times at which the householder went out—in the morning, at the third, sixth, ninth, and eleventh hours—signify five epochs in history and five ages of conversion in the life of man.[7]

This interpretation of the parable can be traced from a specific sermon to a particular didactic poem. The sermon is one by Maurice de Sully, Bishop of Paris, active at the time when the Parisian schools were flourishing. Around 1170 this influential figure, famed for his preaching, composed a group of mass-homilies organized to follow the liturgical year. The collection circulated widely, both in a Latin version, generally regarded as original, and in French adaptations attributed by certain scholars to Maurice himself.[8] Well versed in school exegesis, particularly lines promulgated by the Victorine school, and writing in traditional forms, Maurice is considered to be a link between the early medieval homilist and the later medieval preacher. The sermon he prepared for Septuagesima Sunday contains a recital of the Parable of the Workers and an account of its spiritual significance traceable ultimately to Gregory. The

hours are said to signify both *les divers tans de cest siecle* and *de cascun home*: God sends workers into his vineyard at different stages of life, from *enfance* to *vieillece*.[9]

In due course, it has long been recognized, this sermon was studied by Guillaume le Clerc of Normandy. The poet frankly acknowledged his debt to "Li bons evesqes de Paris Morices" in the verse rendition of the parable and its exegesis which he appended to his *Bestiaire* (1210/1211) and incorporated into his *Besant de Dieu* (1226/1227).[10] In the latter work he set the Gospel story, together with an account of the five times in history and the five times in the human life when God comes down to hire laborers, within a moralizing matrix.[11] The parable, Guillaume suggests, should move us to avoid delay in turning to God. Though God takes men at any age and generously gives to all the full reward of eternal life, it is the devil who deceives man into thinking that he can continue in sin until old age: no one knows the time of his death. The interpretation of the parable is thus made to support the message of the whole of *Le besant de Dieu*, the product of Guillaume's grim reflections in bed one Saturday night. Filled with humbling observations on the moral and physical uglinesses characteristic of the various stages of life, its purpose was to exhort the reader to despise the world and to serve Christ in preparation for the Day of Judgment.

Exegesis involving the ages of man had an impact, too, upon English didactic verse. The Parable of the Workers in the Vineyard, "as Mathew mele3 in your messe," was narrated in the *Pearl*. Here its interpretation was applied to the case of the young maiden who entered the vineyard after baptism, in her "euentyde," yet received, first, the full eternal reward.[12] The exegesis of the Parable of the Three Vigils, with its exhortation to turn to the ways of life at one of three ages, made its way into Langland's *Piers Plowman*. "Ymaginatif" speaks to Will, the dreamer, urging him to contemplate his end and to mend his ways sooner rather than later.[13]

In another English fourteenth-century work, a versified Life of Christ composed in Chester, the six ages of the world and the six ages of man were described. This correlation, so widely recorded in the early Middle Ages, had been taken up by scholastic theologians. Robert Grosseteste (d. 1253), Chancellor of Oxford University, later Bishop of Lincoln, incorporated an account of the Augustinian correlation in his *Hexaemeron*, a commentary on the six days of creation.[14] Vincent of Beauvais borrowed from Hugh of St. Victor and described the six epochs and the six ages in his *Speculum naturale*, one part of the vast compendium he produced in Paris in the mid-thirteenth century.[15] Thomas Aquinas himself identified six ages of man and six ages of the world.[16] The Middle English poet, as obscure as these figures were renowned, set out the scheme in seventeen quatrains in the section he devoted to Christ's incarnation:

> Now sex eldes ar rekenet her
> ffrom worldes bygynnyng to ende,
> And other sex eldes in fere
> of mon til that he hethen wende.

The divisions of history he quotes are Augustinian. The durations of the phases of life, as well as the Latin age names supplied in marginal notations—*infancia, puericia, adolescencia, iuventus, gravitas, senectus*—are Isidoran.[17] Yet his characterizations of the stages of life have a distinctly late medieval flavor. "Childhede" is the period which has no thought but to game and play. The "time of soburnesse," the fifth age, is that in which man inclines to "fayntship" and "gret feblenesse." Patristic learning has undergone a transformation.

Entries on the Ages of Man in Preachers' Compendia

WORKING on lines laid by such figures as Isidore of Seville and Hrabanus Maurus, a number of late medieval writers undertook to create large-scale compendia of useful knowledge. The compilers were often now members of the preaching orders, sometimes laymen, and their works reveal a consequent change in orientation.[18] They popularized a wider range of texts, contemporary and classical, some of which, like the works of Aristotle, had only recently become available. Addressing a larger, less homogeneous audience, much of which was nonclerical, they were increasingly concerned with the didactic potential of their material. The works themselves were often translated into or even originally written in vernacular tongues. Many editions, especially those produced for elite patrons, received lavish illustration.

Two encyclopedias compiled in the first half of the thirteenth century, Thomas of Cantimpré's *Liber de natura rerum* and Bartholomaeus Anglicus's *De proprietatibus rerum*, merit particular attention. Popular works, many times translated and reworked, they would be copied and consulted for several centuries. Conservative, like all such reference tools, drawing heavily on earlier compilations, both contain substantial entries on the ages of man. Yet the treatment of the theme reveals significant departures from early medieval norms. One which can be remarked upon at the outset is a weakening in the authority of the patristic six-age scheme. The tendency at the time, observable in many spheres, was to extend the six ages of man to seven or, alternatively, not to pay too much heed to the total number of ages at all. The distich which Roger Bacon quoted in his thirteenth-century computus manual may be compared to the version preserved in later miscellanies. Roger identified six ages:

> Infans inde puer, adoloscens, inde iuventus,
> Inde vir, inde senex, etates signo tibi sex.[19]

Fourteenth- and fifteenth-century writers knew seven:

> Infans postque puer, adolescens, post iuvenis, vir,
> Dicitur inde senex, postea decrepitus.[20]

Both systems are to be found in manuscript miscellanies, but the seven-age program is more often encountered the later one goes. In an English codex of the late thirteenth century, six ages are enumerated in an Isidoran sequence.[21] But in an English manuscript of the fifteenth century, seven ages are named.[22] In a German miscellany of the late fourteenth or early fifteenth century, tables are transcribed which name six ages of the world and six ages of man.[23] Yet in a *tabula vere fidei catholice* dated 1432, composed for the salvation of faithful souls, seven ages of the world and seven ages of man are listed among other sets of moralizing concepts.[24] And in a French manuscript of the fifteenth century, there are seven *eages de l'omme* despite the fact that six ages of the world are listed.[25] The early stages in the move away from the Isidoran scheme can be observed in the two thirteenth-century encyclopedias.

Thomas of Cantimpré, a member of the Dominican order from c. 1232, a writer and a preacher, compiled his *Liber de natura rerum* before 1244, over a period of fifteen years.[26] His purpose, stated in the prologue and epilogue to the work, was to find memorable things concerning the nature and properties of created things, especially animals, as recorded in the writings of diverse authors, and to gather them together into a single volume. Augustine's proposal for such a task, as put forward in *On Christian Doctrine*, remained constantly before his eyes.[27] Thomas prepared the work for the service of preachers. The material within, he felt, could be used for the confirmation of faith and the improvement of morals as an alternative to much-heard scripture. He himself was consciously sparing in his moralizations, giving the spiritual meanings of things only sporadically, in order to avoid prolixity.[28]

Thomas broached the subject of the ages of man at the end of his first book, "On the Anatomy of the Human Body." He seems to have vacillated with regard to the number of ages. In the table of contents the relevant section bears the title "De sex etatibus hominis"; in the body of the work the preferred rubric was "De septem etatibus hominis." Six stages of life are, in fact, listed: *infantia*, till the child speaks, *pueritia* to the 15th year, *adolescentia* from 14, *robur* from 35, *senectus* from 50 to 70 (according to the moderns) or 80 (according to the ancients), and *etas decrepita*. Death counts as a seventh age. Thomas defined each phase in terms of physiological or moral development. He indicates that the infant is the weakest among all newly born animals because it is nourished by menstrual blood. *Pueritia* begins at the point when the boy first speaks, but he does not speak until the "little fountain" (*fonticulus*) which is in the back of the head above the forehead is dried up and the skull is contracted

into a solid. In adolescence the man is able to reproduce: few, he notes, are observed to beget at 14, more at 16. In adulthood full stature is attained in length and breadth. *Senectus*, according to Aristotle, is nothing but a scarcity of blood, thus those who have too little age quickly. In this period all vices but cupidity and parsimony diminish. In the decrepit age, a period of weakening, avarice increases since the individual despairs of being able to work and provide for himself in the future. The much-quoted tenth verse of Psalm 89 is again quoted here: "Our years shall be considered as a spider: the days of our years in them are threescore and ten years. But if in the strong they be fourscore years: and what is more of them is labor and sorrow."[29] Natural philosophy and moral teaching mix and mingle, the one intended for the service of the other.

Thomas's compendium was well received. Manuscripts abound. Long passages, among them the section on the ages of man, were excerpted by later compilers,[30] and the entire text was several times reworked and translated. A version with substantial additions exists in an early fifteenth-century manuscript in Dublin. Its writer, Jean Raynaud, identified as a teacher of law at Avignon, prepared the text for his own use and named it the "Viridarium." When he copied the chapters on the stages of life he felt the need to change the rubric: "On the seven, or properly six, ages of man," adding *aut proprie sex* as an interlinear correction. Illustrations were introduced to supplement the definitions of life's phases, space having been left alongside the texts to contain them (figs. 60-61).[31] Six male figures, differentiated simply by size, facial hair, and clothing, chart the progress of life. The infant wears a laced shirt; the boy, a short belted tunic; the adolescent, a short tunic with a collar; and the man in his prime, carrying a sword, a heroically draped mantle. The older man is garbed in a long tunic and a tied cap, and the most elderly figure, leaning on a stick, wears a long robe and hood. The costume parade is brought to an abrupt end with the figure of death, a skeleton. This grim reminder of the end appeared to haunt no early medieval cycle of the ages of man.

Thomas of Cantimpré's encyclopedia seems to have been widely read in the Low Countries. The prolific didactic poet Jacob van Maerlant around 1270 translated much of the text, which he attributed to Albertus Magnus, into Flemish verse as *Der naturen bloeme*. After a brief prologue enumerating sources, he turned immediately to the ages of man.[32] Seven of the surviving eleven copies received illustration. Images of the ages in a fourteenth-century copy of the work in London operate together with the text (fig. 62).[33] Stationed in the margins or occupying indentations in the text, the figures give structure to the poem, bringing home the point that there are six ages of man—*kint geboren*, *kintschen*, *joncheit*, *manheit*, *outheit*, and *alder outheit*. The pictorial formulae are standard: the suckling babe, the boy playing with a top, the falconer, the soldier, the bearded man, and the bent old man leaning on a stick were

readily recognized representatives of the various times of life. The seventh and last phase, not properly an age of life according to Thomas's system, received no label. Death is portrayed by means of a man in the act of dying. A Christian hoping for salvation, he lies in his deathbed and prays.

The *Liber de natura rerum* also served as one of the sources for a devotional handbook in Dutch, the *Tafel van den Kersten Ghelove*, composed by the Dominican Dirc van Delf. Thomas of Cantimpré's hopes were realized, for here his material was taken up and used to convey an edifying message. Art played its role in the task. Several copies of Dirc's guide, beginning with a manuscript now in Baltimore which was prepared for his patron Albert of Bavaria in 1404, are adorned with large historiated initials. The text, divided for liturgical reasons into a winter and a summer part, combines themes from theology and natural history: the nine choirs of angels, the eight heavens, and the seven planets all receive treatment. Sequential chapters in the "Winterstuc" concern the seven ages of man and the seven ages of the world. Each is illustrated by means of a circle of seven heads which inhabit an initial letter "D" (figs. 63, 64).[34]

The chapters on the ages of man, as L. M. Fr. Daniëls has shown, depend largely upon the entries in Thomas's encyclopedia.[35] Dirc begins his discussion, however, with a doleful introduction. After a life burdened with sorrow, he warns, man dies, his soul returning to God, his body to the earth; and this is the end of all men, of kings, of the rich and poor, of the wise and foolish. Brief characterizations of each age follow, with moralizing interpolations. Dirc was careful to supply the original Latin age designations along with their Dutch equivalents. Following his predecessor, he names six ages—*infantia, puericia, adolescencia, iuventus, senectus,* and *decrepita etas*—concluding with death (*mors, die natuerlike doot*). It is thus of interest that the miniaturist chose to depict the heads of seven living men of increasing age rather than six heads and a skull (fig. 63). The seven-age scheme has won out.

When illustrating the succeeding chapter, the artist also went his own way. Dirc offers an idiosyncratic, extended, scheme of the course of history, inserting Moses into the Augustinian program.[36] The seven ages of the world thus begin respectively with Adam, Noah, Abraham, Moses, David, the Babylonian exile, and Christ; the eighth age commences with the resurrection of the flesh and endures for eternity. The extension served a purpose. Each era, according to Dirc, was dominated by one of the seven deadly sins—*luxuria, superbia, invidia, gula, cupiditas* or *avaricia, ira,* and *accidia*. The illuminator, however, represented the heads of six biblical figures, the sixth being Christ (fig. 64). He then depicted a grinning face, dark, with black mouth, nostrils, and eye sockets—the Antichrist—to signal the last age.

Bartholomaeus Anglicus, an older contemporary of Thomas of Cantimpré, a Franciscan active in Paris and Saxony, composed the most influential of the

later medieval encyclopedias about 1230. His *De proprietatibus rerum*, a large
volume, not so portable as the *Liber de natura rerum*, would become a standard
reference tool. The wealth of extant manuscript copies and the large number
of printed editions, not only in Latin but also in French, English, Italian,
Provençal, Spanish, and Dutch translations, indicate a long and continuous
popularity.[37] Bartholomaeus, following precedent, defended his compendium
on the grounds that it was a valuable aid to understanding the enigmas of the
Bible. Our souls, he says, cannot ascend to contemplative realms but through
consideration of visible things: "For the invisible attributes of God are under-
stood through the things that are made" (Rom. 1:20). A teacher, he addressed
his work to simple men, like himself, and to the young (*simplices et parvuli*).
Those unable to track down things treated in scripture because of the over-
whelming number of books which concern the properties of things, he hoped,
could quickly locate useful information, even if superficial, in his work.[38]

The encyclopedia, in nineteen books, proceeds from God and incorporeal
beings to man, and then to the world and its parts. An entire book, *De pro-
prietatibus aetatum*, is given over to the ages of life.[39] In it a preliminary chapter
defining the ages of man in a general way ("De aetate") is followed by a
discussion of death, an account of the generation of the infant, and a survey
of the characters and functions of the various members of the household. These
include the infant, the boy, the girl, the mother, the nurse, the father, the good
and bad servant, and the good and bad master. The book concludes with advice
on regimen.

Bartholomaeus incorporated both old and newly available learning on the
ages of man into his discussion. He had read widely, his principal sources in
this section being Isidore, Aristotle, and Constantinus Africanus. Isidore is, in
fact, cited some seventeen times in the course of the first chapter, and his
etymologies form its substance. But Bartholomaeus collected alternate opin-
ions. On the issue of the terminating point of adolescence, for instance, he says
that according to the *Viaticus* (of Giles of Corbeil) the period ends at three
septenaries or 21, according to Isidore at four septenaries or 28, and according
to "the doctor" at 30 or 35. The Franciscan, in keeping with the tendencies of
his time, gave increased emphasis to the ills of old age: "The elderly man is
despised by all, judged burdensome, and plagued by coughing, spitting, and
other afflictions until the time when ashes dissolve into ashes and dust returns
to dust."[40] At no point does Bartholomaeus specify the total number of ages,
saying only that they are many and diverse. The text, juxtaposing different
points of view, does nothing to clarify the situation: it is difficult to discover
Isidore's six ages imbedded within.

Petrus Berchorius (d. 1362), also known as Pierre Bersuire, a Benedictine,
was more explicit in his own encyclopedic compendium, the *Reductorium morale*.
The work, which he prepared while resident in the papal city of Avignon in

the 1320s and 1330s, draws heavily from Bartholomaeus's text in its first thirteen books. But Berchorius was concerned to augment his survey of the properties of things with explanations of their moral import, to present the information in such a way that it could be used for increasing faith and correcting morals.[41] By no means a slavish imitator, he condensed and refashioned the material in his model before appending his own edifying words. Book III, *De hominis conditionibus*, patterned after Bartholomaeus's Book VI, contains twenty-two rather than twenty-nine sections. The first chapter, on the ages of man, is much pruned. Whereas Bartholomaeus had quoted many authors and was indecisive about the total number of ages, Berchorius confined himself to the Isidoran material and specified that there were seven ages of man in all. He attributed the numbering to Isidore. Not having the *Etymologies* before him with its statement "gradus aetatis sex sunt," he considered *senium*, which Isidore had defined as the last part of *senectus*, to be a seventh age.

Berchorius applied a learned set of moralizations to the text. "In the seven ages," he says, "one can understand the seven spiritual virtues from which the life of grace is constructed." He reads a lesson into the distinguishing features of each age, equating ages and virtues systematically, with the help of scriptural citations. The first spiritual age is *infantia*, that is, *humilitas*, the beginning of the moral life, for the infant's trait of not speaking belongs to the humble: "He that refraineth his lips is most wise" (Prov. 10:19). *Pueritia*, then, rendering one able to marry, is *charitas*, which works to join man with God, with friends, and with enemies: "The Lord hath been witness between thee, and the wife of thy youth" (Mal. 2:14). The third virtue is *adolescentia*, a period of growth, corresponding to *pietas*, which increases worth: "Young man, I say to thee, arise," that is, grow, Berchorius adds (Luke 7:14). *Iuventus*, which strengthens the man, is *fortitudo*, which gives strength against temptations: "I am writing to you, young men, because you are strong and you have conquered the evil one" (I John 2:14). *Senecta*, which burdens the man, is *honestas*, which curbs youthful impulses: "They shall still increase in a fruitful old age: and they shall be well treated" (Ps. 91:15). The sixth age, *senectus*, that which dulls the bodily senses and illuminates spiritual perception, is the equivalent of *prudentia*, which destroys the wisdom of the flesh and brightens the wisdom of the spirit: "Let him become a fool, that he may come to be wise" (I Cor. 3:18). Finally *senium*, which enfeebles the man and bends him toward earth, is *timor Dei*, which puts down pride and bends the mind to a reflection on death: "Man shall be brought down, and man shall be humbled" (Isa. 5:15). If a man passes through these seven ages he shall, at the last, triumph above with the elect.[42]

Illustrations in certain manuscripts of Bartholomaeus's encyclopedia, especially vernacular translations of the work, provide a kind of commentary on the text in their own right. Set at the head of Book VI, they amplify and clarify it, artists often being compelled to take a stand on the issue of just how many

ages of man there were. Copies of the Latin text, its readership scholarly, tended to receive modest decoration. An owner would decide whether filigree ornament or small historiated initials were desirable.[43] In cases in which information on the ages of man was extracted from the work and incorporated in miscellanies or other compendia, the Latin text sometimes received illustration. A single leaf dating to the mid-fourteenth century, unpublished, bound into a manuscript now in Munich, contains definitions of the phases of life drawn largely from Bartholomaeus. These passages serve as captions for representations (fig. 65).[44] Roundels enclose a sequence of figures, five in all, though six ages are described. The cycle begins with an oversized child, nude with a cap of blond hair, shown crawling. The text below, this one alone attributed to Aristotle, relates that in infancy man goes about on his hands and feet, in adolescence he walks erect, and, finally, in old age he is bent once again toward the earth, since taken from the earth to the earth he returns. This age is said to end at seven years and to be named *infans* for "not speaking," an Isidoran notion. Isidore is quoted as an authority in all the succeeding texts. *Puericia* to 14, named for *puritas* or *pupilla*, is accompanied by an image of a boy playing with a whip top. Shaky lines around the toy, giving an impression of movement, were probably added in the fifteenth century. *Adolescencia* to 21, so named because the individual is mature for procreation, is represented by a young couple embracing. The maid wears a bright red fillet; the man holds a pink flower. *Iuventus* to 45 or 50, at the midpoint of the ages, named for helping, appears as a military man in all his strength with helmet, sword, and lance, standing frontally, gazing boldly at the viewer. A single text and image, labeled *senectus* in the fifteenth century, represents the final age. Its definition, a conflation of Bartholomaeus's description of *senecta* and *senectus*, is illustrated by means of a bearded man with a worried air, clothed only in a mantle, leaning on a T-shaped crutch. One might remark just how little authority the six-age system enjoyed at this point, if Isidore himself was held in reverence. The fourteenth-century artist dropped an age from the cycle, and the fifteenth-century rubricator entitled the page "Quinque aetates hic infra et condiciones earum."

The entire chapter "De aetate," carefully identified as an excerpt from Bartholomaeus's work, was incorporated into an alphabetically arranged compendium dating to the mid-fourteenth century, called "Omne bonum" by its compiler, an Englishman named Jacobus. Hundreds of illustrations on a remarkable range of subjects appear in the manuscript. When one turns to "E" for *etas*, one is met with a lengthy and many-faceted discussion of "age" headed by a miniature (fig. 66).[45] After having quoted the chapter drawn from the *De proprietatibus rerum*, a text larded with quotations from Isidore, the author inserted a quotation from Johannes Balbus's dictionary, the *Catholicon* (A.D. 1286), which had also drawn on the *Etymologies*: the definitions from Book V

and Book XI both appear, along with a list of the six ages of the world and a description of the four ages of man and the four seasons.[46] Two lengthy texts concerning the concept of age in canon law—an aspect of the subject which invites further study—follow. The entry ends with two additional surveys of the ages of the world and a recital of the physical debilities and temperamental idiosyncracies of old age, the latter introduced by the oft-quoted verse, Psalm 89:10. Faced with such a barrage of opinions, the illuminator seems to have opted for simplicity. In the initial which opens the chapter there is a representation of the first ages of life. Three children are shown playing. One pushes a baby walker, one spins a whip top, and one holds a cloth with which, it has been suggested, he is attempting to trap butterflies.

Manuscripts of vernacular translations of the encyclopedia, particularly the French version, were often luxury products, richly endowed with illustrations. The translation itself was sponsored by Charles V, royal bibliophile. In the colophon of the French manuscripts of *Le livre des propriétés des choses*, it is stated that frère Jehan Corbechon, Charles's *petit et humble chappellain*, prepared it for the king in 1372. Many copies would find a place in the libraries of noble patrons.[47] Illustrations to Book VI vary considerably in scale and abundance. Normally a miniature was inserted within a column of text before the opening of the book. In a particularly lavish codex not only was a large headpiece planned, but the separate chapters received their own small illustrations.[48] A variety of pictorial formulae were developed. Yet the images are generically related, all making use of a similar range of stock characters.

Illuminators normally chose to represent assorted figures dotted about a landscape or placed in an interior. Together these individuals present a panorama of the activities of man at different ages and point a contrast between the carefree pleasures of youth, the responsibilities of middle age, and the woes of old age. In a very common type of illustration, characteristic of the earliest manuscripts, no effort at all was made to survey the entire life. An old man, often humpbacked, is shown speaking to a group of sumptuously clad young men, no doubt admonishing them on the themes of the transience of youth and the vanity of things of this world.[49]

Full sequences of the ages were also represented. Bartholomaeus not being dogmatic about the number of the phases of life, artists felt free to form their own opinions. Four figures were portrayed in a miniature in an early fifteenth-century manuscript in Paris (fig. 67). A boy in the foreground plays with a toy, a young man embraces a woman, and a mature man rakes a pile of money toward him, while an old man with a disgruntled expression sits enthroned to the left and oversees the whole.[50] In another rendition, of greater artistic interest, six figures inhabit a landscape suffused with golden light (fig. 68). The manuscript, according to Millard Meiss, was made c. 1414 in the shop of the Boucicaut Master for a noble patron, Béraud III, comte de Clermont.[51] Elegant

figures act out appropriate occupations: a child plays with a top; another holds
a bow and arrows; an aristocratic falconer on a white horse rides off into the
background while a middle-aged man sits in a store front and counts his money;
two sedate older men converse, and one points toward the actively engaged
individuals to their left. In these two images the row format is abandoned. The
line breaks up and the familiar figures move in space. But more schematic
images were also being produced. In another early fifteenth-century copy of
the French text, the artist fixed six figures, ranging from a nude infant to an
elderly man with a stick, onto an arch (fig. 69).[52] Life is shown to be a process
of ascent and decline. The last figure makes a meaningful gesture. He points
toward the center of the composition where a man labeled *decrepitus*, repre-
senting the seventh and final age, sits with folded hands above a skeleton labeled
la mort. The reader is urged to reflect on his inevitable end.

Seven ages were also portrayed in the manuscript image destined to be
adopted for early printed editions of the French text.[53] Seven figures occupy
an interior. In the front plane an infant lies in a cradle, a child pushes a baby-
walker, and a boy holding a windmill energetically rides a stick horse. A slightly
older boy in a long robe, and a sword-bearing youth ostentatiously dressed in
a short pink tunic and hose decorated with a zig-zag pattern, stand behind.
Two older gentlemen, large in size, one with a stick, sit together on a bench
against the wall. Seven figures were also represented, but in more systematic
fashion, in the woodcut in the Dutch edition of the work.[54] They appear in a
row in a landscape above a medical scene illustrating Book VII. A seated child
picks a flower, a boy holding a windmill rides a stick horse, and an older boy
shoots an arrow. Next in line, a well-dressed young man with a feathered cap
and a sword holds a falcon. Finally, three heavily clad figures in a group
represent the last phases of life. The grinning figure of a skeleton lies on the
ground as a reminder of ever-approaching death. Despite the varying com-
plexity of the scenes, the message and moral remain constant.

The conservatism of the encyclopedia writers is striking. Drawing on older
reference works, collecting rather than synthesizing opinions, they kept the
old schemes current. Isidore's *Etymologies* stood behind all the later works. The
work continued to be consulted in the original, being printed many times, first
in Strasbourg, c. 1470. Nor did the other early medieval encyclopedias fall into
oblivion. Illustrated copies of Hrabanus Maurus's *De rerum naturis* exist from
the twelfth century (a fragment), from the late fourteenth, and from the fif-
teenth century.[55] The text was printed at an early date, c. 1474.[56] Lambert's
Liber floridus, too, continued to be copied. In addition to the autograph codex
in Ghent (c. 1120) and the twelfth-century copy in Wolfenbüttel, there exist
two manuscripts from the thirteenth century and five from the fifteenth; a
French translation was made for Philippe de Cleves in 1512.[57]

Despite the tenacity of old lines of thought, the entries in the later medieval

encyclopedias reveal significant changes in orientation. The most obvious is a weakening in dogmatism about the number of the ages of man and, at the same time, a growing preference for the seven-part division of life. Various factors no doubt fostered the rise of this particular scheme. The knowledge of the correlation between the ages and the planets, and also that between the ages and the canonical hours, would certainly have had an effect. More difficult to pin down is the role which popular habits of mind would have played; groups of seven things seem to have a more prominent place in folklore than do collections of six or four.[58] In the later Middle Ages encyclopedia writers and the artists who illustrated their works tended to present an interpretation of life directed toward an edifying end. The overriding issue is increasingly proper conduct, right living. Information is to be used in moral exhortation even if its moralizing significance is not explicitly stated. Particular attention is paid to old age and its miseries, such thoughts believed to curb youthful tendencies to indulgence. Death casts its shadow over the whole. Personified, it now even becomes a tangible presence in representations of the life cycle.

VII. THE MORALIZED LIFE
IN IMAGES

THE MORALIST, it has become apparent, tended to emphasize the weaknesses, moral and physical, to which the various phases of life were prone. He lamented man's continuing attraction to vain pleasures, coming down hard on light-hearted youth. He stressed the transience of periods of well-being and dwelt upon the miseries of old age. Late medieval pictorial cycles mirror some of his concerns. In serial images a contrast was set up between characters of different ages, young and old. In such figures as the Wheel of Life, the Tree of Life, and the Steps of Life, the moralist's vision of the overall pattern of human existence took on concrete form. For each proclaimed the mutability and futility of life, implying a contrast to the eternal joys of contemplation of God, by showing a rise from birth to a briefly enjoyed period of prime, followed by a prolonged decline to death.

It was in the later medieval centuries that cycles of the ages of man came to be represented on their own account, outside numerologically determined programs. No longer did the writer have a clear upper hand. Visual images inspired literary metaphors. Artists and versifiers collaborated in fashioning didactic schemata, a characteristic product of the period, assigning equal status to text and image. A relatively small stock of pictorial forms and lines of verse on the theme of the ages of man, combined and recombined, served them as they created edifying artistic works, aids to pious meditation.

Series of the Seven Ages

SURVIVING pictorial cycles confirm that the seven-age scheme had become the popular favorite in the later Middle Ages. Artists, when no constraints were placed upon them by accompanying texts, normally represented life in seven phases. An illumination in a luxury codex in Paris is a case in point (fig. 70). The manuscript in question is the third and last copy of the ninth-century Utrecht Psalter, a copy produced c. 1200 in Canterbury. Its text was fully transcribed at that time, but its pictorial decoration remained incomplete until the later fourteenth century when a Catalan artist with Italian leanings, it is thought, took on the project.[1] Not having access to the model, he devised an independent set of miniatures, representations no longer characterized by the

literalness of the original program. Psalm 89 was illustrated by means of a cycle of the seven ages of man.[2] The reasoning behind the designer's choice is, perhaps, not difficult to follow. For the psalm is in part a comment on the transience of life: "In the morning man shall grow up like grass; in the morning he shall flourish and pass away: in the evening he shall fall, grow dry, and wither" (v. 6). It includes the verse so often quoted in definitions of old age: "The days of our years . . . are threescore and ten years. But if in the strong they be fourscore years: and what is more of them is labor and sorrow" (v. 10).[3] In this period when the ages of man were regularly described in a melancholy manner, when the preacher harped upon life's miseries and the ills of old age, the Hebrew verses on the brevity and sorrow of life would have readily called the theme to mind.

The illuminator distributed the seven figures, following his preferred format, in two registers. Within these zones he allotted each individual a separate space, there to act out a scene. A child plays with a whip top in the first compartment while an angel emerges from a cloud holding a scroll, uninscribed; a boy in a landscape shoots a bird in a tree; a colorfully dressed adolescent with a touch of a beard, bearing a falcon on his gloved wrist, rides a dappled grey horse; the man at prime, bearded, at the peak of life, holds a flowering stalk. Three men of declining years occupy the lower register. The first sits at a lectern calmly turning the pages of a manuscript; the older man walks through a landscape supporting himself on crutches; the most elderly sits with hands raised and looks toward heaven. Attributes and occupations in the upper zone suggest bodily vigor and active pursuits. The sedate scenes below present a forcible contrast. The last years bring gradual slowing, but the artist indicates that a good old age has its rewards. The very last figure might be interpreted as Augustine's *novus homo* born to a spiritual life or, better, Petrus Berchorius's *senex* whose bodily senses are dulled while his spiritual perception is heightened.

One discovers with some surprise that the same cycle was painted onto the walls of a corridor in the Palazzo Trinci in Foligno in the early fifteenth century (figs. 71-74).[4] An L-shaped passage runs between a transept of the cathedral and that spacious hall in which the hours of the day and the ages of man, the seven planets and the seven liberal arts, had been represented (fig. 42).[5] An individual approaching the hall passed, on his right, portraits of the Pagan, Jewish, and Christian heroes and, on his left, the figures of the ages of man. The seven characters now inhabit a continuous landscape. A scroll-bearing angel hovers above each of them, not just the first. Their banderoles are inscribed with question-and-answer verses in French, most of which are now fragmentary. The first begins, "Enfes, que demande tu en tenfanse." A child, looking down, holds a whip (fig. 71); the frescoes are damaged, but one can easily supply the top spinning on the ground. A boy again shoots an arrow toward a tree, and after a pair of windows a handsome youth, sumptuously

garbed in a patterned doublet, rides in profile, holding a falcon on his wrist. He leads the viewer around a corner to a man with a moustache and short beard, dressed in an elegant high-collared garment, who would once have held a branch in his left hand (fig. 72). Following him there is a man with a grey beard who sits in a high-backed chair, reading a book. Beyond a second pair of windows the program draws to a close with a white-bearded man, melancholy in expression, dressed in dark colors, who walks with the aid of two crutches (fig. 73). Finally a seated figure, bearded, hand raised, gazes upwards (fig. 74). Inscriptions, so far as they can be deciphered, place the terminations of the ages at 7, 15, 2-, —, 40, 60, and 84.

The parallels between this cycle and that in the psalter, painted by an artist working in an Italianate mode, are self-evident. The gestures and attributes of all seven figures are, in fact, identical. Only scale, style, and a certain courtly ambience separate the two. The wall painter, working for noble patrons in the then current International Style, clothed the figures in the gorgeous costume of his day. Only rarely do surviving cycles match up so closely. The designer has, one thinks, worked out of a library, finding inspiration in a luxury codex. Sketches of the ages of man, smaller in size, have come to light in the plaster underneath the frescoes on the opposite side of the corridor, suggesting something of the artist's working procedure. It is no coincidence that the other cycle of the ages of man in the Palazzo Trinci (fig. 42) shows close manuscript connections (figs. 40-41).

The theme of the ages of man became part of the stock in trade of the late medieval house decorator. Representations of the life cycle ornamented the halls. Seven ages were painted, for example, in a room of the Castle at Sargans in Switzerland around 1470. A sequence of framed genre scenes, now in very poor condition, appeared along two walls. In the first compartment a pair of boys holding windmills rode on stick horses; in the last a man and a woman knelt before an altar.[6]

Tapestries showing the ages of man survive, and others are known to have existed.[7] The subject even found a place on domestic furnishings. On a Florentine cassone panel of the second half of the fifteenth century, an artist supplied a panorama of the human life, courtly in tone.[8] The scenes follow one another in a single, continuous interior. The dividing lines between the age groups become so subtle that it is difficult to determine the total number of the stages of life. Fragmentary inscriptions running along the top of the frieze suggest that seven were intended: *infantia, pueritia, adolescentia, iuventus, virilitas* (?), *senectus,* and *decrepitas* can be discerned in the photographs. Nursery scenes head the cycle. Three women care for four small infants, one lying in a cradle, one about to be washed. A group of five boys, three of whom are nude, one of whom holds a ball, appears next, to be followed by a cluster of youths around the figure of a master. In the succeeding vignette a well-dressed man

stands with his lady while two musicians play. At this point the articulation of the scenes becomes less clear. Two men holding spears, accompanied by hounds, ride horses while a dignified man with a sword and lance stands isolated and looks over at a group of five elderly figures. The latter are huddled together: one man leans on two crutches, and a seated woman prays with a rosary. Life takes its inevitable course.

Versatile, the theme was considered appropriate for the decoration of religious as well as secular structures.[9] In Siena one section of the famous intarsia pavement in the Cathedral was given over to the seven ages of man. Figures representing the first six phases of life, in octagons, surround a man representing the last age in a central diamond (figs. 75-77).[10] Archival documents name Antonio Federighi as the artist responsible for the design and 1475 as its date of execution. The original panels, badly worn, are now set into the floor of the Museo dell'Opera del Duomo, a copy having been installed before the Chapel of the Madonna del Voto in 1870. Much of the linear detail has been rubbed away. The figures survive as silhouettes, white against a black marble ground, set within evocative landscapes of rocks, grass, and flowers. *Infantia* is represented as a child running; *pueritia* is a boy holding a ring in his right hand (fig. 76); *adolescentia*, a youth in a cape (fig. 77); and *iuventus*, a graceful young man holding a bird with outstretched wings. *Virilitas*, the best preserved of the figures, stands with a book in his hand, and *senectus*, a bearded man, holds a stick and a ring. The central panel, representing *decrepitas*, is, as ironically befits its subject, in particularly ruinous condition. An old man in a stark setting totters toward his open tomb on two sticks. The cycle of life, set out in a circle, has as its centerpiece death.

Some English Accounts of Life's Passage

THE PRIVATE residence of the Thorpe family, Longthorpe Tower near Peterborough, received painted decoration of a moralizing cast under the owner Robert Thorpe, it is thought, around 1330. A vaulted hall on the first floor provided the setting for an extensive program which included the seven ages of man (fig. 78).[11] Taking advantage of the room's structure, the artist distributed the seven figures on an arch and was thus able to show a rise from infancy to prime and a subsequent, symmetrical decline from prime into decrepitude. Though several of the figures survive in a fragmentary state and some of the inscriptions, written on the band beneath them, are illegible, it is possible to gain a clear sense of the whole. The range of character types is familiar. A babe, labeled *infans*, asleep in his cradle, begins the sequence. *Puer* then appears in a short tunic, holding a ball and playing with a whip top. Only the lower half of *adolescens* survives, but more can be made of the partial figure of the fourth age, once labeled *iuvenis* no doubt, stationed at the top of the

arch. He is a falconer fitted out with the equipment of his trade, glove, lure, and hood. The remains of a sword-bearing figure represent a fifth age (*vir?*), and fragments of a man with a money bag mark the sixth (*senex?*). A hooded figure in a long robe walking on two crutches, identified as *decrepitus*, brings the series to its conclusion. Infancy and old age are aligned across the wall: the elderly man turns away and departs from the scene.

The life cycle is but one of a medley of subjects introduced in the decoration of the room. Other sets of images, as well as certain religious scenes, are represented, namely, the twelve occupations of the months, the twelve apostles bearing the twelve articles of the creed, the five senses on a wheel, the four evangelists, and the three living and three dead kings. Yet numerical correspondences do not provide a structural underpinning for the program. Like the lists so often to be found in manuscript miscellanies,[12] they act as a kind of table of faith. Themes considered aesthetically and ethically appropriate in a secular setting were chosen, those which might lead to edifying meditations on the part of the viewer.

A richly decorated Book of Hours, a devotional book now in the Morgan Library, first owned by one of the daughters of Robert de Lisle of Yorkshire, contains unique illustrations of the ages of man. Dated c. 1320-1330 and placed in the region of York, the manuscript is distinguished iconographically by the initials which mark the divisions of the Little Office of the Virgin (figs. 79-80).[13] The text of this office, the core of every Book of Hours, consisting of a round of prayers, psalms, and hymns to be recited at the canonical hours, regularly received illustration. Normally, scenes from the life of the Virgin or, especially in English Books of Hours of Sarum use, representations of the Passion of Christ were introduced.[14] The Morgan manuscript, of Sarum use, contains full-page miniatures of the Passion, now eight but certainly once ten in number, namely the Temptation of Christ, the Betrayal, Christ before Pilate, the Mocking of Christ and the Scourging of Christ on facing pages, Christ Bearing the Cross, [the Crucifixion], [the Deposition], and, together at the end, the Entombment and the Harrowing of Hell. But on following pages, in the large opening initials, the stages of life are represented. A woman and a man, the latter growing older image by image, carry scrolls inscribed with dialogue in French, now only partially legible, concerning life's course.

The sequence, painted by more than one hand, begins at the first division, but humbly, in the bas-de-page. The initial which heads the readings for matins shows the crowned Virgin blessed by the Lord and, under a Gothic arch, a small praying figure, the owner of the book. Below them, however, the illuminator has represented a courtly woman in an orange robe with a grey mantle and a white headpiece, together with a boy, both of whom hold long scrolls with remnants of inscriptions. The two stand on a bar border, seeming to interrupt the marginal chase of a dog after a hare. A woman, nearly identical

in pose and costume, inhabits the large initial which opens the office for lauds (fol. 29r, fig. 79). Here she is accompanied by a youth who combs his hair and admires himself in a round mirror. His vain preoccupations are further manifested in the ostentatious garment he wears, blue with orange and white stripes. In the succeeding images the woman, whose sole function is that of scroll-bearer and question-poser, remains a constant: her costume changes but her age does not, and she at no point holds anything but a banderole.[15] At prime the *iuvensel* with her carries a round object, perhaps again a mirror, and at terce she is joined by a sword-bearing figure who supports a falcon on his wrist. By sext the man has donned a cap and a sober, if distinguished, garment of grey with rich vair lining. At none his beard is white, his expression is worried, and he holds a cane in his hand (fol. 68r, fig. 80). Old age upon him, at vespers, wrinkled, garbed in dusky blue, he bends over a T-staff. With compline, having taken to bed, he lies beneath a coverlet, his eyes closed.

As the canonical hours follow one another, the stages of life, eight in all since matins and lauds are distinct, pass by. A pious reader would have been drawn to reflect on the course of human existence, to ponder the empty pleasures of youth, the miseries of old age, and the approach of death. Keeping pace on facing folios, the stages of Christ's passion unfold, reminding the reader of his sacrifice and the promise of salvation. Scenes of Christ's Entombment and the Harrowing of Hell (fols. 79v-80r) precede the representation of man's death (fol. 81r). At the very end, his female companion raises an admonishing hand.

Stronger in tone, if related in sentiment, is an English lyric of the fifteenth century which begins, "As I went one my playing." A child listens to a hoary old man mourning the futility of his life.[16] The man likens his existence to the passing day, describing it in again eight phases which correspond to morrow-tyde, myde-morroo-daye, vnder-day, mydday, nonne, myd-vndure-none, ewynsong tyme, and ny3t. Good fortune proved transient. At mydday he was dubbed a knight, none would stand up to him in battle. Yet, he asks, where has all our pride, our jollity, our fair beauty gone? "Frow dethe I may not me here hyd." Each stanza closes with the melancholy refrain that this world is but a vanity.

Evil temptations were seen to threaten man's virtue at every stage of life. Dynamic accounts of the struggle for his soul were produced. On a small scale, there is a poem in dialogue form, "Of the Seuen Ages," which is found with illustrations in a manuscript from the first half of the fifteenth century in London (fig. 81).[17] It comprises the reflections of Man at each age and the advice he is offered along the way by "the gode angel and the yll." Art and text are intertwined. The child, lying naked, first says to himself, "Nakyd in to this warlde borne am I," and then, standing between his two counselors, announces, "I wil go play with my felowe." The figure representing 3outhe, outfitted in

a short tunic, cap, and fashionably pointed shoes, says, "With women me lyst both play and rage." Next Man, brandishing an axe, boasts, "Now I am in strenthe; who dar to me say nay?" Age, holding a money bag, states, "Of thies ryches I hafe gret wone." The "crepil," holding his rosary beads, moans, "Now must I beddes byd thof my bones ake; I drede that ded persewes me fast." All the while the angel, represented robed, with wings and halo, and the bestial fiend, shown with horns, claws, and spiky wings, whisper good and evil suggestions to their charge. The one urges him to do God's work while the other tries to lure him away. The drama resolves at the man's death. The good angel is successful in his plea for Man's repentance, and the devil slinks away as Last old age cries for mercy:

> I deele my godes for gods sake now sone in hy,
> And amendes me life whils I hafe space;
> And for mercy to god dos crye,
> To send me his godenes and his grace.
> Therfore my saule to hym I take,
> And dos goode werkes whils that I may;
> For lytel wil men do for my sake
> When I am hence paste away.

The battle against vicious urgings had dramatic appeal. The psychological contest could be made concrete through the use of personifications. In an English morality play of the first half of the fifteenth century, *The Castle of Perseverance*, the main character, Mankind, proceeds through life constantly beset by his enemies—the World, the Devil, and the Flesh. The vices assail him and the virtues protect him. A bad angel offers destructive advice and a good angel gives sound counsel. He at last repents to be saved after death through God's mercy.[18] A similar staffage appears in a contemporary didactic poem called by its editor, "The Mirror of the Periods of Man's Life, or Bids of the Virtues and Vices for the Soul of Man." Again a good and a bad angel and a range of virtues and vices contend for influence over Man, the battle this time extending over a finely divided life span of one hundred years.[19] These pieces, too, focus on the individual's long, losing struggles against the temptations of the world, temptations which work upon his latent weaknesses as they change from age to age. They urge him to remember death, and to mend his ways so that he may assure himself a place among the blessed at the end.

The Tree of Wisdom

THE GOOD MAN progressed toward wisdom, employing each age to his spiritual advantage. A diagram, the *Arbor sapientie*, had been created by the late thirteenth century to chart the passage to this elevated state through the seven

liberal arts and through the seven ages of man. The tree form was adopted to set out the scheme, its usefulness in didactic constructions having long been recognized.[20] Since the tree's various members—trunk, branches, and leaves— fall into a natural hierarchy, one part growing out of another, it was seen that ideas could be established as primary, secondary, or tertiary if inscriptions and images were fixed onto the appropriate arboreal elements. The tree's bilateral symmetry, made unnaturally regular by artists, suggested that it be used for aligning sets of concepts: interconnections could be made horizontally between ideas distributed at the branch ends and on the trunk. Further, the tree's organic nature led to its being used to set out progressions of ideas: one normally reads a tree schema upwards, from roots to crown, in orderly sequence. Some of the diagrammatic trees were quite naturalistically rendered. Others appear in very stylized form, their branches transformed into bars which terminate in roundels rather than in leaves. In their various shapes they supported a wide range of material—historical, genealogical, legal, logical, rhetorical, moral, and catechetical. Those of devotional cast were sometimes grouped together so as to form allegorical groves in which a reader might "wander" at his leisure.

The Tree of Wisdom made full use of the tree's symmetrically hierarchical structure and organic associations (figs. 82-85). At its crown *Sancta Trinitas*, the embodiment of divine wisdom, speaks: "I order, I create, I bestow all things" ("Omnia dispono, creo singula, cunctaque dono"). At its roots the same voice is heard: "I wish it, I command it, I effect it according to my law" ("Sic volo, sic iubeo, sic ago iure meo"). On the left, at the branch ends, *Natura* heads a series of the seven ages of man running upwards from *infans* to *decrepitus*. On the right, balancing this set, *Philosophia* initiates a sequence of the seven liberal arts progressing through the trivium and the quadrivium, from grammar to astrology. Bar branches connecting the ages and the arts to the trunk contain lines of verse.

Wisdom is the keynote of the schema. The seven ages and the seven liberal arts are twin modes of approaching this desired state, by nature and through philosophy, by growing old and through study. Specific correlations between individual ages and arts do not seem to be meaningful, although number acts to bind the two sets together. The emphasis on the hebdomad was a calculated one. The age-old idea that the ascent to wisdom is a seven-stage process would have done much to determine the shape of the diagram.[21] Symmetry, too, demanded the adoption of a seven-part division of life, a scheme winning general acceptance at the time, to match the well-established hebdomad of the arts.

The Tree of Wisdom is regularly to be found as one of a collection of didactic diagrams, members of which fluctuated considerably. As few as three or four or as many as ten or fifteen of the schemata might appear together in a given manuscript. No single one is present in every extant collection, but some,

among them the Tree of Wisdom, are more commonly encountered than others.[22] The question of authorship is a vexed one. Two of the older diagrams incorporated in the set, twelfth-century products, have pedigrees: the Tree of Life (*lignum vitae*) is associated with Bonaventure and the six-winged cherub, with Alan of Lille. Complicating the issue is the appearance in certain four-teenth- and fifteenth-century manuscripts of the names of the Franciscan Johannes Metensis and the Dominican Bonacursus, Archbishop of Tyre in Syria. Both men have been credited with the invention of a "core group" of diagrams consisting of the most frequently encountered members.[23] Yet even the degree to which the collection can be considered the product of individual imagination remains unclear. The diagrams were created as didactic tools, props for public instruction and aids to private meditation. They circulated widely after being loosely gathered in the late thirteenth century, picking up new members and submitting to alterations and improvements. A given diagram's layout, its inscribed verses, and its illustrations vary from copy to copy. Parts of one schema were freely incorporated into another. Certain of the verses transcribed in the Tree of Wisdom, for example, are also to be found in a tetradic *rota* (fig. 55), in circular and tabular versions of a diagram called the "Twelve Attributes of the Human Condition" (*Duodecim proprietates condicionis humane*) (fig. 90), and in a Wheel of Life, the *Rota vite alias fortune* (fig. 92). A comprehensive study of the diagrams which includes a tabulation of their variant forms, their distribution, and the types of manuscripts in which they appear, as well as an investigation into their doctrinal cast, is wanted before generalizations concerning their origins can be made.

Possibly the earliest of the surviving manuscripts to contain a selection of the schemata is a large, lavish volume of questionable quality which has been tentatively dated to the last decade of the thirteenth century and located in Picardy. The collection of diagrams is given the title the "Vrigiet de solas" on the first folio: "This book can be called the 'Grove of Consolation,' for whoever wishes to enter by thought and by study will find there pleasing trees and fruits sufficient to nourish the soul and educate and train the body."[24] The diagrams, some unusual, are richly endowed with figural illustration. Last in the set comes the Tree of Wisdom (fol. 16r, fig. 84). In this version the Lord, holding an orb and cross, his right hand raised in a gesture of blessing, sits enthroned in the center of the composition against a beige and blue diapered ground. Lines of verse radiate from his person to end in roundels, gold with green and orange rims, which contain the ages and the arts, while inscriptions extending from the trunk end at the figures of Nature and Philosophy. *Natura*, in the lower left corner, is shown seated beneath a trefoil arch, raising her left hand. She introduces the cycle of the stages of life by proclaiming herself the source of nature's laws: "Illic natura per me recipit sua iura." Above her, each of the seven ages in turn describes himself:

INFANS: Infans absque dolo, matris fruor ubere solo.

[An infant without guile, I enjoy only my mother's breast.]

PUER: Est michi sors munda, nature purior unda.

[Mine is a pure destiny, I am more pure than the water of nature.]

ADOLESCENS: Informans mores, in me flos promit odores.

[Shaping my character, the flower in me gives forth its perfumes.]

IUVENIS: Nature decore, iuvenili gaudeo flore.

[Thanks to nature's embellishment, I delight in my youthful flowering.]

VIR: Viribus ornatus, in mundo regno letatus.

[Adorned with strength, joyful I reign in the world.]

SENEX: Hoc reor esse senum, sensum discernere plenum.

[This I believe to be the quality of old men, to plumb the full meaning.]

DECREPITUS: In dubio positus est homo decrepitus.

[The decrepit man is cast into doubt.]

Figural imagery is in some cases affected by poetic imagery, the result being an eccentric pictorial cycle. The guileless infant enjoying his mother's milk quite properly appears as a swaddled baby lying at a woman's breast. The boy, to indicate his purity, strokes a dove. The adolescent, at the stage of character formation, reads a book under the guidance of a teacher bearing a switch. This goes against the spirit of the verse, but then Wisdom is the guiding theme of the diagram. Cheerful *iuvenis* is a falconer riding on a horse. The period in which man reigns strong is uniquely represented by means of a couple reaching to a flaming disk suspended between them. The wise *senex* instructs two children, and finally, the decrepit man cast into doubt is shown leaning on a stick. *Philosophia* and a series of figures engaged in activities representative of the liberal arts appear on the right-hand side. Running through the trivium and the quadrivium, the latter show no sign of systematic aging.

Two early fourteenth-century copies of the Tree of Wisdom, neither figured, serve to demonstrate the range of formal variation between the surviving diagrams. In a French manuscript in Paris the tree appears as one of a series of beautifully rendered compositions, delicately painted in dark blue, red, and green (fig. 82).[25] Though schematic, the trunk and each of the branches end in lush foliage. The diagram in a German manuscript at Yale University is, in comparison, crudely robust and starkly unnaturalistic (fig. 83).[26] Its trunk grows from an urn, and its branches are transformed into a block of diagonals ending in overlapping roundels. A compromise was achieved in a copy of the schema in a southern German manuscript of the early fifteenth century (fig. 85).[27] In this, another figured version, the tree has roots, a trunk with knobs, and branches with leaves, although each of its members ends in a roundel. The pictorial cycle, in this case not so closely related to the verse texts, has certain peculiarities. Here for the first and perhaps only time, a sequence of the ages

of man is headed by a representative of the prenatal phase of existence. The roundel given over to *Natura* is occupied by a baby in the womb in fetal position, labeled *embrio*. The characters who follow are more familiar: an infant in a cradle is succeeded by a child pushing a baby walker, then a boy shooting at a bird in a tree, a youth with a falcon and lure, a man with a sword, a man bent over a stick, and an elderly figure in bed whose physician examines a urine bottle. Context helps to explain the medical cast of the iconography. The manuscript, a wide-ranging miscellany, is unusual for containing a good deal of medical material, including drawings of embryos in different positions (fols. 37v–38r) and a *rota* of urine types (fol. 42r).[28] The artist applied his experience in medical illustration to the representation of the ages of man.

Wheels of Life

IN CREATING the Wheel of Life, medieval artists succeeded in giving pictorial form to the moralist's sentiment that time is fleeting, life is short, and worldly gain is vain in the face of eternity. The image is a variant of the Wheel of Fortune, a popular motif which enjoyed the authority of Boethius. In Book II of his *Consolation of Philosophy* the sixth-century writer presented *Fortuna* as a figure who gives and withholds her favors as she pleases, inconstant, two-faced, blind, and deaf. She has a wheel which she turns, and man, fixed onto the rim, is powerless to stop its rotation: "But I," she says, "shall I be bound by the insatiable desire of men to a constancy quite foreign to my nature? For this is my nature, this is my continual game: turning my wheel swiftly I delight to bring low what is on high, to raise high what is down."[29] Yet Fortune's powers should not be rated too highly. Boethius qualified them, distinguishing providence, God's all-encompassing plan, from fate, the unfolding of things in time. Divine intelligence employs the seemingly random acts of Fortune to a purpose.[30]

Artists gave the literary image its specific shape.[31] To them is owed the vision of a personified Fortune, often blindfolded, standing behind a large wheel clutching its spokes, or beside it turning a crank. Men cling to the rim, four in the simplest representations: one figure ascends, one sits poised on top, one plummets headlong, and one lies prostrate. The image tells a tale of worldly prosperity. Success is defined in terms of power and wealth. The man on top normally appears as a king, crowned, bearing a scepter; a popular set of inscriptions, placed in the mouths of the four figures, defines four states relative to ruling: "I shall rule, I rule, I have ruled, I am without rule" ("Regnabo, regno, regnavi, sum sine regno").[32] Rarely are the figures differentiated according to age. An individual, it is inferred, might pass through the cycle of gain and loss repeatedly. The man at the bottom may soon be on top. The man enjoying success should ready himself for a plunge.

The Wheel of Fortune was transformed into the Wheel of Life when artists ranged figures of the ages of man along its rim. Youths ride upwards, a man in his prime perches on top, and those past prime descend, often now in dignified fashion, feet first. While taking on the associations of the Wheel of Fortune and, thus, suggesting the instability and mutability of the earthly things, the Wheels of Life have as a subject the whole of the earthly existence. Prime is not only the period of maximum prosperity and power over others, but also the time in which the life forces are most strong. Death and the dissolution of the body lie opposite, at the base of the wheel. The cycle is a closed one. An individual is allotted a single revolution, and at its end he has arrived only at the point where he started. The implication is that a man should look beyond the worldly life, so transitory, so deceitful, to a spiritual existence which is not bound by time, the vagaries of chance, and the rhythms of growth and decay.

Scholarly study of the ages of man began in the nineteenth century with the identification of various "Wheels of Life." Didron and others after him interpreted in this light the sculpted figures encircling certain rose windows, notably the twelfth-century window at the Church of St. Étienne at Beauvais and at the thirteenth-century rose on the south transept of the Cathedral at Amiens. Yet few of the sculpture groups, which have long since been classed with the Wheels of Fortune, show traces of age differentiation.[33] At Amiens alone is there a clearly marked distinction between youth and age. Seventeen figures occupy cusps bordering the upper half of the rose.[34] Eight beardless men ascend, a royal figure sits on top, and eight bearded men descend, tumbling downwards, head over heels. These last are miserable in expression, dressed in tatters. The sculptor's primary aim was to draw a contrast between rising and declining fortunes. He used youth as an attribute of the former, age of the latter.

The full-fledged Wheel of Life developed out of the Wheel of Fortune, never to be completely divorced from it. The relation between the types is well demonstrated in a complicated wheel illuminated by the English artist William de Brailes c. 1240, to adorn a psalter (fig. 86).[35] William and his Oxford-based school created a distinctive style characterized by unusual subject matter and complex, segmented compositions. The image in question is a case in point. In the first analysis it is a Wheel of Fortune. The goddess sits in the center behind a wheel with golden spokes, her arms braced to set it in motion. Prominent figures at the four cardinal points hold scrolls inscribed with verses which appear in variant forms on other Wheels of Fortune. An ascending figure, youthful, says, "I am borne again to the stars." A seated king announces, "I exalt on high." A falling figure complains, "Reduced, I descend." At the bottom a recumbent individual, hands clasped, says, "Lowest, I am ground by the wheel."[36]

The wheel remains a Wheel of Fortune, but it is transformed into something

more by the addition of twelve figures who fill out a sequence of the ages of man. In the medallion in the lower left a woman, possibly Fortune herself, bears a scroll which identifies the cycle: *Incipit rota fortune.* She is joined by a swaddled babe and its mother. In the succeeding semicircle a child is shown learning to walk with the aid of a baby walker, an unusual scene at this date, and in the next after that, a child appears shooting an arrow. The fine age differentiation according to characteristic activities ceases here. The figures who represent adolescence and young manhood, each lightly bearded, in two cases bear scepters like the king above them. Those who descend, all bearded, tumble in unwieldy postures, as would be the case at Amiens. The contrast between youth and age similarly takes prominence. But by showing that man is subject to the whims of fortune from infancy, William de Brailes extended the lesson to encompass the whole of the earthly life. Further, by representing a saint's legend, that of Theophilus, in an inner ring, he was able to draw a contrast between the life of the worldly man and the life of a man of God.

It was related in this legend, one of the most popular of the miracles of the Virgin, that Theophilus, a priest, on account of his very great humility, refused to become Bishop of Adana in Cilicia. Slander, however, soon led to his being deprived of his humbler office. Now fervently desiring the bishopric, he summoned the devil, with the help of a Jewish necromancer, and made a pact, written and sealed with his own ring, that he would serve the fiend in exchange for renewed power and influence. Established as bishop, he began to repent his deed. Sorrowing, he called upon the Virgin. At length she appeared, as in a vision, and returned to the penitent his sealed pact. In joy he related his story to the people, and three days later died.[37] This, briefly, is the story recounted in eight scenes in William de Brailes's composition. The particular interest of the cycle lies in its relation, in counterpoint, to the outer ring. The story begins at the opposite point: *Incipit ystoria Theopili* is inscribed in the upper right-hand space. When Theophilus is exalted as a bishop, he is placed at the lowest part of the wheel, directly across from his secular counterpart, the crowned king. His saintly death is represented at the top of the wheel, opposite the death of the man attached to the Wheel of Fortune. Success in the world's eyes, the image asserts, is spiritual failure. Corporal death for the man of God is spiritual triumph.

William de Brailes's composition survives as a unicum. Another English Wheel of Life, an illustrated poem in the form of a ring of ten roundels joined by ten spokes to a central hub, exists in at least four copies. By far the most impressive of these, well-known and frequently described, is a sumptuous schema which appears in the so-called De Lisle Psalter. Here it is one of a series of diagrams painted by a Westminster artist active c. 1310 whom Lucy Sandler has named the "Madonna Master" (fig. 87).[38] The wheel which he illuminated, showing ten clearly distinguished stages of growth and decline in its ten roun-

dels and four in the corners,[39] is more emphatically a Wheel of Life than William de Brailes's had been. Fortune herself does not appear. Her central position is usurped by the nimbed bust of the godhead, circumscribed by the verse, "I perceive all at once, I govern the whole with reason" ("Cuncta simul cerno : totum racione guberno"). God becomes the still center around which man's life unfolds in time. The more distant something is from the pivot of the divine mind, so Boethius would say, the more it is subject to fate.

The phases of the temporal existence of man are defined in five rhyming couplets which circumscribe the ten representations of the stages of life in the outer roundels. Written in the first person, they chart man's changing occupations and preoccupations and his evolving attitudes toward death:

> Mitis sum et humilis, lacte vivo puro.
>> [Meek am I and humble, I live on pure milk.]
> Numquam ero labilis, etatem mensuro.
>> [Never shall I stumble, I measure my age.]
> Vita decens seculi, speculo probatur.
>> [A life worthy of the world is tested by the mirror.]
> Non ymago speculi, set vita letatur.
>> [Not the mirror's image, but life itself delights.]
> Rex sum, rego seculum, mundus meus totus.
>> [I am king, I rule the world, the entire world is mine.]
> Sumo mihi baculum morti fere notus.
>> [I take up a staff for myself, at death's door.]
> Decrepitati deditus mors erit michi esse.
>> [Given over to decrepitude, death shall be my lot.]
> Infirmitati deditus incipio deesse.
>> [Given over to feebleness, I begin to fail.]
> Putavi quod viverem, vita me decepit.
>> [I thought that I would go on living, life has deceived me.]
> Versus sum in cinerem, vita me decepit.
>> [I have been turned into ashes, life has deceived me.][40]

The designer of the pictorial cycle followed the poet's line of thinking to a point. When a verse contained a concrete image, he illustrated it. When the content was more conceptual, he devised a concordant scene. As a result of this close association with verbal imagery, the cycle has peculiarities. It begins in the lower left. The representative of the first age, nourished on pure milk, appears as a child seated on a woman's lap before an open fire on which a pot is heating. This is straightforward. The second inscription and image, the latter incorrectly placed in the third roundel, has attracted more attention. The boy's curious attribute, a balance, has been understood to refer both to his occupation and to his character: as an apprentice, "he has to weigh out the quantities of

his master's goods, and at the same time, symbolically, he begins to estimate the value and contents of life."[41] It is more appropriate to consider the representation an artist's visualization of the odd verse, "I measure my age." The boy confidently believes himself to be in control of his existence.

Since in the following verse the adolescent speaks of the mirror's testimony, he is shown in the corresponding image, wrongly located in the second roundel, combing his hair and gazing into a mirror. The sentiment expressed in the succeeding line, that youth is no longer content with the image in the mirror, gave the designer little to go on. The representation of this high-spirited phase takes the familiar form of a falconer on horseback. The individual at prime, a king who owns the world, is depicted, as on Wheels of Fortune, with a crown and scepter. In the next verse and, thus, in the accompanying image, an older man takes up his staff. He is growing conscious of death. The next two figures announce its approach. One is shown wearily resting his hand on the shoulder of a playful child. The other appears on his deathbed while a physician examines a urine bottle. Death comes, and the next two verses are, in fact, voices from the beyond. The despairing tone taken by the cadavers contrasts with the arrogant optimism of the men in the first half of life. One speaks from a coffin over which a monk reads the Office of the Dead: "I thought that I would go on living." The other, imprisoned in a sarcophagus, brings the cycle to a close: "I have been turned into ashes."

The story of the corporal life is thus taken to its logical conclusion, the dissolution of the body. This is not, properly speaking, a cycle of the "ten ages of man." The individual dies in the eighth age. Efforts to find sources and parallels to other ten-part, or eight-part, schemes can be abandoned as inappropriate. Number would have played little role in the genesis of either the poetic or the artistic program. Symmetry was the dominant formal consideration: the man at prime and the man in the coffin had to be opposed and the phases of increase had to be balanced by an equivalent number of stages of decline.

After the splendid image in the De Lisle Psalter, the same wheel, as it appears on the first leaf of an Irish miscellany of the late thirteenth century in Dublin, comes as rather a shock (fig. 88).[42] Crude and asymmetrical, having no illustrations, its verses are even incorrectly placed. The sequence begins in the uppermost disk, with the result that the line "rex sum, rego seculum" is inscribed in a lower roundel; the scribe sought to compensate for the anomaly by crowning this roundel with a triangle. Despite its aesthetic inadequacies, the diagram, little known, has a value. The label at the hub of the wheel, *Rota etatis*, indicates that it was understood to be a thing distinct from the Wheel of Fortune. A variant reading in the final verse permits a textual emendation. The last line becomes "Versus sum in cinerem : terra me suscepit," and the awkward repetition of the clause *vita me decepit* is eliminated. Inscriptions writ-

ten on the spokes have an even greater interest. These may be interpreted as running descriptions of a set of images in the model which were left uncopied. In each line an age is named and a scene is described. The scene in every case corresponds to the relevant representation in the De Lisle *rota* if, again, the second and third images are restored to their proper places:

> Infans ad ubera
> Puer tenens stateram ma[nu]
> Adolescens ad speculum
> Iuvenis avem portans
> Vir quasi rex
> Senex cum baculo
> Decrepitus cum sustentante puero
> Infirmus in lecto
> Mortuus in feretro
> Incineratus in sepulcro

One has, in effect, a list of pictorial identifications composed by a medieval "iconographer."

The two manuscript versions of the wheel, one so carefully, the other so carelessly executed, were both copied after earlier models. Illuminations like their prototypes no doubt inspired the wheels painted in certain thirteenth-century English churches, notably at Leominster in Herefordshire (c. 1275)[43] and at nearby Kempley in Gloucestershire (fig. 89).[44] At Leominster a representation of David playing his harp flanks the wheel, a feature which suggests its source may have been a psalter. The wall-paintings, both fragmentary, add little to what the manuscripts tell us. At Leominster the surviving images and inscriptions, now written on the outer rim and in auxiliary bands, can be deciphered only insofar as they relate to the De Lisle *rota*. All that remains of the diagram at Kempley is an armature. Yet the paintings document the diffusion of the schema in Britain, an edifying image which tended to appear in contexts where members of the laity might have seen it and profited from its message.

A French Wheel of Life dated c. 1400, copied on a large single leaf, has a different cast.[45] Labeled *La Roe de Mere Natur, Sa Ceste Pourtraiture*, its theme is the inexorable flow of time. Mother Nature, bare-breasted, stands at the base of the wheel, her gloved hands aloft, "generation" and "corruption" inscribed beside her. It is she who guides the wheel to which men of seven different ages and a skeleton representing death are attached. The personified Time is represented above. She is a three-faced figure, her faces signifying the past, the present, and the future. The seasons and the months are inscribed on her four wings, day and night at her feet. The seven canonical hours appear on the rim of the wheel—*heure de prime, tierche, midy, none, vespres, conplie*, and

matines. These are loosely aligned with the seven ages of man in the familiar correlation.

The figures representing the stages of life are again accompanied by verse, but in this case the connection between the two is relatively distant. The poem is in dialogue form. Couplets written between the spokes pose questions:

> Petit enfant pour quoy tant pleures
> De vie quant tu prens les heures?

Quatrains inscribed outside the wheel provide answers:

> En pleurant comme est de coustume,
> Jentre en la terre damertune.
> Le primer eage est dit enfance
> Jusques [vii] ans qui a durance.[46]

There are eight such exchanges. They prove to be loose translations of eight of a total of twelve stanzas in a double poem in Latin which survives in a number of manuscripts, often inscribed within schemata. In the De Lisle Psalter the twenty-four couplets are written within the wheel called the *Duodecim proprietates condicionis humane* (fig. 90).[47] The godhead, *Sancta Trinitas*, takes the central position, and the four evangelist symbols are fit into the corners. The verses, questions asked by *racio* and answered by one of the twelve stages of life, are inscribed sequentially in radial segments. The series begins in the upper left and proceeds in a counterclockwise direction:

> RACIO: Parvule, cur ploras, dum vitales capis horas?
> [Child, why do you cry as you seize life's hours?]
> NASCENS: Nudus, ut est moris, terram flens intro laboris.
> [Naked, as is customary, weeping I enter the world of labor.]

The French translator added two extra lines to each of the responses and in them named the ages and gave their durations—to 7, 15, 28, 35, 50, 70, the end of life, and the Day of Judgment.

The seven ages of man and death, in this image, are depicted clinging to Mother Nature's wheel. A nude infant is followed by a child holding a windmill. An adolescent with a fancy hat and pointed shoes is followed by a well-dressed falconer. A man with a satisfied air is poised at the top. Then the decline begins. A figure sits pensively, hand on chin, and after him a bearded man with a money bag falls head first. A skeletal figure, straddling the wheel, moves upward, brandishing the Grim Reaper's scythe. Despite evident iconographic parallels with other Wheels of Life, the emphasis on the domination of Time and Nature in this one sets it apart. Man is presented as a being subject to natural and inevitable rhythms of growth and decay, his bodily transmutations determined by forces outside himself.[48]

A Wheel of Life which makes its appearance in Germany in the fifteenth century, called the *Rota vite alias fortune*, is more closely allied to the Wheel of Fortune. Like *La Roe de Mere Natur*, it emphasizes man's submission to natural processes of generation and corruption. Several copies survive. Line and wash drawings are to be found in two richly illustrated didactic miscellanies dated to the first quarter of the fifteenth century, sister manuscripts, one in the Biblioteca Casanatense in Rome,[49] one in the Wellcome Institute for the History of Medicine in London (fig. 91).[50] Another appears, along with several variant Wheels of Fortune, in a German fortune-telling manuscript now in Munich, a codex transcribed during the third quarter of the century (fig. 92).[51] A woodcut had been produced by 1460-1470.[52] All share a few basic pictorial elements. Fortune (or, in the print, Life?) occupies the center of the wheel, and an angel stands below. Seven figures representing the stages of life are mounted on the rim. *Infans* in every case lies in a cradle. *Puericia* rides a stick horse in the manuscripts and carries a windmill in the print. *Adolescencia*, gaudily dressed, holds a falcon in all but the Wellcome manuscript. *Iuventus*, crowned in the Casanatense copy, hands raised in the Wellcome copy, appears as a military man in the other two. *Virilitas* generally clutches a money bag, but in the print sits at a counting or gaming table. *Senectus* holds a stick. A last figure, labeled *decrepitus*, nude, with a skull-like visage, prepares to enter or has already entered his tomb. In the Munich copy, busier than the rest, the seven figures and the angel below hold scrolls inscribed with verses which were normally given to the seven ages and the personified Nature in "Trees of Wisdom." The angel who holds the banderole has a significant role. Arms outstretched, he makes a visual connection between the first and last figure, forcing a comparison between the naked infant lying in its cradle and the naked cadaver going to rest in its coffin. *Generatio* is inscribed by the one, *corruptio* by the other. The message is clear. We come into being and pass away, ending where we began, our lives a vanity.

Trees of Life

THE SCHEMATIC Trees of Wisdom are to be distinguished from the more naturalistic Trees of the Ages of Life. In the latter no attempt was made to demonstrate interrelations between sets of ideas. Figures of different ages were simply set among the branches, the sequence following up one side and down the other as it would in a Wheel of Life. The tree's organic nature might have suggested that it could appropriately bear a cycle showing physical change: man reaches prime in the same way that a tree grows to achieve a maximum height. Still, a healthy tree is not a wholly logical setting for a story of growth and decay, and it is unorthodox for a tree's two sides to read in opposite directions.

A large tree diagram supporting figures at twelve stages of life is copied into the *Concordantia caritatis* (figs. 93-94).[53] This compendium, put together by Ulrich of Lilienfeld after 1351, contains a number of such arboreal schemata along with representations of the virtues and vices and a lengthy series of texts and typological compositions arranged to follow the liturgical year. The original remains in Lilienfeld, and at least five illustrated copies from the fifteenth century survive, one of which, an Austrian copy of the mid-fifteenth century, is particularly finely drawn (figs. 95-96).[54] Several of Ulrich's trees accommodate themselves to the proportions of a codex only with difficulty. The Tree of Life is cut in the middle, the bottom half painted on a verso folio, the top half on a facing recto. In the later copy the artist rationalized the odd arrangement: cutting the trunk on the diagonal, he drew in the tree rings. Twelve figures representing the ages of man are nestled in large curling tendrils. Naming such an extended series must have taxed the designer's imagination. Imbecile, infirm, dying, and dead join the more familiar terms—*nascens, infans, puer, adolescens, iuvenis, vir, senex, decrepitus, inbecillis, infirmus, moriens,* and *mortuus.* All carry scrolls inscribed with verses. These prove to correspond almost precisely to the twelve responses in the diagram called the *Duodecim proprietates condicionis humane* (fig. 90).

In the first three scenes the mother watches over her child, first holding him "nude," then breastfeeding him, and then teaching him to walk.[55] These images conform quite closely to the verses, two of them already familiar:

> Nudus, ut est moris, terram flens intro laboris.
> Infans absque dolo, matris fruor ubere solo.
> Ambulo securus, dum vivo crimine purus.

In the later copy verse instructions were ignored: the newborn lies in his mother's bed, the suckling infant instead learns to walk with a baby-walker, and the ambulating child is instead given a school tablet. Moving to the second folio, one finds in both a boy playing with a whip top, a youth standing in elaborate dress, and an armored man, bearing a sword, holding a spear. There is no figure at the crown of the tree, the number of ages being even. The first of the stages of decline is represented in the early copy by means of two men who through their gestures are shown to be discoursing on some subject. In the later codex it is a single figure. Things worsen. The following character sits dejectedly. The next stands with a stick. The final three lie prostrate. Death occurs in the penultimate scene, man's soul in the form of a nude infant shown passing from his mouth. At the very end he lies in grave wrappings in his sarcophagus. The contrast between the mother lying with an infant and the recumbent corpse, symmetrically set out, must be intentional.

An earlier tree, one painted by an Italian miniaturist identified as the "Biadaiolo Illuminator" c. 1335, has a different character. Nor is it a member of

the schemata set to which so many of the diagrams have belonged. The tree comes after the explicit in a copy of Brunetto Latini's thirteenth-century encyclopedia, the *Tesoro* (fig. 97).[56] Inscriptions are confined to Roman numerals supplying the durations of the ages. These, placed beside the seven figures perched on the branches, count up the phases of life in decades. Two scenes, a baby on its mother's lap and a child chasing a bird, represent the first period. The second is illustrated by means of a maiden and a twenty-year-old youth looking into a mirror, and the third by a young man with a book. A kneeling figure, hands clasped in prayer, occupies the exalted position at the crown of the tree, "XL" inscribed above him. The fifty-year-old then stands quietly, and the sixty-year-old sits head on hand. At age seventy a man kneels before a seated monk who, in turn, places his hand on the aged penitent's head in blessing. The generally pious air which pervades the cycle is heightened by scenes at the base of the tree. Here the two principal sacraments are enacted, baptism on the left and communion, presumably last communion, on the right. The worthy life is outlined, more explicitly than elsewhere, with a more pronounced ecclesiastical orientation. Man enters the church in his infancy, remembers to be grateful to God at prime, repents when he is old, and dies in a state of blessedness.

Steps of Life

ONLY in the sixteenth century, a period which lies beyond the bounds of this study, did a pyramid of steps come to be employed as an armature for representing the stages of life. An engraving in four blocks by Jörg Breu the Younger, dated 1540, is the earliest known of its representations (fig. 98).[57] Figures of the ages of man, ten in all, beginning with the babe in its cradle on the left, proceeding to the man of middle years at the top, and ending with the elderly man on the right, occupy nine steps, while nine animals fill the niches beneath. Clouds darken the sky above the men on the downward slope. The skeletal figure of Death, with bow and arrow, is stationed at the summit of the pyramid, directly behind the man secure at the prime of life. A coffin stands ready at the base of the steps in close proximity to the scene of the Last Judgment. The lesson which this mélange of motifs suggests is by now familiar. As in the Wheels and Trees of Life, human existence is shown to be but a rise to a fleeting period of strength followed by a weary decline. Death, a concrete presence, haunts the scene.

Later versions of the steps of life, and there are many, agree in all essentials, though sometimes women, sometimes couples stand on the stairs. In certain cases numbers giving the durations of the ages are inscribed beside the figures, in decades, ten to one hundred, fifty representing the peak. Often titulus verses, commonly beginning "ten years a child," accompany the images. These fea-

tures place the steps of life in an older tradition. In Germany, as early as the thirteenth century, the human life had been divided into ten stages, each lasting ten years. The system was defined in a numerical poem which circulated widely, with variations, in the late Middle Ages. An engraving of the ten ages of life dated 1482 preserves it in this form:

10 iar ein kint
20 iar ein jungling
30 iar ein man
40 iar wolgetan
50 iar stillstan
60 iar abgan
70 iar die sele bewar
80 iar der welt tor
90 iar der kinder spot
100 iar nu gnad dir got.[58]

In the fifteenth century and after it became common to place these ten ages in conjunction with ten animals.[59] The qualities of the beasts then contributed to the characterizations of the different ages, sometimes with humorous effect. The list of animals selected varied from case to case, and a completely different set was devised for the representation of the ages of woman. In the print of 1482 the catalogue appears as follows:

10 iar ein kycz [kid]
20 iar ein kalb [calf]
30 iar ein styr [bull]
40 iar ein lew [lion]
50 iar eyn fuchs [fox]
60 iar eyn wolf [wolf]
70 iar eyn hunt [hound]
80 iar ein kacz [cat]
90 iar ein esel [ass]
100 iar eyn ganz [goose]

Designers of the steps of life adapted this line of thought, creating appropriate figures and placing them on massive architectural bridges which gave structure to life's progress. A symmetrical pyramid must, of course, have an uneven number of steps. Nine stairs were depicted and these supported nine, but sometimes ten, figures and nine or ten corresponding animals. It was an image which took hold. Artists from the sixteenth to the twentieth century, German, French, Italian, Spanish, English, and American, experimented with the pictorial form, updating costumes, rethinking the occupations.[60] Thus, despite

changing circumstances and sensibilities, a late medieval interpretation of the human life was perpetuated long beyond its time.

Popular art kept the scheme of age division alive, one of the simplest to have been created, one which reveals little of the richness and complexity of medieval thinking about life's course. In the previous centuries significant scholars and important artists, as well as humble imitators and minor talents, had turned their attention to the ages of man. Speculations about the stages of life were many and diverse, competing systems arising in different spheres of learning to serve different ends. In each act of division and definition an interpretation of the human life is to be found. There is a wisdom in certain of the perceptions and in some of the questions asked from which, one thinks, the twentieth century might learn.

NOTES

NOTES TO THE INTRODUCTION

1. Ps.-Bede, *Collectanea* (PL 94, 545): "Septem sunt quae non inveniuntur in hoc mundo: vita sine morte, iuventus sine senectute, lux sine tenebris, gaudium sine tristitia, pax sine discordia, voluntas sine iniuria, regnum sine commutatione. Septem vero haec inveniuntur in regno coelorum."

2. Karl Goedeke (1856); Wilhelm Wackernagel (1862); Leopold Löw (1875). For full references see Bibliography.

3. "Die Lebensalter: Ein Beitrag zur antiken Ethologie und zur Geschichte der Zahlen," *Neue Jahrbücher für das klassische Altertum, Geschichte und deutsche Literatur und für Pädagogik*, 31 (1913), pp. 89-145.

4. *The Pilgrimage of Life* (New Haven and London, 1962).

5. *Lebensalter-Darstellungen im 19. und 20. Jahrhundert: Ikonographische Studien*, Diss., Munich, 1970 (Bamberg, 1971).

6. "Die Einteilung des menschlichen Lebens im römischen Altertum," *Rheinisches Museum für Philologie*, N.F. 116 (1973), pp. 150-190.

7. Roderich Schmidt (1955-1956); Auguste Luneau (1964); Paul Archambault (1966). For full references see Bibliography.

NOTES TO CHAPTER I

1. *De generatione animalium* V, 3 (784a14-19) (ed. Drossaart Lulofs, p. 190; trans. Arthur Platt, n.p.). Aristotle is discoursing on the phenomenon of baldness in man and the reasons for its irreversibility.

2. The literature on the medieval divisions of philosophy is large. Particularly useful is James A. Weisheipl's study, "Classification of the Sciences in Medieval Thought," *Mediaeval Studies*, 27 (1965), pp. 54-90.

3. Hrabanus Maurus, *De rerum naturis* XV, 1 (PL 111, 413). For sources and parallels to Hrabanus's scheme see Bernhard Bischoff, "Eine verschollene Einteilung der Wissenschaften," *AHDLMA*, 33 (1958), pp. 5-20; rpt. in his *Mit-*

telalterliche Studien, 1 (Stuttgart, 1966), pp. 273-288.

4. *Bibliotheca historica* X, 9, 5 (ed. and trans. Oldfather, 4, pp. 68-69). Holger Thesleff believes Diodorus's source to have been early Pythagorean, possibly of the fourth century B.C. See *An Introduction to the Pythagorean Writings of the Hellenistic Period* (Åbo, 1961), pp. 25-26, 109, 113.

5. *Vitae philosophorum* VIII, 10 (ed. Long, 2, pp. 396-397; trans. Hicks, 2, p. 329). The ages in this case are παῖς, νεηνίσκος, νεηνής, and γέρων, although the author supplied alternative designations for the second and third terms: μειράκιον, ἀνήρ.

6. *Metamorphoses* XV, 199-213 (ed. Anderson, pp. 364-365). A description of the changing shape and strength of the human body from conception through old age follows (*Met.* XV, 214-227). Ovid is thought to have consulted a Pythagorean source which Thesleff would place in the third-second century B.C. (pp. 26, 109, 113).

7. For a judicious account of the nature of early Pythagorean thought and its evolution in antiquity see Walter Burkert, *Lore and Science in Ancient Pythagoreanism*, translated from the German edition of 1962 by E. L. Minar, Jr. (Cambridge, Mass., 1972).

8. Aristotle, an important source of information on primitive Pythagoreanism, wrote (*Metaphysica* 1080b16): "Now the Pythagoreans, also, believe in one kind of number—the mathematical; only they say it is not separate but sensible substances are formed out of it. For they construct the whole universe out of numbers . . ." (Diels, no. 58B9 [I, 453, 39], trans. Ross). Cf. *Met.* 985b23, 987a13, 987b28, 1083b8, 1090a20. On Pythagorean number theory see especially W.K.C. Guthrie, *A History of Greek Philosophy*, 1 (Cambridge, 1962), pp. 212-306; Burkert, pp. 427-482.

9. The oath is quoted by many authors in several variants (Diels, no. 58B15 [I, 455, 9]). Macrobius, fifth-century Neoplatonist, made

it available to the Latin West in his influential *Commentary on the Somnium Scipionis* I, 6, 41 (ed. Willis, p. 25): "per qui nostrae animae numerum dedit ipse quaternum." For theories concerning the definition and significance of the tetractys see Armand Delatte, "La tétractys pythagoricienne" in *Études sur la littérature pythagoricienne* (Paris, 1915), pp. 249-268; Paul Kucharski, *Étude sur la doctrine pythagoricienne de la tétrade* (Paris, 1952).

10. The earliest works in the tradition are lost. Speusippus, successor to Plato as head of the Academy, wrote a tract *On the Pythagorean Numbers* which contained a section devoted to the decad. Telauges, son of Pythagoras, is credited with a work on the tetractys, and Archytas, student of Philolaus, is named as the author of a text *On the Decad*. Both the latter are generally placed among the pseudepigrapha. On arithmological literature see Paul Tannery, "Sur l'arithmétique pythagoricienne" in *Mémoires scientifiques*, 2 (Toulouse and Paris, 1912), pp. 179-201; Delatte, *Études*; Frank Egleston Robbins, "Posidonius and the Sources of Pythagorean Arithmology," *Classical Philology*, 15 (1920), pp. 309-322; idem, "The Tradition of Greek Arithmology," *Classical Philology*, 16 (1921), pp. 97-123.

11. *Expositio rerum mathematicarum ad legendum Platonem utilium* (ed. Hiller, pp. 93-99 [tetractys], p. 98 [ages]; trans. Taylor, pp. 235-239). See Tannery, "Sur Théon de Smyrne" in *Mémoires scientifiques*, 2, pp. 455-465; Kucharski, pp. 31-39.

12. [Iamblichus], *Theologumena arithmeticae* 16-24 (ed. de Falco, pp. 20-30, esp. 25). The compiler's chief sources were a lost arithmological work by the second-century Neopythagorean Nicomachus of Gerasa and Anatolius's *On the Decad*. See F. E. Robbins and L. C. Karpinski, "Studies in Greek Mathematics" in Nicomachus of Gerasa, *Introduction to Arithmetic*, trans. M. L. D'Ooge (New York, 1926), esp. pp. 82-87. On the false attribution to Iamblichus see Bent Dalsgaard Larsen, *Jamblique de Chalcis: Exégète et philosophe*, Diss., Aarhus, 1970 (Aarhus, 1972), pp. 146-147.

13. *Commentarius in aureum pythagoreorum carmen*, verse 47 (ed. Koehler, p. 89). For sources see Theo Kobusch, *Studien zur Philosophie des Hierokles von Alexandrien* (Munich, 1976), pp. 188-191.

14. Cf. Aristoxenus in Stobaeus, *Florilegium* IV, 1, 49 (Diels, no. 58D4 [I, 469, 29]); Iambli-

chus, *De vita pythagorica* 201-202 (Diels, no. 58D8 [I, 473, 42]; trans. Taylor, pp. 104-105). See Kathleen Freeman, *The Pre-Socratic Philosophers: A Companion to Diels, Fragmente der Vorsokratiker* (Oxford, 1946), p. 257, and the not wholly satisfactory account by C. J. de Vogel, *Pythagoras and Early Pythagoreanism* (Assen, 1966), pp. 166-168. Michael von Albrecht supplies a context for analysis in his "Das Menschenbild in Iamblichs Darstellung der pythagoreischen Lebensform," *Antike und Abendland*, 12 (1966), pp. 51-63.

15. On the evolution of tetradic cosmology see especially Erich Schöner, *Das Viererschema in der antiken Humoralpathologie*, Sudhoffs Archiv, Beiheft 4 (Wiesbaden, 1964); Raymond Klibansky, Erwin Panofsky, and Fritz Saxl, *Saturn and Melancholy* (London, 1964), pp. 3-15.

16. Cited by Simplicius (Diels, no. 31B17 [I, 316, 12]). On the parallels between Empedoclean and Pythagorean thought see W.K.C. Guthrie, *A History of Greek Philosophy*, 2 (Cambridge, 1965), pp. 141-142. For an account of the genesis of the Empedoclean tetrad which stresses its empirical foundation see James Longrigg, "The 'Roots of All Things,' " *Isis*, 67 (1976), pp. 420-438. Plato gave authority to the system, demonstrating in the *Timaeus* (31B-32C) that on mathematical grounds there can be neither more nor fewer than four elements. See F. M. Cornford, *Plato's Cosmology* (London and New York, 1937), pp. 43-52.

17. For an account of early forms of the theory and an analysis of the positive and negative values placed on the different qualities see G.E.R. Lloyd, "The Hot and the Cold, the Dry and the Wet in Greek Philosophy," *Journal of Hellenic Studies*, 84 (1964), pp. 92-106; idem, *Polarity and Analogy: Two Types of Argumentation in Early Greek Thought* (Cambridge, 1966), pp. 15-85. Aristotle discussed the binding of qualities and elements at length, giving theoretical weight to the system, in his *De generatione et corruptione* (329a30-331a6). See Schöner, pp. 66-67.

18. On the identification of the humors, in addition to Schöner and Klibansky-Panofsky-Saxl, see Hellmut Flashar, *Melancholie und Melancholiker in den medizinischen Theorien der Antike* (Berlin, 1966); Bennett Simon, *Mind and Madness in Ancient Greece: The Classical Roots of Modern Psychiatry* (Ithaca and London, 1978), pp. 228-237.

19. *De natura hominis* 1-7 (ed. and trans. Jouanna, CMG I, 1, 3, pp. 164-186). See Schöner, pp. 17-21; Flashar, pp. 39-44. Jouanna argues for Empedoclean influence.

20. *Aphorismi* III, 18 (ed. and trans. Jones, 4, pp. 128-129). In a succeeding section (*Aph.* III, 24-31) diseases characteristic of the different times of life are enumerated. Also to be noted is *Aph.* I, 13 (Jones, 4, pp. 104-105): "Old men (γέροντες) endure fasting most easily, then men of middle age (καθεστηκότες), youths (μειράκια) very badly, and worst of all children (παιδία), especially those of a liveliness greater than the ordinary."

21. *De diaeta* I, 33 (ed. and trans. Joly, pp. 28-29). On this passage see Lloyd, "Hot and Cold," p. 103, n. 43.

22. *De diaeta* I, 32, 4 (ed. and trans. Joly, p. 27).

23. *Definitiones medicae* 104 (ed. Kühn, 19, pp. 373-374). See Jutta Kollesch, *Untersuchungen zu den pseudogalenischen Definitiones medicae*, Schriften zur Geschichte und Kultur der Antike, 7 (Berlin, 1973), pp. 101 and passim. On the pneumatic school see Fridolf Kudlien, "Pneumatische Ärtze" in *Paulys Realencyclopädie*, Supplementband XI (Stuttgart, 1968), cols. 1097-1108. On its founder see Eberhard Kulf, *Untersuchungen zu Athenaios von Attaleia: Ein Beitrag zur antiken Diätetik*, Diss., Göttingen, 1970. Schöner argues, largely on the basis of negative evidence, that humoral theory and the tetradic schema held comparatively little place in medicine from c. 300 to the first century B.C. (p. 78).

24. On Galen's brand of humoral theory and its extraordinary influence see especially Rudolph E. Siegel, *Galen's System of Physiology and Medicine: An Analysis of His Doctrines and Observations on Bloodflow, Respiration, Humors and Internal Diseases* (Basel, 1968); Owsei Temkin, *Galenism: Rise and Decline of a Medical Philosophy* (Ithaca and London, 1973).

25. *De elementis ex Hippocrate* I, 7-8 (ed. Kühn, 1, pp. 473-480). Galen advanced similar ideas in his late *In Hippocratis de natura hominis commentaria* (ed. Mewaldt, CMG V, 9, 1). See Siegel, pp. 145-151; Wesley D. Smith, *The Hippocratic Tradition* (Ithaca and London, 1979), pp. 87-89, 98-99.

26. Schöner, pp. 86-93.

27. *De placitis Hippocratis et Platonis* VIII, 693 (ed. and trans. de Lacy, CMG V, 4, 2, pp. 518-521). Galen quotes the Hippocratic aphorism concerning the seasons and the ages (III, 18) in the *De placitis* (VIII, 697) and comments on it in his *In Hippocratis aphorismos commentarii* (ed. Kühn, 17:2, pp. 612-614). For Galen on regimen see below, p. 44.

28. *De temperamentis* I, 8 (ed. Helmreich, pp. 29-32). Cf. *De sententiis* 5 (currently being edited for CMG by Vivian Nutton). See Schöner, p. 93; Flashar, pp. 105-111; L. J. Rather, "Two Questions on Humoral Theory," *Medical History*, 15 (1971), pp. 396-398.

29. *On the Constitution of the Universe and of Man* III, 1-4 (ed. Ideler, 1, p. 304). The age groups, labeled παιδία, νεανίσκοι, ἄνδρες, and γέροντες, are then said to terminate at years 14, 28, 42, and 80 (IV, 3). On this text see Klibansky-Panofsky-Saxl, *Saturn and Melancholy*, pp. 58-59; Schöner, pp. 96-97.

30. *Tetrabiblos* I, 10 (28-30) (ed. and trans. Robbins, pp. 58-65).

31. *Thesaurus*, "proemium" (ed. Boll, CCAG I, p. 143). See Franz Boll and Carl Bezold, *Sternglaube und Sterndeutung*, 4th ed. (Leipzig and Berlin, 1931), p. 54. Fragments only of this text survive, incorporated into a compendium by Rhetorius, possibly in the early seventh century. See David Pingree, "Antiochus and Rhetorius," *Classical Philology*, 72 (1977), pp. 203-223.

32. *De medicina* II, 1, 17-22 (ed. and trans. Spencer, pp. 92-97): "As regards the various times of life, children and adolescents (*pueri proximique his*) enjoy the best health in spring, and are safest in early summer; old people (*senes*) are at their best during summer and the beginning of autumn; young and middle-aged adults (*iuvenes quique inter iuventam senectutemque sunt*) in winter." Cf. *Aphorismi* III, 18 and 24-31. Celsus has turned the analogy around, giving prominence to the ages. He also supplied a variant of *Aph.* I, 13 in *De medicina* I, 3, 32 (Spencer, pp. 64-65): "As to what pertains to age: the middle-aged (*mediae aetates*) sustain hunger more easily, less so young people (*iuvenes*), and least of all children (*pueri*) and old people (*senectute confecti*)" [ref. above, n. 20]. On Roman hygiene and its relation to Hellenistic medicine see Georg Harig, "Die Diätetik der römischen Enzyklopädisten," *NTM*, 13 (1976), pp. 1-15.

33. *Astronomica* 2, 841-855 (ed. and trans. Goold, pp. 148-149).

34. *De senectute* 10, 33 (ed. Simbeck, p. 17): "Cursus est certus aetatis et una via naturae ea-

que simplex suaque cuique parti aetatis tempestivitas est data, ut et infirmitas puerorum et ferocitas iuvenum et gravitas iam constantis aetatis et senectutis maturitas naturale quiddam habeat, quod suo tempore percipi debeat."

35. *Ars poetica* 153-178 (ed. Klingner, pp. 300-301). On this passage see P. Colmant, "Les quatre âges de la vie," *Les études classiques*, 24 (1956), pp. 58-63.

36. See above, p. 10.

37. On the place of didactic diagrams in ancient book illumination see Kurt Weitzmann, *Illustrations in Roll and Codex: A Study of the Origin and Method of Text Illustration* (Princeton, 1947; rpt. with addenda, 1970), pp. 47-53, 120-121.

38. The medieval diagram, perhaps because it falls into a no man's land between text and image, suffered scholarly neglect until quite recently. Its study came of age in several articles by Harry Bober, namely "The Zodiacal Miniature of the *Très Riches Heures* of the Duke of Berry—Its Sources and Meaning," *Journal of the Warburg and Courtauld Institutes*, 11 (1948), pp. 1-34; "An Illustrated Medieval School-Book of Bede's 'De Natura Rerum,' " *Journal of the Walters Art Gallery*, 19-20 (1956-1957), pp. 65-97; "In Principio. Creation Before Time" in *De Artibus Opuscula XL: Essays in Honor of Erwin Panofsky*, ed. Millard Meiss (New York, 1961), pp. 13-28. Recent studies of interest include: Anna C. Esmeijer, *Divina Quaternitas: A Preliminary Study in the Method and Application of Visual Exegesis* (Amsterdam, 1978); Gerhart B. Ladner, "Medieval and Modern Understanding of Symbolism: A Comparison," *Speculum*, 54 (1979), pp. 223-256; Michael Evans, "The Geometry of the Mind," *Architectural Association Quarterly*, 12 (1980), pp. 32-53; Madeline H. Caviness, "Images of Divine Order and the Third Mode of Seeing," *Gesta*, 22/2 (1983), pp. 99-120; Karl-August Wirth, "Von mittelalterlichen Bildern und Lehrfiguren im Dienste der Schule und des Unterrichts" in *Studien zum städtischen Bildungswesen des späten Mittelalters und der frühen Neuzeit*, Bericht über Kolloquien der Kommission zur Erforschung der Kultur des Spätmittelalters 1978 bis 1981, ed. Bernd Moeller et al. (Göttingen, 1983), pp. 256-370; John E. Murdoch, *Album of Science: Antiquity and the Middle Ages* (New York, 1984).

39. See Ernest Wickersheimer, "Figures médico-astrologiques des IXe, Xe et XIe siècles,"

Janus, 19 (1914), esp. pp. 157-159; Bober, "In Principio."

40. For the origin and transmission of the treatise see Jacques Fontaine's study, *Isidore de Séville: Traité de la nature* (Bordeaux, 1960), pp. 1-83. On the diagrams Fontaine, pp. 15-18; Bernard Teyssèdre, "Un exemple de survie de la figure humaine dans les manuscrits précarolingiens: Les illustrations du De natura rerum d'Isidore," *Gazette des Beaux-Arts*, 56 (1960), pp. 19-34; Wesley M. Stevens, "The Figure of the Earth in Isidore's 'De natura rerum,' " *Isis*, 71 (1980), pp. 268-277.

41. Paris, Bibliothèque Nationale, ms. lat. 6400 G, fol. 122v. On this manuscript, probably French, dated to the late seventh or early eighth century, see Fontaine, pp. 25-26, 71; Teyssèdre, esp. pp. 29-31, figs. 1-4, 7, 9-10, 15-16; E. A. Lowe, *Codices latini antiquiores*, 5 (Oxford, 1950), p. 14 (no. 564a).

42. *De natura rerum* XI, 2-3 (ed. and trans. Fontaine, pp. 214-217). Cf. Ambrose, *Hexaemeron* III, 4 (18) (ed. Schenkl, CSEL 32:1, pp. 71-72; trans. Savage, FC 42, pp. 80-81). For the various strands of the ancient and medieval tradition see Peter Vossen, "Über die Elementen-Syzygien" in *Liber Floridus* (Festschrift Paul Lehmann), ed. Bernhard Bischoff and Suso Brechter (St. Ottilien, 1950), pp. 33-46.

43. An identically structured diagram, labeled *annus*, illustrated the section of the treatise concerning the seasons and demonstrated the relations between the four seasons and the four directions through the four qualities. This schema and the *mundus-annus-homo* diagram sometimes migrated together to scientific miscellanies to be rendered as a pair. See, for example, Paris, Bibliothèque Nationale, ms. lat. 5543, fol. 136r (9th c.) [repr. Bober, "School-Book," fig. 13b]; ms. nouv. acq. lat. 1618, fols. 85r, 95r (11th c.); ms. lat. 5239, fol. 145r (11th c.); Baltimore, Walters Art Gallery, ms. 73, fol. 8r (late 12th c.) [repr. Bober, "School-Book," fig. 4]; Vienna, Österreichische Nationalbibliothek, cod. 12600, fol. 76v (late 12th c.).

44. Many useful studies on the subject exist: Rudolf Allers, "Microcosmus from Anaximandros to Paracelsus," *Traditio*, 2 (1944), pp. 319-407; Fritz Saxl, "Macrocosm and Microcosm in Mediaeval Pictures" in *Lectures* (London, 1957), pp. 58-72; W.K.C. Guthrie, "Man's Role in the Cosmos. Man the Microcosm: The Idea in Greek Thought and Its Leg-

acy to Europe" in *The Living Heritage of Greek Antiquity* (The Hague, 1967), pp. 56-73; M.-D. Chenu, "Nature and Man—The Renaissance of the Twelfth Century" in *Nature, Man, and Society in the Twelfth Century*, translated from the French edition of 1957 by Jerome Taylor and Lester K. Little (Chicago and London, 1968), pp. 1-48; Marian Kurdzialek, "Der Mensch als Abbild des Kosmos" in *Miscellanea mediaevalia*, 8: *Der Begriff der Repraesentatio im Mittelalter* (Berlin and New York, 1971), pp. 35-75; Marie-Thérèse d'Alverny, "L'homme comme symbole. Le microcosme" in *Simboli e simbologia nell'alto medioevo*, Settimane di studio del Centro italiano di studi sull'alto medioevo, 23 (Spoleto, 1976), pp. 123-183. Only in the last is the notion of the temporal microcosm introduced.

45. *Consolatio philosophiae* III, metrum 9 (ed. Bieler, CCL 94, pp. 51-52). See Helga Scheible, *Die Gedichte in der Consolatio philosophiae des Boethius* (Heidelberg, 1972), pp. 101-112.

46. Gloss on *mediam animam* (ed. Silk, p. 336): "Prudentioribus autem videtur hoc loco potius animam rationabilem debere intellegi quae magnam concordiam habet cum mundo; unde et homo Graece microcosmos dicitur, id est minor mundus. Sicut enim mundus quatuor elementis et quatuor temporibus constat ita et homo quatuor humoribus et quatuor temporibus."

Excerpts of the text had been published by H. F. Stewart in "A Commentary by Remigius Autissiodorensis on the *De consolatione philosophiae* of Boethius," *Journal of Theological Studies*, 17 (1916), pp. 22-42. See also Pierre Courcelle, *La Consolation de Philosophie dans la tradition littéraire: Antécédents et postérité de Boèce* (Paris, 1967), esp. pp. 241-274, 278-290; Diane K. Bolton, "Remigian Commentaries on the 'Consolation of Philosophy' and Their Sources," *Traditio*, 33 (1977), pp. 381-394.

47. Biblioteca Apostolica Vaticana, cod. Pal. lat. 1581, fol. 35r. Cited by Léon Pressouyre, "Le cosmos platonicien de la Cathédrale d'Anagni," *Mélanges d'archéologie et d'histoire* (École Française de Rome), 78 (1966), p. 557, n. 1. See Courcelle, p. 405. The diagram is to be found in a tenth-century codex in the Berlin Staatsbibliothek, cod. Maihingensis I. 2. lat. 4°, fol. 86v (and no doubt in many others as well). Cf. Vossen, p. 43; Esmeijer, pp. 36-38.

48. Paris, Bibliothèque Nationale, ms. lat. 12999, fol. 7r (diagram), fols. 6v-7v (text). The pastiche was hitherto unidentified. See Léopold Delisle, *Inventaire des manuscrits conservés à la Bibliothèque Impériale* (Paris, 1863), p. 84; Brian Stock, *Myth and Science in the Twelfth Century* (Princeton, 1972), pp. 20-21, pl. IIIB (wrongly identified).

49. London, British Library, ms. Cotton Faustina C. I, fol. 89r. Alison Peden discusses the manuscript and reproduces the diagram in her article, "Science and Philosophy in Wales at the Time of the Norman Conquest: A Macrobius Manuscript from Llanbadarn," *Cambridge Medieval Celtic Studies*, 2 (1981), pp. 21-45, esp. p. 38, pl. IV.

50. *Comm. in Somnium Scipionis* II, 12, 11 (ed. Willis, p. 132): "ideo physici mundum magnum hominem et hominem brevem mundum esse dixerunt." Macrobius manuscripts without gloss normally contain no more than five diagrams (zodiac, rain, zones, and ecliptic schemata, and a world map). See Bruce Charles Barker-Benfield, "The Manuscripts of Macrobius' Commentary on the *Somnium Scipionis*," D. Phil. Thesis, Oxford, 1975.

51. Ghent, Universiteitsbibliotheek, ms. 92, fol. 228v. The diagram appears in six of the nine later copies of the work. See Léopold Delisle, *Notice sur les manuscrits du 'Liber Floridus'* (Paris, 1906), pp. 128-129 (no. 260). The manuscript will be discussed more fully below, pp. 67-69.

52. *De nuptiis Philologiae et Mercurii* I, 16-17 (ed. Willis, pp. 8-9; trans. Stahl and Johnson, p. 12).

53. For cosmological subjects in medieval pavements see Hiltrud Kier, *Der mittelalterliche Schmuckfussboden unter besonderer Berücksichtigung des Rheinlandes* (Düsseldorf, 1970), esp. pp. 69-72. A fragmentary pavement dating 1153-1162 from the Cathedral of Hildesheim has been called a cycle of the four ages of life and the virtues because the labeled figure of *Iuventus*, a female, survives along with *Fortitudo* and *Sapientia* (Kier, pp. 100-102). The reconstruction is unsatisfactory since "youth" on its own can, like joy, be a virtue and because virtues, not ages of man, are normally represented as female personifications.

54. On the fresco cycle as a whole see Pietro Toesca, "Gli affreschi della Cattedrale di Anagni," *Le gallerie nazionali italiane*, 5 (1902), pp. 116-187; M. Q. Smith, "Anagni: An Example of Medieval Typological Decoration," *Papers of the British School at Rome*, 33 (1965), pp. 1-47;

Pressouyre, pp. 551-593; Otto Demus, *Roman-esque Mural Painting*, translated from the German edition of 1968 by Mary Whittall (New York, 1970), pp. 304-305. On the tetradic diagram in context see Toesca, pp. 128-130; Smith, pp. 9-13; Pressouyre, pp. 573-576, fig. p. 574; d'Alverny, "Microcosme," pp. 182-183, pl. VII; Esmeijer, pp. 39-40, fig. 19b.

55. Pressouyre suggests that the learned subjects "émanent d'une méditation sur la Genèse" and are representative of the long-standing efforts among theologians to reconcile Platonic philosophy with the biblical account of creation (p. 589).

56. *Tractatus de fabrica mundi* 3 (ed. Hausslei-ter, CSEL 49, p. 4; trans. Wallis, pp. 388-389). On Victorinus see Johannes Quasten, *Patrology*, 2 (Westminster, Md., 1953), pp. 411-413.

57. *De Abraham* II, 9, 65 (ed. Schenkl, CSEL 32:1, p. 619ff.). Ambrose ends by comparing the desired growth of faith through the four periods with the phases in the growth of a tree: "feramus etiam fructum fidei ab ipsa pueritia, augeamus in adulescentia, coloremus in iuventute, conpleamus in senectute." For a comparison of the passage to Cicero, *De senectute* 51, and Tertullian, *De virginibus velandis* I, 5-6, see Paul Archambault, "The Ages of Man and the Ages of the World: A Study of Two Traditions," *Revue des études augustiniennes*, 12 (1966), pp. 201-202.

58. *De nuptiis Philologiae et Mercurii* VII, 734 (ed. Willis, p. 264). I quote from the translation by William Harris Stahl and Richard Johnson in *Martianus Capella and the Seven Liberal Arts*, 2 (New York, 1977), pp. 278-279. For commentary see Stahl and Johnson, 1 (1971), pp. 151-154. Martianus's immediate source for this section has not been established. Some have suggested the book on arithmetic in Varro's lost compendium, the *Disciplinarum libri IX*. See Manfred Simon, "Zur Abhängigkeit spät-römischer Enzyklopädien der artes liberales von Varros Disciplinarum libri," *Philologus*, 110 (1966), pp. 88-101, esp. 99.

59. Claudio Leonardi catalogued 241 manuscripts, ranging in date from the ninth to the sixteenth century, in his study of the fortunes of Martianus Capella, *I codici di Marziano Capella* (Milan, 1959-1960) [appeared concurrently as a series of articles in *Aevum*, vols. 33, 34]. Most of the complete copies fall into the ninth and tenth centuries. The tract continued to be taken seriously by schoolmen, however,

into the twelfth century. As is often noted, the learned Thierry of Chartres selected Martianus's Book VII (on arithmetic), along with Boethius's *De arithmetica* and a short anonymous tract, to represent the discipline of arithmetic in his own compendium of the Liberal Arts, the *Eptateuchon* (formerly Chartres, Bibliothèque Municipale, mss. 497-498; destroyed in World War II).

60. *Commentum in Martianum Capellam* 369, 21 (ed. Lutz, 2, p. 187): "QUATTUOR AETATES infantiam, pueritiam, adolescentiam, iuventutem. Hic status est incrementi, ultra enim non crescit homo nec ingenio nec statura corporis. Quidam quartam aetatem dicunt senectutem esse." Elsewhere in the commentary he states that growth is complete by the thirty-fifth year (374, 5). On the gloss tradition and related issues see William H. Stahl, "To a Better Understanding of Martianus Capella," *Speculum*, 40 (1965), pp. 102-115.

61. For the four ages in a Remigian gloss on Boethius see above, p. 18. John Scottus Eriugena also wrote a commentary on Martianus Capella, but Books VI-IX of the text published under his name have been judged to be a condensed version of Remigius's gloss. See his *Annotationes in Marcianum* 369, 23 (ed. Lutz, p. 157).

62. *Liber numerorum qui in sanctis scripturis occurrunt* (PL 83, 179-200). The authenticity of the work has been questioned by Bernhard Bischoff ("Einteilung," pp. 9-10 [ref. above, n. 3]) and Robert E. McNally. See the latter's "Isidorian Pseudepigrapha in the Early Middle Ages" in *Isidoriana* (León, 1961), pp. 314-315. Jacques Fontaine, accepting the work, provides an analysis of it in his *Isidore de Séville et la culture classique dans l'Espagne wisigothique*, 1 (Paris, 1959), pp. 369-391. On the relation of the text to Martianus's *De nuptiis* see Claudio Leonardi, "Intorno al 'Liber de numeris' di Isidoro di Siviglia," *Bullettino dell'Istituto storico italiano per il medio evo e Archivio muratoriano*, 68 (1956), pp. 203-231.

Another arithmological tract doubtfully included in Isidore's canon is the *Liber de numeris*. McNally identified it as an Irish work produced in Salzburg c. 750 in his dissertation, *Der irische Liber de numeris* (Munich, 1957). It is the richer tract, and unfortunately only a fragment (numbers 1-3) is published (PL 83, 1293-1302). Isidore is reported to have written a book on numbers (PL 81, 16), either extant as the *Liber*

numerorum, or lost. For a precursor see Eucherius of Lyons' fifth-century *Liber formularum spiritalis intelligentiae* 11 (PL 50, 769-772).

63. *Liber numerorum* 5 (24) (PL 83, 184): "Mortalium quoque rerum quatuor vitae sunt, initium, augmentum, status et declinatio." See Leonardi, "Liber de numeris," p. 223, n. 2. It was Jacques Fontaine who observed the parallel to terms used in describing the progress of disease. He cites by way of example the sixth-century Latin translation of Oribasius' *Synopsis* 7, 24 (*Culture classique*, 1, p. 377 n. 1). To this one may add a passage in the *Quaestiones medicinales* of Ps.-Soranus, 88 (ed. Rose, 2, p. 257): "Quae sunt tempora aegritudinum? acutarum, quas Graeci oxypathes appellant, caeroe aut chronoe sunt quattuor, id est initium, augmentum, status et declinatio." Cf. William D. Sharpe, *Isidore of Seville: The Medical Writings*, Transactions of the American Philosophical Society, n.s. 54:2 (Philadelphia, 1964), p. 67. It may be that the author avoided giving proper age names since he would do so when treating the six ages of man. See below, pp. 62-63.

64. The text is preserved in a manuscript thought to have been produced in Ramsey in the mid-eleventh century: Oxford, Bodleian Library, ms. Ashmole 328, pp. 207-247. On the arithmological section see the brief comments by Robert Anthony Lucas, *Prolegomena to Byrhtferth's Manual*, Diss., University of Illinois, 1970, pp. 172-178; Cyril Hart, "Byrhtferth and His Manual," *Medium Aevum*, 41 (1972), pp. 95-109, esp. 100-101. Byrhtferth's computistic work will be treated below, pp. 33-35.

65. Ashmole 328, pp. 209-213 (ed. and trans. Crawford, EETS o.s., no. 177, pp. 200-205). On the ages of man, p. 212: "Est quaternarius adhuc humano bis bino septus stémate, id est, pueritia, adholescentia, iuventute, senectute." Old English equivalents are given in interlinear glosses: cildhád, cnihthád, geþungen yld, fulre ylde. The first age is wet and hot, the second hot and dry, the third dry and cold, the fourth cold and wet.

66. See below, pp. 33-34.

67. Cambridge, Gonville and Caius College, ms. 428. See Montague Rhodes James, *A Descriptive Catalogue of the Manuscripts in the Library of Gonville and Caius College*, 2 (Cambridge, 1908), pp. 500-502; Fritz Saxl and Hans Meier, *Verzeichnis astrologischer und mythologischer illustrierter Handschriften des lateinischen*

Mittelalters, ed. Harry Bober, 3:1 (London, 1953), pp. 422-423; Klibansky-Panofsky-Saxl, *Saturn and Melancholy*, pp. 292-294. Professor A. C. Esmeijer (Amsterdam) informs me that one of her students, Ellen Muller, prepared an M.A. thesis on the work.

68. The first two figures are labeled *cholera rubea* and *sanguis*, but phlegm and black gall are replaced by their macrocosmic counterparts, *aqua* and *terra*. See Saxl-Meier, 3:2, fig. 223.

69. Fols. 29v-30r: "Est autem prima ętas adolescentia quę secundum quorumdam opinionem calidę et humidę conplexionis est. Et est ab ortu nativitatis usque ad xxv vel xxx annum. Est et iuventus calidae et siccae secundum eosdem conplexionis ad xlv vel l annum perseverans. Est et senectus frigida et sicca lv vel lx annum appetens a finibus suis. Huic succrescit senium frigidę et humidę conplexionis. Quę etas sui temporis cursus termino vitę metitur . . ." The system corresponds to one outlined in Johannicius's *Isagoge*, a text just at that time translated from the Arabic. See below, pp. 30-31. For the author's account of the seven ages, p. 52.

70. Fols. 31v: "Reor enim et veritati assistere mihi videtur quoniam prima etas sive adolescentia sive pueritia nominetur frigida et humida flegmati consimilis usque ad xiiii⁰ʳ annos perseverans habetur. Deinde vero iuventus calida et humida et sanguinis consimilis usque ad xlv vel l annos habetur. Senectus vero calide et siccę conplexionis et colerę rubeę conparabilis habetur que \ in lx vel lxv anno / terminatur. Senium autem frigidę et siccę naturę conparatur colerę nigrę quo tandem vitę limes adfinitur. Si autem etatum nomina mutaremus, ordinem tamen qualitatum ut dictus est retineamus, dicimus, Pueritia frigida et humida, Adolescentia humida et calida, Iuventus calida et sicca, Senectus sicca et frigida . . ." The system should be compared to one found in certain early medieval medical works, long available. See below, pp. 26-27.

71. Klibansky, Panofsky, and Saxl interpreted the image along these lines but, with arguably little justification, considered it in the context of evolving humoral illustration. Thus, by their reckoning, the figure labeled *pueritia, frigida et humida, flegma* appears with legs crossed owing to the "physical and mental indifference of both the phlegmatic temperament and the age of childhood" (*Saturn and Melancholy*, p. 294). It should be noted that the

humors and the qualities were inscribed after the figures of the ages were drawn and labeled, in darker ink.

72. Professor Karl-August Wirth (Munich, Zentralinstitut für Kunstgeschichte) made this suggestion to me in the course of a profitable discussion.

73. Cf. Isidore, *Etymologiae* IV, 13, 1-5 (ed. Lindsay, n.p.). The same idea is encountered in an early medieval commentary on the Hippocratic *Aphorisms* and in the prologue to Ps.-Soranus's *Quaestiones medicinales*. For the former see Pearl Kibre, "Hippocrates Latinus: Repertorium of Hippocratic Writings in the Latin Middle Ages (II)," *Traditio*, 32 (1976), pp. 259-260; for the latter, Brian Lawn, *The Salernitan Questions* (Oxford, 1963), pp. 9-10.

74. On the manuscript tradition see especially Hermann Diels, *Die Handschriften der antiken Ärzte*, 2 vols. (Berlin, 1905-1906); Walter Puhlmann, "Die lateinische medizinische Literatur des frühen Mittelalters: Ein bibliographischer Versuch," *Kyklos*, 3 (1930), pp. 395-416; Augusto Beccaria, *I codici di medicina del periodo presalernitano (secoli IX, X, e XI)* (Rome, 1956); Ernest Wickersheimer, *Les manuscrits latins de médecine du Haut Moyen Âge dans les bibliothèques de France* (Paris, 1966); Gerhard Baader, "Handschrift und Inkunabel in der Überlieferung der medizinischen Literatur" in *Buch und Wissenschaft*, ed. Eberhard Schmauderer (Düsseldorf, 1969), pp. 15-47. On the epistolary genre see Walter Wiedemann, *Untersuchungen zu dem frühmittelalterlichen medizinischen Briefbuch des Codex Bruxellensis 3701-15*, Diss., Berlin, 1976; Pearl Kibre, "Hippocrates Latinus (V)," *Traditio*, 35 (1979), pp. 273-292.

75. See Augusto Beccaria, "Sulle tracce di un antico canone latino di Ippocrate e di Galeno (II)," *Italia medioevale e umanistica*, 4 (1961), pp. 1-75; Kibre, "Hippocrates Latinus (II)," *Traditio*, 32 (1976), pp. 257-292 [includes a list of thirty-one manuscripts containing the sixth-century translation, dating from the eighth to the twelfth century]; Kibre, "Hippocrates Latinus (III)," *Traditio*, 33 (1977), pp. 253-278. For an indication of the importance of the *Aphorisms* in medical study see L. C. MacKinney, "Tenth-Century Medicine as Seen in the Historia of Richer of Rheims," *Bulletin of the History of Medicine*, 2 (1934), pp. 347-375, esp. 357-360.

76. "Peri diatis ipsius Ypogratis," 33 (ed. Deroux and Joly, p. 144). The text of the (fairly garbled) sixth-century translation of *Regimen*, Book I, is preserved in an Italian manuscript of the middle or second half of the ninth century now in Paris (Bibliothèque Nationale, ms. lat. 7027, fols. 55r-66r). See the editors' comments in *Lettres latines du Moyen Âge et de la Renaissance*, Collection Latomus, 158 (Brussels, 1978), pp. 130-131.

77. See Diels, *Handschriften*, I, pp. 58-150; Richard J. Durling, "Corrigenda and Addenda to Diels' Galenica," *Traditio*, 23 (1967), pp. 461-476; Beccaria, "Tracce (III)," *Italia medioevale e umanistica*, 14 (1971), pp. 1-23.

78. See Henning Mørland, *Die lateinischen Oribasiusübersetzungen*, Symbolae Osloenses, fasc. supplet. 5 (Oslo, 1932), esp. pp. 44-45.

79. *Epistula Vindiciani ad Pentadium nepotem suum* (ed. Rose, pp. 487-488): "Dividuntur etiam hi umores quattuor per quattuor aetates, id est flegma in pueris cum sanguine ab ineunte aetate usque in annos XIIII, exinde cholera rubea dominatur cum parte sanguinis in iuvenibus usque ad annos XXV. Exinde usque in annos XLII maxima pars sanguinis dominatur cum cholera nigra. Exinde usque ad summam aetatem sicut in pueris flegma dominatur. Moriente autem homine haec omnia revertuntur in sua loca." See Karl Deichgräber, "Vindicianus" in *Paulys Realencyclopädie*, 2nd ser., 9:1 (Stuttgart, 1961), cols. 29-36. The passage is closely related to one in a slightly earlier text published by Albanus Torinus (Basel, 1528) with an attribution to Soranus, *In artem medendi isagoge* 5 (*De re medica*, fol. 3r [= *Medici antiqui omnes* (Venice, 1547), fol. 160r]). The connection was noted by Klibansky, Panofsky, and Saxl in *Saturn and Melancholy*, pp. 11, n. 24, 60-61. See also Valentin Rose, *Anecdota graeca et graecolatina*, 2 (Berlin, 1870; rpt. Amsterdam, 1963), pp. 169-170.

80. *Sapientia artis medicinae* 11 (ed. Wlaschky, p. 106): "A die autem qua nascitur infans usque in annos XIIII flegmaticus et reumaticus erit. Completis XV annis accedit illi caliditas sanguinis et exurget illi colera rubea, iam flebotomum meretur. Dominatur illi colera rubea usque in annos XXV, et exurget illi colera nigra et dominatur usque in annos XLII. Infra XXX autem annos iam illi catarticum oportet; tamen si necessitas evenerit, ne interroges annos aetatis ipsius, sed fac secundum rationem sicut scriptum est. Post annos autem LVI iam declinant humores corporis et caliditas minuit; reuma corporis dominat et flegma. Iam sus-

pende flebotomum, per catarticum subveni et adiutoria calida; et si in infantia caput purgavit, repurget propter gravitatem capitis et caliginem oculorum; nec Venere utantur." See the editor's comments in *Kyklos*, I (1928), p. 112. I am grateful to Ann Hanson for discussing the translation with me.

Beccaria (*Codici*) lists twenty manuscripts dating from the ninth to the eleventh century which contain Vindicianus's *Epistula* and twelve which contain the *Sapientia artis medicinae*. The tracts appear in the same codex in ten cases.

81. Chartres, Bibliothèque Municipale, ms. 62, fol. 37v. The manuscript exists as a stack of charred fragments, but a microfilm made from photographs taken before World War II is available at the library. For descriptions of the codex and a reproduction of the diagram see Beccaria, *Codici*, pp. 126-129 (no. 10), and Wickersheimer, *Manuscrits*, pp. 17-21 (no. 10), pl. I.

82. Ps.-Bede, *De mundi celestis terrestrisque constitutione* I, 6-12 (ed. and trans. Burnett, pp. 18-19): "Sunt enim quatuor humores in homine qui imitantur diversa elementa, crescunt in diversis temporibus, regnant in diversis etatibus. Sanguis imitatur aerem, crescit in vere, regnat in pueritia. Colera imitatur ignem, crescit in estate, regnat in adolescentia. Melancolia imitatur terram, crescit in autumpno, regnat in maturitate. Flegma imitatur aquam, crescit in hieme, regnat in senectute. Hi cum nec plus nec minus iusto exuberant, viget homo." See Pierre Duhem, *Le système du monde*, 3 (Paris, 1915), pp. 76-87.

83. On William of Conches and his oeuvre see Tullio Gregory, *Anima mundi: La filosofia di Guglielmo di Conches e la scuola di Chartres* (Florence, 1955), esp. pp. 1-40; Édouard Jeauneau, ed., Guillaume de Conches, *Glosae super Platonem* (Paris, 1965), pp. 9-31.

84. *Philosophia mundi* IV, 29 (54) (ed. and trans. Maurach, pp. 113f., 201f.): "In prima vero aetate nec praecessit usus experientia, nec est tempus doctrinae conveniens. Cum enim illa aetas calida sit et humida, statim cibum digerit et appetit. Unde frequenti influxione indiget et effluxione, spississusque fumus generatur. Qui ascendens cerebrum, in quo vis est discernendi et intelligendi, turbat. —Hanc aetatem sequitur iuventus, quae est calida et sicca. Desiccatus est enim ille naturalis humor, quem contrahit homo ex matris utero. Unde non tam spissus

nascitur fumus neque cerebrum ita turbatur. Estque aetas conveniens ad discernendum et cetera, et maxime si lampas diligentis doctrinae accendatur. —Sequitur senectus frigida et sicca. Extinctus est enim naturalis calor, unde in hac aetate viget memoria, sed vires corporis deficiunt. Ex frigiditate enim et siccitate, cuius est constringere, est memoria, ex calore vero, cuius est impetum facere, vires corporis. —Hanc sequitur senium frigidum et humidum. Extincto enim naturali calore crescit frigidum flegma, unde in illa aetate deficit memoria fiuntque homines pueriles. Est enim a flegmate vis expulsiva. —Hanc sequitur animae et corporis dissolutio. Non enim extincto naturali calore diu potest homo vivere." Cf. *Glosae super Platonem* 128-132 (ed. Jeauneau, pp. 226-233); *Dragmaticon* 6 (*Dialogus de substantiis physicis*, pp. 311-312).

85. *Phil. mundi* IV, 32 (57) (ed. Maurach, p. 115). Cf. *Dragmaticon* 6. Anselm of Canterbury employed the same metaphor. He is reported by his biographer Eadmer to have concerned himself especially with the spiritual training of *adolescentes* and *iuvenes* and to have defended his actions by means of an extended simile. He compared the period of youth (*iuvenis aetas*) to wax neither too hard nor too soft to receive a clear and complete impression. A man who has followed the ways of the world from infancy (*infantia*) to extreme old age (*profunda senectus*), on the other hand, is like hard wax, and a boy (*puer*) resembles soft, nearly liquid wax, unable to take the image of a seal. See Eadmer, *Vita Sancti Anselmi* I, 11 (ed. and trans. Southern, pp. 20-21). I am grateful to Elaine Beretz for supplying this reference.

86. *Phil. mundi* II, 14 (47, 51-53, 56) (ed. Maurach, pp. 59-61). Cf. *Dragmaticon* 4 (*Dialogus*, pp. 120-127).

87. A. Vernet gives a preliminary list of sixty-seven surviving copies of each work in his "Un remaniement de la *Philosophia* de Guillaume de Conches," *Scriptorium*, I (1946-1947), pp. 243-259.

88. *Dragmaticon* 4 (*Dialogus*, p. 129): "Sed quomodo loquente de anni temporibus, diximus tempora, elementa, humores, complexiones, aetates assimilari, *visibilem constituemus figuram*, ut appareat quae ibi assimilentur." The diagram is reproduced on page 130 of the edition.

89. Paris, Bibliothèque Nationale, ms. lat. 11130, fol. 48r. The manuscript contains two

other cosmological works, Bede's eighth-century *De natura rerum* and Honorius Augustodunensis' twelfth-century *Imago mundi*. See Vernet, p. 254 (no. 46); Brian Stock, *Mediaeval Studies*, 33 (1971), p. 351. The identical diagram appears as a frontispiece to Honorius's *Imago mundi* in a manuscript in the Vatican Library (cod. Pal. lat. 1357, fol. 1v). Charles Burnett kindly supplied this information.

90. Giorgio Rialdi enumerates William's medical sources in *Il De philosophia mundi, XII sec.: L'autore, la storia, il contenuto medico* (Genoa, 1965), pp. 67-70.

91. On the translating activity see especially Charles Homer Haskins, *Studies in the History of Mediaeval Science* (Cambridge, Mass., 1924); Heinrich Schipperges, *Die Assimilation der arabischen Medizin durch das lateinische Mittelalter*, Sudhoffs Archiv, Beiheft 3 (Wiesbaden, 1964); Gerhard Baader, "Galen im mittelalterlichen Abendland" in *Galen: Problems and Prospects*, A Collection of Papers Submitted at the 1979 Cambridge Conference, ed. Vivian Nutton (London, 1981), pp. 213-228. The Arabic background is supplied by Manfred Ullmann, *Die Medizin im Islam*, Handbuch der Orientalistik, Ergänzungsband 6:1 (Leiden and Cologne, 1970).

92. *Pantegni*, Theorica, I, 21 (*Opera omnia Ysaac* [Lyons, 1515], fol. 4r): "Omnis etas apud medicos quadrifarie dividitur: aut enim puericia: aut iuventus: aut senectus: aut senium. Puerorum corpora in augmente sunt posita usque ad annos .xxx. Ut enim fatentur phisici infantia est annorum .xv. et puericia sive adolescentia .xv. Sic ergo sunt .xxx. Iuventutis augmentate sunt complementa .xxxv. vel .xl. Complementa senectutis sunt cum corpus iam declinat: sed nondum tamen deficiunt virtutes. Hec maxime durat usque ad annos .xlv. sive .l. Senium esse dicunt cum corpus declinat et vires deficiunt." Marco T. Malato and Umberto de Martini, in their *L'arte universale della medicina* (Rome, 1961), provide an edition and translation of the first book of the *Pantegni* based on three Vatican manuscripts. Their version of the passage in question contains small variants (pp. 66-67).

Stephen of Antioch, a Pisan who worked in Syria, retranslated Haly Abbas in 1127, finding Constantine's version inadequate. In his rendering of the text the four ages become *pueritie etas, iuventus, grandiorum etas,* and *senectus* (*Liber regius* I, 1, 21 in *Liber totius medicine necessaria continens* [Lyons, 1523], n.p.).

93. *Pantegni*, Practica, I, 20-23 (*Opera omnia Yssac*, fols. 62v-63v).

94. *Liber canonis* (*Qānūn*) I, 3, 3 (Venice, 1507; rpt. 1964, fol. 3v; trans. Shah, pp. 31-32): "Etates omnes sunt quatuor. Etas adolendi que vocatur etas adolescentie et est fere usque ad .xxx. annos. Postea est etas consistendi que vocatur etas pulchritudinis et est fere usque ad .xxxv. aut .xl. annos. Et etas minuendi cum virtus non amittitur et hec est etas senectutis que fere est ad annos .lx. Et est etas minuendi cum manifesta virtutis debilitate: et hec quidem est etas senium et finis vite. Adolescentie vero etas dividitur in etatem infantie: et hec quidem est cum membra pueri nondum ad motiones et ambulandum sunt apta: et in etatem apta [*sic*]: et in etatem dentium plantativam que est post ambulationem et antequam sit fortis: et illud est cum nondum gingive sunt omnibus dentibus replete. Postea est etas concussionis quod quidem est post vehementiam et nativitatem dentium et antequam poluantur. Deinde est etas algulemati vel alguadi: et rehac .i. cum ab eo egreditur sperma que est quousque barbescant. Postea est etas fortitudinis que est donec sinat crescere . . ."

The four ages also figure in the *Cantica Avicennae* 54-58 (ed. and trans. Jahier and Noureddine, pp. 14-15), a poem incorporating much of the information in the *Canon*. It was translated into Latin in the twelfth and again in the thirteenth century, the latter version alone surviving (cf. vv. 32-35, p. 113).

95. On Hunain, ninth-century Nestorian Christian, physician and prolific writer and translator, see Ullmann, pp. 115-119, as well as the remarks by recent editors: Diego Gracia and Jose-Luis Vidal, "La 'Isagoge de Ioannitius': Introducción, edición, traducción y notas," *Asclepio*, 26-27 (1974-1975), pp. 267-382, esp. 293-298; Gregor Maurach, "Johannicius: Isagoge ad Techne Galieni," *Sudhoffs Archiv*, 62 (1978), pp. 148-149.

96. See Paul Oskar Kristeller, "Bartholomaeus, Musandinus and Maurus of Salerno and Other Early Commentators of the 'Articella,' with a Tentative List of Texts and Manuscripts," *Italia medioevale e umanistica*, 19 (1976), pp. 57-87.

97. *Isagoge* 18 (ed. Maurach, p. 155): "Quattuor sunt aetates, i. adolescentia, iuventus, senectus et senium. Adolescentia complexionis videlicet calidae et humidae est, in qua crescit et augetur corpus usque ad vicesimum quintum vel tricesimum annum. Hanc iuventus insequi-

tur, quae calida est et sicca, perfectum sine di-
minutione virium corpus conservans, quae vel
tricesimo quinto vel quadragesimo anno fini-
tur. Huic succedit senectus frigida et sicca, in
qua quidem minui et decrescere corpus incipit,
tamen virtus non deficit quinquagesimo quinto
vel sexagesimo persistens anno. Huic succedit
senium collectione flegmatici humoris frigi-
dum et humidum, in quo virtutis apparet de-
fectus, quod suos annos vitae termino meti-
tur." The translation is H. P. Cholmeley's,
with revisions (rpt. in *A Source Book in Medieval
Science*, p. 707).

98. Bodleian Library, ms. lat. Misc. e. 2, fol.
3r. Described by F. Madan, *Summary Catalogue
of Western Manuscripts in the Bodleian Library at
Oxford*, 3 (Oxford, 1895), p. 15 (no. 8847);
Otto Pächt and J.J.G. Alexander, *Illuminated
Manuscripts in the Bodleian Library, Oxford*, 1
(Oxford, 1966), p. 10 (no. 133).

99. On computistic literature see especially
Charles W. Jones, *Bedae Opera de Temporibus*
(Cambridge, Mass., 1943); Lynn Thorndike,
"Computus," *Speculum*, 29 (1954), pp. 223-
238; and the several studies written by Alfred
Cordoliani, among them, "Les traités de com-
put du Haut Moyen Âge (526-1003)," *Bulletin
du Cange*, 17 (1943), pp. 51-72; "Contribution
à la littérature du comput ecclésiastique au
Moyen Âge," *Studi medievali*, ser. 3, 1:1 (1960),
pp. 107-137, and 2:1 (1961), pp. 169-208.

100. *De divisionibus temporum* I (PL 90, 653):
"Atomus, momentum, minutum, punctus,
hora, quadrans, dies, hebdomada, mensis vi-
cissitudo triformis, annus, cyclus, aetas, sae-
culum, mundus . . ." On this text see Charles
W. Jones, *Bedae Pseudepigrapha: Scientific Writ-
ings Falsely Attributed to Bede* (Ithaca and Lon-
don, 1939), pp. 48-51.

101. See below, pp. 55-58.

102. *De temporum ratione* 35 (ed. Jones, CCL
123B, pp. 391-395, esp. 392): "Et quidem san-
guis in infantibus maxime viget, in adolescen-
tibus cholera rubea, melancholia in transgres-
soribus, id est fel cum faece nigri sanguinis
admixtum, phlegmata dominantur in senibus
. . ." *Transgressores* is a little used age designa-
tion. A Carolingian glossator, in a commen-
tary which Jones publishes with his edition (p.
392), defined members of this age group as
those who are crossing over from manhood to
old age ("qui a iuventute transgrediuntur in se-
nectutem").

103. Jones (*Bedae Opera*, p. 370) rightly
notes a similarity to Vindicianus's *Epistula* as

well as to Ps.-Soranus's *In artem medendi isagoge*
5 [ref. above, n. 79]. The specific correlations
between the ages and the humors are, of
course, different.

104. See Charles W. Jones, "Bede's Place in
Medieval Schools" in *Famulus Christi*, ed. Ger-
ald Bonner (London, 1976), pp. 261-285.

105. On Abbo and his computistic writings,
presently published in part among the works of
Bede in PL 90, see A. van de Vyver, "Les
oeuvres inédites d'Abbon de Fleury," *Revue
Bénédictine*, 47 (1935), pp. 125-169, esp. 140-
158; Patrice Cousin, *Abbon de Fleury-sur-Loire*
(Paris, 1954), esp. pp. 75-90.

106. Oxford, Bodleian Library, ms. Ash-
mole 328 (mid-eleventh century). See N. R.
Ker, *Catalogue of Manuscripts Containing Anglo-
Saxon* (Oxford, 1957), pp. 349-350 (no. 288).
On Byrhtferth's life and work see Heinrich He-
nel, *Studien zum altenglischen Computus*, Bei-
träge zur englischen Philologie, 26 (Leipzig,
1934); and, more recently, Robert Anthony
Lucas, *Prolegomena to Byrhtferth's Manual*,
Diss., University of Illinois, 1970; Cyril Hart,
"Byrhtferth and His Manual," *Medium Aevum*,
41 (1972), pp. 95-109; Michael Lapidge,
"Byrhtferth and the *Vita S. Ecgwini*," *Mediae-
val Studies*, 41 (1979), pp. 331-353; Peter S.
Baker, "The Old English Canon of Byrhtferth
of Ramsey," *Speculum*, 55 (1980), pp. 22-37.

107. See above, p. 23.

108. Michael Lapidge, who attributes the
saint's life to Byrhtferth, in part because of the
hagiographer's penchant for number symbol-
ism, quotes the relevant passage: "constat istius
vita breviter edita, et in bis binis partibus di-
visa; quae quatuor partes demonstrant quid in
pueritia vel adolescentia sive in iuventute atque
in senectute gessit" ("*Vita S. Ecgwini,*" pp.
338, 348-350).

109. Ashmole 328, pp. 9-12 (ed. and trans.
Crawford, EETS o.s., no. 177, pp. 10-13). Cf.
Bede, *De temporum ratione* 35. Byrhtferth, of
course, might have had access to a glossed
manuscript. M. L. Cameron briefly reviews
both Bede's and Byrhtferth's medical refer-
ences in his article, "The Sources of Medical
Knowledge in Anglo-Saxon England," *Anglo-
Saxon England*, 11 (1983), pp. 135-155.

110. Ashmole 328, p. 84 (Crawford, pp. 86-
87).

111. Ashmole 328, p. 90 (Crawford, pp. 90-
91). I follow Crawford's translation.

112. Ashmole 328, pp. 92-93 (Crawford,
pp. 90-93).

113. Oxford, St. John's College, ms. 17, fol. 7v. See Ker, *Cat. of Mss. Containing Anglo-Saxon*, p. 435 (no. 360); C. M. Kauffmann, *Romanesque Manuscripts, 1066-1190*, A Survey of Manuscripts Illuminated in the British Isles, 3 (London, 1975), pp. 56-57 (no. 9), fig. 21. For analysis of the manuscript and its relation to Byrhtferth's Manual see Cyril Hart, "The Ramsey *Computus*," *English Historical Review*, 85 (1970), pp. 29-44 [who argues that the manuscript was copied at Ramsey between 1086 and 1092 for Thorney Abbey]; Hart, "Byrhtferth and His Manual," esp. pp. 108-109; Peter S. Baker, "Byrhtferth's *Enchiridion* and the Computus in Oxford, St John's College 17," *Anglo-Saxon England*, 10 (1982), pp. 123-142.

114. London, British Library, ms. Harley 3667, fol. 8r. See Ker, *Cat. of Mss. Containing Anglo-Saxon*, pp. 259-260 (no. 196); Kauffmann, pp. 76-77 (no. 37). It was Neil Ker who established that this manuscript was originally part of the computistic compendium prepared in Peterborough, now British Library, ms. Cotton Tiberius C. I ("Membra Disiecta," *British Museum Quarterly*, 12 [1937-1938], p. 132).

115. "Byrhtferth's Diagram" is the one schema which has arguably received more than its share of scholarly attention. Discussed most fully in studies of Byrhtferth, it is also introduced in medical, historical, and art historical works, in the last on account of its "prototypical" forms. The imprecise title attached to it, "Diagram of the Physical and Physiological Fours," is the legacy of an early article, Charles and Dorothea Singer's "Byrhtferð's Diagram," *Bodleian Quarterly Record*, 2 (1917), pp. 47-51. Singer later reproduced, transcribed, and translated the diagram in a book he coauthored with J.H.G. Grattan, *Anglo-Saxon Magic and Medicine* (London, 1952), figs. 14-16.

116. The list is transcribed at the perimeter of both copies: "Retinet hęc figura .xii. signa, et duo solstitia, atque bina equinoctia, et bis bina tempora anni; in qua descripta sunt .iiii. nomina elementorum, et duodenorum ventorum onomata, atque .iiii. etates hominum. Sunt insimul coniuncta bis binę litterę nominis protoplastis adę."

117. Ashmole 328, pp. 210-211 (Crawford, pp. 202-203). Cf. Augustine, *In Iohannis evangelium tractatus* 9, 14; 10, 12 (ed. Willems, CCL 36, pp. 97-98, 108); *Enarrationes in psalmos* 95, 15 (ed. Dekkers and Fraipont, CCL 39, pp.

1352-1353). Cited by d'Alverny, "L'homme comme symbole," pp. 165-171.

118. In the Old English *Prose Solomon and Saturn*, a dialogue, one finds the following exchange: "Tell me from where was Adam's name created. I tell you, from four stars [6]. Tell me what they are called. I tell you, Arthox, Dux, Arotholem, Minsymbrie [7]." See the edition, translation, and commentary on the text by James E. Cross and Thomas D. Hill (Toronto, 1982), esp. pp. 26, 66-67. Max Förster's article on the legend remains fundamental, "Adams Erschaffung und Namengebung," *Archiv für Religionswissenschaft*, 11 (1908), pp. 477-529.

119. References above, n. 113. Byrhtferth wrote a *proemium*, also preserved in the Ramsey Computus (St. John's College, ms. 17, fols. 12v-13r), which shares some material with his diagrammatic "harmony of the months and elements." Before giving Bede's dates for the solstices and equinoxes, and the durations of times between them, he quotes a passage from Wisdom (7:17-18) in the master's honor: "For [God] hath given me the true knowledge of the things that are: to know the disposition of the whole world, and the virtues of the elements, the beginning, and ending, and midst of the times," which continues, "the alterations of their courses, and the changes of the seasons, the revolutions of the year, and the dispositions of the stars." For the text see George Frank Forsey, "Byrhtferth's *Preface*," *Speculum*, 3 (1928), pp. 505-522, esp. 518.

120. This is more likely than the suggestion that it originally belonged to the manual (Hart, "Byrhtferth," p. 103). The diagram, carrying such a quantity of information, would reduce with difficulty. The sizes of the surviving manuscripts are revealing: Byrhtferth's Manual was copied in a small format, 198 x 127 mm., whereas the Ramsey Computus measures 342 x 242 mm. and the Peterborough Computus, 310 x 210 mm.

121. Dijon, Bibliothèque Publique, ms. 448, fol. 8or. On the basis of calendar entries the manuscript has been assigned to the region of Toul, possibly to the Abbey of St. Evre. Cf. *Catalogue général des manuscrits des bibliothèques publiques de France*, 5 (Paris, 1889), pp. 106-109; Wickersheimer, *Manuscrits*, pp. 30-34 (no. 22), pl. II; and, most recently, Ewald Könsgen, "Eine neue komputistische Dichtung des Agius von Corvey," *Mittellateinisches Jahrbuch*,

14 (1979), pp. 66-75. Könsgen identifies and edits the poem. Inc.: "Compotus hic alfabeto confectus habetur . . . Tunc ad predictos additur una dies." A very crudely executed pair of tetradic diagrams appears on fol. 73r. These are reproduced by Wickersheimer in "Figures," fig. 2.

122. Honorius is a difficult figure to pin down. He is now believed to have been active in Canterbury and Regensburg in the late eleventh and early twelfth centuries. For recent views on his life and work, together with an account of the various recensions of the *Imago mundi* (1110, 1123, 1133, 1139) and an edition of the 1139 recension, see Valerie I. J. Flint, "Honorius Augustodunensis, *Imago mundi*," *AHDLMA*, 49 (1982), pp. 7-153. For her suggestion that Honorius is to be identified with a documented figure, Canon Henry of Augsburg, see "Heinricus of Augsburg and Honorius Augustodunensis: Are They the Same Person?" *Revue Bénédictine*, 92 (1982), pp. 148-158.

123. *Imago mundi* II, 59 (ed. Flint, p. 106): "Hisdem qualitatibus est humanum corpus temperatum, unde et microcosmus, id est minor mundus, appellatur. Sanguis namque, qui vere crescit, est humidus et calidus. Et hic viget in infantibus. Colera rubea, crescens in estate, est calida et sicca. Et hęc habundat in iuvenibus. Melancolia, id est colera nigra, crescens autumno in provectioribus. Flegmata quę hieme dominantur in senibus." For Honorius's views on man as microcosm see Heinrich Schipperges, "Honorius und die Naturkunde des 12. Jahrhunderts," *Sudhoffs Archiv*, 42 (1958), pp. 71-82.

124. *De temporum ratione* 35.

125. *Computus ecclesiasticus*, "De quatuor anni temporibus": "Istorum quidem quatuor anni temporum qualitates, quatuor mundi regiones, quatuor venti cardinales, quatuor elementa corporis, quatuor humores, et quatuor hominis etates, conplexione connectuntur, prout in subiecta patefiunt figura." I follow the reading in Princeton University, ms. Garrett 99, fol. 149r. The edition of the text printed in the *Libellus de sphaera* (Wittenberg, 1543), fol. M5, is corrupt. On the life and works of John of Sacrobosco see Lynn Thorndike, *The Sphere of Sacrobosco and Its Commentators* (Chicago, 1949), pp. 1-75.

126. New York Public Library, ms. 69, fol. 38v. Seymour de Ricci and W. J. Wilson, *Census of Medieval and Renaissance Manuscripts in the United States and Canada*, 2 (New York, 1937), p. 1326; Thorndike, pp. 68-69. The diagram appears regularly in manuscripts of the *Computus*. I am grateful to Adelaide Bennett for permitting me to use her photograph.

127. *De planctu Naturae*, prose 3 (ed. Wright, Rolls Series 59:2, p. 454; I follow the translation by James J. Sheridan in *Plaint of Nature*, p. 123). See Rosemond Tuve, *Seasons and Months* (Paris, 1933), pp. 18-21.

NOTES TO CHAPTER II

1. The number seven attracted considerable scholarly attention in the early twentieth century. Wilhelm Heinrich Roscher's name looms large in the literature. For references to some of his many publications on the subject see the Bibliography. Other investigations include: Ferdinand v. Andrian, "Die Siebenzahl im Geistesleben der Völker," *Mittheilungen der anthropologischen Gesellschaft in Wien*, 31 (1901), pp. 225-274; Boll, "Lebensalter," pp. 112-137; J. H. Graf, *Die Zahl "Sieben"* (Bern, 1917). In more recent times psychologists have tried to account for the powers of the number. See George A. Miller, "The Magical Number Seven, Plus or Minus Two: Some Limits on Our Capacity for Processing Information," *Psychological Review*, 63 (1956), pp. 81-97; Michael Kubovy and Joseph Psotka, "The Predominance of Seven and the Apparent Spontaneity of Numerical Choices," *Journal of Experimental Psychology*, 2 (1976), pp. 291-294.

2. Cited by Lydus, *De mensibus* II, 12 (Diels, no. 44B20 [I, 416, 8]). The authenticity of the fragment is disputed, but see Walter Burkert, *Lore and Science in Ancient Pythagoreanism*, trans. E. L. Minar, Jr. (Cambridge, Mass., 1972), pp. 249, 467, n. 9.

3. *Theologumena arithmetica* 43 (ed. de Falco, p. 57).

4. Aulus Gellius gives a description of Varro's *Hebdomades* in his *Noctes atticae* (III, 10) (ed. Marshall, 1, pp. 146-148). Clement of Alexandria draws material from Hermippus's *On the Hebdomad* in his *Stromata* (VI, 16, 145) (ed. Stählin, GCS 52, p. 506).

5. Philo and Macrobius supply especially detailed accounts of the material shared by the whole line of Greek and Latin arithmologists. For references see below, nn. 15, 21. Roscher collected and collated many of the relevant texts in his *Die Hebdomadenlehren der griechischen*

Philosophen und Ärzte, Abhandlungen der philologisch-historischen Klasse der Königl. Sächsischen Gesellschaft der Wissenschaften, 24:6 (Leipzig, 1906), pp. 109-127.

6. Anatolius, *On the Decad* (ed. and trans. Heiberg, pp. 36, 51); Theon of Smyrna, *Expositio rerum mathematicarum ad legendum Platonem utilium* (ed. Hiller, p. 104).

7. See W. H. Roscher, *Die enneadischen und hebdomadischen Fristen und Wochen der ältesten Griechen: Ein Beitrag zur vergleichenden Chronologie und Zahlenmystik*, Abhandlungen der philologisch-historischen Klasse der Königl. Sächsischen Gesellschaft der Wissenschaften, 21:4 (Leipzig, 1903), esp. pp. 28-68.

8. Ed. West, 2, p. 136; trans. Lattimore, p. 23. See Boll, "Lebensalter," pp. 114-115; Joanne H. Phillips, "Early Greek Medicine and the Poetry of Solon," *Clio Medica*, 15 (1980), pp. 1-4.

9. Alois Dreizehnter, *Die rhetorische Zahl: Quellenkritische Untersuchungen anhand der Zahlen 70 und 700* (Munich, 1978), pp. 70-81.

10. Ps. 89 (90), 10: "Dies annorum nostrorum in ipsis septuaginta anni. Si autem in potentatibus octoginta anni, et amplius eorum labor et dolor." See R. Borger, "An Additional Remark on P. R. Ackroyd, *JNES*, XVII, 23-27," *Journal of Near Eastern Studies*, 18 (1959), p. 74. The limited evidence for ancient Near Eastern divisions of life does not point to a partiality for hebdomads. A fragment on an Assyrian tablet (seventh century B.C.) lists the later ages in decades: "40 is the flower of age, 50 a short life, 60 the age of mastery, 70 an advanced age, 80 old age, 90 extreme old age." There would seem to be a total of ten ages, as in Solon's scheme. See J. Nougayrol, "Notes Brèves, 3," *Revue d'assyriologie et d'archéologie orientale*, 62 (1968), p. 96. Professor William Hallo kindly drew my attention to this text.

11. The work was assigned to the fifth or fourth century B.C. until Jaap Mansfeld, having found Stoic, and more particularly Posidonian, elements in its cosmology, argued for a Hellenistic date (60-30 B.C.). See his study *The Pseudo-Hippocratic Tract ΠΕΡΙ ῾ΕΒΔΟΜΑΔΩΝ Ch. 1-11 and Greek Philosophy* (Assen, 1971), esp. pp. 229-231. A mid-fourth-century date is suggested by M. L. West in "The Cosmology of 'Hippocrates,' *De Hebdomadibus*," *Classical Quarterly*, 65, n.s. 21 (1971), pp. 365-388.

12. *De hebdomadibus* 5 (ed. Roscher, pp. 9-10 [after Ambrosiana, cod. G. 108 Inf., fols. 4r-15r]): "Sic autem in hominis natura septem

tempora sunt; aetates appellantur puerulus, puer, adolescens, iuvenis, vir, senior, senex. Haec sunt sic: puerulus usque ad septem annos in dentium mutationem; puer autem usque ad seminis emissionem, quatuordecim annorum, ad bis septenos; adulescens autem usque ad barbam unum et viginti annorum, ad ter septenos, usque ad incrementum corporis; iuvenis autem consummatur in XXXV annos et in quinque septenos; vir autem usque ad XL et VIIII annos, ad septies septem; senior vero LX et III ad VIIII ebdomadas; exinde senex in quatuordecim ebdomadas."

The ages thus end at 7, 14, 21, 35, 49, 63, and 98. Philo quoted a version in which they terminate at 7, 14, 21, 28, 49, 56, and death: παιδίον, παῖς, μειράκιον, νεανίσκος, ἀνήρ, πρεσβύτης, γέρων (*De opificio mundi* 105, ed. and trans. Colson and Whitaker, 1, pp. 84-87). Armand Delatte published a Greek arithmological fragment found in a tenth-century manuscript in Paris (Bibliothèque Nationale, ms. Coislin 345, fol. 224v) in which the age terms match Philo's but another numerical progression is followed: 7, 14, 21, 28, 35/49, 63, and 98. See his "Fragments arithmologiques sur les âges de la vie de l'homme" in *Études sur la littérature pythagoricienne* (Paris, 1915), pp. 182-183. The Arabic version of Hippocrates' text preserved by ῾Arib ibn Sa῾id is quite close to the Latin. See below, p. 51.

13. See Mansfeld, p. 174; West, "Cosmology," p. 383.

14. Frank Egleston Robbins constructed a complex stemma, deriving all the arithmological texts from an anonymous source "S," composed before the second half of the second century B.C., now lost. The passage on sevens in the life cycle represents, by his reckoning, an interpolation of Posidonian material. See "The Tradition of Greek Arithmology," *Classical Philology*, 16 (1921), pp. 97-123, esp. 112-113. Mansfeld accepts Robbins' divisions of the surviving texts into two major families but returns to the old idea that the tradition began in comments on the *Timaeus* by Posidonius (pp. 156-204).

15. *De opificio mundi* 89-128 (ed. and trans. Colson and Whitaker, 1, pp. 72-101).

16. *Stromata* VI, 16, 142-145 (ed. Stählin, GCS 52, pp. 504-506; trans. Wilson, 12, pp. 389-390). Clement quotes Solon, but not Hippocrates. See Delatte, "Un fragment d'arithmologie dans Clément d'Alexandrie" in *Études*, pp. 231-245.

17. *On the Decad* (ed. and trans. Heiberg, pp. 35-38, 49-52). It may be noted, too, that Hippocrates is paraphrased in a scholion to Julius Pollux' rhetorical handbook of the second century A.D., the *Onomasticon*, II, 1 (ed. Bethe, 1, p. 80). In this version the seven ages are counted in single hebdomads, with the result that a man is γέρων from age 42. Cited by John Winter Jones, "Observations on the Origin of the Division of Man's Life into Stages," *Archaeologia*, 35 (1853), p. 170.

18. *De die natali* 14, 3-4, 7 (ed. Sallmann, pp. 25-27; cf. translation by Rocca-Serra, pp. 18-19): "Hippocrates medicus in septem gradus aetates distribuit . . . Solon autem decem partes fecit, et Hippocratis gradum tertium et sextum et septimum singulos bifariam divisit, ut unaquaeque aetas annos haberet septenos . . . Sed ex eis omnibus proxime videntur accessisse naturam, qui hebdomadibus humanam vitam emensi sunt. Fere enim post septimum quemque annum articulos quosdam et in his aliquid novi natura ostendit, ut et in elegia Solonis cognoscere datur." The *Liber de die natali*, composed in A.D. 238, is a tract devoted to time and its measurement.

19. Epistola 44, 10-12 (PL 16, 1139-1140; trans. Beyenka, FC 26, pp. 269-270): "Celebretur itaque hebdomas, eo quod per septem aetatum cursus vita hominum usque ad senectutem transcurritur, sicut Hippocrates, medicinae magister, scriptis explicuit suis . . ." Cf. Émilien Lamirande, "Les âges de l'homme d'après Saint Ambroise de Milan," *Cahiers des études anciennes*, 14 (1982), pp. 227-233.

20. *Theol. arith.* 45-50 (ed. de Falco, pp. 61-67). See above ch. I, n. 12. Earlier in the section on seven (42), the author, paraphrasing Anatolius whom he identified by name, quoted Hippocrates.

21. *Comm. in Somnium Scipionis* I, 6, 62-76 (ed. Willis, pp. 30-33; trans. Stahl, pp. 112-115). Virtually the whole of the sixth chapter is given over to a discussion of the hebdomad.

22. *Noctes atticae* III, 10, 7-8 (ed. Marshall, 1, p. 147; trans. Rolfe, 1, pp. 268-271).

23. *Commentarius* 37 (ed. Waszink, pp. 85-86).

24. *Disputatio de Somnio Scipionis* 14 (ed. and trans. Scarpa, pp. 18-21). Favonius, working from memory by his own admission, appears to mix the two arithmological traditions. See Mansfeld, p. 162, n. 33.

25. *De nuptiis* 739 (ed. Willis, pp. 267-268).

26. *Comm. in Somnium Scipionis* I, 6, 62 (ed.

Willis, p. 30; I follow the translation by Stahl, p. 112): "hic denique est numerus qui hominem concipi, formari, edi, vivere, ali ac per omnes aetatum gradus tradi senectae atque omnino constare facit."

27. *Comm. in Somnium Scipionis* I, 6, 65 (ed. Willis, pp. 30-31; trans. Stahl, p. 113).

28. *De sanitate tuenda* (ed. Koch, CMG V, 4, 2, pp. 3-198; trans. Green). Yet Galen censures the introduction of hebdomadic arithmology into medical thought. Cf. *De diebus decretoriis* III, 11 (ed. Kühn, 9, pp. 934-936). Dr. Vivian Nutton supplied this reference.

29. Milan, Biblioteca Ambrosiana, cod G. 108 Inf., fols. 3v-15r; Paris, Bibliothèque Nationale, ms. lat. 7027, fols. 32v-55r. Beccaria, *Codici*, pp. 151-52, 288-291 (nos. 28, 92).

30. Macrobius, *Comm. in Somnium Scipionis* I, 6, 76 (ed. Willis, p. 32): "cum vero decas"; Ambrose, Epistola 44, 11 (PL 16, 1140). Alison White [Peden], whose dissertation (Oxford, 1982) concerns early glossed Macrobius manuscripts, very kindly supplied this information.

31. *De nuptiis* VII, 739 (ed. Willis, pp. 267-268; I follow the translation by Stahl and Johnson, p. 283): "Dehinc parvulis mense septimo dentes emergunt ac septimo anno mutantur. Item secunda hebdomas pubertatem movet gignendique possibilitatem, tertia florem genarum; quarta incrementa staturae finiuntur; quinta iuvenalis aetatis plena perfectio est."

32. *De arithmetica* 143-148 (ed. de Winterfeld, p. 252). See Ernst Robert Curtius, *European Literature and the Latin Middle Ages*, translated from the German edition of 1948 by Willard R. Trask (Princeton, 1953), pp. 503-504.

33. *Commentum in Martianum Capellam* 374, 5 (ed. Lutz, 2, p. 193): "SECUNDA EBDOMAS id est XIIII annus vel XV. GIGNENDI generandi. TERTIA ebdomas, id est XXI; QUARTA scilicet ebdomas, id est XXVIII. INCREMENTA id est augmenta, STATURAE scilicet in longitudinem, FINIUNTUR. QUINTA scilicet ebdomas, id est XXXV, IUVENALIS AETATIS PLENA PERFECTIO EST. Hic status est incrementi, ultra enim non crescit homo nec ingenio nec statura corporis." Cf. ch. I, n. 60.

34. See above, p. 162 n. 62.

35. *Liber numerorum qui in sanctis scripturis occurrunt* 8 (35) (PL 83, 186). Cf. *Moralia in Iob* 35, 15 (PL 76, 757-758). Gregory is explicating a passage in the Book of Job (42:8): "Take unto you therefore seven oxen, and seven rams, and

go to my servant Job, and offer for yourselves a holocaust . . ." José A. de Aldama identified borrowings from Gregory in his "Indicaciones sobre la cronología de las obras de S. Isidoro" in *Miscellanea Isidoriana* (Rome, 1936), p. 77, n. 80. On the number seven in Christian thought see Heinz Meyer and Rudolf Suntrup, "Zum Lexikon der Zahlenbedeutungen im Mittelalter. Einführung in die Methode und Probeartikel: Die Zahl 7," *Frühmittelalterliche Studien*, 11 (1977), pp. 1-73.

36. *Liber numerorum* 8 (46) (PL 83, 188): "Parvulis etiam septimo mense dentes emergunt, septimo anno mutantur. Item secunda hebdomada, id est, quarto decimo anno infans pubescit, et possibilitatem gignendi accipit. Tertia vero lanuginem et florem genarum producit. Quarta incrementa staturae definiuntur; quinta iuvenilis aetatis plena perfectio datur; sexta defluxio est; septima senectutis initium."

37. Claudio Leonardi suggested that, seven hebdomads being the more plausible reading, Martianus's text should be amended on the basis of the Isidoran work ("Intorno al 'Liber de numeris,'" p. 227 [ref. above, ch. I, n. 62]).

38. Ashmole 328, pp. 219-220 (ed. and trans. Crawford, pp. 210-213).

39. The poem, of 695 lines, exists in a single manuscript dating to the late twelfth century (Vorau, Augustiner-Chorherrenstift, ms. 276, fols. 129v-133v) which has been reproduced in facsimile. See *Die deutschen Gedichte der Vorauer Handschrift* (*Kodex 276—II. Teil*), ed. Karl Konrad Polheim (Graz, 1958). On the structure and contents of the poem see Wolfgang Mohr, "Vorstudien zum Aufbau von Priester Arnolds 'Loblied auf den heiligen Geist' ('Siebenzahl')" in *Die Wissenschaft von deutscher Sprache und Dichtung*, Festschrift Friedrich Maurer (Stuttgart, 1963), pp. 320-351.

40. *Loblied auf den heiligen Geist* 33 (ed. Maurer, p. 72):

> Nu wil ich iu sagen ze diute
> umbe siben alter der liute.
> dei nenne ich iu sa:
> daz ein ist infancia;
> so ist daz ander aver sa
> geheizen puericia.
> so ist daz tritte aver sa
> geheizen adolescencia.
> so ist daz vierde aver sus
> geheizen iuventus.
> ze ware sagen ich iu daz
> daz vunfte heizet etas.

> so ist daz sehste aver sus
> geheizen senectus.
> ze ware sagen ich iu daz,
> daz decrepita etas
> ist daz sibente genennet.
> damit uns des libes zerinnet.

41. One may compare a passage in a Chiemsee manuscript of the eleventh century (Munich, Bayerische Staatsbibliothek, clm. 5257, fol. 28r) in which seven ages are counted up in hebdomads but actual terms are given for only six: *infantia* to 7, *pueritia* to 14, *adolescentia* to 28, *iuventus* to 48, *senectus* to 56, (*sexta etas*) to 70, and *senium* to death. On this text see Georg Höhn, *Die Einteilungsarten der Lebens- und Weltalter bei Griechen und Römern* (Würzburg, 1912), pp. 13-14, 49.

42. For these texts see above, ch. I, nn. 79 and 80.

43. Bibliothèque Municipale, ms. 62, fol. 37r: "Infantia habet VII annos, puericia VII, adolescentia VII, iuventus ter VII, senectus quater VII." A tetradic diagram, containing the four ages—*pueritia, adolescentia, iuventus, senectus*—appears on the verso of the same folio. See above, p. 27.

44. Bibliothèque Nationale, ms. lat. 2825, fol. 80r. The text is transcribed by Wickersheimer in *Manuscrits*, pp. 56-57 (no. 48).

45. Bibliothèque Nationale, ms. lat. 11218, fols. 23r-23v. Beccaria, *Codici*, pp. 161-166; Wickersheimer, *Manuscrits*, pp. 100-112 (no. 76). The manuscript also contains Vindicianus's epistle with its description of four ages (fols. 30r-32v) and an extract from Isidore's *Etymologiae* (XI, 2, 2-8) with a list of six (fol. 115r).

46. *Tetrabiblos* IV, 10 (203-204) (ed. and trans. Robbins, p. 440-441).

47. *Tetrabiblos* I, 4-5 (17-19) (Robbins, pp. 34-39). See A. Bouché-Leclercq, *L'astrologie grecque* (Paris, 1899), pp. 88-104.

48. See Klibansky-Panofsky-Saxl, *Saturn and Melancholy*, pp. 127-130.

49. *Tetrabiblos* IV, 10 (204-207) (ed. and trans. Robbins, pp. 440-447). Ptolemy's ages put into like grammatical form are: βρέφος, παῖς, μειράκιον, νεανίσκος, ἀνήρ, πρεσβύτης, and γέρων. The description falls outside the plan outlined in Book III, 3 (111), as Franz Boll noted in his *Studien über Claudius Ptolemäus* (Leipzig, 1894), p. 123. For analysis of the text see Bouché-Leclercq, pp. 500-502, and especially Boll, "Lebensalter," pp. 118-128.

50. The rationale for determining the periods of the planets is in some cases obscure. See Bouché-Leclercq, pp. 408-410; Boll, "Lebensalter," pp. 122-123. For the mathematical logic behind Ptolemy's ordering of the planets see Noel Swerdlow, "Ptolemy's Theory of the Distances and Sizes of the Planets: A Study of the Scientific Foundations of Medieval Cosmology," Diss., Yale University, 1968, esp. pp. 99-106.

51. Bouché-Leclercq, pp. 476-484; F. H. Colson, *The Week: An Essay on the Origin and Development of the Seven-Day Cycle* (Cambridge, 1926).

52. *Mathesis* III, 1, 10-14 (ed. Kroll and Skutsch, 1, pp. 94-95). On the planets and the ages see Franz Cumont, CCAG 4 (Brussels, 1903), pp. 113-114, as well as the useful summary by H. J. Rose in *The Eclogues of Vergil* (Berkeley and Los Angeles, 1942), pp. 214-217.

53. See Boll, *Studien*, pp. 127-131.

54. *De rev. nat.* I, 7 (ed. Pingree, pp. 19-22). The astrologer's thought is analyzed by Richard Lemay in *Abu Ma'shar and Latin Aristotelianism in the Twelfth Century* (Beirut, 1962).

55. Delatte published a scheme in which the ages terminate at 4, 14, 22, 44, 57, 68, and death (Paris, Bibliothèque Nationale, ms. gr. 1788, fol. 159v) but notes another preserved in a manuscript in Athens in which the Ptolemaic system is followed precisely ("Fragments" in *Études*, pp. 184-185 [ref. above, n. 12]).

56. For a recent study of seven-month parturitions in Greek and Arabic literature see Ursula Weisser, "Die hippokratische Lehre von den Siebenmonatskindern bei Galen und Ṭābit ibn Qurra," *Sudhoffs Archiv*, 63 (1979), pp. 209-238.

57. *Kitâb Khalq al-Janin* . . . 6, 15 (ed. and trans. Jahier and Noureddine, pp. 45-46, 87-89).

58. *Comm. in Somnium Scipionis* I, 12, 13-14 (ed. Willis, p. 50; trans. Stahl, pp. 136-137).

59. *De natura rerum* III, 4 (ed. and trans. Fontaine, pp. 184-185). Cf. Boll, "Lebensalter," pp. 125-127.

60. *Tractatus de quaternario* III, 2-4 (Cambridge, Gonville and Caius College, ms. 428, fols. 30r-30v): "Philosophi vero secundum vii planetas et secundum vii planetarum naturas descripserunt vii etates . . ." The text can be compared to Macrobius, *Comm. in Somnium Scipionis* I, 6, 70-76 (ed. Willis, pp. 31-33; trans. Stahl, pp. 114-115).

61. For accounts of translations and translators see Charles Homer Haskins, *Studies in the History of Mediaeval Science* (Cambridge, Mass., 1924); Francis J. Carmody, *Arabic Astronomical and Astrological Sciences in Latin Translation: A Critical Bibliography* (Berkeley and Los Angeles, 1956); Fritz Saxl, "The Revival of Late Antique Astrology" in *Lectures* (London, 1957), pp. 73-84. On earlier translating activity, A. van de Vyver, "Les plus anciennes traductions latines médiévales (Xᵉ-XIᵉ siècles) de traités d'astronomie et d'astrologie," *Osiris*, 1 (1936), pp. 658-691.

62. Lemay, pp. 20-40, 197-257; Charles S. F. Burnett, "Arabic into Latin in Twelfth Century Spain: The Works of Hermann of Carinthia," *Mittellateinisches Jahrbuch*, 13 (1978), pp. 100-134; idem, Hermann of Carinthia, *De essentiis: A Critical Edition with Translation and Commentary* (Leiden and Cologne, 1982), pp. 1-56.

63. *De essentiis* 79vG-80rA (ed. and trans. Charles Burnett, pp. 232-235): "Recepto siquidem semine, statim ad retinendum accedit virtus saturnia; retentum digestione salubri Iupiter nutrit; deinde Mars consolidat; post hunc Sol informat; informato Venus reliquias temperate expellit; expulsioni Mercurius moderate obvians necessaria retinet; postremo Lucina succedens gemina virtute partum maturum absolvit. Que ipsa continuo tenerum fetum suscipiens eo usque tuetur quoad cessante materie nutrimentique lunaris illuvie—utpote in corporis augmentum diffusa ac digesta—excitato paulatim sensu animeque semitis adapertis, Mercurius in rationabilem institutionem succedens usque in veneriam adolescentiam provehat; hinc temperata iam voluptuosa levitate, in phebeam iuventutis plenitudinem conscendit, qui usque in martie virtutis statum provehit; hic virili animo roborato iovialis auctoritas succedit; postrema est etas saturnia, nature orbe expleto finem origini continuans."

64. [Alfredus Anglicus], *De motu cordis* 13, 2 (ed. Baeumker, pp. 63-64).

65. *Speculum naturale* XV, 49 (*Speculum quadruplex sive speculum maius*, 1 [Douai, 1624; rpt. Graz, 1964], col. 1122f.). Cited by Lynn Thorndike, *A History of Magic and Experimental Science*, 1 (New York, 1923), p. 757. The planets here are shown to control the formation of the bodily members, a well-established line of thought represented in several works translated from the Arabic: Ps.-Apollonius's *De secretis*

nature, Ps.-Ptolemy's *Iudicia*, and Alcabitius's *Isagoge*. See Burnett, *De essentiis*, p. 344G.

NOTES TO CHAPTER III

1. *De doctrina christiana*, esp. Book II (ed. Martin, CCL 32, pp. 32-77; trans. Robertson, pp. 34-78). Heading the list of secondary sources on the interpretation of scripture is Henri de Lubac's *Exégèse médiévale: Les quatre sens de l'Écriture*, 2 vols. in 4 (Paris, 1959-1964).

2. *De civitate Dei* 11, 8 (ed. Dombart and Kalb, CCL 48, pp. 327-328): "Cum vero in die septimo requiescit Deus ab omnibus operibus suis et sanctificat eum, nequaquam est accipiendum pueriliter, tamquam Deus laboraverit operando, qui *dixit et facta sunt* verbo intelligibili et sempiterno, non sonabili et temporali." Cf. *De genesi contra Manichaeos* I, 22 (PL 34, 189-190). For general accounts of Augustine's spiritual exegesis see Marie Comeau, *Saint Augustin: Exégète du quatrième évangile* (Paris, 1930); Henri-Irénée Marrou, *Saint Augustin et la fin de la culture antique* (Paris, 1938), pp. 444-453; Maurice Pontet, *L'exégèse de S. Augustin prédicateur* (Paris, 1944), esp. pp. 149-194.

3. *De genesi ad litteram inperfectus liber* 7 (ed. Zycha, CSEL 28:1, pp. 478-479); *De civitate Dei* 11, 6 (CCL 48, p. 326). Augustine quoted the passage from Ecclesiasticus numerous times, citing this translation rather than the Vulgate "Qui vivit . . ." On the creation of "all things together" see Jacques de Blic, "Le processus de la création d'après Saint Augustin" in *Mélanges offerts au R. P. Ferdinand Cavallera* (Toulouse, 1948), pp. 179-189; William A. Christian, "Augustine on the Creation of the World," *Harvard Theological Review*, 46 (1953), pp. 1-25.

4. For the roots of Augustine's system see Auguste Luneau, *L'histoire du salut chez les Pères de l'Église: La doctrine des âges du monde* (Paris, 1964); Karl-Heinz Schwarte, *Die Vorgeschichte der augustinischen Weltalterlehre* (Bonn, 1966).

5. *De genesi contra Manichaeos* I, 23 (PL 34, 190-193). Cf. *De civitate Dei* 16, 43 (CCL 48, p. 550). References to the ages of man appear in many other works: *De vera religione* 26 (48)-27 (50), (CCL 32, pp. 217-220); *De diversis quaestionibus octoginta tribus* 58, 2; 64, 2 (CCL 44A, pp. 105-107, 137-138); *Enchiridion* 27 (103) (CCL 46, p. 105); *Enarrationes in psalmos* 127, 15 (CCL 40, p. 1878); *Epistula* 213, 1 (CSEL 57, p. 373). For a summary of Augustine's ideas see

Luneau, pp. 295-327. Studies which treat his correlation between the ages of man and the ages of the world include: Joseph de Ghellinck, "Iuventus, gravitas, senectus" in *Studia mediaevalia in honorem R. J. Martin* (Bruges, 1948), pp. 42-44; Roderich Schmidt, "Aetates mundi: Die Weltalter als Gliederungsprinzip der Geschichte," *Zeitschrift für Kirchengeschichte*, 67 (1955-1956), pp. 288-317; Olivier Rousseau, "La typologie augustinienne de l'hexaéméron et la théologie du temps" in *Festgabe Joseph Lortz: Glaube und Geschichte*, ed. Erwin Iserloh and Peter Manns, 2 (Baden-Baden, 1958), pp. 47-58; Paul Archambault, "The Ages of Man and the Ages of the World: A Study of Two Traditions," *Revue des études augustiniennes*, 12 (1966), pp. 193-228; Schwarte, pp. 43-52. Gunar Freibergs (Los Angeles Valley College) has kindly let me see a draft of his study "The Ages of the World from Augustine to Joachim."

6. Cf. Ptolemy, *Tetrabiblos* IV, 10 (205-206) (ed. and trans. Robbins, pp. 444-445).

7. For a definition of perfect numbers see Nicomachus of Gerasa, *Introduction to Arithmetic* I, 16 (trans. D'Ooge, pp. 209-212). Augustine, it has been observed, could have known this second-century summary of ancient arithmetic through a Latin translation, no longer extant, by Apuleius of Madaura. On perfect numbers and Christian allegory see Heinz Meyer, *Die Zahlenallegorese im Mittelalter: Methode und Gebrauch* (Munich, 1975), pp. 61-63. The next perfect number was 28, then 496 and 8128.

8. *De genesi ad litteram* IV, 7 (ed. Zycha, CSEL 28:1, p. 103; trans. Taylor, ACW 41, p. 112): "We cannot, therefore, say that the number six is perfect precisely because God perfected all His works in six days, but rather we must say that God perfected His works in six days because six is a perfect number. Hence, even if these works did not exist, this number would be perfect; and if it had not been perfect, these works would not have been perfected according to it." Cf. *De trinitate* IV, 4, 7 (CCL 50, pp. 169-170); *De civ. Dei* 11, 30 (CCL 48, p. 350).

On Augustine's application of number symbolism to the creation story see Alois Schmitt, "Mathematik und Zahlenmystik" in *Aurelius Augustinus: Die Festschrift der Görres-Gesellschaft zum 1500. Todestage des Heiligen Augustinus*, ed. Martin Grabmann and Joseph Mausbach (Co-

logne, 1930), pp. 353-366, esp. 356, 364; Lu-
neau, pp. 333-356; Meyer, *Zahlenallegorese*, pp.
26-35, 129-130. For a precursor see Philo, *De
legum allegoria* I, 2 (ed. and trans. Whitaker, 1,
pp. 146-149).

9. *De civ. Dei* 11, 31 (CCL 48, pp. 350-351;
trans. Walsh and Monahan, FC 14, pp. 236-
238).

10. *De civ. Dei* 22, 30 (CCL 48, p. 866; trans.
Walsh and Honan, FC 24, pp. 510-511).

11. *De vera religione* 26 (49) (ed. Daur, CCL
32, pp. 218-219; trans. Burleigh, p. 249). See
Étienne Gilson, *Introduction à l'étude de Saint
Augustin*, 2nd ed. (Paris, 1943), pp. 223-225.

12. See above, p. 42.

13. *De diversis quaestionibus octoginta tribus* 58,
2 (ed. Mutzenbecher, CCL 44A, pp. 105-106; I
follow the translation by David L. Mosher, FC
70, pp. 105-106). Fulgentius, a North African
writer of the late fifth or early sixth century,
was responsible for a bizarre extension of the
analogy between the historic and human ages
(*De aetatibus mundi et hominis*, ed. Helm, pp.
129-179). Seeing that the alphabet had twenty-
three letters, he set out to distinguish twenty-
three phases of universal history and link them
to twenty-three phases in the human life. His
promise was to omit a single letter of the alpha-
bet from each discussion: thus, for example, he
allowed himself no A's in the section dealing
with the innocent age of infancy and the era of
Adam, who was necessarily referred to as "the
first man." The work, as it survives, ends with
the fourteenth section, omitting the letter "O,"
the reign of Valentinian III, and what, if the
analogy had been maintained consistently,
would be the seventieth year. Fulgentius de-
serves applause for having got so far. See the
translation and commentary by Leslie George
Whitbread, *Fulgentius the Mythographer* (Co-
lumbus, Ohio, 1971), pp. 179-231.

14. *Satisfactio* 221-230 (ed. Vollmer, MGH,
AA 14, p. 126; I follow the translation by Sister
M. St. Margaret, p. 41):

Sex sunt aetates hominum procul usque senectam,
 hae distincta tenent tempora quaeque sua.
Numquid adultorum strepitus infantia simplex
 vindicat aut fremitus pigra senectus habet?
Non catulaster agit puerilia, non puer audet
 attrectare tener Martia tela manu.
Non furit in venerem nondum pubentibus annis
 nec sub flore genae marcidus est iuvenis,
Maturus tractat, gemit et tremebunda senectus
 nescia fervoris vel levitatis inops.

See Domenico Romano, *Studi Draconziani*
(Palermo, 1959), pp. 46-52.

15. *De laud. Dei* I, 116-754 [with redaction
by Eugenius] (ed. Vollmer, MGH, AA 14, pp.
27-67; trans. Irwin). See Romano, pp. 53-72.

16. "Monosticha recapitulationis septem di-
erum" 27-33 (ed. Vollmer, MGH, AA 14, p.
69). Eugenius also revised the *Satisfactio*. Both
works circulated in Visigothic Spain; Isidore of
Seville knew them (Romano, p. 91). Michael
Evans kindly supplied the reference to Eugen-
ius. I am grateful to William Heckscher and to
Peter Godman for improving my Latin trans-
lations, here and elsewhere.

17. Among the many studies of Isidore's
work, particularly valuable is Jacques Fon-
taine's *Isidore de Séville et la culture classique dans
l'Espagne wisigothique*, 2 vols. (Paris, 1959). See
also Ernest Brehaut, *An Encyclopedist of the
Dark Ages: Isidore of Seville* (New York, 1912);
William D. Sharpe, *Isidore of Seville: The Med-
ical Writings, An English Translation with an In-
troduction and Commentary*, Transactions of the
American Philosophical Society, n.s. 54:2
(Philadelphia, 1964); Hans-Joachim Diesner,
Isidor von Sevilla und das westgotische Spanien,
Abhandlungen der sächsischen Akademie der
Wissenschaften zu Leipzig, Philologisch-his-
torische Klasse, 67:3 (Berlin, 1977).

18. *De doctrina christiana* II, 39 (59) (ed. Mar-
tin, CCL 32, pp. 72-73; trans. Robertson, p.
74). See Jacques Fontaine, "Isidore de Séville et
la mutation de l'encyclopédisme antique" in *La
pensée encyclopédique au Moyen Âge* (Neuchâtel,
1966), pp. 43-62.

19. On antique and medieval "encyclope-
dias" see Michel de Boüard, "Encyclopédies
médiévales sur la 'connaissance de la nature et
du monde' au Moyen Âge," *Revue des questions
historiques*, 112 (1930), pp. 258-304; Robert
Collison, *Encyclopaedias: Their History through-
out the Ages*, 2nd ed. (New York and London,
1966), pp. 21-81; *La pensée encyclopédique au
Moyen Âge* (Neuchâtel, 1966), a collection of
essays which first appeared in *Cahiers d'histoire
mondiale*, 9:3 (1966). For an ambitious analysis
of encyclopedic structure see Richard McKeon,
"The Organization of Sciences and the Rela-
tions of Cultures in the Twelfth and Thirteenth
Centuries" in *The Cultural Context of Medieval
Learning*, ed. John Emery Murdoch and Edith
Dudley Sylla, Boston Studies in the Philoso-
phy of Science, 26 (Dordrecht and Boston,
1975), pp. 151-192.

20. *Etym.* I, 29, 1-2 (ed. Lindsay; I follow the translation by Ernest Brehaut, pp. 99-100). See Fontaine, *Culture classique*, 1, pp. 40-44; Joseph Engels, "La portée de l'étymologie isidorienne," *Studi medievali*, ser. 3, 3:1 (1962), pp. 99-128. For the history of etymologies concerning man and his parts see Roswitha Klinck, *Die lateinische Etymologie des Mittelalters* (Munich, 1970), pp. 72-80.

21. *Etym.* V, 38, 3-5 (ed. Lindsay, n.p.; cf. the partial translation by Brehaut, p. 179): "Aetas plerumque dicitur et pro uno anno, ut in annalibus, et pro septem, ut hominis, et pro centum, et pro quovis tempore . . . Aetas autem proprie duobus modis dicitur: aut enim hominis, sicut infantia, iuventus, senectus: aut mundi, cuius prima aetas est ab Adam usque ad Noe; secunda a Noe usque ad Abraham; tertia ab Abraham usque ad David; quarta a David usque ad transmigrationem Iuda in Babyloniam; quinta deinde usque ad adventum Salvatoris in carne; sexta, quae nunc agitur, usque quo mundus iste finiatur."

22. Karl Heinrich Krüger, *Die Universalchroniken*, Typologie des sources du Moyen Âge occidental, fasc. 16 (Turnhout, 1976), pp. 26-27, 41 (Table V). On Isidore's use of the scheme see Diesner, pp. 93-96.

23. It is worth noting that Isidore had aligned the days of creation with the ages of the world in Augustinian fashion in his commentary on Genesis, *Quaestiones in vetus testamentum,* In Genesin 2 (PL 83, 213-215). For an analysis of this work see Jean Châtillon, "Isidore et Origène: Recherches sur les sources et l'influence des *Quaestiones in Vetus Testamentum* d'Isidore de Séville" in *Mélanges bibliques rédigés en l'honneur d'André Robert* (Paris, 1957), pp. 537-547.

24. *Etym.* XI, 2, 1-8 (ed. Lindsay, n.p.; I follow the translation by William D. Sharpe, p. 49): "Gradus aetatis sex sunt: infantia, pueritia, adolescentia, iuventus, gravitas atque senectus. Prima aetas infantia est pueri nascentis ad lucem, quae porrigitur in septem annis. Secunda aetas pueritia, id est pura et necdum ad generandum apta, tendens usque ad quartumdecimum annum. Tertia adolescentia ad gignendum adulta, quae porrigitur usque ad viginti octo annos. Quarta iuventus firmissima aetatum omnium, finiens in quinquagesimo anno. Quinta aetas senioris, id est gravitas, quae est declinatio a iuventute in senectutem; nondum senectus sed iam nondum iuventus, quia seni-

oris aetas est, quam Graeci πρεσβύτην vocant. Nam senex apud Graecos non presbyter, sed γέρων dicitur. Quae aetas a quinquagesimo anno incipiens septuagesimo terminatur. Sexta aetas senectus, quae nullo annorum tempore finitur; sed post quinque illas aetates quantumcumque vitae est, senectuti deputatur. Senium autem pars est ultima senectutis, dicta quod sit terminus sextae aetatis. In his igitur sex spatiis philosophi vitam discripserunt humanam, in quibus mutatur et currit et ad mortis terminum pervenit."

25. *Etym.* XI, 2, 9-37 (ed. Lindsay, n.p.; trans. Sharpe, pp. 49-51).

26. *Diff.* I, 310, 448, 460, 531, 588, 601 (PL 83, 42ff.). On this work see Fontaine, *Culture classique*, I, pp. 27, 33, 38-40, 202-203.

27. *Diff.* II, 19-21 (74-84) (PL 83, 81-82): "Inter *infantiam* et *pueritiam*, et reliquas aetates, sapientes ita definierunt. Prima hominis aetas infantia, secunda pueritia, tertia adolescentia, quarta iuventus, quinta senectus, sexta senium. Duae primae aetates singulis annorum terminantur hebdomadibus, propter simplicem vitam. Nam infantia septimo anno finitur, quartodecimo pueritia, dehinc sequens adolescentia duabus constat hebdomadibus propter intellectum et actionem. Quae duae nondum erant in pueris, et porrigitur haec aetas a quinto decimo anno usque ad XXVIII. Post haec succedens iuventus tribus hebdomadibus permanet, propter tria illa, intellectum et actionem, corporisque virtutem. Ista aetas a XXVIII anno exoritur, et quadragesimo nono consummatur, quando et in feminis partus deficit. Porro senectus quatuor hebdomadibus completur propter accedentem illis tribus animi et corporis gravitatem. Incipit enim haec aetas a quinquagesimo anno, et septuagesimo septimo terminatur. Ultima vero senium nullo certo annorum tempore definitur, sed solo naturae fine concluditur . . ."

28. On the transmission of the text see especially Bernhard Bischoff, "Die europäische Verbreitung der Werke Isidors von Sevilla" in *Isidoriana* (León, 1961), pp. 317-344; rpt. in his *Mittelalterliche Studien*, 1 (Stuttgart, 1966), pp. 171-194. On the manuscript families see Marc Reydellet, "La diffusion des *Origines* d'Isidore de Séville au Haut Moyen Âge," *Mélanges d'archéologie et d'histoire* (École Française de Rome), 78 (1966), pp. 383-437. For a list of 967 manuscripts containing all or part of the *Etymologies*, see Jose Maria Fernandez Caton, *Las Etimolo-*

gías en la tradición manuscrita medieval estudiada por el Prof. Dr. Anspach (León, 1966).

29. *Liber numerorum* 7 (31) (PL 83, 185): "Sex enim aetatibus cursus mortalium consummatur . . ." On this work see above, ch. I, n. 62.

30. See above, p. 32.

31. *De temporum ratione* 66 (ed. Jones and Mommsen, CCL 123B, pp. 463-535). See also *De temporibus* 16-22 (ed. Jones and Mommsen, CCL 123C, pp. 600-611). Cf. *De civitate Dei* 16, 43 (CCL 48, p. 550). For Augustine's influence on chroniclers, especially Isidore and Bede, see Charles W. Jones, *Bedae Opera de Temporibus* (Cambridge, Mass., 1943), pp. 117, 345; Schmidt, "Aetates mundi," pp. 289-290.

32. *Opus excerptum ex libro compoti* I, 18 (185-188) (ed. Meersseman and Adda, pp. 103-104). See the editors' remarks in *Manuale di computo con ritmo mnemotecnico dell'arcidiacono Pacifico di Verona* (Padua, 1966).

33. *De computo* 96, "De aetatibus" (ed. Stevens, CCL, Cont. med. 44, pp. 318-321). Maria Rissel, *Rezeption antiker und patristischer Wissenschaft bei Hrabanus Maurus: Studien zur karolingischen Geistesgeschichte* (Bern and Frankfurt/M., 1976), pp. 19-75, esp. 40.

34. Byrhtferth's Manual, Ashmole 328, pp. 243-247 (ed. and trans. Crawford, pp. 236-239). The passage is discussed by Max Förster in "Die Weltzeitalter bei den Angelsachsen" in *Neusprachliche Studien: Festgabe Karl Luick*, "Die neueren Sprachen," 6. Beiheft (Marburg, 1925), pp. 188-189. For Byrhtferth on the four ages of man see above, pp. 23, 33-35.

35. *Imago mundi* II, 78, "De ętate" (ed. Flint, p. 110): "Sunt quoque .vi. ętates hominis. Prima infantia ad .vii. annos. Secunda puericia ad .xiiii. annos. Tercia adolescentia ad .xxi. annum. Quarta iuventus ad .l. annum. Quinta senectus ad .lxx. annum. Sexta decrepita, ad .c. annos vel usque ad mortem. . ." One hundred years is thus life's terminus.

36. *Chronicon*, "De etatibus" (ed. Garufi, Rerum italicarum scriptores 7:1, pp. 3-5). Quoted by Joseph de Ghellinck, "Iuventus, gravitas, senectus" in *Studia mediaevalia in honorem R. J. Martin* (Bruges, 1948), p. 57. The editor wrongly identifies the source; Romualdo was probably working from an intermediary text in any case. A similarly extended version of Isidore's definition is to be found in a mid-twelfth-century astronomical miscellany in Oxford (Bodleian Library, ms. Digby 83, fol.

75v). Again six ages are named, along with their durations—*infantia* to 7 years, *pueritia* to 14, *adolescentia* to 28, *iuventus* to 49, *gravitas* to 70, and *senectus*, its final part called *senium*, ending at no fixed time. Cf. *Etymologiae* XI, 1-8. On the manuscript see C. M. Kauffmann, *Romanesque Manuscripts, 1066-1190* (London, 1975), p. 103 (no. 74).

37. *Disputatio puerorum* 5 (PL 101, 1112-1113).

38. Bibliothèque Nationale, ms. lat. 11218, fol. 115r. See above, ch. II, n. 45.

39. Bibliothèque Municipale, cod. 26, fols. 111v-123r (*Etym.* XI, 1-2). *Catalogue général des manuscrits des bibliothèques publiques de France*, 1 (Paris, 1886), pp. 8-10; Charles Henry Beeson, *Isidor-Studien* (Munich, 1913), p. 100.

40. Bibliothèque Nationale, ms. lat. 2796, fols. 55v-56r. Beeson, p. 100; Bibl. Nat., *Catalogue général des manuscrits latins*, 3 (Paris, 1952), pp. 90-95.

41. *Summarium* III, 8 (ed. Hildebrandt, 1, pp. 136-138).

42. Cambridge University Library, ms. Ii. 4. 26, fols. 73v-74v (*Etym.* XI, 2, 1-26). For a facsimile reproduction see M. R. James, ed., *The Bestiary* (Oxford, 1928), trans. T. H. White in *The Book of Beasts* (New York, 1954), pp. 219-226. On second family manuscripts, James, pp. 13-22, 34; Florence McCulloch, *Mediaeval Latin and French Bestiaries* (Chapel Hill, 1962), pp. 34-38.

43. Cambridge, Corpus Christi College, ms. 183, fol. 68v; ms. 320, p. 98; London, British Library, ms. Cotton Vespasian B.VI, fol. 107r [M. R. James, *A Descriptive Catalogue of the Manuscripts in the Library of Corpus Christi College, Cambridge* (Cambridge, 1912), I, pp. 439-440; II, p. 137]; Chartres, Bibliothèque Municipale, ms. 62, fol. 37r [see above, ch. II, n. 43]; Munich, Bayerische Staatsbibliothek, clm. 14532, fol. 93v [*Catalogus codicum manuscriptorum Bibliothecae Regiae Monacensis*, 4:2 (Munich, 1876; rpt. Wiesbaden, 1968), pp. 188-189]; Bonn, Universitätsbibliothek, cod. S. 218, fol. 63v [Rainer Reiche, *Ein rheinisches Schulbuch aus dem 11. Jahrhundert* (Munich, 1976), pp. 167-168]; Biblioteca Apostolica Vaticana, cod. Reg. lat. 204, fol. 24v [André Wilmart, *Codices Reginenses Latini*, 1 (Vatican City, 1937), pp. 482-483].

44. Bodleian Library, ms. Laud. Misc. 277, fol. 71v. Transcribed by O. Lottin in "Nouveaux fragments théologiques de l'école d'An-

selme de Laon: Deux manuscrits d'Oxford," *Recherches de théologie ancienne et médiévale*, 14 (1947), p. 20 (no. 452): "Etates sic distingue. Infantia in prioribus VII annis terminatur et tunc incipit aliqua mutatio: tunc enim mutantur dentes. In VII sequentibus pueritia terminatur et tunc incipit inferior pubes. Adolescentia hanc etatem duplicat et in XXVIII annis terminatur, quamvis in XXI aliqua incipiat mutatio, quia tunc superius pubescit et in altum crescere desinit. A XXVIII autem anno non est crementum inspissum nisi de superfluis incrementis. Deinde incipit iuventus que duplicat totum supradictum spatium et in LVI anno terminatur. Illuc usque virtus est in homine indeficiens. Sed ex tunc incipit defectus virium, et totum reliquum tempus senectus appellandum est; virilis enim etas similis est cum iuventute."

45. *Commentum super sex libros Eneidos Virgilii* (ed. J. W. Jones and E. F. Jones, pp. 4, 14, 15, 23, 25; trans. Schreiber and Maresca). See, in addition to editors' and translators' introductions, Winthrop Wetherbee, *Platonism and Poetry in the Twelfth Century: The Literary Influence of the School of Chartres* (Princeton, 1972), pp. 106-111.

46. Transcribed from Munich, Bayerische Staatsbibliothek, clm. 14641, fol. 32r. On the manuscript, E. A. Lowe, *Codices latini antiquiores*, 9 (Oxford, 1959), p. 21 (no. 1306). There is an eleventh-century copy in Wolfenbüttel: Herzog August Bibliothek, cod. 335. Gud. lat. 4° (4642), fols. 40r-40v. A twelfth/thirteenth-century copy is preserved in Berlin: cod. Phill. 1694, fol. 77v. Cited by Walther, *Initia*, p. 922 (no. 17601); Schaller-Könsgen, *Initia*, p. 665 (no. 14971).

The material would be versified again. An anonymous writer, at one point, collected from Isidore's *Etymologies* all terms which had to do with medicine, age designations among them, and worked the definitions into a long poem. The work is preserved in a single thirteenth-century manuscript of Italian origin. On the ages of man, *Speculum hominis* 891-953 (ed. and trans. Malato and Alicandri-Ciufelli, pp. 75-79, 134-137).

47. Fontaine, "Mutation," pp. 60-62 [ref. above, n. 18]; Elisabeth Heyse, *Hrabanus Maurus' Enzyklopädie 'De rerum naturis': Untersuchungen zu den Quellen und zur Methode der Kompilation* (Munich, 1969).

48. *De rerum naturis* VII, 1 (PL 111, 179-185, esp. col. 182). Heyse finds the *Clavis* of Ps.-

Melito to be the source of Hrabanus's allegories, here and elsewhere (pp. 90-91).

49. Montecassino, Monastery Library, ms. 132, p. 150. Ambrogio Maria Amelli, *Miniature sacre e profane dell'anno 1023 illustranti l'enciclopedia medioevale di Rabano Mauro* (Montecassino, 1896), p. IX, pl. 35 [colored line drawing]; Fritz Saxl, "Illustrated Mediaeval Encyclopaedias: The Classical Heritage" in *Lectures* (London, 1957), pp. 233-241, fig. 164e; Marianne Reuter, *Text und Bild im Codex 132 der Bibliothek von Montecassino "Liber Rabani de originibus rerum"* (Munich, 1984), p. 103, fig. 35.

50. Ms. 132, p. 379. See Amelli, pl. 103.

51. Adolph Goldschmidt, "Frühmittelalterliche illustrierte Enzyklopädien," *Vorträge der Bibliothek Warburg, 1923-1924* (Leipzig and Berlin, 1926), pp. 216-218; Saxl, pp. 234-235; Diane O. le Berrurier, *The Pictorial Sources of Mythological and Scientific Illustrations in Hrabanus Maurus' De rerum naturis*, Diss., University of Chicago, 1975 (New York and London, 1978). Reuter, who usefully summarizes views on the creation of the pictorial cycle, casts doubt on the idea that the illustrated text that the Montecassino artist copied originated in Carolingian Fulda (pp. 22-32).

52. Biblioteca Apostolica Vaticana, cod. Pal. lat. 291, fol. 68r. Paul Lehmann, who discovered and identified the manuscript, believed it to derive not from the Montecassino copy but from another model, possibly Carolingian. See his "Fuldaer Studien: Illustrierte Hrabanuscodices," in Sitzungsberichte der Bayerischen Akademie der Wissenschaften, Philosophisch-philologische und historische Klasse, 1927:2 (Munich, 1927), pp. 13-47. Lehmann located, in time, fragmentary pictorial cycles from late twelfth-, late fourteenth-, and early fifteenth-century Hrabanus manuscripts. See his "Reste einer Bilderhandschrift des Hrabanus in Berlin," *Zentralblatt für Bibliothekswesen*, 55 (1938), pp. 173-181; Reuter, pp. 14-21.

53. In support of the Iberian origin of the cycle, an idea which Goldschmidt had rejected (pp. 218-219), Saxl argued that a ninth-century artist could not have had knowledge of classical pictorial motifs which the images reveal (pp. 236-239).

54. Ghent, Universiteitsbibliotheek, ms. 92. The entire text has been transcribed and the images reproduced in facsimile in a publication, *Liber Floridus*, edited by Albert Derolez

(Ghent, 1968). Papers from a conference held at the University Library, 3-5 September 1967, are gathered in a companion volume, *Liber Floridus Colloquium*, ed. Derolez (Ghent, 1973). On the later manuscripts see Léopold Delisle, *Notice sur les manuscrits du 'Liber Floridus' de Lambert, Chanoine de Saint-Omer* (Paris, 1906); Gerard Isaac Lieftinck, "Een Handschriften-Filiatie van vier Eeuwen: De Liber Floridus van Lambert van Sint-Omaars, 1120-1512," *Tijdschrift van de Vrije Universiteit Brussel*, 8 (1965-1966), pp. 69-82.

55. This is the opinion of Albert Derolez, *Lambertus qui librum fecit: Een codicologische Studie van de Liber Floridus-Autograph* (Brussels, 1978), pp. 442-445.

56. Fritz Saxl shared Delisle's low estimation of the coherence of the work. See his "Illustrated Mediaeval Encyclopedias: The Christian Transformation" in *Lectures*, pp. 242-245. With Penelope Mayo, Lambert found a vigorous advocate. Taking as her point of departure the several representations of allegorical trees in the *Liber floridus* and interpreting them as symbols of the Church Triumphant with specific reference to the First Crusade and the recovery of Jerusalem in 1099, she constructed an ingenious synthesis of historical, theological, and moral motifs. See "The Crusaders under the Palm: Allegorical Plants and Cosmic Kingship in the *Liber Floridus*," *Dumbarton Oaks Papers*, 27 (1973), pp. 29-67. I have profited from her study. Derolez, in his codicological survey of the manuscript, isolated fifteen phases of production and concluded that an initially lucid structure was weakened by successive alterations and additions (*Lambertus*, passim).

57. See above, pp. 19-20.

58. Fol. 20v, ch. VI (transcribed by Derolez): "MICROCOSMOS, HOC EST MINOR MUNDUS, PER VII ETATES HOMINIS DESCRIPTUS. DESCRIPTIO ETATIS HOMINIS. Infantia usque ad annos VII. Pueritia usque ad annos XIIII. Adolescetia [*sic*] usque ad annos XXVIII. Iuventus usque ad annos L. Gravitas usque ad annos LXX. Senectus usque ad annos LXXX. Decrepita usque ad annos finis." See Mayo, pp. 65-67, fig. 12; Derolez, *Lambertus*, p. 53. Seven ages are again named on fol. 23v, along with a list of six ages and other hexads.

59. Wolfenbüttel, Herzog August Bibliothek, cod. Guelf. 1 Gud. lat., fol. 31r (north France). See Wolfgang Milde, *Mittelalterliche*

Handschriften der Herzog August Bibliothek, Sonderband I (Frankfurt am Main, 1972), pp. 92-105. See also Delisle, p. 55 (no. 47); Saxl, *Lectures*, pp. 243-244, pl. 166b. On "W" manuscripts, J. P. Gumbert, "Recherches sur le stemma des copies du Liber Floridus" in *Liber Floridus Colloquium*, pp. 37-50.

60. Upper diagram: "Mundus maior et etates seculorum. Mundus a motu dicitur. Secula vero a seno cultu quia per .vi. etates vita humana colitur." Lower diagram: "Mundus minor id est homo et etates eius cum elementis mundi quibus nulla concessa est requies." Lambert extended the definition of *mundus* on the outer rim of the lower diagram: "Mundus a mundicia nomen accepit, quia in principio omnis creatura verbo domini ad mundum apparuit, hoc est aperta et clara. Sive a motu, quia mundi elementa semper in motu sunt, ut celum, sol, luna et omnia que in eis sunt."

61. Nabuchodonosor dreamed that he saw a statue, its head of gold, breast and arms of silver, belly and thighs of brass, legs of iron, and feet part of iron and part of clay, which was destroyed by a stone cut out of a mountain. Daniel interpreted this to signify that four world empires, the Babylonian kingdom and subsequent lesser kingdoms, would be brought to an end in the final kingdom established by God. Lambert incorporated the statue's body parts and metals into his diagram, creating iron thighs and lead legs to round out the hexad. Cf. Mayo, esp. pp. 57-58, 60.

62. See below, pp. 80-88. The information contained in the upper *rota* corresponds in part to that listed in Ghent, ms. 92, fol. 23v.

63. Lower diagram reading clockwise from the top: "Prima etas hominis infantia est usque ad annos .vii. et ver humidus vernans in etate primeva floridus. / Secunda etas hominis puericia est usque ad annos .xiiii. et aer celerrimus et instabilis ventus mobilis moribus. / Tercia etas hominis adolescentia est usque ad annos xx et viii. et ignis fervens et estas calida fortis viribus. / Quarta etas hominis iuventus est usque ad annos .l. et siccus autumpnus tendens ad hyemem factus tepidus. / Quinta etas hominis senectus est usque ad annos lxxx. et hiemps frigidus tendens ad occasum gravis factus. / Sexta etas hominis decrepita est usque ad finem vite eius et elemento terre digne comparandus." On paired tetradic diagrams see above, ch. I, n. 43.

64. The exegetical history is set out by Adolf Smitmans, *Das Weinwunder von Kana:*

Die Auslegung von Jo 2, 1-11 bei den Vätern und heute (Tübingen, 1966), pp. 64-261, esp. 129-135; Hans-Jörg Spitz, *Die Metaphorik des geistigen Schriftsinns: Ein Beitrag zur allegorischen Bibelauslegung des ersten christlichen Jahrtausends* (Munich, 1972), pp. 142-154.

65. *De principiis* IV, 2, 5 (12) (ed. and trans. Crouzel and Simonetti, SC 268, pp. 316-319; cf. translation by Butterworth, p. 278): "Sex vero hydriae consequenter dictae sunt de his, qui in hoc mundo positi purificantur. In sex enim diebus (qui perfectus est numerus) mundum hunc et omnia, quae in eo sunt, legimus consummata." See R.P.C. Hanson, *Allegory and Event: A Study of the Sources and Significance of Origen's Interpretation of Scripture* (London, 1959), p. 235; Smitmans, pp. 65, 130-131. The work was translated into Latin by Rufinus in the late fourth century.

66. *In Iohannis evangelium tractatus* IX, 6 (ed. Willems, CCL 36, p. 94; trans. Gibb, p. 65): "Ideo *erant ibi sex hydriae*, quas iussit impleri aqua. Sex ergo illae hydriae, sex aetates significant, quibus non defuit prophetia. Illa ergo tempora sex, quasi articulis distributa atque distincta, quasi vasa essent inania, nisi a Christo implerentur. Quid dixi, tempora quae inaniter currerent, nisi in eis Dominus Iesus praedicaretur? Impletae sunt prophetiae, plenae sunt hydriae; sed ut aqua in vinum convertatur, in illa tota prophetia Christus intellegatur." See Comeau, pp. 134-135, 145-146 [ref. above, n. 2]; Smitmans, pp. 131-135, 222.

67. *Sermo* 169, 1, (ed. Morin, CCL 104, p. 692; trans. Mueller, FC 47, pp. 413-414): "Non ergo tibi mirum videatur, quando audis mundum istum sex aetatibus consummari, cum hoc videas etiam in hominum aetatibus adimpleri." Smitmans, p. 134, n. 3.

68. *Homeliae* I, 14, "Post Epiphaniam" (ed. Hurst, CCL 122, pp. 95-104). Réginald Grégoire, *Les homéliaires du Moyen Âge: Inventaire et analyse des manuscrits* (Rome, 1966), p. 85.

69. Smaragdus, *Expositio libri comitis*, "Dominica II post Theophania" (PL 102, 84-90); Haimo, *Homiliae de tempore* 18, "Dominica II post Epiphaniam" (PL 118, 131-135). Smaragdus' source for the passage, according to Fidel Rädle, was Augustine's tract, though he also knew Bede's homily and Alcuin's commentary on John. See *Studien zu Smaragd von Saint-Mihiel* (Munich, 1974), pp. 216-217. Analyzing the manuscript evidence, Rädle concludes that Smaragdus' period of popularity

extended from the ninth to the twelfth century, while Haimo's real influence began in the twelfth (pp. 128-129).

70. See, for example, a commentary on John believed to have been written in southeastern Germany, c. 780-785 (ed. Kelly, CCL 108C, pp. 111-112) and the ninth- or tenth-century "Catechesis celtica" (ed. Wilmart, pp. 76-77).

71. Aelfric, *Sermones catholici*, "Dominica II post Aepiphania Domini" (ed. and trans. Thorpe, 2, pp. 54-73); Byrhtferth's Manual, Ashmole 328, pp. 217-218 (ed. and trans. Crawford, pp. 208-211). Milton McC. Gatch calls Aelfric's homily "an adaptation of a homily of Bede from the Homiliary with a few touches drawn from Haymo of Auxerre" in *Preaching and Theology in Anglo-Saxon England: Aelfric and Wulfstan* (Toronto and Buffalo, 1977), p. 77.

72. Bruno of Segni, *Commentaria in Ioannem* I, 2 (PL 165, 462-465); Rupert of Deutz, *Commentaria in evangelium Sancti Iohannis* II (2, 12) (ed. Haacke, CCL, Cont. med. 9, 111-116).

73. *Miscellanea* I, titulus 82 (PL 177, 517-518): ". . . quia tunc aquae in vinum convertuntur, quando in mente hominis opus Dei, quod laboranti primum non sapuit, per spiritalem intelligentiam illuminato dulcescit." The text is considered authentic: P. Glorieux, *Pour revaloriser Migne*, Mélanges de science religieuse, 9, Cahier supplémentaire (Lille, 1952), p. 70; Roger Baron, *Science et sagesse chez Hugues de Saint-Victor* (Paris, 1957), p. xxv. On Hugh's spiritual exegesis and his view of history, see Baron, pp. 97-145, esp. 123-124; Joachim Ehlers, *Hugo von St. Viktor: Studien zum Geschichtsdenken und zur Geschichtsschreibung des 12. Jahrhunderts* (Wiesbaden, 1973), esp. pp. 140-141.

74. *Homiliae in Hiezechihelem prophetam* I, hom. 6, 7 (ed. Adriaen, CCL 142, p. 70): "Sed impleri hydrias aqua iubet, quia prius per sacrae lectionis historiam corda nostra replenda sunt. Et aquam nobis in vinum vertit, quando ipsa historia per allegoriae mysterium in spiritalem nobis intelligentiam commutatur." Spitz, pp. 144-145 [ref. above, n. 64].

75. *Ex novo testamento* 19, "Quid sex nuptiarum hydriae designent" (PL 171, 1278). The poem has been accepted into Hildebert's corpus: Glorieux, *Pour revaloriser Migne*, p. 65; A. B. Scott, "The Biblical Allegories of Hildebert of Le Mans," *Sacris erudiri*, 16 (1965), pp. 404-424, esp. 422. A series of devotional

diagrams in a manuscript in Munich (Bayerische Staatsbibliothek, clm. 7960, fols. 1r-4r) provides another kind of testimony to twelfth-century exegetical currents. Six urns were drawn, filled with text, for the use of nuns in their meditations. "Pure water" fills the lower half of each vessel and signifies the *historia*: the inscribed texts relate the works of the six days of creation and the events of the six ages of the world. "Wine" fills the upper sectors and represents the higher levels of interpretation, *allegoria* and *moralitas*. See Jean Leclercq, "Textes et images dans l'explication d'un symbole" in *Hommages à André Boutemy*, ed. Guy Cambier, Collection Latomus, 145 (Brussels, 1976), pp. 231-243.

76. On the typological windows see Montague Rhodes James, *The Verses Formerly Inscribed on Twelve Windows in the Choir of Canterbury Cathedral* (Cambridge, 1901); Bernard Rackham, *The Ancient Glass of Canterbury Cathedral* (London, 1949), pp. 51-65; Madeline Harrison Caviness, *The Early Stained Glass of Canterbury Cathedral, circa 1175-1220* (Princeton, 1977), pp. 115-138, app. figs. 8-19; eadem, *The Windows of Christ Church Cathedral, Canterbury*, Corpus Vitrearum Medii Aevi, Great Britain, 2 (London, 1981), pp. 77-156.

77. For information on the three manuscripts in question see Caviness, *Windows*, p. 77. James published the inscriptions preserved in a roll manuscript, Canterbury Cathedral Archives and Library, ms. C246, which he suggests was hung as a guide for medieval visitors (*Verses*, pp. 13-26).

78. The panels were originally set in Caviness's window n.XIII; they appear at present in n.XIV. For descriptions see Rackham, pp. 63-64, pls. 19d-f; Caviness, *Glass*, p. 127, app. fig. 11; Caviness, *Windows*, pp. 106-111, pls. 80, 82-83.

79. On the place of Jechonias in Augustine's genealogy see Pontet, pp. 160-161 [ref. above, n. 2]. Adelheid Heimann discusses a related representation of the figure in "A Twelfth-Century Manuscript from Winchcombe and its Illustrations: Dublin, Trinity College, Ms. 53," *Journal of the Warburg and Courtauld Institutes*, 28 (1965), pp. 92-93.

80. M. R. James, "Pictor in Carmine," *Archaeologia*, 94 (1951), pp. 141-166. From the prologue: "Therefore it is that, to curb the licence of painters, or rather to influence their work in churches where paintings are permit-

ted, my pen has drawn up certain applications of events from the Old and New Testaments, with the addition in every case of a couple of verses which shortly explain the Old Testament subject and apply it to that of the New . . . These distichs are to be inscribed about the Old Testament incident, or about any other of mystical or typical application. For about the New Testament incident (as being of commoner occurrence and better known) it suffices to write merely the names of the personages . . ." (James, p. 142). See also Floridus Röhrig, "Rota in medio rotae: Ein typologischer Zyklus aus Österreich," *Jahrbuch des Stiftes Klosterneuburg*, 14, N.F. 5 (1965), esp. pp. 12-29, 56-82.

Typological programs appear to have been a specialty in twelfth-century England, though the Marriage of Cana was a member in no other. On these cycles see, most recently, Neil Stratford, "Three English Romanesque Enamelled Ciboria," *Burlington Magazine*, 126 (1984), pp. 204-216.

81. *Pictor in carmine* 36, "Mutat Christus aquam in vinum." Transcribed below, the first distich from each set as found in a thirteenth-century copy, Oxford, Bodleian Library, ms. Rawl. C. 67, fols. 46r-46v. *Allegorica intelligentia de sex ydriis per sex etates seculi*:

> Sex docet etatum par ydria significatum,
> Est aqua scriptura, vinum patefacta figura.

and *Tropologica intelligentia de sex ydriis per sex gradus etatis humane*:

> Quelibet hic habite notat ydria tempora vite,
> Insipidos mores aqua missa, merum meliores.

Karl-August Wirth (Munich) has prepared a transcription of the important Cambridge copy (Corpus Christi College, ms. 300), to appear shortly.

82. Caviness, *Windows*, p. 111.

83. Cambridge, Fitzwilliam Museum, ms. 330, no. 4. See below, pp. 145-146.

84. Comte Alexandre de Laborde, *Étude sur la Bible moralisée illustré*, 5 vols. (Paris, 1911-1927); Reiner Haussherr, "Sensus litteralis und sensus spiritualis in der Bible moralisée," *Frühmittelalterliche Studien*, 6 (1972), pp. 356-380; idem, *Commentarium*, published with the *Bible moralisée: Faksimile-Ausgabe im Originalformat des Codex Vindobonensis 2554 der Österreichischen Nationalbibliothek* (Graz and Paris, 1973). On questions of style and technique see

Robert Branner, *Manuscript Painting in Paris during the Reign of Saint Louis: A Study of Styles* (Berkeley, 1977), pp. 22, 32-65. Reviewed by Reiner Haussherr in *Kunstchronik*, 33 (1980), pp. 165-173.

85. Walter Kuhn, "Die Ikonographie der Hochzeit zu Kana von den Anfängen bis zum XIV. Jahrhundert," Diss., Freiburg i. Br., 1955, pp. 161-166.

86. Vienna, Österreichische National-bibliothek, mss. 1179 (Latin) and 2554 (French). Haussherr dates these manuscripts 1220-1230 (*Commentarium*, pp. 31-39); Branner placed them in an atelier active between c. 1212/1215 and c. 1225 (p. 48).

87. Toledo Cathedral, vol. III, fol. 21r (Latin and French). The last eight folios of the manuscript, including the controversial dedication miniature that may represent Louis IX and his mother, Blanche of Castille, are preserved in New York (Pierpont Morgan Library, ms. M.240). Laborde, 5, pp. 41-73; Branner, pp. 41-42, 48 (Toledo III), 49-57, 64 (Toledo I, II, III).

88. Oxford, Bodleian Library, ms. 270b; Paris, Bibliothèque Nationale, ms. lat. 11560; London, British Library, ms. Harley 1526-1527 (Latin). The miniature of the Marriage in Cana and its type appear in ms. Harl. 1527, fol. 23r. See Laborde, 5, pp. 23-41; Branner, pp. 49-57, 65. Laborde publishes reproductions of the entire manuscript.

89. London, British Library, ms. Add. 18719, fol. 251r (Latin), a copy after the Oxford-Paris-London exemplar; Paris, Bibliothèque Nationale, ms. fr. 167, fol. 251r (Latin and French). François Avril argues that the latter was in turn copied after ms. Add. 18719 for Jean le Bon between 1349 and 1353. See "Un chef-d'oeuvre de l'enluminure sous le règne de Jean le Bon: La Bible moralisée, manuscrit français 167 de la Bibliothèque Nationale," *Monuments et mémoires: Fondation Eugène Piot*, 58 (1972), pp. 91-125.

90. Toledo Cathedral, vol. III, fol. 21r: "Erant ibi .vi. lapidee ydrie et dicit Iesus ministris, implete ydrias aqua, et impleverunt eas usque ad summum. Hoc significat quod scriptura legis data fuit hominibus .vi. etatum sed dum in eo Christus latuit quasi aqua fuit insipida."

91. The ages are specifically identified as the ages of the world in a French version of the commentary (Paris, Bib. Nat., ms. fr. 167, fol. 251r): "Ceci segnefie que lescripture de la loy fu donnee aus hommes selon les .vi. aages du munde . . ."

92. On *Ecclesia lactans* see Gertrud Schiller, *Ikonographie der christlichen Kunst*, 4:1 (Gütersloh, 1976), pp. 86-89. Schiller (p. 87) notes that Honorius Augustodunensis, elaborating the metaphor of the Church as a body, identified her breasts as the two testaments (*Expositio in Cant. Cant.* I, 1-2; PL 172, 361). For an example of *Sapientia* suckling elderly gentlemen, biblical figures, see the miniature heading the book of Wisdom in a Bible of the early thirteenth century, French, now in London (British Library, ms. Add. 15452, fol. 233v). Professor John Plummer kindly supplied this reference. The motif of the old man being breast fed (*caritas romana*) is itself ancient; Valerius Maximus related the story of Pero who suckled her starving father Cimon in prison, in his work of the first century A.D., *Factorum et dictorum memorabilium libri novem* V, 4, ext. 1 (ed. Kempf, p. 247). Almuth Seebohm Désautels suggested I look into *Ecclesia* iconography. Professor Lowry Nelson brought to mind the verse from the Song of Songs.

93. London, British Library, ms. Harl. 1527, fol. 5r: "Concepit elisabet et occultabat se mensibus quinque. Hoc significat quod spiritualis doctrina legis gravida in promissis in quinque etatibus seculi et quinque libris moysi latuit." Cf. British Library, ms. Add. 18719, fol. 242r; Paris, Bibliothèque Nationale, ms. fr. 167, fol. 242r.

94. *De diversis quaestionibus octoginta tribus* 58, 3, "De Iohanne baptista" (ed. Mutzenbecher, CCL 44A, pp. 107-108; trans. Mosher, FC 70, pp. 107-108): "Qua visitatione incipit manifestari prophetia, quae superioribus quinque aetatibus latebat . . . Sexto autem mense visitatur a Maria matre domini, et exultat infans in utero, tamquam primo adventu domini, quo in humilitate dignatus est apparere, prophetia manifestari incipiat . . ."

95. Ps.-Jerome, *Expositio quatuor evangeliorum* (Lucas) (PL 30, 586): "*mensibus quinque*, id est, v millia saeculi, sive quinque libri Moysis.*" On the text see Dekkers, *Clavis*, p. 143 (no. 631); Bernhard Bischoff, "Wendepunkte in der Geschichte der lateinischen Exegese im Frühmittelalter," *Sacris erudiri*, 6 (1954), pp. 210, 236-237.

96. *De naturis rerum* IV, 1 (PL 111, 74-75).

97. The ages of man are not represented in the Toledo copy (vol. III, fol. 2r). In the top

medallion, Elizabeth sits alone. Below, the
horned Moses, head on hand, reaches to touch
the Torah while Christ, who brought the
promises to fruition, places his hands on the
holy books as the dove of the Holy Spirit de-
scends from above.

98. Branner, pp. 36-37.

99. Haussherr, "Sensus," pp. 371-372, 380.
Cf. Laborde, 5, pp. 143-154. Beryl Smalley
similarly argued that Hugh's work, a "mosaic
of quotations," was a controlled collaborative
effort, carried out by Hugh and a team of
young friars. See "The Gospels in the Paris
Schools in the Late 12th and Early 13th Centu-
ries," *Franciscan Studies*, 39 (1979), esp. pp.
249-251; 40 (1980), pp. 298-316.

100. Rolf Sprandel, a historian of "mentali-
ties," has prepared a study of attitudes toward
old age as revealed in works of Parisian exe-
gesis, especially commentaries on the Psalms
and the Pauline Epistles, through the whole of
the later Middle Ages. He provides a survey of
libraries in Paris and an account of the form and
appearance of exegetical manuscripts. See *Al-
tersschicksal und Altersmoral: Die Geschichte der
Einstellungen zum Altern nach der Pariser Bibel-
exegese des 12.-16. Jahrhunderts* (Stuttgart,
1981).

101. *Expositio in Hexaemeron* (PL 178, 771-
773): "Sex aetates saeculi senarius iste dierum
quibus mundus perfectus est atque adornatus
exprimit. Prima aetas saeculi quasi eius infantia
est ab Adam usque ad Noe. Inde secunda usque
ad Abraham quasi pueritia. Deinde tertia ad
David tanquam adolescentia. Postea quarta us-
que ad transmigrationem Babylonis quasi iu-
ventus, id est virilis aetas. Inde quinta usque ad
Christum tanquam senectus. Denique sexta us-
que ad finem saeculi tanquam senium vel de-
crepita aetas . . ." Very traditional. On Abe-
lard's approach to scripture in this text see
Eileen Kearney, "Peter Abelard as Biblical
Commentator: A Study of the *Expositio in He-
xaemeron*," in *Petrus Abaelardus (1079-1142): Per-
son, Werk und Wirkung*, ed. Rudolf Thomas
(Trier, 1980), pp. 199-210.

102. *Sententie* I, 1, 17 (ed. Martin, 3:1, pp.
202-205).

103. *Miscellanea*, I, tit. 82 (PL 177, 517-518).
For a discussion of this text see above, p. 71.
The text of the *Didascalicon* is translated, with
commentary, by Jerome Taylor (New York
and London, 1961). On the Victorines see
Beryl Smalley, *The Study of the Bible in the Mid-
dle Ages*, 3rd rev. ed (Oxford, 1983), pp. 83-
195.

104. *Liber exceptionum* II, 11, 3 (ed. Châtil-
lon, p. 442) [=PL 175, 753-754, incorrectly
identified].

105. *Microcosmus* 13-15 (ed. Delhaye, 1, pp.
40-44). Philippe Delhaye provides a close anal-
ysis of the work in *Le Microcosmus de Godefroy
de Saint-Victor: Étude théologique* (Lille and
Gembloux, 1951).

106. *Tractatus quidam de philosophia et partibus
eius* (ed. Dahan, pp. 184-185): "Etates secun-
dum quosdam sex sunt . . . Secundum alios,
quatuor sunt, et prima dividitur in duas: in in-
fantiam et pueritiam; secunda in adolescentiam
et iuventutem; unde dicit Salomon: *Letare iu-
venis in adolescentia tua*; tertia, id est virilis etas,
mansit indivisa; quartam, id est virilem etatem,
in senectutem et decrepitam etatem." Gilbert
Dahan briefly considers the passage in "Une in-
troduction à la philosophie au XIIe siècle,"
AHDLMA, 49 (1982), pp. 174-175.

107. On the Portail de la Vierge and its re-
liefs see William M. Hinkle, "The King and the
Pope on the Virgin Portal of Notre-Dame,"
Art Bulletin, 48 (1966), pp. 1-13, esp. 3-4, fig.
4; idem, "The Cosmic and Terrestrial Cycles
on the Virgin Portal of Notre-Dame," *Art Bul-
letin*, 49 (1967), pp. 287-295, esp. 287, fig. 2;
Willibald Sauerländer, *Gothic Sculpture in
France, 1140-1270*, translated from the German
edition of 1970 by Janet Sondheimer (New
York, 1972), pp. 454-457, esp. 455, pl. 154.

108. William Hinkle, who identifies the lost
statue at the end of the left embrasure as Philip
Augustus, crowned at age fourteen, draws a
connection between the hound and falcon
carved on the spandrel below him and the
hound and falcon which accompany the repre-
sentative of the third age, *adolescentia* ("King,"
pp. 3-4).

NOTES TO CHAPTER IV

1. *Adversus haereses* II, 22, 4 (ed. Rousseau
and Doutrelau, SC 294, pp. 220-223; I follow
the translation by Roberts and Rambaut, 5, p.
200): "Omnes enim venit per semetipsum sal-
vare: omnes, inquam, qui per eum renascuntur
in Deum, infantes et parvulos et pueros et iu-
venes et seniores. Ideo per omnem venit aeta-
tem, et [in] infantibus infans factus, sanctificans
infantes; in parvulis parvulus, sanctificans hanc
ipsam habentes aetatem, simul et exemplum il-

lis pietatis effectus et iustitiae et subiectionis; in iuvenibus iuvenis, exemplum iuvenibus fiens et sanctificans Domino: sic et senior in seniori-bus, ut sit perfectus magister in omnibus, non solum secundum expositionem veritatis, sed et secundum aetatem, sanctificans simul et seni-ores, exemplum ipsis quoque fiens." The idea is echoed in *Adv. haer.* III, 18, 7 (SC 211, pp. 366-367). Cited by Auguste Luneau, *L'histoire du salut chez les Pères de l'Église* (Paris, 1964), p. 176 n. 2.

2. *Adv. haer.* II, 24, 4 (SC 294, pp. 242-247): "Quinque aetates transit humanum genus . . ."

3. Censorinus, in his *De die natali*, 14, 2 (ed. Sallmann, p. 25) names the ages, which progress in fifteen-year leaps, as *puer, adules-cens, iuvenis, senior, senex.* Servius writes in his commentary on the *Aeneid*, V, 295 (ed. Rand et al., 3, p. 527): "aetates omnes Varro sic dividit; infantiam, pueritiam, adulescentiam, iuven-tam, senectam." For a list of further authors employing the fivefold division of life see E. Eyben, "Die Einteilung des menschlichen Lebens im römischen Altertum," *Rheinisches Museum für Philologie*, N.F. 116 (1973), pp. 159-160; on Varro, pp. 172-176.

4. *De anima* 56, 5-7 (ed. Waszink, pp. 75-76; with comm. pp. 569-572). Tertullian argues that the soul passes through the ages of life (*in-fantia, pueritia, adulescentia, iuventa, senecta*), but only when inhabiting the body. After death, in the underworld, the soul awaits resurrection at the stage of life at which it fell; on that day it will arise at a "perfect" age. For the state of the soul at conception, birth (infancy), and puberty (fourteen years) see *De anima* 27, 1; 31, 2; 38, 1.

5. *Protrepticus* X, 108, 2-3 (ed. and trans. Mondésert, SC 2, p. 176).

6. *Contra Symmachum* II, 317-323 (ed. Cun-ningham, CCL 126, p. 222; I follow the trans-lation by M. Clement Eagen, FC 52, p. 151). See Wolfgang Schmid, "Die Darstellung der Menschheitsstufen bei Prudentius und das Problem seiner doppelten Redaktion," *Vigiliae Christianae*, 7 (1953), pp. 171-186.

7. *Adversus haereses* I, 1, 3 (SC 264, pp. 32-35).

8. *Commentariorum in Matthaeum series* XV, 32, 36 (ed. Klostermann, GCS 40, pp. 446-447, 456-458).

9. *Commentariorum in Matheum libri IV*, III (ed. Hurst and Adriaen, CCL 77, pp. 174-175):

"Mihi videtur primae horae esse operarios Sa-muhel et Hieremiam et baptistam Iohannem qui possunt cum psalmista dicere: *Ex utero ma-tris meae Deus meus es tu* [Ps. 21:11]. Tertiae vero horae operarii sunt qui a pubertate Deo servire coeperunt; sextae horae qui matura aetate sus-ceperunt iugum Christi; nonae qui iam decli-nante ad senium; porro undecimae qui ultima senectute, et tamen omnes pariter accipiunt praemium licet diversus labor sit."

10. *Sermo* 87, 5 (7) (PL 38, 533). Cf. *Sermo* 49, 2 (2) (PL 38, 320). On their dating see Pierre-Patrick Verbraken, *Études critiques sur les sermons authentiques de Saint Augustin* (Steen-brugge, 1976), pp. 74, 64. Isidore, in his *Alle-goriae* 178-182 (PL 83, 121-122), followed Au-gustine in interpreting the hours of the day as times when the individual may turn to the faith—*a rudimentis infantiae, ab adolescentia, in iuventutis aetate, a iuventute in senectutem decli-nantes, decrepiti.*

11. *Homiliae in evangelia* I, 19, 1-2 (PL 76, 1154-1155): "Possumus vero et easdem diver-sitates horarum, etiam ad unumquemque hominem per aetatum momenta distinguere. Mane quippe intellectus nostri *pueritia* est. Hora autem tertia *adolescentia* intelligi potest, quia quasi iam sol in altum proficit, dum calor aetatis crescit. Sexta vero *iuventus* est, quia ve-lut in centro sol figitur, dum in ea plenitudo roboris solidatur. Nona autem *senectus* intelligi-tur, in qua sol velut ab alto axe descendit, quia ea aetas a calore iuventutis deficit. Undecima vero hora ea est *aetas quae decrepita vel veterana dicitur.* Unde Graeci valde seniores, non γέρ-οντας sed πρεσβυτέρους appellant, ut plus quam senes esse insinuent quos provectiores vocant. Quia ergo ad vitam bonam alius in pueritia, alius in adolescentia, alius in iuven-tute, alius in senectute, alius in decrepita aetate perducitur, quasi diversis horis operarii ad vi-neam vocantur."

See Roderich Schmidt, "Aetates Mundi," *Zeitschrift für Kirchengeschichte*, 67 (1955-1956), pp. 302-303. Gregory, in his *Moralia in Iob* XI, 46 (62) (ed. Adriaen, CCL 143A, p. 621), out-lined five phases of mental growth, the ages named being *infantia, pueritia, adolescentia, iu-ventus, senectus.*

12. Lessons 7, 8, and 9 in the modern Ro-man Breviary. For Gregory's role in the devel-opment of the liturgy for the three Sundays be-fore Lent see C. Callewaert, "L'oeuvre

liturgique de S. Grégoire: La Septuagésime et l'Alleluia," *Revue d'histoire ecclésiastique*, 33 (1937), pp. 306-326.

13. Réginald Grégoire, *Les homéliaires du Moyen Âge* (Rome, 1966), p. 87.

14. Smaragdus, *Expositio libri comitis*, "Dominica in Septuagesima" (PL 102, 102-103); Hrabanus, *Comm. in Matthaeum* 20 (PL 107, 1026-1027); Haimo, *Homiliae de tempore* 21, "Dominica in Septuagesima" (PL 118, 156-158); Aelfric, *Sermones catholici*, "Dominica Septuagesima" (ed. and trans. Thorpe, 2, pp. 72-89). On the last see Gatch, *Preaching and Theology*, pp. 78, 93-94 [ref. above, ch. III, n. 71].

15. See, for example, Ps.-Hildebert of Le Mans, *Sermones de tempore* 17 (PL 171, 421) [on authenticity, Glorieux, *Pour revaloriser Migne*, pp. 63-64]; Garnerus, *Gregorianum* XII, 5-6 (PL 193, 369-370); Werner of St. Blasien, who quotes Jerome fully, in *Deflorationes SS. Patrum* 1, "Dominica Tertia in Septuagesima" (PL 157, 844). See also Honorius Augustodunensis, whose rendition is independent, *Speculum ecclesiae*, "Dominica in Septuagesima" (PL 172, 858). The history of the exegesis is briefly set out by Schmidt, "Aetates Mundi," pp. 301-304, and Hartmut Freytag, "Die Bedeutung der Himmelsrichtungen im Himmlischen Jerusalem," *Beiträge zur Geschichte der deutschen Sprache und Literatur* [PBB], 93 (Tübingen, 1971), pp. 142-143.

16. London, British Library, ms. Add. 28106, fol. 6r. For a thoroughgoing analysis of the initial see Wayne Dynes, *The Illuminations of the Stavelot Bible*, Diss., New York University, 1969 (New York and London, 1978), pp. 94-151, figs. 4-12; on liturgical sources, pp. 118-121. I have also had access to an unpublished note by Neil Stratford in the Warburg Institute, in which it is confirmed that Gen. 1:1, Matt. 20:1-16, and Gregory's homily were read at matins on Septuagesima Sunday in Stavelot c. 1100.

17. The scene in the medallion of the fifth age, that which shows a cross-nimbed figure speaking to a group of barefoot, robed, book-bearing figures, is oddly identified by Wayne Dynes as an apostle addressing the people rather than as Christ addressing the apostles (pp. 98-99, 147-149). He argues that the centrally placed life of Christ can be linked both to the ages of the world, typologically, and to the

annual cycle of viticultural planting, through the liturgical year (pp. 137-147).

18. Vienna, Österreichische National-bibliothek, cod. 2739*, fols. 4v, 10v, 11v, 12v; corresponding prayers appear on fols. 10r, 11r, 12r, 13r. See Hermann Julius Hermann, *Die deutschen romanischen Handschriften*, Beschreibendes Verzeichnis der illuminierten Handschriften in Österreich, 8:2 (Leipzig, 1926), pp. 249-251 (no. 170), figs. 143-144. Elisabeth Klemm draws the connection between this cycle and parable exegesis, citing both textual and pictorial parallels, in "Das sogenannte Gebetbuch der Hildegard von Bingen," *Jahrbuch der kunsthistorischen Sammlungen in Wien*, 74, N.F. 38 (1978), pp. 34-35, 70-74, esp. 49-52, fig. 31. I have not been able to come by a relevant article, published in the war years, H. Menhardt's "Lilienfelder Heilsgeschichte," *Zeitschrift für deutsches Altertum und deutsche Literatur*," 78 (1941), pp. 145-184.

19. Cod. 2739*, fol. 10r: "Deus iuste iudex fortis et paciens, qui per ministerium famuli tui *noe* arcam fabricari voluisti, in qua diluvio omnem carnem delente ipse cum paucis salvaretur . . ."

Fol. 11r: "Omnipotens sempiterne deus . . . qui famulo tuo *abrahe* ob insignia fidei opera signum circumcisionis in omni generis sui posteritate servandum tradisti . . ."

Fol. 12r: "Omnipotens eterne deus, qui populum tuum filios israhel in manu *moysi* famuli tui per mare rubrum eductos et ab egyptia servitute liberatos quadraginta annos in heremo manna cibasti atque in terram repromissionis fortissimis habitatoribus eius occulti iudicii tui examine deletis induxisti . . ."

Fol. 13r: "Domine sancte Pater omnipotens eterne deus . . . qui coeternum et consubstanciale verbum tuum dominum nostrum *iesum christum* unigenitum filium tuum de inmaculate virginis utero carnem assumere voluisti . . ."

20. The manuscript is incomplete, and many of its folios are bound out of sequence. The image of Noah (fol. 4v), at present inserted, not illogically, between a scene of the Expulsion and another of Abraham and the three Angels, is separated from its prayer (fol. 10r), which is transcribed on the verso of the illustration of Abraham (fol. 10v). Examination of the codex confirms that fol. 4 was added to the first quire as a single leaf. The representations of Abraham, Moses, and Christ appear in a quire

comprising now four leaves, while quires of eight leaves are normal in the manuscript. If the image of Noah were restored to its original position as a bifolio, six leaves would be accounted for. Another bifolio with a scene from Adam's history would complete the quire. The prayer on the recto of the folio showing Noah (fol. 4r), that which would have accompanied the reconstructed image of Adam, does not decide the issue. It is a general plea for God's mercy with an oblique reference to the Fall (fol. 4r): "Adonay Domine magne et misericors . . . qui iuste indignationis tue contra genus humanum iracundiam adeo dignatus es mitigare ut carnem cui dictum est terra es et in terram ibis . . ." Elisabeth Klemm comes to much the same conclusions with regard to the reconstruction of the quire (p. 52).

21. For a description and analysis of the portal see Géza de Francovich, *Benedetto Antelami: Architetto e scultore e l'arte del suo tempo*, 2 vols. (Milan and Florence, 1952), pp. 169-171, 202-211, pls. 142-148. Ursula Mielke interprets the program with reference to the baptismal function of the building in *Die Plastik am Baptisterium in Parma und ihre Beziehung zum Taufsakrament*, Diss., Berlin, 1970. In her search for literary parallels to the jamb carving, she avoided the obvious, homilies on the parable itself (pp. 22, 81-84).

22. Surviving illustrations of the parable tend to be straightforward narrations, age differentiation not carried out systematically. The illustration of the parable in the Codex Aureus of Echternach, a manuscript dating before 1039, is supplied with inscriptions which give its spiritual sense (Nuremberg, Germanisches Nationalmuseum, no. 156142, fol. 76v): "Quidam conduit, quos mundi vinea poscit diversis horis hominis aetatibus aptis . . ." See Peter Metz, *The Golden Gospels of Echternach*, translated from the German edition of 1956 by Ilse Schrier and Peter Gorge (New York, 1957), p. 77, pl. 67. The manuscript has recently been reproduced in facsimile. Edmund Bennett kindly supplied this reference.

23. See above, pp. 58, 60-61.

24. *Historia scholastica* 104 (PL 198, 1590-1591): "Cumque nonnisi quinque horae diei ibi numerentur, tamen omnes subintelliguntur sex aetates, tam temporis quam hominis. In undecima enim quinta, et sexta aetas, vel chilias intelligitur. In eadem quoque senectus, et decrepita." Cited by Hartmut Freytag, "Him-

melsrichtungen," pp. 141-142. Lambert of St. Omer, in the *Liber floridus* (c. 1120), filled out the hexad by adding a tenth hour to the sequence (fig. 17). See above, pp. 68-69.

25. *Homiliae in evangelia* I, hom. 13, 5 (PL 76, 1125): "Prima quippe vigilia primaevum tempus est, id est pueritia. Secunda, adolescentia vel iuventus, quae auctoritate sacri eloquii unum sunt, dicente Salomone: *Laetare iuvenis in adolescentia tua*. Tertia autem, senectus accipitur. Qui ergo vigilare in prima vigilia noluit custodiat vel secundam, ut qui converti a pravitatibus suis in pueritia neglexit ad vias vitae saltem in tempore iuventutis evigilet. Et qui evigilare in secunda vigilia noluit tertiae vigiliae remedia non amittat, ut qui in iuventute ad vias vitae non evigilat saltem in senectute resipiscat . . ."

26. Bede, *In Lucae evangelium expositio* XII, 38 (ed. Hurst, CCL 120, p. 257); Smaragdus, *Expositio libri comitis*, "In natalem sanctorum plurimorum" (PL 102, 539); Haimo, *Homiliae de sanctis* 10, "Item de confessoribus" (PL 118, 789). On the exegesis of the parable see John Burrow, "Langland *Nel Mezzo Del Cammin*," in *Medieval Studies for J.A.W. Bennett*, ed. P. L. Heyworth (Oxford, 1981), pp. 22-24.

27. *Glossa ordinaria*, Evan. Luc. XII, 32 (PL 114, 298). For the proper identification of the text and an account of its great influence see Beryl Smalley, *The Study of the Bible in the Middle Ages*, 3rd rev. ed. (Oxford, 1983), pp. 46-66.

28. *Gemma animae* II, 50 (PL 172, 629).

29. *Summa de ecclesiasticis officiis* 22h (ed. Douteil, CCL, Cont. med. 41A, p. 47): "Tres lectiones tres etates designant, scilicet puericiam, iuventutem, senectutem, in quibus ne a diabolo seducamur, bene vigilando Deum laudare tenemur."

30. *Gemma animae* II, 54 (PL 172, 633): "Dies etiam repraesentat nobis vitam uniuscuiusque, quo diversis aetatibus, quasi diversis horis, docetur ex lege Domini quasi in vinea laborare . . ."

31. *Summa de ecclesiasticis officiis* 28a (ed. Douteil, CCL, Cont. med. 41A, p. 55).

32. *Mitrale* IV, 3 (PL 213, 159-160): "Ergo septies, id est semper; quia dum septies in die laudem Domino dicimus, totum saeculi tempus, et totam vitam hominis ad Deum referendam notamus." Cf. William Durandus (d. 1296), *Rationale divinorum officiorum* V, 1, 4 (Venice, 1568, fol. 138r).

33. For the history of this line of thought, and its application in a poem in Middle High German, see Friedrich Ohly, "Zum Text des Himmlischen Jerusalem" and "Zum 'Himmlischen Jerusalem' v. 61ff." in *Zeitschrift für deutsches Altertum und deutsche Literatur*, 86 (1955-1956), pp. 210-215; 90 (1960-1961), pp. 36-40; Freytag, pp. 139-150; Barbara Maurmann, *Die Himmelsrichtungen im Weltbild des Mittelalters* (Munich, 1976), pp. 106, 196. I am grateful to Professor Ohly (Münster) for having first drawn my attention to this exegetical tradition and to Dr. Heinz Meyer for supplying a wealth of bibliographic suggestions.

34. *Expositio in Apocalypsim* VII, 21 (PL 165, 722). Rupert of Deutz (d. 1129) gave a slightly different reading in his *Commentaria in Apocalypsim* XII, 21 (PL 169, 1197). Ohly, 1955-1956, p. 211. Rupert quotes Prudentius (d. 410) in authority. In the *Psychomachia* the early Christian poet had drawn a connection between the ages of man and the four sides of the temple built by the Virtues on the plan of the Heavenly Jerusalem. The soul enters the shrine "whether it be in childhood's early dawn, the heat of ardent youth, the full sunlight of man's maturity, or wintry chill of feeble age." *Psychomachia* 845-848 (ed. Cunningham, CCL 126, p. 179; trans. by Eagen, FC 52, p. 108). See Christian Gnilka, *Studien zur Psychomachie des Prudentius* (Wiesbaden, 1963), pp. 104-106.

35. *Homilia* 22 (PL 165, 771-772): "Templum igitur et vinea idem significant: sancta namque Ecclesia et vinea nobis est, in qua laboramus, et templum in quo oramus. In hanc enim vineam et in hoc templum pueri et infantes et primo mane, et per portas orientis ingrediuntur. Adolescentes autem intrant hora tertia, et per angustas portas magisque difficiles aquilonis. Intrant autem per portas australes iuvenes et senes, qui sexta et nona hora in vinea Domini laborare coeperunt." Freytag, p. 144.

Adolf Katzenellenbogen observed that the figures of the four Rivers of Paradise on the Trivulzio Candlestick in Milan Cathedral (c. 1200) are depicted at four distinctly different ages. If it was the artist's intention to represent the rivers as the ages of man, his grounds for linking the themes might be sought in the four directions. For a description see Katzenellenbogen, "The Representation of the Seven Liberal Arts" in *Twelfth-Century Europe and the Foundations of Modern Society*, ed. M. Clagett, G. Post, and R. Reynolds (Madison, 1961), p.

53; for reproductions, Otto Homburger, *Der Trivulzio-Kandelaber: Ein Meisterwerk frühgotischer Plastik* (Zurich, 1949), figs. 9, 11, 13, 15. Peter Barnet, currently preparing a doctoral dissertation on the candlestick (Yale University), drew this cycle to my attention.

36. *De caelo* I, 1 (268a10-a13) (ed. Allan, n.p.; trans. Stocks, n.p.). Franz Boll draws attention to the passage and discusses the place of the triad in Aristotle's thought ("Lebensalter," pp. 98-101).

37. *Ars rhetorica* II, 12-14 (1388b31-1390b13) (ed. Ross, pp. 100-104; trans. Roberts, n.p.).

38. This is the version of the riddle preserved by Apollodorus (first or second century A.D.) in his *Bibliotheca* III, 5, 8 (ed. and trans. Frazer, 1, pp. 346-349).

39. *De nuptiis Philologiae et Mercurii* I, 76 (ed. Willis, p. 23; I follow the translation by Stahl and Johnson, p. 28): "facie autem mox ingressus est pueri renidentis, in incessu medio iuvenis anheli, in fine senis apparebat occidui." Martianus adds, "There are some who think he has a dozen different appearances." Franz Boll discusses the alignment of the three ages with natural cycles ("Lebensalter," p. 96). For other passages in *De nuptiis* concerning the ages of man see above, pp. 21-22, 45.

40. Fundamental literature on the subject in both its literary and artistic aspects includes: Hugo Kehrer, *Die Heiligen Drei Könige in Literatur und Kunst*, 2 vols. (Leipzig, 1908-1909); Émile Mâle, *L'art religieux du XIIIe siècle en France*, 7th ed. (Paris, 1931), pp. 213-217; Henri Leclercq, "Mages," *Dictionnaire d'archéologie chrétienne et de liturgie*, 10:1 (Paris, 1931), cols. 980-1067; Gilberte Vezin, *L'adoration et le cycle des mages dans l'art chrétien primitif* (Paris, 1950); Ugo Monneret de Villard, *Le leggende orientali sui magi evangelici* (Vatican City, 1952); Marianne Élissagaray, *La légende des rois mages* (Paris, 1965); Gertrud Schiller, *Iconography of Christian Art*, translated from the second German edition of 1969 by Janet Seligman, 1 (Greenwich, Conn., 1971), pp. 94-114.

41. Robert E. McNally, "The Three Holy Kings in Early Irish Latin Writing" in *Kyriakon: Festschrift Johannes Quasten*, ed. Patrick Granfield and Josef A. Jungmann, 2 (Münster Westf., 1970), pp. 667-690.

42. *Collectanea* (PL 94, 541): "Magi sunt, qui munera Domino dederunt: primus fuisse dicitur Melchior, senex et canus, barba prolixa et capillis, tunica hyacinthina, sagoque mileno, et

calceamentis hyacinthino et albo mixto opere, promitrario variae compositionis indutus: aurum obtulit regi Domino. Secundus, nomine Caspar, iuvenis imberbis, rubicundus, mylenica tunica, sago rubeo, calceamentis hyacinthinis vestitus: thure quasi Deo oblatione digna Deum honorabat. Tertius, fuscus, integre barbatus, Balthasar nomine, habens tunicam rubeam, albo [sago] vario, calceamentis milenicis amictus: per myrrham Filium hominis moriturum professus est. Omnia autem vestimenta eorum Syriaca sunt."

Kehrer, followed by McNally (p. 670), believed the description to be Greek in origin on account of its unusual vocabulary (*milenicus* for apple-green, *hyacinthinus* for purple, and *promitrarium* for mithraic cap); he suggested the description might derive from an early painter's guide (I, pp. 66-67). The unique manuscript containing the *Collectanea* was lost after its sixteenth-century printing, hence its dating is insecure. Some have treated it as a twelfth-century product; most, on the basis of its relation to other early Irish texts, place it in the late eighth or early ninth century. See Dekkers, *Clavis*, pp. 250-251 (no. 1129); Bischoff, "Wendepunkte," pp. 216-217 [ref. above, ch. III, n. 95].

43. The account appears with slight variations in the Ps.-Isidoran *Liber de numeris* (8th c.), the *Collectaneum in Mattheum* of Sedulius Scottus (mid-9th c.), the "Catechesis celtica" (9th or 10th c.), a gloss to an Irish hymn (11th c.), an Irish poem inserted into the Gospels of Máel-Brigte (early 12th c.), and an apocryphal text incorporated in the *Lebar Brecc* (15th c.). See McNally, "Kings," passim; Leclercq, cols. 1062-1063. It is also transcribed in a codex dating to the early ninth century, believed to be a Bavarian copy of an Anglo-Saxon text (Munich, Bayerische Staatsbibliothek, clm. 22053, fols. 45r-46r). See Glenys A. Waldman, "Excerpts from a Little Encyclopaedia—the Wessobrun Prayer Manuscript Clm. 22053," *Allegorica*, 2:2 (1977), pp. 9-26, esp. 20-24.

In the tale of the sixth-century voyage of St. Brendan, a narrative probably composed in the tenth century, the motif of the three ages of man is introduced. The Irish saint and his band arrive at a barren island to find three groups of men chanting: one of them is composed of youths (*pueri*) dressed in white, another of men (*iuvenes*) dressed in jacinth, and a third of old men (*seniores*) dressed in purple. *Navigatio*

Sancti Brendani 17 (ed. Selmer, pp. 49-50; trans. Webb, p. 55).

44. In sum: Kehrer gives pride of place to the Etchmiadzin cover (2, pp. 63, 80, fig. 46) but finds the first bearded magus on the architrave relief of the north portal of the west façade of S. Marco in Venice (2, p. 45), a work of uncertain date; he places the Monza ampulla second in line (2, p. 50, fig. 33). Mâle (*XIII^e siècle*, p. 215, n. 2), Élissagaray (p. 28), and Schiller (1, p. 101), like Kehrer, consider the Magi's age differentiation to be an eastern development, accomplished by the sixth century. Vezin (pp. 64-65) uses several sarcophagi published by Leclerq (figs. 7474, 7475) to support a fourth-century date for the origin of the motif. E. Weigand rightly draws a distinction between occasional appearances of one, two, or three bearded Magi in the Early Christian works and later representations in which three ages are consciously distinguished. His candidate for the first securely dated image of three-aged Magi is a fresco in S. Maria Antiqua in Rome painted under John VII (A.D. 705-707). See "Zur Datierung der kappadokischen Höhlenmalereien," *Byzantinische Zeitschrift*, 36 (1936), pp. 358-362.

45. Kehrer, 2, pp. 50-51, fig. 34; Giuseppe Bovini, *Ravenna Mosaics*, translated from the Italian edition of 1957 by Giustina Scaglia (Oxford and New York, 1978), p. 36, pl. 21 [color repr.].

46. Stuttgart, Württembergische Landesbibliothek, Bibl. fol. 23, fol. 84r. The image is reproduced in facsimile and described in *Der Stuttgarter Bilderpsalter*, 2 vols. (Stuttgart, 1965-1968), I, fol. 84r; II, pp. 108, 178-179. See also Ernest T. DeWald, *The Stuttgart Psalter* (Princeton, 1930), p. 65.

47. Both Kehrer (1, p. 67) and McNally ("Kings," p. 670) translate *rubicundus* as "red hair" rather than "ruddy."

48. Helmut Buschhausen, *Der Verduner Altar* (Vienna, 1980), p. 32, pl. 11 [color repr.]. The inscription reads: "The three kings give three mystic gifts to the true God" ("Mistica dona deo dant reges tres tria vero"). Part of a great typological program, the panel depicting the Magi is juxtaposed with representations of its Old Testament types: Abraham offering tithes to Melchizidek (Gen. 14:20) and the Queen of Saba giving gifts to Solomon (3 Kings 10:10). In charting the development of the motif of the ages of the Magi, I made prof-

itable use of the photographic files at the Index of Christian Art in Princeton.

49. Translated by Paul Hetherington in *The "Painter's Manual" of Dionysius of Fourna* (London, 1974), p. 32. For an intriguing Byzantine image of the three Magi and the three stages of Christ's life, pointed out to me by Adelaide Bennett, see Tamar Avner, "The Impact of the Liturgy on Style and Content: The Triple-Christ Scene in Taphou 14," XVI. Internationaler Byzantinistenkongress, Akten II:5, *Jahrbuch der Österreichischen Byzantinistik*, 32:5 (1982), pp. 459-467, figs. 1, 1a.

50. "Catechesis celtica" (ed. Wilmart, p. 78, desc. on pp. 73-74): "Magorum autem aetates et habitus ad quaerendum et ad inveniendum deum nos docent multum. Vetustas namque primi nos docet sobrietatem in moribus habere. Iuventus vero secundi nos ammonet impigritatem et floridam mentem in mandatis dei habere. Perfecta autem aetas III nos ammonet vitam perfectam in omni re habere." See McNally, "Kings," pp. 685-686. André Wilmart published only a portion of this interesting collection of homilies (Biblioteca Apostolica Vaticana, cod. Reg. lat. 49) in his *Analecta Reginensia*, Studi e testi, 59 (Vatican City, 1933), pp. 29-112.

51. *Sermo 202*, "In Epiphania Domini" (PL 38, 1033): "Quia et illi Magi quid iam fuerunt, nisi primitiae Gentium? Israelitae pastores, Magi gentiles." On the importance of Augustine's interpretation see Kehrer, 1, p. 34.

52. *Tractatus 33*, 3 (ed. Chavasse, CCL 138, p. 173; trans. Feltoe, p. 146): "Adorent in tribus magis omnes populi universitatis auctorem . . ."

53. Ps.-Bede, *In Matthaei evangelium expositio* I, 2 (PL 92, 13): "Mystice autem tres Magi tres partes mundi significant, Asiam, Africam, Europam, sive humanum genus, quod a tribus filiis Noe seminarium sumpsit." See Glorieux, *Pour revaloriser Migne*, p. 52; McNally, "Kings," p. 677. Similar ideas are to be met, for example, in the *Glossa ordinaria* (PL 114, 73), in Honorius Augustodunensis' *Speculum ecclesiae* (PL 172, 845) and his *Gemma animae* III, 19 (PL 172, 647), and in Sicardus of Cremona's *Mitrale* V, 9 (PL 213, 235).

54. *The Description of the World* 31 (trans. Moule and Pelliot, 1, p. 114).

55. *Chronicle* (ed. Delisle, 1, p. 349): "[1164] . . . Rainaldus, Coloniensis electus, cancellarius Frederici imperatoris Alemannorum, trans-

tulit trium Magorum corpora de Mediolano Coloniam, quorum corpora, quia balsamo et aliis pigmentis condita fuerant, integra exterius, quantum ad cutem et capillos, durabant. Eorum primus, sicut mihi retulit qui eos se vidisse affirmabat, quantum ex facie et capillis eorum comprehendi poterat, quindecim annorum, secundus triginta, tercius sexaginta videbantur . . ." On the relics of the Magi in Cologne see *Achthundert Jahre Verehrung der Heiligen Drei Könige in Köln, 1164-1964*, published as *Kölner Domblatt*, 23-24 (Cologne, 1964); *Die Heiligen Drei Könige: Darstellung und Verehrung*, exhib. Cologne, Wallraf-Richartz-Museum, 1 December 1982–30 January 1983 (Cologne, 1982).

56. *Historia trium regum* 21 (ed. Horstmann, EETS o.s., no. 85, p. 237): "et erat Malchiar minor in persona, Balthazar mediocris, Jaspar maior in persona, et ethiops niger, de quo nulli [dubium]." On the text, which was translated into many vernacular languages, see Élissagaray, pp. 61-78.

57. *Catalogus sanctorum et gestorum eorum* II, 48 (Venice, 1493): "Gaspar fuisse annorum sexaginta; Balthasar quadraginta; & Melchior viginti; & ita communiter pinguntur." Mâle, *XIII^e siècle*, p. 216, n. 2.

NOTES TO CHAPTER V

1. *Compotus Fratris Rogeri* I, 1 (ed. Steele, 6, pp. 4-8).

2. See above, pp. 30-31.

3. See above, pp. 29-30.

4. See above, pp. 55-58.

5. *De miseria condicionis humane*, esp. Book I (ed. and trans. Lewis, pp. 92-143).

6. *Tractatus de regimine sanitatis virorum spiritualium ac devotorum* 12-21 (ed. Koch, p. 18): "Primo periclitamur in matris utero, deinde cum magnis eximus doloribus et periculo matrum nostrarum, postea in infancia sustinemus multos infirmitates, dolores et anxietates: tunc enim cum labore et dolore discimus ampulare, fari et opera vite humane exercere, in puericia ad artes varias discendas penimur et in miseria magna et labore ac dolore ibidem sumus. In evidenter adulescentia cogitamus de matrimonio, et ibi eciam sunt multe erumpne et pericula. Maledictus namque vir qui sortitur mulierem malam; sic maladicta mulier que aquirit virum maleficiorum, cum quo omnibus diebus vite manere debet et quiescere, ymo pocius

perturbari: et contrario vir cum muliere. Iuventute autem quando debet uxorem et pueros nutrire, varia ocurrunt negocia et impedimenta: videt in varys negocys multas resistencias in familia, in ancillis, in servis, in vicinis, in amicis et extraneys et vix in aliquo veram invenit fidem. In senio acdum cure et sollicitudines plus quam in prioribus etatibus et officitur homo sibi ipsi tediosus et miseria impletur in anima et corpore: varie enim passiones male animam continue perturbant: nunc ira inmunderata, nunc gaudium vanum, nunc spes seculi honoris et dignitatis, nunc tristicia que sepius mortem anime operatur." The text is analyzed by Manfred Peter Koch in Das "Erfurter Kartäuserregimen": Studien zur diätetischen Literatur des Mittelalters, Diss., Bonn, 1969.

7. Robert Steele, ed., Secretum Secretorum cum glossis et notulis, Opera hactenus inedita Rogeri Baconi, fasc. 5 (Oxford, 1920), pp. vii-lxiii; M. A. Manzalaoui, ed., Secretum Secretorum: Nine English Versions, EETS o.s., no. 276 (Oxford, 1977), pp. ix-l. The text exists in hundreds of manuscripts. See Friedrich Wurms, Studien zu den deutschen und den lateinischen Prosafassungen des pseudo-aristotelischen "Secretum Secretorum," Diss., Hamburg, 1970, pp. 22-126. On the French translations see J. Monfrin, "La place du Secret des secrets dans la littérature française médiévale" in Pseudo-Aristotle, The Secret of Secrets: Sources and Influences, ed. W. F. Ryan and Charles B. Schmitt, Warburg Institute Surveys, 9 (London, 1982), pp. 73-113.

8. Secretum secretorum II, 10-13 (ed. Steele, pp. 76-81): (Ver) "[Tellus] fit sicut sponsa pulcherrima, speciosa iuvencula parata monilibus, ornata variis coloribus, ut appareat hominibus in festo nupciali." (Estas) ". . . et fit mundus quasi sponsa corpore completa, etate perfecta, calore inflammata." (Autumpnus) "Mundus comparatur femine plene etatis, indigenti vestibus, quasi si recesserit ab ea iuventus et festinat senectus." (Hyemps) "Et tunc est mundus quasi vetula gravida etate decrepita, indumento nuda, morti propinqua."

9. These have been collected, edited, and introduced by A. G. Little and E. Withington in Opera hactenus inedita Rogeri Baconi, fasc. 9 (Oxford, 1928). Withington's statement (p. xxxvii) that Roger could not have derived his division of old age into senectus and senium from the "ancients," but must have been influenced

by Christian sources and Psalm 89:10, stands in need of revision. See above, pp. 29-31.

10. De aetate sive de iuventute et senectute I, 2-6 (ed. Borgnet, 9, pp. 306-315). See James A. Weisheipl, "The Life and Works of St. Albert the Great" in Albertus Magnus and the Sciences: Commemorative Essays 1980, ed. Weisheipl (Toronto, 1980), pp. 13-51, esp. 35; also app. I, p. 571. For Albert's use of Avicenna see the article by Nancy G. Siraisi in the same volume, "The Medical Learning of Albertus Magnus," pp. 379-404.

11. George Sarton, Introduction to the History of Science, 2:2 (Baltimore, 1931), pp. 893-900.

12. In addition to the editors' introduction see Ernest Wickersheimer, Dictionnaire biographique des médecins en France au Moyen Âge (1936; rpt. Geneva, 1979), pp. 17-18; Supplément by Danielle Jacquart (Geneva, 1979), pp. 15-16.

13. Régime I, 20 (ed. Landouzy and Pépin, p. 79): Comment on doit le cors garder en cascun aage et sa viellece targier et soi maintenir jovenes. "Premierement, vous devés savoir que li phisitiien dient qu'il sont .iiii. aege, si com adolescentia, iuventus, senectus, senium. De le premiere dient qu'ele est caude et moiste, et en cest aages croist li cors, et dure jusques à .xxv. ans ou à .xxx. Li seconde est caude et seche, et dure li cors en se vigeur et en se force juskes à .xl. ans ou .xlv. Le tierche est froide et seche et dure juskes à .lx. ans. La quarte est froide et moiste, por habundance des froides humeurs qui habundent par defaute de caleur, et dure jusques à le mort; et en ces aages va tous jors li cors à nient. Mais, se nous volons parler .i. pau plus soutiument, si poons dire qu'il en i a .vii. aages, si com li premiers quant li enfes est nés, et dure jusques à tant ke li dent commencent à venir: est infantia. L'autre, si est dentium plantatura, et c'est quant li dent sont venu, et dure jusques à .vii. ans. La tierce est pueritia et dure jusques à .xiiii. ans; et sachiés que ces .iii. se contienent sor le premiere que dite vous avons deseure, ki a nom adolescentia . . ." Cf. Johannicius, Isagoge 18; Avicenna, Canon III, 3, 3. The editor, Roger Pépin, identifies Aldobrandinus's borrowings from Arabic tracts (pp. LX-LXIX, esp. LXV).

14. Régime I, 20 (ed. Landouzy and Pépin, p. 81).

15. Les quatre âges de l'homme (ed. de Fréville). See Ch.-V. Langlois, La vie en France au

Moyen Âge de la fin du XII^e au milieu du XIV^e siè-cle d'après des moralistes du temps, Vie en France, 2 (Paris, 1925), pp. 205-240; Cesare Segre, "Le forme e le tradizioni didattiche" in *La littérature didactique, allégorique et satirique*, ed. Hans Robert Jauss, GRLMA, 6:1 (Heidelberg, 1968), p. 94; GRLMA, 6:2 (1970), p. 142 (no. 2764).

16. Bibliothèque de l'Arsenal, ms. 2510, fol. 27v. Henry Martin, *Catalogue des manuscrits de la Bibliothèque de l'Arsenal*, 3 (Paris, 1887), pp. 26-27; Landouzy and Pépin, pp. XXXIII-XXXIV, repr. p. 79. For lists of manuscripts see, in addition to the editors' introduction (pp. XXI-LI), Édith Brayer, "Notice du manuscrit: Paris, Bibliothèque Nationale, français 1109" in *Mélanges dédiés à la mémoire de Félix Grat*, 2 (Paris, 1949), pp. 237-240; K. A. de Meyier, "Un manuscrit de Leyde contenant le 'Régime du corps' d'Aldebrandin de Sienne," *Scriptorium*, 15 (1961), pp. 112-114.

17. British Library, ms. Sloane 2435, fol. 31r. Landouzy and Pépin, p. XXXVIII; Klibansky-Panofsky-Saxl, *Saturn and Melancholy*, fig. 76. The image is structurally related to the initial at the head of the chapter on the seasons (fol. 23r).

18. Bibliothèque Nationale, ms. fr. 12323, fol. 99r. Landouzy and Pépin, pp. XXX-XXXI.

19. Biblioteca Apostolica Vaticana, cod. Reg. lat. 1256, fol. 42v. Landouzy and Pépin, pp. XLIII-XLIV. The chapter on the ages might alternatively be introduced with the image of a doctor instructing a young man (New York, Pierpont Morgan Library, ms. M.165, fol. 47r) or a woman being bled (Cambridge University Library, ms. Ii. 5. 11, fol. 36v). For an illustrated manuscript of the end of the fourteenth century see Augusto da Silva Carvalho, "Le manuscrit du 'Régime du corps' d'Aldebrandino, de la Bibliothèque d'Ajuda, à Lisbonne," *Supplements to the Bulletin of the History of Medicine*, no. 3 (Baltimore, 1944), pp. 318-324.

20. Paris, Bibliothèque Nationale, ms. fr. 12581, fols. 387r-407v. The miniatures appear on fols. 387r, 390r, 395r, 401v. *Catalogue général des manuscrits français: Ancien supplément français*, 2 (Paris, 1896), pp. 566-567. The editor lists and describes five manuscripts containing the text (pp. XIV-XVIII). Paul Meyer adds another, from the late thirteenth century, in his "Notice du manuscrit fr. 17177 de la Biblio-

thèque Nationale," *Bulletin de la Société des anciens textes français*, 21 (1895), pp. 112-113. Philippe's concluding *sommes* (VI, 227-230) are copied into a codex published by Meyer, who did not recognize the source. See "Notice d'un ms. messin (Montpellier 164 et Libri 96)," *Romania*, 15 (1886), pp. 171-172.

21. *Convivio* IV, canzone terza, 121-140 (ed. Busnelli and Vandelli, 2, pp. 6-7; I follow the translation by K. Foster and P. Boyde in *Dante's Lyric Poetry*, 1, pp. 137-139.

22. *Convivio* IV, 23-28 (ed. Busnelli and Vandelli, 2, pp. 287-362; trans. Jackson, pp. 271-295). For an analysis of the text in the light of Aristotelian and scholastic thought see Bruno Nardi, "L'arco della vita (Nota illustrativa al 'Convivio')" in his *Saggi di filosofia dantesca*, 2nd ed. (Florence, 1967), pp. 110-138. See also the extensive comment in the Busnelli-Vandelli edition.

23. Dante cites *De meteoris* IV, tr. 1, as his source (*Convivio* IV, 23, 12-14). Nardi (p. 125) observes that the information is repeated in Albertus Magnus's *De iuventute et senectute* I, 6 [see above, n. 10] and compares the text to Avicenna's *Canon* I, 3, 3 [see above, ch. I, n. 94].

24. See above, p. 16. The manuscript tradition of *De senectute* begins in the ninth century, but most of the some 150 surviving copies date to the thirteenth century and after. See Rolf Sprandel, *Altersschicksal und Altersmoral* (Stuttgart, 1981), pp. 134-138.

25. *Convivio* IV, 24, 12-18 (ed. Busnelli and Vandelli, 2, pp. 314-319; trans. W. W. Jackson, pp. 278-279).

26. For biographical information, Antoine Thomas's *Francesco da Barberino et la littérature provençale en Italie au Moyen Âge* (Paris, 1883) remains important. See also Segre, "Forme" in *Littérature didactique*, GRLMA, 6:1, pp. 94-96; GRLMA, 6:2, pp. 139-140 (no. 2746).

27. Biblioteca Apostolica Vaticana, cod. Barb. lat. 4077, 4076. On the manuscripts see Francesco Egidi, "Le miniature dei Codici Barberiniani dei 'Documenti d'Amore,' " *L'arte*, 5 (1902), pp. 1-20, 78-95; idem, *I Documenti d'Amore di Francesco da Barberino secondo i mss. originali*, 4 (Rome, 1927), pp. XVI-XXXIII; Bernhard Degenhart and Annegrit Schmitt, *Corpus der italienischen Zeichnungen, 1300-1450*, 1:1 (Berlin, 1968), pp. 31-38 (no. 13). The poet's attitude toward images is explored by Daniela Goldin in "Testo e immagine nei *Documenti*

d'Amore di Francesco da Barberino," *Quaderni d'italianistica*, 1 (1980), pp. 125-138.

28. *Documenti* VII, 9 (ed. Egidi, 3, pp. 168-175): "Solem quidem et alios planetas ab occidente naturali motu moveri generalis fere omnium phylosophorum fuit sententia . . . qui tunc abundant periclitantur homines." Cf. *Dragmaticon* IV (*Dialogus*, pp. 115-129). On the diagram (fol. 79v) see Egidi, "Miniature," p. 5.

29. *Documenti* VII, 9 (ed. Egidi, 3, pp. 136-140): "dic quod dierum alius naturalis alius usualis . . . in ortu et occasu." Cf. *Dragmaticon* 4 (*Dialogus*, pp. 133-137).

30. Cod. Barb. lat. 4076, fols. 76v-77r (ed. Egidi, 3, pp. 137-139): ". . . figuras vide etiam ut tibi pulcrior appareat hic tractatus quod insimul cum horis representantur etates ita etiam per se in ipso officiolo presentabantur ystorie ut in completorio decesserit virgo beata et complete sint etates et completus sit dies . et actente quod in matutino non presentatur etas sed nox in prima autem etas incipit ut aurora de qua hic mentio adhibetur." On this image see Egidi, "Miniature," pp. 6, 94, repr. p. 93; Goldin, pp. 127-128 (who did not make out all the inscriptions). I am very grateful to Mgr. Ruysschaert at the Vatican Library for permitting me to study the badly flaked miniature under ultraviolet light.

31. The fact that the figure is identified as the *virgo beata* has implications for the cycle's interpretation. It is possible, following Goldin (p. 132), that Francesco's lost *officiolum* was a Book of Hours. If so, this cycle might have been created to adorn the Hours of the Virgin. For a parallel see below, pp. 138-139.

32. Ed. Egidi, 3, p. 287; 2, p. 165.

33. Mario Salmi, "Gli affreschi del Palazzo Trinci a Foligno," *Bollettino d'arte*, 13 (1919), pp. 147-153, fig. 9.

34. Salmi transcribes the extant inscriptions, filling in lacunae with notations made in the seventeenth century by Lodovico Iacobilli (pp. 175-176).

35. Salmi seems to have known the *Documenti d'amore* (p. 152), but he did not explore the iconographic connections between the cycles.

36. A cycle of the seven ages of man, again showing manuscript connections, is painted in an adjacent corridor. See below, pp. 135-136, figs. 71-74.

37. See above, pp. 47-53.

38. *Recueil des plus célèbres astrologues* (ed. Wickersheimer, p. 197). The author was himself condemned for superstitious practice.

39. *Liber astronomicus* I, 3 (Basel, 1550, cols. 97-152). On Guido see Lynn Thorndike, *A History of Magic and Experimental Science*, 2 (New York, 1923), pp. 825-835. On Alcabitius's works, Carmody, *Arabic Astronomical and Astrological Sciences*, pp. 144-150 (no. 27) [ref. above, ch. II, n. 61].

40. *Liber astronomicus* I, 3, 1-7 (Basel, 1550): "[Saturnus] Et etiam primus qui exercet operationem suam in concepto post casum seminis in matricem, constringendo & coadunando materiam illam de qua formatur conceptus . . . Quod si fuerit significator alicuius nativitatis & ipse orientalis, & fuerit nativitas diurna de levi, non perveniet natus ad complementum suae vitae naturalis: poterit tamen pervenire usque ad initium senectutis quę est à 60. anno in antea, nisi aliud impediat contra naturam . . . Si autem fuerit orientalis & nativitas fuerit nocturna, significat quod nati vita erit usque ad finem senectutis, nisi praedicta impediant . . . [cols. 97-98]. [Iupiter] Et est similiter Iupiter secundus Planeta, qui exercet operationem suam in concepto, scilicet tribuendo ei spiritum & vitam . . . Et de aetate significat iuventutem usque ad perfectionem aetatis, quae dicitur iuventus, & est à 14. anno, vel à 21. usque 40. vel 45. annum . . . [col. 101]. [Mars] Et est similiter Mars tertius Planeta, qui exercet operationem suam in hoc concepto, scilicet operando in eo per sanguinem, & rubificando illum . . . Et habet ex aetate hominum iuventutem collectam à 22. anno scilicet usque ad 45. ita quod utrique includantur . . . [col. 103]." For Guido's views on Saturn, see Klibansky-Panofsky-Saxl, *Saturn and Melancholy*, pp. 189-190. Thorndike translates a portion of the section on Jupiter (2, pp. 834-835).

41. *Liber astronomicus* I, 3, 9-10 (Basel, 1550, cols. 120-122).

42. Capital 22 (15). Descriptions of the capital have been provided by a succession of scholars, among them: John Ruskin, *The Stones of Venice*, 4th ed., 2 (Orpington, Kent, 1886), pp. 360-361; A. Didron and W. Burges, "Iconographie du Palais Ducal, à Venise," *Annales archéologiques*, 17 (1857), pp. 196, 300; Gino Rossi and Giovanni Salerni, *I capitelli del Palazzo Ducale di Venezia* (Venice, 1952), pp. 82-84, with repr.; Herma Bashir-Hecht, *Die Fas-*

sade des Dogenpalastes in Venedig: Der ornamentale und plastische Schmuck (Cologne and Vienna, 1977), pp. 38-39, 97-99.

43. On the study of astrology/astronomy, especially useful is Nancy G. Siraisi's study, *Arts and Sciences at Padua: The Studium of Padua before 1350* (Toronto, 1973), pp. 77-94. See also Richard Lemay, "The Teaching of Astronomy in Medieval Universities, Principally at Paris in the Fourteenth Century," *Manuscripta*, 20 (1976), pp. 197-217.

44. *Conciliator*, differentia 26 (Venice, 1526, fols. 35v-36r). On Peter see Thorndike, 2, pp. 874-947. Passage cited p. 895.

45. Lynn Thorndike, "The Clocks of Jacopo and Giovanni de' Dondi," *Isis*, 10 (1928), pp. 360-362; Silvio A. Bedini and Francis R. Maddison, "Mechanical Universe: The Astrarium of Giovanni de' Dondi," *Transactions of the American Philosophical Society*, n.s. 56:5 (1966); Siraisi, pp. 90-93.

46. Antonio Barzon, *I cieli e la loro influenza negli affreschi del Salone in Padova* (Padua, 1924); *Il Palazzo della Ragione di Padova* (Venice, 1964), especially contributions by Lucio Grossato and Nicola Ivanoff; Carlo Ludovico Ragghianti, *Stefano da Ferrara* (Florence, 1972), pp. 131-157.

47. Adolfo Venturi, "La fonte di una composizione del Guariento," *L'arte*, 17 (1914), pp. 49-57, with repr.; Sergio Bettini and Lionello Puppi, *La Chiesa degli Eremitani di Padova* (Vicenza, 1970), fig. 56, pl. V [Venus]; Francesca Flores d'Arcais, *Guariento: Tutta la pittura*, 2nd ed. (Venice, 1974), pp. 34, 65, figs. 109-115.

48. For the evolution of the iconography of the planetary gods, including Mercury's transformation into a scribe, see Fritz Saxl, "Beiträge zu einer Geschichte der Planetendarstellungen im Orient und im Okzident," *Der Islam*, 3 (1912), pp. 151-177; Jean Seznec, *The Survival of the Pagan Gods*, translated from the French edition of 1940 by Barbara F. Sessions (New York, 1953), pp. 149-163.

49. Bodleian Library, ms. Can. Misc. 554, fols. 171r-174r. See Fritz Saxl and Hans Meier, *Verzeichnis astrologischer und mythologischer illustrierter Handschriften des lateinischen Mittelalters*, 3:1-2 (London, 1953), pp. 341-344, fig. 192 [Venus]; Otto Pächt and J.J.G. Alexander, *Illuminated Manuscripts in the Bodleian Library, Oxford*, 2 (Oxford, 1970), p. 60 (no. 598), pl. LVII [Venus and Mars]. Cited by Flores d'Ar-

cais, p. 65. On Prosdocimus see Giovanni Santinello, "Prosdocimo de' Beldomandi" in *Scienza e filosofia all'Università di Padova nel quattrocento*, ed. Antonino Poppi (Padua, 1983), pp. 71-84.

50. Biblioteca Estense, ms. lat. 697 (α. W. 8. 20), fols. 3r-8v. See Hermann Julius Hermann, "Zur Geschichte der Miniaturmalerei am Hofe der Este in Ferrara: Stilkritische Studien," *Jahrbuch der kunsthistorischen Sammlungen des allerhöchsten Kaiserhauses*, 21 (1900), esp. pp. 135-137, figs. 4, 6-8; Domenico Fava and Mario Salmi, *I manoscritti miniati della Biblioteca Estense di Modena*, 2 (Milan, 1973), pp. 42-44. Venturi posits that an earlier exemplar of the *Liber physionomie*, containing twelve similarly lively "popular" drawings, was Guariento's source.

51. Cf. Ptolemy, *Tetrabiblos* I, 17 (37-38) (ed. and trans. Robbins, pp. 78-83).

52. London, British Library, ms. Add. 16578, fols. 52r-53v. The images follow upon a copy of the *Speculum humanae salvationis*. Saxl and Meier, *Verzeichnis*, 3, pp. 53-54, figs. 197-198.

A number of northern manuscripts contain references to the ages of man. In a southern German codex in Salzburg dated c. 1430-1440 (Universitätsbibliothek, ms. M III 36, fols. 236r-239r), each of seven folios contains the labeled figure of a planetary god in a large roundel with the signs of its zodiacal house or houses in small rings to either side. Below, in a medium-sized roundel, a man and a woman are shown variously occupied; inscriptions name an age of life and one of the canonical hours of the day (matins, prime, terce, sext, none, vespers, compline). Problems arose from the fact that the designer chose to proceed from the outermost planetary sphere to the innermost but began to list the ages and the hours in their natural temporal sequences, basing his program, it would seem, on a misconception. Thus Saturn, the ruler of old things, is juxtaposed with two children, nude, playing with balls or bubbles (*infancia, metten*), while the fast-moving Moon has under its control a man on his deathbed (*senectus, complet*). Cf. Karl-August Wirth, "Neue Schriftquellen zur deutschen Kunst des 15. Jahrhunderts: Einträge in einer Sammelhandschrift des Sigmund Gossembrot (cod. lat. mon. 3941)," *Städel-Jahrbuch*, N.F. 6 (1977), pp. 319-408, esp. 381, figs. 37-43.

A description of the seven ages of man fol-
lows representations of the planets in a German
scientific manuscript dated between 1410 and
1440 in Ulm (Bibliothek Schermariana, Libri
Med. No. 8, fols. 82v-84r). Cited by A.
Hauber, *Planetenkinderbilder und Sternbilder: Zur
Geschichte des menschlichen Glaubens und Irrens*
(Strassburg, 1916), pp. 39-40. In a later Ger-
man codex (1458-1459) an astronomical tract in
verse includes a description of the effect of the
planets on the growth of the embryo and on the
human life (Stuttgart, Württembergische Lan-
desbibliothek, cod. HB XI. 43). Cited by
Hauber, pp. 74-75.

53. Hauber, passim; Fritz Saxl, "Probleme
der Planetenkinderbilder," *Kunstchronik und
Kunstmarkt*, 54, N.F. 30 (1918/1919), pp. 1013-
1021; Klibansky-Panofsky-Saxl, *Saturn and
Melancholy*, pp. 204-207.

54. See above, pp. 18-19.

55. Osterreichische Nationalbibliothek,
cod. 2642, fol. 33r. See Hermann Julius Her-
mann, *Die romanischen Handschriften des Abend-
landes*, Beschreibendes Verzeichnis der illumi-
nierten Handschriften in Österreich, N.F. 8:3
(Leipzig, 1927), pp. 37-38 (no. 31); Antoine
Thomas and Mario Roques, "Traductions
françaises de la *Consolatio Philosophiae* de
Boèce," *Histoire littéraire de la France*, 37 (1938),
pp. 419-488, esp. 423-432. See also Alastair
Minnis, "Aspects of the Medieval French and
English Traditions of the *De Consolatione Phi-
losophiae*" in *Boethius: His Life, Thought and In-
fluence*, ed. Margaret Gibson (Oxford, 1981),
pp. 312-361. Nigel Palmer, writing in the same
volume, addresses important codicological
questions and extends the sphere to Germany.
See "Latin and Vernacular in the Northern Eu-
ropean Tradition of the *De Consolatione Philo-
sophiae*," pp. 362-409.

56. Victor Le Clerc, "L'image du monde, et
autres enseignements," *Histoire littéraire de la
France*, 23 (1856), pp. 287-335, esp. 294-332;
GRLMA, 6:2, pp. 191-192 (no. 3672). Tetradic
cosmology was common fare in vernacular
cosmological handbooks. The elements, hu-
mors, and qualities were correlated in *La map-
pemonde de Pierre* of the early thirteenth cen-
tury. See Ch.-V. Langlois, *La connaissance de la
nature et du monde d'après des écrits français à
l'usage des laïcs* (Paris, 1927), pp. 125-126.

57. Paris, Bibliothèque de l'Arsenal, ms.
3516, fol. 179r. See Martin, *Cat. des mss.*, 3, pp.
395-405; Le Clerc, pp. 326-327; Ellen J. Beer,

*Die Rose der Kathedrale von Lausanne und der kos-
mologische Bilderkreis des Mittelalters* (Bern,
1952), pp. 36-39, fig. 10 (inaccurately tran-
scribed). The diagram, labeled in the table of
contents "L'ymage du monde et le mape-
monde," seems to belong with Gossuin's text.
The schema of the months and days of the
week which follows (fol. 179v) opens a new
chapter identified as "Le nature des tans."

58. Paris, Bibliothèque de l'Arsenal, ms.
1234. See Martin, *Cat. des mss.*, 2 (Paris, 1886),
pp. 360-361. A manuscript copy of the *Com-
pendium* dating to the second half of the four-
teenth century, sold at Sotheby Parke Bernet,
is described as containing "a huge astronomical
circle of fourteen rings, showing the zodiac,
elements, etc." (fol. 3v). *Catalogue of the Cele-
brated Library of the Late Major J. R. Abbey*
(Tuesday, 20 June 1978), pp. 33-34 (no. 2980).
On texts and illustrations in the *Compendium*
see Philip S. Moore, *The Works of Peter of Poi-
tiers, Master in Theology and Chancellor of Paris
(1193-1205)* (Notre Dame, 1936), pp. 97-117;
William H. Monroe, "A Roll-Manuscript of
Peter of Poitiers' Compendium," *Bulletin of the
Cleveland Museum of Art*, 65 (1978), pp. 92-107.
For the later life of the tetradic diagram see
S. K. Heninger, Jr., *The Cosmographical Glass:
Renaissance Diagrams of the Universe* (San Mar-
ino, Calif., 1977), pp. 99-110.

59. *Regimen san. Sal.* 1696-1697, 1702-1703,
1708-1709, 1714-1715 (ed. de Renzi, 5, pp. 48-
49): "Largus, amans, hilaris, ridens, rubeique
coloris . . ." Walther, *Initia*, p. 514 (no. 10131);
Thorndike-Kibre, *Incipits*, p. 811. The verses
had a wide circulation. Karl Sudhoff published
a thirteenth-century text in which they were
linked to tetrads including the ages of man,
puericia, iuventus, senectus, senium. See "Zum
Regimen Sanitatis Salernitanum (XIII)," *Sud-
hoffs Archiv*, 12 (1920), p. 152. They were cop-
ied and translated into French in a manuscript
of the late thirteenth-century encyclopedic
tract, *Placides e Timéo* (ed. Thomasset, pp. 251-
253).

60. See below, pp. 140-144.

61. Cf. Honorius Augustodunensis, *Sacra-
mentarium* 22 (PL 172, 758-759), after Amalar-
ius of Metz; idem, *Gemma animae* III, 150-151
(PL 172, 684-685).

62. *Rat. div. off.* VI, 6, 6 (Venice, 1568, fols.
173r-173v): "Tertio ideo, quia Ver refertur ad
pueritiam, aestas ad adolescentiam, autumnus
ad maturitatem, sive virilitatem: hyems ad se-

nectutem. Ieiunamus ergo in vere, ut simus pueri, per innocentiam. In estate, ut efficiamur iuvenes, per constantiam. In Autumno, ut maturi per modestiam. In hyeme, ut senes per prudentiam et honestam vitam."

63. "A Stanzaic Life of Christ" 5073-5104 (ed. Foster, EETS o.s., no. 166, p. 171). The rubric reads: "Septima ratio, quoniam ver refertur Ad puericiam, estas ad adolescenciam, Autumpnus ad maturitatem, yems ad senectutem."

64. That highly original thinker, Hildegard of Bingen (d. 1179), is the exception. In her *Liber divinorum operum simplicis hominis* I, visio IV, 98 (PL 197, 877-884), she set out to show how the seasons and the months of the year, because of their qualities and the movements of the sun and the moon, can be correlated with man's bodily members, his ages, and the properties of the humors. Barbara Newman kindly drew my attention to this passage.

65. For the history of the poem and editions of two early versions see J. Morawski, "Les douze mois figurez," *Archivum romanicum*, 10 (1926), pp. 351-363; Erik Dal and Povl Skårup, *The Ages of Man and the Months of the Year* (Copenhagen, 1980), esp. pp. 11-14, 42-50. See also Émile Mâle, *L'art religieux de la fin du Moyen Âge en France*, 2nd ed. (Paris, 1922), pp. 303-306.

66. *Les douze mois figurez* (ed. Dal and Skårup, p. 42). Cf. Morawski, p. 356.

67. *Compost* (Paris, 1493; rpt. Paris, 1926). See Vincent Foster Hopper, *Medieval Number Symbolism* (New York, 1938), pp. 91-92; Dal and Skårup, passim.

68. New York, Pierpont Morgan Library, ms. M. 813 (Use of Rome), fols. 2v, 4r, 5v, 7r, 8v, 10r, 11v, 13r, 14v, 16r, 17v, 19r. I am grateful to Professor John Plummer for drawing my attention to this manuscript, not included in Dal and Skårup's study. The Morgan Library's unpublished catalogue was my source for information on ownership. For further manuscripts (fifteenth and sixteenth centuries) which contain the verses see V. Leroquais, *Les Livres d'heures manuscrits de la Bibliothèque Nationale*, 2 (Paris, 1927), pp. 59-63 (no. 196); Édith Brayer, "Livres d'heures contenant des textes en français," *Bulletin d'information de l'Institut de Recherche et d'Histoire des Textes*, 12 (1963), pp. 31-102, esp. 40, 73 (nos. 9, 94). A related pictorial cycle, apparently bawdier in tone, decorated the Chartrain "Hours of Marie Chantault," dated to the first

half of the sixteenth century (Paris, Bibliothèque Nationale, donation Smith-Lesouëf, ms. 39, fols. 2v-14r). Described by V. Leroquais in *Supplément aux Livres d'heures manuscrits de la Bibliothèque Nationale* (Mâcon, 1943), pp. 34-38 (no. 21), pl. XXXVI.

69. Dal and Skårup provide transcriptions from sixteenth-century printed versions (pp. 58-59).

70. The image at August is reversed in the printed books, a change which suggests that a manuscript, one of the same redaction as M. 813, was its source. Henri Monceaux gives an account of the 1509 editions, one of Paris, one of Rome use, produced by Guillaume Le Rouge and Jehan Barbier in his *Les Le Rouge de Chablis, calligraphes et miniaturistes, graveurs et imprimeurs: Étude sur les débuts de l'illustration du livre au XV^e siècle*, 2 (Paris, 1896), pp. 149-159 with repr. (January and October), 284-287. Dal and Skårup reproduce the whole set of engravings as found in a later Book of Hours, one printed by Nicolas Vivian in Paris in 1515. Mâle describes the set of engraved images in illustrated Books of Hours published by Thielman Kerver (*Fin du Moyen Âge*, pp. 305-306).

71. Biblioteca Nacional, cod. Vit. 24-3, pp. 3-14. See Brayer, "Livres d'heures," pp. 78-79 (no. 120); Ana Domínguez Rodríguez, *Libros de horas del siglo XV en la Biblioteca Nacional* (Madrid, 1979), pp. 82-105, esp. 86-88 (no. 13). I am grateful to the author for alerting me to the existence of this cycle. The images are reproduced in full and the poem transcribed by Dal and Skårup, pp. 18-20, 38-39, 41.

72. Another cycle of the ages and the months dating to the early sixteenth century, that on a set of four tapestries in the Metropolitan Museum of Art, New York, stands apart from earlier works in its use of classical and biblical exempla to illustrate the stages of life. A complex mélange of themes includes the four seasons with their deities, the twelve signs of the zodiac, the (twenty-three) winds, and the twelve months. The twelve ages of man, each six years in duration, are related to times of the year in Latin distichs, the first being:

Ut riget informis sub Aquari sydere tellus,
Sic primis annis mente stupescit homo.

Edith Standen provides this translation: "As the formless earth freezes under the constellation of the Water-bearer, so man is benumbed in mind in his first years." She describes this

and later tapestries on the same theme, finding an iconographic source in the *Kalendrier des bergiers*. See "The Twelve Ages of Man: A Further Study of a Set of Early Sixteenth-Century Flemish Tapestries", *Metropolitan Museum Journal*, 2 (1969), pp. 127-168.

NOTES TO CHAPTER VI

1. For an introduction to preaching in Latin and the vernacular see G. R. Owst, *Preaching in Medieval England: An Introduction to Sermon Manuscripts of the Period c. 1350-1450* (Cambridge, 1926); idem, *Literature and Pulpit in Medieval England* (Cambridge, 1933); D. L. d'Avray, "The Transformation of the Medieval Sermon," Diss., Oxford, 1976; Michel Zink, *La prédication en langue romane avant 1300* (Paris, 1976); Richard H. Rouse and Mary A. Rouse, *Preachers, Florilegia and Sermons: Studies on the Manipulus florum of Thomas of Ireland* (Toronto, 1979); Jean Longère, *La prédication médiévale* (Paris, 1983). I am indebted to David d'Avray (London) for valuable counsel in this area.

2. *Ars praedicandi* 1 (PL 210, 112). I follow the translation by Gillian R. Evans in *The Art of Preaching*, p. 17.

3. On these exegetical tools see André Wilmart, "Un répertoire d'exégèse composé en Angleterre vers le début du XIIIᵉ siècle" in *Mémorial Lagrange* (Paris, 1940), pp. 307-346; Richard H. Rouse and Mary A. Rouse, "Biblical Distinctions in the Thirteenth Century," *AHDLMA*, 41 (1974), pp. 27-37; Rouse and Rouse, *Preachers*, pp. 3-42.

4. Hans Robert Jauss makes a beginning in "Entstehung und Strukturwandel der allegorischen Dichtung" in *La littérature didactique, allégorique et satirique*, ed. Jauss, GRLMA, 6:1 (Heidelberg, 1968), esp. pp. 152-170 ("Die Ablösung der volkssprachlichen Allegorie von der Bibelexegese").

5. See above, pp. 69-72, 82-84.

6. *Distinctiones dictionum theologicalium* (PL 210, 814). For an analysis of Alan's approach to biblical terminology, see Gillian R. Evans, "Alan of Lille's *Distinctiones* and the Problem of Theological Language," *Sacris erudiri*, 24 (1980), pp. 67-86. For Gregory's homily see above, pp. 71-72.

7. *Distinctiones* (PL 210, 849). See above, pp. 83-84. Age names found in scripture, among them *adolescentula, iuvenis, iuventus,* appear in the list. Following the normal formula, each definition is supported by a biblical citation: "*Iuvenis,* properly, means renewed through grace, whence in the psalm: *Iuvenes* and *virgines . . .*" (PL 210, 825).

8. See C. A. Robson, *Maurice of Sully and the Medieval Vernacular Homily* (Oxford, 1952); Jean Longère, *Oeuvres oratoires de maîtres parisiens au XIIᵉ siècle: Étude historique et doctrinale,* 1 (Paris, 1975), pp. 14-18; Zink, esp. pp. 32-36.

9. Versions of the French text of this sermon have been published by both C. A. Robson, pp. 92-94 (no. 6), and Julius Brakelmann in "Über Le Besant de Dieu, ed. Martin," *Zeitschrift für deutsche Philologie,* 3 (1871), pp. 215-218. The Latin text has yet to be edited. Brakelmann's version (Paris, Bibliothèque National, ms. fr. 13314), more complete, reads: "Et ausi com nos vos avons dit des divers tens de cest siecle, que Deus mist ovriers en sa vigne al matin, quant il apele de tels en i a en lor enfance en son servise. Li matins senefie l'aage de .XV. ans, u de vint u de mains, li miedis senefie l'aage de .XXX. ans u de .XL: quar ausi come li jor sont plus caut entor miedi, ensement l'umaine nature est de greignor calor environ cest eage. Li vespres senefie la vieillece, c'est la fins de la vie. Damedeus nostres sires met ovriers en sa vigne vers le vespre, quant il les pluisors en lor vieillece torne de pecié a son servise, et ausi come cil qui entrerent daarrainement en la vingne al preudome, orent un denier. Autresi averont cil, qui el servise Deu enterront en lor viellece, le denier: c'est la vie pardurable."

10. *Le Bestiaire* 3655-3882 (ed. Reinsch, pp. 382-392; trans. Druce, pp. 98-103); *Le Besant de Dieu* 2921-3138 (ed. Ruelle, pp. 144-149). The use of Maurice's sermon, established by Brakelmann (pp. 214-219), is discussed by Ruelle (pp. 49-52). On Guillaume and his works, in addition to the editors' remarks, see Ch.-V. Langlois, *La vie en France au Moyen Âge,* 2 (Paris, 1925), pp. 107-128; GRLMA, 6:2, pp. 206-207, 221-222 (nos. 4060, 4200).

11. *Besant de Dieu* 3075-3090 (ed. Ruelle, p. 148):

> E uncore, en autre latin,
> Deus aloe ovriers au matin
> Quant il prent un home en enfance
> En sa lei e en sa creance.
> A tierce aloe les asquanz
> Quant il les prent endreit trente anz
> En sa lei e en son servise.
> E li midis nus redevise
> Cels q'endreit quarante anz visite

La grace del saint Espirite.
Endreit none prent il plusors
Qui ont pres assomé lor cors.
Vers le vespre redescent il
Come dolz e come gentil
Quant il les prent en lor fieblesce
E en la fin de lor veillesce . . .

12. *Pearl* 497-588 (ed. Gordon, pp. 18-21). Ian Bishop argues for a specific connection to Honorius Augustodunensis' interpretation of the parable in his sermon for Septuagesima Sunday (PL 172, 858). See *Pearl in its Setting: A Critical Study of the Structure and Meaning of the Middle English Poem* (Oxford, 1968), pp. 122-125.

13. *Piers Plowman* (B-text), Passus XII, 1-11 (ed. Kane and Donaldson, p. 465). On the poet's use of parable exegesis see D. W. Robertson, Jr., and Bernard F. Huppé in *Piers Plowman and Scriptural Tradition* (Princeton, 1951), p. 149; Burrow, "Langland," pp. 21-41. On the exegesis of the parable see above, pp. 88-89.

14. *Hexaemeron* VIII, 30, 1-7 (ed. Dales and Gieben, pp. 253-255).

15. *Spec. nat.* XXXII, 26 (*Speculum quadruplex sive speculum maius*, I [Douai, 1624; rpt. Graz, 1964], col. 2419). Cf. Hugo, *Miscellanea* I, tit. 82. Discussed above, pp. 71, 78.

16. *In epist. ad Heb.* 9, lect. 5. Cited by M.-D. Chenu in *Nature, Man, and Society in the Twelfth Century* (Chicago and London, 1968), p. 183.

17. "A Stanzaic Life of Christ" 77-144 (ed. Foster, EETS o.s., no. 166, pp. 3-5). The editor suggests that the specific sources for these verses are Ralph Higden's *Polychronicon* and the *Catholicon* of Johannes Balbus (pp. xxvii, 372).

18. On trends in encyclopedia writing in this period see Michel de Boüard, "Encyclopédies médiévales sur la 'connaissance de la nature et du monde' au Moyen Âge," *Revue des questions historiques*, 112 (1930), pp. 258-304; Pierre Michaud-Quantin, "Les petites encyclopédies du XIIIᵉ siècle" in *La pensée encyclopédique au Moyen Âge* (Neuchâtel, 1966), pp. 105-120.

19. See above, p. 97.

20. M. R. James transcribes the version found in Cambridge, Corpus Christi College, ms. 441, p. 35 (fourteenth century) in his catalogue to the collection (Cambridge, 1912), p. 350. For further examples see Walther, *Proverbia*, 2:2, p. 517 (no. 12287a).

21. London, British Library, ms. Royal 8 A.

VI, fol. 66v: *infantia* to 7 years, *puericia* to 14, *adolescensia* to 30, *etas viri* to 50, *senectus* to 70, and *senium* to death. See George F. Warner and Julius P. Gilson, *Catalogue of Western Manuscripts in the Old Royal and King's Collections*, I (London, 1921), pp. 208-210.

22. Oxford, Bodleian Library, ms. Rawl. D. 251, fol. 31v: "Prima etas est ab infantia . . ." Thorndike-Kibre, *Incipits*, col. 1092. Johannicius's list of four ages is also given.

23. Munich, Bayerische Staatsbibliothek, clm. 18462, fols. 13v, 16v. *Catalogus codicum manuscriptorum Bibliothecae Regiae Monacensis*, 4:3 (Munich, 1878), p. 166.

24. Wolfenbüttel, Herzog August Bibliothek, cod. 75. 3. Aug. fol., fols. 132r-133r: *infantia* extends to 7, *puericia* to 14, *adolescentia* to 25, *iuventus* to 35, *virilitas* to 55, *senectus* to 75, and *decrepitus* to death. Otto von Heinemann, *Die Handschriften der herzoglichen Bibliothek zu Wolfenbüttel*, 2:3, Die Augusteischen Hss. (Wolfenbüttel, 1898), pp. 383-385 (no. 2715).

25. Paris, Bibliothèque Nationale. ms. fr. 1968, fols. 140r-141v. *Catalogue des manuscrits français*, I (Paris, 1868), pp. 340-341.

26. On Thomas and his work see Alexander Kaufmann, *Thomas von Chantimpré* (Cologne, 1899); Michaud-Quantin, pp. 113-116; J. Engels, "Thomas Cantimpratensis redivivus," *Vivarium*, 12 (1974), pp. 124-132. Helmut Boese's edition of the text (Berlin and New York, 1973), containing a useful introduction, is to be followed by a volume of comment.

27. *De natura rerum* XIX, 7 (ed. Boese, p. 414). Cf. *De doctrina christiana* II, 39 (59). Discussed by Engels, pp. 129-130. See above, p. 60.

28. *De natura rerum*, prol. 60, 91 (ed. Boese, pp. 4-5).

29. *De natura rerum* I, 78-84 (ed. Boese, pp. 80-82): "Infans natus omnium animalium nascentium debilitatem excedit, et hoc, ut dictum est, quia de sanguine menstruo nutritus est . . . Sed spiritum vite singulariter dictum fuit, ut illum intelligamus, qui non habet terminum mortis."

30. The chapters on the ages of man were, for example, copied into a fifteenth-century medical manuscript in London (British Library, ms. Sloane 405, fols. 36v-37v). Cited in Thorndike-Kibre, *Incipits*, col. 743 (source unidentified). The remainder of Book I was transcribed elsewhere in the codex (fols. 23v, 65r, and following).

31. Chester Beatty Library, ms. 80, fols. 6v, 7r, 7v. See Eric George Millar, *The Library of A. Chester Beatty: A Descriptive Catalogue of the Western Manuscripts*, 2 (Oxford, 1930), pp. 244-254, pls. CLXXXIX, CXC.

32. *Der naturen bloeme* I, 159-658 (ed. Gysseling, pp. 19-31). On the author see J. van Mierlo, *Jacob van Maerlant, zijn leven, zijn werken, zijn beteekenis* (Turnhout, 1946), pp. 47-53. Konrad von Megensberg adapted the text to create his German tract, *Das Buch der Natur*, in the fourteenth century.

33. British Library, ms. Add. 11390, fols. 1v-2r. On the manuscripts see *Jacob van Maerlant's Der naturen bloeme*, Exhib. Utrecht, Instituut de Vooys, 1 October 1970-1 February 1971, *Naar de letter*, no. 4, pp. 8-13; on the London manuscript, pp. 11-12; Jan Deschamps, *Middelnederlandse handschriften uit Europese en Amerikaanse bibliotheken*, 2nd rev. ed. (Leiden, 1972), pp. 78-81.

34. Walters Art Gallery, ms. 171, fols. 30r, 32v. Related images are to be found in London, British Library, ms. Add. 22288, fols. 20r, 21r, and in Brussels, Bibliothèque Royale, ms. 21974, fols. 13v, 14v. On the manuscripts see Margaret Rickert, "The Illuminated Manuscripts of Meester Dirc van Delf's Tafel van den Kersten Ghelove," *Journal of the Walters Art Gallery*, 12 (1949), pp. 79-108, esp. 106, figs. 9, 10. L. M. Fr. Daniëls, editor of the text, also wrote a biography, *Meester Dirc van Delf, zijn persoon en zijn werk* (Nijmegen-Utrecht, 1932). Professor James Marrow kindly drew my attention to this text.

35. *Tafel*, "Winterstuc," 15 (ed. Daniëls, 2, pp. 67-71): "Dit sijn die seven ouderdom der menschen, dair hi doer leeft mit veel lidens vervolt . . ." For Dirc's range of sources see Daniëls, 1, pp. 29-45. I am grateful to Walter Melion for help in translating the Dutch.

36. *Tafel*, "Winterstuc," 16 (ed. Daniëls, 2, pp. 71-78): "Die werelt is inden begin der tijt van Gode begonnen ende van niet ghescapen . . ."

37. On the author, his work, and its influence see Thomas Plassmann, "Bartholomaeus Anglicus," *Archivum Franciscanum Historicum*, 12 (1919), pp. 68-109; Gerald E. Se Boyar, "Bartholomaeus Anglicus and His Encyclopaedia," *Journal of English and Germanic Philology*, 19 (1920), pp. 168-189; Michaud-Quantin, pp. 109-113; Donal Byrne, "Rex imago Dei: Charles V of France and the *Livre des propriétés*

des choses*," Journal of Medieval History*, 7 (1981), pp. 97-113. D. C. Greetham offers an analysis of the encyclopedist's attitude toward especially the miraculous in "The Concept of Nature in Bartholomaeus Anglicus," *Journal of the History of Ideas*, 41 (1980), pp. 663-677. For a list of manuscripts and printed editions see Edmund Voigt, "Bartholomaeus Anglicus, De proprietatibus rerum: Literarhistorisches und bibliographisches," *Englische Studien*, 41 (1910), pp. 347-359.

38. *De prop. rerum*, "praefatio" and "epilogus" (ed. Bartholdo [Frankfurt, 1601; rpt. Frankfurt, 1964], pp. 1-3, 1261).

39. *De prop. rerum* VI, 1-29 (ed. Bartholdo, pp. 231-276). Certain chapters (4-7, 9, 10, 14) have been translated by Michael Goodich in "Bartholomaeus Anglicus on Child-Rearing," *History of Childhood Quarterly*, 3 (1975-1976), pp. 75-84.

40. *De prop. rerum* VI, 1 (ed. Bartholdo, pp. 231-234): "Aetas igitur hominis, secundum Remigium, nihil aliud est nisi tenor virtutum naturalium . . . Et haec omnia in senio; senex ab omnibus vilipenditur, et gravis et onerosus ab omnibus iudicatur, tussibus, sputis et aliis passionibus fatigatur, quousque resolvatur cinis in cinerem, et pulvis in pulverem revertatur. His enim spaciis temporis et aetatis, philosophi descripserunt humanam vitam, in quibus mutatur et ad mortis terminum defluit continue. Hucusque Isidorum."

41. On the *Reductorium* and the influence of a work called *De moralisacione libri de proprietatibus rerum* upon it, see Charles Samaran, "Pierre Bersuire, Prieur de Saint-Éloi de Paris," *Histoire littéraire de la France*, 39 (Paris, 1962), pp. 259-450, esp. 304-325.

42. *Reductorium morale* III, 1 (*Opera omnia* 2 [Cologne, 1631], p. 342): "Per istas septem aetates, possunt intelligi septem virtutes spirituales, ex quibus vita gratię constituitur, et per quarum decursum finis ultimus aeternę glorię reportatur . . . Et si homo per istas septem aetates percurrit, restat quod ad finem et terminum aeternę glorię prosperabit et in mensura aetatis plenitudinis Christi, in virum perfectum, cum electis superius triumphabit."

Berchorius confirms this definition in the short entry "aetas" in his moralized dictionary, the *Repertorium* (*Opera omnia* 3, p. 125): "Ideo breviter nota, quod sicut vita naturalis per septem aetates usque ad finem decurrit: sic vita spiritualis et moralis per septem speciales vir-

tutes ad suum pervenit complementum. In vita enim naturali septem aetates secundum aliquos computantur, scilicet, infantia, pueritia, adolescentia, iuventus, senectus, senium, decrepitas." He also here describes a fivefold system in which the natural ages are aligned with particular virtues: "Secundum vero alios quinque aetates tantummodo computantur, scilicet, infantia, pueritia, adolescentia, iuventus, senectus. Et possumus dicere, quod similiter in vita morali debent esse quinque speciales virtutes. Sit igitur in nobis, scilicet,

> Infantia verecundiae et humilitatis,
> Pueritia innocentiae et puritatis,
> Adolescentia perseverantiae et continuitatis,
> Iuventus constantiae et probitatis,
> Senectus prudentiae et maturitatis."

43. The university booksellers in Paris made exemplars of the text available for copy. In 1286 one could rent the text, in 102 pecia units, for four solidi. See Lynn Thorndike, *University Records and Life in the Middle Ages* (New York, 1944), p. 113. M. C. Seymour has compiled lists of owners in "Some Medieval French Readers of *De Proprietatibus Rerum*," *Scriptorium*, 28 (1974), pp. 100-103, and "Some Medieval English Owners of *De proprietatibus rerum*," *Bodleian Library Record*, 9 (1974), pp. 156-165.

44. Bayerische Staatsbibliothek, clm. 19414, fol. 180r. The manuscript itself, a miscellany of works of different dates bound together in Tegernsee c. 1491, contains a contemporary *Biblia pauperum*. For other components see Roger E. Reynolds, "A Florilegium on the Ecclesiastical Grades in Clm 19414: Testimony to Ninth-Century Clerical Instruction," *Harvard Theological Review*, 63 (1970), pp. 235-259.

45. London, British Library, ms. Royal 6 E. VII, fols. 67v-68v. Warner and Gilson, *Catalogue*, 1, pp. 157-159; Christina von Nolcken, "Some Alphabetical *Compendia* and How Preachers Used Them in Fourteenth-Century England," *Viator*, 12 (1981), pp. 271-288, esp. 273, 284. Lucy Freeman Sandler will identify the compiler in a forthcoming article.

46. *Catholicon*, "etas" (Mainz, 1460; rpt. Westmead, Farnborough, 1971).

47. Donal Byrne, in the course of his iconographical studies, has considered patronage. See "Two Hitherto Unidentified Copies of the 'Livre des Propriétés des Choses,' from the Royal Library of the Louvre and the Library of

Jean de Berry," *Scriptorium*, 31 (1977), pp. 90-98, and "The Boucicaut Master and the Iconographical Tradition of the 'Livre des Propriétés des Choses,' " *Gazette des Beaux-Arts*, 92 (1978), pp. 149-164. On the character and function of the French translation see Byrne, "Rex imago Dei," pp. 97-113 [ref. above, n. 37].

48. Paris, Bibliothèque Nationale, ms. fr. 22532, fol. 82r, and following. A couple in erotic embrace represents "la creacion de l'enfant" (VI, 3; fol. 83r), a baby in a crib is "l'enfant" (VI, 4; fol. 84r), a boy with a playing stick is "le second aage de l'enfant" (VI, 5; fol. 84v), etc. The headpiece was never completed.

49. London, British Library, ms. Royal 17 E. III, fol. 80r; ms. Add. 11612, fol. 87v; Paris, Bibliothèque Nationale, ms. fr. 216, fol. 91r; ms. fr. 16993, fol. 73v; Paris, Bibliothèque Sainte-Geneviève, ms. 1028, fol. 105r [repr. by A. Boinet in *Bulletin de la Société française de reproductions de manuscrits à peintures*, 5 (1921), pl. XXXVIII, 3]. A related image in Jacques le Grant's *Le livre de bonnes meurs* illustrates the chapter "De l'estat de vieillesse." See, for example, Paris, Bibliothèque Nationale, ms. fr. 1023, fol. 57v).

50. Bibliothèque Nationale, ms. fr. 22531, fol. 99v. Millard Meiss names as the artist the "Boethius Illuminator," and dates the manuscript c. 1418. *French Painting in the Time of Jean de Berry: The Limbourgs and Their Contemporaries* (London and New York, 1974), pp. 372, 403, 475, n. 30. In a related image in a manuscript in Wolfenbüttel, the old man sits and the young man embraces a woman, but the child blows a horn and the middle-aged man carries a barrel or a loaf (Herzog August Bibliothek, cod. 1. 5. 3. 1 Aug. fol., fol. 81v). Four ages are represented in a manuscript of the mid-fourteenth century Provençal translation of the work (Paris, Bibl. Ste.-Geneviève, ms. 1029, fol. 66v): an initial "R" encloses a child playing with a whip top, a youth in a short red tunic and hood, a bearded man in armor carrying a sword and shield, and a man with a beard in a long tunic. See Boinet, pp. 112-122.

51. Paris, Bibliothèque Nationale, ms. fr. 9141, fol. 98r. See Millard Meiss, *French Painting in the Time of Jean de Berry: The Boucicaut Master* (London, 1968), pp 58-59, 122-123; Byrne, "Boucicaut Master," esp. pp. 156-161.

52. Minneapolis, University of Minnesota, James Ford Bell Library, 1400/f Ba. See H. P. Kraus, *The Eightieth Catalogue* (New York,

1956), pp. 121-122 (no. 128), fig. c. Professor Walter Cahn kindly drew my attention to this image.

53. Bibliothèque Nationale, ms. fr. 218, fol. 95r. The first French edition was printed in Lyon by Mathieu Huss in 1482 (Voigt, p. 351). The representation of the ages was reworked for the Spanish edition printed in Toulouse by Henr. Meyer, 1494.

54. Haarlem, Jacob Bellaert, 1485 (Voigt, p. 354). This image was adapted for use in the first English edition of the work, produced in Westminster by Wynkyn de Worde, c. 1495. I was able to study all the printed editions in the British Library.

55. See above, p. 178 n. 52.

56. Arnold C. Klebs, "Incunabula scientifica et medica: Short Title List," *Osiris*, 4 (1938), p. 178 (no. 524.1).

57. See above, ch. III, n. 54.

58. One would ideally introduce the evidence of sermon literature in tracing the diffusion of the scheme, but the state of scholarship does not permit this. Bernadette Paton (Linacre College, Oxford), engaged in the study of medieval preaching in Siena, finds references to the seven ages of man in the following fifteenth-century manuscripts: Siena, Biblioteca Comunale, ms. F. X. 18, fols. 100, 101, 114 (Sermons of Petrus Paulus Salimbene, 1478); ms. F. X. 19, fol. 8 (Anonymous sermons, mid-fifteenth century); ms. G. IX. 26, fol. 180 (Sermons of Fra Mariani, 1460). There is a reference to three ages of man in ms. F. X. 19, fol. 30. I am grateful to her for the information.

NOTES TO CHAPTER VII

1. Paris, Bibliothèque Nationale, ms. lat. 8846, fol. 161r. The illustrations are reproduced by Henri Omont in *Psautier illustré (XIIIᵉ siècle)* (Paris, 1906); pl. 98 [Ps. 89]. The text is described by V. Leroquais, *Les psautiers manuscrits latins des bibliothèques publiques de France* (Mâcon, 1940-1941), vol. 1, p. CI; 2, pp. 78-91 (no. 324). Here it is suggested that verse 6 inspired the illustration. For date and localization see Millard Meiss, "Italian Style in Catalonia and a Fourteenth-Century Catalan Workshop," *Journal of the Walters Art Gallery*, 4 (1941), pp. 45-87, esp. 70-76.

2. Parallels are difficult to come by. Greek psalters sometimes contain marginal illustrations in which the first line of Psalm 89, "a prayer of Moses, man of God," is accompanied

by the figure of Moses, and verse 10, by an old man leaning on a staff. Examples in the Index of Christian Art, Princeton, range from a ninth-century manuscript in Moscow (Historical Museum, ms. gr. 129, fols. 90v, 91r) to a thirteenth/fourteenth-century codex in Berlin (Kgl. Kupferstichkab., ms. 78. A. 9, fols. 168v, 169r). Among western manuscripts, the initial heading the psalm in the early twelfth-century St. Albans Psalter points a contrast between youth and old age: a young man with a slight beard holds two branches, and a man bent over, supporting himself on a T-shaped crutch, holds a single branch (Hildesheim, St. Godehard, p. 254). The miniature is shown to illustrate verse 6. See Otto Pächt, C. R. Dodwell, and Francis Wormald, *The St. Albans Psalter (Albani Psalter)*, Studies of the Warburg Institute, 25 (London, 1960), p. 238, pl. 68a.

3. The codex is a *psalterium triplex*. All three of Jerome's translations of the psalms are arranged in parallel columns: the Hebrew (with interlinear Old French translation), the Roman, and the Gallican (with Latin commentary). Verse 10 of Psalm 89 is given a mystical interpretation by the English glossator: seven and eight years signify both the Old Testament, on account of the Sabbath, and the New, on account of the Resurrection; seventy is temporal, eighty, eternal.

4. Mario Salmi, "Gli affreschi del Palazzo Trinci a Foligno," *Bollettino d'arte*, 13 (1919), esp. pp. 153-155, figs. 10-13; Raimond van Marle, *Iconographie de l'art profane au Moyen-Âge et à la Renaissance*, 2 (The Hague, 1932), p. 156, figs. 186-187. Salmi sees a stylistic relation between the frescoes and French illumination (p. 171).

5. See above, pp. 106-107.

6. J. R. Rahn, "Die Wandgemälde im Schlosse Sargans," *Kunstdenkmäler der Schweiz: Mitteilungen der schweizerischen Gesellschaft für Erhaltung historischer Kunstdenkmäler*, N.F. 2 (1902), pp. 13-14, fig. 9, pl. XI; Erwin Rothenhäusler, *Die Kunstdenkmäler des Kantons St. Gallen*, 1, Die Kunstdenkmäler der Schweiz, 25 (Basel, 1951), p. 352, fig. 351 (reconstruction). Cited by van Marle, 2, pp. 156-159.

7. Betty Kurth, *Die deutschen Bildteppiche des Mittelalters* (Vienna, 1926), p. 126, pls. 122b, c (three scenes of old age); van Marle, 2, p. 159. Cf. ch. V, n. 72; ch. VII, n. 21.

8. Formerly in the Collection of Mrs. Arthur Grenfell, the piece was sold (to "Fellowes") at Christie's, 12 June 1931, lot 54. It is

reproduced in the Christie's catalogue, opp. p. 9. Cited by van Marle, 2, p. 159 n. 2.

9. A cycle of the seven ages of man has been identified in the Cistercian Abbazia delle Tre Fontane in Rome. The composition, a large circle enclosing six roundels which in turn surround a seventh roundel in the center, was painted in the late thirteenth century on the outside wall of the structure which bounds the cloister to the east. In a bad state of preservation when photographed, it is difficult to decipher. The first roundel, at the lower left, appears to contain two tussling figures, an unusual type for the frolics of the first age. Nor is the next any more common: a youth reaches toward a large orange globe or ball. The figure who should represent prime stands with arms raised. The last four figures are reassuringly orthodox. Three men in robes are seen to have increasingly long beards and to stand in increasingly bent postures. At the very end of the cycle an old man lies recumbent, his infirmities having sent him to his deathbed. For a description and reproduction see Carlo Bertelli, "L'enciclopedia delle Tre Fontane," *Paragone* (Arte), 235 (1969), pp. 24-49, esp. 31, figs. 11-13. John Mitchell kindly drew my attention to this cycle.

10. Robert H. Hobart Cust, *The Pavement Masters of Siena (1369-1562)* (London, 1901), pp. 84-86; on the artist, pp. 118-120; fig. XVIII.

11. E. Clive Rouse and Audrey Baker, *The Wall-Paintings at Longthorpe Tower, near Peterborough, Northants* (Oxford, 1955), pp. 10, 33, 43-44, fig. 3, pls. VII, VIIIb, XVa, XVIb.

12. Cf. above, p. 125.

13. New York, Pierpont Morgan Library, ms. G. 50, fols. 19r, 29r, 50r, 58v, 64r, 68r, 72r, 81r. See John Plummer, *The Glazier Collection of Illuminated Manuscripts* (New York, 1968), pp. 29-30 (no. 37), pl. 35 (fol. 58v).

14. On Books of Hours and their illustration see V. Leroquais, *Les Livres d'heures manuscrits de la Bibliothèque Nationale*, 2 vols. (Paris, 1927), and *Supplément* (Mâcon, 1943). L.M.J. Delaissé, "The Importance of Books of Hours for the History of the Medieval Book" in *Gatherings in Honor of Dorothy E. Miner*, ed. U. E. McCracken, L. M. Randall, and R. H. Randall, Jr. (Baltimore, 1974), pp. 203-225; John Harthan, *Books of Hours and Their Owners* (London, 1977).

15. In an early sixteenth-century window in the Church of St. Nizier in Troyes, already badly damaged in the nineteenth century, each of the seven ages of man was accompanied by a woman who, in this case, presented him with an object. For an early description see A. Didron, "Symbolique chrétienne: La vie humaine," *Annales archéologiques*, 1 (1844), p. 248.

16. Edited by Carleton Brown in *Religious Lyrics of the XVth Century* (Oxford, 1939), pp. 230-233 (no. 147), and discussed by Douglas Gray in *Themes and Images in the Medieval English Religious Lyric* (London and Boston, 1972), p. 174.

17. British Library, ms. Add. 37049, fols. 28v-29r. See R. H. Bowers, "A Medieval Analogue to *As You Like It* II. vii. 137-166," *Shakespeare Quarterly*, 3 (1952), pp. 109-112; Ernest C. York, "Dramatic Form in a Late Middle English Narrative," *Modern Language Notes*, 72 (1957), pp. 484-485; Alan H. Nelson, " 'Of the Seuen Ages': An Unknown Analogue of *The Castle of Perseverance*," *Comparative Drama*, 8 (1974), pp. 125-138. I follow Nelson's transcription.

18. *The Castle of Perseverance* (ed. Eccles, EETS o.s., no. 262, pp. 1-111). See Edgar T. Schell, "On the Imitation of Life's Pilgrimage in *The Castle of Perseverance*" in *Medieval English Drama: Essays Critical and Contextual*, ed. Jerome Taylor and Alan H. Nelson (Chicago and London, 1972), pp. 279-291. *Mundus et infans*, a morality play of the early sixteenth century, is even more clearly patterned on the ages of man. See John Matthews Manly, *Specimens of the Pre-Shaksperean Drama*, 1 (Boston and London, 1897), pp. 353-385.

19. "Mirror" (ed. Furnivall, EETS o.s., no. 24, pp. 58-78). Cited by Bowers, pp. 109-110.

20. Analyses of tree schemata are supplied by Ladner, "Medieval and Modern Understanding of Symbolism," esp. pp. 233-254, and Evans, "The Geometry of the Mind," esp. pp. 36-39 [ref. above, ch. I, n. 38].

21. Cf. Marie-Thérèse d'Alverny, "La Sagesse et ses sept filles: Recherches sur les allégories de la philosophie et des arts libéraux du IXᵉ au XIIᵉ siècle" in *Mélanges dédiés à la mémoire de Félix Grat*, 1 (Paris, 1946), pp. 245-278. Raimond van Marle notes the existence of a tapestry in an inventory (1379) of Charles V described as the "Sept Ars et Estats des Âges des gens" (2, p. 159) [ref. above, n. 4].

22. Some forty manuscripts containing various of the diagrams have been identified by Robert Suckale in his "Untersuchungen zu den mettener Handschriften (clm 8201 und clm

8201d)," Habilitationsschrift, Munich, 1975, pp. 68-75, Christiane Laun in her "Bildkatechese im Spätmittelalter: Allegorische und typologische Auslegungen des Dekalogs," Diss., Munich, 1979, pp. 148, 156, and Lucy Freeman Sandler in *The Psalter of Robert De Lisle in the British Library* (London, 1983), pp. 134-139. The *Arbor sapientie* is to be found in many, among them: Düsseldorf, Hauptstaatsarchiv, cod. s.n., fol. 6r; London, Wellcome Institute, ms. 49, fol. 69v; Munich, Bayerische Staatsbibliothek, clm. 11465, fol. 90r; clm. 16104a, fol. 113v; New Haven, Beinecke Library, ms. 416, fol. 6r; Paris, Bibliothèque de l'Arsenal, ms. 1037, fol. 5v; ms. 1100, fol. 61r; ms. 1234 (in schemata group at end of roll); Paris, Bibliothèque Nationale, ms. fr. 9220, fol. 16r; ms. lat. 3445, fol. 70v; ms. lat. 3464, fol. 174v; ms. lat. 10630, fol. 81r; ms. lat. 14289, fol. 216v; ms. lat. 15125, fol. 48v.; Rome, Biblioteca Casanatense, ms. 1404, fol. 19v; Vienna, Österreichische Nationalbibliothek, cod. 1548, fol. 6r; cod. 12465, fol. 73v. The diagram is also listed in the table of contents in Paris, Bibliothèque Mazarine, ms. 924.

23. The group is believed to include: the Tree of Life; trees of the virtues and vices; the six-winged cherub; the Tower of Wisdom; a wheel of septenaries; trees or tables of the ten commandments and ten plagues; the twelve articles of faith, the twelve prophets, and the twelve apostles; the seven acts of the passion, the seven canonical hours, and the seven "gifts of remembrance." Cf. Fritz Saxl, "A Spiritual Encyclopaedia of the Later Middle Ages," *Journal of the Warburg and Courtauld Institutes*, 5 (1942), pp. 107-115, 120-121; Sandler, *Psalter*, pp. 23-27. The former argues for Bonacursus, the latter for John of Metz. For a summary see Laun, pp. 9-13. Karl-August Wirth, who promises a study of the *Arbor sapientie*, will interpret the evidence differently. Cf. his "Von mittelalterlichen Bildern und Lehrfiguren," esp. pp. 284-285 [ref. above, ch. I, n. 38]. Michael Evans would place the invention of the *Arbor sapientie* in the late twelfth century and assign it to Peter of Poitiers, reported to have devised some trees of virtues and vices ("Personifications of the *Artes* from Martianus Capella up to the End of the Fourteenth Century," Diss., University of London, 1970, pp. 92-97).

24. Paris, Bibliothèque Nationale, ms. fr. 9220, fol. 1r: "Cest liure puet on apieler: Vrigiet de solas. Car ki uioult ens entrer par pensee et par estude il i trueue arbres plaisans et fruis suffissans pour arme nourir et pour cors duire et aprendre." For contents and date of the manuscript see Bibliothèque Nationale, *Les manuscrits à peintures en France du XIIIe au XVIe siècle* (Paris, 1955), p. 35 (no. 66); Sandler, *Psalter*, pp. 137-138 [as early fourteenth century].

25. Bibliothèque de l'Arsenal, ms. 1037, fol. 5v. See Henry Martin, *Catalogue des manuscrits de la Bibliothèque de l'Arsenal*, 2 (Paris, 1886), pp. 248-249.

26. New Haven, Beinecke Rare Book and Manuscript Library, ms. 416, fol. 6r. See Walter Cahn and James Marrow, "Medieval and Renaissance Manuscripts at Yale: A Selection," *Yale University Library Gazette*, 52 (1978), pp. 195-196 (no. 23); Ladner, p. 252, fig. 21.

27. London, Wellcome Institute for the History of Medicine, ms. 49, fol. 69v. The manuscript, a fascinating miscellany containing everything from an illustrated copy of Holcot's *Moralitates* to anatomical diagrams, is described by Saxl, "Spiritual Encyclopedia," pp. 115-117; Almuth Seebohm Désautels, "Texts and Images in a Fifteenth-Century German Miscellany (Wellcome MS 49)," Diss., Warburg Institute, University of London, 1982.

28. On the medical imagery see Otto Kurz, "The Medical Illustrations of the Wellcome Ms.," *Journal of the Warburg and Courtauld Institutes*, 5 (1942), pp. 137-142; Boyd H. Hill, Jr., "Another Member of the Sudhoff Fünfbilderserie—Wellcome MS. 5000," *Sudhoffs Archiv*, 43 (1959), pp. 13-19. The manuscript also contains a tetradic *rota* in which the four qualities, directions, winds, seasons, elements, humors, and ages of man are correlated (fol. 45v).

29. *Consolatio philosophiae* II, pr 2, 8-9 (ed. Bieler, CCL 94, p. 20; I follow the translation by S. J. Tester, p. 183): ". . . nos ad constantiam nostris moribus alienam inexpleta hominum cupiditas alligabit? Haec nostra vis est, hunc continuum ludum ludimus: rotam volubili orbe versamus, infima summis, summa infimis mutare gaudemus." Cf. *Con. phil.* II, metr. 1. For Boethius on fortune see Pierre Courcelle, *La Consolation de Philosophie dans la tradition littéraire* (Paris, 1967), pp. 103-158.

30. Cf. *Con. phil.* IV, pr 6 (ed. Bieler, pp. 78-84; trans. Tester, pp. 357-371).

31. On the Wheel of Fortune see Karl Weinhold, *Glücksrad und Lebensrad* (Berlin, 1892);

A. Doren, "Fortuna im Mittelalter und in der Renaissance," *Vorträge der Bibliothek Warburg, 1922-1923: I. Teil*, ed. Fritz Saxl (Leipzig and Berlin, 1924), pp. 71-144; Howard R. Patch, *The Goddess Fortuna in Mediaeval Literature* (Cambridge, Mass., 1927), pp. 147-177; F. P. Pickering, *Literature and Art in the Middle Ages* (London, 1970), pp. 168-222. Michael Schilling studies the diverse functions which the pictorial motif served in manuscript illumination. See "Rota Fortunae: Beziehungen zwischen Bild und Text in mittelalterlichen Handschriften" in *Deutsche Literatur des späten Mittelalters* (Hamburger Colloquium, 1973), ed. W. Harms and L. P. Johnson (Hamburg, 1975), pp. 293-313. For good selections of photographs see Courcelle, *Consolation*, figs. 65-86; Tamotsu Kurose, *Miniatures of Goddess Fortune in Mediaeval Manuscripts* (Tokyo, 1977), passim [text in Japanese].

32. Walther, *Initia*, p. 863 (no. 16534).

33. The literature on the windows, other examples of which survive at Basel, Lausanne, Trento, Verona, and Parma, begins with Didron, "Symbolique chrétienne," pp. 241-251. See also Doren, pp. 71-72, 102-103; van Marle, 2, p. 190, figs. 217, 218. On wheel symbolism, Helen J. Dow, "The Rose-Window," *Journal of the Warburg and Courtauld Institutes*, 20 (1957), pp. 248-297, esp. pp. 268-272, 281-284. Elaine Beretz (Yale University) is completing a doctoral dissertation on the Beauvais Window, "The Iconography of the Wheel-Window of Saint-Étienne, Beauvais."

34. Édouard Jourdain et Théophile Duval, "Roues symboliques de N.-D. d'Amiens et de St.-Étienne de Beauvais," *Bulletin monumental*, 11 (1845), pp. 59-64; Maurice Eschapasse, *Notre-Dame d'Amiens* (Paris, 1960), p. 110, fig. 68.

35. Cambridge, Fitzwilliam Museum, ms. 330, no. 4. See Sydney C. Cockerell, *The Work of W. de Brailes, an English Illuminator of the Thirteenth Century*, The Roxburghe Club (Cambridge, 1930), pp. 16-18, pl. XVIIb; Nigel Morgan, *Early Gothic Manuscripts [I], 1190-1250*, Survey of Manuscripts Illuminated in the British Isles, 4 (London, 1982), pp. 118-119 (no. 72a).

36. Glorior elatus, descendo minorificatus
Infimus axe teror, rursus ad astra feror."

Cockerell, p. 17; Pickering, pp. 190, n. 2, 215-216; Hans Walther, "Rota Fortunae im lateinischen Verssprichwort des Mittelalters," *Mit-*

tellateinisches Jahrbuch, 1 (1964), pp. 48-58.

37. Karl Plenzat, *Die Theophiluslegende in den Dichtungen des Mittelalters* (Berlin, 1926); Alfred C. Fryer, "Theophilus, the Penitent, as Represented in Art," *Archaeological Journal*, 92 (1935), pp. 287-333, esp. 318-319 (no. 5).

38. London, British Library, ms. Arundel 83, fol. 126v. Described by John Winter Jones, "Observations on the Origin of the Division of Man's Life into Stages," *Archaeologia*, 35 (1853), pp. 174-176; G. McN. Rushforth, "The Wheel of the Ten Ages of Life in Leominster Church," *Proceedings of the Society of Antiquaries of London*, 2nd ser., 26 (1914), esp. pp. 48-50, fig. 2; Samuel C. Chew, *The Pilgrimage of Life* (New Haven and London, 1962), p. 150, fig. 104; R. E. Kaske, "*Piers Plowman* and Local Iconography," *Journal of the Warburg and Courtauld Institutes*, 31 (1968), pp. 164-166, fig. 60a; Sandler, *Psalter*, p. 40, pl. 4.

39. These figures, representatives of four ages of man, do not appear in the other copies of the diagram. An adolescent standing for the first age of life (*infantia*) reaches upward, while a man at prime (*iuventus*) is depicted as a crowned king bearing a scepter. An older man (*senectus*) looks back, and a yet older man (*decrepitus*), clad only in a mantle, lies prostrated. The connections with Wheel of Fortune iconography are clear.

40. For a variant reading of the last line see below, p. 148. Alan Nelson (Berkeley), in a forthcoming study, transcribes twelve Latin poems on the ages of man written in the first person which he calls "Wheel of Life poems." Several of these appear in schemata, whether wheels, trees, or tables. One which does not, but which has a strongly visual quality, is copied in a codex in Cambridge along with three other poems on the seven ages of man (Corpus Christi College, ms. 481, pp. 421-425). It is entitled *Rota septem etatum* and begins: "Hanc homo cerne rotam, seriem circumspice totam, / Quomodo res prima circumvertetur ad yma." Walther, *Initia*, p. 385 (no. 7644). On the manuscript see M. R. James, *A Descriptive Catalogue of the Manuscripts in Corpus Christi College*, 2 (Cambridge, 1912), pp. 424-432. For a poem in which an old man describes his turn on Fortune's Wheel see Rosemary Woolf, *The English Religious Lyric in the Middle Ages* (Oxford, 1968), p. 334.

41. Rushforth, p. 49.

42. Trinity College Library, cod. 347, fol.

11. Cited by Marvin L. Colker, "America Rediscovered in the Thirteenth Century?" *Speculum*, 54 (1979), p. 719.

43. Leominster, Priory Church, north wall of west bay of north aisle. See Rushforth, esp. pp. 50-55, fig. 3; E. W. Tristram, *English Medieval Wall Painting: The Thirteenth Century* (London, 1950), pp. 261-262, 558-559; Kaske, pp. 165-167, fig. 60b.

44. Kempley, Church of St. Mary, nave. Rushforth, pp. 47, 55, fig. 1; Tristram, pp. 262, 555. Tristram also reports traces of thirteenth-century wheels on the north wall of the north aisle of the Cathedral at St. Albans (pp. 262, 499) and on the west wall of the nave of the Church of St. Mary in Kemsing, Kent (pp. 555-556).

45. Formerly Strasbourg, Collection Forrer. See R. Forrer, *Unedierte Miniaturen, Federzeichnungen und Initialen des Mittelalters*, 2 (Strasbourg, 1907), pp. 15-16, pl. LX.

46. Forrer provides transcriptions of the verses between the spokes (with errors). I follow the readings supplied by Alan Nelson in his unpublished study. Two additional quatrains and two larger blocks of verse which Forrer transcribed, beginning "Entre toutes bestes vraiement, L'omme naist le plus pouvrement," concern the frailty of man and the misery of the human condition.

47. London, British Library, ms. Arundel 83, fol. 126r. Sandler, *Psalter*, p. 38, pl. 3. The same verses are set out in tabular form in at least three manuscripts: Cambridge University Library, ms. Gg. 4. 32, fol. 15v, "Speculum etatis hominis" (14th c.); Oxford, Bodleian Library, ms. Laud. Misc. 156, fol. 66v (15th c.); Paris, Bibliothèque Nationale, ms. lat. 3473, fol. 84v (15th c.). Cf. Walther, *Initia*, pp. 634, 710 (nos. 12353, 13757, 13759). The twelve responses turn up in a tree diagram in the *Concordantia caritatis*. See below, p. 152, figs. 93-96. The names of eleven of the twelve ages are inscribed in an incomplete ring of roundels in a preacher's miscellany in Paris (Bibliothèque de l'Arsenal, ms. 937, fol. 127r). Nelson transcribes the poem and shows its connection to the French verses on the Forrer wheel in his unpublished study.

48. The Byzantine tradition offers a closely related wheel. Precise instructions for representing "the vain and deceitful and fraudulent world" in the eighteenth-century "Painter's Manual" of Dionysius of Fourna indicate that concentric rings around the figure of the World should contain the seasons, the zodiacal signs and the months, and the seven ages of man. The last are to be supplied with identifying labels and inscriptions in the first person placed near their mouths. Further, Death, holding a sickle, and a dragon devouring a man should appear in a tomb below while angels outside, representing Day and Night, turn the wheel with cords. The passage is translated by Paul Hetherington, p. 83. Didron found paintings of the wheel in churches in Thessaly and on Mount Athos ("Symbolique chrétienne," pp. 242-244). A wheel bearing the seven ages of man turned by Day and Night is represented in an uncatalogued manuscript dating to the eighteenth century in the Dawkins Collection, Taylorian Library, Oxford (Photo: Warburg Institute).

49. Biblioteca Casanatense, ms. 1404, fol. 4v. Saxl, "Spiritual Encyclopaedia," pp. 97-98. A Wheel of Fortune is represented on folio 24 of the manuscript with the inscriptions *regnabo, regno, regnavi, sum sine regno*.

50. Wellcome Institute, ms. 49, fol. 30v. The image appears amid texts on the theme of *memento mori*. Saxl, "Spiritual Encyclopaedia," pp. 115-117. For further bibliography see above, n. 27.

51. Bayerische Staatsbibliothek, cgm. 312, fol. 98r. Boll, "Lebensalter," fig. 4; Karin Schneider, *Die deutschen Handschriften der Bayerischen Staatsbibliothek München*, 2, Catalogus codicum manuscriptorum Bibliothecae Monacensis, 2nd ed., 5:2 (Wiesbaden, 1970), pp. 295-301. A portion of the manuscript (fols. 120r-143r) has been reproduced in facsimile, *Ein Losbuch Konrad Bollstatters aus Cgm 312 der Bayerischen Staatsbibliothek München* (Wiesbaden, 1973). The commentator, Karin Schneider, provides a description of the codex (pp. 48-52). The manuscript's five wheels are described by Irmgard Meiners, "Rota Fortunae: Mitteilungen aus cgm 312," *Beiträge zur Geschichte der deutschen Sprache und Literatur* [PBB], 93 (Tübingen, 1971), pp. 399-414.

52. London, British Library, IC. 35. The engraving is pasted on the inside of the back cover of a folio volume. See Jones, "Observations," pp. 186-188, pl. VII; W. L. Schreiber, *Handbuch der Holz- und Metallschnitte des XV. Jahrhunderts*, 4 (Leipzig, 1927), p. 57 (no. 1883); Chew, p. 151. An eight-line poem is inscribed below, beginning, "Est hominis status in flore

significatus / Flos cadit et periit sic homo cinis erit." There is a German version of the print in Berlin (Schreiber, no. 1883a).

53. Lilienfeld, Stiftsbibliothek, cod. 151, fols. 257v-258r. See Hans Tietze, "Die Handschriften der Concordantia Caritatis des Abtes Ulrich von Lilienfeld," *Jahrbuch der K. K. Zentral-Kommission*, N.F. 3:2 (1905), cols. 27-64, esp. cols. 33, 41, fig. 16; Alfred A. Schmid, "Concordantia caritatis" in *Reallexikon zur deutschen Kunstgeschichte*, 3 (Stuttgart, 1954), cols. 833-853.

54. New York, Pierpont Morgan Library, ms. M. 1045, fols. 258v-259r. Formerly Vienna, Fürstl. Liechtensteinsche Bibliothek. See Tietze, cols. 44-59, who publishes reproductions of the top part of both this tree and one from a paper manuscript dated 1471 in Paris (Bibliothèque Nationale, ms. nouv. acq. lat. 2129, fol. 216r), figs. 22, 29.

55. On the use of this motif see Hans Wentzel, "Maria mit dem Jesusknaben an der Hand. Ein seltenes deutsches Bildmotiv," *Zeitschrift des deutschen Vereins für Kunstwissenschaft*, 9 (1942), pp. 203-250.

56. Florence, Biblioteca Laurenziana, ms. Plut. 42-19, fol. 96r. Richard Offner, *A Critical and Historical Corpus of Florentine Painting: The Fourteenth Century*, 3:7 (New York, 1957), pp. 3-10, esp. 6, 10, pl. I, s.

57. *Die Lebenstreppe: Bilder der menschlichen Lebensalter*, Exhib. Brauweiler, Kleve (Cologne and Bonn, 1983), p. 103 (no. 1), fig. p.

26. For comment see Peter Joerissen, "Lebenstreppe und Lebensalterspiel im 16. Jahrhundert" in *Lebenstreppe*, pp. 25-38.

58. London, British Museum (Augsburg or Bodensee). *Lebenstreppe*, fig. p. 17. The verses are transcribed by W. L. Schreiber in his *Handbuch*, vol. 4, p. 56 (no. 1881). The ten-part division of life attracted much scholarly attention early on: Karl Goedeke, ed., *Pamphilus Gengenbach* (Hannover, 1856), pp. 571-605; Wilhelm Wackernagel, *Die Lebensalter: Ein Beitrag zur vergleichenden Sitten- und Rechtsgeschichte* (Basel, 1862), pp. 28-39; E. Matthias (from the notes of Julius Zacher), "Die zehn Altersstufen des Menschen," *Zeitschrift für deutsche Philologie*, 23 (1891), pp. 385-412; Anton Englert, "Die menschlichen Altersstufen in Wort und Bild," *Zeitschrift des Vereins für Volkskunde*, 15 (1905), pp. 399-412; Wilhelm Molsdorf, *Christliche Symbolik der mittelalterlichen Kunst*, 2nd ed. (Leipzig, 1926), pp. 248-250 (no. 1143).

59. On this practice see especially Hans von der Gabelentz, *Die Lebensalter und das menschliche Leben in Tiergestalt* (Berlin, 1938); Hubert Wanders, "Das springende Böckchen—Zum Tierbild in den dekadischen Lebensalterdarstellungen" in *Lebenstreppe*, pp. 61-71.

60. *Lebenstreppe*, passim, especially Rudolf Schenda, "Die Alterstreppe—Geschichte einer Popularisierung," pp. 11-24, and Katalog, pp. 103-161. For a witty recasting of the motif in contemporary graphic art see Saul Steinberg, *The Inspector* (Penguin Books, 1976).

BIBLIOGRAPHY

PRIMARY SOURCES

Peter Abelard. *Expositio in Hexaemeron.* PL 178, 731-784.

Aelfric. *Sermones catholici.* Ed. and trans. Benjamin Thorpe. In *The Homilies of the Anglo-Saxon Church.* 2 vols. London, 1844-1846.

Alan of Lille. *Ars praedicandi.* PL 210, 109-195. Trans. Gillian R. Evans. *The Art of Preaching.* Kalamazoo, Mich., 1981.

————. *De planctu Naturae.* Ed. Thomas Wright. In *The Anglo-Latin Satirical Poets and Epigrammatists of the Twelfth Century.* Rolls series, 59:2, pp. 429-522. London, 1872. Trans. James J. Sheridan. *The Plaint of Nature.* Toronto, 1980.

————. *Distinctiones dictionum theologicalium.* PL 210, 685-1012.

Albertus Magnus. *De aetate sive de iuventute et senectute.* Ed. Auguste Borgnet. In *Opera omnia,* 9, pp. 305-319. Paris, 1890.

Albumasar (Abu Ma'shar). *De revolutionibus nativitatum.* Ed. David Pingree. BT. Leipzig, 1968.

Ps.-Alcuin. *Disputatio puerorum.* PL 101, 1097-1144.

Aldobrandinus of Siena. *Le régime du corps.* Ed. Louis Landouzy and Roger Pépin. Paris, 1911.

Alfred of Sareshel. *De motu cordis.* Ed. Clemens Baeumker. Beiträge zur Geschichte der Philosophie des Mittelalters, 23:1-2. Münster i.W., 1923.

Ambrose. *De Abraham.* Ed. Karl Schenkl. CSEL 32:1, pp. 501-638. Vienna, 1897.

————. *Epistolae.* PL 16, 875-1286. Trans. Sister Mary Melchior Beyenka. FC 26. New York, 1954.

————. *Hexaemeron.* Ed. Karl Schenkl. CSEL 32:1, pp. 3-261. Vienna, 1897. Trans. John J. Savage. FC 42, pp. 3-283. New York, 1961.

Anatolius. *On the Decad.* Ed. and trans. J.-L. Heiberg. In *Annales internationales d'histoire: Congrès de Paris, 1900* (5ᵉ section, Histoire des sciences), pp. 27-57. Paris, 1901.

Antiochus of Athens. *Thesaurus.* Ed. Franz Boll. CCAG 1, pp. 140-164. Brussels, 1898.

Apollodorus. *Bibliotheca.* Ed. and trans. James George Frazer. LCL. 2 vols. London and New York, 1921.

'Arib ibn Sa'id. *Book on the Generation of the Fetus and the Treatment of Pregnant Women and the Newborn.* Ed. and trans. Henri Jahier and Noureddine Abdelkader [Arabic and French]. *Le livre de la génération du foetus . . .* Algiers, 1956.

Aristotle. *Ars rhetorica.* Ed. W. D. Ross. Oxford, 1959. Trans. W. Rhys Roberts. The Works of Aristotle translated into English, 11. Oxford, 1924.

————. *De caelo.* Ed. D. J. Allan. Oxford, 1936. Trans. J. L. Stocks. Works of Aristotle, 2. Oxford, 1922.

————. *De generatione animalium.* Ed. H. J. Drossaart Lulofs. Oxford, 1965. Trans. Arthur Platt. Works of Aristotle, 5. Oxford, 1910.

————. *Metaphysica.* Ed. W. Jaeger. Oxford, 1957. Trans. W. D. Ross. Works of Aristotle, 8. 2nd ed. Oxford, 1928.

Ps.-Aristotle. *Secretum secretorum.* Ed. Robert Steele. Opera hactenus inedita Rogeri Baconi, fasc. 5, pp. 1-172. Oxford, 1920. Modern editions of vernacular translations: *Secretum Secretorum: Nine English Versions.* Ed. M. A. Manzalaoui. EETS o.s., no. 276. Oxford, 1977. Hiltgart von Hürnheim. Ed. Reinhold Möller [with Latin text]. *Mittelhochdeutsche Prosaübersetzung des "Secretum secretorum."* Deutsche Texte des Mittelalters, 56. Berlin, 1963. *Poridat de las Poridades.* Ed. Lloyd A. Kasten. Madrid, 1957.

Priester Arnold. "Loblied auf den heiligen Geist." Ed. Friedrich Maurer. In *Die religiösen Dichtungen des 11. und 12. Jahrhunderts,* 3, pp. 53-85 (no. 48). Tübingen, 1970.

"As I went one my playing." Ed. Carleton

Brown. In *Religious Lyrics of the XVth Century*, pp. 230-233 (no. 147). Oxford, 1939.

Augustine. *De civitate Dei*. Ed. Bernhard Dombart and Alfons Kalb. CCL 47, 48. Rev. ed. Turnhout, 1955.
Trans. Gerald G. Walsh et al. FC 8, 14, 24. New York, 1950-1954.

——. *De diversis quaestionibus octoginta tribus*. Ed. Almut Mutzenbecher. CCL 44A, pp. 3-249. Turnhout, 1975.
Trans. David L. Mosher. FC 70. Washington, D.C., 1982.

——. *De doctrina christiana*. Ed. Joseph Martin. CCL 32, pp. 1-167. Turnhout, 1962.
Trans. D. W. Robertson, Jr. *On Christian Doctrine*. New York, 1958.

——. *De genesi ad litteram*. Ed. Josef Zycha. CSEL 28:1, pp. 3-435. Vienna, 1894.

——. *De genesi ad litteram inperfectus liber*. Ed. Josef Zycha. CSEL 28:1, pp. 459-503.
Trans. John Hammond Taylor. ACW 41, 42. New York and Ramsey, N.J., 1982.

——. *De genesi contra Manichaeos*. PL 34, 173-220.

——. *De trinitate*. Ed. W. J. Mountain. CCL 50, 50A. Turnhout, 1968.
Several translations available.

——. *De vera religione*. Ed. K.-D. Daur. CCL 32, pp. 187-260. Turnhout, 1962.
Trans. John H. S. Burleigh. In *Augustine: Earlier Writings*. Library of Christian Classics, 6, pp. 225-283. Philadelphia, 1953.

——. *Enarrationes in psalmos*. Ed. Eligius Dekkers and Jean Fraipont. CCL 38, 39, 40. Turnhout, 1956.
Abridged translation ed. A. Cleveland Coxe. Nicene and Post-Nicene Fathers, 1st ser., 8. New York, 1888. Also trans. (in part) Scholastica Hebgin and Felicitas Corrigan. ACW 29, 30. Westminster, Md., 1960-1961.

——. *Enchiridion*. Ed. E. Evans. CCL 46, pp. 33-114. Turnhout, 1969.
Trans. Bernard M. Peebles. FC 5, pp. 369-472. New York, 1947.

——. *Epistulae*. Ed. Al. Goldbacher. CSEL 34, 44, 57, 58. Vienna, 1895-1923.

——. *In Iohannis evangelium tractatus CXXIV*. Ed. Radbodus Willems. CCL 36. Turnhout, 1954.
Trans. John Gibb and James Innes. Nicene and Post-Nicene Fathers, 1st ser., 7, pp. 7-452. New York, 1888.

——. *Sermones*. PL 38, 39.
Translations of selected sermons available.

Avicenna. *Liber canonis*. Venice, 1507; rpt. Hildesheim, 1964.
Translation of Arabic and Urdu version (in part) by Mazhar H. Shah. *The General Principles of Avicenna's Canon of Medicine*. Karachi, 1966.
Translation of Latin version (in part) by O. Cameron Gruner. *A Treatise on the Canon of Medicine of Avicenna Incorporating a Translation of the First Book*. London, 1930.

——. *Cantica Avicennae*. Ed. and trans. Henri Jahier and Abdelkader Noureddine [Arabic and French]. *Poème de la médecine*. Paris, 1956.

Roger Bacon. *Compotus Fratris Rogeri*. Ed. Robert Steele. Opera hactenus inedita Rogeri Baconi, fasc. 6. Oxford, 1926.

——. *Secretum secretorum cum glossis et notulis*. Ed. Robert Steele. Opera, fasc. 5. Oxford, 1920.

Johannes Balbus. *Catholicon*. Mainz, 1460; rpt. Westmead, 1971.

Bartholomaeus Anglicus. *De proprietatibus rerum*. Frankfurt, 1601; rpt. Frankfurt a.M., 1964.
Modern edition of vernacular translation: John of Trevisa. *On the Properties of Things*. Ed. M. C. Seymour et al. 2 vols. Oxford, 1975.

Bede. *De temporibus*. Ed. Charles W. Jones. In *Bedae Opera de Temporibus*, pp. 295-303. Cambridge, Mass., 1943. Rpt. with the *Chronica minora*, ed. Theodor Mommsen. CCL 123C, pp. 585-611. Turnhout, 1980.

——. *De temporum ratione*. Ed. Charles W. Jones. In *Bedae Opera de Temporibus*, pp. 175-291. Rpt. with the *Chronica maiora*, ed. Theodor Mommsen. CCL 123B. Turnhout, 1977.

——. *Homeliarum evangelii libri II*. Ed. D. Hurst. CCL 122, pp. 1-378. Turnhout, 1955.

——. *In Lucae evangelium expositio*. Ed. D. Hurst. CCL 120, pp. 5-425. Turnhout, 1960.

Ps.-Bede. *Collectanea (Excerptiones patrum)*. PL 94, 539-560.

——. *De computo dialogus*. PL 90, 647-652.

——. *De divisionibus temporum*. PL 90, 653-664.

——. *De mundi celestis terrestrisque constitutione*. Ed. and trans. Charles Burnett. London, 1985.

——. *In Matthaei evangelium expositio*. PL 92, 9-132.

John Beleth. *Summa de ecclesiasticis officiis*. Ed. Herbert Douteil. CCL, Continuatio mediaevalis, 41, 41A. Turnhout, 1976.

Petrus Berchorius. *Reductorium morale, De rerum proprietatibus*. In *Opera omnia*, 2. Cologne, 1631.

Bernardus Silvestris (?). *Commentum super sex libros Eneidos Virgilii*. Ed. Julian Ward Jones and Elizabeth Frances Jones. Lincoln, Nebr., and London, 1977.

 Trans. Earl G. Schreiber and Thomas E. Maresca. *Commentary on the First Six Books of Virgil's Aeneid*. Lincoln and London, 1979.

Biblia vulgata. Douay-Rheims translation.

Boethius. *Consolatio philosophiae*. Ed. Ludwig Bieler. CCL 94. Turnhout, 1957.

 Trans. S. J. Tester [with Latin text]. LCL. Cambridge, Mass. and London, 1973.

Guido Bonatti. *Liber astronomicus*. Published as *Guidonis Bonati Foroliviensis mathematici de astronomia tractatus X*. Basel, 1550.

Bruno of Segni. *Commentaria in Ioannem*. PL 165, 451-604.

 ———. *Expositio in Apocalypsim*. PL 165, 605-736.

 ———. *Homiliae*. PL 165, 747-864.

Byrhtferth. *Manual*. Ed. and trans. S. J. Crawford. EETS o.s., no. 177. London, 1929; rpt. with table of errata by Neil Ker, 1966.

Caesarius of Arles. *Sermones*. Ed. Germain Morin. CCL 103, 104. 2nd ed. Turnhout, 1953.

 Trans. Sister Mary Magdeleine Mueller. FC 31, 47, 66. New York and Washington, D.C., 1956-1973.

Calcidius. *Commentary on the Timaeus*. Ed. J. H. Waszink. Corpus Platonicum Medii Aevi. 2nd ed. London, 1975.

The Castle of Perseverance. Ed. Mark Eccles. In *The Macro Plays*. EETS o.s., no. 262, pp. 1-111. London, 1969.

"Catechesis celtica." Ed. André Wilmart. In *Analecta Reginensia*. Studi e testi, 59, pp. 34-112. Vatican City, 1933.

Celsus. *De medicina*. Trans. W. G. Spencer [with Latin text]. LCL. 3 vols. Cambridge, Mass., and London, 1935-1938.

Censorinus. *De die natali*. Ed. Nicolaus Sallmann. BT. Leipzig, 1983.

 Trans. Guillaume Rocca-Serra. *Le jour natal*. Paris, 1980.

John Chrysostom. *Homiliae in Matthaeum*. PG 57, 58.

 Trans. George Prevost. Nicene and Post-Nicene Fathers, 1st ser., 10. New York, 1888.

Cicero. *Cato maior de senectute*. Ed. K. Simbeck. BT. Leipzig, 1917; rpt. Stuttgart, 1961. Many translations available.

Clement of Alexandria. *Protrepticus*. Ed. and trans. Claude Mondésert [French]. SC 2. 2nd ed. Paris, 1949. [= GCS 12, pp. 3-86]

 ———. *Stromata*. Ed. Otto Stählin. GCS 17, 52. Rev. ed. Berlin, 1960, 1970.

 Trans. William Wilson. Ante-Nicene Christian Library, 4, 12. Edinburgh, 1867, 1869. [= Ante-Nicene Fathers, 2, pp. 299-567]

Le compost et kalendrier des bergiers. Reproduction en fac-similé de l'édition de Guy Marchant (Paris, 1493). Introduction by Pierre Champion. Paris, 1926.

 English version: *The Kalendar of Shepherdes*. Ed. H. Oskar Sommer. London, 1892.

Constantinus Africanus. *Pantegni*. In *Opera omnia Ysaac*. Lyons, 1515.

 Part I, Book I. Ed. and trans. Marco T. Malato and Umberto de Martini [Italian]. *L'arte universale della medicina (Pantegni)*. Rome, 1961.

Dante. *Convivio*. Ed. G. Busnelli and G. Vandelli. 2nd ed. 2 vols. Florence, 1964.

 Trans. William Walrond Jackson. Oxford, 1909. *Canzoni* trans. K. Foster and P. Boyde. In *Dante's Lyric Poetry*. 2 vols. Oxford, 1967.

De arithmetica. Ed. Paul von Winterfeld. MGH, Poetae latini aevi carolini, 4:1, pp. 249-254. Berlin, 1899.

Diodorus Siculus. *Bibliotheca historica*. Trans. C. H. Oldfather et al. [with Greek text]. LCL. 12 vols. London, New York, and Cambridge, Mass., 1933-1967.

Diogenes Laertius. *Vitae philosophorum*. Ed. H. S. Long. 2 vols. Oxford, 1964.

 Trans. R. D. Hicks [with Greek text]. *Lives of the Eminent Philosophers*. LCL. 2 vols. London and New York, 1925.

Dionysius of Fourna. *The Painter's Manual*. Trans. Paul Hetherington. London, 1974.

Dirc van Delf. *Tafel van den Kersten Ghelove*. Ed. L. M. Fr. Daniëls. 4 vols. Nijmegen-Utrecht, 1939.

"Les douze mois figurez" (several versions). Ed. J. Morawski. In *Archivum romanicum*, 10 (1926), pp. 351-363; Erik Dal and Povl Skårup. In *The Ages of Man and the Months of the Year*. Copenhagen, 1980.

Dracontius. *De laudibus Dei*, Book I [with *Hexaemeron* of Eugenius of Toledo]. Ed. Fried-

rich Vollmer. MGH, Auct. ant., 14, pp. 23-
67. Berlin, 1905.

Trans. James F. Irwin [with Latin text]. Dis-
sertation, University of Pennsylvania, 1942.
Philadelphia, 1942.

———. *Satisfactio* [with recension of Eugeni-
us]. Ed. Vollmer, MGH, Auct. ant., 14, pp.
114-131.

Trans. Sister M. St. Margaret [with Latin
text]. Dissertation, University of Pennsyl-
vania, 1935. Philadelphia, 1936.

William Durandus. *Rationale divinorum offi-
ciorum.* Venice, 1568.

Eadmer. *Vita Sancti Anselmi.* Ed. and trans.
R. W. Southern. *The Life of St. Anselm, Arch-
bishop of Canterbury.* London, 1962.

Eucherius of Lyons. *Liber formularum spiritalis
intelligentiae.* PL 50, 727-772.

Eugenius of Toledo. "Monosticha recapitula-
tionis septem dierum." Ed. Friedrich Voll-
mer. MGH, Auct. Ant., 14, pp. 67-69.

Favonius Eulogius. *Disputatio de Somnio Sci-
pionis.* Ed. and trans. [Italian] Luigi Scarpa
[Italian]. Padua, 1974.

Firmicus Maternus. *Mathesis.* Ed. W. Kroll,
F. Skutsch, and K. Ziegler. BT. 2 vols. Leip-
zig, 1897, 1913; rpt. Stuttgart, 1968.

Trans. Jean Rhys Bram. *Ancient Astrology:
Theory and Practice.* Park Ridge, N.J., 1975.

Francesco da Barberino. *I documenti d'amore.*
Ed. Francesco Egidi. 4 vols. Rome, 1905-
1927.

Fulgentius. *De aetatibus mundi et hominis.* Ed.
Rudolf Helm. BT. Leipzig, 1898; rpt. with
addenda, Stuttgart, 1970, pp. 129-179.

Trans. Leslie George Whitbread. In *Fulgen-
tius the Mythographer*, pp. 187-221. Colum-
bus, Ohio, 1971.

Galen. *De diebus decretoriis.* Ed. Karl Gottlob
Kühn. *Galeni Opera omnia*, 9, pp. 769-941.
Leipzig, 1825; rpt. Hildesheim, 1965.

———. *De elementis ex Hippocrate.* Ed. Kühn.
Opera omnia, 1, pp. 413-508. Leipzig, 1821;
rpt. Hildesheim, 1964.

———. *De placitis Hippocratis et Platonis.* Ed.
and trans. Phillip de Lacy. *On the Doctrines of
Hippocrates and Plato.* CMG V, 4, 1 and 2.
Berlin, 1978, 1980.

———. *De sanitate tuenda.* Ed. Konrad Koch.
CMG V, 4, 2, pp. 3-198. Leipzig and Berlin,
1923.

Trans. Robert Montraville Green. *A Trans-
lation of Galen's Hygiene.* Springfield, Ill.,
1951.

———. *De temperamentis.* Ed. Georg Helm-
reich. BT. Leipzig, 1904; rpt. with addenda,
Stuttgart, 1969.

———. *In Hippocratis aphorismos commentaria
VII.* Ed. Kühn. *Opera omnia*, 17:2, pp. 345-
887; 18:1, pp. 1-195. Leipzig, 1829; rpt. Hil-
desheim, 1965.

———. *In Hippocratis de natura hominis commen-
taria.* Ed. Johannes Mewaldt. CMG V, 9, 1,
pp. 3-113. Leipzig and Berlin, 1914.

Ps.-Galen. *Definitiones medicae.* Ed. Kühn.
Opera omnia, 19, pp. 346-462. Leipzig, 1830;
rpt. Hildesheim, 1965.

Garnerus. *Gregorianum.* PL 193, 23-462.

Aulus Gellius. *Noctes atticae.* Ed. P. K. Mar-
shall. 2 vols. Oxford, 1968.

Trans. John C. Rolfe [with Latin text]. LCL.
3 vols. Rev. ed. Cambridge, Mass., and
London, 1946-1952.

Glossa ordinaria. PL 113, 114.

Godfrey of St. Victor. *Microcosmus.* Ed. Phi-
lippe Delhaye. Lille and Gembloux, 1951.

Gregory the Great. *Homiliae in evangelia.* PL
76, 1075-1312.

———. *Homiliae in Hiezechihelem prophetam.*
Ed. Marcus Adriaen. CCL 142. Turnhout,
1971.

———. *Moralia in Iob.* PL 75, 76. Ed. (in part)
Marcus Adriaen. CCL 143, 143A. Turn-
hout, 1979.

Guillaume le Clerc. *Le besant de Dieu.* Ed.
Pierre Ruelle. Brussels, 1973.

———. *Le bestiaire.* Ed. Robert Reinsch. Leip-
zig, 1890; rpt. Wiesbaden, 1967.

Trans. George Claridge Druce. *The Bestiary
of Guillaume le Clerc.* Ashford, Kent, 1936.

Haimo of Auxerre. *Homiliae de sanctis.* PL 118,
747-804.

———. *Homiliae de tempore.* PL 118, 11-746.

Haly Abbas (ʿAlī ibn al-ʿAbbas). *Liber regius.*
Published as *Liber totius medicine necessaria
continens.* Lyons, 1523.

Heinricus. *Summarium.* Ed. Reiner Hilde-
brandt. 2 vols. Berlin and New York, 1974,
1982.

Hermann of Carinthia. *De essentiis.* Ed. and
trans. Charles Burnett. Leiden and Cologne,
1982.

Hierocles. *Commentarius in aureum pythagoreo-
rum carmen.* Ed. Friedrich Wilhelm Koehler.
BT. Stuttgart, 1974.

Trans. Nicholas Rowe. *Commentary of Hier-
ocles on the Golden Verses of Pythagoras* (1707).
Rpt. London, 1971.

Hildebert of Le Mans. *Ex novo testamento*. PL 171, 1275-1282.

Ps.-Hildebert of Le Mans. *Sermones de tempore*. PL 171, 343-606.

Hildegard of Bingen. *Liber divinorum operum simplicis hominis*. PL 197, 741-1038.

Hippocratic Corpus. *Aphorismi*. Ed. and trans. W.H.S. Jones, vol. 4, pp. 98-221. LCL. London and New York, 1931.
Edition of French translation: Martin de Saint-Gille. *Les Amphorismes Ypocras*. Ed. Germaine Lafeuille. Geneva, 1954.

————. *De diaeta (Regimen)*. Ed. and trans. Robert Joly [French]. Paris, 1967. [=Jones, 4, pp. 224-447]
Edition of Latin translation of Book I: *Peri diatis ipsius Ypogratis*. Ed. Carl Deroux and Robert Joly. "La version latine du livre I du traité pseudo-hippocratique *Du régime* (editio princeps)." In *Lettres latines du Moyen Âge et de la Renaissance*. Collection Latomus, 158, pp. 129-151. Brussels, 1978.

————. *De natura hominis*. Ed. and trans. Jacques Jouanna [French]. CMG I,1, 3. Berlin, 1975. [=Jones, 4, pp. 2-41]

————. *De hebdomadibus*. Ed. W. H. Roscher. In *Die hippokratische Schrift von der Siebenzahl in ihrer vierfachen Überlieferung*. Studien zur Geschichte und Kultur des Altertums, 6:3-4, pp. 1-80. Paderborn, 1913.

Honorius Augustodunensis. *Expositio in cantica canticorum*. PL 172, 347-496.

————. *Gemma animae*. PL 172, 541-738.

————. *Imago mundi*. Ed. Valerie I. J. Flint. In *AHDLMA*, 49 (1982), pp. 48-151. [= PL 172, 115-188]

————. *Sacramentarium*. PL 172, 737-806.

————. *Speculum ecclesiae*. PL 172, 807-1108.

Horace. *Ars poetica*. Ed. Friedrich Klingner. BT. 2nd ed. Leipzig, 1950.
Many translations available.

Hrabanus Maurus. *Commentaria in Matthaeum*. PL 107, 727-1156.

————. *De rerum naturis (De universo)*. PL 111, 9-614.

————. *De computo*. Ed. Wesley M. Stevens. CCL, Continuatio mediaevalis, 44, pp. 199-321. Turnhout, 1979.

Hugo of St. Victor. *Miscellanea*. PL 177, 469-900.

Iamblichus. *De vita pythagorica*. Ed. Ludwig Deubner. BT. Leipzig, 1937; rpt. with addenda, Stuttgart, 1975.
Trans. Thomas Taylor. *Iamblichus' Life of Pythagoras, or Pythagoric Life* (1818); rpt. London, 1965.

Innocent III. *De miseria condicionis humane*. Ed. and trans. Robert E. Lewis. Athens, Georgia, 1978.

Irenaeus. *Adversus haereses*. Ed. and trans. Adelin Rousseau et al. [French]. SC. 10 vols. Paris, 1965-1982. [= PG 7, 433-1224].
Trans. Alexander Roberts and W. H. Rambaut. Ante-Nicene Christian Library, 5, 9. Edinburgh, 1868, 1869. [= Ante-Nicene Fathers, 1, pp. 315-567]

Isidore of Seville. *Allegoriae quaedam sacrae scripturae*. PL 83, 97-130.

————. *Differentiae*. PL 83, 9-98.

————. *Etymologiae (Origines)*. Ed. W. M. Lindsay. 2 vols. Oxford, 1911. [=PL 82, 73-728]
Trans. (in part) Ernest Brehaut. In *An Encyclopedist of the Dark Ages*. Studies in History, Economics and Public Law, 48. New York, 1912; William D. Sharpe. In *Isidore of Seville: The Medical Writings*. Transactions of the American Philosophical Society, n.s. 54:2, pp. 38-64. Philadelphia, 1964.

————. *Liber de natura rerum*. Ed. and trans. Jacques Fontaine. In *Traité de la nature*. Bordeaux, 1960. [= PL 83, 963-1018]

————(?). *Liber de numeris*. PL 83, 1293-1302.

————(?). *Liber numerorum qui in sanctis scripturis occurrunt*. PL 83, 179-200.

————. *Quaestiones in vetus testamentum*. PL 83, 207-424.

Jacob van Maerlant. *Der naturen bloeme*. Ed. Maurits Gysseling. Corpus van Middelnederlandse Teksten, 2:2. 's-Gravenhage, 1981.

Pietro Jacopo de Jennaro. *Le sei etate de la vita umana*. Ed. Antonio Altamura and Pina Basile. Naples, 1976.

Jerome. *Commentariorum in Matheum libri IV*. Ed. D. Hurst and M. Adriaen. CCL 77. Turnhout, 1969.

Ps.-Jerome. *Expositio quatuor evangeliorum*. PL 30, 549-608.

Johannicius. *Isagoge ad Tegni Galieni*. Ed. Gregor Maurach. In *Sudhoffs Archiv*, 62 (1978), pp. 151-174.
Trans. H. P. Cholmeley. In *John of Gaddesden and the Rosa Medicinae*, pp. 136-166. Oxford, 1912. Rpt. in *A Source Book in Medieval Science*, pp. 705-715. Ed. Edward Grant. Cambridge, Mass., 1974.

John of Hildesheim. *Historia trium regum*. Ed.

C. Horstmann. EETS o.s., no. 85, pp. 206-312. London, 1886.

John of Sacrobosco. *Computus ecclesiasticus*. In *Ioannis de Sacrobusto Libellus de sphaera*. Wittenberg, 1543.

John Scottus Eriugena. *Annotationes in Marcianum*. Ed. Cora E. Lutz. Cambridge, Mass., 1939.

Lambert of St. Omer. *Liber floridus*. Autograph manuscript transcribed by Albert Derolez. Ghent, 1968.

William Langland. *Piers Plowman* (The B version). Ed. George Kane and E. Talbot Donaldson. London, 1975.

Leo the Great. *Tractatus*. Ed. Antoine Chavasse. CCL 138, 138A. Turnhout, 1973. Trans. Charles Lett Feltoe. Nicene and Post-Nicene Fathers, 2nd ser., 12. New York, 1895.

Macrobius. *Commentarii in Somnium Scipionis*. Ed. James Willis. BT. Leipzig, 1963. Trans. William Harris Stahl. *Commentary on the Dream of Scipio*. New York, 1952.

―――. *Saturnalia*. Ed. James Willis. Leipzig, 1963. Trans. Percival Vaughan Davies. New York, 1969.

Manilius. *Astronomica*. Ed. and trans. G. P. Goold. LCL. Cambridge, Mass., and London, 1977.

Marco Polo. *The Description of the World*. Trans. A. C. Moule and Paul Pelliot. London, 1938.

Martianus Capella. *De nuptiis Philologiae et Mercurii*. Ed. James Willis. BT. Leipzig, 1983. Trans. William Harris Stahl and Richard Johnson. *Martianus Capella and the Seven Liberal Arts*, 2. New York, 1977.

Maurice de Sully. *Homilies* [in French]. Ed. C. A. Robson. In *Maurice of Sully and the Medieval Vernacular Homily*. Oxford, 1952.

"The Mirror of the Periods of Man's Life." Ed. Frederick J. Furnivall. In *Hymns to the Virgin & Christ*. EETS o.s., no. 24, pp. 58-78. London, 1867.

Mundus et infans. Ed. John Matthews Manly. In *Specimens of the Pre-Shaksperean Drama*, 1, pp. 353-385. Boston and London, 1897.

Navigatio Sancti Brendani Abbatis. Ed. Carl Selmer. Notre Dame, 1959. Trans. J. F. Webb. In *Lives of the Saints*, pp. 33-68. Baltimore, 1965.

Nicomachus of Gerasa. *Introduction to Arithmetic*. Ed. Richard Hoche. BT. Leipzig, 1866. Trans. Martin Luther D'Ooge. University of Michigan Studies, 16, pp. 181-286. New York, 1926.

"Of the Seuen Ages." Ed. Alan H. Nelson. In *Comparative Drama*, 8 (1974), pp. 130-132.

On the Constitution of the Universe and of Man. Ed. Julius Ludwig Ideler. In *Physici et medici graeci minores*, 1, pp. 303-304. Berlin, 1841.

Origen. *Commentariorum in Matthaeum series*. Ed. Erich Klostermann. GCS 38, 40, 41:1, 41:2. Leipzig, 1933-1941; Berlin, 1955.

―――. *De principiis*. Ed. and trans. Henri Crouzel and Manlio Simonetti [French]. SC 252, 253, 268, 269, 312. Paris, 1978-1984. Trans. G. W. Butterworth. *On First Principles*. London, 1936; rpt. New York, 1966.

Ovid. *Metamorphoses*. Ed. William S. Anderson. BT. Leipzig, 1977. Many translations available.

Pacificus of Verona. *Opus excerptum ex libro compoti*. Ed. G. G. Meersseman and E. Adda. In *Manuale di computo con ritmo mnemotecnico dell'arcidiacono Pacifico di Verona*, pp. 82-137. Padua, 1966.

Pearl. Ed. E. V. Gordon. Oxford, 1953.

Peter Comestor. *Historia scholastica*. PL 198, 1053-1722.

Peter of Abano. *Conciliator*. Venice, 1526.

Petrus de Natalibus. *Catalogus sanctorum et gestorum eorum*. Venice, 1493.

Philippe de Novarre. *Des IV tenz d'aage d'ome*. Ed. Marcel de Fréville. *Les quatre âges de l'homme*. Société des Anciens Textes Français, 27. Paris, 1888.

Philo. *De opificio mundi*. Trans. F. H. Colson and G. H. Whitaker [with Greek text], 1, pp. 6-137. LCL. London and New York, 1929.

―――. *Legum allegoria*. Colson and Whitaker, 1, pp. 146-473.

Placides et Timéo ou Li secrés as philosophes. Ed. Claude Alexandre Thomasset. Geneva, 1980.

Plato. *Timaeus*. Translated with commentary by Francis MacDonald Cornford. *Plato's Cosmology*. London and New York, 1937.

Julius Pollux. *Onomasticon*. Ed. Erich Bethe. 3 vols. BT. Leipzig, 1900-1937.

Promptorium parvulorum. Ed. A. L. Mayhew. EETS e.s., no. 102. London, 1908.

Prudentius. *Contra Symmachum*. Ed. Maurice P. Cunningham. CCL 126, pp. 182-250. Turnhout, 1966.

Trans. M. Clement Eagen. In *The Poems of Prudentius*. FC 52, pp. 113-176. Washington, D. C., 1965.

———. *Psychomachia*. Ed. Cunningham. CCL 126, pp. 149-181.

Trans. Eagen, FC 52, pp. 79-110.

Ptolemy. *Tetrabiblos*. Ed. and trans. F. E. Robbins. LCL. Cambridge, Mass., and London, 1940.

Regimen sanitatis Salernitanum. Ed. Salvatore de Renzi. In *Collectio Salernitana*, 1, pp. 445-516. Naples, 1852.

Trans. Sir John Harington (1607). Rpt. in *The School of Salernum*. London, 1922.

Remigius of Auxerre(?). *Commentum in Boetii consolationem philosophiae*. Ed. Edmund Taite Silk. In *Saeculi noni auctoris in Boetii consolationem philosophiae commentarius*. Papers and Monographs of the American Academy in Rome, 9, pp. 312-343 (appendix). Rome, 1935.

———. *Commentum in Martianum Capellam*. Ed. Cora E. Lutz. 2 vols. Leiden, 1962, 1965.

Richard of St. Victor. *Liber exceptionum*. Ed. Jean Châtillon. Paris, 1958.

Robert Grosseteste. *Hexaëmeron*. Ed. Richard C. Dales and Servus Gieben. London, 1982.

Robert of Melun. *Sententie*. Ed. Raymond M. Martin. In *Oeuvres de Robert de Melun*, 3:1-2. Louvain, 1947, 1952.

Robert of Torigni. *Chronicle*. Ed. Léopold Delisle. 2 vols. Libraire de la Société de l'Histoire de Normandie, 3. Rouen, 1872-1873.

Romualdo of Salerno. *Chronicon*. Ed. C. A. Garufi. Rerum italicarum scriptores (L. A. Muratori), 7:1. Città di Castello, 1914-1935.

Rupert of Deutz. *Commentaria in Apocalypsim*. PL 169, 827-1214.

———. *Commentaria in evangelium Sancti Iohannis*. Ed. Rhaban Haacke. CCL, Continuatio mediaevalis, 9. Turnhout, 1969.

Sapientia artis medicinae. Ed. M. Wlaschky. In *Kyklos*, 1 (1928), pp. 104-110.

Scriptores hiberniae minores. Ed. Joseph F. Kelly. CCL 108C. Turnhout, 1974.

Servius. *In Aeneidem commentarii*. Ed. (in part) E. K. Rand et al. Servianorum in Vergilii carmina commentariorum editio Harvardiana. Lancaster, Penn., 1946; Oxford, 1965.

Sicardus of Cremona. *Mitrale*. PL 213, 13-434.

Simon de Phares. *Recueil des plus célèbres astrologues et quelques hommes doctes*. Ed. Ernest Wickersheimer. Paris, 1929.

Smaragdus of St. Mihiel. *Expositio libri comitis (Collectiones in epistolas et evangelia)*. PL 102, 13-552.

Solon. "Elegy on the Ages of Man." Ed. M. L. West. In *Iambi et elegi Graeci ante Alexandrum cantati*, 2, pp. 135-137 (no. 27). Oxford, 1972.

Trans. Richmond Lattimore. *Greek Lyrics*, p. 23. 2nd ed. Chicago and London, 1960.

Ps.-Soranus. *Isagoge in artem medendi*. Published by Albanus Torinus in *De re medica*, fols. 1r-10r. Basel, 1528. Rpt. in *Medici antiqui omnes*, fols. 158v-163v. Venice, 1547.

———. *Quaestiones medicinales*. Ed. Valentin Rose. In *Anecdota graeca et graecolatina*, 2, pp. 243-274. Berlin, 1870.

Speculum hominis. Ed. and trans. Marco T. Malato and Concezio Alicandri-Ciufelli [Italian]. Rome, 1960.

"Stanzaic Life of Christ." Ed. Frances A. Foster. EETS o.s., no. 166. London, 1926.

Tertullian. *De anima*. Ed. J. H. Waszink. Amsterdam, 1947. [= PL 2, 641-752].

Trans. Peter Holmes. Ante-Nicene Christian Library, 15, pp. 410-541. Edinburgh, 1870. [= Ante-Nicene Fathers, 3, pp. 181-235]

Theologumena arithmeticae. Ed. Vittorio de Falco. BT. Leipzig, 1922; rpt. with revisions, Stuttgart, 1975.

Theon of Smyrna. *Expositio rerum mathematicarum ad legendum Platonem utilium*. Ed. E. Hiller. BT. Leipzig, 1878.

Trans. (in part) Thomas Taylor. In *Iamblichus' Life of Pythagoras, or Pythagoric Life*. London, 1818; rpt. London, 1965, pp. 235-239.

Thomas of Cantimpré. *Liber de natura rerum*. Ed. H. Boese. Berlin and New York, 1973.

Tractatus de regimine sanitatis virorum spiritualium ac devotorum. Ed. Manfred Peter Koch. In *Das "Erfurter Kartäuserregimen,"* pp. 17-33. Dissertation, Bonn, 1969.

Tractatus quidam de philosophia et partibus eius. Ed. Gilbert Dahan. In *AHDLMA*, 49 (1982), pp. 181-193.

Valerius Maximus. *Factorum et dictorum memorabilium libri novem*. Ed. Karl Kempf. BT. Leipzig, 1888; rpt. Stuttgart, 1966.

Victorinus of Pettau. *Tractatus de fabrica mundi*. Ed. Johannes Haussleiter. CSEL 49, pp. 3-9. Vienna, 1916.

Trans. Robert Ernest Wallis. Ante-Nicene

Christian Library, 18, pp. 388-393. Edinburgh, 1870. [= Ante-Nicene Fathers, 7, pp. 341-343]

Vincent of Beauvais. *Speculum naturale*. In *Speculum quadruplex, sive, speculum maius*, 1. Douai, 1624; rpt. Graz, 1964.

Vindicianus. *Epistula ad Pentadium nepotem suum*. Ed. Valentin Rose. In *Theodori Prisciani Euporiston*, pp. 485-492. BT. Leipzig, 1894.

Werner of St. Blasien. *Deflorationes SS. Patrum*. PL 157, 729-1256.

William of Conches. *Dragmaticon*. Published as *Dialogus de substantiis physicis*. Strasbourg, 1567; rpt. Frankfurt a.M., 1967.

———. *Glosae super Platonem*. Ed. Édouard Jeauneau. Paris, 1965.

———. *Philosophia mundi*. Ed. and trans. [German] Gregor Maurach. Pretoria, 1980. [= PL 172, 39-102]

SECONDARY SOURCES

In order to give focus to the bibliography, only those works which deal directly with the ages of man have been included.

d'Alverny, Marie-Thérèse. "L'homme comme symbole. Le microcosme." In *Simboli e simbologia nell'alto medioevo*. Settimane di studio del centro italiano di studi sull'alto medioevo, 23:1, pp. 123-183. Spoleto, 1976.

Amelli, Ambrogio Maria. *Miniature sacre e profane dell'anno 1023 illustranti l'enciclopedia medioevale di Rabano Mauro*. Montecassino, 1896.

Amend, Andreas. *Über die Bedeutung von MEIPAKION und ANTIΠAIΣ*. Programm des k. humanistischen Gymnasiums zu Dillingen für das Schuljahr 1892/93. Dillingen, 1893.

Archambault, Paul. "The Ages of Man and the Ages of the World: A Study of Two Traditions." *Revue des études augustiniennes*, 12 (1966), pp. 193-228.

Ariès, Philippe. *Centuries of Childhood: A Social History of Family Life*. Translated from the French edition of 1960 by Robert Baldick. New York, 1962.

Avner, Tamar. "The Impact of the Liturgy on Style and Content: The Triple-Christ Scene in Taphou 14." XVI. Internationaler Byzantinistenkongress, Akten II:5. *Jahrbuch der Österreichischen Byzantinistik*, 32:5 (1982), pp. 459-467.

Axelson, B. "Die Synonyme *adulescens* und *iuvenis*." In *Mélanges de philologie, de littérature et d'histoire anciennes offerts à J. Marouzeau*, pp. 7-17. Paris, 1948.

Barbier de Montault, X. *Traité d'iconographie chrétienne*. 2 vols. Paris, 1890.

Barth, Suse. *Lebensalter-Darstellungen im 19. und 20. Jahrhundert: Ikonographische Studien*. Dissertation, Munich, 1970. Bamberg, 1971.

Bashir-Hecht, Herma. *Die Fassade des Dogenpalastes in Venedig: Der ornamentale und plastische Schmuck*. Cologne and Vienna, 1977.

Beccaria, Augusto. *I codici di medicina del periodo presalernitano (secoli IX, X, e XI)*. Rome, 1956.

Beer, Ellen J. *Die Rose der Kathedrale von Lausanne und der kosmologische Bilderkreis des Mittelalters*. Bern, 1952.

Bertelli, Carlo. "L'enciclopedia delle Tre Fontane." *Paragone* (Arte), 235 (1969), pp. 24-49.

Bishop, Ian. *Pearl in Its Setting: A Critical Study of the Structure and Meaning of the Middle English Poem*. Oxford, 1968.

Bloomfield, Morton W. *The Seven Deadly Sins*. East Lansing, 1952.

Boll, Franz. "Die Lebensalter: Ein Beitrag zur antiken Ethologie und zur Geschichte der Zahlen mit einem Anhang 'Zur Schrift Περὶ ἑβδομάδων.'" *Neue Jahrbücher für das klassische Altertum, Geschichte und deutsche Literatur und für Pädagogik*, 31 (1913), pp. 89-145.

———. *Studien über Claudius Ptolemäus: Ein Beitrag zur Geschichte der griechischen Philosophie und Astrologie*. Leipzig, 1894.

———, and Carl Bezold. *Sternglaube und Sterndeutung: Die Geschichte und das Wesen der Astrologie*. 4th ed. Leipzig and Berlin, 1931.

Bouché-Leclercq, A. *L'astrologie grecque*. Paris, 1899; rpt. Brussels, 1963.

Bowers, R. H. "A Medieval Analogue to *As You Like It* II.vii.137-166." *Shakespeare Quarterly*, 3 (1952), pp. 109-112.

Brakelmann, Julius. Review of *Le Besant de Dieu*, ed. Ernst Martin. *Zeitschrift für deutsche Philologie*, 3 (1871), pp. 210-227.

Burkert, Walter. *Lore and Science in Ancient Pythagoreanism*. Translated from the German edition of 1962 by Edwin L. Minar, Jr. Cambridge, Mass., 1972.

Burnett, Charles, ed. *Hermann of Carinthia: De essentiis. A Critical Edition with Translation and Commentary*. Leiden and Cologne, 1982.

Burrow, John. "Langland *Nel Mezzo Del Cam-*

min." In *Medieval Studies for J.A.W. Bennett*, pp. 21-41. Ed. P. L. Heyworth. Oxford, 1981.

Caviness, Madeline Harrison. *The Early Stained Glass of Canterbury Cathedral, circa 1175-1220*. Princeton, 1977.

———. *The Windows of Christ Church Cathedral, Canterbury*. Corpus Vitrearum Medii Aevi, Great Britain, 2. London, 1981.

Chenu, M.-D. *Nature, Man, and Society in the Twelfth Century: Essays on New Theological Perspectives in the Latin West*. Translated from the French edition of 1957 by Jerome Taylor and Lester K. Little. Chicago and London, 1968.

Chew, Samuel C. *The Pilgrimage of Life*. New Haven and London, 1962.

Cockerell, Sydney C. *The Work of W. de Brailes, an English Illuminator of the Thirteenth Century*. Cambridge, 1930.

Colmant, P. "Les quatre âges de la vie (Horace, *Art poétique*, 153-175)." *Les études classiques*, 24 (1956), pp. 58-63.

Dahan, Gilbert. "Une introduction à la philosophie au XIIe siècle: Le *Tractatus quidam de philosophia et partibus eius*." *AHDLMA*, 49 (1982), pp. 155-193.

Dal, Erik, with Povl Skårup. *The Ages of Man and the Months of the Year: Poetry, Prose and Pictures Outlining the Douze mois figurés Motif Mainly Found in Shepherds' Calendars and in Livres d'Heures (14th to 17th Century)*. Det Kongelige Danske Videnskabernes Selskab, Historisk-filosofiske Skrifter, 9:3. Copenhagen, 1980.

Delatte, Armand. *Études sur la littérature pythagoricienne*. Bibliothèque de l'École des Hautes Études, Sciences historiques et philologiques, fasc. 217. Paris, 1915.

Demandt, Alexander. *Metaphern für Geschichte: Sprachbilder und Gleichnisse im historisch-politischen Denken*. Munich, 1978.

Didron, Adolphe Napoléon. "Symbolique chrétienne: La vie humaine." *Annales archéologiques*, 1 (1844), pp. 241-251, 296-306.

———, and W. Burges. "Iconographie du Palais Ducal, à Venise." *Annales archéologiques*, 17 (1857), pp. 69-88, 193-216.

Diesner, Hans-Joachim. *Isidor von Sevilla und das westgotische Spanien*. Abhandlungen der sächsischen Akademie der Wissenschaften zu Leipzig, Philologisch-historische Klasse, 67:3. Berlin, 1977.

Domínguez Rodríguez, Ana. *Libros de Horas del siglo XV en la Biblioteca Nacional*. Madrid, 1979.

Doren, A. "Fortuna im Mittelalter und in der Renaissance." In *Vorträge der Bibliothek Warburg, 1922-1923: I. Teil*, pp. 71-144. Ed. Fritz Saxl. Leipzig and Berlin, 1924.

Dreizehnter, Alois. *Die rhetorische Zahl: Quellenkritische Untersuchungen anhand der Zahlen 70 und 700*. Munich, 1978.

Duby, Georges. "Youth in Aristocratic Society: Northwestern France in the Twelfth Century." Translated from the French version of 1964 by Cynthia Postan. In *The Chivalrous Society*, pp. 112-122. London, 1977.

Dynes, Wayne. *The Illuminations of the Stavelot Bible*. Dissertation, New York University, 1969. New York and London, 1978.

Egidi, Francesco. "Le miniature dei Codici Barberiniani dei 'Documenti d'Amore.' " *L'arte*, 5 (1902), pp. 1-20, 78-95.

Englert, Anton. "Die menschlichen Altersstufen in Wort und Bild." *Zeitschrift des Vereins für Volkskunde*, 15 (1905), pp. 399-412.

Esmeijer, Anna C. *Divina quaternitas: A Preliminary Study in the Method and Application of Visual Exegesis*. Amsterdam, 1978.

Evans, Michael. "The Geometry of the Mind." *Architectural Association Quarterly*, 12 (1980), pp. 32-53.

———. "Personifications of the *Artes* from Martianus Capella up to the End of the Fourteenth Century." Dissertation, University of London, 1970.

Eyben, E. *De jonge Romein volgens de literaire bronnen der periode ca. 200 v. Chr. tot ca. 500 n. Chr.* Brussels, 1977.

———. "Die Einteilung des menschlichen Lebens im römischen Altertum." *Rheinisches Museum für Philologie*, N.F. 116 (1973), pp. 150-190.

Fava, Domenico, and Mario Salmi. *I manoscritti miniati della Biblioteca Estense ai Modena*. 2 vols. Milan, 1950-1973.

Flores d'Arcais, Francesca. *Guariento: Tutta la pittura*. 2nd ed. Venice, 1974.

Förster, Max. "Die Weltzeitalter bei den Angelsachsen." In *Neusprachliche Studien: Festgabe Karl Luick*. "Die neueren Sprachen," 6. Beiheft, pp. 183-203. Marburg, 1925.

Fontaine, Jacques. *Isidore de Séville et la culture classique dans l'Espagne wisigothique*. 2 vols. Paris, 1959.

Forrer, R. *Unedierte Miniaturen, Federzeichnun-*

gen und Initialen des Mittelalters. 2 vols. Stras-
bourg, 1902-1907.

de Francovich, Géza. Benedetto Antelami: Archi-
tetto e scultore e l'arte del suo tempo. Milan and
Florence, 1952.

de Fréville, Marcel, ed. Les quatre âges de
l'homme: Traité moral de Philippe de Navarre.
Société des Anciens Textes Français, 27.
Paris, 1888.

Freytag, Hartmut. "Die Bedeutung der Him-
melsrichtungen im Himmlischen Jerusa-
lem." Beiträge zur Geschichte der deutschen
Sprache und Literatur [PBB], 93 (Tübingen,
1971), pp. 139-150.

Friedman, Mira M. "Hunting Scenes in the Art
of the Middle Ages and the Renaissance."
Dissertation, Tel Aviv University, 1978.
(Volume Two: English Summary of the He-
brew Text).

von der Gabelentz, Hans. Die Lebensalter und
das menschliche Leben in Tiergestalt. Berlin,
1938.

Gatch, Milton McC. Preaching and Theology in
Anglo-Saxon England: Aelfric and Wulfstan.
Toronto and Buffalo, 1977.

de Ghellinck, Joseph. "Iuventus, gravitas, se-
nectus." In Studia mediaevalia in honorem Ray-
mundi Josephi Martin, pp. 39-59. Bruges,
1948.

Gilson, Étienne. Introduction à l'étude de Saint
Augustin. Paris, 1929.

Gnilka, Christian. Aetas spiritalis: Die Überwin-
dung der natürlichen Altersstufen als Ideal früh-
christlichen Lebens. Bonn, 1972.

————. Studien zur Psychomachie des Prudentius.
Wiesbaden, 1963.

Goedeke, Karl, ed. Pamphilus Gengenbach.
Hannover, 1856.

Goldin, Daniela. "Testo e immagine nei Docu-
menti d'Amore di Francesco da Barberino."
Quaderni d'italianistica, 1 (1980), pp. 125-138.

Goodich, Michael. "Bartholomaeus Anglicus
on Child-Rearing." History of Childhood
Quarterly: The Journal of Psychohistory, 3
(1975-1976), pp. 75-84.

Grattan, J.H.G., and Charles Singer. Anglo-
Saxon Magic and Medicine. London, 1952.

Gray, Douglas. Themes and Images in the Medi-
eval English Religious Lyric. London and Bos-
ton, 1972.

Gruner, O. Cameron. A Treatise on the Canon
of Medicine of Avicenna Incorporating a Trans-
lation of the First Book. London, 1930.

Häussler, Reinhard. "Vom Ursprung und

Wandel des Lebensaltervergleichs." Hermes,
92 (1964), pp. 313-341.

Hart, Cyril. "Byrhtferth and His Manual."
Medium Aevum, 41 (1972), pp. 95-109.

Heninger, S. K., Jr. The Cosmographical Glass:
Renaissance Diagrams of the Universe. San
Marino, Calif., 1977.

Hermann, Hermann Julius. "Zur Geschichte
der Miniaturmalerei am Hofe der Este in
Ferrara: Stilkritische Studien." Jahrbuch der
kunsthistorischen Sammlungen des allerhöchsten
Kaiserhauses, 21 (1900), pp. 117-271.

Heyse, Elisabeth. Hrabanus Maurus' Enzyklo-
pädie 'De rerum naturis': Untersuchungen zu den
Quellen und zur Methode der Kompilation. Mu-
nich, 1969.

Hinkle, William M. "The Cosmic and Terres-
trial Cycles on the Virgin Portal of Notre-
Dame." Art Bulletin, 49 (1967), pp. 287-295.

————. "The King and the Pope on the Virgin
Portal of Notre-Dame." Art Bulletin, 48
(1966), pp. 1-13.

Höhn, Georg. Die Einteilungsarten der Lebens-
und Weltalter bei Griechen und Römern. Pro-
gramm des k. Humanistischen Gymnasiums
Lohr a. M. für das Schuljahr 1911/12. Würz-
burg, 1912.

Hofmeister, Adolf. "Puer, Iuvenis, Senex:
Zum Verständnis der mittelalterlichen Al-
tersbezeichnungen." In Papsttum und Kaiser-
tum (Festschrift Paul Kehr), pp. 287-316. Ed.
Albert Brackmann. Munich, 1926.

Hopper, Vincent F. Medieval Number Symbol-
ism. New York, 1938.

James, Montague Rhoaes. "Pictor in Car-
mine." Archaeologia, 94 (1951), pp. 141-166.

————. The Verses Formerly Inscribed on Twelve
Windows in the Choir of Canterbury Cathedral.
Cambridge and London, 1901.

Jimenez Delgado, Jose. "Zona de extensión de
la palabra 'adulescens.'" Revista Calasancia,
38 (1964), pp. 227-239.

Jones, Charles W., ed. Bedae Opera de Tempo-
ribus. Cambridge, Mass., 1943.

Jones, John Winter. "Observations on the Or-
igin of the Division of Man's Life into
Stages." Archaeologia, 35 (1853), pp. 167-
189.

Jourdain, Édouard, and Théophile Duval.
"Roues symboliques de N.-D. d'Amiens et
de St.-Étienne de Beauvais." Bulletin monu-
mental, 11 (1845), pp. 59-64.

Kaske, R. E. "Piers Plowman and Local Iconog-

raphy." *Journal of the Warburg and Courtauld Institutes*, 31 (1968), pp. 159-169.

Katzenellenbogen, Adolf. "The Representation of the Seven Liberal Arts." In *Twelfth-Century Europe and the Foundations of Modern Society*, pp. 39-55. Ed. Marshall Clagett, Gaines Post, and Robert Reynolds. Madison, Wis., 1961.

Kehrer, Hugo. *Die Heiligen Drei Könige in Literatur und Kunst*. 2 vols. Leipzig, 1908-1909.

Kier, Hiltrud. *Der mittelalterliche Schmuckfussboden unter besonderer Berücksichtigung des Rheinlandes*. Düsseldorf, 1970.

Klemm, Elisabeth. "Das sogenannte Gebetbuch der Hildegard von Bingen." *Jahrbuch der kunsthistorischen Sammlungen in Wien*, 74, N.F. 38 (1978), pp. 29-78.

Klibansky, Raymond, Erwin Panofsky, and Fritz Saxl. *Saturn and Melancholy: Studies in the History of Natural Philosophy, Religion, and Art*. London, 1964.

Koch, Manfred Peter. *Das "Erfurter Kartäuserregimen": Studien zur diätetischen Literatur des Mittelalters*. Dissertation, Bonn, 1969.

Könsgen, Ewald. "Eine neue komputistische Dichtung des Agius von Corvey." *Mittellateinisches Jahrbuch*, 14 (1979), pp. 66-75.

Kollesch, Jutta. *Untersuchungen zu den pseudogalenischen Definitiones Medicae*. Schriften zur Geschichte und Kultur der Antike, 7. Berlin, 1973.

Krüger, Karl Heinrich. *Die Universalchroniken*. Typologie des sources du Moyen Âge occidental, fasc. 16. Turnhout, 1976.

Kuhn, Walter. "Die Ikonographie der Hochzeit zu Kana von den Anfängen bis zum XIV. Jahrhundert." Dissertation, Freiburg i. Br., 1955.

Künstle, Karl. *Ikonographie der christlichen Kunst*. 2 vols. Freiburg i. Br., 1926-1928.

Kurth, Betty. *Die deutschen Bildteppiche des Mittelalters*. Vienna, 1926.

Lambrechts, P. "Het begrip 'Jeugd' in de politieke en godsdienstige hervormingen van Augustus." In *Miscellanea philologica, historica et archaeologica in honorem H. van de Weerd*, pp. 355-372. Brussels, 1948.

Lamirande, Émilien. "Les âges de l'homme d'après Saint Ambroise de Milan." *Cahiers des études anciennes*, 14 (1982), pp. 227-233.

———. "Âges de l'homme et âges spirituels selon Saint Ambroise: Le commentaire du psaume 36." *Science et esprit*, 35:2 (1983), pp. 211-222.

Landouzy, Louis, and Roger Pépin, eds. *Le Régime du Corps de Maître Aldebrandin de Sienne*. Paris, 1911.

Langlois, Ch.-V. *La connaissance de la nature et du monde d'après des écrits français à l'usage des laïcs*. Paris, 1927.

———. *La vie en France au Moyen Âge de la fin du XIIe au milieu du XIVe siècle d'après des moralistes du temps*. Paris, 1925.

Lapidge, Michael. "Byrhtferth and the *Vita S. Ecgwini*." *Mediaeval Studies*, 41 (1979), pp. 331-353.

Die Lebenstreppe: Bilder der menschlichen Lebensalter. Eine Ausstellung des Landschaftsverbandes Rheinland, Rheinisches Museumamt, Brauweiler in Zusammenarbeit mit dem Städtischen Museum Haus Koekkoek, Kleve. Cologne, 1983.

Lehmann, Paul. *Fuldaer Studien, Neue Folge*. Sitzungsberichte der Bayerischen Akademie der Wissenschaften, Philosophisch-philologische und historische Klasse, 1927:2. Munich, 1927.

Leonardi, Claudio. "Intorno al 'Liber de numeris' di Isidoro di Siviglia." *Bullettino dell'Istituto storico italiano per il medio evo e Archivio muratoriano*, 68 (1956), pp. 203-231.

Leroquais, Victor. *Les Livres d'heures manuscrits de la Bibliothèque Nationale*. 2 vols. Paris, 1927.

———. *Les psautiers manuscrits latins des bibliothèques publiques de France*. 2 vols. Macon, 1940-1941.

Lloyd, G.E.R. "The Hot and the Cold, the Dry and the Wet in Greek Philosophy." *Journal of Hellenic Studies*, 84 (1964), pp. 92-106.

———. *Polarity and Analogy: Two Types of Argumentation in Early Greek Thought*. Cambridge, 1966.

Löw, Leopold. *Die Lebensalter in der jüdischen Literatur, von physiologischem, rechts-, sitten- u. religionsgeschichtlichem Standpunkte betrachtet*. Szegedin, 1875.

Luneau, Auguste. *L'histoire du salut chez les Pères de l'Église: La doctrine des âges du monde*. Paris, 1964.

MacKinney, Loren C. *Early Medieval Medicine with Special Reference to France and Chartres*. Baltimore, 1937.

Mâle, Émile. *L'art religieux de la fin du Moyen Âge en France*. 2nd ed. Paris, 1922.

———. *L'art religieux du XIIIe siècle en France*. 7th ed. Paris, 1931.

Mansfeld, Jaap. *The Pseudo-Hippocratic Tract ΠΕΡΙ ἙΒΔΟΜΑΔΩΝ Ch. 1-11 and Greek Philosophy.* Assen, 1971.

van Marle, Raimond. *Iconographie de l'art profane au Moyen-Âge et à la Renaissance.* 2 vols. The Hague, 1931-1932.

Matthias, E. (from the notes of Julius Zacher). "Die zehn Altersstufen des Menschen." *Zeitschrift für deutsche Philologie*, 23 (1891), pp. 385-412.

Maurmann, Barbara. *Die Himmelsrichtungen im Weltbild des Mittelalters: Hildegard von Bingen, Honorius Augustodunensis und andere Autoren.* Munich, 1976.

Mayo, Penelope C. "The Crusaders under the Palm: Allegorical Plants and Cosmic Kingship in the *Liber Floridus*." *Dumbarton Oaks Papers*, 27 (1973), pp. 29-67.

Meiners, Irmgard. "Rota Fortunae: Mitteilungen aus cgm 312." *Beiträge zur Geschichte der deutschen Sprache und Literatur* [PBB], 93 (Tübingen, 1971), pp. 399-414.

Meyer, Heinz, and Rudolf Suntrup. "Zum Lexikon der Zahlenbedeutungen im Mittelalter. Einführung in die Methode und Probeartikel: Die Zahl 7." *Frühmittelalterliche Studien*, 11 (1977), pp. 1-73.

Mielke, Ursula. *Die Plastik am Baptisterium in Parma und ihre Beziehung zum Taufsakrament.* Dissertation, Berlin, 1970.

Mohr, Wolfgang. "Vorstudien zum Aufbau von Priester Arnolds 'Loblied auf den heiligen Geist' ('Siebenzahl')." In *Die Wissenschaft von deutscher Sprache und Dichtung* (Festschrift Friedrich Maurer), pp. 320-351. Stuttgart, 1963.

Molsdorf, Wilhelm. *Christliche Symbolik der mittelalterlichen Kunst.* 2nd ed. Leipzig, 1926.

Morawski, J. "Les douze mois figurez." *Archivum romanicum*, 10 (1926), pp. 351-363.

Murdoch, John E. *Album of Science: Antiquity and the Middle Ages.* New York, 1984.

Nardi, Bruno. "L'arco della vita (Nota illustrativa al 'Convivio')." In *Saggi di filosofia dantesca*, pp. 110-138. 2nd ed. Florence, 1967.

Nelson, Alan H. " 'Of the Seuen Ages': An Unknown Analogue of *The Castle of Perseverance*." *Comparative Drama*, 8 (1974), pp. 125-138.

Offner, Richard. *A Critical and Historical Corpus of Florentine Painting: The Fourteenth Century*, 3:7. New York, 1957.

Ohly, Friedrich. "Zum Text des Himmlischen Jerusalem." *Zeitschrift für deutsches Altertum und deutsche Literatur*, 86 (1955-1956), pp. 210-215.

———. "Zum 'Himmlischen Jerusalem' v. 61ff." *Zeitschrift für deutsches Altertum und deutsche Literatur*, 90 (1960-1961), pp. 36-40.

Owst, G. R. *Literature and Pulpit in Medieval England: A Neglected Chapter in the History of English Letters and of the English People.* Cambridge, 1933.

Phillips, Joanne H. "Early Greek Medicine and the Poetry of Solon." *Clio Medica*, 15 (1980), pp. 1-4.

Pickering, F. P. *Literature and Art in the Middle Ages.* London, 1970.

Poeschke, Joachim. "Leben, menschliches." In *Lexikon der christlichen Ikonographie*, 3, cols. 38-39. Ed. Engelbert Kirschbaum. Freiburg i. Br., 1971.

Pressouyre, Léon. "Le cosmos platonicien de la Cathédrale d'Anagni." *Mélanges d'archéologie et d'histoire* (École Française de Rome), 78 (1966), pp. 551-593.

Rackham, Bernard. *The Ancient Glass of Canterbury Cathedral.* London, 1949.

Rahn, J. R. "Die Wandgemälde im Schlosse Sargans." *Kunstdenkmäler der Schweiz: Mitteilungen der schweizerischen Gesellschaft für Erhaltung historischer Kunstdenkmäler*, N.F. 2 (1902), pp. 13-14.

Reiche, Rainer. *Ein rheinisches Schulbuch aus dem 11. Jahrhundert.* Munich, 1976.

Reuter, Marianne. *Text und Bild im Codex 132 der Bibliothek von Montecassino "Liber Rabani de originibus rerum": Untersuchungen zur mittelalterlichen Illustrationspraxis.* Munich, 1984.

Rickert, Margaret. "The Illuminated Manuscripts of Meester Dirc van Delf's Tafel van den Kersten Ghelove." *Journal of the Walters Art Gallery*, 12 (1949), pp. 79-108.

Robbins, Frank Egleston. "The Tradition of Greek Arithmology." *Classical Philology*, 16 (1921), pp. 97-123.

Roscher, Wilhelm Heinrich. *Die enneadischen und hebdomadischen Fristen und Wochen der ältesten Griechen: Ein Beitrag zur vergleichenden Chronologie und Zahlenmystik.* Abhandlungen der philologisch-historischen Klasse der Königl. Sächsischen Gesellschaft der Wissenschaften, 21:4. Leipzig, 1903.

———. *Die Hebdomadenlehren der griechischen Philosophen und Ärzte.* Abhandlungen . . ., 24:6. Leipzig, 1906.

———. *Die hippokratische Schrift von der Siebenzahl in ihrer vierfachen Überlieferung.* Studien

zur Geschichte und Kultur des Altertums, 6:3-4. Paderborn, 1913.

Rossi, Gino, and Giovanni Salerni. *I capitelli del Palazzo Ducale di Venezia*. Venice, 1952.

Rouse, E. Clive, and Audrey Baker. *The Wall-Paintings at Longthorpe Tower, near Peterborough, Northants*. Oxford, 1955. [=*Archaeologia*, 96 (1955), pp. 1-57]

Ruelle, Pierre, ed. *Le Besant de Dieu de Guillaume le Clerc de Normandie*. Brussels, 1973.

Rushforth, G. McN. "The Wheel of the Ten Ages of Life in Leominster Church." *Proceedings of the Society of Antiquaries of London*, 26 (1914), pp. 47-70.

Salmi, Mario. "Gli affreschi del Palazzo Trinci a Foligno." *Bollettino d'arte*, 13 (1919), pp. 139-180.

Sandler, Lucy Freeman. *The Psalter of Robert De Lisle in the British Library*. London and New York, 1983.

Sauerländer, Willibald. *Gothic Sculpture in France, 1140-1270*. Translated from the German edition of 1970 by Janet Sondheimer. New York, 1972.

Saxl, Fritz. "Illustrated Mediaeval Encyclopaedias." In *Lectures*, pp. 228-254. London, 1957.

————. "A Spiritual Encyclopaedia of the Later Middle Ages." *Journal of the Warburg and Courtauld Institutes*, 5 (1942), pp. 82-134.

Schapiro, Meyer. "The Bowman and the Bird on the Ruthwell Cross and Other Works: The Interpretation of Secular Themes in Early Mediaeval Religious Art." *Art Bulletin*, 45 (1963), pp. 351-355.

Schell, Edgar T. "On the Imitation of Life's Pilgrimage in *The Castle of Perseverance*." In *Medieval English Drama: Essays Critical and Contextual*, pp. 279-291. Ed. Jerome Taylor and Alan H. Nelson. Chicago and London, 1972.

Schmid, Wolfgang. "Die Darstellung der Menschheitsstufen bei Prudentius und das Problem seiner doppelten Redaktion." *Vigiliae Christianae*, 7 (1953), pp. 171-186.

Schmidt, Roderich. "Aetates mundi: Die Weltalter als Gliederungsprinzip der Geschichte." *Zeitschrift für Kirchengeschichte*, 67 (1955-1956), pp. 288-317.

Schöner, Erich. *Das Viererschema in der antiken Humoralpathologie*. Sudhoffs Archiv, Beiheft 4. Wiesbaden, 1964.

Schreiber, W. L. *Handbuch der Holz- und Me-tallschnitte des XV. Jahrhunderts*. Vol. 4. Leipzig, 1927.

Schwarte, Karl-Heinz. *Die Vorgeschichte der augustinischen Weltalterlehre*. Bonn, 1966.

Sharpe, William D. *Isidore of Seville: The Medical Writings. An English Translation with an Introduction and Commentary*. Transactions of the American Philosophical Society, n.s. 54:2. Philadelphia, 1964.

Singer, Charles and Dorothea. "Byrhtferð's Diagram. A Restoration: Byrhtferð of Ramsey's Diagram of the Physical and Physiological Fours." *Bodleian Quarterly Record*, 2 (1917), pp. 47-51.

Smith, M. Q. "Anagni: An Example of Medieval Typological Decoration." *Papers of the British School at Rome*, 33, n.s. 20 (1965), pp. 1-47.

Smitmans, Adolf. *Das Weinwunder von Kana: Die Auslegung von Jo 2, 1-11 bei den Vätern und heute*. Beiträge zur Geschichte der biblischen Exegese, 6. Tübingen, 1966.

Sprandel, Rolf. *Altersshicksal und Altersmoral: Die Geschichte der Einstellungen zum Altern nach der Pariser Bibelexegese des 12.-16. Jahrhunderts*. Stuttgart, 1981.

Stahl, William Harris. *Macrobius: Commentary on the Dream of Scipio*. New York, 1952.

————, and Richard Johnson, with E. L. Burge. *Martianus Capella and the Seven Liberal Arts*. 2 vols. New York and London, 1971-1977.

Standen, Edith A. "The Twelve Ages of Man: A Further Study of a Set of Early Sixteenth-Century Flemish Tapestries." *Metropolitan Museum Journal*, 2 (1969), pp. 127-168.

Thesleff, Holger. *An Introduction to the Pythagorean Writings of the Hellenistic Period*. Acta Academiae Aboensis Humaniora, 24:3. Åbo, 1961.

Tietze, Hans. "Die Handschriften der Concordantia Caritatis des Abtes Ulrich von Lilienfeld." *Jahrbuch der K. K. Zentral-Kommission für Erforschung und Erhaltung der Kunst und historischen Denkmale*, N.F. 3:2 (1905), cols. 27-64.

Toesca, Pietro. "Gli affreschi della Cattedrale di Anagni." *Le gallerie nazionali italiane*, 5 (1902), pp. 116-187.

Tristram, E. W. *English Medieval Wall Painting: The Thirteenth Century*. London, 1950.

Tristram, Philippa. *Figures of Life and Death in Medieval English Literature*. London, 1976.

Turville-Petre, Thorlac. "The Ages of Man in

The Parlement of the Thre Ages." *Medium Ae-vum*, 46 (1977), pp. 66-76.

Tuve, Rosemond. *Seasons and Months: Studies in a Tradition of Middle English Poetry.* Paris, 1933.

Venturi, Adolfo. "La fonte di una composizione del Guariento." *L'arte*, 17 (1914), pp. 49-57.

Vezin, Gilberte. *L'adoration et le cycle des mages dans l'art chrétien primitif.* Paris, 1950.

de Vogel, C. J. *Pythagoras and Early Pythagoreanism: An Interpretation of Neglected Evidence on the Philosopher Pythagoras.* Assen, 1966.

Vossen, Peter. "Über die Elementen-Syzygien." In *Liber Floridus: Mittellateinische Studien* (Festschrift Paul Lehmann), pp. 33-46. Ed. Bernhard Bischoff and Suso Brechter. St. Ottilien, 1950.

Wackernagel, Wilhelm. *Die Lebensalter: Ein Beitrag zur vergleichenden Sitten- und Rechtsgeschichte.* Basel, 1862.

Waller, J. G. "Christian Iconography and Legendary Art: The Wheel of Human Life, or the Seven Ages." *The Gentleman's Magazine*, n.s. 39 (1853), pp. 494-502.

Weigand, E. "Zur Datierung der kappadokischen Höhlenmalereien, I: Die Differenzierung der Magier nach dem Lebensalter." *Byzantinische Zeitschrift*, 36 (1936), pp. 358-362.

Weinhold, Karl. *Glücksrad und Lebensrad.* Berlin, 1892.

West, M. L. "The Cosmology of 'Hippocrates,' *De Hebdomadibus.*" *Classical Quarterly*, 65, n.s. 21 (1971), pp. 365-388.

Wetherbee, Winthrop. *Platonism and Poetry in the Twelfth Century: The Literary Influence of the School of Chartres.* Princeton, 1972.

Whitbread, Leslie George. *Fulgentius the Mythographer.* Columbus, Ohio, 1971.

Wickersheimer, Ernest. "Figures médico-astrologiques des IXᵉ, Xᵉ e XIᵉ siècles." *Janus*, 19 (1914), pp. 157-177.

———. *Les manuscrits latins de médecine du Haut Moyen Âge dans les bibliothèques de France.* Paris, 1966.

Wirth, Karl-August. "Neue Schriftquellen zur deutschen Kunst des 15. Jahrhunderts: Einträge in einer Sammelhandschrift des Sigmund Gossembrot (cod. lat. mon. 3941)." *Städel-Jahrbuch*, N.F. 6 (1977), pp. 319-408.

———. "Von mittelalterlichen Bildern und Lehrfiguren im Dienste der Schule und des Unterrichts." In *Studien zum städtischen Bildungswesen des späten Mittelalters und der frühen Neuzeit*, Bericht über Kolloquien der Kommission zur Erforschung der Kultur des Spätmittelalters 1978 bis 1981, pp. 256-370. Ed. Bernd Moeller, Hans Patze, and Karl Stackmann. Göttingen, 1983.

Wlaschky, M. "Sapientia Artis Medicinae: Ein frühmittelalterliches Kompendium der Medizin." *Kyklos*, 1 (1928), pp. 103-113.

Woolf, Rosemary. *The English Religious Lyric in the Middle Ages.* Oxford, 1968.

York, Ernest C. "Dramatic Form in a Late Middle English Narrative." *Modern Language Notes*, 72 (1957), pp. 484-485.

INDEX OF MANUSCRIPTS

BALTIMORE
Walters Art Gallery
 ms. 73 ("School-book"): 160 n.43
 ms. 171 (Dirc van Delf): 127, 198 n.34,
 figs. 63-64
BERLIN
Kupferstichkabinett
 ms. 78. A. 9 ("Hamilton Psalter"): 200
 n.2
Staatsbibliothek
 Maihingensis I. 2. lat. 4° (glossed Boe-
 thius): 161 n.47
 Phill. 1694 (poems and epistles): 178 n.46
BONN
Universitätsbibliothek
 cod. S. 218 (miscellany): 64, 177 n.43
BRUSSELS
Bibliothèque Royale
 ms. 21974 (Dirc van Delf): 198 n.34
CAMBRIDGE
Corpus Christi College
 ms. 183 (miscellany): 64, 177 n.43
 ms. 300 (Pictor in carmine): 181 n.81
 ms. 320 (miscellany): 64, 177 n.43
 ms. 441 (miscellany): 197 n.20
 ms. 481 (miscellany): 203 n.40
Fitzwilliam Museum
 ms. 330, no. 4 (Wheel of Fortune): 74,
 145-146, 203 n.35, fig. 86
Gonville and Caius College
 ms. 428 (Tractatus de quaternario): 23-25,
 163 n.67, 173 n.60, fig. 6
Cambridge University Library
 ms. Ii. 4. 26 (bestiary): 64, 177 n. 42
 ms. Ii. 5. 11 (Aldobrandinus of Siena):
 191 n.19
 ms. Gg. 4. 32 (miscellany): 204 n.47
CANTERBURY
Canterbury Cathedral Archives and Library
 ms. C246 (inscriptions): 181 n.77
CHARTRES
Bibliothèque Municipale
 ms. 62 (medical miscellany): 27, 47, 64,
 165 n.81, 177 n.43
 mss. 497-498 (Eptateuchon): 162 n.59
DIJON
Bibliothèque Publique

ms. 448 (computistic miscellany): 35, 168
 n.121, 172 n.43, fig. 12
DUBLIN
Chester Beatty Library
 ms. 80 ("Viridarium"): 126, 198 n.31,
 figs. 60-61
Trinity College Library
 cod. 347 (miscellany): 148-149, 203 n.42,
 fig. 88
FLORENCE
Biblioteca Medicea Laurenziana
 ms. Plut. 42-19 (Brunetto Latini): 152-
 153, 205 n.56, fig. 97
GHENT
Universiteitsbibliotheek
 ms. 92 (Liber floridus): 19-20, 67-69, 161
 n.51, 178 n.54, figs. 4, 16
HILDESHEIM
St. Godehard
 St. Albans Psalter: 200 n.2
JERUSALEM
Greek Patriarchal Library
 ms. 14 (homilies): 189 n.49
LILIENFELD
Stiftsbibliothek
 cod. 151 (Concordantia caritatis): 152, 205
 n.53, figs. 93-94
LONDON
British Library
 Add. 11390 (Jacob van Maerlant): 126-
 127, 198 n.33, fig. 62
 Add. 11612 (Bartholomaeus Anglicus):
 199 n.49
 Add. 15452 (Bible): 182 n.92
 Add. 16578 (Speculum humane salvationis):
 113, 193 n.52, fig. 52
 Add. 18719 (Bible moralisée): 182 n.89
 Add. 22288 (Dirc van Delf): 198 n.34
 Add. 28106 ("Stavelot Bible"): 84-85,
 185 n.16, fig. 25
 Add. 37049 (miscellany): 139-140, 201
 n.17, fig. 81
 Arundel 83 ("De Lisle Psalter"): 142,
 146-148, 150, 203 n.38, 204 n.47, figs.
 87, 90
 Cotton Tib. C. I ("Peterborough Com-
 putus"): 168 n.114

LONDON, British Library (*cont.*)
> Cotton Faust. C. I (Macrobius): 19, 161
> n.49
> Cotton Vesp. B. VI (miscellany): 64, 177
> n.43
> Harley 1526-1527 (*Bible moralisée*): 75,
> 76-77, 182 nn.88, 93, figs. 21, 23
> Harley 3667 ("Peterborough Compu-
> tus"): 34-35, 168 n.114, fig. 11
> Royal 6 E. VII ("Omne bonum"): 130-
> 131, 199 n.45, fig. 66
> Royal 8 A. VI (miscellany): 125, 197 n.21
> Royal 17 E. III (Bartholomaeus Angli-
> cus): 199 n.49
> Sloane 405 (medical miscellany): 197 n.30
> Sloane 2435 (Aldobrandinus of Siena):
> 102, 191 n.17

Wellcome Institute for the History of
Medicine
> ms. 49 (miscellany): 143-144, 151, 202
> n.28, 204 n.50, figs. 85, 91

MADRID
Biblioteca Nacional
> cod. Vit. 24-3 (Book of Hours): 119-120,
> 195 n.71, figs. 58-59

MILAN
Biblioteca Ambrosiana
> cod. G. 108 Inf. (medical miscellany):
> 170 n.12, 171 n.29

MINNEAPOLIS
University of Minnesota, James Ford Bell
Library
> 1400/f Ba (Bartholomaeus Anglicus):
> 132, 199 n.52, fig. 69

MODENA
Biblioteca Estense
> lat. 697 (α. W.8.20) (*Liber physionomie*):
> 111-113, 193 n.50, figs. 50-51

MONTECASSINO
Monastery Library
> ms. 132 (Hrabanus Maurus): 66-67, 178
> n.49, fig. 14

MOSCOW
Historical Museum
> ms. gr. 129 ("Chludoff Psalter"): 200 n.2

MUNICH
Bayerische Staatsbibliothek
> cgm. 312 (Losbuch): 142, 150, 204 n.51,
> fig. 92
> clm. 5257 (miscellany): 172 n.41
> clm. 7960 (sermons and schemata): 180
> n.75
> clm. 11465 (miscellany): 202 n.22
> clm. 14532 (miscellany): 64, 177 n.43
> clm. 14641 (miscellany): 65, 178 n.46

> clm. 16104a (miscellany): 202 n.22
> clm. 18462 (miscellany): 125, 197 n.23
> clm. 19414 (miscellany): 130, 199 n.44,
> fig. 65
> clm. 22053 ("Wessobrun Prayer Manu-
> script"): 188 n.43

NEW HAVEN
Yale University, Beinecke Rare Book and
Manuscript Library
> ms. 416 ("Turris virtutum"): 143, 202
> n.26, fig. 83

NEW YORK
New York Public Library
> ms. 69 (John of Sacrobosco): 36, 169
> n.126, fig. 13
Pierpont Morgan Library
> G. 50 (Book of Hours): 138-139, 201
> n.13, figs. 79-80
> M. 165 (Aldobrandinus of Siena): 191
> n.19
> M. 240 (*Bible moralisée*): 182 n.87
> M. 813 (Book of Hours): 118-119, 195
> n.68, figs. 56-57
> M. 1045 (*Concordantia caritatis*): 152, 205
> n.54, figs. 95-96

NUREMBERG
Germanisches Nationalmuseum
> no. 156142 ("Codex Aureus"): 186 n.22

OXFORD
Bodleian Library
> Ashmole 328 ("Byrhtferth's Manual"):
> 23, 33-34, 167 n.106, 168 n.120, fig. 9
> Bodley 270b (*Bible moralisée*): 182 n.88
> Can. Misc. 554 (Prosdocimus of Bel-
> domandi): 111, 193 n.49, fig. 49
> Digby 83 (astronomical miscellany): 177
> n.36
> Lat. Misc. e. 2 (*Articella*): 30-31, 167
> n.98, fig. 8
> Laud. Misc. 156 (theological tables): 204
> n.47
> Laud. Misc. 277 (theological miscellany):
> 64, 177 n.44
> Rawl. C. 67 (*Pictor in carmine*): 181 n.81
> Rawl. D. 251 (medical miscellany): 125,
> 197 n.22
St. John's College
> ms. 17 ("Ramsey Computus"): 34-35,
> 168 n.113, fig. 10

PARIS
Bibliothèque de l'Arsenal
> ms. 937 (preacher's miscellany): 204 n.47
> ms. 1037 (schemata): 143, 202 n.25, fig.
> 82

ms. 1100 (miscellany): 202 n.22
ms. 1234 (Peter of Poitiers): 115, 142, 194 n.58, 202 n.22, fig. 55
ms. 2510 (Aldobrandinus of Siena): 102, 191 n.16
ms. 3516 (miscellany): 114, 194 n.57, fig. 54

Bibliothèque Mazarine
ms. 924 (summa of virtues and vices): 202 n.22

Bibliothèque Nationale
Coislin 345 (miscellany): 170 n.12
fr. 167 (*Bible moralisée*): 75, 182 n.89, fig. 22
fr. 216 (Bartholomaeus Anglicus): 199 n.49
fr. 218 (Bartholomaeus Anglicus): 132, 200 n.53
fr. 1023 (Jacques le Grant): 199 n.49
fr. 1968 (miscellany): 125, 197 n.25
fr. 9141 (Bartholomaeus Anglicus): 131-132, 199 n.51, fig. 68
fr. 9220 ("Vrigiet de solas"): 142-143, 202 n.24, fig. 84
fr. 12323 (Aldobrandinus of Siena): 102, 191 n.18, fig. 33
fr. 12581 (Philippe de Novarre): 102-103, 191 n.20, figs. 35-38
fr. 13314 (Maurice de Sully): 196 n.9
fr. 16993 (Bartholomaeus Anglicus): 199 n.49
fr. 17177 (Philippe de Novarre): 191 n.20
fr. 22531 (Bartholomaeus Anglicus): 131, 199 n.50, fig. 67
fr. 22532 (Bartholomaeus Anglicus): 131, 199 n.48
gr. 1788 (miscellany): 173 n.55
lat. 2796 (miscellany): 64, 177 n.40
lat. 2825 (miscellany): 47, 172 n.44
lat. 3445 (miscellany): 202 n.22
lat. 3464 (miscellany): 202 n.22
lat. 3473 (miscellany): 204 n.47
lat. 5239 (scientific miscellany): 160 n.43
lat. 5543 (scientific miscellany): 160 n.43
lat. 6400 G (Isidore of Seville): 17, 160 n.41, fig. 1
lat. 7027 (medical miscellany): 64 n.76, 171 n.29
lat. 8846 (psalter): 134-135, 200 n.1, fig. 70
lat. 10630 (miscellany): 202 n.22
lat. 11130 (William of Conches): 28, 165 n.89, fig. 7
lat. 11218 (medical miscellany): 47, 64, 172 n.45, 177 n.38
lat. 11560 (*Bible moralisée*): 182 n.88

lat. 12999 (miscellany): 19, 161 n.48, fig. 3
lat. 14289 (miscellany): 202 n.22
lat. 15125 (miscellany): 202 n.22
nouv. acq. lat. 1618 (scientific miscellany): 160 n.43
nouv. acq. lat. 2129 (*Concordantia caritatis*): 205 n.54
Smith-Lesouëf 39 (Book of Hours): 195 n.68

Bibliothèque Sainte-Geneviève
ms. 1028 (Bartholomaeus Anglicus): 199 n.49
ms. 1029 (Bartholomaeus Anglicus): 199 n.50

PRINCETON
Princeton University, Rare Book and Manuscript Library
Garrett 99 (John of Sacrobosco): 169 n.125

ROME
Biblioteca Casanatense
ms. 1404 (miscellany): 151, 202 n.22, 204 n.49

ROUEN
Bibliothèque Municipale
cod. 26 (miscellany): 64, 177 n.39

SALZBURG
Universitätsbibliothek
ms. M III 36 (miscellany): 193 n.52

SIENA
Biblioteca Comunale
ms. F. X. 18 (sermons): 200 n.58
ms. F. X. 19 (sermons): 200 n.58
ms. G. IX. 26 (sermons): 200 n.58

STUTTGART
Württembergische Landesbibliothek
Bibl. fol. 23 ("Stuttgart Psalter"): 92-93, 188 n.46, fig. 31
HB XI 43 (scientific miscellany): 194 n.52

TOLEDO
Cathedral Treasury
(*Bible moralisée*): 75-76, 182 n.87, fig. 20

VATICAN CITY
Biblioteca Apostolica Vaticana
Barb. lat. 4076 (Francesco da Barberino): 104-106, 191 n.27, figs. 39-41
Barb. lat. 4077 (Francesco da Barberino): 104-105, 191 n.27
Pal. lat. 291 (Hrabanus Maurus): 67, 178 n.52, fig. 15
Pal. lat. 1357 (Honorius Augustodunensis): 166 n.89

VATICAN CITY, Bib. Apost. Vat. *(cont.)*
 Pal. lat. 1581 (glossed Boethius): 19, 161
 n.46, fig. 2
 Reg. lat. 49 (homilies): 93, 180 n.70, 188
 n.43, 189 n.50
 Reg. lat. 204 (Bede etc.): 64, 177 n.43
 Reg. lat. 1256 (Aldobrandinus of Siena):
 102, 191 n.19, fig. 34
VIENNA
 Österreichische Nationalbibliothek
 cod. 1179 (*Bible moralisée*): 75, 182 n.86
 cod. 1548 (miscellany): 202 n.22
 cod. 2554 (*Bible moralisée*): 75, 182 n.86
 cod. 2642 (Boethius): 114, 194 n.55, fig.
 53
 cod. 2739★ (prayerbook): 85-86, 185
 n.18, figs. 26-29

cod. 12465 (theological miscellany): 202
 n.22
cod. 12600 (scientific miscellany): 160
 n.43
VORAU
 Augustiner-Chorherrenstift
 ms. 276 (poetic miscellany): 172 n.39
WOLFENBÜTTEL
 Herzog August Bibliothek
 Guelf. 1. 5. 3. 1 Aug. fol. (Bartholo-
 maeus Anglicus): 199 n.50
 Guelf. 75. 3. Aug. fol. (miscellany): 125,
 197 n.24
 Guelf. 335. Gud. lat. 4° (miscellany): 65,
 178 n.46
 Guelf. 1 Gud. lat. fol. (*Liber floridus*): 68-
 69, 179 n.59, fig. 17

INDEX

Abbo of Fleury, 33

Abelard, Peter, 77

Abu Maʿshar, 50, 52

Adam's name interpreted, 34-35

adolescens, adolescentia, passim; aligned with sext, 106; with terce, 83, 89; correlated with phlegm, 24; with red gall, 27, 32, 33; equated with *pietas*, 129; extending to twenty-one, or twenty-eight, or thirty/thirty-five, 128; to twenty-five, 104; to twenty-five/thirty, 24, 30, 190 n.13; to thirty, 29; to appearance of beard, 41; from fourteen to twenty-one, 41, 47, 130; from fourteen to twenty-five, 197 n.24; from fourteen to twenty-eight, 35, 47, 61, 64, 69, 172 n.41, 177 n.36; from fourteen to thirty, 197 n.21; from fourteen to thirty-five, 125; from fifteen to twenty-one, 78; from fifteen to twenty-eight, 63; governed by Venus for seven years, 109; lasts seven years, 47; lasts two hebdomads, 47, 62; period in which religious orders are taken, 89; in which devil is active, 90; in which marriage is contemplated, 98-99; period of ability to reproduce, 56, 61, 126, 130; of growth, 30, 104, 129, 190 n.13; of increase in heat, 83; qualitatively cold and wet, 24; hot and wet, 24, 30, 97, 104, 190 n.13; represented by figure embracing woman, 130, fig. 65; holding bow and arrow, 85, 144, figs. 26, 85; falcon, 151, fig. 92; flower, 115, 130, figs. 55, 65; mirror, 149; scepter, 73-74, fig. 19; learning arithmetic, 109; playing with whip top, 152, figs. 94, 96; reading under master, 143, fig. 84; same as *iuventus*, 88; as *pueritia*, 24; subdivided, 29-30, 97, 100

adolescentula, 196 n.7

Aelfric, 71, 84

aetas, see *etas*

ages of Christ's life, 81, 189 n.49

ages of man: aligned with animals, 153-154, fig. 98; compared to phases of moon, 46; correlated with letters of alphabet, 175 n.13; in Assyrian, 170 n.10; in Dutch, 127; in Flemish, 126; in French, 100-103, 114, 117, 118, 123, 125, 135, 138-139, 150; in German, 46, 86, 154, fig. 92; in Greek, 10-14, 56, 61, 157 n.5, 159 nn.20, 29, 170 n.12, 171 n.17, 172 n.49; in Italian, 104; in Latin, *see individual entries*; in Middle English, 116, 139-140; in Old English, 163 n.65

ages of man, three: adulthood posited as mean between extremes, 90, 93; compared to soft, hard, and medium wax, 165 n.85; correlated with vigils in Parable of the Three Vigils, 88-89; in guise of three Magi, 91-94, figs. 31, 32; in riddle of the Sphinx, 90, cf. 130; inhabiting island visited by St. Brendan, 188 n.43

ages of man, four, 9-37, 99-105, 114-116, figs. 1-13, 33-39, 53-55, 67; aligned with virtues, 102, 116, 118; correlated with directions of access to heavenly Jerusalem, 89-90; with heavenly quadrants, 16; with hours of day, 37, 104; with humors, 14-15, 24, 26-33, 36, 51; with qualities, 13-15, 24-33, 51, 100, 104, 163 n.65, 190 n.13; with seasons, 10-16, 19, 28, 33, 36-37, 99-100, 101, 104, 105, 116-118, 131; with temperaments, 15, 28; in guise of four rivers of paradise, 187 n.35; lasting eighteen years each, 118; twenty years each, 10, 101; reconciled with six-age scheme, 22, 68-69, 78, fig. 17

ages of man, five, 80-82; aligned with virtues, 199 n.42; correlated with hours of day and ages of world, 82-88, 122-123, figs. 26-29; extended to six, 87, fig. 30; reduced from six, 130, fig. 65; representing five ages of prophecy, 76-77, fig. 24

ages of man, six, 54-79, 97-98, 105-106, 122-133, figs. 14-15, 17-22, 24, 30, 40-41, 60-62, 68; correlated with ages of the world, 55-79, 97-98, 123-124; with days of creation, 55-59, 68-69, 77, 176 n.23; with hours of day, 69, 86-87, 105-106; with seasons and elements, 69; with vessels at Cana, 69-79; found in first six books of *Aeneid*, 64-65; seventh age the afterlife, 55-58, 59

ages of man, seven, 38-53, 105-106, 124-133, 134-144, 149-151, 153, figs. 16, 42-51, 63, 69-78, 81-85, 91-92, 97; aligned with virtues, 129; correlated with hours of day, 89,

ages of man, seven (*cont.*)

106-107, 149-150, 193 n.52; with liberal arts, 140-144, 201 n.21; with planets, 47-53, 107-113, 193 n.52; derived from subdividing four ages, 100; increase in hebdomads, 41, 46, 47, 51; lasting ten years each, 153; preferred to six-age scheme, 124-133; represented in tree, 140-144, 153; on wheel, 149-150, 151, 203 n.40; spiritual ages, 57

ages of man, eight: correlated with hours of day, 138-139, figs. 79-80

ages of man, ten, 40, 153-155, fig. 98; lasting seven years each, 40, 42; ten years each, 153-154, 170 n.10

ages of man, twelve: correlated with twelve months, 116-120, 195 n.64, figs. 56-59; with signs of zodiac, 112-113, figs. 50-51; inscribed in *rota*, 150, fig. 90; represented in tree, 152-153, figs. 93-96

ages of man, pictorial representations

ATTRIBUTES: *armor*, 67, 126, 130, 151, 152, 199 n.50, figs. 15, 62, 65, 92; *axe*, 75, fig. 20; *baby-walker*, 131, 132, 144, 146, 152, figs. 66, 85, 86, 95; *balance*, 147-148, fig. 87; *ball*, 73, 75, 102, 115, 136, 137, 193 n.52, figs. 19, 20, 55, 78; *battle-axe*, 140, fig. 81; *book*, 109, 110-112, 135-136, 137, 153, figs. 70, 75, 97; *bow and arrow*, 75, 78, 85, 102, 119, 132, figs. 20, 24, 26, 34, 68; see also below, occupations: shooting arrow; *brazier*, 111-113, figs. 48, 51; *bread*, 73, 199 n.50, fig. 19; *comb*, 139, 148, figs. 79, 87; *cradle*, 132, 136, 137, 144, 151, 153, figs. 15, 78, 85, 98; *crown*, 148, 151, fig. 87; *doll*, 110, figs. 45, 49, 50; *dog*, 78-79, fig. 24; *dove*, 143, fig. 84; *falcon* (and lure etc.), 75, 77, 78, 109, 126, 132, 135-136, 137, 138, 139, 144, 150, 151, figs. 20, 23, 24, 62, 68, 70, 75, 78, 85, 92; *flower*, 112, 115, 130, 132, figs. 55, 65; *flowering branch*, 24, 135-136, 200 n.2, figs. 6, 70; *garland*, 106-107, fig. 40; *gloves*, 102, fig. 34; *horn*, 199 n.50; *lance*, 130, 137, figs. 15, 65, 92, 94, 96; *mandolin*, 112; *mirror*, 106-107, 139, 148-149, 153, figs. 40, 79, 87, 97; *money bag*, 73, 111, 119, 138, 140, 150, figs. 19, 47, 78, 81; *playing stick*, 73, 118, figs. 19, 56; *ring*, 137, figs. 15, 76; *rosary*, 111-112, 137, 140, fig. 81; *scepter*, 73-74, 146, 148, figs. 19, 86, 87; *scroll*, 86, 109, 138-139, 145, 152, figs. 28, 43, 79-80, 86, 92, 93-96, 98; *shield*, 85, 126, 199 n.50, figs. 27, 62; *spindle* (and distaff, scissors, spool etc.), 24, 111-112, figs. 6, 47; *stick* (cane, crutch, staff), 66, 73, 75, 77, 79, 86, 90, 102, 106, 109, 112, 115, 126, 130, 132, 137, 139, 143, 144, 148, 151, 152, 200 n.2,

figs. 14, 15, 19-24, 29, 37, 41, 44, 55, 61, 62, 65, 69, 75, 80, 84, 85, 87, 91-92, 94, 96, 98; *two sticks*, 102, 103, 135-136, 137, 138, figs. 34, 38, 70, 73, 75, 78; *stick horse* (and whip), 110-112, 132, 136, 151, figs. 45, 49, 50, 91-92, 98; *sword*, 73, 77, 85, 109, 111, 126, 130, 132, 137, 138, 139, 144, 152, 199 n.50, figs. 19, 23, 27, 47, 61, 62, 65, 78, 85, 92, 94, 96, 98; *wheeled toy*, 110-112, figs. 45, 49, 50; *whip top*, 126, 130, 131, 132, 135, 137, 152, 199 n.50, figs. 62, 65-68, 70, 71, 78, 94, 96; *windmill* (toy), 132, 136, 150, 151; *writing tablet*, 109, 152, figs. 43, 95

OCCUPATIONS: *acquiring goods*, 119; *cared for by mother*, 102, 106, 126, 147, 152, 153, figs. 35, 41, 62, 84, 87, 93, 95, 97; *combing hair before mirror*, 139, 148, figs. 79, 87; *confessing*, 153, fig. 97; *counting money*, 131, 132, 151, figs. 67, 68; *courting*, 111-112, 119, 136, figs. 46, 58, 67; *crawling*, 130, fig. 65; *discoursing*, 132, 152, figs. 68, 94; *embracing*, 120, 130, 131, 199 n.50, figs. 58, 65, 67; *examined by doctor*, 119, 144, 146, 148, figs. 85, 86, 87; *gazing in mirror*, 106, 154, figs. 40, 97; *learning to walk*, see above, attributes: baby-walker; *lying in deathbed*, 109, 119, 120, 127, 139, 140, 144, 148, 152, 193 n.52, 201 n.9, figs. 44, 57, 59, 62, 81, 85, 87, 93, 95; *giving instruction*, 143, fig. 84; *marrying*, 119; *playing*, 110-112, 118, 126, 130, 131, 132, 135-136, 137, 153, 199 n.50, figs. 45, 49, 50, 56, 62, 65-68, 70, 71, 78, 94, 96, 97, 98; *praying*, 111-112, 120, 126, 136, 137, 153, figs. 62, 97; *rearing children*, 106-107, 119, fig. 41; *receiving instruction from master*, 110-113, 119, 136, 143, fig. 84; *riding horse*, 119, 137; *with falcon*, 132, 135-136, 143, 148, figs. 68, 70, 84, 87; *riding stick horse*, see above, attributes: stick horse; *ruling*, 145, 148, 203 n.19, fig. 87; *shooting arrow*, 119, 132, 135, 144, 146, figs. 70, 71, 85, 86; *spinning* (and related activities), 101, 111-112, figs. 6, 47; *splitting log*, 75, fig. 20; *studying*, 109, 111-112, 135-136, fig. 70; *suckling*, 75, 126, 143, 149, 152, figs. 20, 62, 93, 95; *warming body*, 111-113, figs. 48, 51

ages of woman: aligned with animals, 154; compared to earth's seasonal change, 99-100; contrasted with ages of man, 101, 110-113, figs. 45-51; represented in diagrams, 23-25, 105-106, figs. 6, 40-41; on steps of life, 153-154; *see also* ages of man, passim

ages of world, 54-79, 82-88, 89-90, 125, 127, 175 n.13, figs. 16-18, 25-30, 64

aging: coming to know God, 71; compared to

sun's course, 83-84; explained on basis of qualities, 100; of quantity of blood, 126; in hebdomadic rhythms, 40-47, 51, 60, 62, 64, and passim; in intervals equaling the periods of the planets, 49-50, 108-109; in intervals of six years, 117-119, 195 n.72; of ten years, 40, 170 n.10; of fifteen years, 93, 184 n.3; of twenty years, 10, 101

Agius of Corvey, 35

Alan of Lille, 36-37, 121, 122, 142

Albertus Magnus, 100; cited by Dante, 104; by Jacob van Maerlant, 126

Alcabitius, 108, 174 n.65

Ps.-Alcuin, see *Disputatio puerorum*

Aldobrandinus of Siena, *Régime du corps*, 99-103, figs. 33, 34

Alfred of Sareshel (Alfredus Anglicus), 53

Amalarius of Metz, 194 n.61

Ambrose: compares growth of faith to growth of tree, 162 n.57; on alliances of the elements, 17-18; on seven, 42; on the tetrad, 21

Amiens, Cathedral, south transept, rose window, 145

Anagni, Cathedral, crypt, wall painting, 20, fig. 5

Anatolius, 42, 158 n.12, 171 n.20; see also Herophilus

angel, 135, 139-140, 151, figs. 70, 81, 91-92

Anselm of Canterbury, 165 n.85

Anselm of Laon, 64, 88

Antelami, Benedetto, 86-88

Antichrist, 127, fig. 64

Antiochus of Athens, 15-16

anus, 61

Aphorisms, Hippocratic, 13, 25, 29, 30, 164 n.75; precepts correlating ages and seasons, 13; ages and fasting, 159 n.20; commented on, 164 n.73; quoted by Celsus, 16, 159 n.32; by Galen, 159 n.27

Apollodorus, 187 n.38

Ps.-Apollonius, *De secretis nature*, 173 n.65

Aquinas, Thomas, 123

Arabic learning transmitted to West, 29-31, 50-53, 97, 99-100, 107

arch of life, 104, 132, 137-138, figs. 69, 78

Archytas, 158 n.10

'Arib ibn Sa'id, 50-51

Aristotle: contrasts human aging with nature's seasonal change, 9; defines three ages, 90; on the binding of qualities and elements, 158 n.17; on primitive Pythagoreanism, 157 n.8; on youth and age, 100; referred to by medieval writers, 126, 128, 130

Ps.-Aristotle, see *Secretum secretorum*

"arithmology": definition, 11; literature of the decad, 39-44; its Christian reworkings, 20-25, 44-47, 62-63, 162 n.62; scholarship, 41

Arnald of Villanova, 100

Arnold, Priester, 46-47

Articella, 30, fig. 8

"As I went one my playing," 139

astrology, *see* ages of man, seven; planets and planetary deities

Augustine: defines useful learning, 54, 60; enumerates ages of man and/or ages of world in exegesis of days of creation, 55-58; of hours in Parable of Workers in the Vineyard, 83; of vessels at Cana, 70; of Visitation, 76; interprets Magi, 93; influence in Middle Ages, 61, 63, 69, 71, 77-78, 123-124, 125

Avicenna, 29-30, 166 n.94; influence, 190 n.13, 191 n.23

Bacon, Roger, 97-98, 100, 124

Balbus, Johannes, 130-131, 197 n.17

baldness, 157 n.1

baptism, 153, fig. 97

Bartholomaeus Anglicus, *De proprietatibus rerum*, 127-132, figs. 67-69

bathing, *see* regimen

beard, 40-41, 45, 86

Beauvais, Church of St. Étienne, rose window, 145

Bede: defines four ages of man, 32; six, 63; interprets vessels at Cana, 71; vigils in Parable of the Three Vigils, 88; read by later authors, 33-36, 63, 168 n.119, 180 n.69

Ps.-Bede, see *Collectanea; De divisionibus temporum; De mundi celestis terrestrisque constitutione; In Matthaei evangelium expositio*

Beleth, John, 89

Berchorius, Petrus, 128-129

Bernardus Silvestris, *see* Virgil

Bersuire, Pierre, *see* Berchorius, Petrus

bestiary, 64

"Biadaiolo Painter," 152-153

Bible moralisée, 74-79, figs. 20-23

Biblia pauperum, 199 n.44

Biblical passages cited in discussions of ages of man: *Ps. 21:11*, 184 n.9; *Ps. 89:10*, 40, 78, 126, 131; illustrated, 134-135, 200 n.2, fig. 70; *Ps. 91:15*, 129; *Ps. 118:164*, 89; *Prov. 10:19*, 129; *Prov. 22:15*, 66; *Eccles. 11:9*, 88; *Ecclus. 18:8*, 97; *Isa. 5:15*, 129; *Mal. 2:14*, 129; *Luke 7:14*, 129; *John 9:21*, 97; *I Cor. 3:18*, 129; *I John 2:13-14*, 66, 129

Biblical passages interpreted with reference to the ages of man: *Gen. 1:1-2:3*, 55-56, 77, 123, 176 n.23; *Gen. 15:16*, 21; *Matt. 2:1-12*, 91-94, figs. 31, 32; *Matt. 20:1-16*, 69, 82-90, 122-

Biblical passages (*cont.*)
123, figs. 17, 25-30; *Luke 1:5-45*, 76-77, fig. 23; *Luke 12:35-38*, 88-89, 123; *John 2:1-11*, 69-79, 122, figs. 18-22; *Apoc. 21:13*, 89-90
bleeding, *see* regimen
Boethius: on fortune, 144, 147; Philosophy's hymn glossed, 18-19; translated, 114; illustrated with tetradic diagrams, figs. 2-3, 53; works studied, 28, 162 n.59
"Boethius Illuminator," 199 n.50
Bonacursus, Archbishop of Tyre, 142
Bonatti, Guido, 108
Bonaventure, 142
"Book of Hours of Charles V," 119-120, figs. 58-59
Books of Hours, cycles of ages of man in, 118-120, 138-139, 192 n.31, 195 nn.68, 70, figs. 56-59, 79-80
"Boucicaut Master," 131
Breu, Jörg, the Younger, 153, fig. 98
Bruno of Segni, 71, 89-90
Byrhtferth of Ramsey: arithmological work, 23, 33, 46, 71; computistic tract, 33-35, figs. 9-11

cadaver, 62
Caesarius of Arles, 71
Calcidius, 43
canities, 61
canon law, ages of man in, 131
Canterbury, Christ Church Cathedral, "typological windows," 72-74, figs. 18-19
Cantica Avicennae, 166 n.94
caritas romana, 182 n.92
cassone panel, 136-137
Castle of Perseverance, 140
"Catechesis celtica," 93, 180 n.70, 188 n.43
Celsus, 16
Censorinus, 42
child care, 44, 50, 100-101
child development, 43
Cicero: *De senectute*, 16; cited by Dante, 104; *Somnium Scipionis* glossed by Favonius Eulogius, 43; by Macrobius, 42-43
Clement of Alexandria, 42, 82; *see also* Hermippus of Berytus
Collectanea (Excerptiones patrum), 91-92, 157 n.1
communion, 153, fig. 97
Le compost et kalendrier des bergiers, 118, 196 n.72
computus, art of time reckoning, 31-36, 63, 97-98, 118
Concordantia caritatis, 152, figs. 93-96
Constantinus Africanus, translates Haly Ab-

bas, 29; cited by Bartholomaeus Anglicus, 128
Corbechon, Jehan, translates Bartholomaeus Anglicus, 131

Dante, 103-104, 108
De arithmetica, 45
De diaeta (Regimen), 13-14, 25
De divisionibus temporum, 31-32
De hebdomadibus, 40-42, 51
"De Lisle Psalter," 142, 146-149, 152, figs. 87, 90
De mundi celestis terrestrisque constitutione, 27
De natura hominis, 13
death: cadaver's testimony, 147-148, fig. 87; comes to all men, 127; exhaustion of natural heat, 28, 100; not untimely after seventy, 40; penalty of sin, 109, fig. 44; personified as skeleton, 126, 132, 149-150, 153, figs. 69, 98; represented as man dying, 109, 119, 120, 127, 140, 147-148, 152, figs. 44, 57, 59, 62, 81, 87, 93, 95; time unknown, 123; *see also* life span
decrepitus, decrepitas, decrepita etas, passim: aligned with compline, 106; with eleventh hour, 84; with vespers, 89; correlated with black gall, 24; extending to death, 47, 107; from seventy-five, 197 n.24; from eighty, 63, 69; governed by Saturn, until death, 109; period in which one turns to better life, 89; in which strength diminishes, 107; qualitatively cold and dry, 24; cold and wet, 28; represented by figure clutching beard, 86, fig. 29; examined by doctor, 144, fig. 85; holding spindle, 24, fig. 6; leaning on stick(s), 86, 109, 126, 138, 143, figs. 29, 44, 61, 78, 84; moving toward tomb, 137, 151, figs. 75, 91-92; supported by child, 148-149, fig. 87; with skull's head, 151, figs. 91-92; same as *permatura*, 71; as *veterana*, 84
Definitiones medicae, 14
defunctus, 62
dentium plantativa, 97, 100, 166 n.94
Diocles of Carystus, 42
Diodorus Siculus, *see* Pythagoras
Diogenes Laertius, *see* Pythagoras
Dionysius of Fourna, "Painter's Manual," 92, 189 n.49
Dirc van Delf, *Tafel van den Kersten Ghelove*, 127, figs. 63-64
directions, 21; *see also* ages of man, four
disease, correlated with age, 28, 47
Disputatio puerorum, 63-64
distinctiones, 121-122

"Les douze moys figurez," 117-118

Dracontius, 58-59

Duodecim proprietates condicionis humane, 142, 150, 152, fig. 90

Durandus, William, 116, 186 n.32

duration of ages, *see* aging; life span

Eadmer, 165 n.85

education, according to age, 12, 28, 101, 109, 110-111, 165 n.85

Egidius de Tebaldis, translates Ptolemy, 52

embryo, represented, 144, fig. 85

embryology, 43, 50-53, 108, 194 n.52

Empedocles, 12

"encyclopedia," 60-69, 124-133

etas (aetas), defined, 60, 63, 97-98, 128, 130-131, 198 n.42

etas adolendi, same as *etas adolescentie*, 166 n.94

etas algulemati vel alguadi, 166 n.94

etas concussionis, 166 n.94

etas consistendi, same as *etas pulchritudinis*, 166 n.94

aetas, constans, 160 n.34

etas fortitudinis, 166 n.94

etas, grandiorum, 166 n.92

etas minuendi, same as *etas senectutis*, 166 n.94

aetas, primaeva, 90

etas pulchritudinis, 29

"Etchmiadzin Gospels," cover, 92

etymology: defined, 60; of age designations, 60-62, 97, 101, 104, 128-130

Eucherius of Lyons, 163 n.62

Eugenius of Toledo, 59; read by Isidore of Seville, 175 n.16

exempla, used to illustrate ages of man, 195 n.72

Expositio quatuor evangeliorum, 76

fasting: on ember days, interpreted with reference to ages of man, 116; relative ability of ages to endure, 159 n.20

Favonius Eulogius, 43

Federighi, Antonio, 137

femina, 61

Firmicus Maternus, 50

Foligno, Palazzo Trinci, wall paintings, 106-107, 135-136, figs. 42, 71-74

fortune, *see* personification: Fortune; Wheel of Fortune

Francesco da Barberino, *I documenti d'amore*, 104-107, figs. 39-41

Fulgentius, 175 n.13

funus, 62

Galen: criticizes medical arithmology, 171 n.28; defends Hippocratic humoral theory, 14; quotes aphorism on ages and seasons, 159 n.27; writes on regimen, 44

Ps.-Galen, see *Definitiones medicae*

Garnerus, 185 n.15

Gellius, Aulus, *see* Varro

Gerard of Cremona, translates Avicenna, 29

Giles of Corbeil, cited by Bartholomaeus Anglicus, 128

Giotto, Arena Chapel frescoes, 106, 110

Giovanni de' Dondi, 110

Glossa ordinaria, 88, 189 n.53

Godfrey of St. Victor, 78

gods, *see* pagan gods

Gossuin of Metz, 114

gravitas, 58, 61, 124; from forty-nine to seventy, 177 n.36; from fifty to seventy, 61; same as *senecta*, fig. 65

Gregory the Great: describes properties of seven, 46; interprets hours in Parable of Workers in the Vineyard, 83-84; vessels at Cana, 71-72; vigils in Parable of the Three Vigils, 88; outlines five phases of mental growth, 184 n.11; read by later authors, 84-86, 88-89, 122-123

growth, 41, 43, 45, 126

Guariento, 110-113

Guillaume le Clerc, 123

Haimo of Auxerre, 71, 84, 88

Haly Abbas, 29

Heinrich, see *Summarium Heinrici*

Hermann of Carinthia, 52-53

Hermippus of Berytus, on the hebdomad (transmitted by Clement of Alexandria), 39

Herophilus, cited by Anatolius and Theon of Smyrna, 40

Hierocles, 12

Higden, Ralph, 197 n.17

Hildebert of Le Mans, 72

Ps.-Hildebert of Le Mans, 185 n.15

Hildegard of Bingen, 195 n.64

Hildesheim, Cathedral, pavement, 161 n.53

Hippocrates, cited in arithmological texts, 40-42

Hippocratic Corpus, 13; *see also* Aphorisms, Hippocratic; *De diaeta; De hebdomadibus; De natura hominis*

Holcot, Robert, 202 n.27

Honorius Augustodunensis: interprets Church, 182 n.92; hours of liturgical day, 89; hours of Parable of Workers in the Vineyard, 185 n.15, 197 n.12; lections of night office,

Honorius Augustodunensis (*cont.*)
89; on ages of man and ages of the world, 63; on the microcosm, 35-36; on the Magi, 189 n.53; *see also* William of Conches

Horace, 16

hours of day, *see* ages of man, four; five; six; seven; eight

"Hours of Marie Chantault," 195 n.68

Hrabanus Maurus, 65-67, 132; defines physics, 10; interprets Elizabeth's pregnancy, 76; moralizes Isidore's *Etymologiae*, 65-66; quotes Bede and Isidore, 63; Gregory, 84

Hugh of St. Cher, 77

Hugh of St. Victor, 71, 78; quoted by Vincent of Beauvais, 123

humors, 12-13; *see also* ages of man, four

Hunain ibn Isḥāq, *see* Johannicius

hygiene, *see* regimen

Iamblichus, 12, 158 n.14

Ps.-Iamblichus, see *Theologumena arithmeticae*

In Matthaei evangelium expositio, 93

inbecillis, 152

incineratus, 149

infans, infantia, passim; aligned with *aurora*, 105-106; with *matutina*, 89; correlated with blood, 32, 36; equated with *humilitas*, 129; extending from birth to seven years, 47, 61, 63, 69, 98, 100, 130, 172 n.41, 177 n.36, 197 nn.21, 24; to time child speaks, 125; governed by Moon for four years, 109; lasts seven years, 47, 62, 64; memory of it erased by flood of forgetfulness, 55, 71, 98; period named for inability to speak, 56, 61, 97, 129, 130; period of baptism, 89; of learning to walk, to speak, 98; represented by figure crawling, 130, fig. 65; in cradle, 137, 144, 151, figs. 15, 78, 85, 91-92, pushing baby walker, 152, fig. 95; running, 137, fig. 75; seated, 73, 109, figs. 19, 43; suckling, 143, 147, 152, fig. 93; swaddled, 66, 143, figs. 14, 84

infirmus, 149, 152

Innocent III, 98

Irenaeus, 81, 82

Irish exegesis, 71, 91, 93

Isidore of Seville: etymological method, 59-62; interprets days of creation, 176 n.23; hours of Parable of Workers in the Vineyard, 184 n.10; on elements, seasons, humors, 17-18, fig. 1; on planetary gods, 51-52; on six ages of man, 60-62; influence of hexadic scheme, 62-66, 124-132; see also *Liber de numeris; Liber numerorum qui in sanctis scripturis occurrunt*

iuvenis, iuventus, aetas iuvenalis, passim; aligned with none, 106-107; with second vigil, 88; with sext, 84, 89; with sun at midpoint of course, 84; correlated with black gall, 33; with blood, 24; with red gall, 26, 36; equated with *fortitudo*, 129; extending from twenty-one to thirty-two/thirty-three, 78; from twenty-one to thirty-five, 41; from twenty-one to forty-two, 47; from twenty-one to forty-five/fifty, 130; from twenty-five to thirty-five, 197 n.24; from twenty-five to forty-five, 104; from twenty-five/thirty to thirty-five/forty, 30; from twenty-five/thirty to forty-five/fifty, 24, 100; from twenty-eight to forty-eight, 35, 172 n.41; from twenty-eight to forty-nine, 47, 63, 177 n.36; from twenty-eight to fifty, 61, 69; from twenty-eight to fifty-six, 64; from thirty to forty, 29; governed by Sun for nineteen years, 109; lasts three hebdomads, 47, 62; four hebdomads, 64; perfect age, 104; period in which grades of deacon, presbyter reached, 89; in which wife and children must be supported, 99; period named for ability to help, 61, 104, 130; period of discernment, 28; of end of growth, 22, 41, 45; of greatest strength, 30, 61, 84, 190 n.13; which rules among ages, 56; personified, 161 n.53; qualitatively hot and dry, 24, 25, 28, 30, 97, 104, 190 n.13; hot and wet, 24; represented by figure armed, 73, 85, 130, 151, figs. 15, 19, 27, 65, 92; crowned, 151, fig. 87; holding branch, 24, fig. 6; falcon, 109, 137, 143, 144, 147, figs. 75, 84, 85; scepter, 203 n.39, fig. 87; stick, 66, fig. 14; sword, 73, fig. 19; with child, 106, fig. 41; term closer to *puerilis* than to *virilis aetas*, 100; distinguished from *iuventa*, 62

Jacob van Maerlant, *Der naturen bloeme*, 126-127, fig. 62

Jacobus, *see* "Omne bonum"

Jacopo de' Dondi, 110

Jacques le Grant, *Le livre de bonnes meurs*, 199 n.49

Jerome, 83, 185 n.15

Ps.-Jerome, see *Expositio quatuor evangeliorum*

Jerusalem, heavenly, *see* ages of man, four

Johannes Metensis, 142

Johannicius, defines four ages of man, 30-31, fig. 8; possible influence, 31, 36, 97, 100, 115, 163 n.69, 197 n.22

John of Hildesheim, 93-94

John of Sacrobosco, *Computus ecclesiasticus*, 36, fig. 13

John of Seville, translates Alcabitius, 108; *Secretum secretorum*, 99

John Scottus Eriugena, glosses Martianus Capella, 162 n.61

Jupiter, 19; governs sixth age, 49-50, 108-109, 111-113

Kempley, Church of St. Mary, wall painting, 149, fig. 89

Kemsing, Church of St. Mary, wall painting, 204 n.44

"Klosterneuburg Altar," 92, fig. 32

Konrad von Megensberg, 198 n.32

Lambert of St. Omer, *Liber floridus*, 19-20, 67-69, 132, figs. 4, 16, 17

Langland, William, 123

Last Judgment, 85, 87-88, 153, figs. 25, 98

Latini, Brunetto, *Tesoro*, 153

Leo the Great, 93

Leominster, Priory Church, wall painting, 149

Liber de numeris, 162 n.62, 188 n.43

Liber floridus, see Lambert of St. Omer

Liber numerorum qui in sanctis scripturis occurrunt, 22, 45-46, 62-63

Liber physionomie, 111-113, figs. 50-51

liberal arts, *see* ages of man, seven

life span: seventy years, 40, 43, 101; seventy or eighty, 40; seventy-two, 117-118; ninety-eight, 41; one hundred, 140; one hundred and twenty, 51

Longthorpe Tower, hall, wall painting, 137-138, fig. 78

Lydus, *see* Philolaus

Macrobius: on macrocosm/microcosm, 19; on sevens in human development, 42-43; on soul's descent through spheres, 51; work glossed, 28, 45; quoted, 52; *see also* tetractys

macrocosm, represented as old man, 68, fig. 17; *see also* microcosm

madness and age, 15

"Madonna Master," 146

Magi, *see* ages of man, three

man (*homo*), represented nude, 20, fig. 5; *see also* ages of man; macrocosm; microcosm

Manilius, 16

Mappemonde de Pierre, 194 n.56

Marco Polo, 93

Mars, governs fifth age, 49, 108-109, 111-113, fig. 47

Martianus Capella: on Apollo's four urns, 19-20; on the decad, 21-22; on sevens in human development, 43, 45; on the Sun's three ages, 90-91; work adapted, 22, 45-46; glossed, 29;

quoted, 162 n.59; versified, 45; *see also* Varro

maturitas, 21, 27, 42, 83

Maurice de Sully, 122-123

Ps.-Melito, *Clavis*, 178 n.48

menstrual blood, 125

mental development, 40, 109, 184 n.11, 195 n.72

Mercury: governs second age, 49, 108-109, 110-113, fig. 43; marries Philology, 21-22; represented as scholar, 110, 112

microcosm: defined in relation to macrocosm, 18-19, 20, 32, 35, 36, 78, 114; represented as child, 68, fig. 17; underlies correlation of ages of man and ages of world, 56-57, 64, 68-69

"middle age," 14, 101, 130

mid-life crisis, caused by Mars, 49

minor mundus, see microcosm

Miracle at Cana, 69-79, 122

"Mirror of the Periods of Man's Life," 140

Monza ampullae, 92

Moon: governs first age, 49, 108-109, 110-113, figs. 45, 49, 50; in planetary cycles, 107, 113, figs. 42, 52

morality plays, 140, 201 n.18

moriens, 152

mors, see death

mortuus, 152

mulier, 61

Mundus et infans, 201 n.18

mundus-annus-homo diagram, *see* tetradic diagram

nascens, 150, 152

Navigatio Sancti Brendani, 188 n.43

Nicholas of Verdun, 92

Nicomachus of Gerasa, 158 n.12, 174 n.7

noviter genita, 97

numbers, properties and associations of: three, 90; four, 11-13; five, 80-81; six, 57, 62-63; seven, 39-40, 46-47, 57; eight, 57; ten, 11; twelve, 46, 116-117

numerology, *see* "arithmology"

"Of the Seuen Ages," 139-140, fig. 81

old age: contrasted with youth, 131, 145, 146, 200 n.2, fig. 86; period of exhaustion of natural heat, 100; of increase in avarice, 126; of miseries and infirmities, 62, 99, 128; of scarcity of blood, 126; of wisdom, 43, 61-62; preparation for, 117, 199; retarding of, 100-101; seemly behavior in, 102

"Omne bonum," 130-131, fig. 66

On the Constitution of the Universe and of Man, 15

On the Nature of Man, see De natura hominis

On Sevens, see *De hebdomadibus*
Oribasius, 25, 163 n.63
Origen, 70, 82-83
Ovid, *see* Pythagoras

Pacificus of Verona, 63
Padua, Church of the Eremitani, apse, wall painting, 110-113, figs. 45-48
Padua, Palazzo della Ragione, Salone, wall painting, 110
pagan gods, 19-20, 21-22, 39; hostility toward, 22, 46, 51-52; *see also* planets and planetary deities
panel painting, *see* cassone panel
Parable of the Three Vigils, 88-89, 123
Parable of the Workers in the Vineyard, 69, 80-90, 122-123
Paris, Cathedral of Notre-Dame, Portal of the Virgin, 78-79, fig. 24
Parma, Baptistery, west portal, 86-88, fig. 30
parvulus, 81, 128
Paul the Deacon, 71, 84
pavement, *see* Hildesheim, Cathedral; Siena, Cathedral
Pearl, 123
perfect age, 43, 61, 93, 104
perfect numbers, 39, 57, 62, 70, 174 n.7
personification: Arithmetic, 21-22; Earth, 78; Church, 75-76, 182 n.92; Fortitude, 161 n.53; Fortune, 144-146, 151, figs. 86, 91-92; Liberal Arts, 21, 106; Nature, 36-37, 141, 149, fig. 84; Night, 105, fig. 40; Philology, 21; Philosophy, 18, 141, 143, figs. 84, 85; Sea, 78; Soul, 103; tetradic sets (elements, directions, etc.), 21; Time, 149; virtues, 104, 106, 110; Wisdom, 161 n.53, 182 n.92; Youth, 161 n.53
Peter Comestor, 87
Peter of Abano, 109-110
Peter of Poitiers, 115, 202 n.23
"Peterborough Computus," 34, fig. 11
Petrus de Natalibus, 94
Philip of Tripoli, translates *Secretum secretorum*, 99
Philippe de Novarre, *Des IV tenz d'aage d'ome*, 99, 100-103, figs. 35-38
Philo, 42, 175 n.8
Philolaus, cited by Lydus, 39
phlebotomy, *see* regimen
Pictor in carmine, 73
Piers Plowman, 123
Placides e Timéo, 194 n.59
planetarium, 110
planets and planetary deities: aligned with

qualities, 48, 51, 52; with humors, 48-49; "children of the planets," 113; listed, fig. 4; *see also* ages of man, seven; Moon; Mercury; Venus; Sun; Mars; Jupiter; Saturn
Plato, 18, 27, 28, 158 n.16
Plato of Tivoli, translates Ptolemy, 52
pneumatic physicians, 14
Pollux, Julius, 171 n.17
preaching, defined, 121
Proros of Cyrene, cited in the *Theologumena arithmeticae*, 39
Prosdocimus of Beldomandi, 111
provectiores, 36
Prudentius, 82, 187 n.34
Ptolemy: correlates ages and seasons, 15; describes planetary influence on ages, 48-50; influence in Middle Ages, 50-53, 107
Ps.-Ptolemy, *Iudicia*, 174 n.65
puberes, 61
puberty, 29-30, 40, 43, 45, 56, 61, 62, 83, 126, 184 n.4
puer, pueritia, aetas puerilis, passim; aligned with first vigil, 88; with *mane*, 83; with prime, 89; with terce, 106; correlated with blood, 27, 32; with phlegm, 24, 26; equated with *charitas*, 129; extending to fourteen, 24, 26, 35; to thirty, 29; to emission of seed, 41; from seven to fourteen, 41, 47, 61, 63, 69, 100, 130, 172 n.41, 177 n.36, 197 nn.21, 24; from seven to fifteenth year, 78; from time boy speaks to fifteenth year, 125; governed by Mercury for ten years, 109; lasts seven years, 47, 62, 64; period in which child is beaten into learning, 98; comes to know books, 89; learns to speak, 56; period named for purity, 61, 64; unsuited to procreation, 56, 61; qualitatively cold and wet, 24; hot and wet, 25; represented by figure holding ring, 137, figs. 15, 76; balance, 147, fig. 87; ball and playing stick, 73, fig. 19; writing tablet, 152, fig. 95; learning to read, 109, fig. 43; nude, 66, fig. 14; playing with whip top, 130, 137, figs. 65, 78; pushing baby-walker, 144, fig. 85; riding stick horse, 151, figs. 91-92; stroking dove, 143, fig. 84; subdivided, 29, 100; term distinguished from *pubertas*, 62
puerpera, 61, 62
puerulus, 41
pulse, 30
purging, *see* regimen
Pythagoras: correlates ages with seasons (transmitted by Diodorus Siculus, Diogenes Laertius, Ovid), 10; made Arithmetic's torchbearer by Martianus Capella, 21

quadrants, heavenly, 16; *see also* ages of man, four

qualities, 12, 26; *see also* ages of man, four

"Ramsey Computus," 34-35, fig. 10
Ravenna, S. Apollinare Nuovo, mosaics, 92
Raynaud, Jean, "Viridarium," 126, figs. 60-61
regimen: according to age, 14, 26, 28, 43-44, 99-101, 128; moralized, 98-99
Regimen, see *De diaeta*
Regimen sanitatis Salernitanum, 115
relics, of Magi, 93
Remigius of Auxerre: glosses Boethius, 18-19; Martianus Capella, 22, 45
Rhetorius, 159 n.31
Richard of St. Victor, 78
Robert Grosseteste, 123
Robert of Melun, 77
Robert of Torigni, 93
robur, 125
La Roe de Mere Natur, 149-150
Rome, Abbazia delle Tre Fontane, cloister building, wall painting, 201 n.9
Rome, S. Maria Antiqua, wall painting, 188 n.44
Romualdo of Salerno, 63
Rota vite alias fortune, 151, figs. 91-92
Rufinus, translates Origen, 180 n.65
Rupert of Deutz, 71, 187 n.34

St. Albans, Cathedral, wall painting, 204 n.44
"St. Albans Psalter," 200 n.2
Sapientia artis medicinae, 26, 47
Sargans, Switzerland, Castle, wall painting, 136
Saturn, 20; governs last age, 49-50, 108-109, 111-113, figs. 44, 48, 51
"schemata": defined, 17; late medieval set, 115, 140-144, 146-149, 150, 202 n.23; tree diagram, 141; *see also* tetradic diagram; vessels at Cana
sculpture, *see* Amiens, Cathedral; Beauvais, Church of St. Étienne; Paris, Cathedral of Notre-Dame; Parma, Baptistery; Venice, Palazzo Ducale
seasons, *see* ages of man, four
second childhood, 28; medical explanation, 61
Secretum secretorum and translations, 99-100, 101
Sedulius Scottus, 188 n.43
senecta, 59, 130, 184 n.4; equated with *honestas*, 129
senex, senectus, passim; aligned with compline, 107; with none, 84, 89; with third vigil, 88;

with vespers, 106; correlated with phlegm, 27, 32, 33, 36; with red gall, 24; equated with *prudentia*, 129; extending from thirty-five/forty to fifty-five/sixty, 30; from forty to sixty, 29; from forty/forty-five to sixty, 190 n.13; from forty-five to seventy, 104; from forty-five/fifty to fifty-five/sixty, 24; from forty-five/fifty to sixty/sixty-five, 24; from forty-eight to fifty-six, 172 n.41; from forty-eight to seventy/eighty, 35; from forty-nine to seventy-seven, 47; from fifty to seventy, 197 n.21; from fifty to seventy/eighty, 125; from fifty to seventy-nine, 63; from fifty to eighty, 69, 78; from fifty-five to seventy-five, 197 n.24; from fifty-six to end of life, 64; from sixty-three to ninety-eight, 41; from seventy to end of life, 61, 177 n.36; governed by Mars for fifteen years, 109; lasts four hebdomads, 47, 62; period in which high ecclesiastical offices taken, 89; in which new man is born to spiritual life, 56, 129; in which vices but for cupidity diminish, 126; period of decline, 28, 30, 56; but memory strong, 28; of dulling of senses, 61-62, 129; of misery and infirmity, 62; of wisdom, 61-62; qualitatively cold and dry, 24, 28, 30, 97, 104, 190 n.13; cold and wet, 25; hot and dry, 24; represented by figure discoursing, 152, figs. 94, 96; giving instruction, 143, fig. 84; holding hand at chin, 66, fig. 14; holding scroll, 86, fig. 28; sword, 109; using stick, 66, 73, 115, 130, 144, 147, 151, figs. 14-15, 19, 55, 65, 84, 87, 91-92; winding thread, 24, fig. 6; termed *gravis senectus*, 63; *profunda senectus*, 165 n.85; *ultima senectus*, 83; distinguished from *senium* (and *senecta*), 24, 28-31, 52, 61-63, 89, 97, 100, 105, 129, 177 n.36
senicies, governed by Jupiter, 109
senior, aetas senioris, 41, 56, 61, 65, 81
senium, passim; correlated with black gall, 24; with phlegm, 28, 30; equated with *timor Dei*, 129; extending to death from fifty-five/sixty, 24, 30; from sixty, 29; from sixty/sixty-five, 24; from seventy, 104, 172 n.41, 197 n.21; from seventy-seven, 47, 62; final part of old age, 61, 177 n.36; qualitatively cold and dry, 24; cold and wet, 24, 28, 30, 97, 104, 190 n.13; period of anxieties, 99; of decline in strength, 30; of failing memory, 28; same as *aetas decrepita*, 100; as *decrepitus, nimium senex*, 47
sepultus, 62
sermons, 121; incorporating theme of ages of man, 122-123, 200 n.58

Servius, *see* Varro

Sicardus of Cremona, 89, 189 n.53

Siena, Cathedral, pavement, 137, figs. 75-77

Simon de Phares, 108

skeleton, *see* death

Smaragdus of St. Mihiel, 71, 84, 88

Solon, 40

Ps.-Soranus, 27, 163 n.63, 164 n.79, 167 n.103

soul, 18, 103; aging in body, 81-82; represented as nude infant, 120, 152, figs. 59, 81, 93, 95

Speculum hominis, 178 n.46

Speculum humane salvationis, 193 n.52

Speusippus, 158 n.10

stained glass, *see* Canterbury, Christ Church Cathedral; Troyes, Church of St. Nizier

"Stanzaic Life of Christ," 116, 123-124

"Stavelot Bible," 84-85, fig. 25

Stephen of Antioch, translates Haly Abbas, 166 n.92

Steps of Life, 153-155, fig. 98

Strato, 42

"Stuttgart Psalter," 92-93, fig. 31

Summarium Heinrici, 64

Sun: governs fourth age, 49, 108-109, 111-113; possessed of many faces, 90-91

syzygy of elements, 17, 19

tapestry, 136, 195 n.72, 201 n.21

teeth: growth in children, 29, 40-41, 43, 45, 100; relation to speech, 43, 61; see also *dentium plantativa*

Telauges, 158 n.10

temperaments, 14-15, 32, 115; *see also* ages of man, four

Tertullian, 81-82

tetractys, 11; quoted by Macrobius, 157 n.9

tetradic diagram, 16-20, 23-24, 28, 30-31, 33-36, 114-115, 202 n.28, figs. 1-13, 39, 53-55; announced in text, 17, 28, 36; converted to hexadic diagram, 68-69, fig. 17

Theologumena arithmeticae, 11-12, 42; *see also* Proros of Cyrene

Theon of Smyrna, 11; *see also* Herophilus

Theophilus, legend of, 146, fig. 86

Thierry of Chartres, copies Boethius, Martianus Capella, 162 n.59

Thomas of Cantimpré, *Liber de natura rerum*, 124-126; influence, 126-127

thread of life, 24

time, divisions of, 31-37, 40, 60, 114, 149-150

Tractatus de quaternario, 23-25, 52, fig. 6

Tractatus de regimine sanitatis virorum spiritualium ac devotorum, 98-99

Tractatus quidam de philosophia et partibus eius, 78

transgressores, 32, 33, 167 n.102

Tree of Life, 142, 151-153, figs. 93-97

Tree of Wisdom, 115, 140-144, figs. 82-85

"Trivulzio Candlestick," 187 n.35

Troyes, Church of St. Nizier, stained glass, 201 n.15

Ulrich of Lilienfeld, 152

urine: glass, 119, 148; type, 30, 144

Valerius Maximus, 182 n.92

vanity, 139

Varro: on five ages of man (transmitted by Censorinus and Servius), 81; on the hebdomad (transmitted by Aulus Gellius), 39, 42-43; read by Censorinus, 42; by Martianus Capella, 162 n.58

Venice, Palazzo Ducale, capitals, 109, figs. 43-44

Venice, S. Marco, west façade, north portal, 188 n.44

Venus, governs third age, 49, 108-109, 111-113, fig. 46

vessels at Cana: as schemata, 180 n.75; *see also* ages of man, six

veteranus, 42, 84

vetula, 61

vices, 126, 127, 139-140

Victorinus of Pettau, 20-21

Vincent of Beauvais, 53, 123

Vindicianus, 26, 47, 165 n.80, 167 n.103, 172 n.45

vir, virilitas, virilis etas, etas viri, 16, 42, 64, 71, 97; extending from thirty to fifty, 197 n.21; thirty-two/thirty-three to fifty, 78; from thirty-five to forty-nine, 41; from thirty-five to fifty-five, 197 n.24; period named for strength, greater than woman's, 61; qualitatively cold and dry, 25; represented by figure armed, 152, figs. 94, 96; as king, 149; counting money, 151; holding book, 137, fig. 75; loaf, 73, fig. 19; money bag, 73, 151, figs. 19, 91-92; sword, 144, fig. 85; touching disk, 143, fig. 84; term distinguished from *homo*, *virus*, 62; similar to *iuventus*, 64

virago, 61

Virgil, *Aeneid*, glossed by Bernardus Silvestris(?), 64-65

virgo, 61

virtues, 140; *see also* ages of man, four; five; seven

"Vrigiet de solas," 142-143, fig. 84

wall painting, *see* Anagni, Cathedral; Foligno,

Palazzo Trinci; Kempley, Church of St. Mary; Kemsing, Church of St. Mary; Leominster, Priory Church; Longthorpe Tower; Rome, Abbazia delle Tre Fontane; Sargans, Switzerland, Castle

Werner of St. Blasien, 185 n.15

Wheel of Fortune, 144-146, 151, 203 nn.39, 40, 204 n.49, figs. 86, 91-92

Wheel of Life, 144-151, 203 n.40, figs. 86-92; images in circular arrangement, 137, 201 n.9, fig. 75

William de Brailes, 145-146

William of Conches, 27-28, 31; *Philosophia mundi* copied with works of Bede and Honorius Augustodunensis, 165 n.89; quoted by Francesco da Barberino, 105

woman, *see* ages of woman

youth, preservation of, 100

zodiac, signs of, 15-16, 34-35, 110, 112, 115, 118, figs. 9-11, 45-48, 50-52, 55-59

LIBRARY OF CONGRESS CATALOGING-IN-PUBLICATION DATA

Sears, Elizabeth, 1952–
The ages of man.

Revision of thesis (Ph.D.)—Yale University, 1982.
Bibliography: p.
Includes index.
1. Life cycle, Human, in art. 2. Art, Medieval. I. Title.

N7625.5.S4 1986 704.9′42′094 86-445
ISBN 0-691-04037-0 (alk. paper)

PLATES

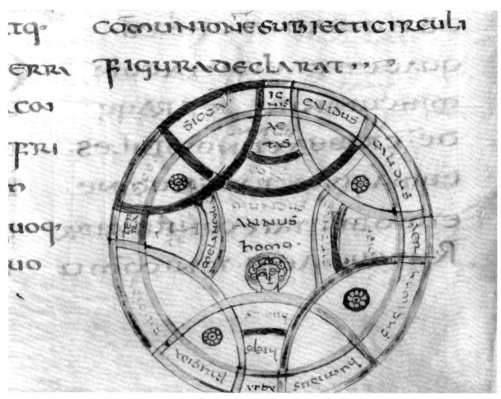

1. Paris, Bibliothèque Nationale, ms. lat. 6400 G (Isidore, *Liber de natura rerum*), fol. 122v, tetradic diagram.

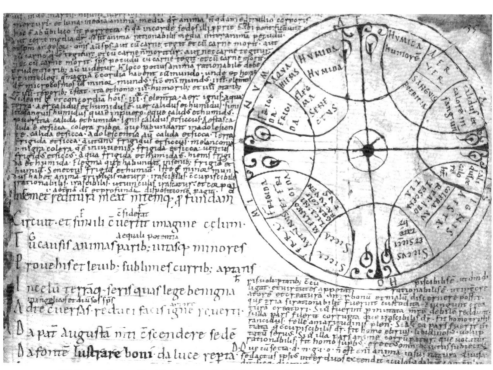

2. Biblioteca Apostolica Vaticana, cod. Pal. lat. 1581 (Remigius, Commentary on Boethius, *Consolatio philosophiae*), fol. 35r, tetradic diagram.

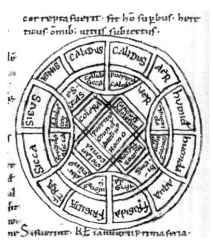

3. Paris, Bibliothèque Nationale, ms. lat.
12999, fol. 7r, tetradic diagram.

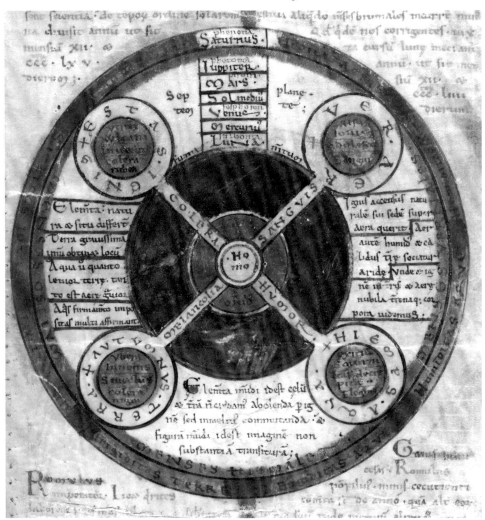

4. Ghent, Universiteitsbibliotheek, ms. 92 (Lambert of St. Omer, *Liber floridus*),
fol. 228v, tetradic diagram.

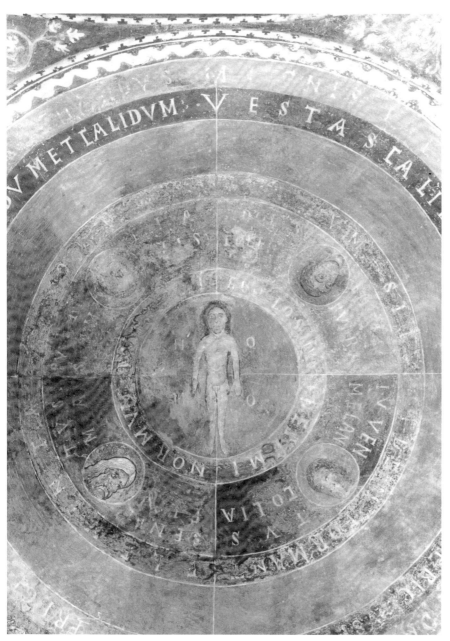

5. Anagni, Cathedral, vault of bay in crypt, tetradic diagram with busts
of the four ages of man.

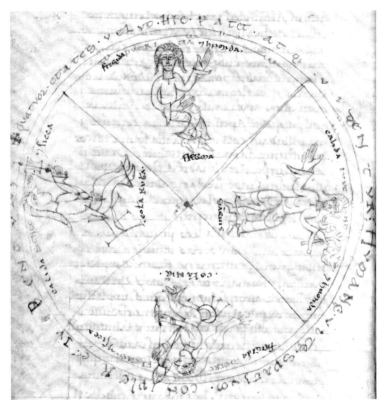

6. Cambridge, Gonville and Caius College, ms. 428 (*Tractatus de quaternario*), fol. 28v, tetradic diagram with figures of the four ages of life.

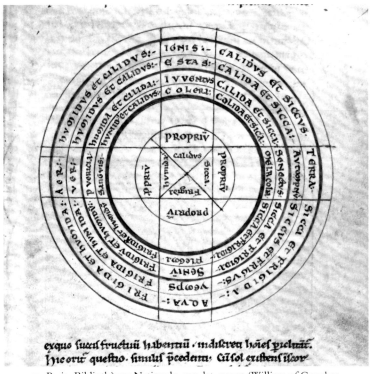

7. Paris, Bibliothèque Nationale, ms. lat. 11130 (William of Conches, *Philosophia mundi*), fol. 48r, tetradic diagram.

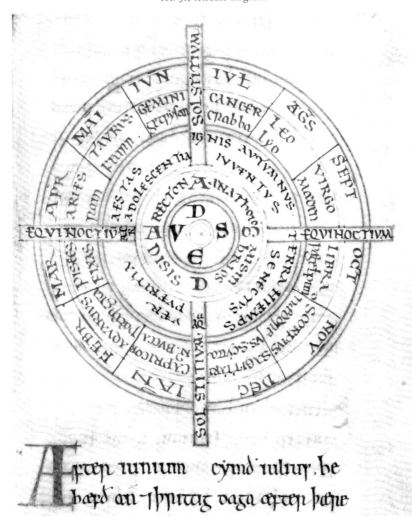

8. Oxford, Bodleian Library, ms. lat. Misc. e. 2 (Johannicius, *Isagoge ad Tegni Galieni*), fol. 3r, tetradic diagram.

9. Oxford, Bodleian Library, ms. Ashmole 328 ("Byrhtferth's Manual"), p. 85, tetradic diagram.

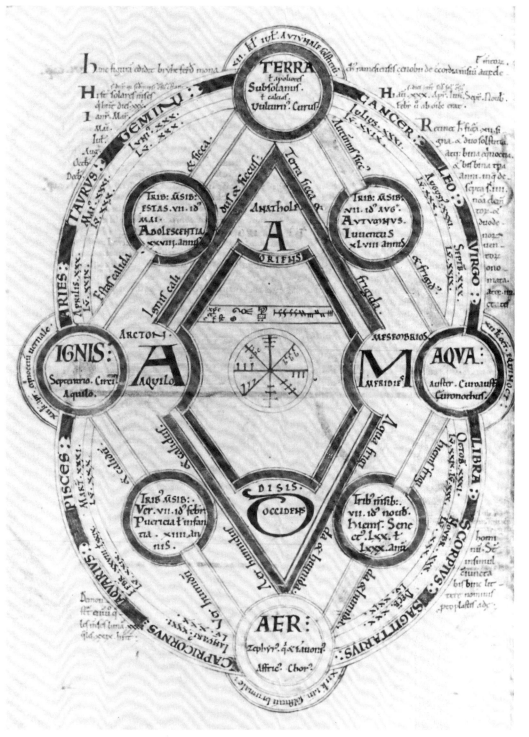

10. Oxford, St. John's College, ms. 17 ("Ramsey Computus"), fol. 7v,
"Byrhtferth's Diagram."

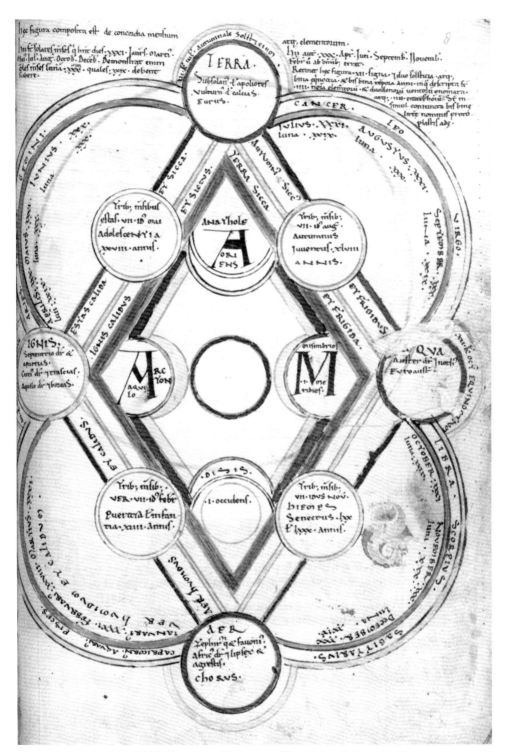

11. London, British Library, ms. Harley 3667 ("Peterborough Computus"),
fol. 8r, "Byrhtferth's Diagram."

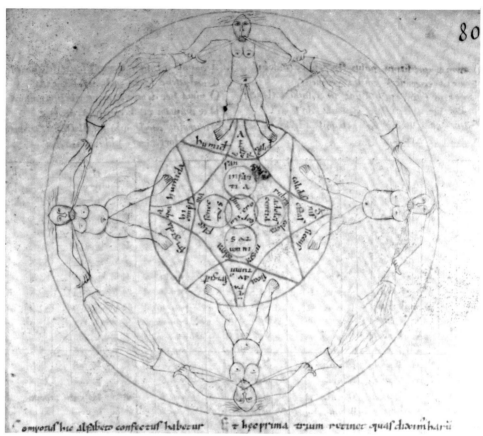

12. Dijon, Bibliothèque Publique, ms. 448, fol. 80r, tetradic diagram.

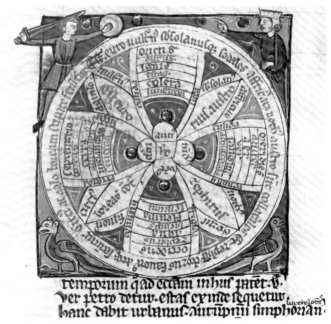

13. New York Public Library, ms. 69 (John of Sacrobosco, *Computus ecclesiasticus*), fol. 38v, tetradic diagram.

14. Montecassino, Monastery Library, ms. 132 (Hrabanus Maurus, *De naturis rerum*),
p. 150, the six ages of man.

15. Biblioteca Apostolica Vaticana, cod. Pal. lat. 291 (Hrabanus Maurus, *De naturis rerum*),
fol. 68r, the six ages of man.

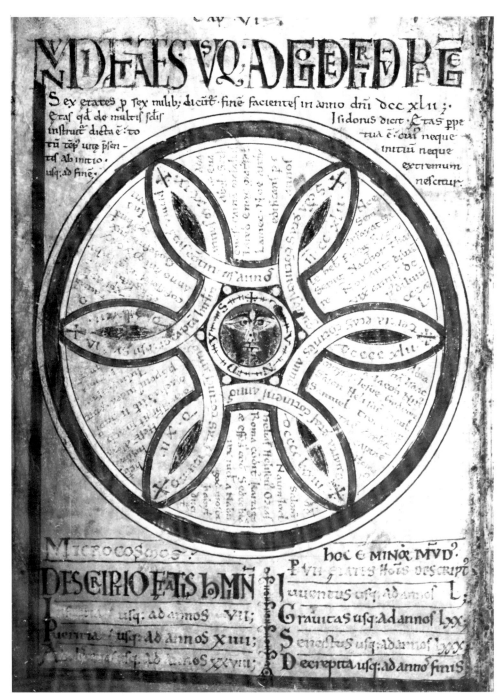

16. Ghent, Universiteitsbibliotheek, ms. 92 (Lambert of St. Omer, *Liber floridus*), fol. 19v, diagram of the six ages of the world.

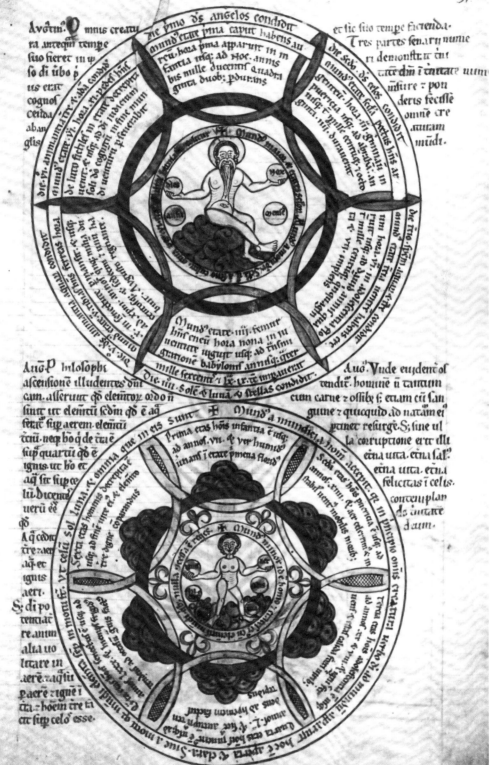

17. Wolfenbüttel, Herzog August Bibliothek, cod. Guelf. 1 Gud. lat. (Lambert of St. Omer, *Liber floridus*), fol. 31r, hexadic diagrams.

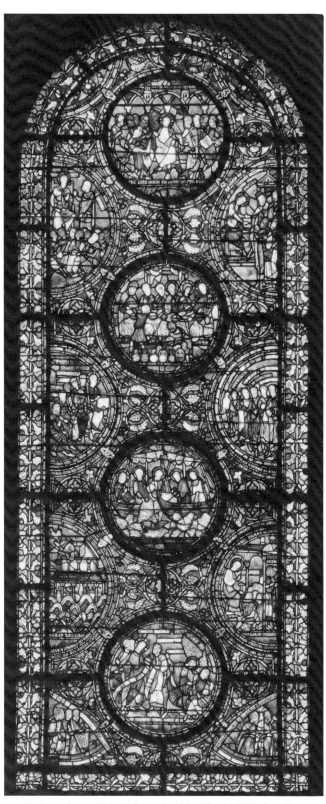

18. Canterbury, Cathedral, north choir aisle, the Miracle at Cana,
the six ages of the world, and the six ages of man.

19. Canterbury, Cathedral, north choir aisle, detail: the six ages of man.

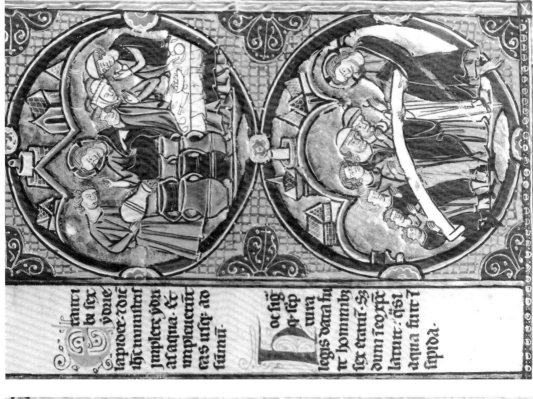

21. London, British Library, ms. Harley 1527 (*Bible moralisée*), fol. 23r, lower right, the six hydriae and the six ages.

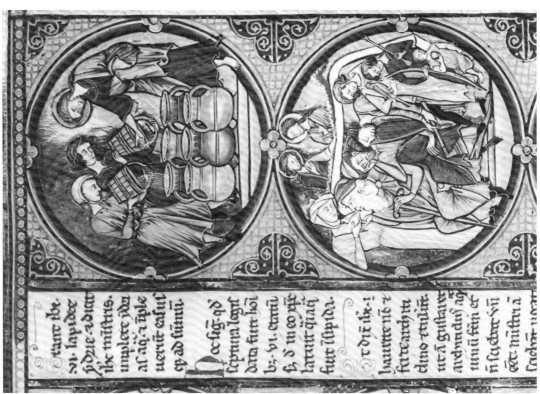

20. Toledo Cathedral (*Bible moralisée*), vol. III, fol. 21r, upper right, the six hydriae and the six ages.

23. London, British Library, ms. Harley 1527 (Bible moralisée), fol. 5r, upper right, Zacharias and Elizabeth and the five ages with Moses.

22. Paris, Bibliothèque Nationale, ms. fr. 167 (Bible moralisée), fol. 251r, lower left, the six hydriae and the six ages.

24. Paris, Notre-Dame, Portal of the Virgin, the six ages of man.

creauit deus celu et terram. Terra aute erat ina
nis et uacua: et tenebre erant sup facie abissi:
et spiritus dni ferebat' sup aquas. Dixitqz de'
fiat lux. Et facta e lux. Et uidit deus luce qp
esset bona: et diuisit luce a tenebris: appella
uitqz lucem die. et tenebras nocte. Factumqz
est vespere et mane dies vnus. Dixit quoqz de
us, fiat firmamentu in medio aquaru: et
diuidat aquas ab aquis. Et fecit deus firma
mentu: diuisitqz aquas que erant sub fir
mamento ab hijs que erant sup firmamen
tu. Et factu est ita. Vocauitqz deus firma
mentu celu: et factu e vespere et mane dies
secundus. Dixit vero deus, Congregentur
aque que sub celo sunt in locu vnu: et appa
reat arida. Et factu est ita. Et vocauit deus
aridam terra: congregationesqz aquaru appella
uit maria. Et vidit deus qp esset bonu: + ait,
Germinet terra herba virente et faciente se
men: et lignu pomiferu faciens fructum
iuxta genus suu: cuius semen i semetipso
sit super terra. Et factu est ita. Et protulit
terra herbam virente et faciente semen iuxta
genus suu: lignumqz faciens fructum: et
habens vnuquodqz semente secundum
speciem suam. Et vidit deus qp esset bonu:
et factum est vespere et mane dies tercius.
Dixit aute deus, fiant luminaria in fir
mamento celi: et diuidant diem ac nocte:
et sint in signa et tpa et dies et annos: vt
luceant in firmamento celi. et illuminent
terra. Et factu est ita. Fecitqz deus duo lu
minaria magna: luminare mai' vt prees
set diei. et luminare min' vt preesset nocti:
et stellas. Et posuit eas in firmamento celi
vt lucerent super terra: et preessent diei ac no
cti: et diuideret luce ac tenebras. Et vidit
deus qp esset bonum: et factum est vespere
et mane dies quartus. Dixit etiam deus,
Producant aque reptile anime viuentis
et volatile super terra: sub firmamento ce
li. Creauitqz deus cete grandia: et omnes
anima viuentem atqz motabile quam p
duxerunt aque in species suas: et omne
volatile secundum genus suu. Et vidit
deus qp esset bonu: benedixitqz eis dicens, Cres
cite et multiplicamini: et replete aquas ma
ris: auesqz multiplicentur super terra. Et
factum est vespere et mane dies quint'. Di
xit quoqz deus, Producat terra animam
viuentem in genere suo: iumenta + repti
lia. et bestias terre secundum species suas.

25. London, British Library, ms. Add. 28106 ("Stavelot Bible"),
fol. 6r, Genesis initial.

27. Vienna, Österreichische Nationalbibliothek, cod. 2739★, vol. 10v,
Abraham, the sixth hour, and *iuventus*.

26. Vienna, Österreichische Nationalbibliothek, cod. 2739★, fol. 4v,
Noah, the third hour, and *adolescentia*.

28. Vienna, Österreichische Nationalbibliothek, cod. 2739★, fol. 11v,
Moses, the ninth hour, and *senectus*.

29. Vienna, Österreichische Nationalbibliothek, cod. 2739★, fol. 12v,
Christ, the eleventh hour, and *etas decrepita*.

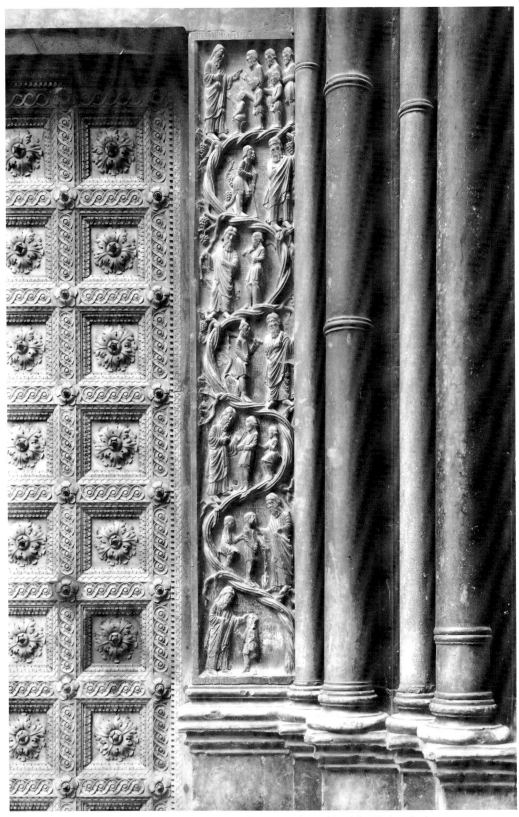

30. Parma, Baptistery, right jamb of west portal, Parable of the Workers in the
Vineyard. By Benedetto Antelami.

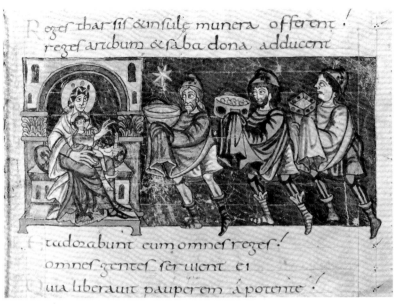

31. Stuttgart, Württembergische Landesbibliothek, Bibl. fol. 23 ("Stuttgart Psalter"), fol. 84r, the three Magi.

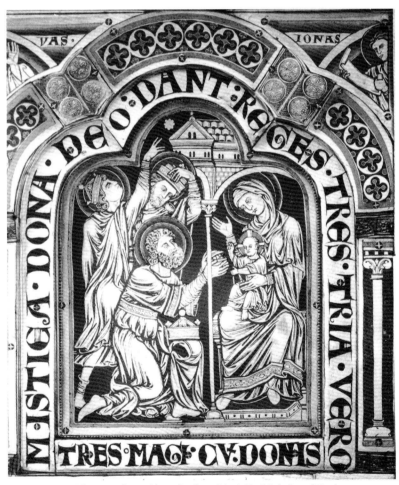

32. Klosterneuburg Altar, the three Magi. By Nicholas of Verdun.

er ne sur les iambes
wer se il na·i· an ou
pour la tendreur des
u volentiers se ploient
ent·

r quant les dens mai
selieres comencent a
ur li est bon de sav
he ce les genciues de
el ce li face on teint
t vne maniere paree
qui ne soit une trop
nece de racine de flors
r ces choses reonfor
chent les humeurs q
des enfans auienet·
mence a parler si est
nourrice sa vouche fro
ne ce de miel· ce plus
viaue verge lauer
nt a celui qui tarde
ler ce comencer a dire

car ce dire nest pas de nostre
entention· Le xx· chap coment
on se doit garder es iiij· eages
ce aidier la viellece ce soi main
tenir ione·

tir v premier eage ce v secot·
Or vous dirons coment chascun
se doit garder es autres eages·
premierement deues sauoir
que communaument li fisicien
dient que les eages sunt iiij·
li sieme adolescence a nmontir·

33. Paris, Bibliothèque Nationale, ms. fr. 12323 (Aldobrandinus of Siena, *Le régime du corps*), fol. 99r, the four ages of man.

onseil le px· que on doit gar
der son corps achastun aage·

a affoiblir ce di
d· ou h· ane·
est froide et me
dauce des froid
qui luy habon
deffaut de la ch
ce dure nistes·
en cel aage va
corps aptemet
sont iiij· aage
volons plet· ce
tilmer si pour

Auiendu aues come vo
demes faire vost esut
nomir ou pnuier aage et
ou second Ce vos dirons come

34. Biblioteca Apostolica Vaticana, cod. Reg. lat. 1256 (Aldobrandinus of Siena, *Le régime du corps*), fol. 42v, the four ages of man.

demeur de moralite q̃ lan ne doit pas
anoir pour seulemt̃ ne poz escouter.
Ançois doit lan mietre vis ⁊ poine a fe
rī ce q̃ue il enseignent.

il qui fist
cest ote a
uoit ber
anz passez
quant il la
print a fin
re. Et en
ce loue esp
ce de me q̃
dier li or
toue auoit il eslarie ⁊ use le poor ⁊ la me
mere des .iiij. tens raage. dome. Cest a

35. Paris, Bibliothèque Nationale, ms. fr. 12581
(Philippe de Novarre, *Des IV tenz d'aage d'ome*),
fol. 387r, first of the four ages of man.

tout ce a retret il otei eu afance q̃ ai ⁊
celes qui les nourrissent le doignent grant
de tous ces enseignemanz. Et arant se rest
li otes dantfance ⁊ parlora de iouent.

st otes dit
que iouent
est li plus sa
uillent de
tous. les .iiij.
tens raage.
dome ⁊ de sa
me. Car au
as ome la bu
che uers q̃
eit en son sune sanz plus tant q̃le sou
bien eschaufee ⁊ anpãse. Ainsi est draitt
ce a iouant. Nature sune en antfance
⁊ en iouent est li fer nature⁊ ⁊ apl

36. Paris, Bibliothèque Nationale, ms. fr. 12581
(Philippe de Novarre, *Des IV tenz d'aage d'ome*),
fol. 390r, second of the four ages of man.

de iouant. ⁊ se print a moien aage q̃
est li plus aroupez ⁊ li meillor de tous
les .iiij. tens raage. a cels ⁊ a celes qui
par la grace nr̃e seignor ensiuent ⁊ puie
ent user reisnablemt̃ selont dieu ⁊
selone droit de nature.

n moien a
age dout en
uestre q̃uoi
sanz. ⁊ diem
pez. ⁊ anne
stures ⁊ res
nables. ⁊ sou
nt afforme
⁊ estables.
en la uertie creance de nr̃e seignor
ihucrī. sages ⁊ porueus a lonor ⁊ au
profit dou cors ⁊ de lame de lui ⁊ des

37. Paris, Bibliothèque Nationale, ms. fr. 12581
(Philippe de Novarre, *Des IV tenz d'aage d'ome*),
fol. 395r, third of the four ages of man.

ieillesse qui est
tarvieux tes
⁊ la fins de la
aage de tous cels
⁊ de toutes ce
les qui uiue
rant est deue
ment uiel est
nuit perilleuse
chose. ⁊ dauge
reuse. Car la sont ce q̃ touons dit on grant
besoing de la grace nr̃e seignor. Et meiles
ce est li greignor besoig por bien finer.
Et touons dit on q̃ala bone fin na tout
Et proce q̃ onoissance ⁊ soutillere nature

38. Paris, Bibliothèque Nationale, ms. fr. 12581
(Philippe de Novarre, *Des IV tenz d'aage d'ome*),
fol. 401v, fourth of the four ages of man.

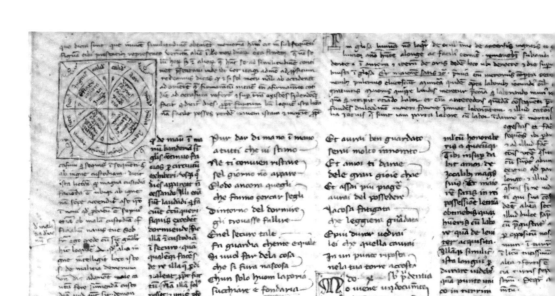

39. Biblioteca Apostolica Vaticana, cod. Barb. lat. 4076 (Francesco da Barberino, *I documenti d'amore*), fol. 79v, tetradic diagram.

40. Biblioteca Apostolica Vaticana, cod. Barb. lat. 4076 (Francesco da Barberino, *I documenti d'amore*), fol. 76v, the hours of the day and the ages of life.

42. Foligno, Palazzo Trinci, the Moon, an hour of the day, and the seventh age of life.

41. Biblioteca Apostolica Vaticana, cod. Barb. lat. 4076 (Francesco da Barberino, *I documenti d'amore*), fol. 77r, the hours of the day and the ages of life.

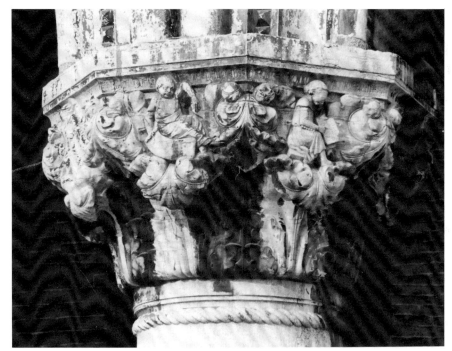

43. Venice, Palazzo Ducale, exterior arcade, capital, the first and second of the seven
ages of man under planetary influence.

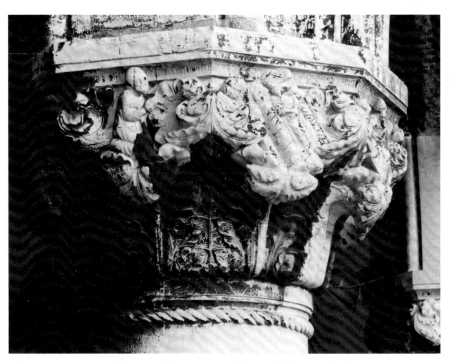

44. Venice, Palazzo Ducale, exterior arcade, capital, the seventh of the seven
ages of man and death.

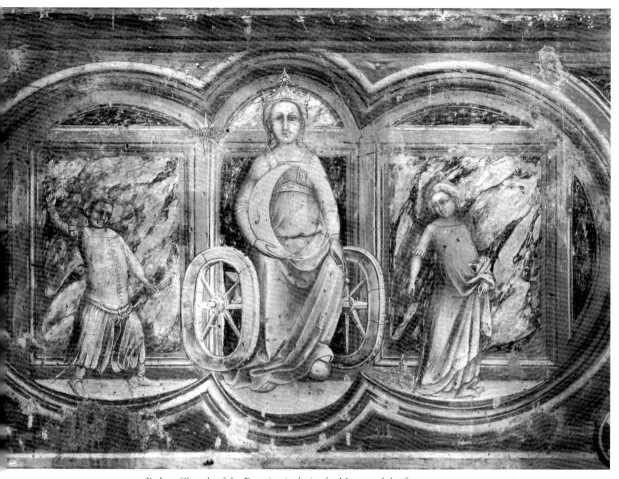

45. Padua, Church of the Eremitani, choir, the Moon and the first age
of life. By Guariento.

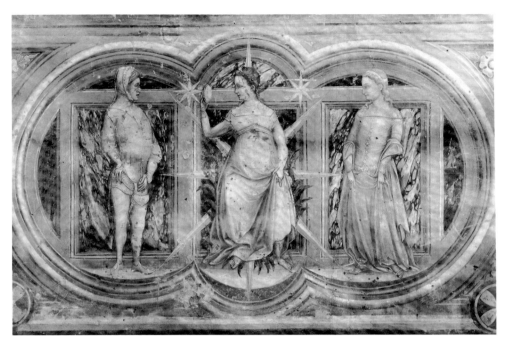

46. Padua, Church of the Eremitani, choir, Venus and the
third age of life. By Guariento.

47. Padua, Church of the Eremitani, choir, Mars and the
fifth age of life. By Guariento.

48. Padua, Church of the Eremitani, choir, Saturn and the
seventh age of life. By Guariento.

49. Oxford, Bodleian Library, ms. Can. Misc.
554, fol. 171r, the Moon and the first age of life.

CANCER

NAtus ſ cancro amedio Juny uſq̃ ad mediuz July. Erit rabens cor
pore uerboſus ſtatura equalis. De mulieribus multuz curabit. Humi
lis eſt hilaris. bonus. famoſus. ſapiens. artificioſus. propter inuidiam
damnuz pacietur ꝑculiuz ei dabitur. Cauſaz aliox ductor erit. Jur
gia lites cũ proximis ſuis habebit. De emulis ſuis ulaonẽ habebit ꝓ
Deigne aut de ferro ſignũ habebit. Jntrinſecus deueneno pacieᵗ dolorẽ
ꝑecuniam abſconſam inueniet. ꝓpter penaſ ſuigis ſue fortiter labo
rabit. Jpius aroganᵗia multis riſum faciet In aquis pluries metum
habebit. Anno. xxx. ꝑculuiz ſuum creſcere uidebit. Mare transibit
Wiuet annis. lxx. fortuna ſibi aplaudens erit. Sufficienter uiuet,

Eodem tp̃ore puella nata. Erit furioſa cito iraſcens cito placabilis. of
ficioſa prudens erit Jocoſa periculla multa pacietur. Sed euadet omnia
Si quis obſequiuz ſibi fecerit fructum habebit. Tempora eius erunt
laborioſa uſq̃ ad annũ. xxx. poſt hæ quietem habebit. Appellabitur
mater filiox uſq̃ ad annuz. lxxxvij. bonam fortunaz habebit. De
inimicis ſuis uictoriam uidebit. Anno deamo quarto nubere debet. Jp̃a
marito ſuo gratulabitur. ac pipius beneficia gratulabitur. Ad honorẽ
pueniet. Cicatrices habebit. ſed amedico curabitur. Jn aqua metum
habebit. Anno ſue etatis tercio de alto ruinam faciet. Canis morſu
ledetur. Anno. xvj. dolorem duriciem pacietur. Ad magnũ periculum
deueniet. ſed ſi euaxerit Wiuet annis. lxxiij. menſibus. vij. Dies Jouis
uteneris ſ istis meliores. dies martis maluſ.

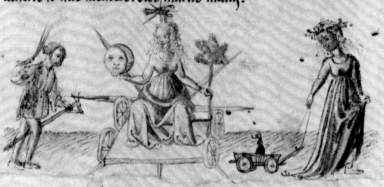

50. Modena, Biblioteca Estense, ms. lat. 697 (α. W. 8. 20) (*Liber physionomie*), fol. 4v,
the Moon and the first age of life.

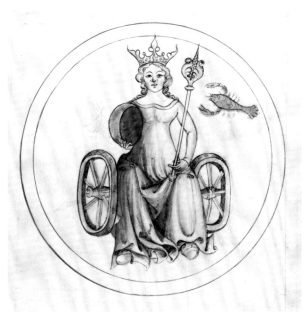

52. London, British Library, ms. Add.
16578, fol. 52r, the Moon.

Puella eo tempore nata. Cito erubesat. Timens erit. Inimicos suos
seperabit. Libenter peregrinabitur. per viaz suuz gaudebit. fortis erit
Curiosla Anno. xxxviij in meliorem partem deueniet Anno quinto
ifirmabitur. Canis morsum ut lupi patietur. Viuet annis. lxxxxx.
secunduz naturam. Dies sabati ⁊ martis st istis meliores. Dies
solis maluz in omni suo negotio.

51. Modena, Biblioteca Estense, ms. lat. 697 (α. W. 8. 20) (*Liber physionomie*), fol. 7v,
Saturn and the final age of life.

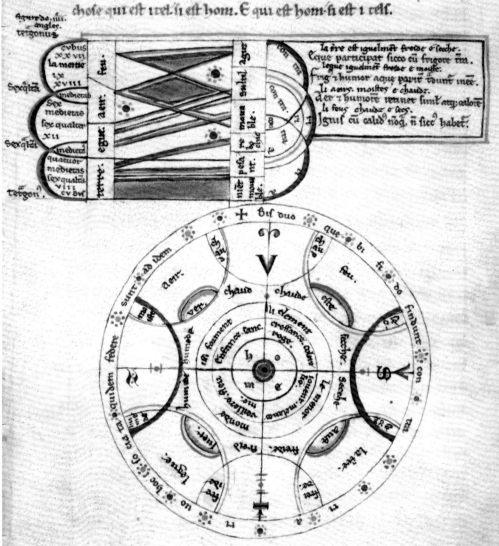

Or auom dit les uers de cest metre. e lesposicion briement. Or
dirom la grant glose de noz maistres. de cest meesmes metre. Phi.
tu qui gouernes le monde par pardurable raison. Phi.
apele deu sanz nom. Cle ne puet auoir en liu del nom.
ne disinicions. ne descriptions. Car descriptions deit
estre faite. de granz par granz. qui seient mene iusq
a egalte. Esample. com est ici. Hom est beste. raisnable. mor
tel. alable. qui a dous piez. paisible. receuable de decepline. Tote la
chose qui est itel. si est hom. E qui est hom. si est itel.

53. Vienna, Österreichische Nationalbibliothek, cod. 2642 (Boethius, *Consolatio philosophiae* in
French translation with gloss), fol. 33r, schema of the elements and tetradic diagram.

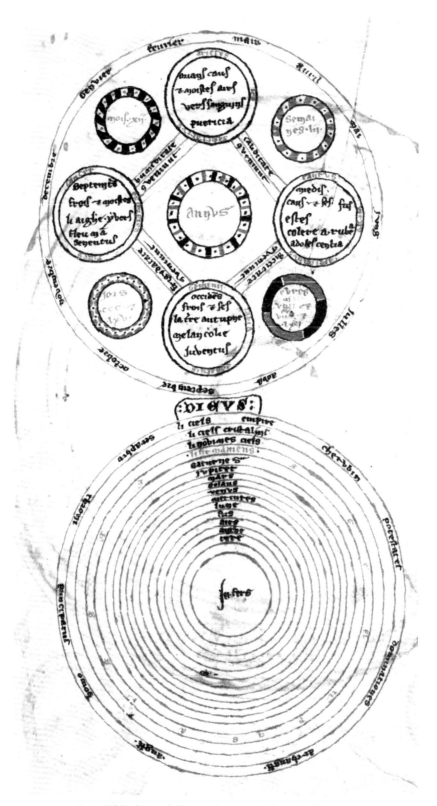

54. Paris, Bibliothèque de l'Arsenal, ms. 3516 (Gossuin of Metz, *Image du monde*), fol. 179r, tetradic diagram.

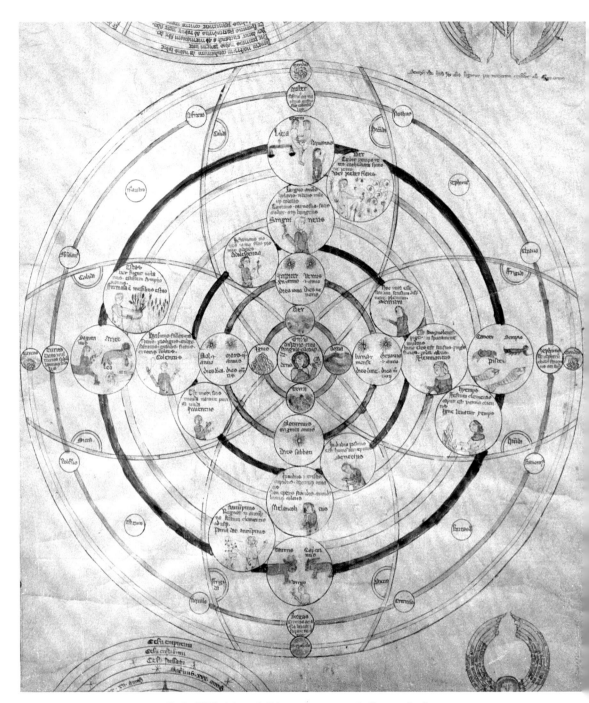

55. Paris, Bibliothèque de l'Arsenal, ms. 1234 (roll), tetradic diagram.

Les six premiers ans q̃ vit lhõme au monde .
Nous comparons a Ianuier droictement .
Car en ce moys vertu ne force habonde . ✓
Non plus que quant six ans ha vng enfant .

Lan par decembre prent fin &ʃe termine
Auʃʃi fait lhõme aux ans ʃoixãte douʒe
Le plus ʃouuent : car vieilleʃʃe le mine
Lheure eʃt venue q̃ pour partir ʃe houʃe

56. New York, Pierpont Morgan Library, ms. M. 813
(Book of Hours), fol. 2v, the first age
of man (January).

57. New York, Pierpont Morgan Library, ms. M. 813
(Book of Hours), fol. 19r, the twelfth age
of man (December).

58. Madrid, Biblioteca Nacional, cod. Vit. 24-3 (Book of Hours), p. 7, a bad and good man at the fifth of twelve ages (May).

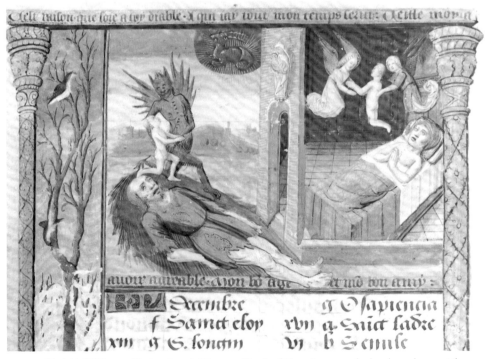

59. Madrid, Biblioteca Nacional, cod. Vit. 24-3 (Book of Hours), p. 14, a bad and good man at the last of twelve ages (December).

60. Dublin, Chester Beatty Library, ms. 80 (Jean Raynaud, "Viridarium"), fol. 6v,
first of the six ages of man.

61. Dublin, Chester Beatty Library, ms. 80 (Jean Raynaud, "Viridarium"), fol. 7r,
five of the six ages of man.

62. London, British Library, ms. Add. 11390 (Jacob van Maerlant, *Der naturen bloeme*), fols. 1v–2r, six ages of man and death.

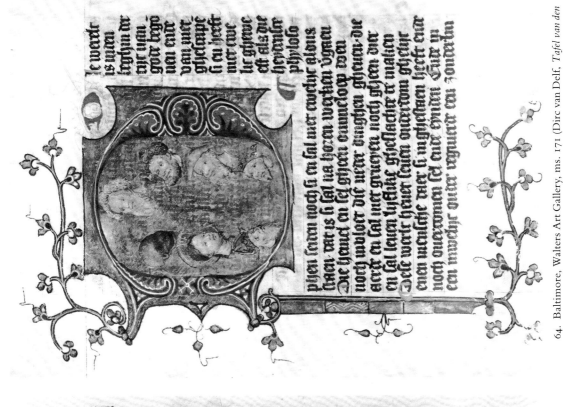

64. Baltimore, Walters Art Gallery, ms. 171 (Dirc van Delf, *Tafel van den Kersten Ghelove*), fol. 32v, the seven ages of the world.

63. Baltimore, Walters Art Gallery, ms. 171 (Dirc van Delf, *Tafel van den Kersten Ghelove*), fol. 30r, the seven ages of man.

65. Munich, Bayerische Staatsbibliothek, clm. 19414,
fol. 180r, five ages of man.

66. London, British Library, ms. Royal 6 E. VII (Jacobus, "Omne bonum"), fol. 67v, children at play.

67. Paris, Bibliothèque Nationale, ms. fr. 22531 (Bartholomaeus Anglicus, *De proprietatibus rerum* in French translation), fol. 99v, four ages of man.

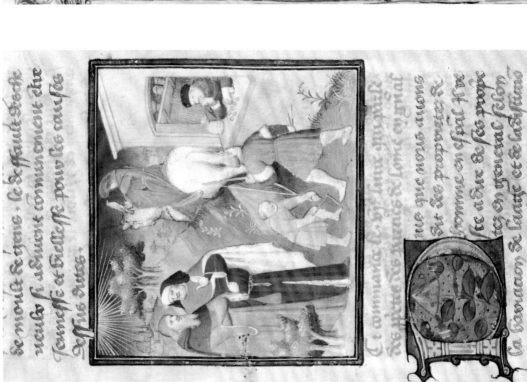

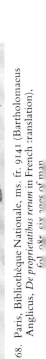

68. Paris, Bibliothèque Nationale, ms. fr. 9141 (Bartholomaeus Anglicus, *De proprietatibus rerum* in French translation), fol. 98r, six ages of man.

69. Minneapolis, University of Minnesota, James Ford Bell Library, 1400/f Ba (Bartholomaeus Anglicus, *De proprietatibus rerum* in French translation) [not foliated], seven ages of man and death.

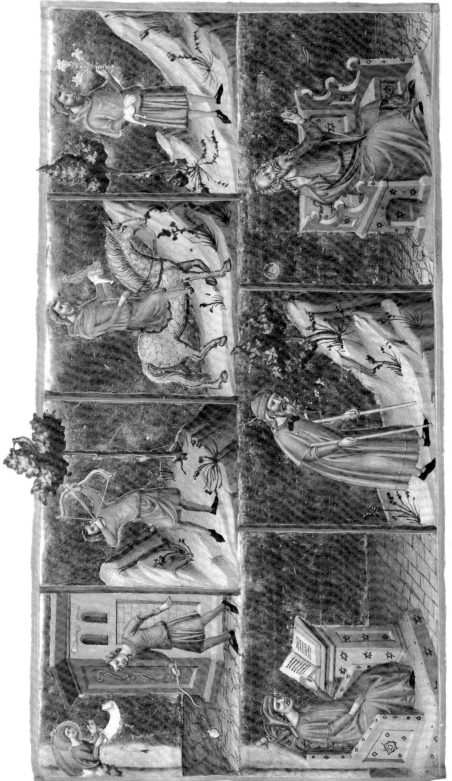

70. Paris, Bibliothèque Nationale, ms. lat. 8846, fol. 161r, the seven ages of man illustrating Psalm 89 (90).

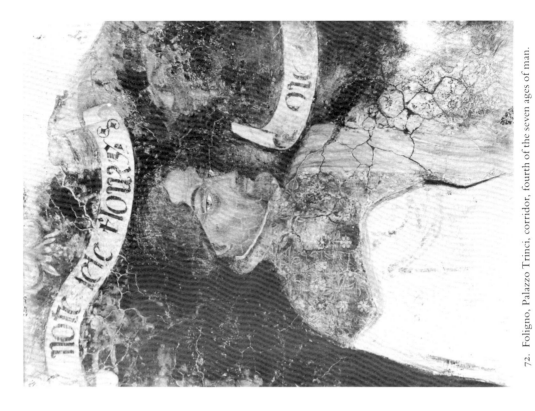

72. Foligno, Palazzo Trinci, corridor, fourth of the seven ages of man.

71. Foligno, Palazzo Trinci, corridor, first of the seven ages of man.

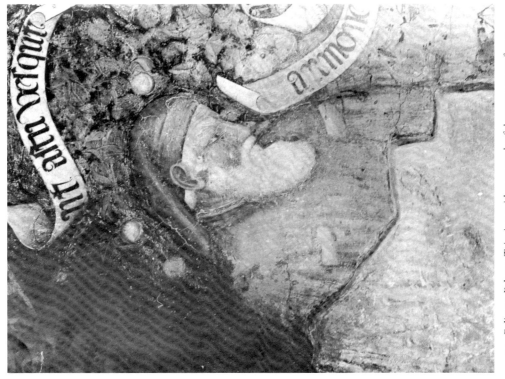

74. Foligno, Palazzo Trinci, corridor, seventh of the seven ages of man.

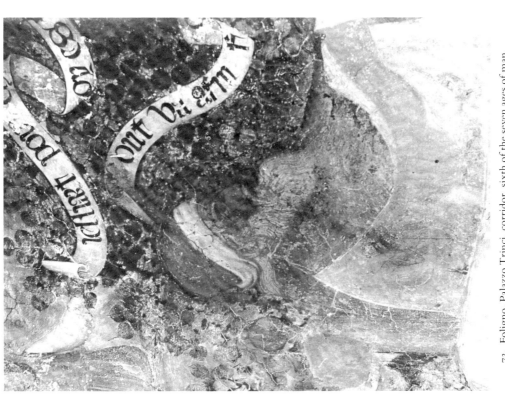

73. Foligno, Palazzo Trinci, corridor, sixth of the seven ages of man.

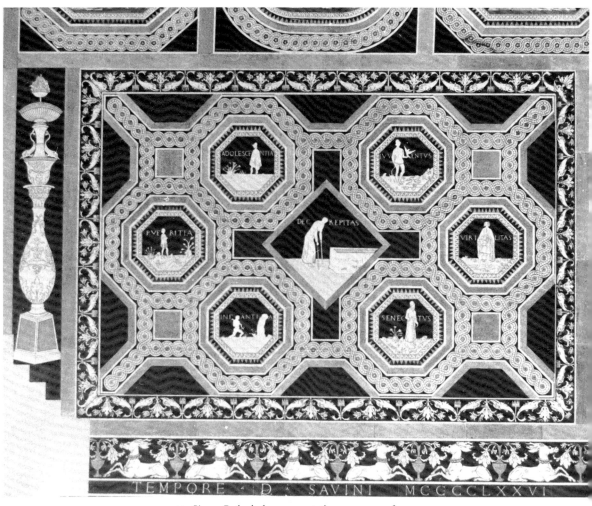

75. Siena, Cathedral, pavement, the seven ages of man
[reconstruction]. By Antonio Federighi.

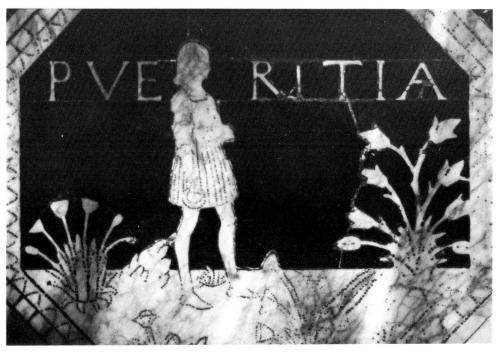

76. Siena, Cathedral, pavement (transferred to the Museo dell'Opera del Duomo),
second of the seven ages of man. By Antonio Federighi.

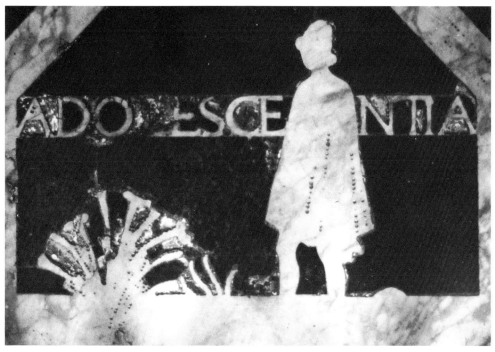

77. Siena, Cathedral, pavement (transferred to the Museo dell'Opera del Duomo),
third of the seven ages of man. By Antonio Federighi.

78. Longthorpe Tower (Northants.), north wall, the seven ages of man.

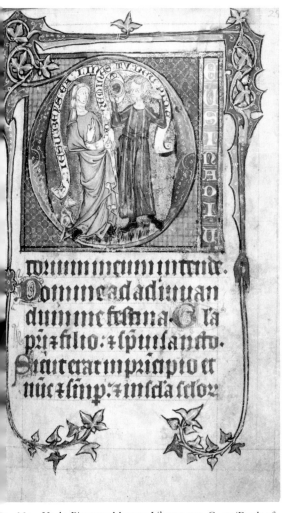

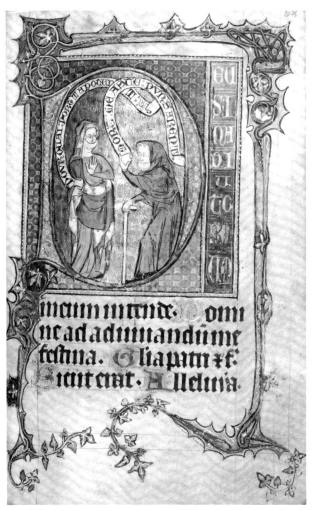

. New York, Pierpont Morgan Library, ms. G. 50 (Book of
 Hours), fol. 29r, lauds and the second age of life.

80. New York, Pierpont Morgan Library, ms. G. 50 (Book of
 Hours), fol. 68r, none and the sixth age of life.

81. London, British Library, ms. Add. 37049, fols. 28v–29r, "Of the Seuen Ages."

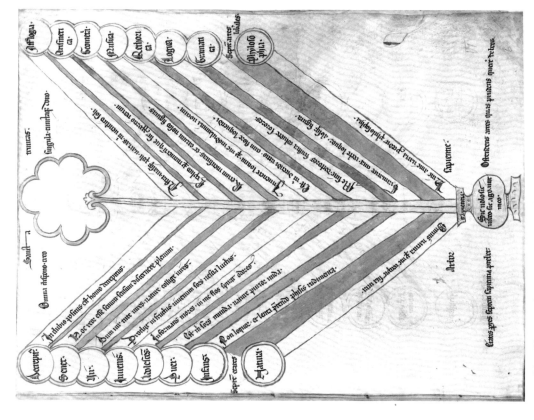

83. New Haven, Yale University, Beinecke Rare Book and Manuscript Library, ms. 416, fol. 6r, Tree of Wisdom.

82. Paris, Bibliothèque de l'Arsenal, ms. 1037, fol. 5v, Tree of Wisdom.

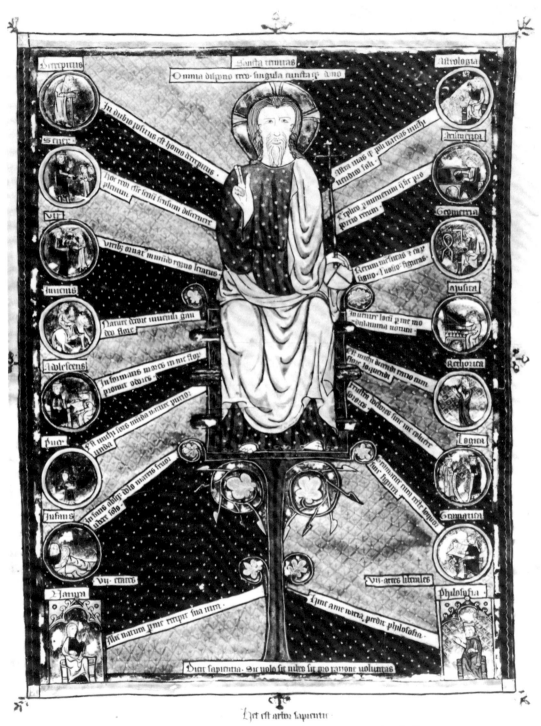

84. Paris, Bibliothèque Nationale, ms. fr. 9220 ("Vrigiet de solas"),
fol. 16r, Tree of Wisdom.

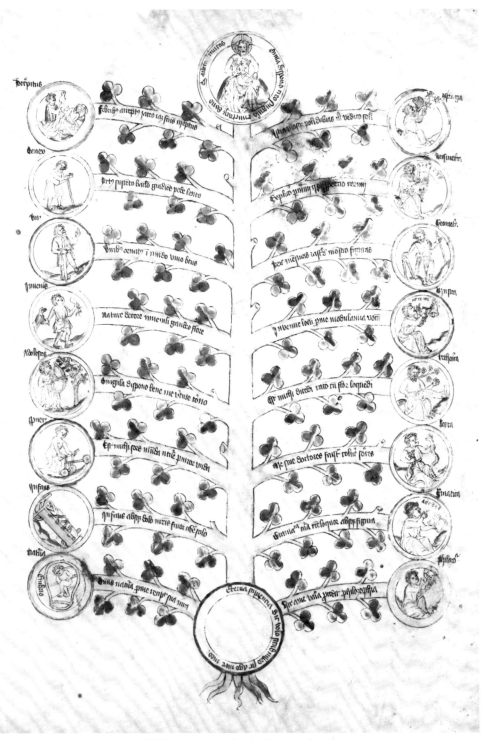

85. London, Wellcome Institute for the History of Medicine, ms. 49,
fol. 69v, Tree of Wisdom.

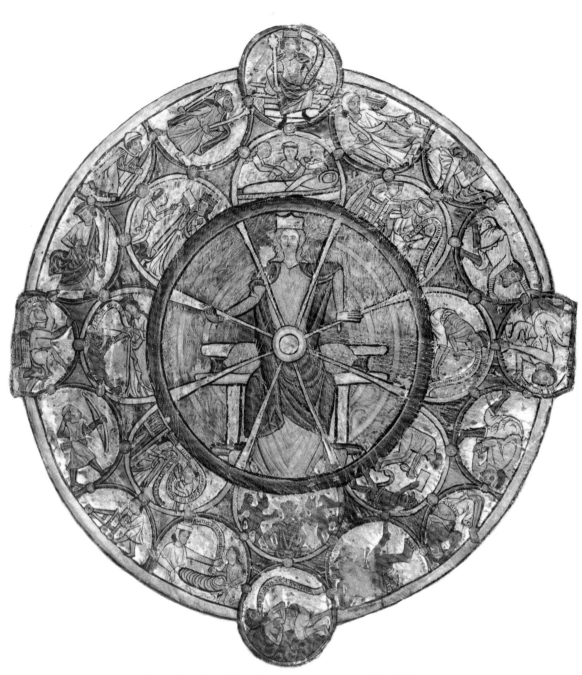

86. Cambridge, Fitzwilliam Museum, ms. 330, no. 4, Wheel of Fortune.
By William de Brailes.

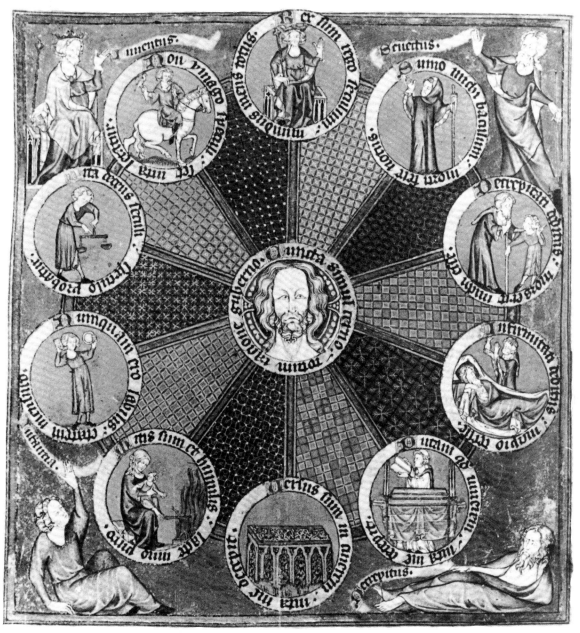

87. London, British Library, ms. Arundel 83 ("Psalter of Robert
De Lisle"), fol. 126v, Wheel of Life.

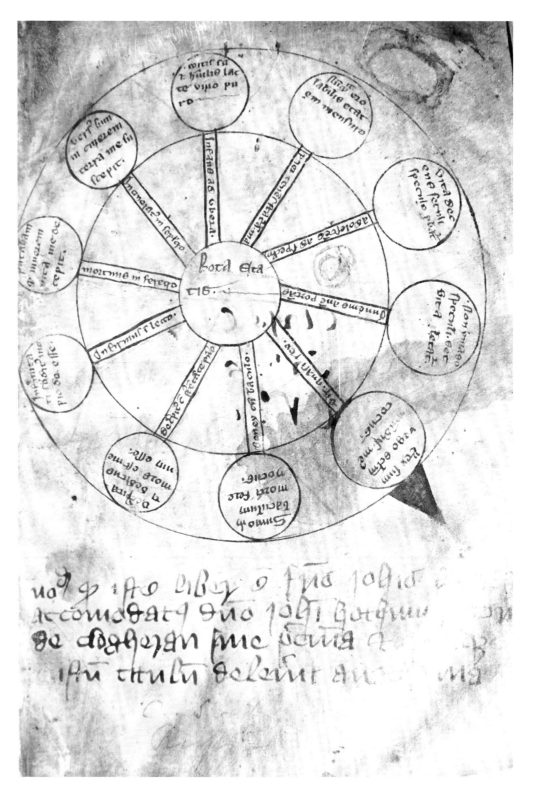

88. Dublin, Trinity College Library, cod. 347, fol. 1r, Wheel of Life.

89. Kempley (Glos.), Church of St. Mary, north wall of nave, Wheel of Life.

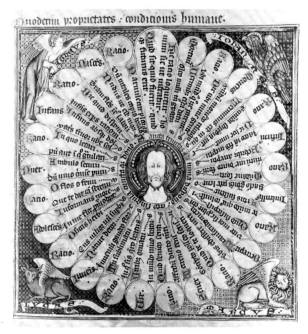

90. London, British Library, ms. Arundel 83 ("Psalter of
Robert De Lisle"), fol. 126r, *Duodecim proprietates
condicionis humane.*

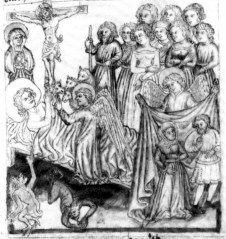

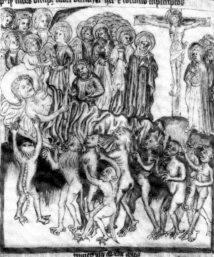

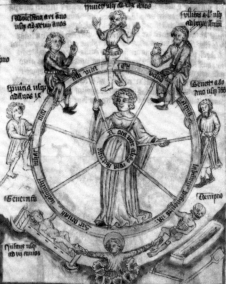

91. London, Wellcome Institute for the History of Medicine, ms. 49, fol. 30v, Wheel of Life.

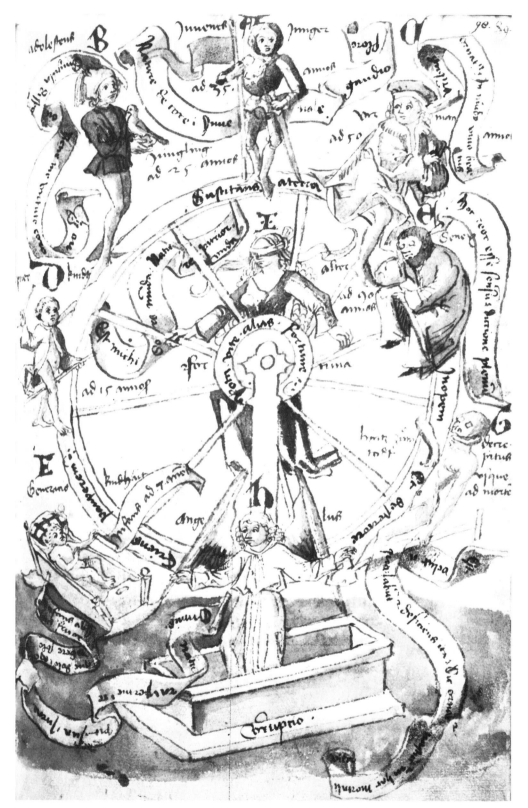

92. Munich, Bayerische Staatsbibliothek, cgm. 312, fol. 98r, Wheel of Life.

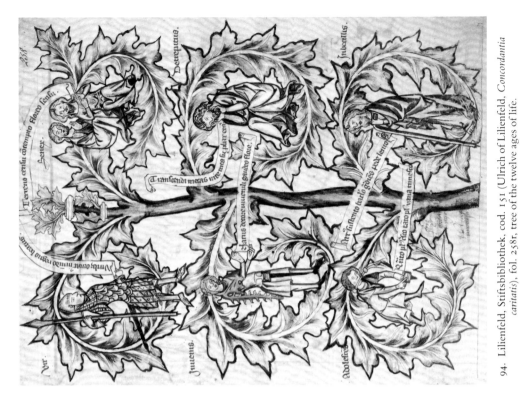

94. Lilienfeld, Stiftsbibliothek, cod. 151 (Ulrich of Lilienfeld, *Concordantia caritatis*), fol. 258r, tree of the twelve ages of life.

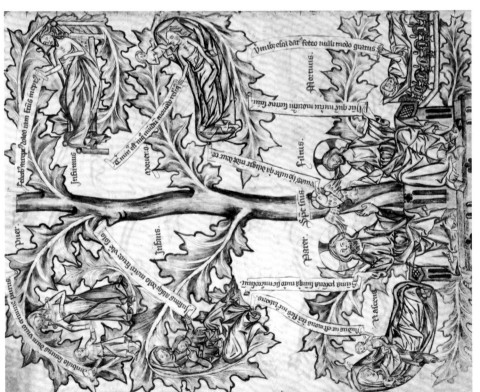

93. Lilienfeld, Stiftsbibliothek, cod. 151 (Ulrich of Lilienfeld, *Concordantia caritatis*), fol. 257v, tree of the twelve ages of life.

96. New York, Pierpont Morgan Library, ms. M. 1045 (Ulrich of Lilienfeld, *Concordantia caritatis*), fol. 259r, tree of the twelve ages of life.

95. New York, Pierpont Morgan Library, ms. M. 1045 (Ulrich of Lilienfeld, *Concordantia caritatis*), fol. 258v, tree of the twelve ages of life.

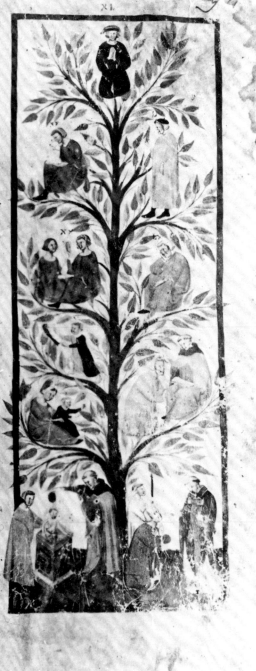

a pagare. Et fa che sieno bene pagati. Apresso
guarda che tenghi qua sempli di tutti li sua
giuramenti de consigli. che tocano ate catio se
namenti de intulianica che ti tene possa
mare. se luomo el che tresse sopra nullo fatto.
De le cose che l signore de sire allu scita del
se ssuo suo.
¶ Quando viene lo di ultimo di ditio of
ficio tu dei numiare la gente de la citta. e di
re dinanci loro di grandi parole egualicose
p acquistare lamore de cittadini. e ricordare
te ale buone opere. e lo nore. e li utilita del cho
mune. che auenuto nel tuo tempo. Engingna
re loro de lonore ede lamore che anno mo
strato ate catioi. Et proferire te et tutto tuo
potere allo nore el su gio loro sempre mai.
Et p meglio errare li cuoi delegenti ate tu
puoi dire. che se alcuno a fallito nel suo te
po de l tuo sanimento. tulli p doni. o p nigli
gentia. o p non sapere. o p altru cagione. se cio
non fosse falsita. o la detto necro. o aleri mase
tori. o condannati de la citta. O ututta uia
tutta signoria in fino a mezza notte con
comenciasti alaprima entrata. A presso
questo parlamento lo di medesimo. o alto
apresso seco l usata de l paese. de tu rende
re al nouel signore o al tra martingo tutti
eli libri e tutte le cose che tu aueui del comu
ne. E poi tene andrai alalbergo oue tu
dei albergare tanto quanto tu di morai a
rendere tua ragione. Come l signore de
dimorare crendere sua ragione.
¶ Quando tu sei acio venuto che comue
One che tu stia a sindacato. e renda ra
gione di tutto el tuo officio. e di tutto
ti se nullo ui fosse che si lamentasse se
dire tu dei fare dire le petitioni ditto
dimando cauere consiglo da tuoi saui
e rispondere come ti consiglieranno. In
questo dei tu dimorare nela citta in fino
al giorno che fu ordinato quando tue
prendesti la signoria. Allora secio pia
ce tu sarai assoluto onoreuolemente et
prenderai comiato dil comune edal
consiglio de la citta. Et andiamene cô
gloria econ onore ecom buona uen
tura.

¶ Finito libro referamus gratia xpo.

¶ Explicit tesaurus ser Burnetti latini.

98. London, British Museum, Steps of Life. By Jörg Breu the Younger.